HENDRIK NEUBAUER (ED.)

THE SURVIVORS

TRIBES AROUND THE WORLD

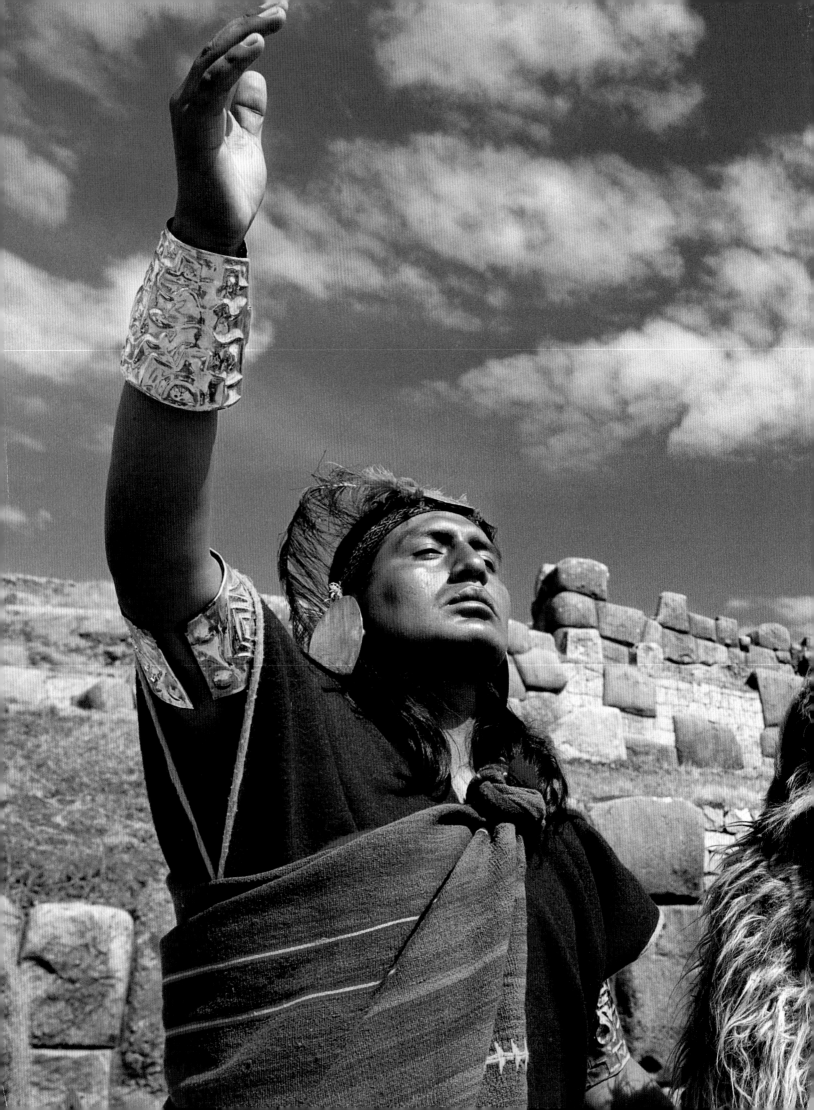

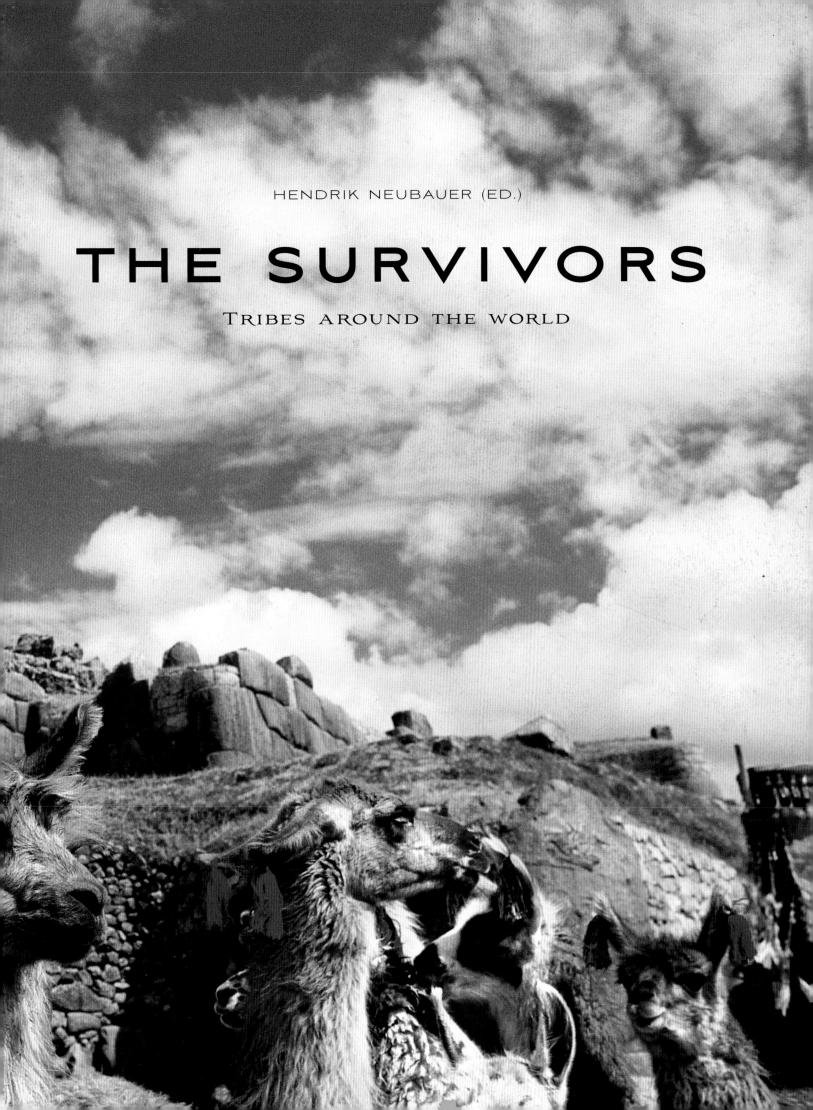

HENDRIK NEUBAUER (ED.)

THE SURVIVORS

TRIBES AROUND THE WORLD

An ethnic diversity made up of over 6,000 different peoples lies embedded within the political maps of the twenty-first century. Many borders, not only those in Africa, crisscross through settlement regions that have been in existence for centuries. Our book takes the borders into account, while giving equal attention to the minorities. The book The Survivors examines how these ethnic groups have withstood the pressure to become integrated exerted by the majority population, and takes a look at their prospects for the future.

The Survivors takes the risk of reducing the staggering variety of ethnic groups. The editors have had a host of brave and proficient assistants on hand to help. These include the photography agency Agentur laif and all its partner agencies. In putting together this overview of the present-day life of minority ethnic groups, they have taken every risk, leaving no path unexplored, in seeking out the particulars that best explain the general situation. Other authors contributed their knowledge and experience in the texts accompanying the photo reportage.

Our reports take you to places which you can travel to yourself at some time, at least virtually, with the help of the coordinates provided. There are also links to artists who communicate in the global language of music. The Survivors is like a map with its own accompanying soundtrack, a book that, in its own unique way, is like a full length documentary film.

Finally, after long and intensive work on the book, I have but one immodest wish for our future: that we respect diversity.

With this in mind,

Hendrik Neubauer

INUPIAT 42
INUIT 40
32 KALAALLIT

THE FAR NORTH

FOUR SEASONS

BLACKFOOT 46
LAKOTA SIOUX 50
SHOSHONE 48

NAVAJO 144
HOPI 148
APACHES 150
TARAHUMARA 152

SUN, SAND AND DUST

HAWAIIANS 288

LACANDON 162
158 TZOTZIL
CAQCHIKEL 168

KUNA 170

ALONG THE EQUATOR

YANOMAMI 172
ZOÉ 178
AWÁ GUAJÁ 182
186 SHUAR
190 QUECHUA

KAYAPO 196
KAMAYURÁ 200

AYMARA 204

RAPANUI 322

WIDE WORLD

MAPUCHE 324

THE FAR SOUTH

ESSAYS

Paradise 2.0

ENCOUNTERS IN THE AGE OF GLOBALIZATION

You are meeting a shaman. Does he even know you are there? He spins and moves around, banging on a drum, dancing to the swaying rhythm. He is reeling, or maybe staggering is a better word. Is he on drugs? You stare until the images begin to swim before your eyes. The illusion is perfect. The video clip is shaky, and there is no soundtrack, but you feel like you just took a trip to the Ecuadorian rainforest. It is all right there on the computer screen, just one click of the mouse away, a brief, sensual experience, but one that can have serious consequences.

Somewhere out there in the wilderness of the World Wide Web, this very same video is waiting for you, on demand. You can pull up adventures like this on your computer screen twenty four hours a day, visiting places and seeing things that once would have been impossible to experience without a great deal of time and money. Where the world's aboriginal peoples are concerned, our field of vision has broadened considerably. The Internet has become our means of connecting with the farthest corners of the world. We can do a Google search and come up with a region, or better yet, a place name, which we can then plug into a satellite image site that will transport us there in seconds. Our spirit of adventure is awakened, and mankind loves to explore. The possibilities available to the media consumer today are simply overwhelming. Globalization also means that the words »remote« and »distant« mean less and less with each passing day. From our seat in front of the computer, we are becoming increasingly interested in other people and their lives. We empathize with their fears, gain respect for their knowledge and wonder about their view of the world. What were abstract problems once take on a human face. Environmental issues in faraway lands, political unrest, and social dis-

crimination are brought closer to home, as are potential solutions, like buying fair trade products. We now understand the world's problems as situations affecting real people, the kind you could come across any day.

We would like to expand your horizons from one end of the world to the other, and into all the out of the way places in between. The subject is aboriginal peoples, their way of life, and their view of the world. The authors of this book hope to convey just how much there is to learn from contacts like this. Perhaps the reader, after looking over these very diverse ethnic identities, will then take the time to reevaluate the frenetic tempo of his or her own life.

»New tribe discovered!« Headlines like this have been selling newspapers for hundreds of years. In fact, nearly all the planet's five thousand ethnic groups and smaller tribes were discovered long ago. Most people think that there are no more white areas on the map, that all the people on the earth have been discovered and plotted. How then, does one explain why there are still reports of undiscovered tribes living in the primeval rainforest in »stone age« conditions? Once the reporters, photographers and film crew arrive, what is it about their stories and pictures that never fail to move us so deeply? Is it melancholy or sadness, or a yearning for a lost paradise? The boundary between deeply felt sentiment and voyeurism can be ephemeral.

Discovery, for the discovered, usually ends in conflict when the discoverer, or those bringing up the rear, wants to return, or stay. The discoverer has consumer goods and guns at the ready. Going back through history of such encounters from the Early Modern period to today, nearly all are stamped with inequality from first contact onward. It was often thought that

mankind was far too advanced, transportation networks too near, the times too progressive, and the possibilities too great for aboriginal peoples to continue living as they always had.

The Survivors pushes open a window into the virtual world by providing coordinates for a Google Earth search and websites with sound files of the music. What do these people sound like? What kind of music do they make? How do they speak their language? All is revealed at a glance. The maps graphically portray the wide range of utterly incomprehensible things that happen on our planet. Where are aboriginal territories disappearing, and where are these people fading away? What invaluable knowledge is dying out with them? What about the survivors, those who have managed to live in the most inhospitable lands in the most ecologically sensible way? Do they paradoxically development- and environment-obsessed age? What does it mean to exist independently on the very edge of our globalized society? What does it mean to be a self-aware aboriginal people struggling to survive as citizens of the world with the same rights as western nation states?

It would be naive to think we could exhaustively answer these questions once and for all. Our book sums up the situation of indigenous ethnic groups at the start of the twenty first century, covering the victories as well as the defeats. Many aboriginal peoples today are little more than a mouse click or telephone call away. When we encounter one another, it is as citizens of the world, a phrase that will have more and more meaning as we each rise up to claim our membership in a global society made up of diverse individual identities. We live in an interconnected, technological and economically integrated world.

HENDRIK NEUBAUER

Shaman of the Shuar, Ecuador. The medicine man is also the social pivot of many indigenous groups.

Global Lobby

SURVIVAL AS THE COMMON GOAL

From the point of view of the »natives,« tourists are picturesque. When the Indians of the Caribbean islands first saw Christopher Columbus with his feathered hat and red silk cape, they thought he was a never before seen, unusual species of parrot.

So commented Uruguyan novelist Eduardo Galeano in a 2005 interview published in Una Citta. In this case, as with every other attempt to describe the thought processes of an aboriginal group, the context is significant. Galeano's intentions are good, for how else can the standpoint of an isolated ethnic group be conveyed, especially when the people themselves are illiterate? There are cultures that for the greater part of the twentieth century had no one standing up for them at all.

There are still aboriginal groups in the Amazon today with next to no contact with the outside world. Estimates point to some twenty-five indigenous ethnicities living largely isolated lives in Brazil, with another ten tribes in Peru. In general, most of these »tribes« consist of one or more groups with a total of less than one hundred members.

In the beginning, the Brazilian FUNAI (Fundacao Nacional do Indio = National Foundation for Indians) promoted the political goal of »civilizing the Indians as fast as possible.« Representatives of the government agency would be met with a hail of arrows, and both visitors and Indians could be killed. Just as often, the aboriginal peoples simply fled deeper into the jungle before them. Sydney Possuelo, an energetic supporter of aboriginal rights and founder of the FUNAI Department of Isolados, described how things were done in the early days.

Earlier, it was utterly normal for forty or fifty Indians to be killed when the government officials from FUNAI entered a tribal area.

The nationalized oil company workers who followed in the wake of FUNAI would often burn down entire villages.

FUNAI's current policy calls for providing the isolated ethnic groups with free territory in protected areas. If a group wants to live in isolation, it is their choice, their own decision, and one which will be officially respected. It is also a good decision for the isolados, as the history of their contact with the civilized world makes clear. Isolated peoples lack antibodies against diseases like whooping cough, chicken pox, measles, tuberculosis and influenza. The vectors for the transmission of viruses like these can be little more than an innocent handshake, a sneeze or cough by a visitor, or even a donated piece of clothing. An infected pair of shorts, or a t-shirt, are enough to wipe out an entire village, should the virus be allowed to spread. Contacts like these still cannot be entirely avoided. Despite the existence of laws and posted areas administered by FUNAI, lumber companies, oil firms, missionaries and adventurers still find their way into the furthest reaches of the most distant territories of the most isolated ethnic groups.

Recent studies have shown that seven tenths of the population of the earth live on just 38 percent of its land. The last wild places still take up nearly half the land on earth, and they still conceal rich deposits of mineral wealth and other raw materials. The logic of the global economy requires that these resources be exploited. Arguments in favor of mining and logging have long been supported by the fact that so few people live in these areas, and that their population is already on the decline. Over the course of the last century, however, the aboriginal peoples have gained a decided advantage. They now either have the support of a lobby, or have started to lobby for themselves. Today, indigenous peoples can count on the support of environmental protection agencies and politicians from the Arctic Circle to the southern tip of South Africa as part of a general policy of wilderness preservation. Support for aboriginal peoples, which began primarily as a human rights movement, is understood as an expression of solidarity today, with the common goal of saving the planet. Our earth desperately needs its green lungs, and saving the people who have made these lungs their home, those who, for many centuries have preserved the environment and made life there a viable proposition, is understood as being in the best interests of all of us. Once the seriousness of the danger to these peoples and places became widely known, a broad front of support emerged, one that crossed the lines of borders, nations and ethnicity. It is the very extent of this lobby that has contributed something utterly new to the situation of aboriginal peoples worldwide.

HENDRIK NEUBAUER

Farmer with his grand children in the province Uttaradit, Thailand. He does not use any chemicals on his fields.

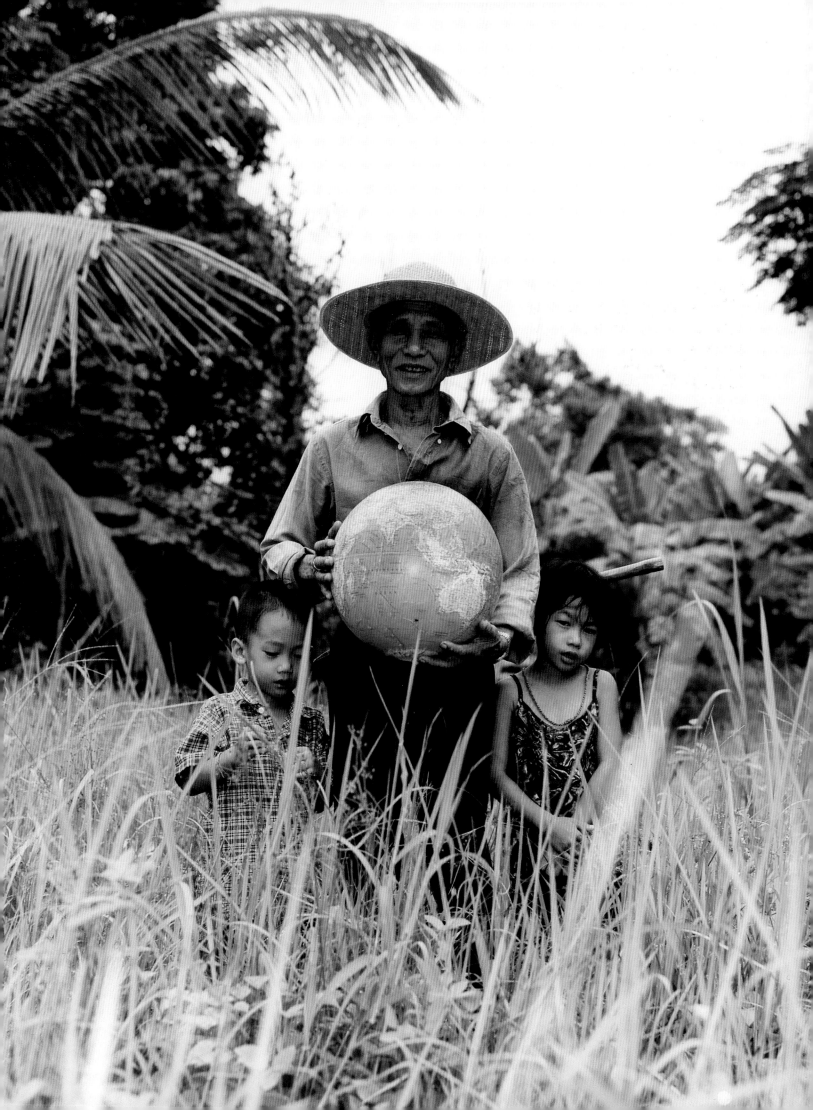

People

ABORIGINES, TRIBES AND ETHNIC GROUPS

There is no such thing! Can there really be aboriginal peoples in the twenty-first century? The term describes people all around the world who continue to live a nomadic lifestyle, or who have only recently settled. They inhabited the land long before Columbus, Magellan or Vasco da Gama »discovered« the world for Europe. The new settlers from the west overthrew, colonized and drove aboriginal peoples out of their home territories. They forced native populations to integrate and, ultimately, subsume their identity under the banner of the newly evolved nation state. Many great and populous cultures were snuffed out, among them the Aztec Empire. In 1521, Hernando Cortez's victory in a vicious, final battle ensured the fall of the greatest and most advanced culture of what is today Mexico. Hundreds of thousands of Aztecs were killed, and centuries of imperial infrastructure went up in flames.

Over the course of world history, many indigenous groups have migrated, reappeared, and then disappeared again. The official estimate is that there are between 250 and 300 million aboriginal people in the world today. Seventy-six nations are home to 5,000 different indigenous population groups. The United Nations Working Groups on Indigenous Populations (WGIP) has four criteria for declaring a people or ethnic group indigenous and aboriginal. That group must qualify as the »first« or earliest in a given territory. It must hold fast to its unique cultural, linguistic and/ or religious characteristics and practices.

There must also be some degree of self-identification as an indigenous group. In other words, it must be clear who is a Basque, Lobi or Wa, and who is not. The final criterion is a historical and/or current experience of marginalization or oppression by an incoming population. Most of the groups examined in these pages, like the Ainu in Japan, call themselves by a name that simply means »the people« or »the humans.« The great colonial powers were not in the least interested in human dignity for the aboriginal peoples. They called them names like »the hairy barbarians,« which is how the Japanese refer to the Ainu, or, as in South Africa, »the Zulu Kaffir« an ethnic slur used for all dark skinned Africans that means something like »heathen.« Whenever white conquerors encountered the inhabitants of the rain forest, be it in the Amazon or the New Guinea Highlands, they were quick to describe the populations they found there as tribal peoples who stood in the way of the land hunger, need for raw materials and power struggles of the rest of the world. In the civilized world, the term »tribal« became interchangeable with anything wild, primitive or hopelessly backward.

What has the advent of the twenty first century brought to the world's aboriginal peoples subsumed under the broad category of »tribal?« Academically defined, tribal peoples possess one or more of the following characteristics: their social groups must extend from the closest blood relationship to the most dis-

tant relatives. There should be a common language, a common economic basis and identical cultural practices. Ideally, all members of a tribe should live in the same area as well. When we call a people tribal, we are talking about groups like the Adavisi, the indigenous peoples of India, as well as tribes of China, which have 70 to 80 million members. Very different groups like the central African pygmies, Malaysian Penan, Tuareg of the Sahara states or Sami of the far north of Europe are also properly described as tribal. All have a common culture with its own language, religious customs and value systems, layered on top of a lengthy, historical struggle for survival, although these days, many aspects of their cultures have changed.

It is this battle for survival and the changes it has wrought that has taken The Survivors around the world and back again. There term »tribe« has been used to open a historical window on the colonial period, and because the term frequently pops up in adventure literature. We wanted nevertheless to present an undisguised view of these groups and their present day situation, whatever they are called, be they aboriginals, races or ethnicities, communities or indigenous peoples, hoping that in the process they would reveal some of their secrets. They continue to speak their own language, preserve their culture and share the same experiences, even if the tribe or group or ethnicity in question is scattered over hundreds or thousands miles.

HENDRIK NEUBAUER

Aborigine at the Rio Conambo, Ecuador. They call themselves Shuar. The Spanish coined the name Jivaro.

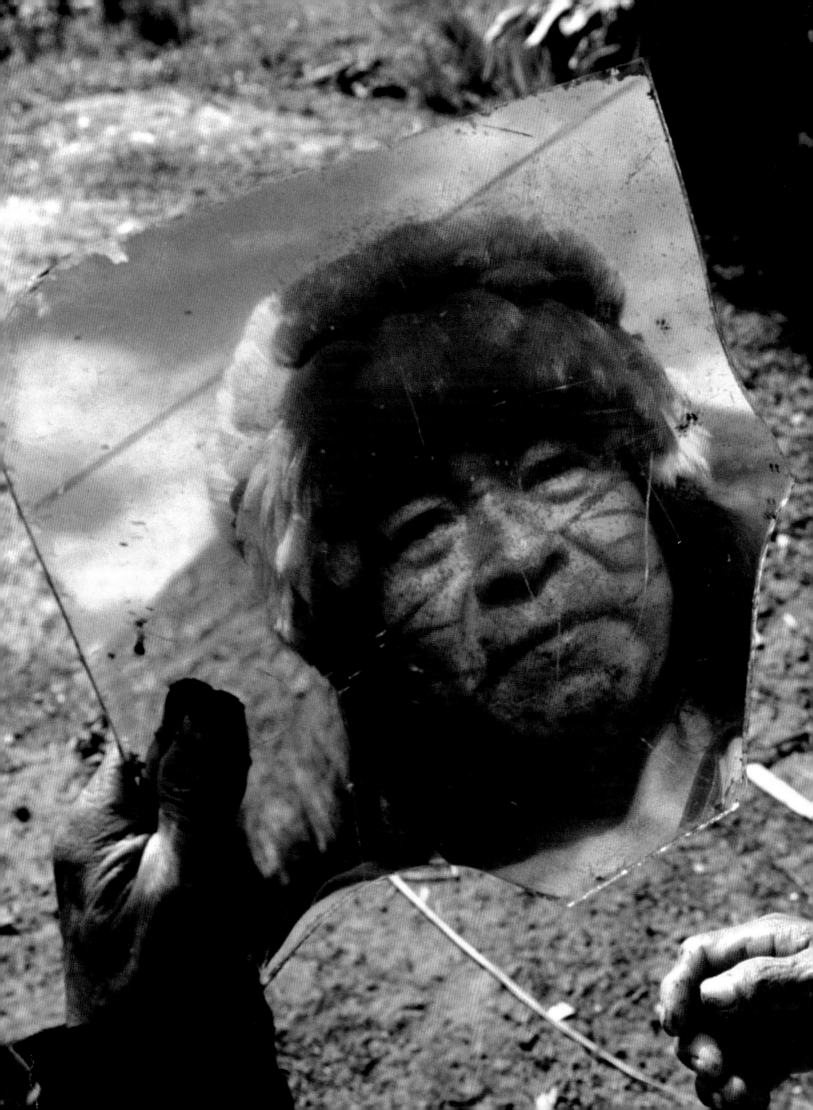

The networked world

ABORIGINES WITH TELEPHONES AND COMPUTERS

A stroller walking down New York's Fifth Avenue on a perfectly normal day sees more people than a hunter-gatherer is likely to see in his or her entire lifetime. This observation belies the reality that more and more twenty-first century aboriginal peoples communicate to a large extent using the Internet, and by mobile telephone via satellite uplink. Cell phones, chat groups, email, websites and news groups are making inroads into the furthest corners of the rainforest and most distant reaches of the steppe. These days, an Internet connection is not all that necessary. In Africa and Asia, a cell phone with satellite uplink capabilities represents the wave of the future. The cell phone companies in Africa are posting enormous profits, with a three-figure annual growth rates. The cleaning lady has one, as does the slum dweller, the night watchman and the farmer. In Africa, more and more people can afford cell phones by using pre-paid phone cards. For poor Africans, there is nothing more desirable as a status symbol.

In Africa, cell phones also serve as a means for transferring small sums of money from the big cities to small villages on the periphery. In principle, it works like a pre-paid bank transfer. All you have to do is buy minutes from a telephone service. The service sends a text message to a provincial »telephone dealer« with the name of the recipient and a code number. The dealer sits somewhere in the provinces behind a folding table loaded with mobile telephones, buying and selling telephone minutes. The minutes function like currency. The dealer loads the minutes sent by the service onto one of his many phones, and pays out the cash equivalent to the recipient, who identifies him or herself using the name and code number attached

to the original transaction. The dealer receives a small commission. Money transfers that had once cost many days of travel are now accomplished in minutes with a couple of text messages and a telephone call. Cell phone technology has also impacted the movement of goods for sale. Farmers and fishermen used to have to rely on their gut instincts when setting prices for their wares. Today, they simply call around to local markets and ask what things are selling for. This represents a quantum leap in the economic sophistication of these otherwise underdeveloped areas.

The new technology has also affected the reporting of news and other information. For centuries, public discourse in Africa has been severely limited by communication difficulties. Decisions were made without the direct involvement of most Africans, who often had little idea of what was going on elsewhere in the country or world. Recent projects like Voices of Africa gave modern satellite radio telephones to local journalists in four countries. This was a radical step on a continent where freedom of the press means little to those who are in control. In earlier days, there was bush radio. Today, there are blogs and Internet television services. In contrast to the typically African »talk culture« that has taken up the cell phone with enthusiasm, using a computer and Internet resources requires some ability in reading and writing, a hurdle that many Africans have yet to overcome. There are, however, aboriginal groups and individuals that make use of the Internet as a means of showcasing their culture and expressing their political goals. The Massai have their own blog, and the Kayapo have their own Internet television channel. The transmission language

is usually English. The targets are the well-connected members of the ethnic groups who either live in Africa's big cities or are scattered around the world. Of course, ethnic groups seeking lobbyers can never know for sure exactly who they will meet up with on the web.

At carnival time, Trinidadians can follow the great parade in the capital of Port of Spain, thanks to webcams streaming video to computers all over the world. With the click of the mouse, there it is: the warmth of the homeland, the climate, the food and the sounds of the street. In the De Trini Lime Internet chat room, thousands of Trinidadians are bustling about. Users with jokey names, like Louisthelover, engage in what Caribbean people call »ole talk and liming,« which means something like hanging out on the corner shooting the breeze with your friends, but with a lot of sexual banter included. Many Trinidadian forms of expression are misunderstood as sexist, vulgar or racist in countries like England, where many Caribbean people live. Only in chat rooms can one be oneself in the company of one's own kind.

Other groups like the Maori, Sami, Ainu and Native Americans have their own online communities similar to De Trini Lime. They also have websites documenting their traditions and achievements. There are projects in the works to develop computer-ready typefaces for language groups like the Maori and Maya. Dictionaries for obscure languages are now available online. The native Hawaiian Leoki electronic mail server is designed to encourage younger people to learn the nearly extinct Ka, ōlelo Hawai'i languages. Survivors everywhere are still hard at work, on and offline.

HENDRIK NEUBAUER

Himba in Opuwo, Namibia. Aborigines often have access to telephones, Internet and mobile phones these days.

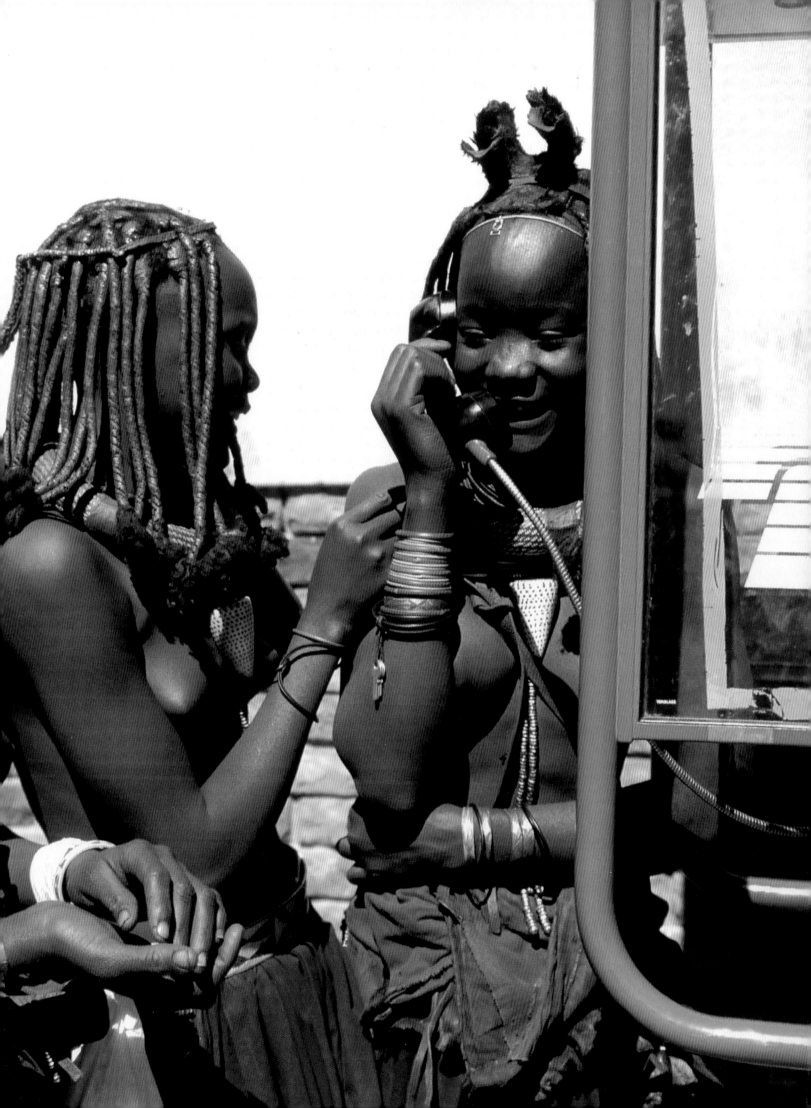

Tipping elements of the climate

THE TIPPING POINT OF GLOBAL WARMING

The tide started going out at the wrong time of the day. The birds were suddenly silent, and for a moment or two, the dolphins and lizards behaved very strangely. These observations made in December 2004 by the aboriginal peoples of the Andaman and Nicobar Islands saved them from the worst effects of the deadly tsunami. While tens of thousands of Asians were falling victim to the flood waves, a tragedy compounded by the failure of high tech early warning systems, the aboriginals survived by following the age old warning signals of the animals.

Deserts and rainforests have long served as retreats for aboriginal peoples because of their relative inaccessibility and the extreme environmental conditions. Doing so has endowed indigenous groups with a sophisticated familiarity with nature from which those of us who live more or less alienated from the natural world can surely profit. Wherever one turns, one sees indigenous peoples threatened by land rights conflicts, expulsion from their home territories, crime waves, military operations, and the environmental damage wrought by the over-exploitation of raw materials. Another consequence of these »effects of globalization« is the distancing of indigenous peoples from their economic subsistence base. Many have no option but to flee to the big cities as economic migrants, or even further, to the industrialized countries of the West. The world's slums are full of them.

When the climate tips over into the extreme, there are dramatic consequences all around the world. While the threat of global warming remains indirect, the dominant majority opinion will be something like »Après nous le deluge,« or »Who cares what happens after we are gone?« It certainly will happen, if one believes the 2008 study conducted by the scientific journal Proceedings of the National Academy of Sciences (PNAS). The study points to several critical locations where even the smallest change in the environment can lead to irreversible climate change. Arctic sea ice and the Greenland ice sheet are two particularly sensitive systems. When sea ice melts, the darker surface of the sea is exposed, and darker surfaces draw more of the sun's rays than light-colored sea ice. The earth's surface will become warmer as a result, making the remaining ice melt more quickly. The tipping point comes when the earth's surface warms by as little as 0.5 to 2.0°C. This means, the Arctic could be ice-free during the summer within a few decades. The melting glaciers of the Greenland ice sheet are also on the brink. Their continued retreat will lead to increased global warming and the loss of more and more continental ice. The tipping point for Greenland would be a regional temperature increase of between 5.0 to 8.0°C.

Researchers predict that rises in temperature of 3.0 to 5.0°C will drastically affect the growth patterns of northern boreal forests. Within fifty years, they will become hotter and dryer in the summer, and subject to a variety of diseases that flourish in warmer environments. The Amazon rainforest, already in grave danger due to unrestricted logging, faces an even greater threat from global warming. Current models predict large scale destruction within the same time period. The situation in the Sahara and dry Sahel region directly south remains unclear. They may become drier, or wetter, than they have been in recent centuries. Much depends on the other tipping elements, including the climatic phenomenon known as El Niño, the Indian summer monsoons, and the thermohaline currents of the Atlantic Ocean.

We now realize that we have passed or are on the verge of passing several tipping points that pose grave risks for humanity and especially for a large fraction of our fellow species on the planet.

All these tipping elements directly affect the extreme climatic zones where the last surviving aboriginal peoples of the earth tend to live. This means that their home territories are among the most deeply affected by climate change. Scientists take a global perspective, parliaments have a national point of view, and economists study the phenomenon from the point of view of the world economy. Over the past decade, the media, the institution that has done the most to bring the subject climate change to the general public, has its own perspective on the matter. Newspapers and magazines tend to provide a populist point of view of the threat of global warming that takes little, if any, account of the situation of ethnic minorities threatened by it. Consider the headline: »King of the Arctic threatened with extinction,« telling us about the plight of king penguins. While this is without a doubt a sensitive article, one can almost hear the western world sigh: »for heaven's sake, not the penguins too!« The »too« makes one question what else is being lost. Is it the good old days? Paradise? What about the people who live in these threatened places? The Survivors focuses on the aboriginal peoples of the world and their thousands of years of accumulated knowledge about their threatened environments.

In the battle against global warming, the aboriginal peoples of the world are at the front lines.

HENDRIK NEUBAUER

Seal hunters in Igloolik in the Canadian Nunavut. The exact observation of nature is day to day business for the Inuit.

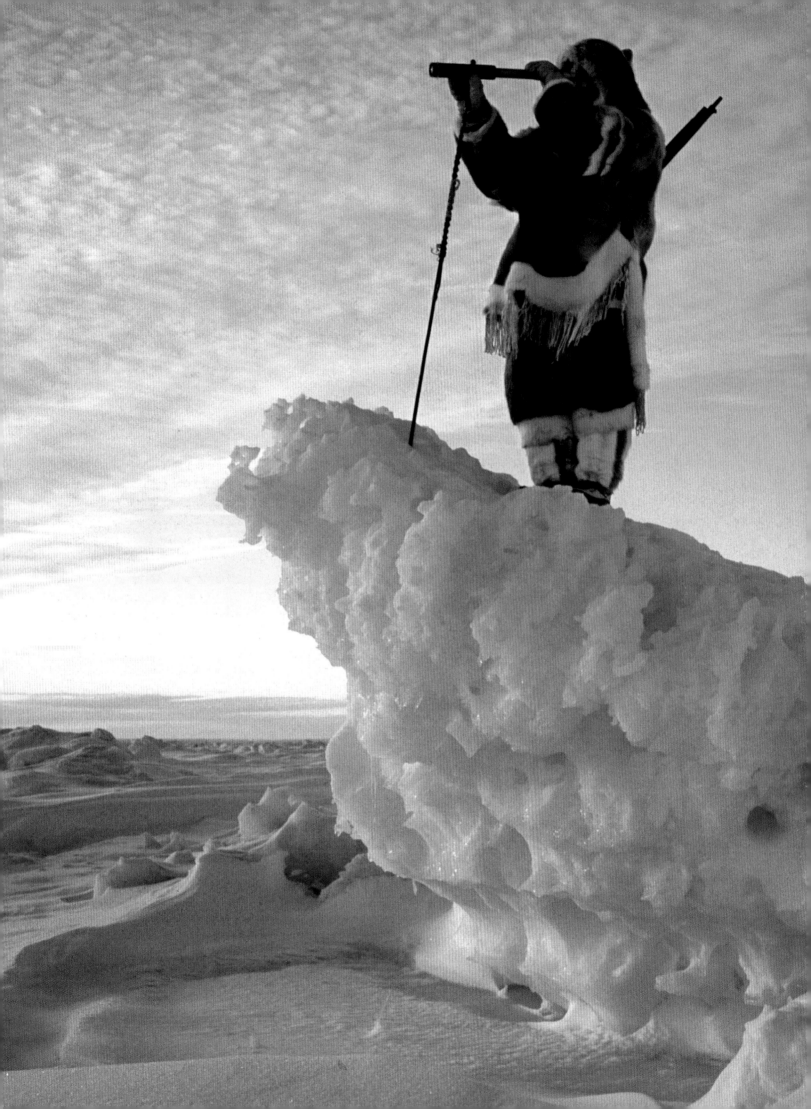

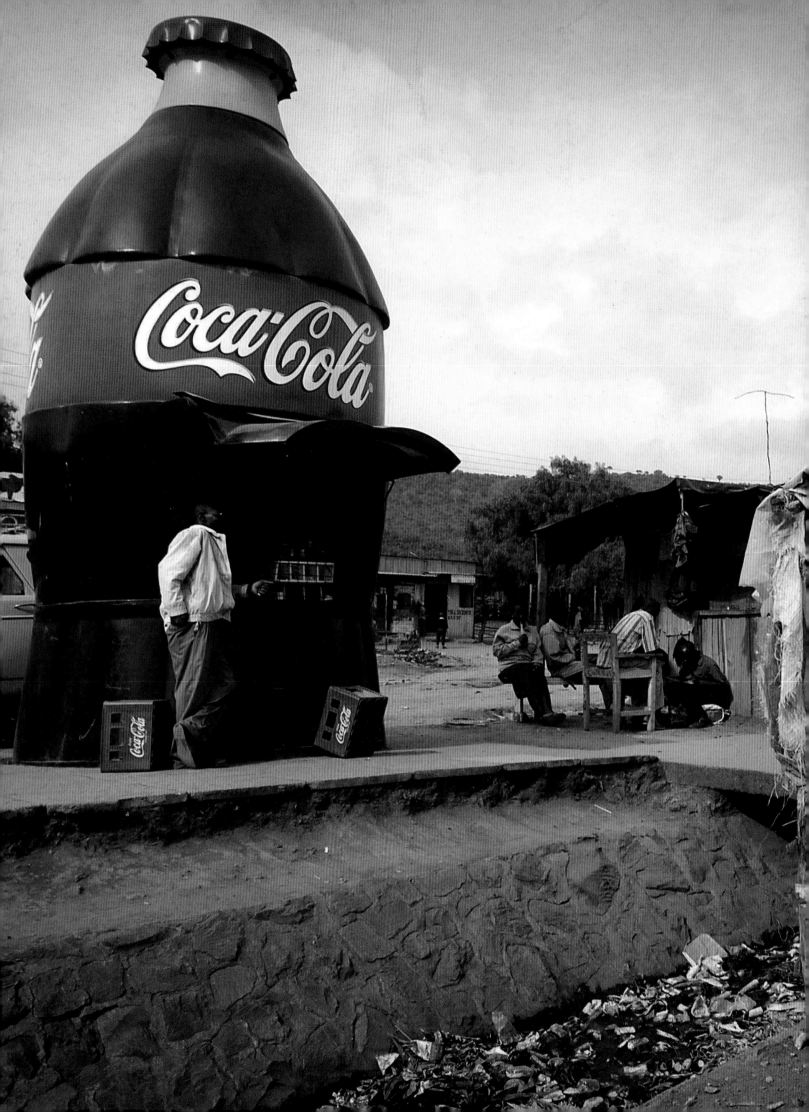

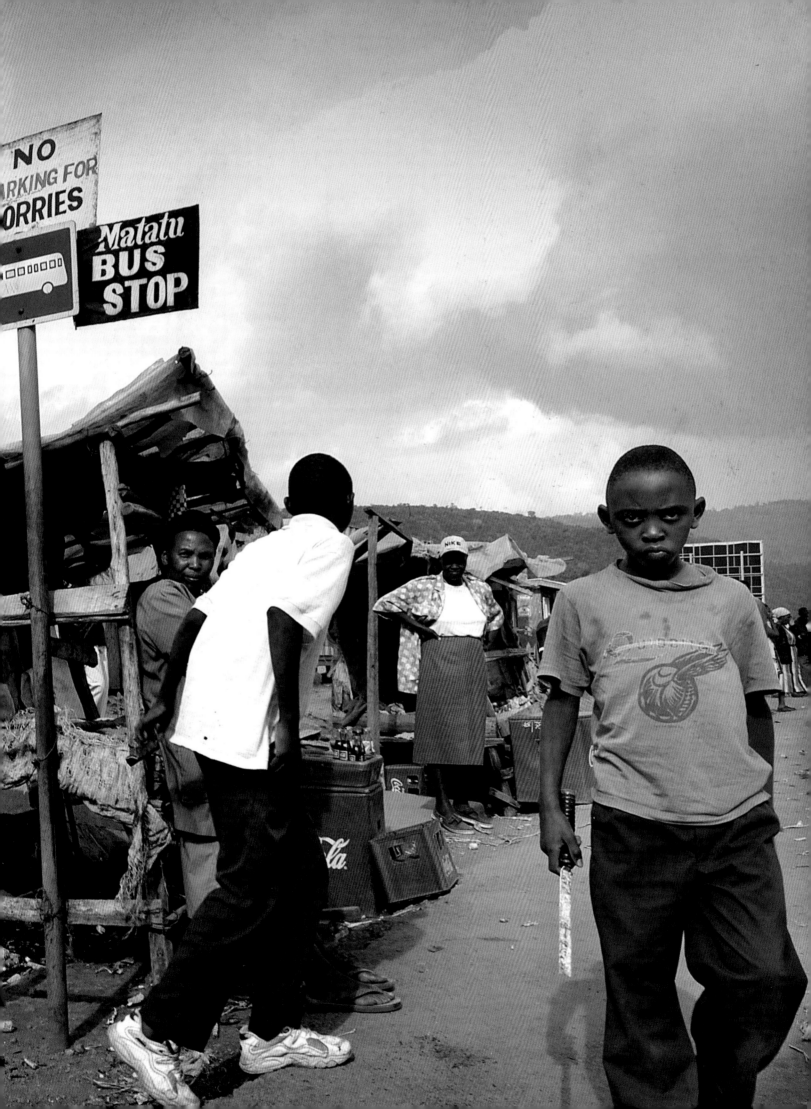

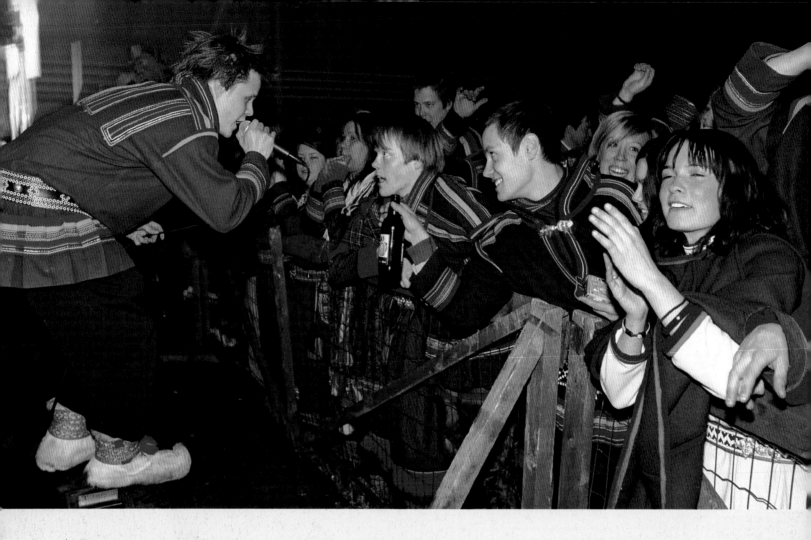

POLAR CLIMATE

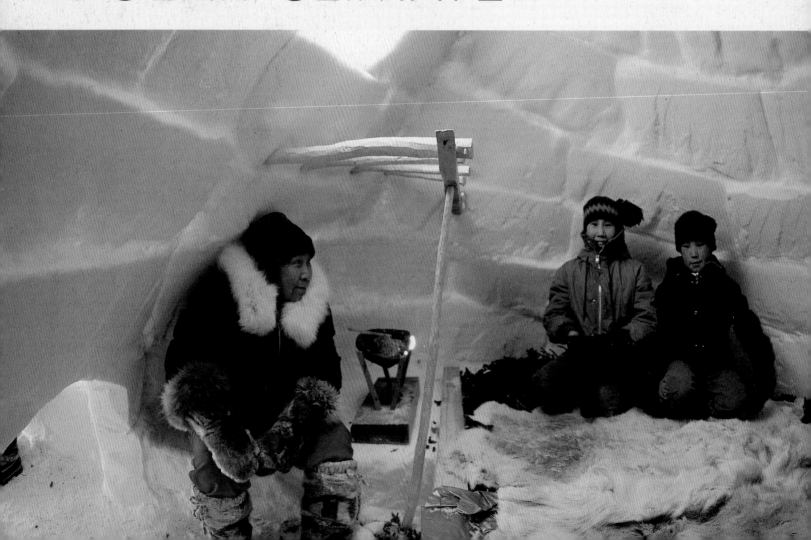

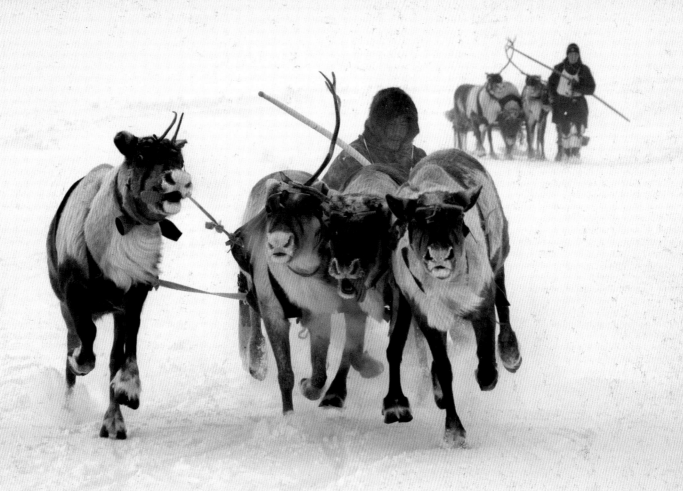

THE FAR NORTH

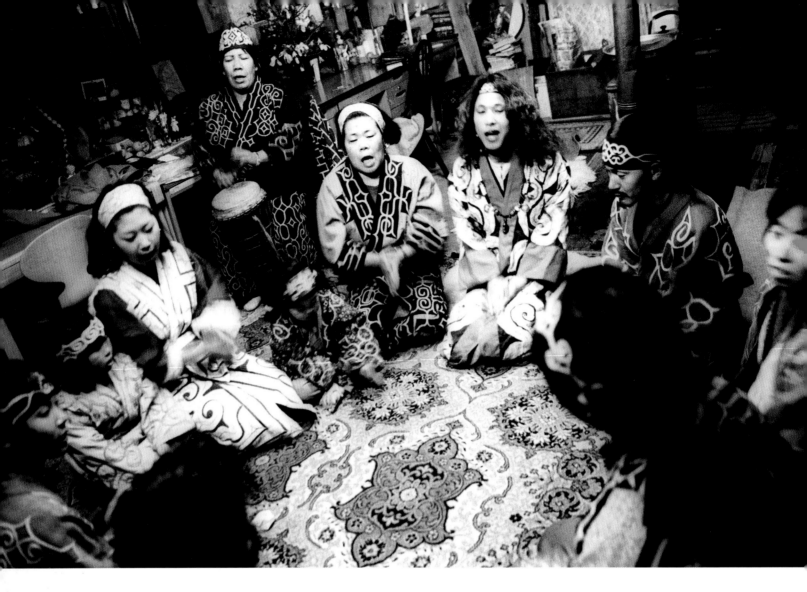

The shinnurappa ceremony honors Ainu ancestors. The museum in Shiraoi has become the minority group's cultural center. Dances and rituals are performed there live, as was done by the bear cult »iyomante,« which has been extinct since the 1960s.

AINU

The nation's misfit ancestors

The multicultural society is certainly not a Japanese invention. »Hairy barbarians with Ainu ancestors« – these were the words with which a Japanese politician tried to insult a political opponent in Parliament in the fall of 2007. Divergent behavior and appearance have never fitted into streamlined Japanese society. »Ethnic diversity« is a foreign phrase in a political culture that is decidedly proud of its homogeneous ethnic character. For this reason, it is only by the late 20th century that the Japanese have even legally recognized the existence of minorities such as the Ainu.

In winter, it is bitterly cold on Hokkaido. Here in the Ainu Museum in Shiraoi, we meet an ekashi, a priest of the natural religion. He stands in the snow in his felt boots beside a kotan, the traditional dwelling, wrapped in a deerskin jacket. Flowing hair and bushy eyebrows, eyes without the Mongolian eyelid-fold, full beard and strong hairy hands; he looks like the archetypical Ainu, a word that means »human« in his own language. For 7,000 years his tribe of hunters, fishers and gatherers has inhabited the islands around Hokkaido. Its origins are still disputed today, since unequivocal lines of relationship cannot be traced either to the Mongols or to any other people.

Since the end of the 19th century, the »Japanization« of the Ainu has taken ever more repressive forms. By as early as the mid-1960s, the Ainu had already almost died out. At that time, the women still had their mouths tattooed to signify that they were already betrothed. Today, there are only a few ethnic group members who still practice this custom, let alone speak the language.

To study and experience Ainu culture today, one must first pass through an atrium of kitsch. In the folk art hall, astonished Japanese tourists are presented with a marketable Ainu culture: here, kimonos mingle with fox and bear skins,

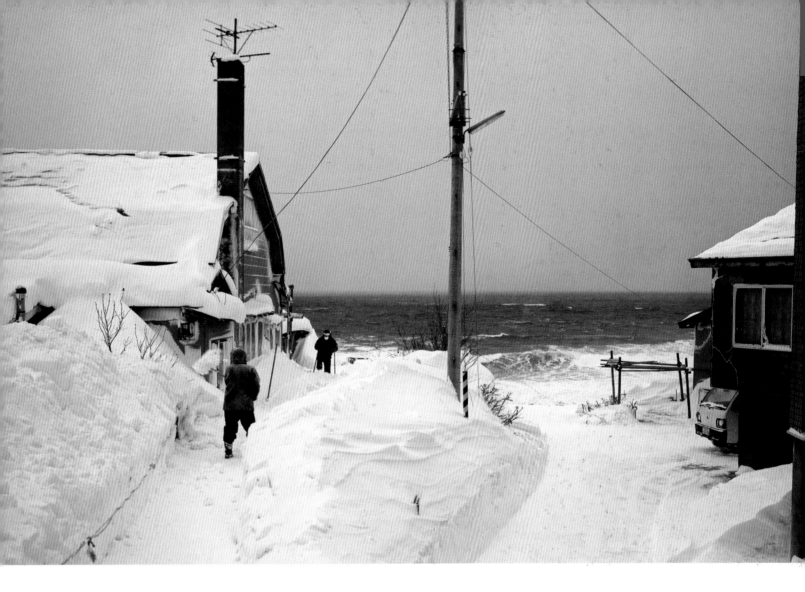

A fishing village on Hokkaido. Japan's northernmost island is teeth-chatteringly cold from March to December, frozen solid by nature. The people on the coasts of these rich fishing grounds traditionally live from the sea. Shiraoi is a district of Hakodate, the fishing capital of southern Hokkaido.

fur caps with colorful shawls. In between are cheap wood carvings, plants, candy, plastic toys. Leaving the merchandizing hell behind, one is rewarded with unique exhibits of the old Ainu culture and an open-air area where folklore traditions are demonstrated several times a day.

Outside the walls of the museum whether on Hokkaido or, even more so, in Tokyo, many Ainu keep quiet about their origins for fear of discrimination. Anyone who confidently confesses his identity as an Ainu still encounters everyday discrimination, such as when the bank declines to give credit, or a snooty hotel refuses admission at the entrance or claims to be fully booked up. Prejudice cares little about the actual legal situation. According to this, however, the Ainu have the status of a national minority, which therefore should be protected. Nevertheless, it is no wonder that the last original inhabitants are making yet another attempt to combat the pressure on them to integrate with the average Japanese.

HENDRIK NEUBAUER

HERE AND TODAY

The population consists of 24,000 Ainu living on Hokkaido, the northernmost of the large islands of Japan. Throughout Japan, there are more Ainu, living in integration. However, all the other ancient peoples of Japan have died out. According to modern anthropological theory, the Ainu played a considerable role in the ethnic genesis of the Japanese. It is to be assumed that today only about 40 people still actively use the Ainu language. The trigger for the decline of Ainu culture was a law for the »Japanization« of the Ainu of 1899. It was only with the Ainu law of 1997 that they have been recognized at all as an indigenous group and minority. The museum in Shiraoi functions as their cultural centre. The Ainu Times, the only newspaper in this language, is published quarterly.

NENETS

In the land of the second sun

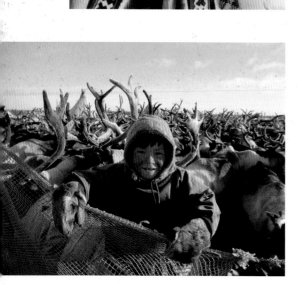

An icy wind is still whistling over the tundra. Across the peninsula of Jamal, north of the Arctic Circle, extends an apparently endless desert of ice. Snow lies here for more than 200 days a year. Although there have been a few warmer days, a snowstorm is still to be expected, but the camp is preparing to leave for the center of the peninsula.

The roads have grown longer for the Nenets and their herds of reindeer, which could formerly move freely here. That was then. Since the largest natural gas fields in the world are here and the state enterprise, Gasprom, has begun to exploit it, pipelines and railroad lines are carving through the area over hundreds of miles.

The nomads must hurry; the female reindeer are pregnant and the birth of the calves is imminent. Today, they must travel by side roads, past pipelines, another 15.5 miles to reach a suitable pasture. In the brief summer months, the Nenets travel to the coast of the Arctic Ocean, where the wind makes the mosquito onslaught more bearable. With the tynzei,

his reindeer-sinew lasso in his hand, Artur runs through the rows of animals, yelling. He is in search of the pack animals, which are trained to pull the sleighs.

The Nenets live on and with the reindeer, following their animals in the search of good pasture land. Their herds supply everything the Nenets need: food in the form of meat, blood, fat, and bone marrow, skins and furs for tents, clothing and bedding. Antlers and bones are used to make knife handles, buttons and other articles of daily use. Of course, the Nenets also sell their reindeer products.

The transformation of the language by gas production is a new challenge for the Nenets. In the 1990s, change had already come with the dissolution of the Soviet Union. Artur used to work on a shift basis for the kolkhoz, the collective farm – two weeks with the herds, two weeks in the villages, where the women lived with the children. In the kolkhoz, everything was provided; there was a school, the house of friendship between nations, and a driver service. A driver would set him down for

In the »Land of the Second Sun,« the moon, glistening snow and stars in the sky combine to bathe the endless winter nights in a magical light. Mobile telephones connect the Nenet with the outside world ABOVE; *the entire family helps out with the animal herds* MIDDLE; *today, the reindeer migration is hindered by pipelines* BELOW.

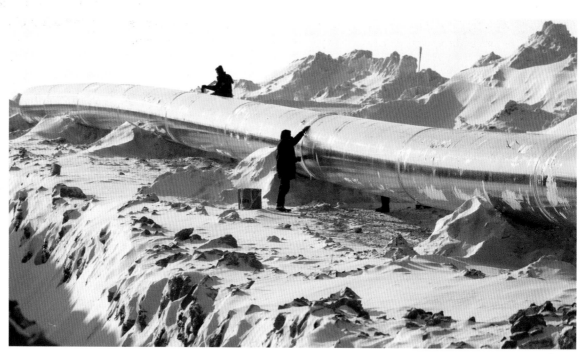

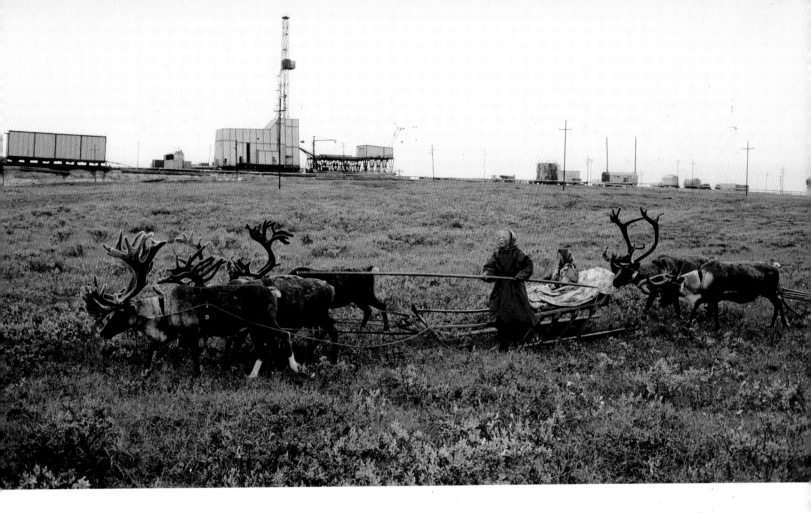

The Tundra Nenets are the largest ethnic group to live primarily by breeding reindeer. Enormous natural gas fields, like this one in Bovanenkov, are found here in the western Jamal Peninsula (in picture). In order to exploit the largest natural gas reserves in Russia, more and more drilling platforms are being built, bringing changes to the local economy.

his shift at the station on the annual route, and Artur would travel through the tundra until his replacement arrived. Later, the Soviet Union collapsed and with it the kolkhozes, which were now considered unprofitable. First, there were no more replacement parts for the decrepit fleet of vehicles, then there were no more wages, and soon Artur was abandoned with his family and was forced to return to his original, independent nomad life.

A ringing sound suddenly buzzes through the air and Masha needs a few moments to extract her cell phone from her thick fur jacket: »Hello, what's happening, darling?« Her son is calling her from Jar-Sale, where he goes to school. In the fall, the school age Nenets children are picked up by helicopter out in the tundra. At that time, Masha's and Artur's son goes to live with relatives in the city. »But the summer holidays will be here soon,« she says, comforting herself as much as her son.

HENDRIK NEUBAUER

HERE & NOW

Most of the 41,000 Nenets live in the European part of Russia and in the northwest of Siberia. On the West Siberian peninsula of Jamal, some 4,700 Nenets lead a nomadic life. The reindeer keepers have survived the collectivization of agriculture and the destruction of the kulaks, with whom they were included for possessing livestock, under Stalin. They returned from the Great Patriotic War which some of them experienced as soldiers on the Leningrad front. They did not allow themselves to be defeated by the constraints of the plan fulfillment for their kolkhozes. Now, their economic zone, the tundra, is threatened by the gigantic natural gas deposits in the region. Geologists have researched Jamal and found formations that suggest the presence of fields of more than 353 quadrillion cubic feet of natural gas. These deposits would compensate for the sinking profits of other Siberian fields. However, Jamal is probably the most difficult production area in the world. The peninsula is crossed by countless rivers and lakes. In summer, it is not at all practicable and on the coasts it is encircled by wandering masses of pack ice, which in some places tears up the sea bed to a 3 feet (1 meter) depth. Then there is the long-term danger that the peninsula, lying only just above sea level, will sink in the course of gas production and then be totally covered with water. Meanwhile, the development of the Bovanenkovo gas field in the west of the peninsula proceedes.

Ancestors

Yet another little stone man. They are traffic signs and scarecrows in the vast Canadian tundra. The Inuit of Nunavut call these stone figures Inuksuit. They know exactly how to differentiate between contemporary signposts that show the way to special hunting grounds, for example, and those that were erected centuries ago by their ancestors. The latter are read as handed down landmarks, messages from the ancestors.

Ancestral worship is the daily guarantee of being

They tell of the forefathers' landmarks, warn of ancient dangerous places, and recall curious and mythical experiences still recounted today in traditional myths. In the semidarkness of the Arctic night, caribou shy away from the figures and run into the sights of hunters' guns. The ancestors of the Inuit do not just stand idle in the landscape. One has to know how to interact with them, to encounter them with respect.

This is a cultural convention. In natural religions, ancestral worship is the daily guarantee of being, an important purpose in life and significant reason for people's existence. The living are actually only a link in the long chain of the ancestors and life after death. This also functions in other cultures in a similar way. How long will the village elder live? That is the question asked in a Dogon village in Mali. However, they do not have to speculate whether the carousel of his succession will then begin to turn. They do not know that this question is autocratically settled before the Hogon's demise, by the high priest himself. According to their concept of life and death, everyone is always alive, whereas only the physical state of existence changes.

Life continually revolves around the relationship that the Living develop and maintain with the dead. The ancestral figures must be constantly addressed. This is not a problem, since the dead do not rest in a cemetery, nor do they wander through some distant paradise beyond the clouds. Instead, they actively participate in family life. Some have a shrine of their own at home; other families go to »their« priest who has set up an altar in a village hut on which the ancestors have a place of their own. The ancestors are a constant reminder to the living, following the motto, »live virtuously.« Only those who keep to the rules and respect the community can be accepted into the ranks of the ancestors. Criminals, trouble makers, and rogues have no place among them.

Moving a household with a host of ancestors

All cultures perform ancestral devotion or death dance. The Aborigines of Australia sing and dance in order to wake up the clan totem. The Mam in Central America celebrate Todos dos Santos and mask themselves, finally finishing off the celebration with a horse race. In their danced ceremonies with masks, the Dogon in Mali suddenly become the »ancestors« while the »self« and the »ego« are communicated at the same time. Masks are important in ancestral cults, for they enable the individual to overcome time and space; it could be said that the mask enables the journey into another world, becoming alive in the ceremony on this side.

However, how on earth do you move a household with a host of ancestors? This is explained with a short look at West Africa. When a Yoruba member of one of the numerous Voodoo cults sets up a household, regardless of whether it is a hut in a slum or a villa in a prosperous suburb, he first prepares the move in of the ancestors to the home with a ceremony that lasts for days. Only when an obligatory priest has consecrated it and signaled that the ancestors have moved in, do the living enter the new home. From this point on, more people live in this house than in a modern »secularized« apartment block. Woe betides whoever is surrounded by devout neighbors and yet renounced the demanding Voodoo pantheon of innumerable gods. Whoever does not consecrate his new house is not safe from

The stump masks of the Dogon in Mali are usually representations of ancestors, but can also serve as schematic representations of individuals from other groups, such as the Fulbe.

Inuksuit in the Canadian territory of Nunavut. These Inuit rock cairns serve as milestones or markers showing the way through the snowy wastes. They have also been interpreted as ancestor symbols

the disfavor of his neighbors. The reason is simple; the new inhabitant is evading the community. He is perhaps not only different. Most importantly, he will not contribute to the continued existence of the community when he already turns from paying for the priest. Then, it is possible that stones may fly against the walls and windows of the »foreign body« under the cover of darkness. In such quarters it is not only about mutual respect; divergent behavior is not something gladly seen.

All over the world, respect for the ancestors is expressed in the way the elderly are dealt with in the here and now. They have made it, sit in the council of elders, and no longer need to contribute productively to the survival of the community. To phrase it in the terms of the industrial society: unemployment as a privilege, not as a worry. At last, no boss, no stress and no fight for survival any more. This is also true for North American Indians, particularly when Sitting Bull said: »There is no freezing for the elderly.«

Death is only a stage on the path

The elderly in animist societies die with the certainty that they live forever. In their societies, a person dies several times during the course of life and is reborn several times; this is the principle of ritual rebirth and the basic principle of belief in natural religion. With initiation and circumcision, the child in man and woman dies. With the birth of a son, at least in patriarchal societies, the man gains a place in the cult of ancestors, in the sense that his place among their ranks is now guaranteed. In this sequence of events, clinical death is only a stage on the path of life. One lives on, but not somewhere in paradise; instead, the ancestor dwells among his own.

HENDRIK NEUBAUER

A Lacandon ancestor shrine. Most Lacandon visit the shrines on a daily basis, honoring their ancestors and gods by lighting candles and leaving behind offerings of food and drink.

SAMI

What will the weather be like on Christmas this year?

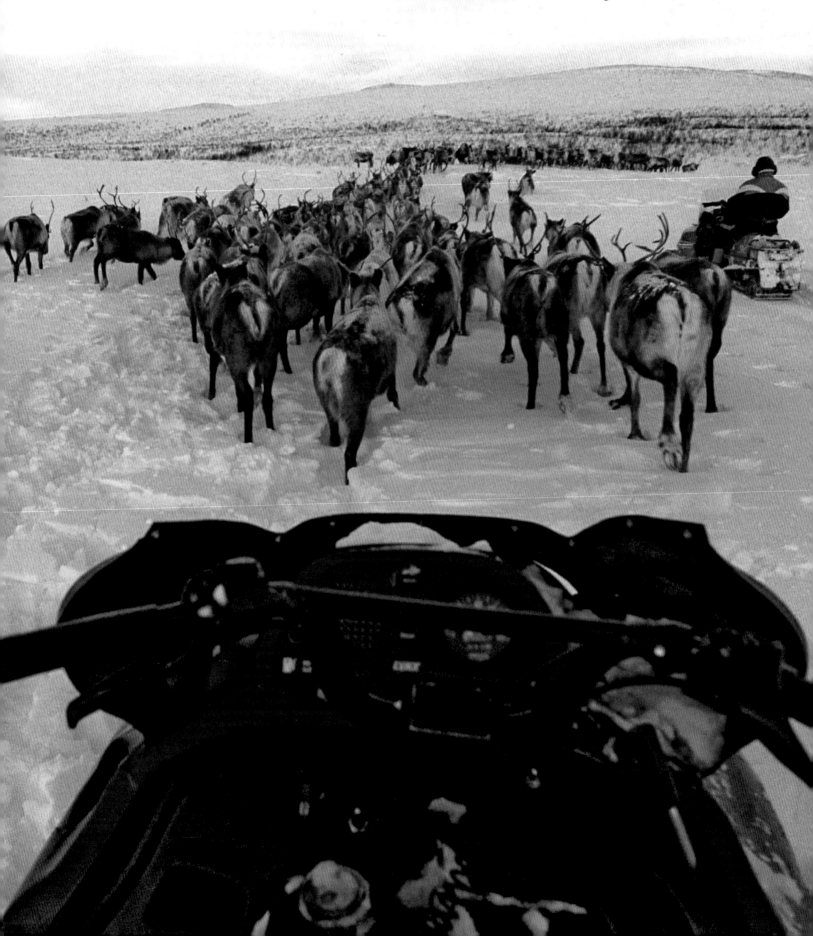

Neon signs advertise Santa Park from far away. The village sits outside the gates of the city just a mile and a half from the airport, ready to welcome visitors during the Christmas season. Most tourists stop by only for an afternoon. The highlight of the day is a visit with Santa Claus.

Anyone wanting to lure throngs of tourists to this frozen wasteland up north near the Arctic Circle needs to come up with something good. In 1920, when »Uncle« Markus Kauno, host of a Finnish radio program called Children's Hour, reinvented the desolate Lapland provincial town of Rovaniemi as Santa's workshop, chance had nothing to do with it. This is how the Sami Christmas story began, a story which, admittedly, is not entirely implausible. The Sami are an indigenous pastoral people living in the far north of Scandinavia and Russia. There are lots of reindeer in the area, and something like the Christmas star in the form of the North Star and aurora borealis. In this northern Finland town, Santa Claus is called Joulupukki. His dwarves work day and night on the mountain of Korvatunturi, making sure that Christmas is also a day for presents. This is how the legend goes.

In 1972, a clever Finnish parliamentarian introduced an official proclamation declaring Lapland to be Santa Claus Land. Since then, there has been some competition from Canada and other places. Let them all argue their case as they will. Even the Japanese believe that Santa and Rudolf the Red-Nosed Reindeer live in Rovaniemi. During the Christmas season, Rovaniemi, the »gateway to the north,« becomes a veritable pilgrimage site for

visitors from around the world. And what is their mission? To see Santa Claus, of course. During the high season, Santa welcomes guests, particularly children, for nine hours per day. The lines are long. Finally, Joulupukki appears; ready to have his picture taken with you in exchange for a hefty charge.

Around Christmas, many air traffic controllers work double shifts directing planes through the northern polar circle. The crowd of Santa fans has barely landed in Rovaniemi's airport when charter busses ferry them off to Santa Claus Village. The property is not part of the city, but home to a total of thirty vendors making a living selling reindeer skins and stuffed animals. An entire mountain was hollowed out in order to build Santapark, another tourist spot. The somewhat unattractive hamlet of Inari some ten minutes by car form the airport begins its preparations long before the start of the Christmas season. The hustle and bustle, the hanging of Christmas lights, new coats of paint and other efforts along these lines have given the region a high profile. Everyone profits, including the Sami who raise the reindeer.

There are still a couple of reindeer herders living around Inari. Their grandfathers drove to school in reindeer-driven sleighs, but today's parents drive

their children around in snowmobiles or the family SUV. Many reindeer breeding families earn only about half of their income from the sale of meat, skins and antlers. The rest comes from giving sleigh rides to tourists, booked well in advance. It is not as easy as it looks. Reindeer need up to five years of training to learn how to pull a sleigh without accidents.

Modern reindeer herders have a long workday. Today, they prefer to use snowmobiles to drive their herds of up to 300 animals. It is simply quicker that way. Finland's entry into the European Union brought deep and lasting changes. Where it was once permitted to slaughter the reindeer and dress the carcasses in the field, all animals must be loaded on ships or tractor-trailer trucks today, and transported to slaughterhouses far away. What happens next to the animals is the same as in less frosty areas. The reindeer's horns get tangled. The animals are very badly stressed, and the adrenaline that courses through their bodies makes their meat unpalatable. Even without these problems, nearly every herder complains about the falling prices for reindeer meat.

There are also snow safaris through the snowy tundra with reindeer bridled in the Sami colors of red, yellow, green and blue. The team takes its passengers on a jolting ride through the hard crust of

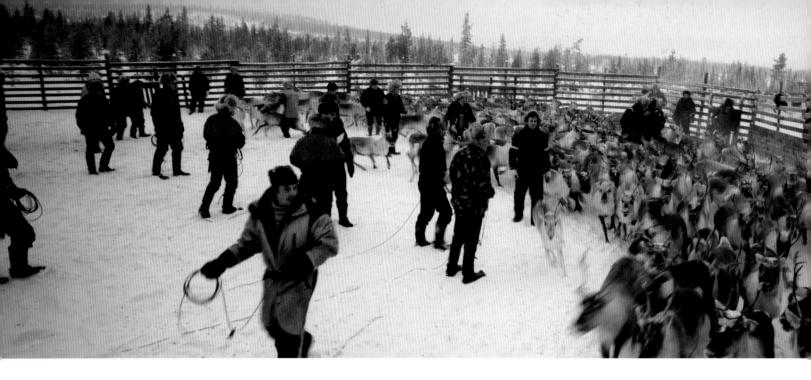

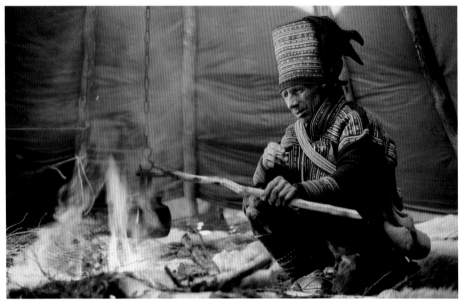

In the region where the borders of Sweden, Norway and Finland meet, reindeer herds, snowmobiles and sleighs cross the land. The Sami, driving their reindeer in Ruokto ABOVE and in a tent camp near Kautokeino LEFT.

the snow. A sleigh driver in extra-extra large overalls directs the sleigh from his seat on top of the runners in the back. Many teams are already out with passengers as early as eight o'clock in the morning. Ten hours later, the Sami go out one last time for a »Northern Lights Expedition,« this time leading a line of snowmobiles. In the glare of the headlights, the trees along the trail whoosh by like

HERE AND NOW

Roughly 75,000 Sami still live in the Scandinavian countries of Norway, Sweden and Finland as well as on Russia's Kola Peninsula. For centuries, the indigenous peoples suffered prejudice and discrimination. They were considered backward, with their culture understood as mere colorful folklore. Well into the mid-twentieth century, many Sami were denied the right to speak their own language or sing yoik, their unique traditional songs.

In the last few decades, the Sami have been recognized as national minorities in most Scandinavian countries. All three have Sami parliaments. These are integrated into the national government and include limited legislative powers, although in practice, their role is primarily advisory. In Russia, as is the case for most minority groups in that country, the Sami have no special rights. The Sami Council, which includes representatives from all the countries, was formed in 1956 as a non-governmental organization promoting the rights of all Sami.

The cultural rights of the Sami people are well protected in comparison to those of other indigenous peoples. The Sami language is approved for administrative use by many government agencies. Sami children learn their lessons in their language, and it is possible to get a degree in Sami at several universities. There are also Sami television programs and radio broadcasts.

Most conflict derives from the environmental situation. The Sami were unable to stop a Norwegian dam project despite international support for their effort. The 1986 Chernobyl disaster poisoned the reindeer habitat with radioactive fallout, a blow from which many herders never recovered. Today, the cutting down of the forests for the paper industry and exploitation of raw materials has led to numerous protests by the Sami.

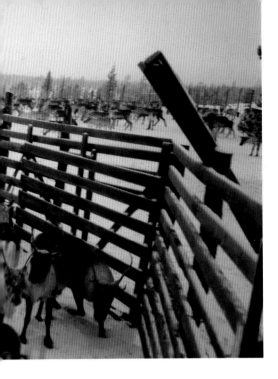

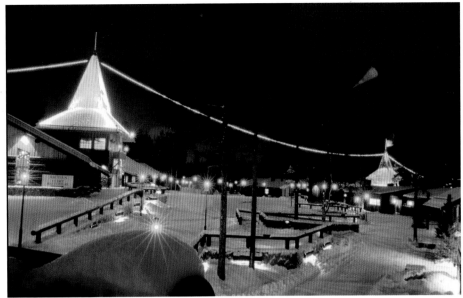

The address for the »Main Post Office of Santa Claus« is P.O. Box FIN-96930, Arctic Circle ABOVE RIGHT, BUILDING ON THE LEFT. *Letters sent to Santa Claus from all over the world are answered there* BELOW RIGHT.

magical creatures. When the mechanical monsters finally halt, the unique experience of wandering out into the vastness of the polar night begins. In the glistening light, the wind whistles by like the soft stroke of tissue paper against the skin. The most spectacular things in this part of the world are often experienced in intricacies like this.

The Sword of Damocles hangs over the success story of Rovaniemi. What will happen to the winter wonderland if the snow and ice stay away? »The last three or four years have been difficult for us,« a local tourist guide says. Local climate researchers forecast further hard times ahead. Reindeer herding has been affected by drastic fluctuations in temperature that led to alternating periods of snow and rain. This causes a build-up of thick layers of ice. The reindeer have difficulty getting through the ice to reach the tender shoots they need to survive. Reindeer herders have to hack through the icy armor, or bring their animals hay and grain all winter long. Rovaniemi's dilemma shows us once again we must include the environment in all our plans and calculations.

HENDRIK NEUBAUER

MARI BOINE

Mari Boine was born in 1956 not far from the North Pole in a small town in northern Norway. At first, the yoik, the ancient song of Sami shaman, played little or no role in her music. A few elements in her mostly Samian language songs, particularly those parts that describe people, plants, animals or simple sentiments, are reminiscent of traditional yoiks. The singer works with influences from many different cultures in her songs, including jazz, folk, rock, West African sounds, and percussion that reminds one of North American native drumming. The result is unmistakable. It is world music in the best sense of the term. More recently, Mari Boine has brought the unique music of the Sami to the fore. She has met with great success on stage, performing in concerts around the world. She is so beloved and popular that Norwegian Crown Prince Haakon and his bride Mette-Marit asked her to perform at their 2001 wedding. This is despite the fact that Boine has excoriated Norway's policy toward minority peoples in many of her lyrics.

www.mariboine.no

Family

All over the world, people organize themselves according to the resilient fluid that pulses through our veins. Among the many phrases coined about it on all continents is the expression »Blood is thicker than water.« If there is a globally accepted truism, it is that in case of doubt, the individual will always come down on the side of his or her own people, because for better or worse it is shared blood that binds us together. Blood relationship is stronger than any other social compact that we enter.

In the global village there are many ways of organizing the family. The European or North American nuclear family, in which father, mother and their children form a household, is merely an obvious transitional form on a path whose end we do not know. Looking at history, larger groups of blood-related individuals living together seem to be the tried and tested means for people in all parts of the world to protect themselves from the dangers of the outside world, and - a decisive reason - to secure the basic means of living for all participants.

»Blood is thicker than water«

Classical ethnology knows only cultures in which the family forms the core of coexistence. The central point of life is the household and its dwelling place, whether it be the igloo of the Inuit family or the shabono, the longhouse of the Yanomami tribe. In social systems which do not have a system of provision for old age in the Western sense, which is in the sense of retirement benefits, the classic arrangement is for three generations to live together. The old people can no longer contribute to the securing of livelihoods, but they take care of the children, often educate them, and receive care accordingly. This is part of a contract between the generations, as it has been understood everywhere over the millennia.

Family traditions have developed out of the cultural heritage of a community or an ethnicity. Matriarchy is among the oldest forms of organizing a family. The Ashanti in central Ghana today still observe matrilinearity; although modern society has for some time been severely eroding the conditions under which the rules of succession and family residence linked to the mother can be maintained. Matrilinear families are a traditional way of delegating responsibility for offspring. For a long time, it was not clear to people that a man, in addition to siring children, could also be their father and thus all responsibility for offspring and family remained with the mother, whose involvement was unquestioned.

It has not always been clear that a man can be a father

The logic of matrilinearity is evident in the case of the Ashanti in Ghana. The successor to the Asantehene, King of the Ashanti, who is in possession not of worldly, but strong symbolic and moral power, will never be the son of the incumbent ruler. Preference will be given to the son of a sister of the Asantahene. For with nephews one can be certain of one thing: even if no one knows for certain who the father is, the mother's identity is known. Thus a succession within the family is ensured. Traditionally, in the Ashanti family, all responsibility within a system determined by blood relationship with the women is passed on. All generations depend on their relationship with the mother, grandmother or great-grandmother. If, for example, a woman dies, a man may take over responsibility for her children, but as a rule it is the brother of the dead woman who, as the son of the same mother, has a duty to serve the family.

The Ghanaian society as a whole faces serious upheavals. The family structure is changing in the face of greater mobility. It is here that the nuclear family comes in, for the units that move away from the base of the greater unit correspond to the father mother child model. Attracted by better job prospects the nuclear family moves from the Ashanti capital Kumasi perhaps to Accra, the capital of this West African country. Thus, as traditions have arisen,

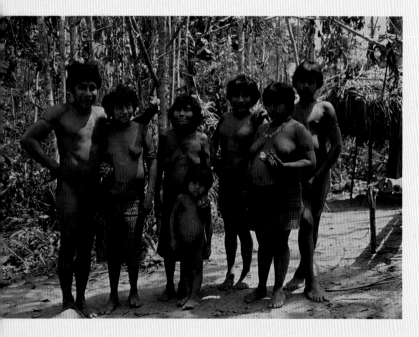

The Amazon basin's some 300 Awa Guaja wander through the forest in forty to fifty family groups with five to six members each. They continue to hunt and gather today, building temporary structures for protection against the elements.

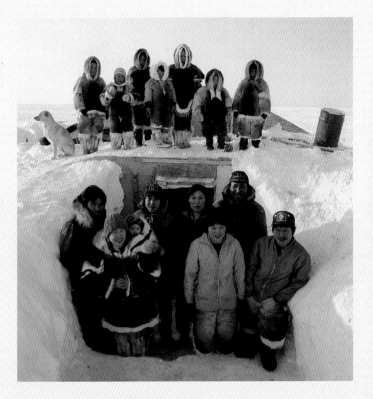

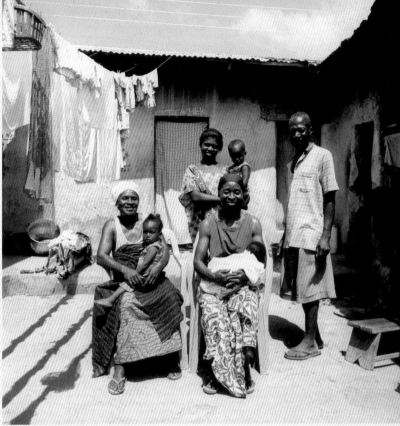

This Inuit extended family lives under one roof in the town of Igloolik in Nunavut. Families living in outpost camps are for the most part self-sufficient, but still rely on the outside world for communication and supplies.

This family owns a Cacao plantation in Serebuoroso in Ghana's Ashanti region. The Ashanti live in extended family groups. Inheritance within this cultural sphere is matrilineal.

so too do they change. Not much can assert against new social and cultural conditions.

Within social structures such as ethnicities there are also organizational connections larger than the family, which are formed around blood relationships. In anthropology there is a term of Scottish origin which denotes a family connection which is not confined to spatial limits such as the nuclear family or group inhabiting a homestead: the clan. The clan extends the idea of the family into a number of ramifications; as a cliché, the concept is, with good reason, familiar from films about the Mafia. The clan is organized hierarchically and resembles a pyramid in structure. Scientists have detected clans in East Asia, but also among the Haudenosaunee, who

today live mainly in Ontario and New York State.

Alongside all traditions in the structure of families there exist also counter models. Women's rights, for example, did not simply come into being anywhere, but were gained by hard struggle. These counter models arose either from the adoption of outside influences or out of firm resistance against the ruling hierarchies. Hardly a group has remained free of them, however secluded a life they may lead. In 1989, in his film Finzan, the long-term cultural minister of Mali, Cheick Oumar Sissoko, told the story of the girl Nanjuma, who resists a juvenile marriage on her own initiative, and from the conviction that her father's decision to marry her to a man of his own age is wrong. Sissoko shows that all forms of social organization

Women's rights did not come into being simply

live in the people who are part of them – and thus also that there can be no standing still, however thick blood may be.

MAX ANNAS

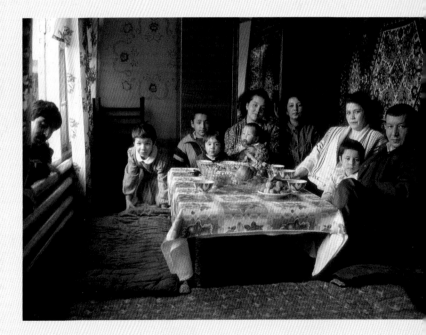

A family in Tashkent. For many centuries, the Usbeki have felt bound primarily to their clan. They first developed an ethnic identity in the early twentieth century after Uzbekistan became a regional republic of the Soviet Union.

Flying towards the largest island in the world, we cross the Ilulissat Icefjord and head towards the Jakobshavn Glacier, also known as the Sermeq Kujalleq in Greenlandic. Gigantic icebergs regularly fall off this glacier's cliffs into the fjord. They loom over 490 feet (150 meters) above the water and rock back and forth. With loud cracking and grinding sounds, some of these icebergs break up in more shallow waters and float out to Disco Bay. In fact, the iceberg that was ultimately responsible for the Titanic's downfall probably calved off of the Jakobshavn Glacier. The impressive backdrop has gained fame around the world. The international bestseller Smilla's sense of snow is set in this region, tourism to the Arctic Circle has significantly increased with the booming cruise industry, and politicians, from the Danish Prime Minister Anders Rasmussen over the German Chancellor Angela Merkel to US Congresswoman and Leader of the House of Representatives Nancy Pelosi, have come to see and discuss first-hand the effects of climatic change. Just like every summer, cruise ships are long-term visitors in Ilulissat's waters. From the upper deck, guests can look over southwestern Greenland onto the narrow, craggy littoral zone. Behind that, the Greenland ice sheet stretches out seemingly endlessly.

»Back then, a long time ago, when the earth was to be created, it all fell from above. Soil, cliffs and stones – everything fell from the heavens.« Fishermen, like the Villadsen brothers, Johan, Kristian and Lars, enjoy sharing the legends of their ancestors. The island's interior is still covered with an ice sheet that can span over 1.5 miles (3 kilometers) in thickness. Other than the small strip of land from Ilulissat, only very few land strips are free from ice; Pearyland to the far north and coastal areas to the south and the west.

This territory, the smallest part of this gigantic island, is what Eric the Red must have had in mind, when he fled from Iceland in 986 C.E., heading west. He ended up on the island that he later named Greenland. Some scientists assume that vegetation grew more abundantly in the coastal areas as a consequence of the Medieval Warm Period. The Norse chieftain and his followers founded the first known Viking settlements in Greenland. Of course, the Inuit, who had emigrated across the Bering Straits around 1000 B.C.E., and were spread out from Alaska to Western Greenland, had inhabited this region for quite some time, even if only seasonally. Danish settlers followed the Norwegians. In the 17th century following orders from Christian IV, they explored the land and took ›Eskimo‹ prisoners to later parade them as freaks to the public in Copenhagen. Greenland was declared Danish sphere of influence shortly thereafter. In 1740, the trading station Jakobshavn was founded in proximity to the prehistoric settlement. Up until 1920, the Danish settlers colonized and Christianized all inhabited parts of the island. Since 1979, Copenhagen has only represented the otherwise autonomous island in foreign policy and defense issues. The Greenlanders withdrew in 1985 from the European Community.

As if hidden behind ships and icebergs, the community of Ilulissat, comprising almost 5,000 inhabitants, lies sheltered along the Disco Bay. Fish continues to be the city's blessing; fishermen work untiringly to reel in the catch of the day. The two fish factories are the city's largest source of employment. Crabs and halibut are processed in the factory buildings. The third-largest city in Greenland also offers some administrative positions and various branches of service industry to meet some of the Greenlanders' needs. Each season brings more and more tourists, even though desire for yet more tourism is often expressed. Dog sledders wax lyric about dog sledding through the Arctic winter when describing it. Indeed, the capacities are therefore more than sufficient. As Illulissat lies north of the dog-sledding zone, each inhabitant has more than one dog; the total dog count lies at around 6,000.

»Give me snow, give me dogs, you can keep the rest,« has been ascribed to one of the most prominent inhabitants of Ilulissat, the polar explorer Knud Rasmussen. Half Dane, half Kalaallit, he went on countless expeditions in Greenland and further up north in the Arctic. Together with his two younger siblings, he was raised biculturally in the red wooden priest's house that

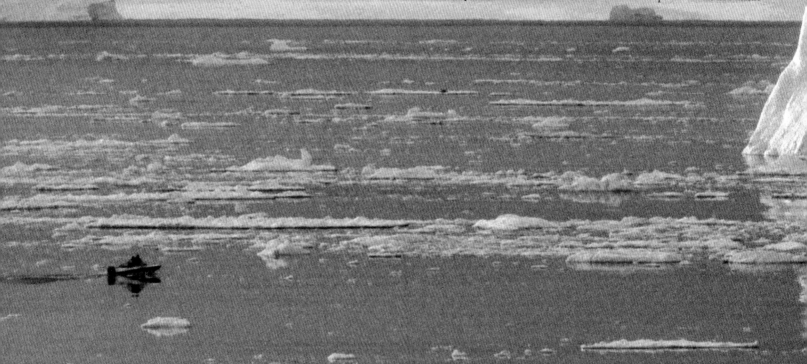

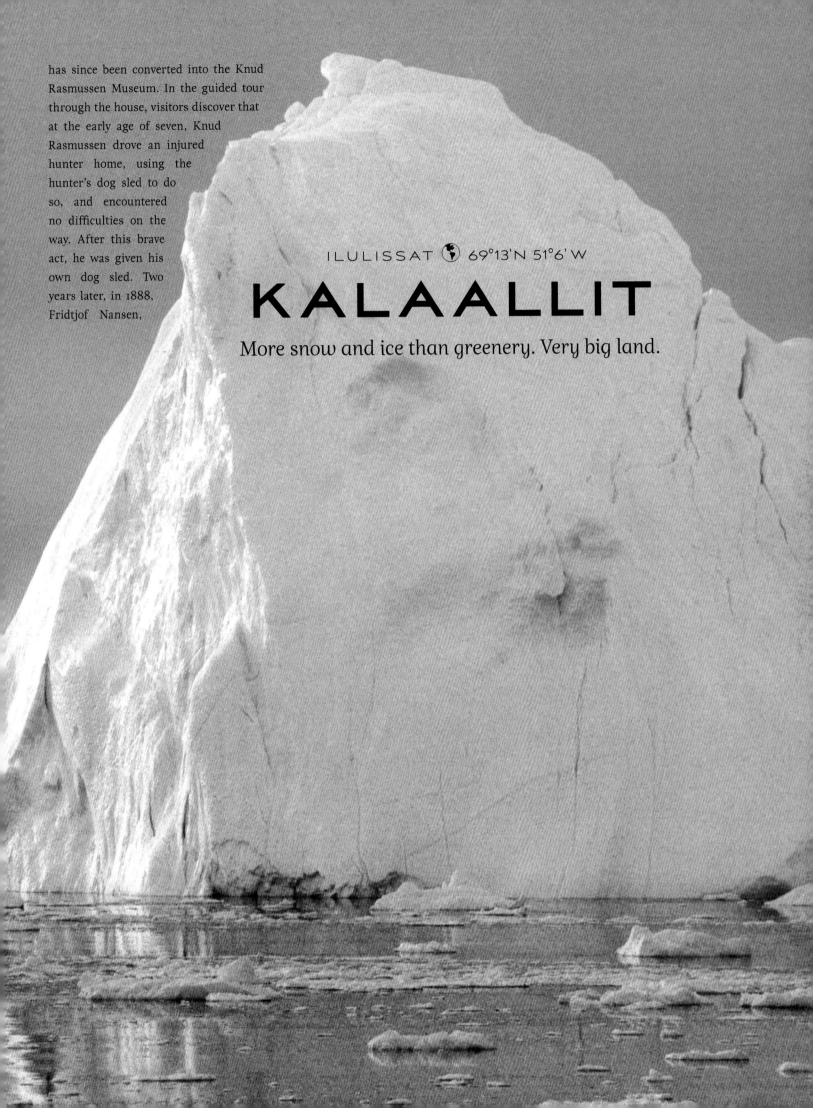

has since been converted into the Knud Rasmussen Museum. In the guided tour through the house, visitors discover that at the early age of seven, Knud Rasmussen drove an injured hunter home, using the hunter's dog sled to do so, and encountered no difficulties on the way. After this brave act, he was given his own dog sled. Two years later, in 1888, Fridtjof Nansen,

ILULISSAT 69°13'N 51°6' W

KALAALLIT

More snow and ice than greenery. Very big land.

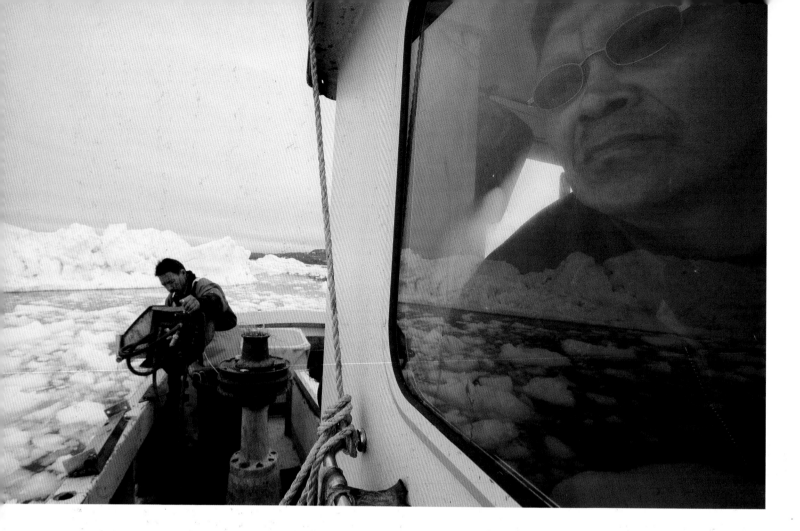

while crossing Greenland on skis, stayed at Rasmussen's house as a guest for several days. From this time onwards, Nansen became a role model for the young Knud. Knud was educated in Denmark, where he also studied ethnology. In 1902, he returned to his home country for his first expedition. Until his death in 1933, Rasmussen gained a reputation as an arctic explorer and a mediator between the Kalaallit culture and the rest of the world.

The ›polar hero‹ transcribed, in his field studies, stories including one of the Kalaallit who spent time in New York with Peary in 1900.

»He gathered all his courage and cheekily began to talk about his trip with the electrical tramway... when Uisakavsak then carried on with the telephone – ›the distance alleviator,‹ fearful of letting skeptics have time to voice their disbelief... judgment was pronounced! The old shaman of the tribe, Sorqaq, stepped out of the circle of men and nailing him, under the eyes of all, to the stake, declared: ›No, Uisakavsak! Go to the women with all of your big lies!‹«

Fisherman Lars Villadsen steers through the icebergs with his brothers ABOVE LEFT. *Nagdlunguaq-48, Iluslissat's local soccer club, plays its matches in the stadium in Nuuk* ABOVE RIGHT. *This city of almost 5,000 inhabitants has its own nightlife concentrated around the hotels, and bars built to encourage tourism* CENTER RIGHT. *Ilulissat, the third largest city in Greenland, is a fishery center and gateway to Disko Bay* BELOW RIGHT.

RASMUS LYBERTH
ATLANTIC OFFSHOOT

Rasmus Lyberth was still at sea at the age of 18, when he decided to become a singer. He has been singing since 1968. Nuannaarnerup nipaata from the album Asanagigavit (2006) is merely one example of the unbelievably hip sound of Greenlandic folk music. The slide guitar adds depth, the rhythm section is contagious, Aviaja Lumholt contributes with positively hymnal choral music and the rest of the band adds to the personal composition, uniting it to a harmonious piece of music on the land and people of Greenland. Rasmus Lyberth's slightly throaty vocals throw in unique flavor. Even his ›Oh yeah‹ sounds Scandinavian. Once the listeners are willing to fully experience the musical tour de force of the island and its horizon, their understanding for this place grows. Lyberth uses instrumentals sparingly in his spectacular melody editions. All of Greenland is musically evoked – the wind blowing through the icebergs, sounds and people, the here and now of the Arctic. Rasmus Lyberth acoustically presents his home and his roots, even if he currently lives in Denmark. Yet, he has gained acclaim here as well. Queen Margarethe II of Denmark recently awarded him the cross of the Order of Knight of Dannebrog.

www.rasmuslyberth.gl · www.myspace.com/rasmuslyberth

HERE & NOW

If the Inuit population were to be determined by the number of speakers, then the Greenland variant Kalaallisut would count 40,000 on the island itself and 7,000 in Denmark. Greenlandic has an official status and is used more frequently than Danish, which is the second official language used.

Countless expeditions led to full exploration of the interior, some of the most known are those by Knud Rasmussen, Fridtjof Nansen (in 1888), Robert E. Peary (from 1891 to 1895) and Alfred Wegener (from 1906 to 1908, in 1912 to 1913 and in 1929 to 1930). In 1951, Greenland and the USA drew up the Greenland Defense Agreement. With the constitution in 1953, Greenland became an equal part of the Danish monarchy. After a referendum, the island was given full autonomy on May 1st, 1979, including a parliament (known as the Landsting) and a Cabinet. After a referendum in 1982, Greenland decided to withdraw from the European community in 1985.

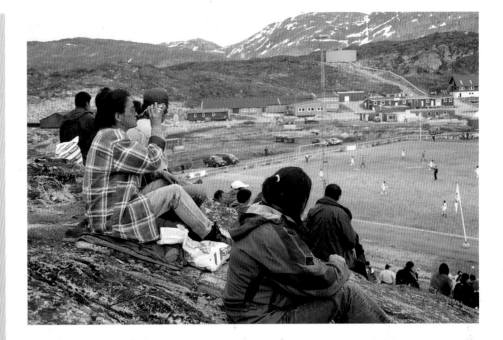

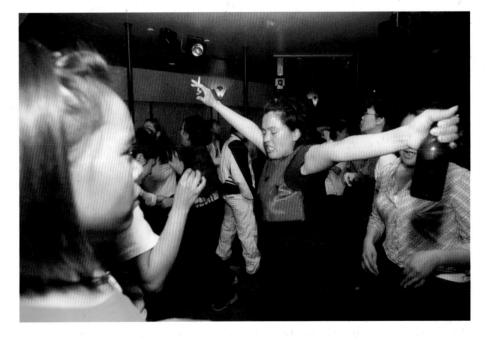

One century has since passed. The sun is high over Ilulissat. Over the past two decades, fishermen have noticed that the ice level of the Greenland Arctic Ocean has increasingly receded. Dates and facts have not documented this perceived change, but seafaring Kalaallit are well aware of the consequences. For when the ice surfaces melt in the north, dark water surface appears which, in turn, absorbs more sunrays than white ice surfaces, which increases the warmth, and thus causes the remaining ice to melt even faster. Kalaallit, like the Villladsens, can only describe what they have seen. Some scientists have listened carefully and can prove with simulations that this transition in the Arctic has already taken place. Others, however, dispute these findings vehemently.

HENDRIK NEUBAUER

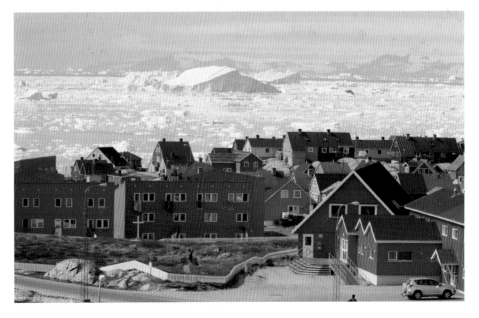

Colonialism

Europeans positively yearned for the riches and raw materials described by those returning from the New World. Unfortunately, people already lived there. Granted, their appearance was bizarre and they obviously had no concept of European civilization, yet these creatures were undoubtedly human beings. In other words, it seemed to be a mere legal problem. As the New World was to be seized, legally binding titles needed to be established and state symbols made in order to legitimize the acquisition of land on both sides of the ocean.

The Spanish government drafted a document, the Requiremento. This solemn text was read to the native population and was generally seen as an official declaration of war and of Spanish sovereignty over the Americas.

Legally binding titles were needed

In contrast, the Portuguese wished to see numbers and have as much information as possible. Portuguese kings asked their new subjects to give them information about the sun's zenith and the location of the stars, in order to formulate their claims to the recently discovered land a later date, based on their own proven findings. This scientifically structured manner of seizing territory always occurred after a carefully studied ritual and schedule; at noon, to be exact, so that the astronomical and geographical descriptions could not be contested. The French could not be bothered with such scientific distractions, and demonstrated their colonial power with parades, military marches and impressive clothes and uniforms. Dutch explorers were far more cautious. Initially, they completed documentation with the precise lines of latitude and longitude and, of course, cartographic sketches. The English usually believed in the power of conditions alone and took quite a pragmatic approach to conquering territory. Instead of deliberately staged depictions of force, they took their shovels and hoes and dug ditches, planted gardens, and erected fences or hedges.

Each colonial force developed its own style

Thus, each colonial force developed its own style in dealing with these native creatures inhabiting the New World. Very generally, the native inhabitants only really had the choice between sinking and swimming, regardless of the colonial variant they faced. Often, they sunk, dying from imported diseases or the permanent destruction of their living spaces.

Historically and globally, the Danish were a comparatively small colonial power. They also had certain notions on what to do with the natives. Under the reign of Christian IV the first expeditions headed out in 1605, towards Ultima Thule. Apparently, the explorers had been ordered by the king himself to catch a number of ›savages‹ in Greenland, and bring them home to the Danish kingdom, where they were to be presented to the monarch. These skraelinger or indigenous peoples of Greenland were exhibited within the framework of a festive parade. Far from being interested in making contact with the natives of Greenland, or even exploring Eskimo territory, the monarch's goal was to parade the ›savages‹ in Copenhagen, in the presence of the king, as a demonstration of national greatness and colonial power.

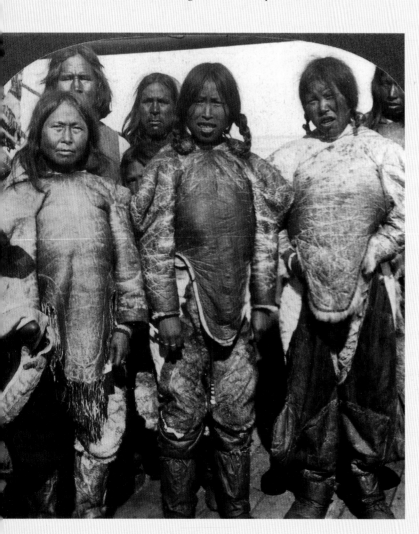

Greenland Inuit pose for the cameras in the nothern town of Cape York around 1900. Admiral Robert Peary embarked from Cape York on his second expedition to the Arctic.

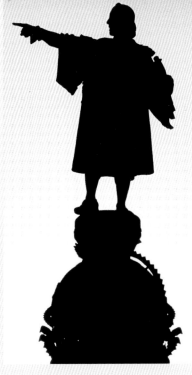

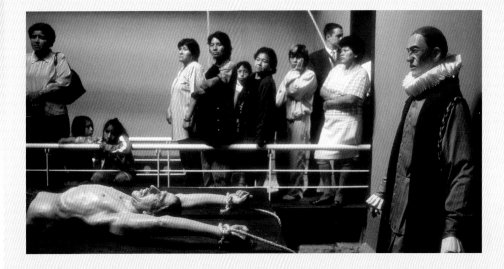

Christopher Columbus died on March 20, 1506. The Columbus monument commemorating the discovery of America was erected in Barcelona during the 1888 World Fair LEFT. *Wax figures portraying a torture scene in Lima's Museum of the Spanish Inquisition* RIGHT.

While the Danish may have favored an individual approach when it came to the acquisition of land, all other aspects from kidnapping to enslavement of the savages were generally the norm in the Age of Discovery. Giovanni Boccacio describes in *De Canaria et insulis* the acquisition of the Canary Islands in the 14ᵗʰ century, which obviously included imprisoning the native population. Reminiscent of the Roman generals, who returned from battle with the Gauls in chains, even Columbus returned from his first trans-Atlantic journey with several ›Indians‹ and exhibited them in a triumphant parade through Seville in March of 1493. Columbus noted in his journal that they commanded the most attention by far; these ›savages‹, forced to carry bright yellow parrots in front of themselves as decoration, were the living proof that a new country, even a new continent, existed across the ocean.

Similarly sensational was the parade held by Henry II and his wife through the former port metropolis Rouen in 1550. France had just founded a coastal colony in northeastern South America. In a stunning staged performance, fifty Brazilian Tupi-Indians were presented together with two hundred and fifty soldiers, who were disguised as cannibals. Together, they showed scenes of war and daily life as it supposedly took place across the ocean. Once again, the similarities to the classical Roman triumphal processions were apparent.

As for the Danish explorers, the 17ᵗʰ century was disillusioning. Neither the hopes for evidence of ancient Nordic ancestors, nor rare metals were found in ice-covered Greenland. In the book *Suggestion for sailing around Greenland* by Tormod Torfæus, published in 1683, something similar to insight could be read for the first time.

›It seems to be ill advised to take individual Greenlanders prisoner and kidnap them. Indeed, I declare hat this was one of the greatest mistakes that was ever made. Firstly, this act was of no use whatsoever. Our young children could

Robbed, kidnapped, struck dead.

have learned their language or the Greenlanders could have learned our language and more, so that they could have been returned to their land and inform their brethren of the [European] nations good nature and piety. They could have also shared their knowledge about the wondrous qualities of our land in comparison to theirs. However, the people in Greenland have become shy and frightened of foreign nations, for they have heard the rumors and news that when they arrive with their ships, they will be robbed, struck dead or have their people kidnapped from their own land.‹

Torfæus' comments on this subject deserved more attention outside of the Danish borders. Yet, they were silenced by the hubris and bigotry of the great colonial powers, which, at best, used moral and legal banter as a pretense.

HENDRIK NEUBAUER

»Bury My Heart at Wounded Knee« was named »Outstanding Made for Television Movie« at the 2007 Emmy Awards. The film was based on Dee Brown's critical non-fiction book of the same title. Here, West Studi as Wovoka.

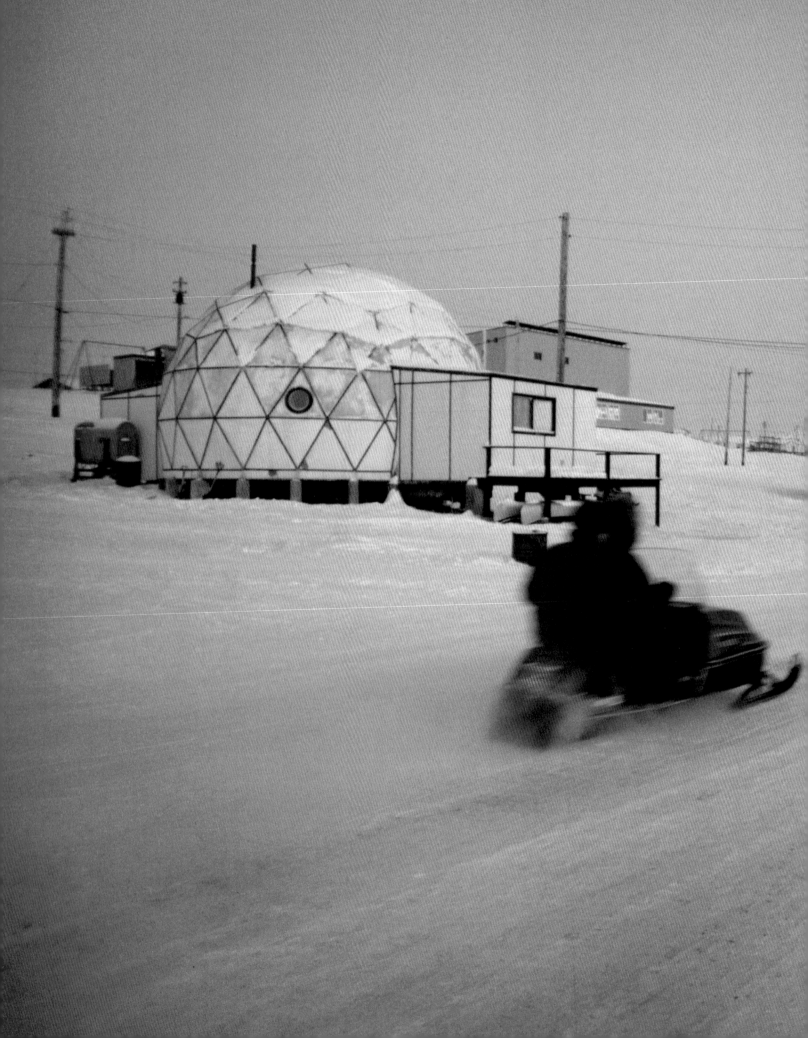

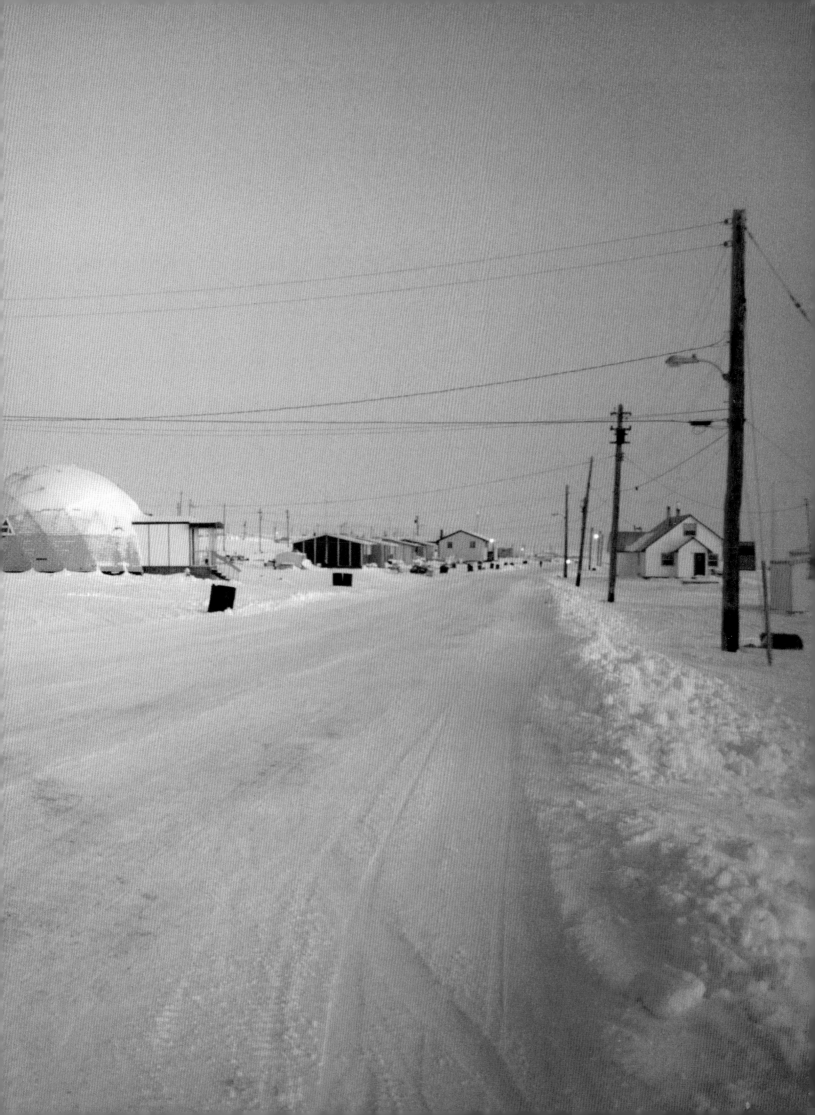

INUIT

An ordinary family

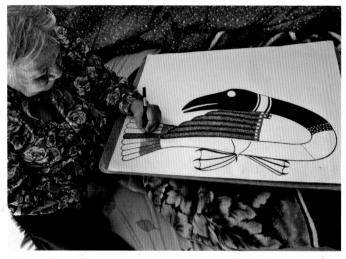

Kenojuak Ashevak lives in Cape Dorset, where she began to draw during the 1950s. She has since become one of the most successful and best-known Inuit artists with an international reputation.

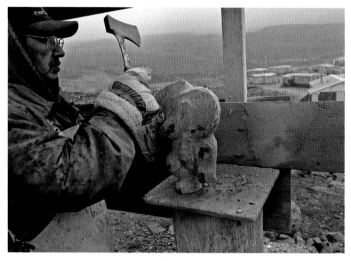

Tuqialuk Nuna works on a soapstone sculpture in his outdoor studio. An artists' colony has established itself in Cape Dorset. One in four of employed in Cape Dorset make their living as artists.

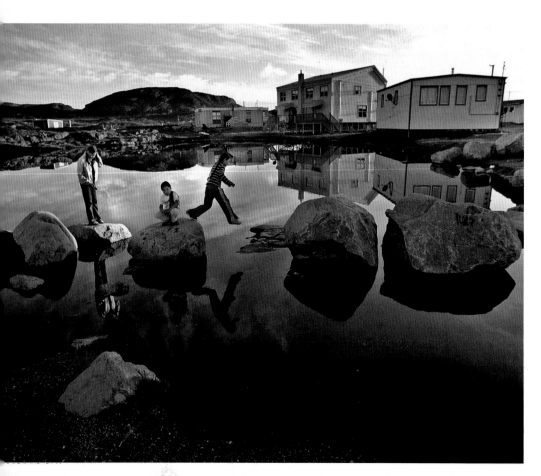

There is no need to search far and wide for stone on the Nunavut coasts. Sculptors collect soapstone here for their artistic works, but also visit quarries eight hours away by boat.

The internationally acclaimed Inuit artist Kenojuak Ashevak is someone you could listen to all night. That's how fascinating and touching the story of her life is. Her basic biographical data gives us only a vague idea of the things she has been through. She was born in an igloo in Camp Ikirasaq on the southwest coast of Baffin Island in 1927. A year later, her parents moved to a different camp. In 1930, her father was murdered by neighbors. The Ashevak family remember him being envied for his hunting skills. Kenojuak grew up in her grandmother's camp. She married at 19 and had three children. In 1952, she fell ill with tuberculosis. After spending three years in a sanatorium in Québec, she recovered and returned to the far north of Canada. Her family had been more or less wiped out. Only her husband Johnniebo survived the illness, their children all died.

At the end of the 1950s, Kenojuak and Johnniebo's life took a new turn. The couple settled in Cape Dorset and adopted children. Johnniebo went hunting, Kenojuak dedicated herself to craftwork. She

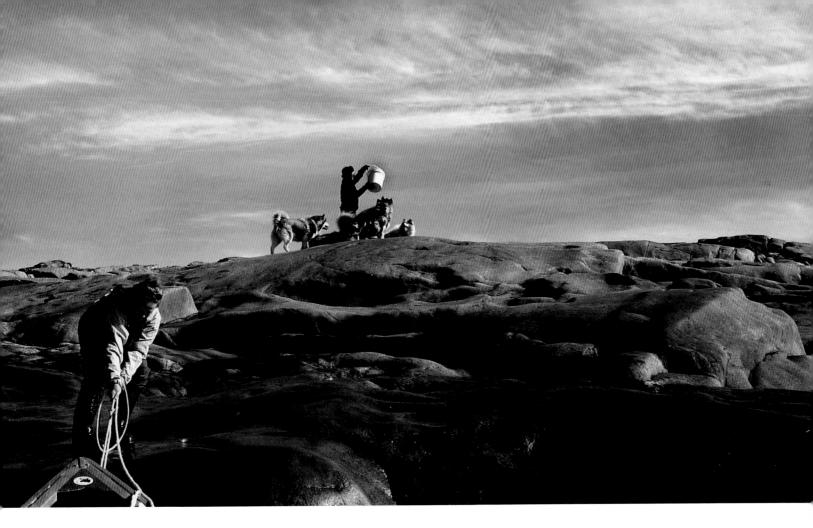

benefited from the support of well-known artists and art historians, such as designer James A. Houston, who had discovered the value of Inuit art and popularized it in the »south.« These »artistic aid workers« passed on their knowledge of art and artistic techniques to the Inuit, mainly in what is now the territory of Nunavut.

Kenojuak's talent was also discovered, and today she is one of the most famous Inuit artists. Her work is in demand all over the world, she has exhibited in famous museums and her motifs appear on postage stamps and coins. Kenojuak Ashevak has therefore played a key role in popularizing the art and crafts of the Inuit. Today, annual turnover for Inuit art is estimated at between 20 and 25 million Euro, about as much as tourism generates in the region. The artistic talent of the Inuit is obvious: almost every family has a painter or illustrator, all of them craftspeople who clearly derive pleasure in decorating everyday objects such as animal hide clothing and boots. In an interview, the artist Kenojuak professed her love of both: hunting and fishing, and painting and drawing, or creating beautiful things. To be happy, she said, she needs both.

HENDRIK NEUBAUER

HERE & NOW

North of Hudson Bay, on an area which makes up almost one fifth of the entire country, the Inuit's first self-administered territory was created in Canada in 1999: Nunavut. No more than about 30,000 people, 25,000 of them Inuit, inhabit this rather bleak and hostile part of the world. The center is the capital of Iqaluit which has a population of approximately 6,000. As a result of the Inuit's endeavors to achieve autonomy, the self-governed region of Nunatsiavut was created on Labrador, the peninsula in eastern Canada, in 2005. The foundation of these territories was the culmination of decades of legal disputes in which the Inuit had to prove their legal right to the land.

The Inuit have high expectations of their newly achieved autonomy. The Inuit parliaments now collect levies from the mining companies, and are responsible for state and international support. The Inuit hope their new status will bring political integration, but above all economic prosperity. New administrative jobs have been created and tourism is being actively promoted. Conditions for selling high-quality Inuit art have never been better.

INUPIAT

Whale songs and background noise at the world's end

In Barrow, the northernmost corner of Alaska, dinner is being served. A total of 4,500 Inupiat live here on the border of civilization, surrounded by pack ice. For dinner, the Browers serve their guests Muktuk, of course. »Isn't it delicious?« asks our hostess Roxanne. Frozen whale skin with the vitamin-laden blubber is firmly attached to the whale meat. Sliced paper-thin and slightly salted, it melts in the mouth and has a slightly nutty aftertaste. Juice accompanies the meal, for, the sale of alcohol is still strictly forbidden in Barrow.

The Inupiat in Barrow may have telephones and cable television, yet most families still subsist on whale hunting. Harpoon hunting is restricted by law and permitted only as »traditional whale hunt for personal use.« In total, the region is allowed a quota of sixty animals per year. The bowhead whale, quite common in the region, and above all recognizable by its rounded head and almost grimacing strongly bowed lower jaw, was put under protection by the International Whaling Commission in 1946.

Yet the idyll is threatened; Alaska has considerable oil resources and oil production is spreading farther and farther up north. While Barrow was previously unaffected by this development, in the summer of 2007, drilling crews from international oil companies arrived. Should the offshore oil boom also reach this region, the Inupiat believe it would have consequences for the whale count. The underwater drilling is said to disturb the whales, which would cause them to change their migration routes. Whales might even avoid the region completely. The Inupiat would not be able to follow them in their boats and, thus, harpoon hunting would also be impossible. Once whaling is at risk, Inupiat livelihood is endangered.

»Why here? I don't drill in the New York Harbor!« Lewis Brower cuts off more slices of Muktuk. Even his two-year-old daughter gulps a piece of the meat down between sips from her bottle. The house, at the end of a windy street is decorated with pictures of protestors and demonstrations for whaling campaigns. Just a few weeks ago, a giant whale was caught by the Mayor-Itta-Crew and butchered on the beach in twelve hours. The captain's wife cooked a big dinner for the entire village that evening.

The mood is changing, reflected in addictions, rampant, in spite of strict prohibition of drugs and the sale of alcoholic beverages. As for the whales, do they even have a chance? Old harpoon tips in bodies of killed whales have shown that bowhead whales can grow to be over 100 years old, even if traditional hunting pays its toll. In May 2007, while carving a 45-ton Greenland whale killed on the Alaskan shoreline, a tip of a harpoon that had been thrown into the whale in 1890 was found. Whales and humans have lived together here for a long time.

HENDRIK NEUBAUER

A whale bone along a country road ABOVE RIGHT. *A container filled with whale residue far from Barrow* CENTER LEFT. *Dry caribou pelts on porches* CENTER RIGHT. *Spear fishing brings in rays, skates, and other fish as well* RIGHT. *Muktuk is a regional delicacy* BELOW LEFT.

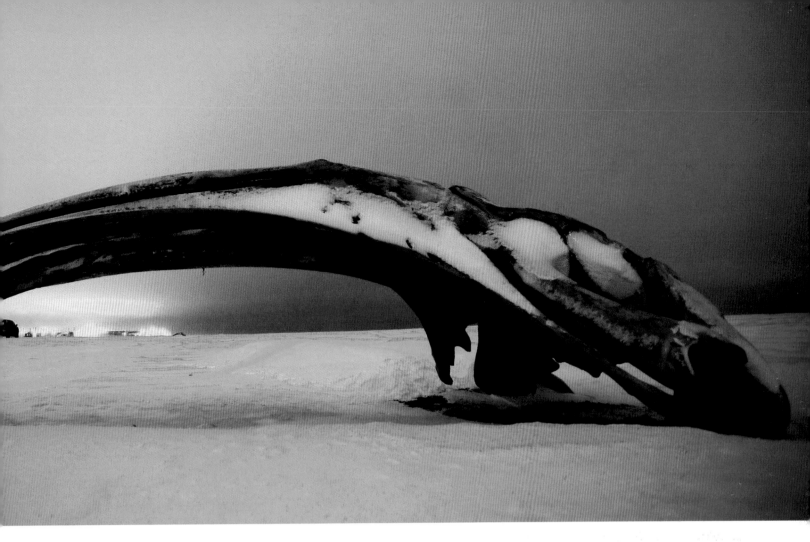

HERE & NOW

The Arctic Slope Regional Corporation (ASRC) in northwestern Alaska comprises 13,000 Inupiat members, of whom around 4,000 still use the regional Inuit dialect. The eight districts of the privately owned corporation govern themselves, as well as the giant nature reservation, which is the size of Wyoming. Oil springs are abundant in neighboring Prudhoe Bay. Huge oil reserves can be found in the reservation around Barrow and especially along the shoreline. The ASRC already collects millions of taxes for onshore activities in the region. The Inupiat are thus not opposed fundamentally to the activities of the corporate groups in the region, on the contrary. Many earn their livelihood through services for the oil industry and activity in the oil fields. Thus, the native population finds itself in a precarious dilemma, for the expansive demands of the oil industry can only be met as long as the subsistence economy, whale hunting, is not endangered. Fraught with risk, it seems a dangerous game to play.

TEMPERATE CLIMATE

FOUR SEASONS

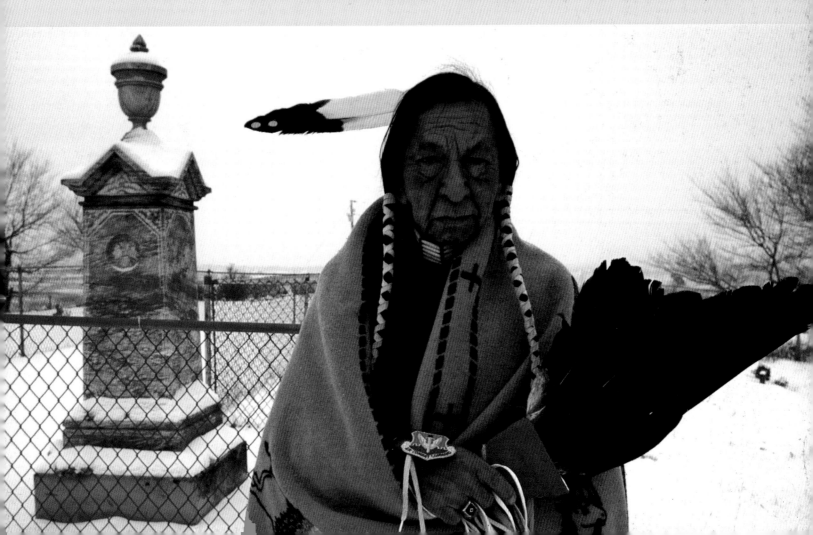

BLACKFOOT

Smoke signals for the future

The tepees have not disappeared altogether. When the Canadian summer arrives in the south of Alberta, the Kainai Indians in Reservation 148 pitch their buffalo-hide tents for their powwows and summer camps and don their traditional festive attire. Over several days and nights of dance and revelry, the area looks a little like it did in the legendary days when the Blackfoot dominated the vast northwestern plains from the upper reaches of the Missouri to the valley of the Saskatchewan. When mounted hunters and gatherers traveled

in small groups across the prairies, traded bearskins and deer hides and worshipped the sun as a supreme deity.

However, Kim Shade is more preoccupied all year with houses. Solidly built houses urgently needed in these more settled times by her brothers and sisters in the reservation of the Kainai or Blood tribe, one of the three main Blackfoot groups. This is the responsibility of the Blood Tribe Housing Department, over which Kim now presides as director. »Kainai« means »many chiefs,« but in the tribal office's most important committee, the young graduate Shade has the final say. A Bachelor's degree in management from the University of Lethbridge, 44 miles (70 kilometers) away, proves she has the knowledge to do the job.

Today, the reservation between the courses of the rivers Belly and St. Mary, some 124 miles (200 kilometers) south of Calgary, is home to over 3,800 of around 7,400 Kainai. The Blackfoot nation has a good 18,000 members registered. This is a fairly impressive statistic, considering the fact that ethnic groups were severely decimated by smallpox epidemics, persecution and the fatal effects of alcoholism at the end of the 19th century. However, for many, »home« means makeshift accommodation rather than a proper house,

which they cannot afford. The possible consequences of this were last experienced in 2005: weeklong rainfall caused the rivers to burst their banks and the floods took everything that was not fixed firmly to the ground.

So it is also a precautionary measure when Kim's authority and the Canada Mortgage and Housing Corporation campaign for the introduction of state-aided schemes to enable the poor particularly to build inexpensive prefabricated houses on a payment-by-installment basis. Up to 40 projects have already been completed per year, but considerable personal effort is required. This has created jobs in the reservation and led to the foundation of the tribe's own business, Kainai Industries, which produces parts for prefabricated houses. These are smoke signals for the next generation, many of whom are more preoccupied with their modest existence today than with the great legacy of the Blackfoot. However beautiful the summer powwows and parties can be, they have never fed anyone in the Kainai reservation.

BERTRAM JOB

Kainai elder on Canada's largest reservation. The »Kainai Indian Days« take place here once a year ABOVE. *In addition to competitions, the festival offers traditional ceremonies, like the Sun Dance* RIGHT.

HERE & NOW

The groups of Algonquin Indians who belong to the nation of the Blackfoot called themselves »Nitsitapii« (true people) or »Sow-Ki-Tapi« (prairie people). They also include the Siksika or Blackfoot, the Kainai (also known as Kainah) or Blood (Blood Tribe) and the Piegan (or Pekuni). Over half of around 18,000 registered members live a largely integrated life outside the four tribal reservations. These are located in the US American state of Montana, near Browning, and in the Canadian province of Alberta (Reservation 146-148). The Kainai region is considered to be Canada's largest ethnic native land. The Blood Tribe is represented politically by the twelve-headed tribal council. All three ethnic groups are members of the Indian Association of Alberta.

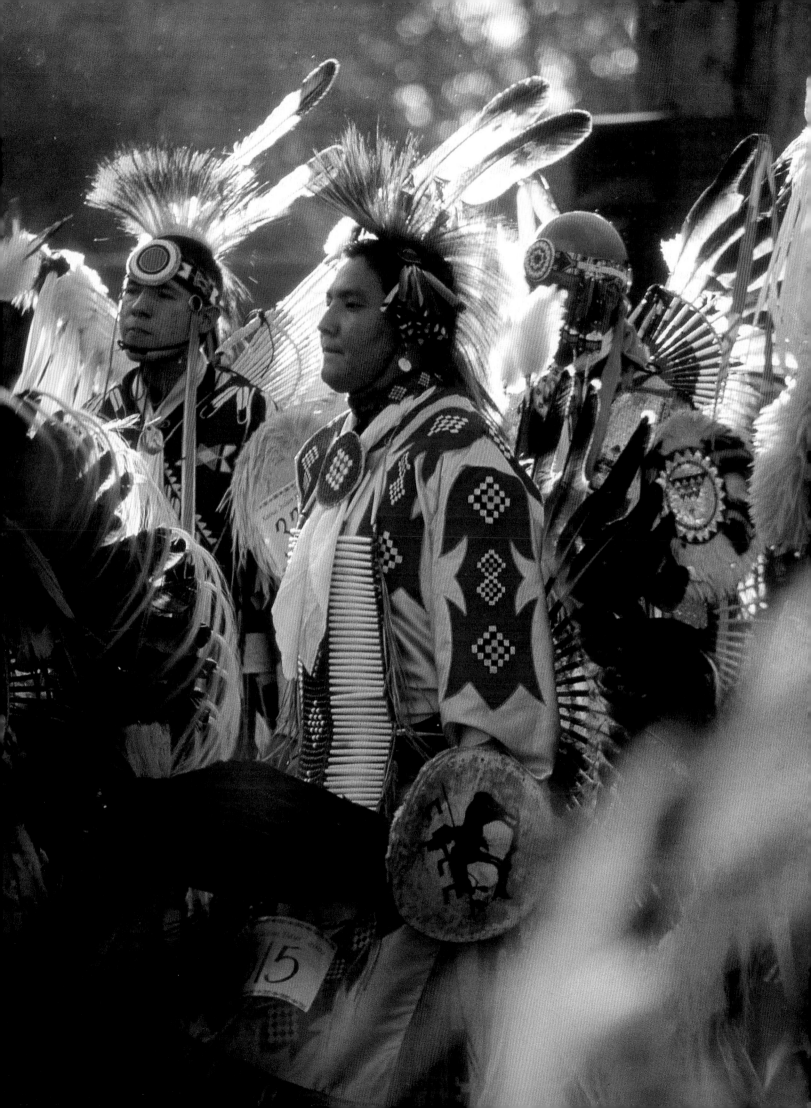

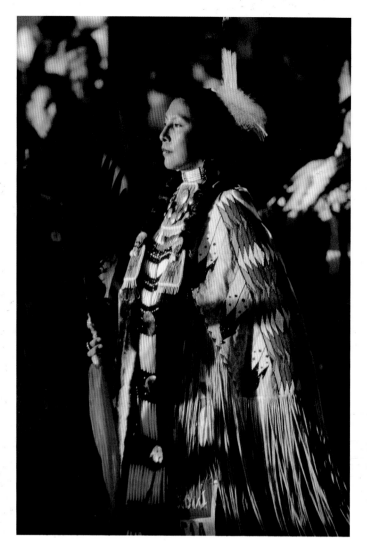

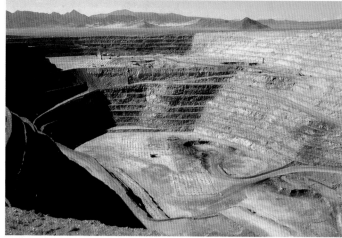

Rose Ann Abrahamson at a Powwow. This Lemhi Shoshone from Idaho is a teacher and cultural historian LEFT. *Gold miners settled in Shoshone territories in Crescent Valley,* ABOVE RIGHT. *The Dann sisters have been fighting for Shoshone land rights in Nevada since the 1970s* BELOW RIGHT.

CRESCENT VALLEY 🌐 40°25'N 116°34'W

SHOSHONE

The rights of the elders

It was like a scene from a cheap Western, but with modern equipment. In September 2002, over 50 armed men forced their way onto Mary and Carrie Dann's ranch near Crescent Valley in Nevada, arriving in jeeps, trucks and even helicopters. Before the two elderly farmers of the Western Shoshone tribe realized what was going on, the entire gang had made off again – with over 200 cattle. The animals were sold off at auctions, but the proceeds were pocketed by the Bureau of Land Management (BLM). This is the way debts are collected today in Eureka County from people who refuse to pay duties on pastureland, and the reason why is because they firmly believe the land still belongs to them.

The state raid on the two elderly ladies is the climax to date of a bizarre conflict

which has been going on for half of the Dann's lives. The authorities have been trying to recover debts on the farm of the Shoshone sisters since 1973. In 1992, 700 horses were confiscated Wild West style. Six years later, they demanded a total of 564,000 US dollars. Mary and Carrie were, however, adamant: their ancestors farmed here too, and in 1863, the peace treaty of Ruby Valley was ratified. This confirmed that large parts of northern Nevada, Wyoming and southern California belonged to the Shoshone, granting the

whites the right to cross the region in their search for gold.

In the meantime, however, a new gold rush has broken out in Nevada; the barren land itself is suddenly valuable. The first companies are already digging down 984 feet (300 meters) to mine for ore containing gold; including the area near the Dann's farm, and the sacred sites of the Shoshone. This is now possible because the state of Nevada is treating the relevant regions not as the ancestral homeland of its native population but

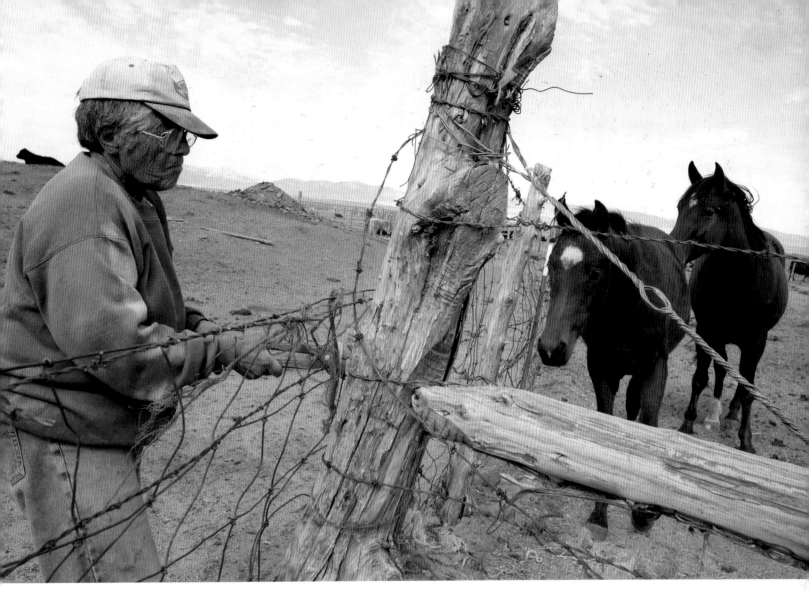

Together with her sister Mary, who died in 2005 (shown repairing a fence in the picture), Carrie Dann (born around 1934) received the 1993 Alternative Nobel Prize in Stockholm. The lands claimed by the Shoshone make up two-thirds of the state of Nevada, and include bordering areas in Idaho and California.

as a »public place,« an area of eminent domain. The Shoshone were offered what was considered to be the generous sum of 27 million dollars as a one-time compensation; an amount that has increased in interest, over the years, to over 100 million dollars. Representatives of the Shoshone are not interested: they want their land rights back, not money.

Thus so, the alternative Nobel-prize winning Dann sisters have unintentionally become key figures in the protest against the unscrupulous appropriation of Nevada's land and property. Unscrupulous is how the Shoshone regard gold mining which contaminates their scarce ground water. The situation could, however, become even more precarious if plans to carry out new nuclear testing and to build an atomic repository near the holy Yucca Mountains come into fruition. »This isn't going to end happily,« says Shoshone activist Larson Bill. »The world doesn't need this, it has enough problems already.«

BERTRAM JOB

HERE & NOW

The homeland of the Shoshone Indians covered almost 15 million hectares of land. Hunting on foot, the Shoshone were early settlers in the Great Basin (between Montana, Idaho, Utah, Oregon and Nevada). The different divisions of the Uto-Aztecan family belong to the northern, eastern and western branches and are estimated to number between 5,000 and 10,000. In Nevada, the Western Shoshone National Council and the Western Shoshone Defense Project are campaigning against the further expansion of ore and gold mining, and new atomic tests. Between 1951 and 1990, some 950 atomic explosions occurred on reclaimed ancestral land. The UN Committee on the Elimination of Racial Discrimination has vehemently criticized the US government's treatment of the Shoshone Indians in Nevada.

LAKOTA SIOUX

Many paths lead to the goal

They used to rely on buffalo here, back when thousands of hoofs thundered through the endless grasslands of the Great Plains. Today, they survive mainly by the tourists who drive down here from Canada to visit places such as the Rosebud Casino, where the one-armed bandits clatter all night long. The tourists may be the herds of today, settling down for the evening on South Dakota's Highway 83, waiting to be milked by the Rosebud Lakota, a band of Sioux. Alas, as seductive as the casino's 260 slot machines blinking in unison around its five gaming tables may be, they cannot solve all the problems.

The constant flow of visitors coming to gamble at Todd County's Rosebud Reservation is an easily manageable crowd. There are perhaps two to four hundred tourists per evening patronizing the casino, the affiliated hotel and two restaurants. The tourists provide around two hundred members of the tribe with a steady income. The millions of dollars that tribes in Cal-

Rosebud Casino, located on the reservation of the same name, is an important economic resource for the Lakota Sioux, althoughit is not as successful as the Indian casinos on the east and west coasts.

KEVIN LOCKE –
THE FLUTE IS MADE OF CEDAR

Whether it is the blood of the Hunkpapa Lakota that flows in his veins or that of the Anishinabe tribe, concerns others much more than it does flautist Kevin Locke. This savvy citizen of the world knows only one spirit that moves everyone like the wind across the plains. It comes from his music, which recreates the sounds of the handmade cedar flutes played by his ancestors. Locke was born in the Standing Rock Sioux reservation in 1954, where he was given the name Tokeya Inajin (First to Arise). A born performer, Locke interprets traditional handed down melodies and verses in his performances, which draw on the ancient Hoop Dance and the vocal skills of traditional storytellers. His modern arrangements for traditional music do not take anything away from the past.

Those who are doubtful should start with Midnight Strong Heart, Locke's most recent album. With the underlying sharp clang of the steel guitar and notes borrowed from blues and country music, Locke's flute tones place the Native American experience in the context of the United States today. This is, in part, due to the participation of Jimmy

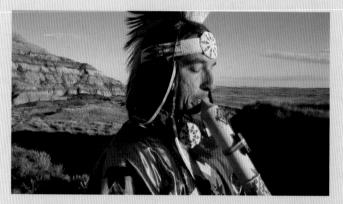

Carlire, formerly of the band America, and the person responsible for the arrangements. From Locke's point of view, the term »crossover artist« has a dimension that goes beyond the music. As the untiring musician, who also travels with his Native Dance Ensemble, has said:»Through my music and dance, I want to create a positive awareness of the oneness of humanity. It doesn't matter where we are from. We can all come together in music.«

www.kevinlocke.com

Buffalo herds are being returned to the wild in places like the Lower Brule reservation, in the hope of attracting tourists ᴀʙᴏᴠᴇ. Powwows like this one here in Duluth, Iowa, began on the Plains reservations in the late nineteenth century, combining tradition and tourism without contradiction ʙᴇʟᴏᴡ.

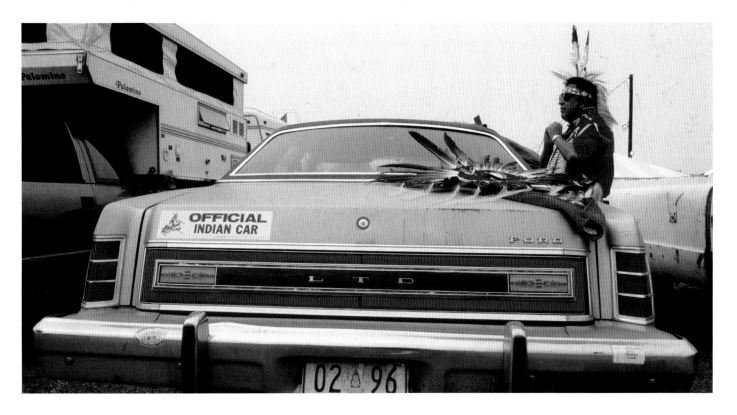

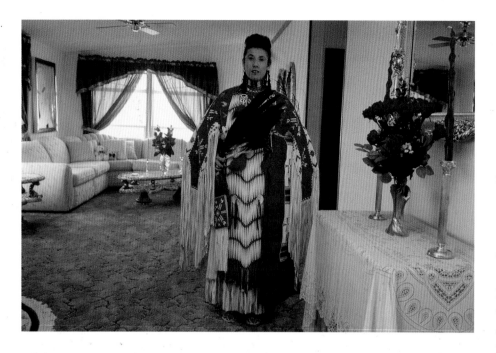

ifornia and on the East Coast earn from gaming tables are not in evidence here, where there are also credit charges and taxes to pay on the investment. Life on the Nebraska border, where the winter winds howl, and summer heat burns, remains as tough as buffalo grass.

The Rosebud Reservation is home to 21,000 tribal members, a total of one-third of all the Lakota. Only very few have managed to secure a middle-class life working as gas station attendants, video store clerks, laundromat employees, salesmen, silversmiths and cattle hands. The unemployment rate is an astonishing 80 percent. The nearest airport is 100 miles away, and Todd County ranks in last place for per capita income out of all of South Dakota's sixty-six counties. In addition to the casino, opened in 1994, schools and government offices are the only major employers. There is almost no private industry.

The situation is similar at most Sioux reservations that spread out across the wide northern prairie, along with those of the Crow, Cheyenne and other tribes. With the end of the enormous buffalo herds and loss of an almost unlimited freedom to move from place to place, the nomadic lifestyle of the plains' tribes came to an end by the late nineteenth century. The natives suffered devastating military defeats against the US Army, which was clearing the way through the plains for the settlers and gold prospectors who

HERE & NOW

Nadowisiwug (little snakes) was the name that the neighboring, half-settled tribes of the northern prairie called the nomadic Sioux, to be spoken with unrestrained animosity. French trappers understood the name as nadouessioux, or »Sioux,« for short. Today, the corrupted name given to them by strangers has been rejected, with most tribes preferring to be called by the names of one of three spoken dialects: Dakota; Lakota and Nakota. Of these, the Lakota, also known as the Teton, live the furthest west, where they are subdivided into the Rosebud (or Sicangu), Oglala, Izipalo, Hunkpapa, Miniconjou, Shiasapa and Ooinunpa.

According to the latest estimates, there are around 70,000 Lakota living in the American Midwest, half of them on reservations in North and South Dakota, Minnesota and Nebraska. Others are settled in smaller groups from Montana to the Canadian border. South Dakota is home to five reservations, thirteen Native American run casinos, numerous tribal schools, one tribal high school and Sinte Gleska University in the town of Mission. The town of Rosebud is the administration center for the Rosebud Reservation. It has a population of just 1,500.

The political leader of the Lakota Sioux is the president of the Tribal Council, who is elected by popular vote every two years. The Great Plains Tribal Chairman's Association (GPTCA) represents the common interests of all Sioux tribes. The Lakota's greatest demand, now as ever, is the return of the Black Hills, which the tribe considers sacred ground. It was lost to the Native Americans when gold was discovered. In 1980, the government offered reparations as high as 122 million dollars for the loss of the Black Hills. The Lakota refused the offer.

This ranch owner, here at home in Rosebud, breeds horses and cattle, and has also made her name in Canada and the USA as a Powwow dancer LEFT TOP. On the edge of a Powwow on the Rosebud Reservation BELOW LEFT. Settlement on the Lower Brule Reservation in South Dakota. The list of twentieth century wars in which veteran Lakota fought as members of the US Army is a long one RIGHT.

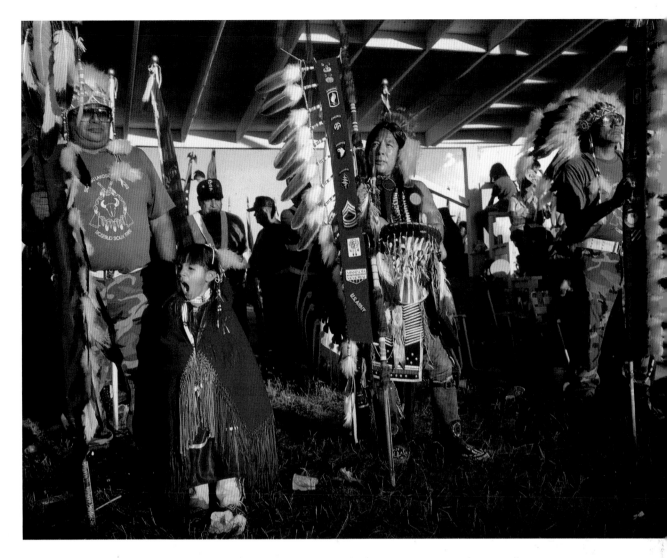

would follow. The era of the reservation began soon afterward, with no successful plan in place for the development of a new, self-sufficient local economy. Meanwhile, the land available for development rapidly became unavailable.

The 1880 peace treaty between the US Government and the tribal chief led to the »Great Sioux Settlement« being reduced by more than half. The Rosebud Lakota alone were forced to move five times. Since then, the descendents of Red Bear, Man Afraid of His Horse and the famous Hunkpapa Lakota, Sitting Bull, have gained the rights of a sovereign nation. The Lakota now administer their territories more or less autonomously with a government made up of twenty five directly elected tribal elders, and with a force of tribal police for keeping order.

Slowly, things are changing, even in the town of Rosebud, where the Tribal Council has offices just like any other Todd County institution. It is a sorry man who sits and bemoans the past. Instead, the Sioux are looking to the future. The plan to build up the infrastructure of the local economy began many years ago with the presentation of ambitious plans that only now are starting to bear fruit. The time has finally come for a reservation economy that can function free of government subsidies. Wind energy and technology programs are on the agenda, as is the enormous Mni Wiconi Rural Water Supply Project, which will revive overexploited groundwater supplies with water redirected from the Missouri River, provided, of course, the government does not turn off the funding tap again, as it has in the past.

Also in the planning stages is a reconstruction of the prairie ecosystem that once dominated the northern plains. This is a hopeful development that could bring back the buffalo, which survives in large herds today only on reservation ranches. It will also revive wild populations of prairie dog, black-footed ferret and other animals. Restoring the prairie to its original, natural state would encourage hiking, hunting and fishing. Why tread the same path over and over again, when there are many roads in this ancient place that can lead to better chances for success? This at least, is something the gamblers in the Rosebud Casino, already know.

BERTRAM JOB

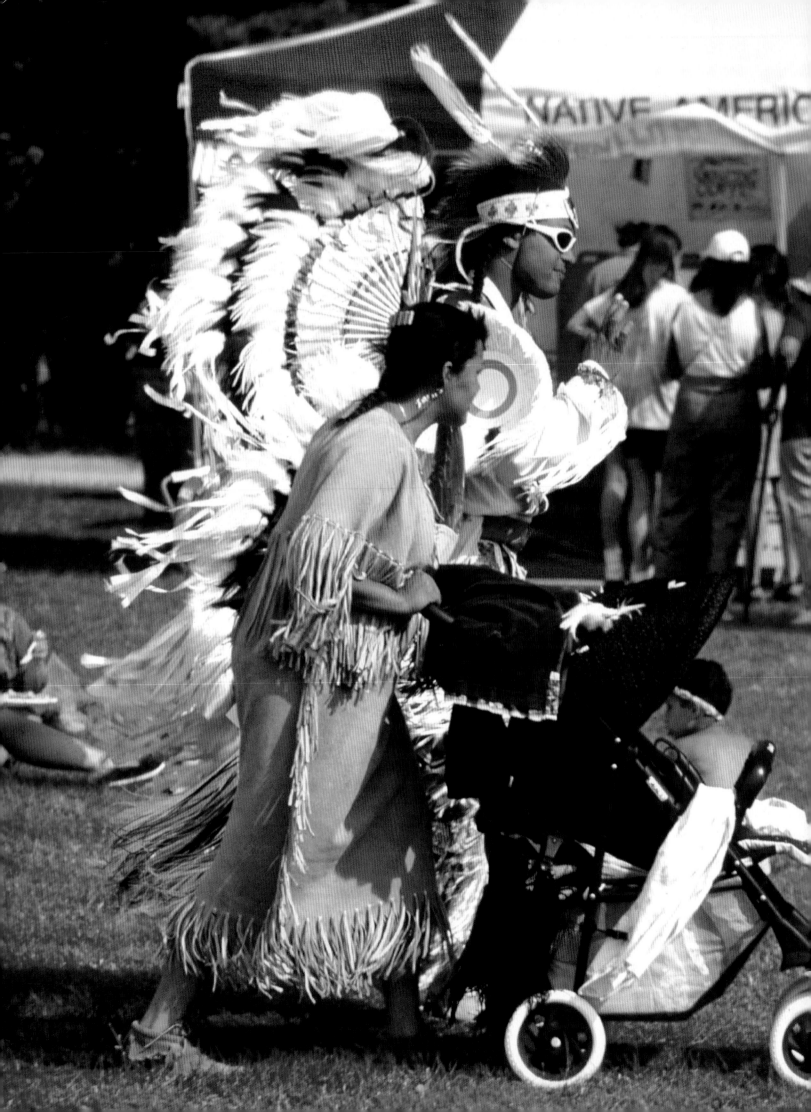

Food

Small groups of natives from the Amazon or the Aka Pygmies in Black Africa meet their nutritional needs almost exclusively by hunting, fishing, and gathering fruit, roots, and other wild plants. They are still around today, the hunters and gatherers who very rarely consume other foodstuffs such as grain or milk. Foragers can only still be found in the arctic, tundra and steppe regions, tropical rain forests, or deserts, where other methods for acquiring food have not developed or are impossible.

In China, water buffalos wade through the water-logged fields, prodded by farmers. China produces a third of the world's rice harvest. Rice is the number one basic food in Asia. In contrast to America, the world's champion in exporting rice, where almost all work is done by machines, Asia's people and animals carry out the laborious task of cultivating rice, mostly.

In Africa, agriculture is ruled by tubers and grain; yams, taro, manioc and sweet potatoes, or millet and corn. These plants are among the most important crops cultivated in the tropical rain forests and wet savannahs. If one were to look into the cooking pots of the world, one would discover that these plants are found precisely in the tropical areas around the equator. Having identified these two basic foodstuffs, a

Agriculture is ruled by tubers and grain

question soon arises: whose idea was it to cultivate and further process them? Man's ancestor once dug these starchy tubers out of the soil with his bare hands. Then, at some time, he threw the tuber into the fire, explains Richard Wrangham, a professor in the Department of Anthropology at the Harvard University in Cambridge. Approximately 250,000 years ago, our ancestors chopped, ground, and cooked the ingredients, making a porridge out of them.

Tubers or grains? In order to see their uses in modern African cooking, one must travel through present-day Africa and look over the shoulders of its cooks. In Ghana, the national dish, Fufu, is comprised of manioc, and enriched with plantains according to taste. Also, Kenkey, a fermented rice ball, should be definitely tried. In Burkina Faso, we find To, corn pudding on the plates; in South Africa, Milliepap, prepared with millet, is less widespread than Pap, which is actually made from corn. Yams, on the other hand, are among the luxury products everywhere, unless perhaps people cultivate them themselves. However, regardless of whether common or refined, porridge is well known as Kitt throughout Africa. It is eaten by forming it into small, bite-sized balls with the fingers and then dipped in sauce.

Cooking has become elementary

A very fundamental activity takes place before food is eaten. Whether in the forest on the Rio Cupanema, in the slums of Lagos, or the penthouses of Jakarta, cooking has become so elementary for all people that it is worth taking a look at its origins. First of all: heat transforms long chains of proteins and carbohydrates into matter that is easier to digest. This wisdom came to Homo erectus at just the right time, as he stepped out of the forest and into the open savannah. Here, he primarily found tough tubers to consume. However, it was only the process of cooking that released their energy. The number of absorbed calories quadruples when potatoes or cassava are cooked.

Homo erectus swapped »chewing time for cooking time,« says Wrangham—with far-reaching consequences. This gave him more time to perfect his hunting and scavaging techniques, allowing him to survive and pass on his genetic mark to Homo sapiens, or modern man. In addition, there was also a firework display of aromas and smells to learn to savor.

Hungry mouths gather around the fire while the ape sizzles on the spit or the camel roasts in the sand oven. Whoever cooks, works around a campfire or the hearth. The meal is eaten communally when prepared. The communal

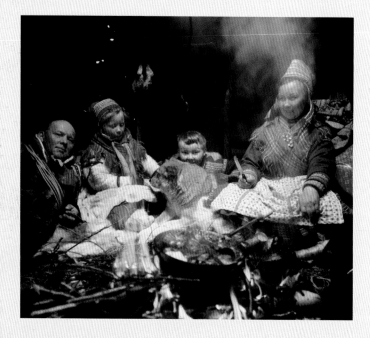

The hunter-gatherers of the Norwegian Sami live off of what nature offers. Their main source of nutrition is still the reindeer. They supplement their diet with canned goods when available.

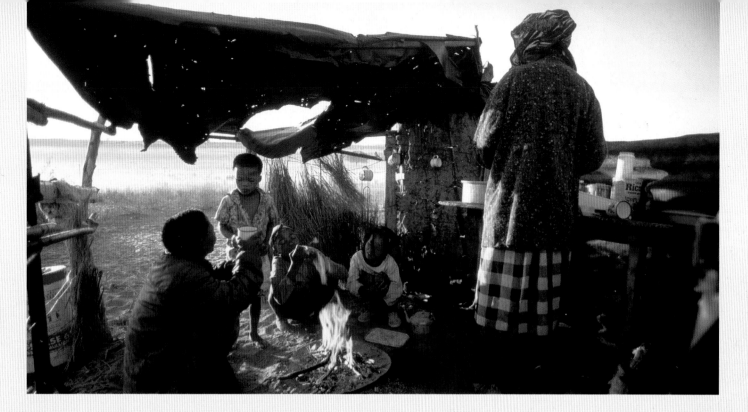

The San of the Kalahari Desert are well known for their skill with the bow and arrow. Today, they mostly hunt small animals. Their main source of subsistence, however, is vegetation, consisting primarily of roots and tubers.

meal is an important part of the development of the social fabric of Human society.

Early Man quickly noticed that stockpiling supplies was essential to suriving long periods of drought. He had to overcome the gatherer mindset of continually living from hand to mouth. However, the invention of the storehouse and the larder was the onset of the »Producer-Thief-Dynamic,« according to Wrangham. »Suddenly, there is food that can be stolen.« The storehouse was a radical turning point in the social history of Man. From then on, the man guarded the supplies and the woman prepared the meals. This activity is profanely called pairing consolidation, thus coining the idiom: the quickest way to a man's heart is through his stomach.

After that short full-speed gallop through the evolution of Man, one must take another look at the aboriginal peoples and their diet. Initially, it is impossible to lump them all together. »The range of diet is enormous,« says Alexander Ströhle from the Institute of Food Science at the University of Hannover, Germany. For example, the Kitava from Papua New Guinea eat 80 percent carbohydrates, and still, heart attacks and diabetes are almost unknown among them. The slim and willowy Tarahumara Indians of Mexico also draw their capability for activity, legendary among anthropologists, primarily from legumes and grain. Massai herdsmen, conversely, nourish themselves almost exclusively from beef, blood, and milk. In short: people eat whatever's available.

Everything that is at all possible physiologically is also tried and cultivated by Homo sapiens, but only those who keep the supply and consumption of energy in harmony live healthily. There is no such thing as a natural diet. Instead, man eats whatever his own culture or society respectively offers, regardless of whether it is the modern fresh food culture or the Stone Age diet. At the beginning of the 21st century, in the face of economic crises, natural disasters, and civil wars, this can mean in the worst of cases: people do not have even one bowl of rice or porridge per day for nourishment.

HENDRIK NEUBAUER

The way to the heart leads through the stomach

The cultures of Central and South America, like the Piarola in Venezuela, bake flatbread made from manioc flour. Maniochas become an important crop in the tropics and subtropics all around the world.

The Welsh are proud of their history, and the hearts of all sports fans beat for rugby. The Welsh national sport can be traced back to the Celtic game of caid. The photograph shows France versus Wales at the 2002 Six Nations Cup. The national team plays all its home games in Cardiff's Millennium Stadium.

YNYS MÔN 🌐 53°17'N 4°22' W

CELTS

The survival of linguistic enclaves

Nowhere in Wales do walkers stumble over as many sacred stones as they do in Anglesey; there is an historic reason for this. On a peninsula in the far northwest, the Celtic people were free to develop their religious cults, unhindered until the numerous druids, or priests, were brutally driven out by Roman troops in the first century C.E. A total of 39 menhirs and 16 megalithic settlements bear witness to the ancient beliefs of the erstwhile »island of the druids,« which has since become a bastion of independence again. Wales' Celtic heritage is emphasized more strongly here than anywhere else in the realm of the Red Dragon.

The majority of the region's 69,000 inhabitants like to call their county on the Irish Sea Ynys Môn, preferring the Welsh version of the name Anglesey to the English. A good 70 percent of the islanders here speak Cymraeg, or Welsh, the traditional Brythonic branch of the Celtic language group. In Wales as a whole, around 20 percent of the population speaks Welsh. This impressive statistic for the Ynys Môn peninsula is the result of language revival measures, which have been consistently pursued in western Wales for many years. Civil disobedience vehemently opposed the discrimination of Cymraeg so rigorously enforced by London, but since the 1960s, a trend reversal has occurred.

There was once a time when school children were punished if they lapsed into their language – or so some older people say. Today, Cymraeg is a compulsory school subject in eight regions in Wales. Public authorities and cultural institutions are bilingual, and almost everything else that reflects the country's Celtic heritage has enjoyed a revival in recent years – from »Mabinogion,« a collection of Welsh legends, to traditional songs and dances. This might encourage the 2.8 million Welsh in their endeavors to achieve greater autonomy.

However, historians are still trying to define the typical characteristics of Celtic culture. The people who once dominated central Europe as the »keltoi« were not necessarily a cohesive ethnic group, but rather a loosely knit cultural and linguistic community, one that regrettably left behind little evidence of its lifestyle and only partially survived on the geographical edges of the old continent.

It is not only in Anglesey but in other parts of the world that the descendants of the ancient island Celts cling to their linguistic roots. The language is not as enduring as the sacred stones, but it is less mysterious and, above all, alive. Even the Welsh national anthem pays special tribute to the living language: »So long as the sea is a wall to this fair beautiful land, may the ancient language remain.«

BERTRAM JOB

HERE & NOW

Independent dialects that go back to Celtic times characterize the six active language communities that follow the historical tradition of the island Celts and which usually live on in ethnic and cultural enclaves. Along with the Welsh, these communities include the Gaelic-speaking Irish and Scots and the people of Cornwall, who specialize in the newly revived Cornish language. On the Isle of Man, north of Wales, the local language of Manx is still cultivated and in parts of Brittany, Breton, or Brezhoneg, is spoken. To promote their common roots, the Celtic Congress was established in 1902 and meetings are held annually. Politically, the country's own affairs are represented by the National Party of Wales (Plaid Cymru) and internationally by the Celtic League.

Mên-an-Tol in Morvah. Wales has a high concentration of three to four thousand year old menhirs ABOVE. The bridge across the Menai Strait joins Ynys Môn with the mainland. The town of Llan-fairpwllgwyngyllgogerychwyrndrobwllllantysiliogogogoch, famous for its name alone, is located on the island BELOW.

The city hugs the bay of La Concha, its grand historical buildings still preserved along its picturesque harbor. Traditionally the summer residence of Spanish royalty, the city of San Sebastian, the second largest Basque city after Bilbao, remains chic and sophisticated today. There are more three-star restaurants here than almost anywhere else in Europe, as well as an international jazz festival, a world-renowned film festival, and the Semana Grande summer festival. The festivities never stop in San Sebastian, all summer long.

Walking around town, it soon becomes obvious that over half the population speaks Basque. The old town of Donostias – the Basque name for San Sebastian – has long been a center of the Basque independence movement. Still, one has to search the city center for quite a while before finding the brightly colored graffiti screaming Euskal Herria, the slogan calling for an independent Basque nation. In suburbs like Hernani, however, one is quickly transported back to the era of bombs and guns. San Sebastián cannot deny its roots. Most of its inhabitants feel that they are Basques, first and foremost, then perhaps European, but not Spanish. In the preliminaries of the 2008 parliamentary elections, the Basques were there again, as hooded men throwing stones, burning barricades, and inviting the wrath of black uniformed Special Forces of the Spanish police. Before the March 2008 election day, the ETA (Euskadi Ta Askatausuna = Basque Homeland and Freedom) claimed responsibility for the murder of an ex-council member in the town of Mondragón/Arrasate.

In 2007, Spanish author and journalist José Manuel Fajardo wrote an essay published in Le Monde Diplomatique. He concluded that the dictatorship of Generalissimo Francisco Franco was responsible for the shadow of violence that still hovers over Spain today. The Spanish Civil War and victory of Franco's forces decimated the Basque and Catalonian independence movements, subjecting those populations to decades of repression. The Spanish democratic government that formed after Franco's death in 1975 was a coalition of opposing forces consisting of both those

BASQUES

In the Shadow of Violence

Basque customs are carried on by many groups here in the Old City of Donostia LEFT. *Tour group leaders extol the Bahía de la Concha as the most beautiful urban beachfront in Europe* RIGHT.

who had supported the dictatorship and those who had stood up against it. As Fajardo wrote, »The victors in the Spanish Civil War agreed to stop persecuting the losers.« They settled on constitutional democracy as the framework that would permit different political sensibilities to exist side by side. In the process, however, the unity of Spain became part of constitutional law. Any movement toward an independent Basque homeland was banned.

Could anyone have thought that radical Basques would accept the 1978 Spanish Constitution and its laws regarding autonomy? The nationalists in Madrid looked at the

autonomy statutes as generous concessions because they permitted some level of regional self-government. For the Basque nationalists in the region, however, regional autonomy was the first step toward full independence. Fajardo brings the conflict between the central government and the Basque independence movement that has raged ever since into focus:

»Since no one had taken responsibility for the forty years of dictatorship, and since the old oppressors still served in the police and military, now as before, and with the interpretation of the autonomy statues still controversial, a minority of

Political Graffiti is a punishable offense and is seldom seen outside of ETA strongholds, like here in a Bilbao pelota court LEFT. *Families demonstrate in 2002 for the transfer of political prisoners to Basque-run prisons* RIGHT.

the Basque population saw the new Spanish democracy as a prettified continuation of the old dictatorship.«

Today, that minority is so large that the terrorist organization ETA feels its activities are legitimate.

Since the September 11, 2001 attacks and, in particular, the Al-Qaida bombings in Madrid on March 11, 2004, the use of

terror for political ends has been radically reassessed. Spain imposed a new wave of prohibitions on Basque parties and organizations. The problems have, in no way, been solved. The legacy of the Franco regime continues to cast its shadow, and the Basque are not the only ones who fight against the problems Spain has inherited. Terrorism and the controversy over the ultimate role of

HERE & NOW

Today, Basque identity revolves around their language. The Basque call themselves Euskaldunak, or the speakers of Euskara, which is their name for the Basque language. Basque bears no relationship to any other known language. It is the only surviving language of what was once a widespread pre-Indoeuropean linguistic group. Genetic studies suggest that the Basque are distant descendents of a post-ice-age population that entered Spain from the deep valleys and high plains of the Pyrenees and Cantabrian mountain ranges. Their current population is more than 1.5 million, of which a little more than half are active Basque speakers. With the end of the Spanish dictatorship, the Basque language was once again taught in schools, leading to its appreciable revival. Similar movements to revive regional languages are underway even in centralistic France, where efforts to push Basque aside in favor of French have been underway since the 1980s. Local languages and dialects are now taught at the elementary school level, with the number of active speakers increasing steadily. The decline of Basque was not the result of political conditions alone; economic forces also played a role. The Basque homeland, with its shipbuilding and other manufacturing, is

heavily industrialized. There has been massive immigration into the region, but also a considerable Basque emigration. A large number left for France and the Americas during the Franco dictatorship.

The slogan of the radical autonomists »four plus three equals one« refers to the three historical Basque provinces of Alava, Guipúicoa, and Vizaya, which in 1979 joined forces as the Communidad Autónoma Vasca, plus the province of Navarre. On the French side of the Pyrenees lie the three historic Basque departments of Labourd, Basse Navarre, and Soulé, today all administered by the Département Pyrénées Atlantiques.

Folklore tends to describe the Basque as fishers and farmers infused with an unconquerable will for self-determination, always standing in opposition to whatever government is in charge. Yet, political history is not so simple. Well before the 1975 democratization of Spain, the ETA, which was founded in 1959, was already leading terror campaigns against the central government in Madrid, which responded with violence and prohibition. The ceasefires that have existed over the intervening years could not halt the spiraling violence.

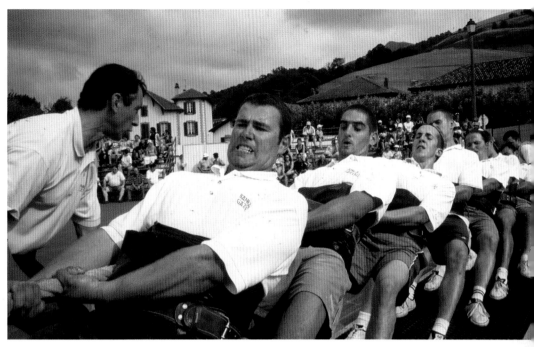

autonomy within the nation state are issues concerning all of Spain, as is the need to come to terms with the past dictatorship.

San Sebastián never was like Gaza City. It continues with its never-ending, pleasure-seeking efforts to escape all its problems. The Basque slogan – jaiak bai, borroka ere bai (»fiestas and struggle«) – fits this place very well. Compared to the rest of Europe, history seems to have taken a very different course here. Elsewhere in Europe, the shadows of the past have been driven away, and Spain and its regions need to do this as well. Former wartime enemies should never be too proud to approach each other and take responsibility for their own mistakes and fears.

HENDRIK NEUBAUER

The town of Arrasate near Donostia is a bastion of the separtist movement. Here, a street scene during a 2002 day of solidarity for political prisoners ABOVE LEFT.
Basque cultural events, like this festival in France, draw visitors from both sides of the border ABOVE.

FERMIN MUGURUZA
DANCING ON THE VOLCANO

Fermin Mugruruza is one of the founders of a popular music style known as Rock Vasco. Since the mid-1980s, he has been the leader of two of the most popular and influential bands in the Basque country. His group Kortatu mixes punk, ska, and dub music in the style of his own favorite band, The Clash. His next group, Negu Gorriak, added a layer of hip hop to the mix. As Muguruza described his career path in 2001:

»After the first group fell apart, I went on a world tour with (the band) Dut. In the meantime I worked on a number of projects on my own, but also with many friends, like Manu Chao, Angel Maure from Fishbone, and The Mad Professor. We had lived through Franco's military dictatorship and the ban on the Basque language. When we got to know punk music, it was for us an expression of freedom, which was very important to us at the time. For me, it was particularly important because it set the course for an entire life of making music.«

Three years later he retired from music, but not from politics. In 2007, he reappeared as composer of the soundtrack for the film Mirant al Cel and the album »Euskal Herria Jamaica Clash.« As lively as ever, the new CD mixed rock, ska, reggae, and dub, still sung in Basque, though with occasional vocals from Jamaica and elsewhere. *Fermin Muguruza fights against globalization with a cosmopolitan party spirit. What many already see as a contradiction in terms is reinforced by his mainly political, highly charged lyrics. It is »like dancing on a volcano,« the musician explains. Fermin Muguruza has shown that you can dance even when you are angry, and in fact, you should jump right in.*

www.muguruzafm.com

FRISIANS

Better to Be Dead Than a Slave

These ancient villages have essentially remained unchanged, and whoever passes through them feels transported back in time. Between Workum and Dokkum, Marum and Joure, the region of Frisia nestles like a huge open-air museum along the Dutch North Sea coast. Here, with their old cottages and often-renewed levees, the descendents of fishermen and sail makers have established themselves as the most acknowledged of all the Royal Republic's ethnic groups. The Westernlauwers Frisians were, after all, among the first people to settle the marshland between the present-day Ijsselmeer and the Lauwers Sea. Therefore, a trip to the swathe of land along the »Friese Wad« means a journey into history for every Dutchman.

The native should be flaxen-blond and as cloddish as possible, if he is to enrich the tourist's snap-shot proof of the weekend trip. This cliché of big-boned giants in wooden clogs is indicative of the ambivalent respect shown for an ethnic group, not to be encountered without giving a certain distance due to the giants' rumored obstinacy. In contrast, for the dominant majority between Westergo and Oostergo, it is the mental idiosyncrasies that characterize the true Frisian.

The most prominent of these is a straightforward, unbending character with roots deep in history. From the Romans and Franks to the present-day royal dynasty, Holland's Frisians have tolerated many official rulers, and even at times, made deals with Angles and Saxons – but always on the condition that their regional autonomy remained intact.

»Leaver dea as slaef« (better to be dead than a slave) stands written on the memorial stone above the Noordostpolder near Warns, commemorating the victory over Dutch invaders in 1345 and marking entry into the Frisian world. Here, it is similar to being in a semi-autonomous republic where, for instance, the »Fryske Folksliet« is played like a full-fledged national anthem on many occasions. These range from official celebrations and festivals to the home games of SC Heerenveen – the region's successful major league soccer team, in whose stadium the Folksliet is still played at the beginning of games, in defiance of

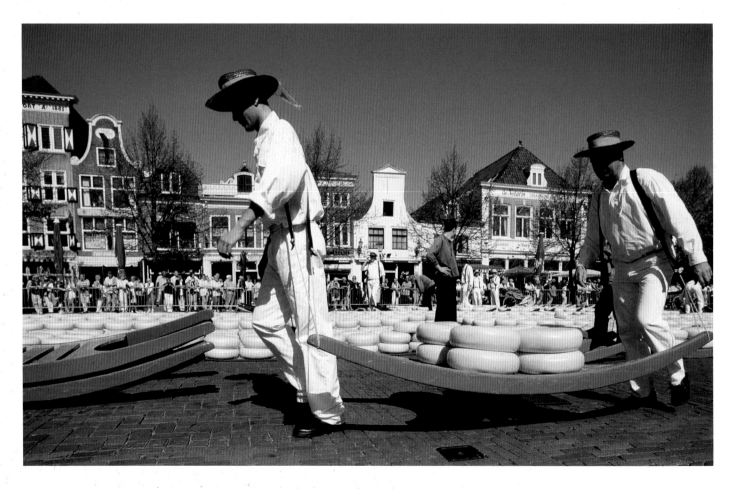

Specialities like Frisian clove cheese are bought and sold in the Alkmar cheese market, where guild regulations, in place since 1751, still apply ABOVE LEFT. *A West Frisian on the island of Schiermonnikoog demonstrates the ancient art of enjoying lightly salted herring* RIGHT.

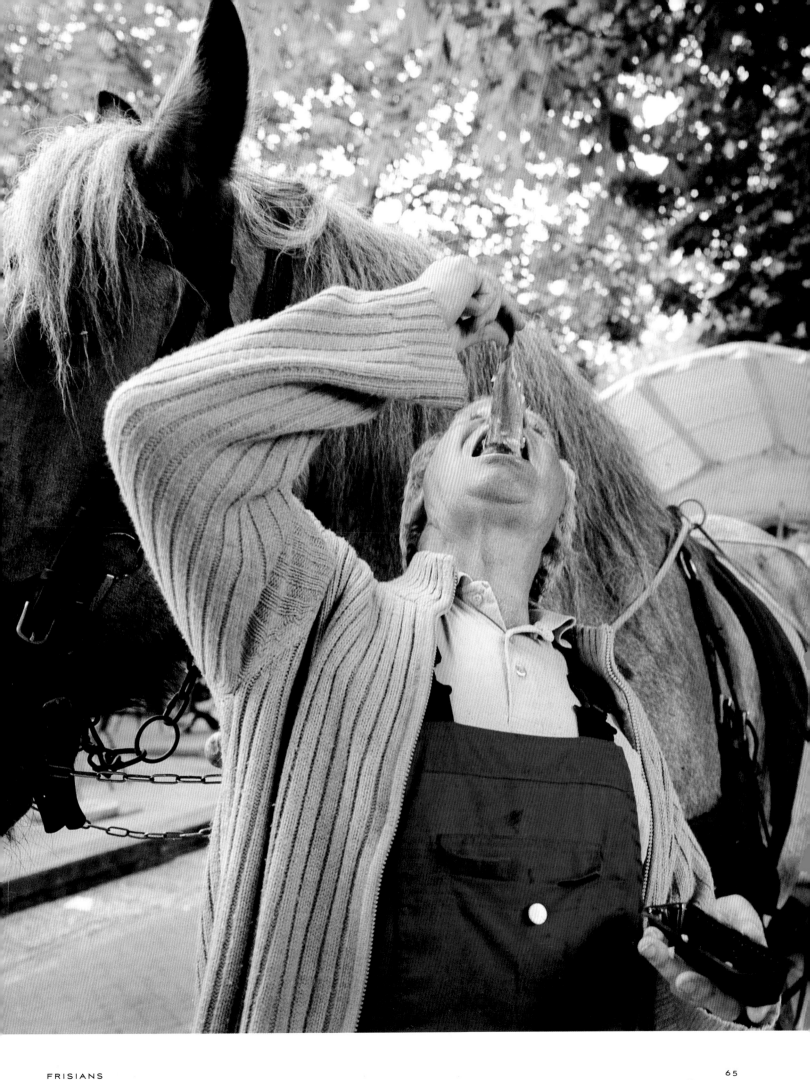

Nynke Laverman – Saudade in Frisian

It is hardly possible to feel more Frisian than Nynke Laverman, who has rapidly established herself as a singer and actress on Dutch stages over the past five years, and at the same time express it in such a cosmopolitan way. The »lekker meisje« from the small village of Weidum near Leeuwarden developed a passion for Portuguese Fado even before her training at the Amsterdam School of Performing Arts. In 2003, the then 22-year-old singer fused together the mel-

ancholies of both cultures for her first major musical theater project. She translated seven poems by the Dutch lyricist J.J. Slauerhoff into Frisian and combined them with Fado compositions by Custódio Castelo, which are interpreted in Portugal by Cristina Branco. The result, complemented by a Theme title of its own, was the enthusiastically-received chanson series »Sielesâlt« (Soul Salt), which has been regarded as the birth of the »Frisian Fado.«

Nynke Laverman willingly strengthens the classical Fado ensemble with percussion and other additional instruments, and, with »Fado Blue,« began a second, more intimate live project. With more than 35,000 copies sold since she published it in 2004, the CD of »Sielesâlt« surprisingly achieved gold status in the Netherlands. The performance and publishing of the song cycle, »De Maisfrou,« a homage to the women of Mexico, with verses by the Frisian author Albertina Soepboer, followed in 2005 and 2006 respectively.

www.nynkelaverman.nl

HERE & NOW

Present-day Frisians are linked by mutual linguistic and historical bonds that span two borders. Although the dialects in Dutch Friesland, German East and North Friesland, and the adjoining areas of Jutland in Denmark may appear different, basic communication is possible. At the same time, there are more variations of Frisian than were generally thought.

650,000 West Frisians live in the 31 comunities of the Dutch province between Ijsselmeer und Groningen. According to estimates, more than 70 percent of them understand the Frisian language, although only about 10 percent of them are proficient in writing. Parallel to this, mixed dialects – such as urban Frisian or the so-called Bildts – can also be heard in many other districts.

This is in contrast to Ostfriesland, which stretches from the border region to beyond the Weser, where the original dialect has almost completely been superseded by East Frisian Platt German (a Low German dialect from Lower Saxony). Conversely, around 2,000 people in Saterland are still fluent in Saterland Frisian. North Frisian is, for its part, maintained in the Schleswig-Holstein administrative district of Nordfriesland as well as in South Jutland.

The 50,000 North Frisians are represented politically by the Südschleswigschen Wählerverband (SSW) [Southern Schleswig Voter's Association], while the 480,000 East Frisians are represented by the »Die Friesen« movement founded in 2007. Once a year, they meet with representatives of the Frisian National Party (FNP) from Holland in the Interfrisian Council.

many protests. With their soccer jerseys of blue and white stripes and stylized lily blossoms, the professional players of SC even play in outfits that match the Frisian flag. The general opinion is that if you do not like it you can go elsewhere – it is the Frisians who decide things in Friesland.

The pronounced feeling of a separate identity is also expressed in the unofficial motor car sticker with the abbreviation FRL for Fryslân, preference for their own language in almost all fields of work – and, last but not least, the widespread penchant for confidential dealings in cash. At the bustling livestock and weekly markets, farmers still prefer to tuck away their proceeds directly in purses dangling around their necks rather than engage in proper accounting – such is the mistrust of tax officials and all kinds of outsiders. They are the only reason why doors in and around Leeuwarden (Frisian: Ljouwert) are locked in the evening, because, as everyone knows, wickedness does not come from within, but from the outside world.

The origins of the Frisians stretch back far into past. The frisii are mentioned in Tacitus' »Germania« as inhabitants of the coastal area between the Ems and the Rhine estuary as early as the first century B.C.E., shortly after the »Great Siltation.« Although initially allies of General Drusus' troops, they later successfully rebelled against Roman occupation and drove out the Chauci in the 6th century, creating »Frisia Magna« in the process,

CLOCKWISE, FROM ABOVE LEFT: *The »black stockings« serve as evidence of Friesia's adoption of Calvinism in 1568. Head chef on Texel. When West Frisians speak of cheese, they say »tsiis« instead of the Dutch »kaas«. Fisherman in Schiermonnikoog. A yacht festival in the harbor of Hylpen, called »Hindeloopen« in Dutch. Marten Boon, the »Strandräuber« (»beach thief«), collects flotsam and jetsam washed ashore by the sea around the island of Texel. They are still here: fishing boats around the Wattenmeer. The typical workdress: the oilskin. Kiosk owner on Beach No. 4 in Schiermonnikoog.*

a kingdom that more or less corresponded to the present-day linguistic area. Trade in amber, sheep wool, and brine produced over peat fires (»Frisian salt«) rapidly expanded thanks to shipbuilding. Diligent merchants built so-called Wiks for their settlements, village mounds with high-water protection.

Probably as a result of the collective battle against the storm floods, autonomous cooperatives were set up early on the North Sea coast. Together, with their

own counsel constitutions, they characterize the period following the reign of the Franks known as the »Frisian Freedom.« This strong cohesion was also felt by German occupying forces who were worn down by the resistance of Frisian partisans during World War II. It is this feeling of tight-knit community that, throughout the ages, identifies Holland's original inhabitants as a paradigm of a largely autonomous enclave with well-preserved traditions.

Something of it can still be felt today – particularly in the villages where the »ancestors'« particular dialects and traditional forms of dress are cultivated like a legacy. Those who live here usually consider themselves citizens of the Dutch Republic or Europeans only secondarily or thirdly – primarily, in the words of the Folksliet, they are proud inhabitants of »it bêste lân fan d'ierde« (the best country in the world).

BERTRAM JOB

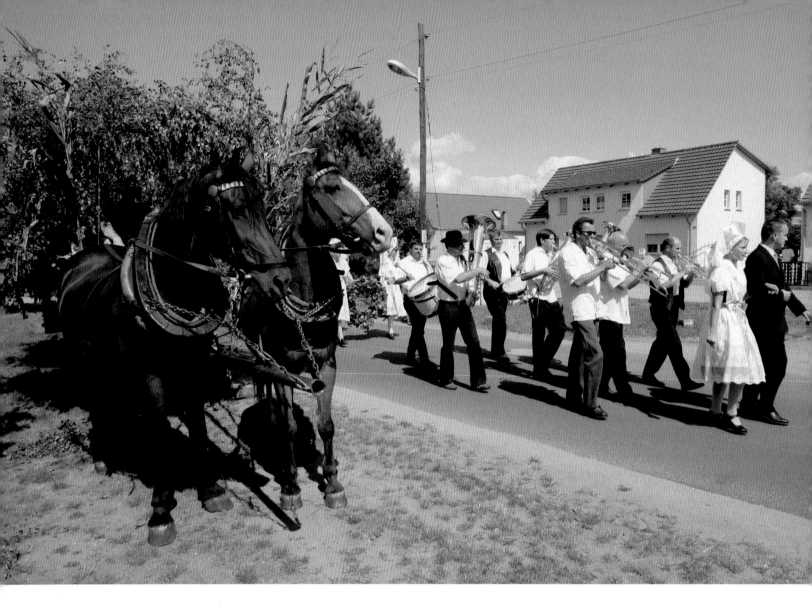

Harvest festival customs like rooster plucking, rooster beating, riding contests, and wreath-spearing are still widespread in the Lausitz today. The festival parade proceeds through the village led by the Harvest King and Harvest Queen. The royal pair has the honor of leading the opening dance.

SORBS

Slavs, one way or another

Only tourists are surprised to see the bilingual signs in the city of Bautzen; the inhabitants of the Saxon county seat in Upper Lausitz hardly even notice them. In the most southeastern part of the German eastern border, there are many ways to meet the ethnographic minority of Sorbs, who see themselves as the descendants of western Slavic settlers.

Hotels and cafés advertise Sorbian-speaking staff; a Sorbian institute and a language center are in the middle of the city. The members of the Sorbian high school choir are eager to wear traditional Sorbian attire when they perform.

Bautzen is the representative capital for 60,000 Sorbs, who live in Upper and Lower Lausitz, between Cottbus and the tri-border region near Görlitz. Yet, the exceptional life of these former farmers can also be seen today in the countryside. In those villages, founded by their ancestors, the Wend traditions and celebrations have remained virtually unchanged. Kindergartens and schools continue to play traditional games and songs, such as the Birds' wedding and use their rattles. Maypoles are still put up and, in November, songs about Saint Martin still sung during lantern processions.

This community is relatively straightforward, sandwiched between western and eastern Europe; it is dedicated to keeping Sorbian identity and traditions alive. The Slavic tribes who settled between Saal and Neiße in the 7th century represent the large majority of this community. Sorbian farmers plowed the land, long before the more than half of the Sorbs were killed during the Thirty Years' War. Thereafter, recognition of this independent culture increasingly needed to be won – a battle that was even more challenging with the prohibition of use of the Sorbian language in Prussian Upper Lausitz (1875).

During the Weimar Republic, tolerance for anything to do with Wend cul-

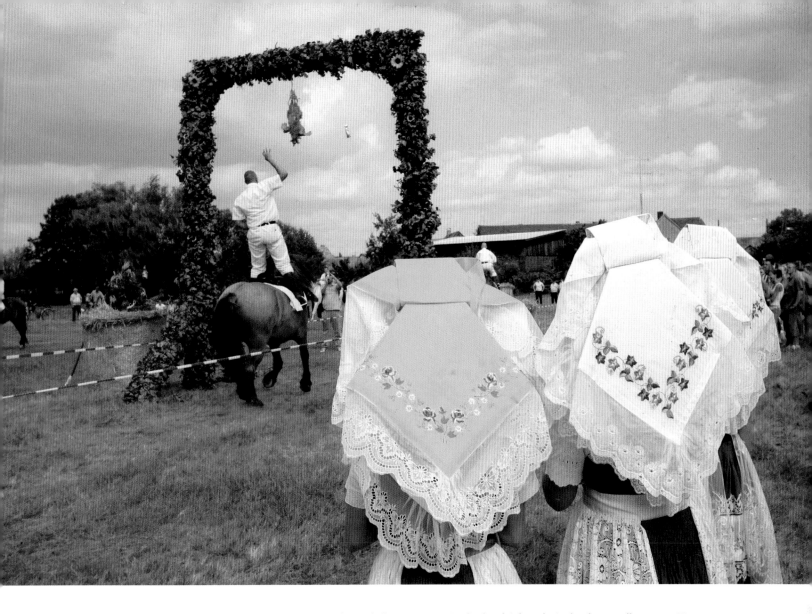

Cock-plucking is one of the most widespread harvest customs in the Niederlausitz region. The dead cock is hung by its feet from a tall gateway. Men on horseback ride through the gate trying to tear off the cock's head. Whoever succeeds is given the title »kral,« which means »king.«

ture alternated between growing suspicion and wariness. Yet, the insanity and racial frenzy of the Third Reich soon saw to it that Sorbs also faced persecution and oppression. Domowina, the main organization of the Sorbian Farmers' associations was prohibited.

After 1945, the Sorbs who had settled east of the Oder were pushed out of the Polish area, as were all of the Germans living there at the time. In the former East German Republic, the Sorbs met with respect, at least on an administrative level. This was expressed in the Law to Preserve the Rights of the Sorbian population, passed for Saxony and Brandenburg in 1948, as well as the foundation of the Institute for Sorbian Studies at the University in Leipzig.

Today, Sorbian life has retreated somewhat, due more-or-less to societal changes. Extensive brown coal mining has cost the existence of more than one of the traditional Sorbian villages. All the same, the touching art and culture associations and half a dozen Sorbian schools ensure that this bicultural life can actively continue in Upper and Lower Lausitz.

BERTRAM JOB

HERE & NOW

Around 60,000 descendants of the Western Slavic people in south Brandenburg and Saxony belong to the autochthonous minority group of the Upper and Lower Sorbs. One third thereof can write the Sorbian language. In the German Unification Treaty, an entry in the minutes was recorded, explicitly promising protection and support of the autonomous language and culture. This was implemented in 1991 with the (now underfinanced) Foundation for the Sorbian People. In addition to the Upper Sorbian daily newspaper, Serbske Nowiny and a Lower Sorbian weekly newspaper, Nove Zazik, several radio programs represent the sovereign Sorbian life. Once a month, German regional television channels ORB and MDR emits a 30-minute program in Lower and Upper Sorbian, respectively.

ROMA

Horns and Tubas. The great exception.

The Cherkezi Orchestra is named after its patriarch, Cherkezi Rashid. The current third generation of the orchestra plays gypsy-brass-band-jazz, but also covers jazz and Latin standards ABOVE.

The temperature on the thermometer is 97 degrees Fahrenheit (35 degrees Celsius) in the shade, not unusual in a Macedonian suburb in the summer. The Cherkezis are here on tour. Their brass band will play for two weddings and a circumcision in the town of Shutka, fifteen minutes by car from the Macedonian capital city of Skopje. Shuto Orizari, the town's full name, is the unofficial capital of the Roma. Some 45,000 live here, a total of 90% of Macedonia's Roma population. Some estimates make it the largest Roma community in the world. Throughout the warm months, it seems as though there is something to celebrate nearly every day. To find it, just follow the music.

The dusty main road of Uliza Shutka goes steeply downhill. Carefully tended trees grace tidy front gardens complete with gnome statues, magical little figures that wink at the passerby from underneath well-tended shrubbery. Individual houses are designed in true suburban-baroque fashion, with tall columns, and stone lions lying ambush. Finally settled down, this community of wanderers now seems to prefer traveling in a Mercedes Benz when they hit the road. Leaving the well-paved streets behind, the road quickly turns to mud, and windblown huts start appearing along the way. The impression of prosperity a few miles back quickly disappears. Here, large extended families live in cramped housing with few luxuries. The outskirts of Shutka may have electricity, but the sewer system came to an end a long way back. This is what suburbs look like when they grow more quickly than planned.

Everything changed for Skopje and the area around it after an earthquake struck on August 23, 1963. Josip Tito, the president of what was then Yugo-slavia, ordered the city rebuilt from the ground up as quickly as possible. Although the Roma living in neighborhoods like Topaana were barely affected by the quake, the city planner decided to play God by building a new satellite town just for the Roma. This led to large numbers of Macedonian Roma going there to live. Following the breakup of Yugoslavia, another wave of Roma moved in, many of them returnees who accepted the funding offered as part of Germany's 1992 Roma Voluntary Return Program. This explains the fancy streetscapes mentioned above.

A glance at the statistics makes it clear that there is little of that prosperity in the dirt road suburbs outside of town. Shutka is one of the most underdeveloped districts in Macedonia. The community's main problem is unemployment, which, at thirty percent, is double the rate of the rest of Macedonia. There are very few people in Shutka with a steady job. The integration of the Roma into the labor market, as well as the need to increase opportunities for education, are two main concerns of Shutka's district mayor, Nezdet Mustafa.

Nezdet Mustafa is the first Roma mayor in the world. He has been in office since 1996, having founded The United Roma Party in 1995. Nezdet Mustafa believes that the Roma can rise out of poverty and cast off the stigma of living in a ghetto only through improved access to education and integration into the labor market. The Roma have no one lobbying for them. Very few countries accept them as persons with the rights of full citizens. As Nezdet Mustafa explains:

In many minds there is still a historical image of the Roma. People think that they are lazy, dirty and unwilling to work.

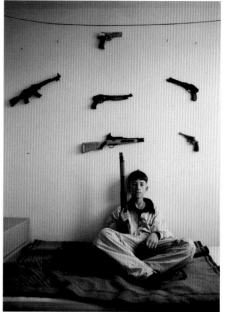

The Roma neighborhood of Topaana. The quarter is just ten minutes by foot from the center of Skopje. The majority of its inhabitants are unemployed LEFT. A young gun collector from Shutka, the Roma satellite town on the outer edge of Skopje. The social situation here is comparably tense RIGHT.

The Cherkezis live in their long-established mahalla (neighborhood), which is in the old Topaana district. They have jobs and make a living with a brass band in which many members of their multi-branched clan also play. They are presided over by »oldest« Cherkezi, a gifted, prizewinning trumpeter. Their performances bring them in contact with a wide range of people from different Roma communities throughout Europe. Rich businessmen hire them to play at weddings, and poor day laborers will scrape together their wages to hire them for their sons' circumcision parties.

The band is now a sensation outside of Shutka as well. Their success is founded on the enormous energy they bring to playing the tuba, trumpet and horn. The musicians perform like an untiring blowing machine, their vitality fed by a certain sense of superiority that is widespread in Shutka. Prosperity and well-being cannot be measured by wealth alone. A man will do well if he is always prepared to re-invent himself anew. Creativity is the reason why there are more competitions held in Shutka than anywhere else in the world. There are neighborhood champions for vampire hunting, singing, for the best collection of Turkish music cassettes, and the most beautiful Sunday clothes. Canaries, pigeons and geese are trained to sing, fly and box competitively.

As everyone knows, God loves Shutka, because he is invoked during these competitions more here than anywhere else. There are also more fatalists in Shutka and its surrounding area. While this point of view is not always shared by the members of the community who have managed to make it, few Roma are immune to criticism from their mayor, Nezdet Mustafa, when he proclaims: »the Roma people must be active subjects and no longer passive spectators of their fate!« What he means is that better organization and more active participation will make resolving the problems of the Roma much easier.

ESMA REDZEPOVA, THE GYPSY QUEEN

As the Parisian L'Express wrote after the release of Esma Redzepova's CD Gypsy Carpet: »A Roma born and bred, with a voice that transports us to seventh heaven.« The chanteuse of the Roma was born in Skopje, where she won a young talent competition at the age of 14. She was discovered there by impresario Stevo Teodosievski, whom she later married. It was the beginning of an exceptional career. The team of Esma and Stevo were popular not only in the Balkans, but in the rest of the world as well, where they regularly held sold out concerts. They have made more than 10,000 appearances and over 700 records. In addition to their career in music, Esma and Stevo have raised 47 adoptive children, most of whom they rescued from the streets. They provided each of their children with a musical education. Esma's Ensemble, the band that accompanies the singer live and in the studio, is made up almost entirely of her adoptive children. She has turned part of her house into a »home for mankind,« and opened a music museum.

www.esma.com.mk · www.myspace.com/redzepova; www.lastfm.de/music/Esma+Redzepova

Toni Kitanovski & Cherkezi Orchestra: www.myspace.com/tonikitanovskiandcherkezi

A wedding party in Topaana ABOVE. *Some ten percent of Skopje's inhabitants live in Shutka, its northernmost district. The population is almost entirely Roma* BELOW.

The Cherkezis work hard for their success. In 2006, they celebrated a triumphant performance with guitarist Toni Kitanovski at the Berlin Jazz Festival. In 2008, they played on stage before thousands of people at the New Year celebrations in downtown Skopje. The Cherkezis are an extraordinary experience, but they are also the exception. Music has always been, and remains today, the way out for only very few Roma.

HENDRIK NEUBAUER

A Roma child beggar on Skopje's Vardar Bridge. The country's economy suffers in general from structural problems brought on by the collapse of socialism ABOVE.

HERE & NOW

Ethnically, the Roma are Indo-Aryans with origins in Northwest India. The 12 million Roma make up the largest minority in Europe, where many countries have awarded them national minority status. About half the Roma speak Romani. The largest Roma communities are found in Hungary, Slovakia, the Balkans and Spain. There are also Roma living in Germany, France and Belgium. Smaller Roma communities can be found in America, Africa and Australia. The longstanding question of what to call these people has been answered. They call themselves Roma, but those with hundreds of years of roots in Germany refer to themselves as the Sinti. Over centuries of migration and settlement, Roma culture has become strongly diversified. This is evident in particular in their religious orientation, which is usually the same as that of the larger region in which they live. Thus, Roma in the Balkans can be of Catholic, Orthodox or Muslim faith.

Music

Several notes in succession, put into order – this is music. Humans communicated by means of noises and sounds before they developed language. Music has existed for as long as human beings have organized themselves into social groups. There is no culture on earth that manages without music, and a culture's music tells us a great deal about that culture. Music not only reflects aesthetic preferences and social values, but also maps the contemporary technical possibilities of production and performance.

First, we must free ourselves from the notion that music has always been a commodity – a commodity which, preserved in recordings available to be downloaded or continuously present on the radio, is always there where one would like it, or where one cannot escape from it. Today, music underlines a promotional clip, dramatizes an insignificant film scene, and rings out shallowly from cell phones when these are contacted.

Until the invention of the technology with which we are surrounded today, music had always been linked with specific places and occasions, characterized by direct performance.

Reasons and occasions for making music were manifold. It was not only festivals and ceremonies of all kinds that inspired drummers, players of plucked or string instruments, singers, and composers, but everyday music as well.

Music, as a means of identification, became important with the abduction

There is no culture without music

of African slaves to what was, for them, a new world – an anticipation of the significance of pop music in general. For a long time, music has been a source of income; African drummers and dancers are rewarded according to the quality of their performance, and no village band would undertake the celebration of a wedding among farmers in a small Central European village without payment – even if it should be in kind.

Away from all genres and regions or backgrounds for the creation of music, one must distinguish between music that was written down in notation and music that was handed down only by performing and listening. In the 3rd millennium B.C.E., musical notation was already known in Egypt, and between the 9th and 15th centuries C.E., the notation which is still in use today was developed in Europe. Since literacy, including reading music, was not very widespread outside the monasteries and palaces in Europe, one must assume that much of the music that was created was passed on in a traditional manner; that is, by playing and re-enacting what was heard.

This is certainly true of societies that lived without writing, such as most African ones. »There is no traditional music in Africa,« the Malian singer Rokia Traoré, however, comments on the situation

Is there traditional music at all?

on her continent. »Europeans call something traditional if it is passed on from generation to generation and does not change. But that does not happen in Africa. There, music was instead always passed on as a further development. The fact that the music was not written down meant that the musicians who performed it reflected their times in the music. So we speak of a never-ending creative process.«

The development of a musical direction is also subject to outside influences. Evidence for this is found in the music of the Roma. Part of this group, which probably started off from the Punjab in India, came to Spain via North Africa, where they developed flamenco. Another part traveled through Turkey to the Balkans. Anyone who has, in recent years, acquired the popular CDs by the Original Kocani Orkestar (Macedonia) or Fanfare Ciocarlia (Romania) knows that the loud and bizarre wind instruments of these two bands have absolutely nothing in common with the flamenco of the Spanish Roma. Nevertheless, both qualify as Roma music.

African music, as the mother of our pop music, has become the definitive sound of our everyday life. And yet it would once have seemed unlikely that the whole world would one day move to African rhythms. In the Americas, the abducted Africans had

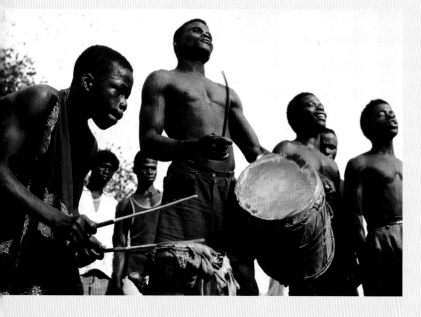

Musicians in central Africa, circa 1950. The photo is by Michel Huet, who published the standard reference book, Danses D´Afrique, in 1978.

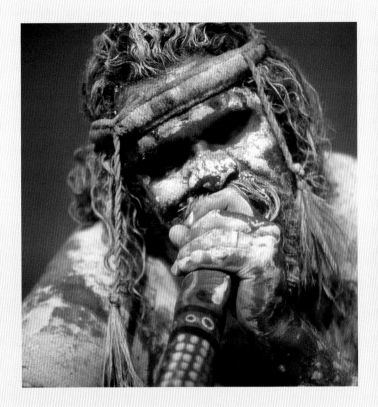

The didgeridoo of the Australian Aborigines. The overtone wind instrument from northern Australia has become the musical symbol for the entire ethnic group.

Manu Chao in Paris. His Bongo Bong was an international hit in 1999. Chao's »mestizo«-style world music mixes rock, rap, ska, reggae, chansons, salsa and raï.

to accept minimal standards. This was partly because they had been taken from different parts of Africa, and, conversely, because they were not allowed instruments. This was true at any rate of most of the areas where slavery was in force. From the blues, which had managed with no more than voices and a few improvised rhythmic aids, creative African Americans began to develop diverse styles which became widespread with the rise of the recording industry. In the big cities of Europe, jazz was already heard soon after the First World War.

With the growth of youth cultures since the end of the Second World War, the most wide-ranging cultural globalization in the history of the world set in. What rock' n' roll and soul never quite managed to do, hip-hop succeeded in doing within a brief 20 years: the penetration

Hip Hop is the global music

of nearly all societies on all continents. Meanwhile, musicologists and African American cultural activists are still able to show that hip-hop is a primevally African musical form. The phenomenon is known as call and response.

Why African music in particular? The clue lies in the purely acoustic tradition and in improvisation where notation is not available - and thus in openness to novelty. This could be splendidly observed when the African population before and after the Second World War streamed into the big cities created by the colonial powers. They brought their own music with them, the music of their peoples, tribes or clans. In the cities they then encountered shellac recordings of Caribbean hits. They mixed them with their own music, whether in Kinshasa, Lagos or Dakar. Thus, African pop music came into being, rumba

and soukous in Kinshasa, highlife in Lagos and salsa or Mbalax in Dakar.

While the definition of music as such is not a problem, it is difficult to define good or bad music. It is a matter of individual taste and also of the experience that one brings to listening. If you do not bring either experience or open-mindedness along, you may not enjoy a Japanese koto concert or a Guinean drum orgy.

MAX ANNAS

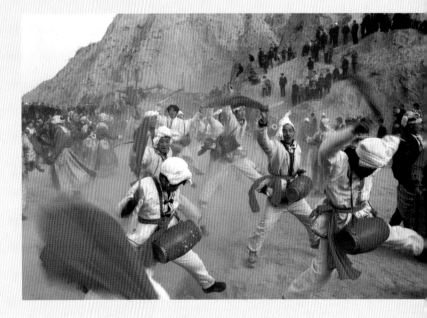

Ansai waist drum dancers from the Chinese province of Shaanxi. Today, it is danced Chinese New Year and on other occasions.

The central Indian Santali first arrived in the the north Indian province of Assam as workers LEFT*. Conflicts with the Bodo, the region's indigenous people, have been the cause of many years of tension. After the armed attacks of the 1990s, the Santali fled to refugee camps, like this one in Sapkata* RIGHT*.*

SANTHAL

Status is everything

The sun rises over the tea plantations of Western Assam as the broad Ganges River flows by, and the white peaks of the Himalayas glisten on the horizon. The tea pickers are already on their way to work. Later, they will run back and forth to the sorting machine in the shed.

Most of the workers on the Assam plantations are earning little more than starvation wages. It is no different for this generation than it was for the last. The tea pickers are usually descendants of Adivasi who immigrated to the north from India's tribal belt, which crosses through the center of the country from coast to coast. In the eighteenth and nineteenth centuries, when these migrations first began, the plantation owners were interested in exactly the same thing as they are today: cheap labor.

People in India who do not belong to one of the four great castes do not have an easy time finding a way out of poverty. It is next to impossible for them to achieve any level of success whatsoever. People who are not averse to slaughtering cattle, drinking alcohol, or whose morals do not conform to Hinduism will have a particularly difficult time in India. The Santhal have no temples or shrines in their impoverished villages and homes. Many of them stick to their own language, Santhi, whether they are in Bengali-speaking Shantiniketan or Hindustani Assam. They hold on to their own customs, because India offers them little more than an endless, vicious circle of poverty, illiteracy, infant mortality and rumbling stomachs. Getting a permanent job with a regular income, or official permission to unionize, is about as likely as winning the lottery.

All sides of the political spectrum praised India's 1950 constitution for its upholding of the principles of democracy. In reality, these principles are too often ignored due to caste consciousness and corruption. The Santhal in Assam were happy to be recognized by the administration as a Scheduled Tribe (ST), a status they retained after independence in their Central Indian home territory from the Bengal coast to the Arabian Sea. ST status lets the Santhal benefit from India's half-century old quota regulations that, for example, determine how many

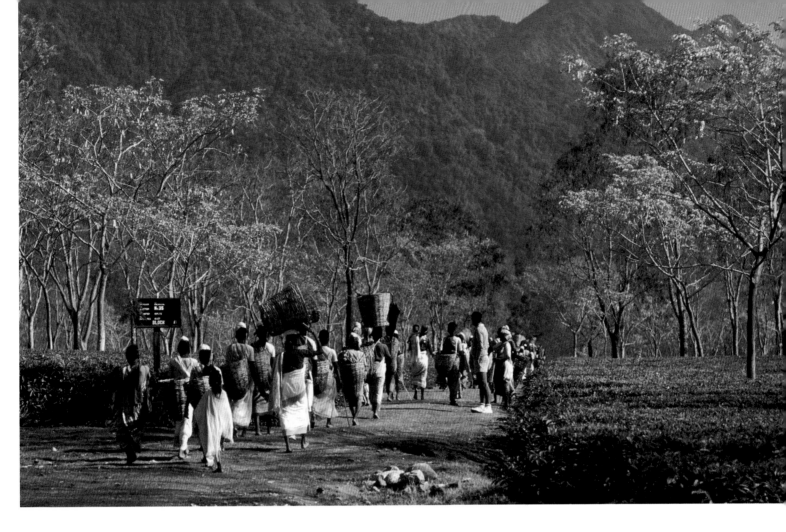

The Assam tea plantations are the largest in India. The production process, from the plucking of the tea leaves to the final sorting, is still mostly done by hand. The work is seasonal, taking place during the spring and autumn harvests.

places will be kept for indigenous people in the state school system. Nonetheless, they continue to occupy the lowest rung of the social ladder. The Hindu or Muslim majorities continue to look down upon Adavasi in Bengal and other Indian states as well.

In Assam, the ethnic problems are rife. The dominant indigenous people in this northern region are the Bodo, who also hold ST status. The influx of Adavasi from the south has threatened their land rights as the majority aboriginal group in the region. In the 1980s, the Bodo founded an armed guerilla movement calling for an independent Bodoland. The Santhal, along with the Karbi and Muslim Bengalis, soon found themselves in the line of fire. The conflict came to a head in 1996, when Bodo rebels killed hundreds and drove marginalized ethnic groups like the Santhal out of the area by burning down their villages.

The government and the Bodo have since come to terms, but even with the weapons silenced, some 8000 Muslim Bengalis still live near Bijini as refugees on either side of the National Highway. They give their reasons as follows:

We cannot go to work in the fields because the Bodo threaten us there. We

HERE & NOW

India's indigenous peoples, known generally as the Adivasi, make up 8 percent of the population of the subcontinent. That means there are about 88 million Adivasi. The dark-skinned Adivasi exist on the lowest level of Indian society, well beneath the lowest-ranked Hindu caste. Since they divide themselves into numerous tribal and ethnic groups, each with their own language, the Adivasi have never been able to improve their condition by means of common representation or organizations that could support their interests.

No one is sure where the Santhal come from, only that they probably arrived in South Asia from somewhere near the Tigris and Euphrates Rivers of Mesopotamia. Today, they are counted among India's indigenous peoples. The Santhal live scattered throughout the provinces of Bengal, Bihar and Orissa, but also in Assam, Tripura, Bangladesh and the far north of India near the border with Nepal. Population figures for the Santhal range from between 8 and 11 million. While that sounds like a lot, the total is only around 1 percent of the total population of India. In their homeland, where they are in the majority, most Santhal grow crops and raise animals on leased land. Others work for large landowners for meager wages.

cannot buy land, because the new Bodo autonomy laws have made that impossible, and we cannot return to our own land.

A similar situation threatens the Santhal living in refugee camps around Sapkata in the Kokrajhar District. More than 30,000 people live there, in makeshift housing. Almost 70,000 Santhal live in very insecure conditions in Gosaigaon. As a Santhal chief told a BBC reporter in 2004: »They tell us we should leave or starve.«

When it comes to being officially recognized as an ethnic group, authorities in Assam and New Delhi set a hard course after decades of stalling. The decision was made that the Santhal and members of a dozen other indigenous groups, who have migrated out of their home territories to work as laborers in other states, cannot receive Scheduled Tribe status in other regions. The logic behind the decision is that having lived for decades in the north, the migrant Santhal have lost the distinctive characteristics of their tribal cultures to the point that little or nothing remains that would define them as a distinct, identifiable ethnic group.

The reaction of the legally marginalized peoples was instantaneous. In early 2008, indigenous groups held demonstrations in all of India's big cities. In Assam, the backlash was particularly violent. A naked Adavasi girl was displayed in the streets, but it remains unclear who was responsible. This act is one of many examples in which the Adavasi are, traditionally, subject to extreme violence.

HENDRIK NEUBAUER

Camps for Muslims from Bengal. Their immediate neighbors are tractor trailer trucks and vehicles like this hazardous cargo tanker ABOVE LEFT. *Designed as a temporary Santali refugee camp, it has become a long term abode* CENTER LEFT. *Young female workers sieve sand on a tea plantation* BELOW LEFT. *The large city of Gauhati is the economic and communications center of Assam, as well as the seat of the provincial government* RIGHT.

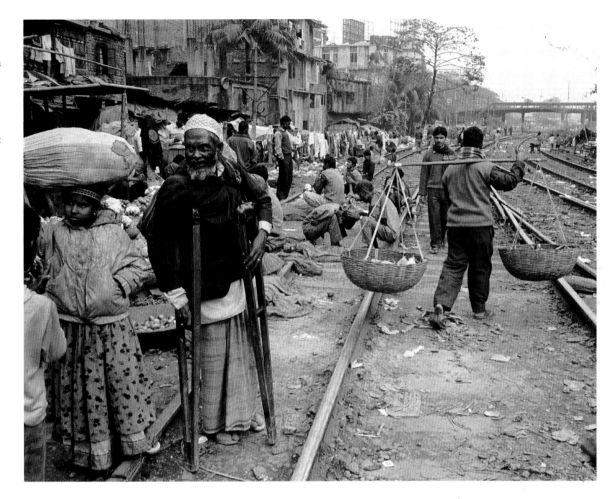

RABINDRANATH TAGORE: THE SONG I CAME TO SING

If you have heard Jana Gana Mana, the Indian National Anthem, you have also heard five stanzas of verse from a poem by Rabindranath Tagore. In 1911, Tagore, (1861-1941) a Bengali poet, published his Ode to God, which revitalized Bengali literature by introducing new genres and motifs. Tagore revolutionized poetic language with a fresh approach that came close to daily speech. His achievements led to his being revered as a kind of mystical holy man in nineteenth century England and Germany. His 1913 Nobel Prize for literature, the first ever awarded to an Asian, came as no surprise.

Rabindranath Tagore was born in Shantiniketan, some 93 miles (150 kilometers) northwest of the Bengali metropolis of Kolkata. His home is a cultural pilgrimage site to this day. Tagore worked not only as a writer, but also as a philosopher, painter, composer and musician. In 1901, he founded a school; in 1921, a university. He stood up against discrimination against the Adivasi in his province, and led protests against underage marriage. He also founded banks, co-ops, and hospitals. Tagore was a dedicated reformer with a humanistic approach. His name is often mentioned in the same sentence as Mahatma Gandhi's, in part because both believed that a just society should be founded within a tradition of civil rights.

Tagore wrote and sang only in Bengali. In 2002, the musician Barka Saren, who lives in Shantiniketan, began to translate Tagore's songs into Santhali and set them to music, so as to bring the poems of the great reformer directly into Santhal villages. Thus, one hope of Rabindranath Tagore has been fulfilled. As he sang in the opera Gijantali (1913):

> The song that I came to sing remains unsung to this day.
> I have spent my days stringing and unstringing my instrument.
> The time has not yet come, the words have not been rightly set;
> There is only the agony of wishing in my heart...
> I live in hope of meeting with him; but the meeting is not yet.

www.bihaanmusic.com

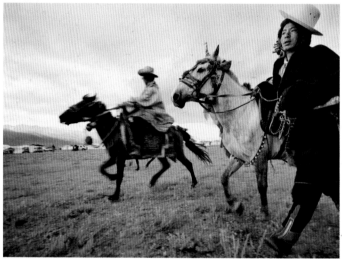

Contests, singing, dancing, eating, drinking, celebrating.... once a year, Khampa Land is in a buzz. The women don fancy clothes and lots of jewelry, and the men also do themselves up. Everything comes together at the Litang Horse Festival. As proof that modernity can penetrate even into the most distant corners of the earth, an increasingly large number of visitors arrive via motorized transport.

LITANG 🌐 29°59'N 100°16'E

KHAMPA

The Wild Riders of Litang

The scent of juniper is heavy in the air on the Tibetan plateau in late July and early August. Hundreds of peasant farmers and nomads have assembled outside the walls of the Ganden Thubchen Choekhorling Monastery in the city of Litang. They have come, as they do every year, in order to test their equestrian skills against all comers. The city's prayer wheels are rattling much louder than usual, as thousands of spectators from the provinces of Quinghai, Sichuan and Tibet work themselves

into a frenzy of anticipation. The most spectacular festival of this barren, mountainous region lying more than 13,000 feet (4,000 meters) above sea level is about to begin. The riders arrive, showing off their acrobatic skills by hanging sideways off a galloping horse, reaching down to swoop up objects off the ground, or shooting at targets with guns and arrows.

The province of Kham in eastern Tibet is a region of wild beauty, with a bloody past.

The Khampa are the indigenous population in an area where the Yangtze, Mekong, Talween and Brahmaputra Rivers converge, and mighty peaks soar to heights of more than 23,000 feet (7,000 meters). The Khampa are famous for their steely temperaments, their skill in riding and with weapons, and their courage. They are a semi-nomadic people subsisting almost entirely from their herds of yak, members of the cattle family with shaggy coats that reach almost to the ground. Yak hair

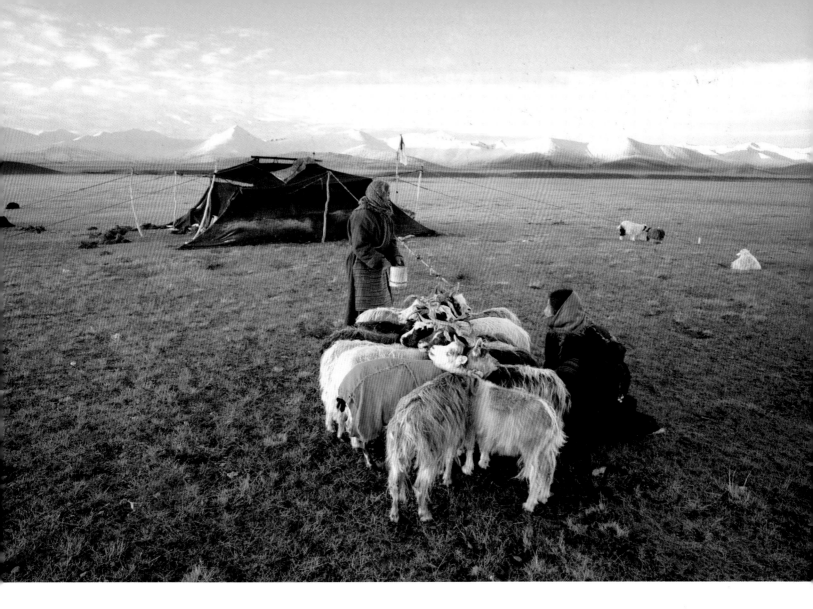

Nothing other than sparse grass grows on the treeless and shrubless plain near the sacred Nam Tso Lake. At 15,400 ft (4,700 m) above sea level, it is the highest salt lake in the world. The undemanding Tibetan goats guarantee a decent living for those nomads at the higher altitudes, who do not own Yak herds. Milk, butter, cheese, leather and the wool similar to Cashmere is all a Khampa needs to survive.

can be combed or cut, and then spun into a thick, waterproof yarn. The Khampa use yak hair to make clothing, footwear, blankets, undergarments, rope, belts and thongs. Most importantly, yak hair is the main material used in the Khampa's enormous black felt tents. Yak meat has a gamey taste and a high nutrition value. The milk of a yak has a fat content of up to 8 percent, making it particularly suited to the production of yak butter, which is one of their staple foods. Yak butter can be smeared on bread, added to a variety of grain dishes, or stirred into the traditional Tibetan butter tea. At higher latitudes, dried yak dung is often the only available source of fuel. The dung burns slowly and gives off little smoke, so it can be comfortably burned inside a tent.

The Khampa spruce up well for the Litang Horse Festival. The men bind their shoulder-length hair with strands of bright red wool beneath broad-brimmed hats. The women don colorful brocade dresses and ropes of necklaces and bracelets. Girls have their hair braided into the traditional 108 knots, a physical representation of a number that has been magical to the Khampa since pre-Buddhist times. The number is reached by multiplying the nine planets by the twelve signs of the zodiac. The juniper branches have been plucked and laid on the hearths of Litang. The festival can now begin.

CHRISTIAN ROLFS

HERE & NOW

The Khampa speak their own language of Tibetan Burmese origin, which is called Khams or Khampa. Kham itself was never an administrative unit, not even during the late Imperial Era of China. The region today includes 50 districts, of which 16 belong to Sichuan, 3 are part of Yunnan, 6 of Quinghai and 25 belong to Tibet. Until the 1950s, the 1.5 million inhabitants of Kham did not let the respective administrations make them assimilate. This was eased by the inaccessibility of the region. Today, there is relative peace, save for a few minor provocations.

Holy places

The Germanic tribes were simple people. They went into the forest and worshiped the tallest tree they could find. They particularly revered the great ash trees. Ashes require a lot of light, which means the most impressive specimens are found in large, bright forest clearings. That was all the Germanic people needed to contemplate life and the fertility of the earth. In those early times, much of the northern and central European forest was still in its pristine, natural state. In addition to tall trees there were also sacred groves where they could make human or animal sacrifices to their gods. Weapons and gear captured from their enemies could also be presented or burned in sacrifice. The Germanic belief system did not survive long after the arrival of Christianity, though there are stories telling of the Bishop of Bremen, who noted that his faithful flock still went off into the woods to pray. He at once ordered the heretical forest cut down.

The Celts were contemporaries of the Germanic tribes, with whom they shared a similar worldview. The Celts also found altars in natural surroundings. Their worship of springs has a plausible foundation, for life flourishes wherever water streams from the ground. Celtic springs were admittedly somewhat more enduring than the trees worshipped by the Germanics. Certain ancient sacred springs are still in use today, providing healing and mineral waters.

They worshipped the trees

The mindscape of some religions continues to be inhabited by natural spirits that live in places where this world and the otherworld seamlessly intersect. Crossroads, caves, boulder fields, deserts, impenetrable thickets and tall mountains fall into this category. Should anyone see something surprising or suffer an unexplained accident at such a place, the event can easily be blamed on wraiths and spirits.

A place can only become sacred if a great enough number of people claim it as such. This is true for natural sanctuaries as well as holy sites crafted by human hands. The latter might take the form of a carefully demarcated area in the village square or stone settings, such as the famous barrow graves and menhirs, or cult buildings like churches and temples. Jerusalem was claimed by three great religions in this way. Jews, Christians and Muslims all have ample reason to declare Jerusalem holy. It is relatively easy to prove that the city was the setting for events in the lives of their prophets.

Jerusalem is holy for three great religions

The Jews have by far the oldest claim, with the Temple of Solomon mentioned some thousand years before the birth of Christ, long before Christianity and Islam ever existed.

The struggle over a city that is sacred to so many people has continued uninterrupted to the present day. When Israeli opposition leader Ariel Sharon visited the Temple Mount in 2000, he did so accompanied by

A fertility ritual in the Peruvian Andes. The people of this mainly Quechua region decorate trees, here with balloons, for this purpose.

Three religions claim Jerusalem as their holy city, but only two of them, Christianity and Islam, went on to conquer the world. Judaism does not have a missionary directive.

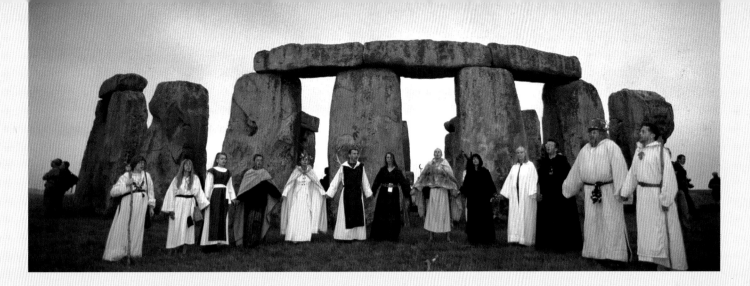

Myth has long attributed the construction of Stonehenge to the Druids. The ancient construction was declared a UNESCO World Heritage Site in 1986. Since then, it has been fenced in and guarded.

around a thousand politicians, security staff and members of the media. To the public, Sharon's visit was an unspoken rebuke of former defense minister Moshe Dayan, who, after occupying all of Jerusalem during the Six Day War, promised that the Islamic sanctuaries of the Temple Mount would remain free of Israeli symbols. The second intifada broke out the day after Sharon's visit. It is assumed, however, that the well-planned protest was not really as spontaneous as it seemed. The staging of the rebellion required a symbolically communicative background, which Jerusalem, with its countless holy sites and hectic politics, could provide for all sides.

It is easy to capitalize on a society's religious sensitivity by consciously mistreating holy sites and sanctuaries, which is a humiliating experience for the religion's followers. Mauna Kea is an imposing volcanic mountain on the island of Hawaii. Its name translates to »white mountain« because the 13,795 feet (4,205 meter) tall peak is covered in snow. In 1898, the United States annexed the Hawaiian Islands, making them the fiftieth state in the union. Soon thereafter Americans built an observatory, and later a bombing range, on the slopes of Mauna Kea, which is sacred to native Hawaiians.

Many societies have no temples or churches because their gods cannot easily be associated with any one place. Religions which are oriented toward nature, such as those of the early inhabitants of Central Europe prior to the arrival of the Roman legions, let worshippers pay homage to the forest or visit a sacred spring. The more hierarchically organized world religions have myths and sacred places that, throughout the centuries, have never really lost their meaning. There are two reasons for this. Writing down religious teachings preserves them for future generations, ensuring that the importance of the holy places continues to be understood. Another reason has to do with the religious architecture known from the very beginning of recorded history. Inscriptions and secondary references to temples, mosques and churches make their sacredness very clear indeed. A building like Cologne Cathedral is more than just a tourist attraction for visitors from all over the world. To practicing Catholics, its size and visual power symbolize the very steadfastness of the Roman Catholic Church. This is much more important than the building itself, or the character of its administrators. Some visitors who step into the cathedral have little interest in the Cardinal or his activities.

Some religions follow a completely different pattern. In many African societies, the deities are spiritually tangible and not confined to any specific place or building. In Voodoo, priests and priestesses can act as stand-ins or spiritual guides for gods and goddesses who can appear in any house or village. Voodoo thus has no need for a church.

MAX ANNAS

Gods can be anywhere

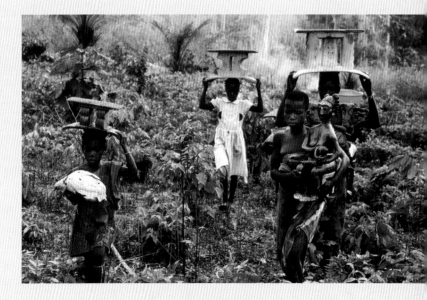

The Agni living in the southeastern part of the Ivory Coast believe that stools like these possess magic powers. They are enshrined in the »sacred forest,« and are only on display during communal ceremonies.

MOSUO

Remote idyll

Xiao Lian decided that now she was 17, it was time for her to become a mother. The father of her child was to be Bao, the son of old Cheng. So she gave him a shawl that she had woven herself. Bao knew what he had to do. The same night, he went to the house where Xiao Lian lived with her mother, scaled the outer wall to her wide-open window, climbed in and stayed with her until morning. If she liked what he did with her, he would be allowed to return. If not, the next shawl would be given to someone else. Bao would be neither surprised nor annoyed about this. He would simply wait for the next one and no one would be angry with anyone else.

Legends like this entwine around the sexuality of the Mosuo. The promiscuous behavior among each other have not only engaged the imagination of ethnologists; lately, there has been an increase in the sex tourism to the area of the Mosuo, who live in the Himalaya near the Tibetan border at the shore of the Lugu Lake. A so-called visiting marriage indeed exists with the Mosuo; they also practice a special kind of matriarchate.

Except for political responsibility, which is the men's concern, women have the upper hand in important matters, since home and inheritance belong to them. There is no marriage in our sense. Regardless, the relationship of the mother to the father of the child often lasts a lifetime. However, the children bear the mother's name and also live permanently in her household. Their fathers do not move in. They stay in the house of their own parents, where they in turn care for the children of their sisters. The immediate education of the children is the sole responsibility of the mother. Their male caregivers come from their own family. Any question as to the biological father is taboo. This has the advantage that there is neither divorce nor dispute about custody. The care of the elderly is also covered in the same way. While in other cultures those parents, who have no sons, are often alone after the daughters have left, with the Mosuo, there is always life in the house, because mostly neither sons nor daughters ever leave the parental home.

The Mosuo mainly conduct agriculture and stock breeding, and live, unlike most of China, more on potatoes and cereals than on rice. They also produce sulima, a kind of wine that is very strong and often served at festivals. Only recently have electricity and running water come to one village or another.

Television entered the life of the Mosuo via satellite and some television sets. This brought new topics into their lives, such as robbery, murder and war, says a legend. Violence however did exist; it is told that women, who hobnobbed with non-Mosuo, were mercilessly bashed up.

CHRISTIAN ROLFS

Among the Mosuo, it is the woman who chooses the man. The criteria vary little from those consulted in other parts of the world. Given the surplus of men on the shores of Lake Lugu, anyone wanting to attract attention needs to be resourceful. This can mean passionately performing a song LEFT, or mixing comic elements into a folk dance RIGHT.

HERE & NOW

At present, the Mosuo population still numbers about 40,000 individuals. Three circumstances are problematic for them: on the one hand the young adult men are increasingly leaving their homes to seek their fortunes in the big cities of China. This leads to an excessive number of women, which upsets the natural equilibrium within the families. The growing strength of Buddhism in relation to the traditional Daba religion leads to the history of the Mosuo becoming increasingly forgotten, because it is only the Daba priests who hand down culture and history. For this reason as well, the Lugu Lake Cultural Development Association is concerned about creating a Mosuo written language.

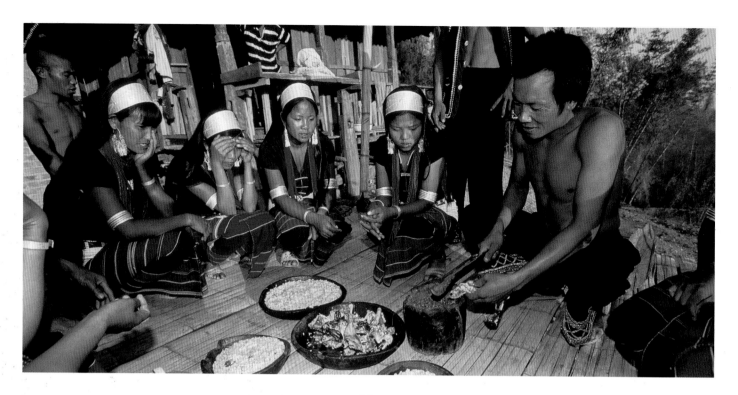

ONGDING ⊕ 25°42'N 100°9'E

WA

Drums for the gods

When Cerui, December, comes to the south-west Chinese province of Yunnan, the rumbling of the drums from the slopes of the Himalayas comes through the border region to Burma, the present-day Myanmar. It announces that the Wa, who call themselves Awa, are celebrating their most important ceremony, the wooden drum festival. This sacred instrument of the Wa is manufactured, every year anew, by four or five men of the village – a task that takes several weeks – from a specially selected, particularly large tree, and kept in the drum house, which is considered a sacred place. The drum is beaten with heavy wooden pestles which, depending on where they land, produce from it two different notes, a deep one and a high one. Earlier, the drums were used only in cases of disaster or emergency, when their thundering voices were allowed to speak to the gods.

Around the drum house the two-story wooden or bamboo structures are grouped, with human living quarters upstairs and cattle accommodated below. Wooden carvings on the roof or the skulls of oxen on the walls show that the owner belongs to the prosperous families of the village. The basic unit of Wa society is the monogamous nuclear family, although polygamy is tolerated. The morality of the Wa is fairly free and easy. As soon as a couple is engaged, the man may sleep with his betrothed. One becomes engaged by making gifts to each other of betel nuts and tobacco. The parents must however agree to the marriage that is to follow. If they withhold their blessing, the couple can still elope together, and the parents have to live with this.

Boom-boom-bang... Again the drums are booming in Ongding. The hair of the dancers swirls around in the shuaifa dance; in other places, the girls are swung around as well. The festivals of the Wa are spectacular; the ceremonial sacrifice is an attraction for miles. In recent months, the villagers have been cultivating the rice fields, have grown and harvested corn, potatoes, peppers, cotton, tobacco, and sugar cane. In this subtropical climate, pineapples, mangoes and dwarf bananas also flourish opulently. The harvest has been brought in, and now it is time for Piaoniu, the festival of sacrifice. To thank the gods and also to put them in a gracious frame of mind for future harvests, a bull is slaughtered. The meat is divided among the families and dedicated to their ancestors. Piaoniu is only one festival among many in the calendar of ceremonies of the Wa. There are sixty feast days in each year.

The Wa, like other ethnic groups of the Yunnan region, have such a richly faceted culture of music and festivals that even the Chinese mainstream makes use of it. The well-known dancer Yang Lijing, for example, a member of the Bai group, was recently inspired to create the musical drama »The Image of Yunnan.« This cultural firework display was successful on many Chinese stages. At some performances, a small Wa also stood on the stage: A Bu, at five years old, was the youngest performer in the show and impressed the audience with a stunning drum solo.

CHRISTIAN ROLFS

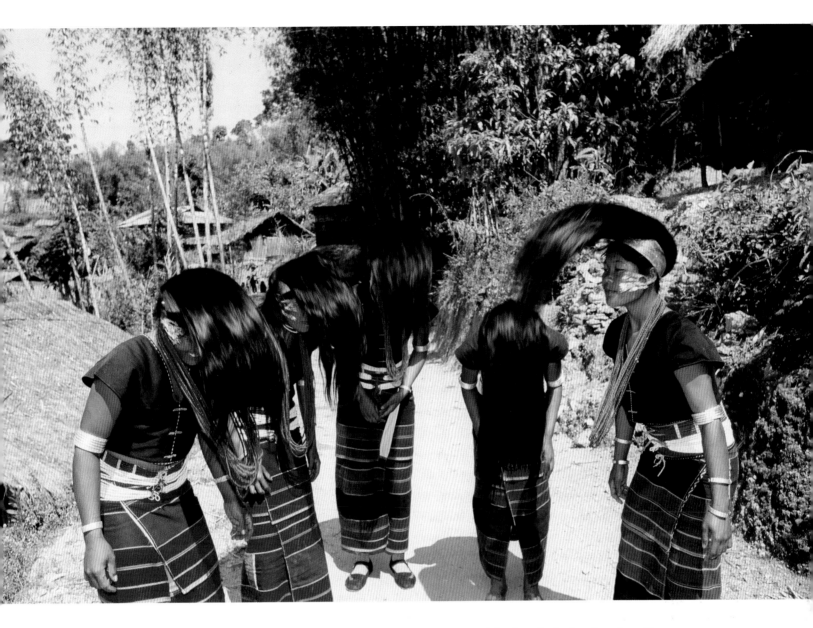

Wa families eat their meals together on the floor of their huts LEFT. The menu is rich and varied thanks to the fertile soils and good harvest.
Wa girls practice new choreography for the Toufa Wu dance, also known as the Long Hair Dance, in preparation for an upcoming festival ABOVE.
Women with opium pipes are a familiar sight in the border region between China and Burma BELOW.

HERE & NOW

At a Chinese census in 2000, 296,000 Wa were registered. According to the administrative district, the Wa adhere to various religions. Apart from animism, Buddhism and Christianity are also followed. They have their own language, also called Wa, which belongs to the Austro-Asiatic family of languages, but had no written language until 1957, when a language based on the Latin alphabet was developed for them. Beyond the border, above all in Myanmar, live between 600,000 and 1 million Wa, who are said to have still been headhunters up to the 1960s and according to government figures to have lived principally from the cultivation and trade of opium – less for reasons of profit than on account of the bad conditions for other crops. For some years, a program has been in force for resettling these Wa to more remote regions, where they will find an equivalent occupation in the cultivation of tea, sugar cane, caoutchouc and fruit, since 26 June 2005, the cultivation of opium has been banned in Myanmar.

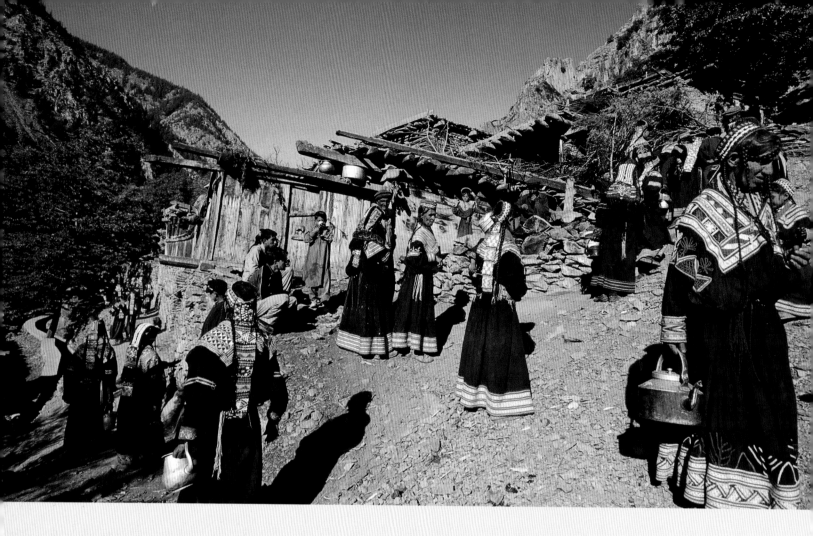

ARID CLIMATE

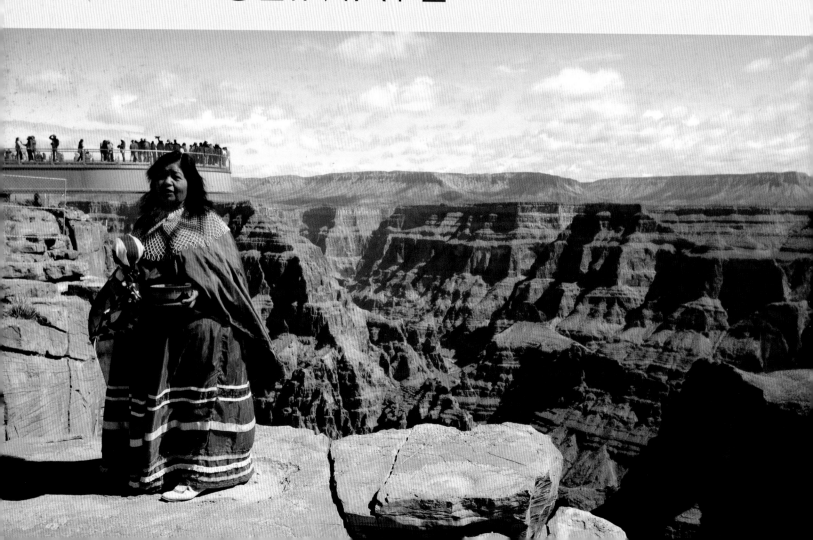

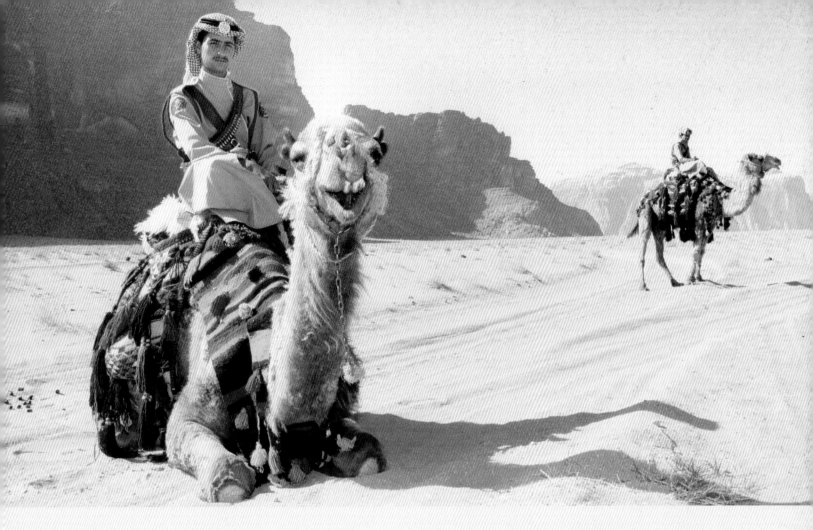

SUN, SAND AND DUST

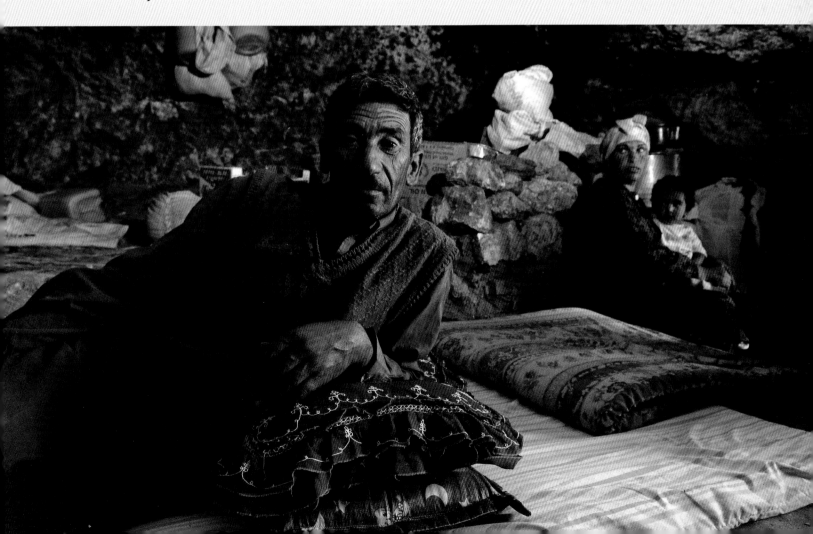

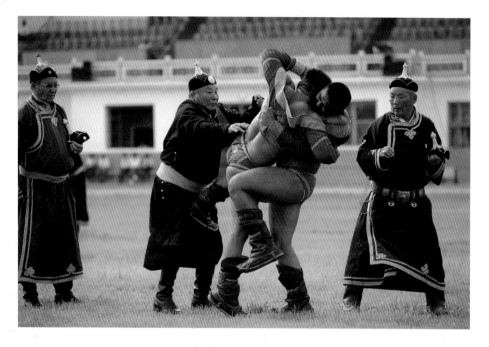

A semi-final wrestling match at the Naadam Festival in Ulan Bator. Wrestling, archery and horseracing are the three »manly games,« which give this Mongolian national celebration its unique character LEFT. The Naadam Festival in the Karakorum. Men playing billiards RIGHT.

CHOWD 🌐 48°1'N 91°34'E

MONGOLS

Tuvans: another Mongolian group

People in search of the great outdoors and the traditional nomadic lifestyle of Mongolian camel, sheep and horse breeders must first pass a huge bottleneck. Ulan Bator is a metropolis with one million inhabitants: on the city outskirts, settlements of uprooted and poverty-stricken rural refugees spread out into the country. Their homes are not built of corrugated iron as they are in most slums around the world, but they are circular and made of felt, and are known as yurts. Here, beyond the city boundaries, the ancient nomadic culture appears to be a thing from the past, a culture plagued by problems such as unemployment and alcoholism.

In Ulan Bator, a surprising number of Mongols speak excellent German. At the time of the Mongolian People's Republic, which was founded in 1924 and, as a satellite of the Soviet Union, remained largely independent, many Mongols went to study or work in the sister state of East Germany. The most famous contemporary Mongol, Galsan Tschinag studied German at the University of Leipzig and has achieved fame as a poet and writer. He later taught German at the University of Ulan Bator. His first novels, stories and anthologies of poems were published in German, and now his books are translated into many languages.

However, it would do Galsan Tschinag an injustice to simply refer to him as a Mongol. Tschinag is a member of the Tuvan minority that is native to the Altai region in the far west of Mongolia and in neighboring regions in Russia and Kazakhstan. It is thanks to Galsan Tschinag that the small group descending from the Turkic-speaking tribes has made its mark on the political map and agenda.

As nomads who depend solely on cattle breeding, the Tuvan were forced to resettle in the 1960s. In 1995, Galsan Tschinag led many of these uprooted people over 6,562 feet (2,000 kilometers) in a long caravan back to their home in the Altai. Today, he takes groups of tourists on guided tours of the country, and tells them about the richness of the Tuvan culture. Television films have been made about him and he regularly travels to Germany and other countries to read from his books.

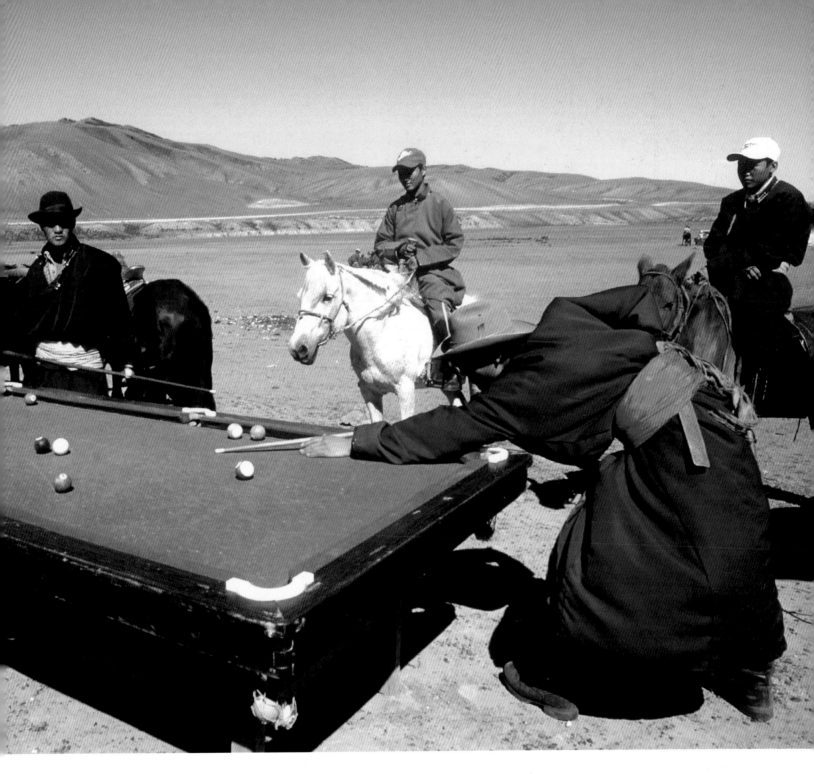

In 1992, the celebrated Tuvan spoke to the World Uranium Hearing in Salzburg about the disastrous effects of atomic policy on his home country. The former Soviet Union's nuclear weapons test site was located near Semipalatinsk in Kazakhstan, and in the area around Lop Nor in the province of Sinkiang, the Chinese tested their atomic weapons from the 1960s. Since 1980 this has occurred above ground. Depending on wind direction, the Tuvans' homeland lay either under Russian or under Chinese radioactive fallout – and man

and animal and the vulnerable fauna of the mountainous region have all suffered from the consequences.

Today, the Tuvan people face other problems. They are dependent above all on the weather. Two thirds of their livestock perished in the exceptionally cold winters between 1999 and 2001. A fate they shared with the other Mongolian peoples. Although Mongolia now has a diversified economy, and industry and the service sector are increasing in importance, Mongolia is still first and foremost an agricultural

country. Only around one percent of its 604 million square miles (1,564 million square kilometers) of land is suitable for arable farming: livestock farming plays the biggest role.

Sheep, goats, camels and a small number of yaks are kept. However, Mongolian culture revolves around the horse. Since the days of Genghis Khan, when the »Mongol hordes« created a huge central Asian empire stretching from China to Central Europe, the symbiosis of horse and rider dominates our notion of the Mongols.

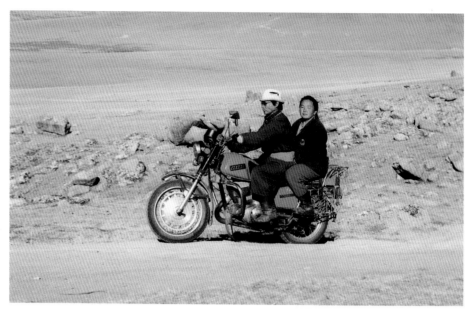

In the wild west of the Mongols, Tuvans lead tourists on trekking tours through the Altai Mountains LEFT. Family on the way to Erdenesant CENTER LEFT. Yurts in the suburbs outside the capital city of Ulan Bator CENTER RIGHT. Whether it is a satellite dish or solar electricity, Mongolian nomads have clearly taken the yurt into the twenty-first century with the addition of modern technology RIGHT. Tuvan shamans in the Altai Mountains conduct their practice in a yurt BELOW RIGHT.

Nomadic children learn to ride at the age of four or five, and at popular horse races such as the Naadam festival in July, seven and eight year-old children can be seen in the saddle. Horse riding is also part of everyday life, and the ride to distant schools is a normal matter for many children. According to legend, during the nomads' Buddhist New Year festival, the men have themselves strapped firmly to the saddle so that they can visit as many relations and friends as possible within a wide radius and survive the ride without falling off their horse. As in every yurt or ger, as the Mongols call their white felt tents, they toast the New Year with airag, a fermented milk drink. Under Genghis Khan, a law on unconditional hospitality has been decreed which the majority of Mongols uphold even today.

Yet it is not unusual to see a cross-country motorbike propped up outside a herder's yurt. Although many families are proud to say they own eight to ten horses, technical progress has not passed them by. It is much faster to round up a herd on a motorbike than on horseback. Even TV aerials erected above the yurt are not an uncommon sight.

Not only the nomads, who are so dependent on the weather, and whose economic survival can be jeopardized by one harsh winter, face an uncertain future. In Ulan Bator, members of the lower classes face the same existential problems that exist in many other cities around the world: unemployment, undernutrition and malnutrition, high child mortality, and many children living on the streets.

YAT-KHA:
IN-A-GADDA-DA-TUVA

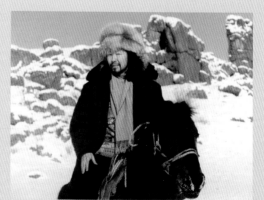

Albert Kuvezin commands the art of harmonic singing, which is usual for someone from Tuwa. Here, overtone singing is something like a national sport. When Kuvezin starts to hum, the old rocker in him also starts to lurk. In times of perestroika, with his guitar, the teenager worked his way through the repertoire of western rock music by Iron Butterfly via Led Zeppelin to Joy Division. Later, he sought out the old masters, in order to train in the Tuwa style of singing, and further studied the instruments in the symphonic orchestra. In the band, Yat-Kha, ties are established between West and East.

When Kuvezin wails away Jimmy Hendrix style, samples, bases and drums meet harmonic singing, zither, horse head violin, jaw's harp and shaman drum. When the zither, which is called Yat-Kha in Tuwa, feels its way into the classic In-a-Gadda-Da-Vida, and then the harmonic turbo is turned on, the piece concentrates and picks up speed; this can only be Albert Kevezin and his band.

www.yat-kha.com

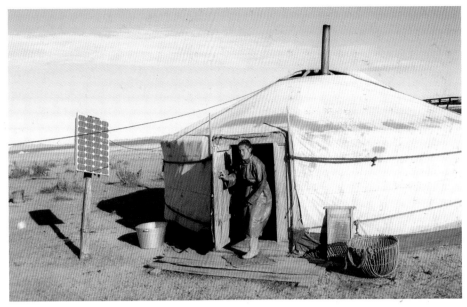

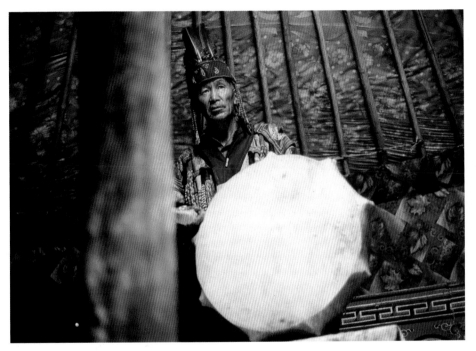

In the winter, these children survive in the canals of the city's underground heating system, living in conditions of squalor.

Perhaps the hospitality law can show the Mongols the way out of poverty and an uncertain future. Words such as Karakorum, the legendary medieval capital of Genghis Khan's realm of horsemen; images of caravans of camels against a backdrop of sand dunes; and not least of all successful film productions such the Oscar-nominated »Story of the Weeping Camel« from 2004 or »Urga« from 1991 inspire western tourists to dream of a »free, natural life« in the yurts of hospitable nomads and show that tourism is an economic prospect to be relied upon

Perhaps the number of Mongols living as nomads will even increase again. If the white yurts, set against the steppe, mountains or desert, are coupled with accommodations for tourists, this can only boost the self-confidence of the proud Mongols.

BERNHARD MOGGE

HERE & NOW

One of the many different ethnic groups in Central Asia was that of the Toba. The home of their descendants, the Tuvans, is the mountainous Altai region, where today the states of Mongolia, Russia and China meet. The majority of Tuvans, who still lead a largely nomadic life breeding animals, settled in the Russian Autonomous Republic of Tuva, where they make up the majority of the population with some 200,000 inhabitants. Several thousand Tuvans live in China, up to an estimated 10,000 in Mongolia.

Since their lifestyle differs insignificantly from that of the nomadic Mongols, the Tuvans of Mongolia are a little known minority. Many were driven away to the steppes of Central Mongolia by the Kazakhs who settled in the Altai around 100 years ago. However, more and more are returning to their home country – usually without any belongings. An increasing number are rediscovering the richness of their culture. Cautious tourism with the hospitable Tuvans in the magnificent countryside of the Altai is a prospect for the future.

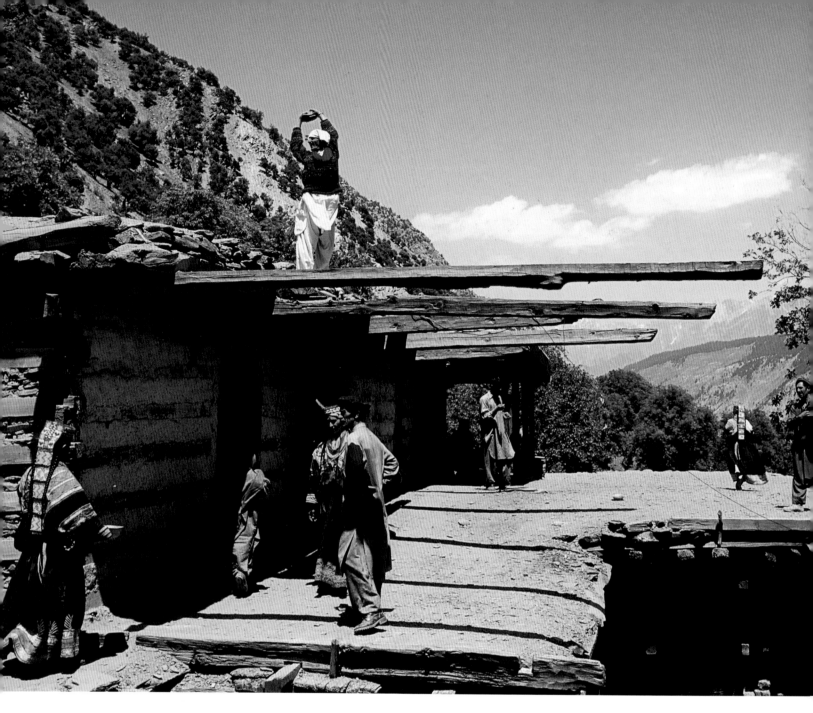

The path to the »unbelievers« or kaffirs, as the Kalasha ethnic minority is disparagingly known by the Muslim population, leads right through the northwestern frontier province of Pakistan. Here, women are very rarely seen in public when, protected by a veil or burka, they make hasty purchases, or slip into a neighbor's house. The Kalasha provide quite a different picture. Crowded into the three mountain valleys of Birir, Rumbur and Bumboret, the last survivors of this originally polytheistic group whose women move freely, unveiled and in black robes with multicolored decoration, are found. They live together in the heart of the Hindu Kush in a cluster of about 20

KALASHA

The valley of the unbelievers

small village communities. Their religious festivals, where they celebrate the beginnings of the various seasons with wine from home-pressed grapes and traditional dances, are legendary.

In the village of Krakal, a dance house is especially erected for these festivals. For the spring festival of Joshi, where prayers are made to the gods for their blessing and for the safety of the herds and the harvest,

the houses are decorated with the first blossoms. On the »milk day,« the prelude to the festival, the villagers march, dancing and singing, from house to house collecting offerings of milk. In their songs, they call on the goats to eat much grass and produce much milk. The dancing and singing continues late into the night.

The sun comes up over the Lowari Pass, promising a bright day. At a height

A typical dwelling in Krakal LEFT. *The Kalasha formally greet each other by kissing each other's hands. Women extend the corners of their cloak and kiss each other's braids.*

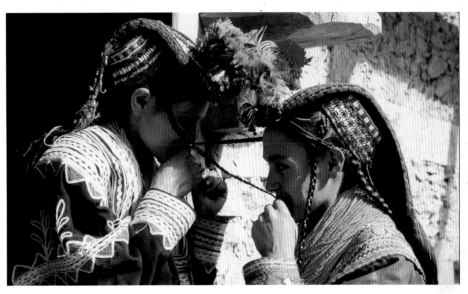

of 10,230 feet (3,118 meters), which is not especially high in this area, there is a wonderful view of the former princely state of Chitral. Today, the administrative district that includes the Kalasha area is accessible from Peshawar only through this pass. The only other route to the valley basin is the longer one over the eastward Shandur Pass, which, at almost 13,123 feet (4,000 meters) in height, is in use every year as the site of the world's highest-placed polo tournament. It is a good thing that it is now summer in the Hindu Kush, for in winter, both passes are impassable for up to six months, and there is no route into or out of the valley basin.

The road to Chitral, the capital of the province of the same name, leads over bumpy dust paths. Here, an exact record is kept of persons entering or leaving the side valleys of the Kalasha. Only registered visitors are allowed to pass, and reach their destination in a few hours, moving past high-towering mountain faces. From the car window, one sees Kalasha women and children, recognizable from their traditional black, floor-length garments, colorfully decorated and fastened with broad beaded belts, working in the fields and in the orchards alongside the streets. Their head covering, the kupa, is also decorated with beads, cowrie shells, buttons, coins, and wool tassels, and reaches down

to their shoulders. The men look comparatively drab in the clothing usual in Pakistan, the salwar kameez, a combination of simple woolen shirts and trousers.

The production of the women's brightly colored head coverings and ornaments often takes months, but each of them, from the youngest girl to the oldest crone, wears the striking costume. Altogether, the role of women in this society is very special and forms a rich contrast to the customs of their numerically far superior Muslim neighbors. Kalasha women have everyday contact with the men and work side by side with them in the fields. Adult women are, in principle, free to choose their own husbands, although even among the Kalasha

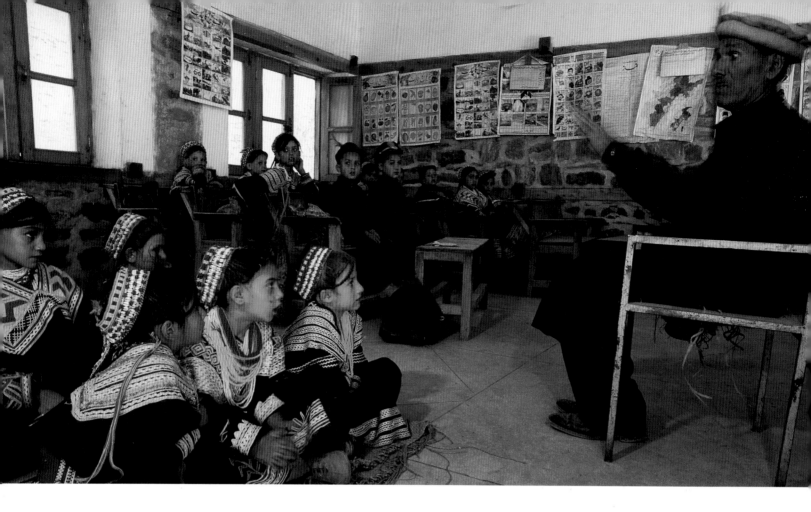

A Kalasha school in Krakal in the Bumboret Valley. Cultures without writing have no source books. Here, storytellers integrate traditional legends and songs into the lesson plan, explaining the animist origins behind old customs and practices, such as the Joshi ceremony still celebrated today.

many marriages are arranged. It is probably these comparatively great freedoms that have led to the misconception by Muslims that all Kalasha women are promiscuous, which regularly leads to protests from Muslim circles.

This ethnic group with its more liberal attitude toward life is visited by both anthropologists and ordinary tourists. The tourist trade in the Kalasha valleys is firmly in the hands of the Muslim Pakistanis. They have settled in the center of the valleys and their many hotels do not really fit in well with the Kalasha villages, in which many massive, mostly two-story, windowless houses cling to the steep mountain slopes. The flat roofs serve as terraces and can be reached by means of logs of wood with steps cut into them. In the cold, harsh winters, the Kalasha share their living space with their livestock, which are driven to the mountain pastures in the summer months. Apart from stock breeding, in their fertile valleys they cultivate fruit, nuts and corn, which they grind in very simple water-driven mills. The technique is hundreds of years old and has been passed on from generation to generation. This is also true of the technique of irrigating the fields, which is made possible by cunning diversion of the mountain streams.

It is these same streams that are polluted by the effluent waters from the hotels; and at some point, the stored refuse from their backyards ends up in the landscape. The cash-based economy is on the march, although the gross income from tourism does not reach the Kalasha. However, in

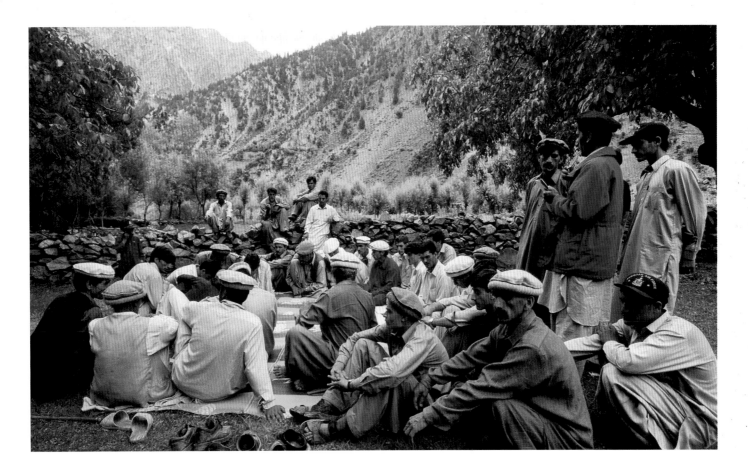

A meeting of Kalash men from the three valleys of Birir, Rumbur and Bumboret in Krakal. They have joined together in an association that protects their cultural rights and gives the Kalasha some control over their own marketing.

order to secure their children's education, the Kalasha need financial support, and the lack of income opportunities often leads to the sale of their land or conversion to Islam in order to fit in with their environment.

The sun is reflected on the corrugated iron roof of a building that is clearly marked out from the rest of the buildings in one of the villages. It is a school, built with sponsorship money from Greece. The interest of Greeks in this remote mountain people is not surprising in view of

the persistent myth that the Kalasha are the descendants of the soldiers of Alexander the Great, who were lost here around 400 B.C. It is more probable, however, that their origin is Indo-Germanic and that they lived in this region long before the invasion of Persia. Their language, Kalashmun, with its elements of Greek, Persian and Sanskrit, points toward this. It is only recently that a written language has been developed for the Kalasha, who until then had to pass on and preserve their traditions orally.

Today, the culture of the Kalasha and the survival of their community are under threat. Particularly after the September 11 attacks and the wars in Afghanistan and Iraq, religious fundamentalists have targeted the Kalasha and would like nothing better than to see them disappear from the face of the earth. »We have always been described as kaffirs, that is, unbelievers, but people mostly left us in peace,« says Azam Kalash, one of the few Kalasha to have attended a university. He now campaigns for the well-being of his people. »Now we are Enemy Number One.«

LAURA ENGEL

The Kalasha make alcoholic beverages from berries, apples and grapes. The tourists enjoy the taste, whereas the Kalasha's Muslim neighbors do not like it at all.

Economy

Half the world population still lives and works in villages. At the same time, there is a noticeable drift to the cities, from Beijing to Lagos. Thousands of suicides in the Indian provincial areas testify to the worldwide existing misery in the periphery. Many people cannot find a way out of insolvency and loss of land.

Barrow in Alaska. The wind whistles around the primitive shanties. In the summer and fall, the Inuit pick up their harpoons and get ready to go on the whale hunt. Their catches are celebrated at home in the little village, and a large capture is amicably shared with neighbors. Whale meat is considered a delicacy. Everywhere in the village there are signs of whaling. These Inuit are primeval hunters in the 21st century; they have nothing in common with the

The San hunt following old traditions

industrialized whaling of the Japanese. It is not long ago since dog-sleighs were made from the leather and skis from the bones of whales. The Inuit still follow the interplay between animal and nature, passing on their knowledge from generation to generation. The lives of these whale hunters are threatened, not by international competition, but by one of the world's largest energy enterprises, which is trying to exploit the last oil reserves in Alaska. For this it needs the land, whatever it may cost.

The Kalahari Desert in the south of Africa. The San, following old traditions, still hunt 55 species of animal, mostly antelope. Apart from poisoned spear tips, the hunters also use pits, corrals, gravity traps, and snares; they cover up to 2,485 miles (4,000 kilometers) in the course of a year's hunting. The women contribute to the diet by gathering nuts, roots and berries. The Bushmen make use of their economic area beyond state boundaries. The example of Botswana however shows the challenges to which the San are exposed. The continued existence of their reservation is threatened by the planning of a diamond mine, many have already been forcibly resettled, and the authorities have banned hunting – but now those affected are defending themselves. This, perhaps, is new.

Kurdistan, Göbekli Tepe. Where archaeologists are digging up remains of an early Neolithic temple complex today in the former Mesopotamia, the original inhabitants first practiced agriculture and cattle breeding. They chose

An economy based on subsistence

individual plants, began to sow their seeds, kept cattle and settled near pastures and fields. A city probably came into being around the temple. About 9000 to 4000 B.C., the inhabitants of the South American Andes region began to cultivate corn, pumpkins, avocadoes and peppers. At about the same time, on the other side of the globe, by the Yellow River and the Yangtze in China, various vegetables, rice and soya were being cultivated. From each of these centers and some smaller ones, agriculture gradually spread across the globe, to every part where climatic and geological conditions encouraged settlement.

Hunters, gatherers, herdsmen, small farmers – all these represent a living anachronism. Their economy is aimed primarily at subsistence

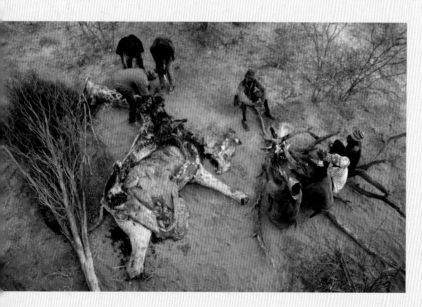

A group of San in the Kalahari Desert with an unusually large kill. The men have brought down a giraffe with five poisoned arrows.

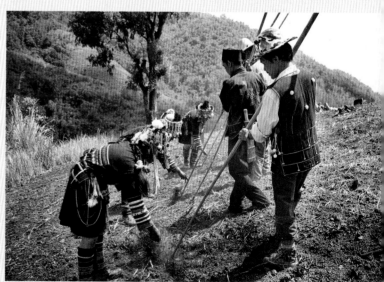

Rice farmers in Yunan province. Chinese peasants continue to work their land using traditional methods.

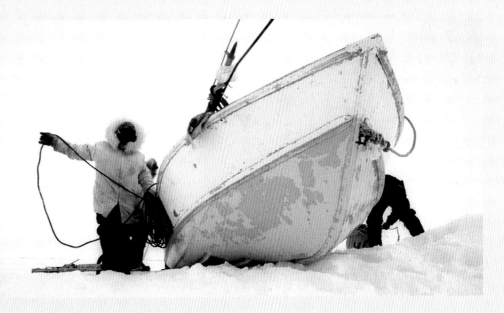

Inuit on Alaska's Bering Strait prepare their whaleboat for the hunt.

and only secondarily at exchange at local markets. Local self-sufficiency is being suppressed however, because profiteering large farmers are growing cash crops, agricultural products for export. In rags and with empty stomachs, the small farmers watch the corn and cotton being transported out of the area. They find themselves in conflict with the offshoots of a world economy in which sociologists such as Immanuel Wallerstein see the original inhabitants as settled in a kind of »external arena.« This arena is distinguished by standing either in a merely peripheral barter relationship or none at all to the capitalistic world. These areas create demand through their natural resources and above all the land that can be put to the plow.

When it comes to primeval forests and reservations, the conflict is pre-programed. The neoliberal economist preaches efficiency as well as the integration of peripheral economic systems into the centers for worldwide division of labor. The old-school ethnologist invokes the independent economy of Massai herdsmen and sees in it the expression of their cultural practice, perhaps overlooking the fact that for a long time, the pastoral nomads have already become linked to other economic cycles. Climatologists stress how important it is for the world climate that the Indians of the

Like with a pair of scissors

river Amazon should continue to be entrusted with the care of the global »green lungs« for permanent forest-plant agriculture.

Despite over-exploitation of nature and the environment, by aboriginal peoples as well as large industrial companies – as is the case with the deforestation of Easter Island by its residents, which is presumably brought about by a cultural impetus or a purely existential need by herders who allow their herds to graze on already barren land – a relative balance generally exists between the economic methods of primeval peoples and their environment. One of the reasons for this equilibrium is that, when their environment demands it, these natives allow change and transformation. They do not persist in hunting and gathering; if necessary they keep cattle or sow crops. They need a great deal of land in order not to disturb the natural balance in such a small area. They adapt to prevailing conditions and survive. However, modern

economic methods form their environment according to demand, and are thus the exact opposite. Like with a pair of scissors, the sharp blade of the center makes the profit absolute, measured in financial terms. This brings only little benefit to the isolado in the Amazon area. Their culture is blunt on the outside; the prestige and well-being of the community is determined by social competence and long-standing rich knowledge of the environment.

The moment these values lose their significance, the poverty of the integrated and yet ignored primeval inhabitants begins. This is also the moment when their right to their ancestral land and their lifestyle in the external arena is denied and they no longer know how to survive. Where is their place in the »new world?« From now on they are alienated and destitute.

SÖREN KÖPPEN,
HENDRIK NEUBAUER

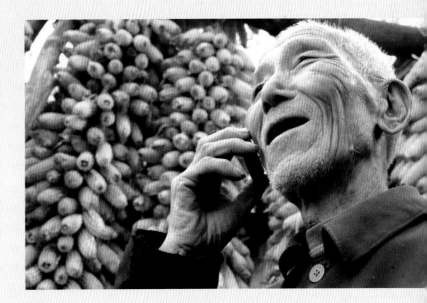

Monoculture and telecommunications should increase China's agricultural yields and halt rural migration.

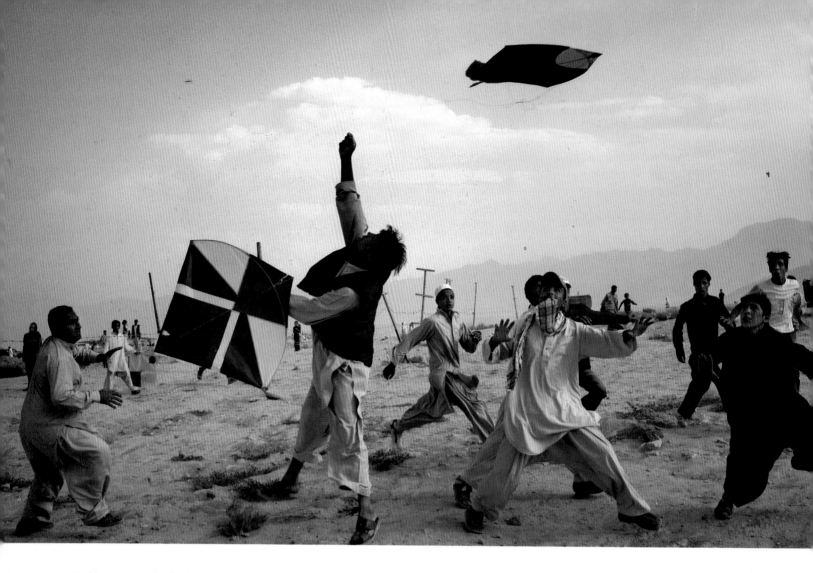

The kite runners of Kabul became world-famous, thanks to the novel of that name by Khaled Hosseini. Anyone who reads the novel becomes well acquainted with the oppression of the Hazara by the Pashtun. When the Taliban were in power, this leisure activity was forbidden.

KABUL 🌐 34°32'N 69°10'E

HAZARA

Fist over fist, and shoulder to shoulder

Kite fighting is an ancient and beloved pastime for every ethnic group in Kabul. Before the Russian invasion there were tournaments in which young people, all wielding kites, tried to cut the string of an opponent's kite in mid-air. These airborne performances are the central metaphor in Khaled Hosseini's bestselling novel The Kite Runner, which has been translated into more than forty languages and made into a Hollywood film. In his book, Hosseini describes a kite fight between the ethnic outsider Hassan, a Hazara who grew up in a courtyard shack, and Amir, a member of the Pashtun majority who grew up in the mansion to which the shack belongs. In doing so, Hosseini sheds light on a long-established source of conflict within Afghan society: minority groups and how they are dealt with by the majority Pashtun.

Guerilla warfare raged in Afghanistan for ten years before the 1992 victory of the Mujahideen. The Taliban cleared Kabul of all symbols of happiness, once and for all. The radical Taliban, dominated by the Pashtun ethnic group, created an Islamic theocracy that damned every trace of Western culture. With civil war ruins dominating the landscape and imposition of a ban on music, cinema and kite fighting, Kabul soon took on the atmosphere of a ghost town.

The Hazarajat, the homeland of the Hazara, is located in a mountainous region of Central Afghanistan. It was here, in 1316, that Il-Khan Abu Sa'id, a direct descendant of Ghengis Khan, converted to Shi'a Islam together with many of his followers. The Hazara remain an important Shi'a community in the midst of Sunni Central Asia to this day. In the region around the city of Herat, there are a handful of Hazara who still speak the language of the historical Mongols.

The Hazara in 2001, waiting in a Kabul mosque for the arrival of their political leader, Abdul Karin Khalili. The Hazara are Shi'ite Muslims, while the Pashtun are Sunni. This difference is one of the causes of the conflict between the two ethnic groups.

This purer form of modern Mongolian has otherwise completely disappeared.

For religious reasons and because of their Mongolian heritage, the Hazara have lived as a despised ethnic and religious minority since the fall of the Persian Safavid Empire and the founding of the modern Afghan state. They are subject to frequent discrimination and persecution by the Pashtun and Tajik elites.

Today, kites fly once again in Kabul, serving as a counterpoint to the uncertainty and ethnic conflicts that continue to plague the country. Every Friday, the sky over Kabul is dotted with color. Standing shoulder to shoulder, the young men follow in the footsteps of Hassan and Amir. High atop a hill in the middle of the capital city, on the only work-free day of the week, the kites climb high into the sky and are driven by the wind.

HENDRIK NEUBAUER

HERE & NOW

The Hazara language is a dialect of Farsi (Persian), with some Turkic and Mongol words. There are currently around 5 million Hazara in Afghanistan, a further 20,000 living as refugees in Iran, and another 100,000 in Pakistan. The Hazara homeland comprises the Central Afghan provinces of Bamiyan, Wardak and Ghor.

During the Afghan Civil War, the Hazara were subject to attacks from all sides. In 1992, the Tajik leader Ahma Shah Massoud focused his Kabul offensive on the Hazara people living there. During the Taliban years the Hazara were regularly butchered, and in the course of the 2001 Yakaolang Massacre, the Taliban murdered many thousands of Hazara because of their ethnic origins, language and religion.

The Hazara resistance movement is organized around the political militia Hizb-e Wahdat. This Hazara-led Shi'a group is supported by massive aid from Iran and the fundamentalist Hezbollah party in Lebanon.

Afghanistan's parliamentary elections in 1969 and 2005 were steps on the road to democracy. The Pashtun continue to dominate the government, and ethnic conflict persists throughout the nation. In June 2007, Kuchi nomads drove more than 4,000 Hazara out of the central highlands' province of Warduk. A number of Hazara earn their living in the drug trade, growing poppies and refining opium. Up to 90 percent of the worldwide production of opium originates in Afghanistan.

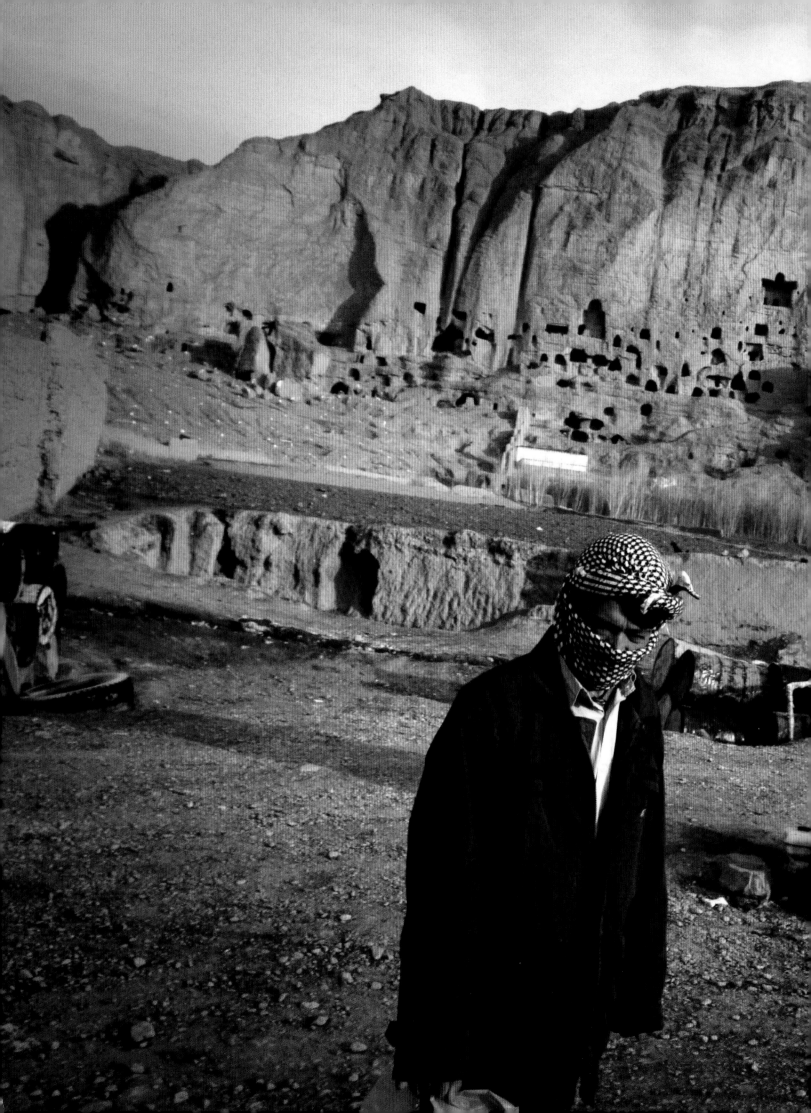

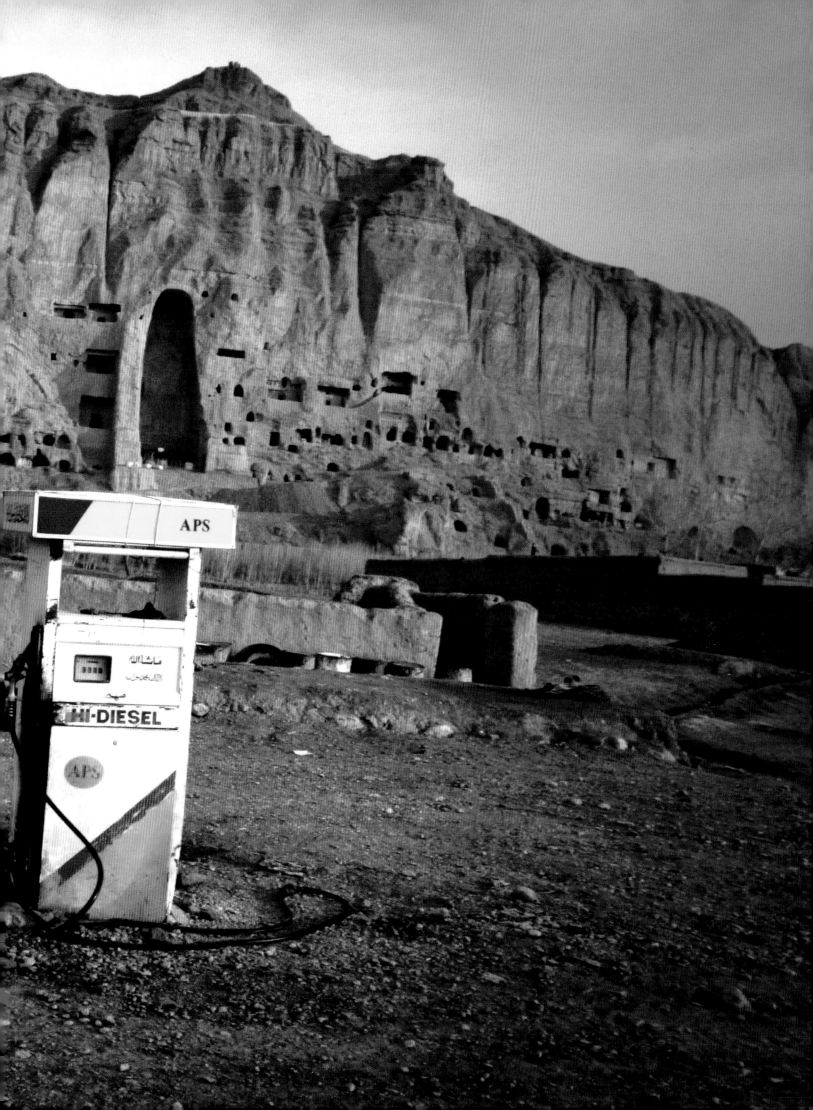

BAKHTIARI

Waiting and praying – high in the mountains

A succinct newsflash in a 1960 edition of the German magazine Der Spiegel reports: »Soraya, 28, divorced for recycling, refused to intervene in the Persian electoral campaign in support of the Shah, and ›for health reasons‹ declined a meeting in Vienna with the Shah's brother Ali Reza Pahlavi. Her brother-in-law Abd el-Rem had intended to persuade the professional holidaymaker to mediate between the Shah and the Bakhtiari tribe, of which Soraya is a member, and on whose goodwill the Shah depends.« The reference is to Soraya Esfandiary Bakhtiari, who had been divorced in 1958 for reasons of state from Shah Mohammed Reza Pahlavi after her eight-year marriage had remained childless. From then on, she did credit to her name as the »nomad« of the European jet set, but turned her back on her ethnic roots and the land of her birth.

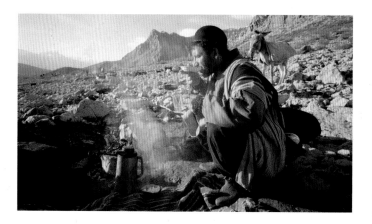

A camp in the Zagros Mountains. The men herd the cattle, coming into camp only to eat LEFT. The mountain passes can be 8,200 feet (2,500 meters) high. In this mountain range, men first domesticated goats.

HERE & NOW

Only about half of the 32 million Iranian citizens are Persians. A minority of the Bakhtiari, a million people, to this day live in the central Zagros Mountains, in the provinces of Isfahan, Bakhtiari, Chahar Mahaal, Lorestan and Khuzestan. Only a small number of them still lead a nomadic life. The Bakhtiari derive their ancestry from Fereydun, the legendary hero from the Persian national epic Shahnameh.

Iran is the only Muslim country in which Shiite Islam is the state religion. Minorities such as Kurds, Arabs or Turkmen, who are Sunni Muslims, are exposed to discrimination and persecution.

To this day, several hundred nomadic clans of the Bakhtiari live in the Zagros Mountains of Khuzestan. At least, in the winter they pitch their tents there. In the spring, if one hurries, one is greeted by the wonderful scent of the Shabdar flowers and catches the families before their departure to their far-off summer camp. Here in Shahrekord, on a plateau southwest of Isfahan, they camp in their tents. They are also found in the Yasuj and Kafe Namdoon areas. From camp to camp one hears different dialects and sees different traditional costumes.

However, what did Reza Pahlavi expect from Soraya's intervention? The eldest inhabitants in Shahrekord remember: »There were some very rich and powerful families among us. And the Shah was desperately looking for allies for his ›White Revolution.‹« The reconstruction of the country according to Western models caused unrest throughout Persia, which could be held in check only by force of arms, even after the implementation of reforms around 1961. It should also be realized that for generations there has been little love lost between the Bakhtiari and the central government in Tehran, as with the Kurds in the north and the Arabs in southern Khuzestan.

This is also true of the post-1979 period. The regime of Ayatollah Khomeini was not actually in command of the situation from the start. At that time, the Bakhtiari still envisaged the possibility of obtaining more rights for themselves. In the evening, by the fireside, they agreed that »the Revolution has destroyed despotism, but it has not overcome discrimination against minorities.« Khomeini proclaimed the Islamic Republic of Iran. After the Shah's regime, the country was remodeled according to the principles of Islamic fundamentalism.

The Bakhtiari follow the state faith, but they are considered anti-nationalistic. The Bakhtiari nomads in the Zagros Mountains live on the periphery of the Islamic Republic. What do the nomads in the camps of Shahrekord think of the way in which campaigners from Tehran are invading their area just as they do the cities of Khuzestan, announcing great plans and promising small boons? »This reminds us of Caliph Haroun al-Rashid, who once passed through the streets of Baghdad with bags of gold and had the money distributed among the people.« Not only from a distance, at the beginning of the 21st century, has this confident trickery seemed outdated and transparent.

HENDRIK NEUBAUER

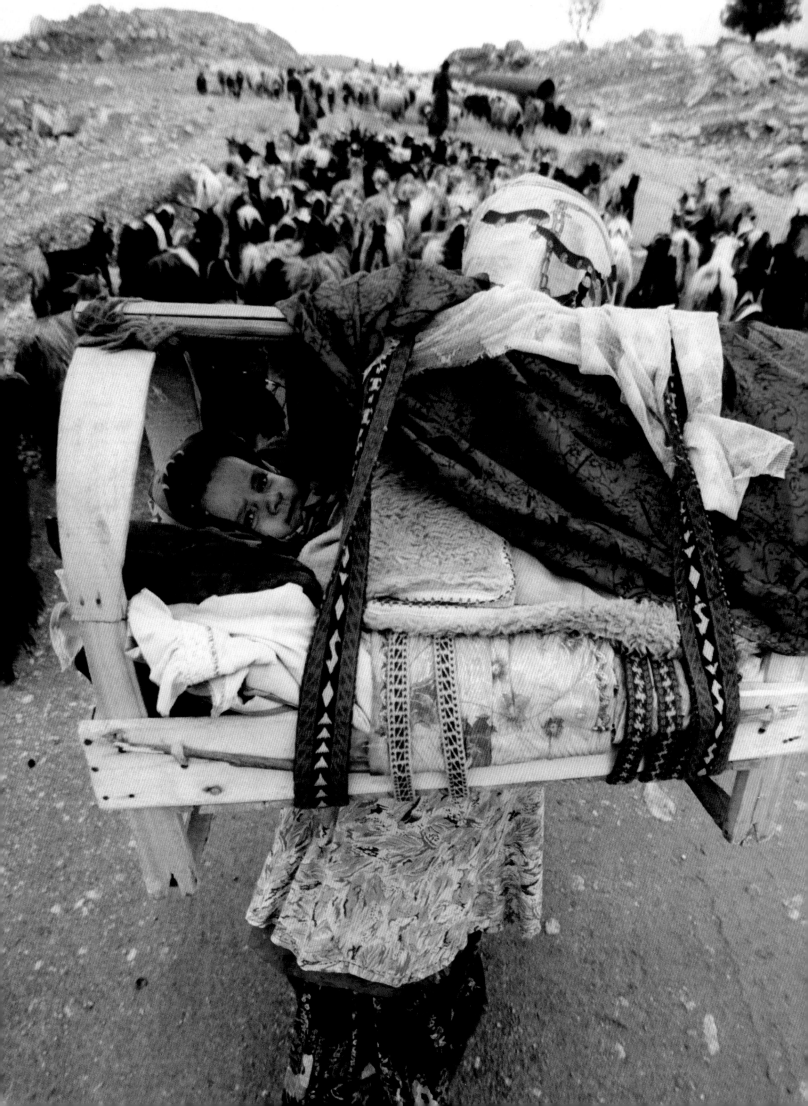

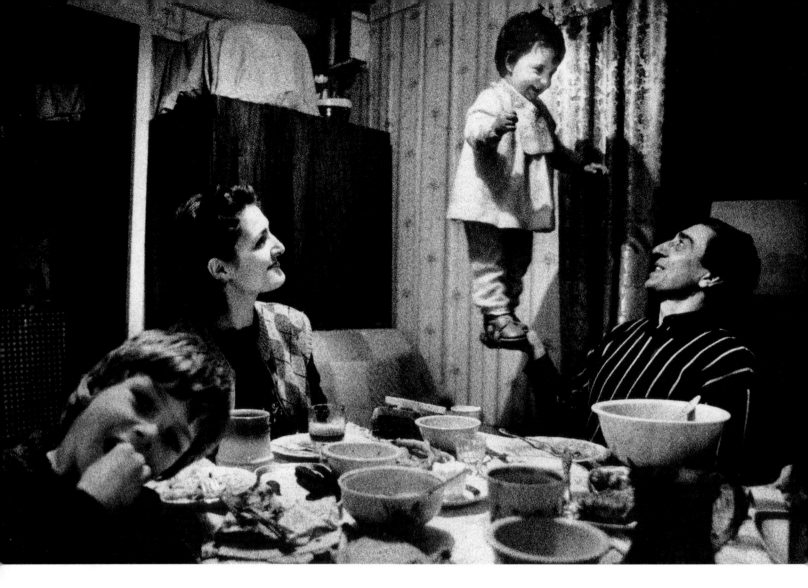

An Armenian family in Eriwan. There are more Armenians living scattered around the world than there are in their Caucasian homeland. Armenians are distinguished by their tight, global network, at the heart of which lie close family relationships.

YEREVAN 🌐 40°10'N 44°30'E

ARMENIANS

A global community

The American multimillionaire Kirk Kerkorian is the son of an Armenian fruit dealer. Armenian blood flows in the veins of Cherilyn Sarkissian, better known as Cher, as well as of the chess grand master and civil rights campaigner Garry Kasparov. And the French singer Charles Aznavour also has his roots here in the Caucasus. The Armenians have set up a monument to him in recognition of his help after the earthquake of 1988. The Armenian diaspora is legendary, widely ramified, and its members send millions of dollars to their old homeland every year. The homeland certainly needs them. While 7.4 million Armenians are spread over Europe, the Near East and the USA, only 3.3 million still live in the historically core country. The Republic of Armenia is today considered the most ethnically homogeneous country in the Caucasus. These indigenous people have been settled here for more than two millennia and have battled for their own language with an original alphabet of 38 »soldiers.« Their national identity developed not least through Christianity, which became the state religion of the nation as early as 301 A.D. Armenians of today like to stress that they live in the »first Christian country in the world.«

Yerevan, the capital, lies in the huge Ararat plain; as a part of the panorama, it resembles a biblical location. However, when, in the course of travel, the contours of the silhouette emerge, smoky industrial backdrops and post-socialist prefabricated buildings come into view. If one searches for them, one finds more prosperous suburbs, which give the impression of wealth. Those who know their way around southern Caucasian

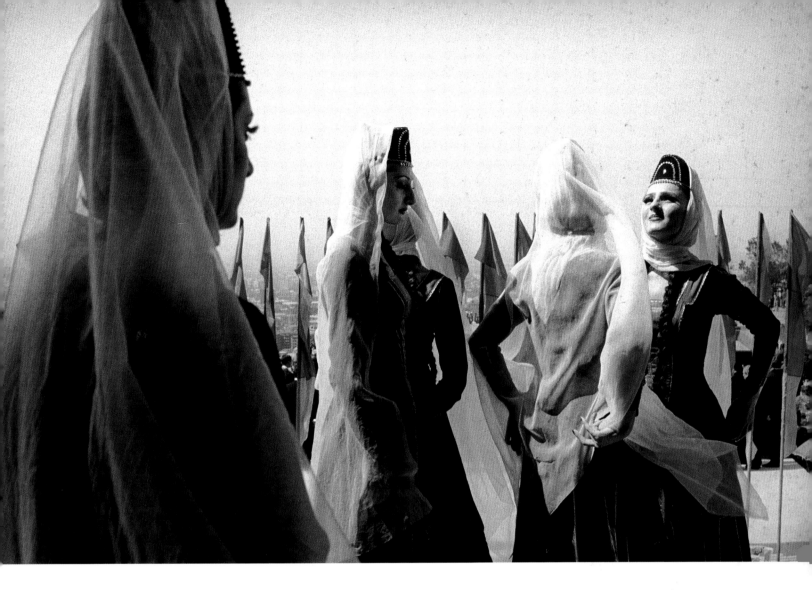

A folk dance troupe on the ninth of May in Eriwan. The Armenians celebrate April 24th as Memorial Day, commemorating the events of 1915.
May 9th is Victory and Peace Day, celebrating the 1945 German surrender. May 28th is celebrating the birth of the Republic of Armenia.

metropolises are able to report that, while there is hardly an elevator functioning in Yerevan, there is not as much crime as in Tiflis in Georgia, not as much corruption as in Baku in Azerbaijan. Yerevanians note, ironically, that the streets are not overcrowded, because half the population of the capital cities had already emigrated during the Soviet regime.

Perhaps it is due to the mostly icy weather, which continues well into April, but Yerevan as a city radiates little lightness of being. In the center, the monumental architecture oppresses those hastening past in dark clothing, degrading them into mere extras. When the evening sun shines on the blocks of buildings, the ubiquitous trass stone bathes the surroundings in an unreal rosy glow.

Summer brings an outbreak of joie de vivre. Wardawar is one of the great festi-vals. In pagan times, Astghik, the goddess of love and beauty, sprinkled rosewater over humans and gave love to all. Today, Christians celebrate Jesus; in some parts of the city, carefree residents pour water over each other by the bucketful and celebrate an all-day »wet T-shirt« contest with song and dance interludes. Supplemented with streams of brandy from the excellent local production, Yerevan briefly becomes the center of a worldwide community, and offers the image of a vital, defiantly celebrating city. It is, above all, Armenians living abroad that use the hustle and bustle as the occasion for a visit to relatives. Yet again, they will have the city to themselves, for the desired stream of tourists and foreign currency simply does not materialize.

HENDRIK NEUBAUER

HERE & NOW

Von Of the 3.3 million resident Armenians, somewhat less than half live in Yerevan. On account of the poor economic situation, many young well-educated persons leave home. In the Islamic diaspora, they are subject to constant attacks.

In 2007, the murder of the Armenian publisher and journalist Hrant Dink in Istanbul recalled the »black stain« on the country's history. Expulsion and repression of Armenians by the Young Turks with an estimated 1.5 million victims resulted in flight to the Near and Middle East in 1915. Murder, discrimination and migration have repeatedly overshadowed the last 150 years of Armenian history.

KURDS

Let the waters loose. On the collapse of a culture

The Kurds call it Amed; the Turks call it Diyarbakir. The city is an important center, though economically underdeveloped. It is located on the Tigris River, which is navigable from here on south. Here, a dam near the city of Batman BELOW RIGHT.

The landmark of Diyarbakir gleams in the morning sun. It is 10 am. The black ring of basalt, a unique relic of Mesopotamian culture, shields the Kurdish metropolis in the southeast of Turkey from the outside world. Here, outside, the green fields extend between the Tigris and the city gates. Our journey leads to the birthplace of agriculture in the heart of Mesopotamia's ancient cultivated landscape. The best watermelons in Turkey grow in these fields by the river; they are not only as gigantic as medicine balls, but with up to 15 kilos, they also weigh just as much. It is the middle of April, and already very warm at this time in the morning. The Kurdish farmers have been plowing since the early morning hours.

Behind the walls of the city of a million people, the atmosphere changes at a stroke. Weathered remains of the souk compete with hastily erected new buildings. The melancholic mood is interrupted by places of interest: the Caravansery for example, Diyarbakir's oldest mosque, and a few idyllic corners in the bazaar. In front of the raised lattices sit the dealers, some of them fiddling around with the displays and feigning a frenzy of activity where none exists. The cafés are already bursting with young men. Those who can afford it draw on a bubbling water pipe, while others prefer to nurse one glass of tea all day.

The workless city lies there on working days like a ship in the roads. Since 1991, the war between the PKK and the Turkish army has washed wave after wave of displaced persons into Diyarbakir. The war has hit practically every Kurdish family in the southeast. The population of the metropolis has grown in a decade from some 300,000 to over a million. There would be enough work available, and there is no lack of cheap labor to do the work, but there is a shortage of investors to get a project going.

Investments are made elsewhere in the country. The Southeast Anatolian Project, called GAP for short, is the most ambitious project in the entire Middle East. A total of 22 reservoir dams and 19 hydroelectric power plants are planned to bring new life to the Turkish part of the old Mesopotamia on 1.7 million acres of land. What began in the mid-1980s with the Atatürk dam project continues to drive people from their land up to today. In the land of the Kurds, villages that had grown over the centuries have perished, and ancient cultural artifacts have often been rescued only at the last minute. Most probably it is here, in the northernmost part of former Mesopotamia, between the Euphrates and the Tigris, that the first hunters settled and

The Southeast Anatolian Project focuses on improving agriculture in the region. Monoculture farming, like here in this cotton field in Harran, requires a great deal of water LEFT. Young man in Amed. Nearly a million people live in and around the city, all trying to make a living CENTER LEFT.

began to live on field crops. On the slopes of the Karacadag lived the primeval sheep, goats and cattle; up to today, wild variants of the oldest crops grow in its luxuriant meadows. With the help of DNA analyses, biologists have shown that even the wild form of the later domesticated einkorn wheat comes from this region. The Kurdish farmers here defied dependency, just as they also stood up to failed harvests, floods, and wars. Up to the 1890s, it was still possible to claim that the Kurds, even if politically oppressed, were a class of survivors.

Will the last small farmers of the region withstand agrarian reform in the wake of the GAP? If the waters are let loose to the extent intended, the smaller businesses will be swept away by the waves of the flood. All that will then remain for the small farmers and their

Turkish lessons in Amed. The Kurdish language is still far away from equal treatment before the law.

AYNUR DOGAN – THE »KURDISH GIRL«

In the musical film Crossing the Bridge of 2005, which traces the sound of Istanbul, there is a scene set in an old hammam, a Turkish bath. Here, the director Fatih Akin meets the Kurdish singer Aynur, who is rehearsing a piece.

Aynur's family moved from Tunceli to Istanbul in 1992. Here at the music school of Arif Sag, who is considered a guru of the long-necked lute called a saz, Aynur discovered its music for herself in 1975. In her releases, although the Kurdish musical tradition is very much at the forefront, she opens up traditional songs and compositions of her own with the use of more westernized folk instruments. Sparing use of synth pop, drum and bass now and then lends a breezy hint of jazz to her brittle and plaintive ballads in the Kurdish language.

With her albums Seyir (2002), Kece Kurdan (2004) and Nupel (2005), Aynur has attained international renown. In 2004, the British magazine fRoots put her in its cover, and the London Sunday Times too used her photograph to adorn a supplement on the »musical riches of Turkey.« Just at a time when her album Kece Kurdan was briefly banned because, as the judges commented, it »encouraged young women to go into the mountains and join the Kurdish resistance.«

www.aynurdogan.net

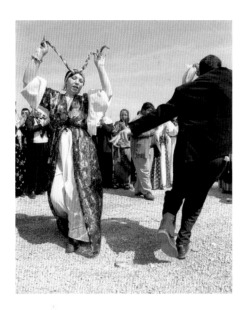

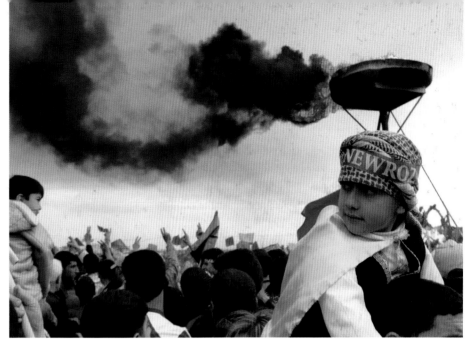

Noruz, the traditional Kurdish New Year holiday, was banned for a long time. In recent years, more than a half a million people have gathered together in Amed to celebrate it CENTER RIGHT. Many participants use the event as a forum for political demonstrations RIGHT.

families will be to flee overland from Kurdistan to the west. Often, there are neither resettlement schemes nor compensation payments. The large landowners, the Agas, as the Kurds call them, are better off. The Agas are among the seven percent of countrymen in the region who own more than half of the land, and who are accepted by the Turkish authorities as business partners. The rural structure of Kurdish life in general has always been organized on the basis of blood relationships and the feudal principle. The Agas drove away the small farmers and casual workers and, according to the situation, even allied themselves with Persians or Turks against their own people. Nevertheless, the Kurds themselves never tire of praising Kurdish unity and their common yearning for national freedom. However, between the Kurdish tribes and groups there is no unanimity on common aims. Thirty million Kurds are distributed over Turkey, Iran, Iraq and Syria. Experts on Kurdish history such as Martin van Bruinissen point out that leading figures such as Abdullah Öcalan come from specifically non-tribal structures, while the development in the region has up to the present day been marked by »tribal rivalries and bloody conflicts between Kurds,« who stand in the way of collective activity. Last not least, there is a great differ-

ence between the Turkish, the Iraqi and the Syrian perspective.

When on March 21, year after year, the people gather to celebrate Newroz, the festival of spring and freedom, a lot of celebrants take the festival as platform for political demonstration.

HENDRIK NEUBAUER

HERE & NOW

The Kurds are an ethnic group without a state. Thirty million Kurds live in Iraq and Iran, in Syria and Turkey. Since the foundation of the Turkish state in 1923, the Kurds have been fighting for greater autonomy to the extent of demanding their own Kurdish state. The Turkish government suppresses their aspirations to autonomy, and hundreds of thousands of Kurds have had to leave their villages. The Kurdish language was until recently banned in public life

In the early 1980s, the Kurdistan Workers' Party (PKK) under Abdullah Öcalan began to offer military resistance. Because of the conflicts between PKK rebels and the military, a state of emergency existed in Eastern Anato-

lia for about ten years. In 1999, Öcalan was arrested, and sentenced to death by a court. The sentence was commuted to life imprisonment. In 2004, under pressure from the EU, the government finally felt compelled to make initial concessions. Permission has since been given for a Kurdish radio and television program and language courses. In the same year however, the PKK ended a cease-fire that had been in force for several years, and since then, has undertaken further attacks. At the end of 2005, the situation escalated, above all in Diyarbakir, where the military and PKK supporters clashed. In total, more than 30,000 individuals are said to have lost their lives in the civil war.

Water

The blue planet supplies its inhabitants with relatively little drinking water. Out of 540 million square miles (1.4 billion square kilometers) of water on Earth, only 2.5 percent is fresh water. The remaining 97.5 percent fills the oceans and seas, is salt water, and therefore undrinkable by humans and useless for agriculture. Experts believe that this negligible proportion of all water would, if fairly distributed, certainly suffice to supply all mankind – in spite of the fact that the per capita consumption, which has multiplied sixfold during the 20th century, has grown even more rapidly than the world population itself, which has »only« trebled during the same period.

Some have to walk long distances to reach the nearest source of water

Some people have plumbing; others have to make do with plastic buckets, jerry cans or leather tubes. Many people have to walk long distances to reach the nearest source of water, and then the question arises how a man, woman or child is to transport the precious liquid home, for very few people have pack animals or motor vehicles in Mali, Mauretania, and other areas in sub-Saharan Africa. Access to water here is problematic if only because there is simply not enough of it. Conversely, people in dry regions have to face the fact that when there is water, it is often polluted or used for agriculture. Agriculture already takes up more than half of all accessible fresh water worldwide, and industry demands much of the rest. So for individuals, the daily water ration is sparse, particularly in regions where water is rare in any case. One person in six has no access to clean drinking water, and one in three lives in inadequate sanitary conditions. The United Nations estimate that some 14,000 people die from polluted water every day.

Where the »oil of the 21st century« still flows, it is now intensively rationed. It is dammed in order to gain energy and to direct it in a purposeful way. At any price, for it has become a valuable commodity in itself. Turkey is investing 30 billion dollars in the Southeast Anatolia Project, a network of 22 dams. These are intended to turn the headwaters of the rivers Euphrates and Tigris into a productive agricultural landscape; hydroelectric plants are to deliver power; and both economically and geostrategically, the country's neighbors at the middle and lower reaches of the rivers, in Iraq and Syria, are being kept in view. For a start, the project will permanently alter the building area itself. Unique evidence from pre-Christian eras, from both Roman and medieval times, partly dug sites, and structures close to collapsing are in danger of being submerged by the floods. 90,000 Kurds already had to abandon their territory.

One person in six has no access to clean drinking water

For the Chinese, this amount may seem negligible. In China too, the battle for water, presumed improvement in prosperity, and prestige in the face of their own population, is going on. For the reservoir of the Three Gorges Dam on the Yangtze River, which is bigger than Switzerland, 1.2 million people had to be displaced. In India, a very similar tragedy is being enacted. In this, the largest democracy in the world, hundreds and thousands of the population are being relocated. More than 100,000 Adivasi, the »first people« of India, have already left their homes in the Narmada valley and been sent to areas where their living conditions have noticeably deteriorated.

The common denominator of many of these measures is that the main sufferers are small farmers and villagers. Culturally and socially, the consequences are devastating. In Asia, certainly, whole cities have had to surrender, but it still seems like a battle of the cities, the inhabitants of the metropolises, against the rural population. In addition to this, national minorities in particular, because of their poor formal recognition, have the cards stacked against them when attempting to assert their rights.

As has been said, if the source and lower course of a river are in different

Guards near a water main in the megalopolis of Mexico City, where drinking water is in short supply.

Canal near Urfa. The Southeast Anatolian Project has built twenty-two dams on the Tigris and Euphrates Rivers.

Aka pygmies in the Cameroon rainforest. There is more than enough water in the wet climatic zones of Central Africa.

countries, water, as a resource, soon becomes a strategic commodity, whose utilization has political consequences. In the case of the Euphrates and Tigris, the project has consequences for Iraq and Syria – countries, whose water was intended to support agriculture in the south-east of Turkey, is withdrawn by the dams at the upper reaches. In Africa, 50 rivers cross national borders. While mighty Egypt puts pressure on less wealthy Ethiopia to limit its water utilization at the upper reaches of the Nile, it wants to increase its agricultural area from six to 25 percent even at the lower reaches; Jordan and Syria in the equally chronically arid Near East are cooperating in the Al Wehda dam project (Unity Dam) on the border river Yarmuk, though at the expense of the Palestinians. Like Jordan, Lebanon, Syria, and the Palestinians on the West Bank, Israel utilizes the river Jordan and its tributaries. The average Palestinian has

Who will be in control of the water?

access to only a fifth of the amount of water available to his Israeli neighbor.

As early as the 1980s, Boutros Boutros-Ghali, later general secretary of the United Nations but at the time still a diplomat in the Egyptian foreign ministry, warned, with a glance at the situation in Egypt, that wars about water were possible, especially if it was used as a strategic weapon. Despite some auspicious examples of diplomatic dealings with this resource, such as the UNECE Water Convention, in many places, climate change and the increase in world population raise the pressure for competition. Forty percent of the world population, after all, lives near rivers that cross borders. Confirming the fact that water can often be seen as a strategic tool, rather than as a general resource, governments such of Sudan and Egypt have failed to tap their significantly huge subterranean stocks of water, a step which could defuse

tensions between Egypt and Ethiopia, or in Sudan between the Arab nomads and black African farmers.

Meanwhile, good business can be done with the sale of drinkable water. By now, water should really be coming out of the taps in the big cities of Asia – but either it does not always come, or it is undrinkable. An alternative for those who can afford it is drinking water, mostly in plastic bottles,

bought for good money from international food and drink companies. In Djakarta one hears from buyers of bottled drinking water that tap water is simply unfit for consumption. »Every time I drink it, I worry, even if I have boiled it. Why can't we be supplied with water that we can just go ahead and drink?« We are facing a global problem that concerns the periphery as much as the centers.

SÖREN KÖPPEN

A cry for help, and drinking water. A serious natural disaster ensued when Hurricane Katrina struck the Gulf Coast of the USA in 2005.

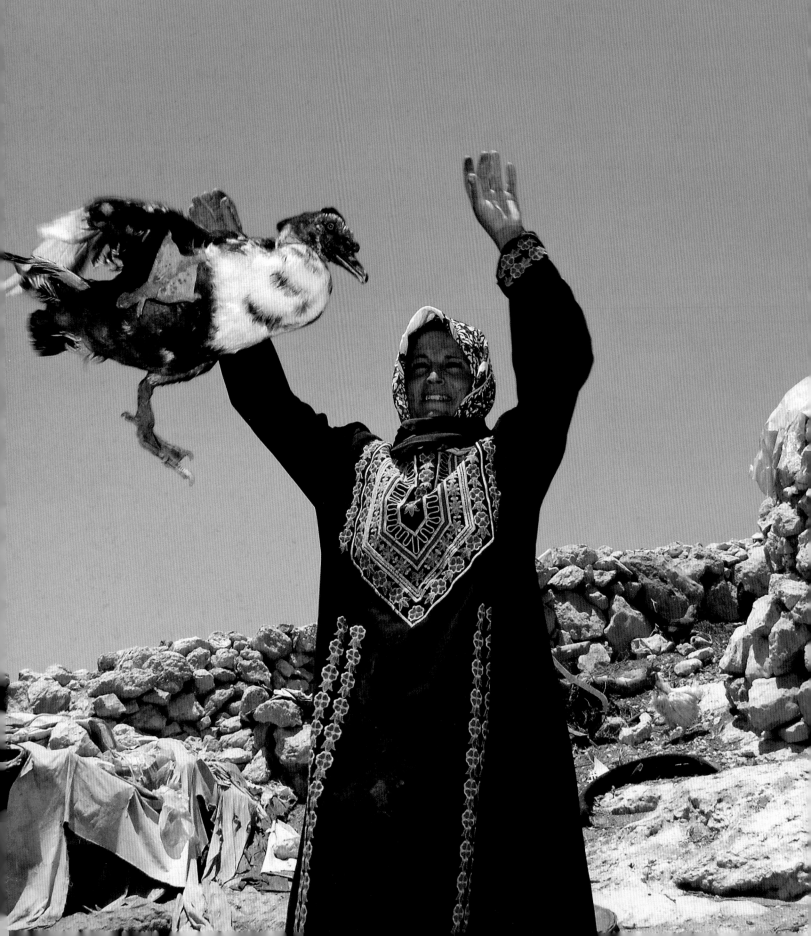

PALESTINIANS

Whose land is this?

It is late March and spring in Palestine. The journey is into the land of the southern Hebron mountains. Coming from Israel, one reaches the checkpoint. If one has an Israeli passport, he will hardly have any difficulty in crossing the border to the West Bank. From Palestinians who go about their business in the opposite direction, one continually hears that they are made to wait for hours and harassed at the turnstiles. As a rule, they spend more time at the border than earning a living.

The road leads to At-Tuwani. The journey from the checkpoint to the mountain village takes a quarter of an hour. Extensive pastureland stretches on both sides of the asphalt road. Tuwani looks like one of the unrecognized Israeli villages on the West Bank. Run-down buildings of sheet-metal and concrete lie scattered without any obvious logic, as though they had sprung spontaneously out of the soil. However, in Area C, since the Oslo Accords, nothing happens without the agreement of the Israeli security forces.

There is continual conflict with Jewish settlers. It is a question of territorial rights and, above all, the very sensitive question: who was there first, and what rights can be derived from this state of affairs? Palestine has been settled by hunters and gatherers since the Paleolithic age. In the 7th millennium B.C.E., Jericho already had the status of a city with fortifications. From the beginning of the 3rd millennium B.C.E., several city states existed in Palestine, inhabited by Semitic immigrants and an older non-Semitic population. Later, the Israelites and the Philistines arrived. Then, the Romans occupied the land and renamed their province Palestine. After the division of the Roman Empire, Palestine belonged to the Byzantine Empire. From 1517, Palestine was part of the Ottoman Empire. In addition to the predominantly Arab–Islamic population, the country has also always had a number of Jewish inhabitants. In view of this history, which should be designated the

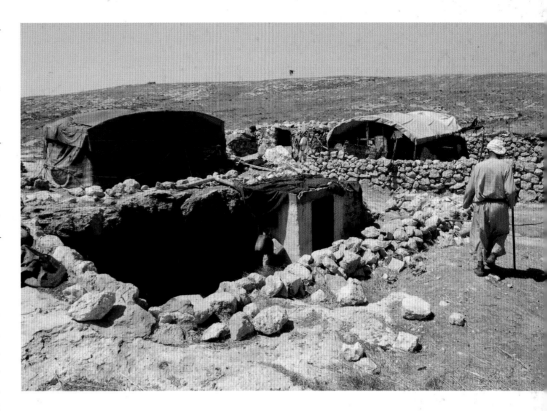

Cave dwelling in Mufakara in the Palestinian West Bank. Several families live in the subdivided caves, with their cattle housed in tents above ground.

original inhabitants, those with older, permanent rights?

Making the way further along in the direction of the outpost of Havat Maon, one encounters Palestinians who live in caves like their forefathers, far from water and electricity. »We have no other place to go. This is where we were born. This is where we will die.« Mahmud Hamamadi speaks from the heart of the Palestinian villagers of Mufakara. He speaks, though, not only on their behalf, for since the ceasefire of 1949, hundreds of people live in this region far from

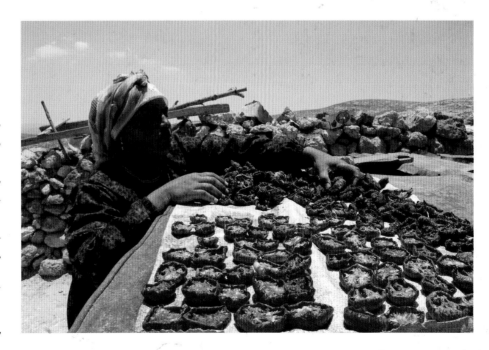

The people make a living as subsistence farmers off the harvest of olives, wine grapes and tomatoes ABOVE. They also raise fowl and goats LEFT.

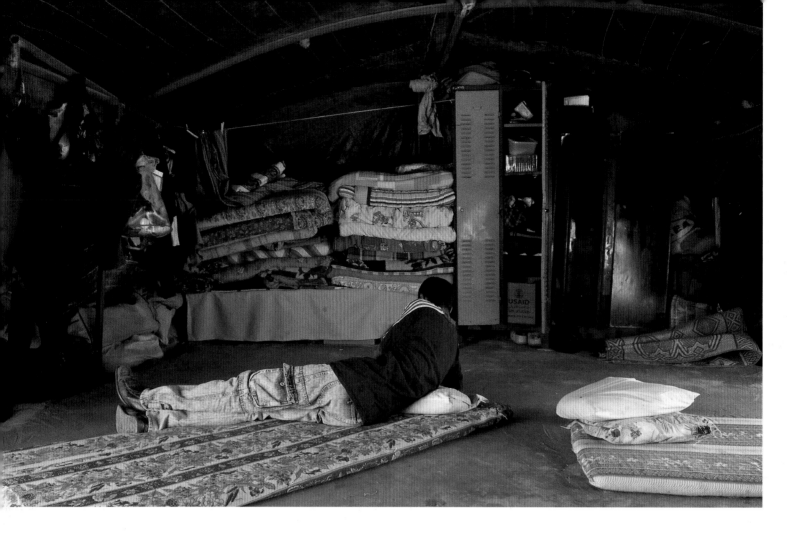

A family tent in Susya. Each family also has its own cave. Many people continue to live in cave dwellings in the Hebron Mountains in defiance of their Israeli neighbors and despite adverse conditions, like water shortages.

water and electricity supply in about 15 such cave settlements. Hamamadi reports on the families in Susya, who have repeatedly been driven from their cave settlement since the 1980s. In 2001, the Israeli Supreme Court gave them the right to continue living in the area and cultivating the land. Mahmud's gaze wanders in the direction of the Jewish outpost Maon on the next hill: »Over there, even the chicken coops have running water and electricity. The peace activists from Israel, however, are a great help to us, over and over again. With their support, we can stop the settlers and the soldiers.«

If one knows the broad spectrum of Israeli society, then it is not surprising that there is a very active, if small, peace movement. It attempts to document, if not prevent, the attacks by soldiers, and work with the Palestinians on pragmatic solutions. Not all that long ago, activists helped the families in Susya to install a wind turbine to supply power. This is enough to provide the cave dwellers with a few hours of television by day and lighting by night, but also to recharge cell phones. Their connection to the world secures their survival strategy – sitting it out patiently in this region.

High politics tends to provoke mockery among Palestinians here in the southernmost tip of the West Bank. Those

JAZZ ON A LUTE
THREE BROTHERS
AND AN OUD: THE
TRIO JOUBRAN

The Palestinian brothers Samir, Wissam and Adnan Joubran have made a name for themselves at international jazz festivals as the Trio Joubran. All three play the oud, the traditional lute. Both lovers of Arab music and jazz fans are enthusiastic about them. When Palestinians play music, and when it is instrumental, politics always comes into it. »For us, the news is our daily bread,« says Samir. »I wish this would change, but even my little daughter already talks about politics. This will be the case as long as we live under the occupation.« The Joubrans are masters of improvisation, and can take some 18 minutes to perform a piece. The cumulative power of three lutes is a sensation even for an Arab audience. »There are enough beautiful sounds to be produced by these five strings.«

www.letriojoubran.com

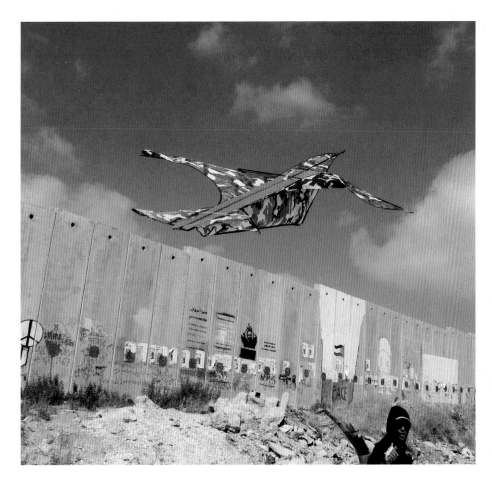

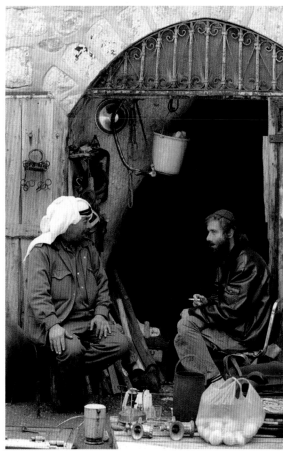

In the course of the 2003 Intifada, Israel erected a nearly 500 mile long fence along its border with the West Bank LEFT. Palestinian merchants and Israeli settlers converse in Hebron RIGHT.

who live a curtained-off life, at the mercy of their own administration, such as the people in Susya and Mufakara, tend to glorify the past. This is expressed in jokes such as this one: Mahmoud Abbas, alias Abu Masen, goes to the Turkish bath with Yasser Arafat. Arafat has to pay 50 shekels to go in, but Abu Masen pays 100 shekels. Angrily, he asks how this can be. The owner of the bath replies: »50 shekels is what the ordinary corrupt people pay. But you pay for two.« Out of the tent that stands in Susya next to the wind turbine, a man's deep laughter resounds and flies off over the Hebron Mountains. It is March and the sun is shining on the fields.

HENDRIK NEUBAUER

HERE & NOW

Palestine was declared a British Mandate area in 1922 by the League of Nations. In 1947, the UN made the decision to divide it into a Jewish and an Arab state. The Jews accepted the Partition Plan, but the Arabs rejected it. From this situation, there arose the Middle East conflict, still unresolved today. The foundation of Israel as a state was followed by the first Arab–Israeli war, and at the ceasefire in 1949, Israel encompassed some three-quarters of the area of Palestine. In 1949, Jordan, opposed by the other Arab states, annexed the West Bank. Egypt occupied the Gaza Strip, but did not annex it. In the Six Day War of 1967, Israel occupied the West Bank and the Gaza Strip and put both under military administration. The secret negotiations in Oslo of 1993 brought a breakthrough in the direction of Palestinian autonomy. In 1996, Arafat was elected president of the Palestinian National Authority with a large majority. After the death in 2005 of Arafat, who built his policy on clientilism and, exclusively, his Fatah party, the political camp broke up into Hamas and Fatah.

In the autonomous districts live 3.6 million Palestinians, including 2.5 million in the West Bank. Sixty percent of the West Bank area is under Israeli control (Area C), while Areas A and B differ in their degree of Palestinian autonomy. After the dissolution of some Israeli settlements in the summer of 2006, 121 of these still exist. In addition to these, there are still around a hundred illegal outposts. The Israeli authorities estimate that there are 250,000 settlers in the West Bank area, not including East Jerusalem.

»The valley of Rum is a wadi, an ancient dried-up riverbed.«

RUM 🌐 29°34'N 35°25'E

HOWEITAT

Extended Families and Small Houses

The men of the patrol all arrange their uniforms the same. The long beige coats look like relics of an Italian Western. They have bound cloths of red and white around their heads, the cartridge bandoleer hangs diagonally over the shoulder. The coat of arms on the shoulder and weapon on the belt identify the men as representatives of the State. The state is Jordan, and the small troop is making its way through Wadi Rum, the spectacular desert canyon in the south of the country. Welcome to the Bedouin desert police. Their task? Well, at one time it was to combat weapon smuggling and drug trafficking. Today, they are more preoccupied with just showing a presence, or perhaps rescuing a pair of tourists who have broken down. No gas in the tank and no power left on the cell phone. Typical!

Hardly anyone knows for sure just how many Bedouin communities there are. They are spread over the whole Arab world, including the Sinai Peninsula, Egypt, and Libya. They classically define themselves as separate, sharply divided groups, based on family and clan. A common proverb among many Bedouin communities clearly expresses their philosophy: »Me against my brother; me and my brother against my cousins; me, my brother, and my cousins against the world.« However, their world is eroding. Many young Bedouin are more oriented to life in the city than old traditions.

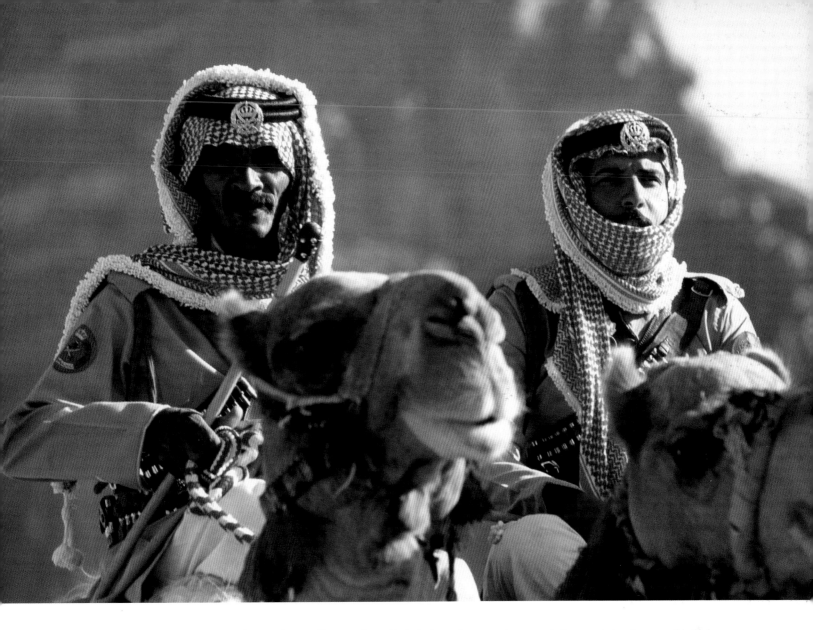

Outfitted with all the national regalia, Jordan's Bedouin police, together with their dromedary camels, are part of a mounted unit responsible for law and order in the valley. As a tradition, the Howeitat continue the custom where each family delegates a son for service in the security forces.

The Howeitat became the standard of Bedouin life for people all over the world when, in 1962, David Lean filmed Thomas E. Lawrence's autobiographical book, »The Seven Pillars of Wisdom,« as »Lawrence of Arabia.« The film, with Peter O'Toole in the title role and Omar Sharif as the Arab noble Sherif Ali Ibn El Kharish, was not free of preconceptions about non-Europeans. For example, in the film, Lawrence asks Sherif Ali what he thinks about the Howeitat: »They are nothing but bandits!« he replies. »They sell themselves to anyone!« Anthony Quinn played the legendary Howeitat Sheik Auda Abu Tayi. Quinn, an Irish Mexican, has always been the favorite for playing the role of outsider.

HERE & NOW

There are many Bedouin communities in Arab and North African states. Many of them live in Jordan. The home of the Howeitat is in the extreme southern part of the country. They are sub-divided into various clans, each consisting of several families. They only marry within their own association of families, leading to their culture developing in a secluded way within an easily manageable framework. Their settlement area in the remote and extremely hot Wadi Rum is another factor for their relative isolation.

The Howeitat live a more or less nomadic lifestyle, adhering to their bond to livestock husbandry. However, this framework is changing due to changes in the living conditions. It is the intention of the Jordanian government to create water projects that assist the process of settlement with the reasoning that livestock no longer has to be driven from watering place to watering place. Itinerant people have always been suspect to those with permanent homes. No census and no attempt to impose the sovereignty of the state can function with them. The Howeitat, of whom less than 500 live in Wadi Rum, are affected by such pressure, as are all nomads throughout the world. Tourism, an economic factor in southern Jordan, does its part too.

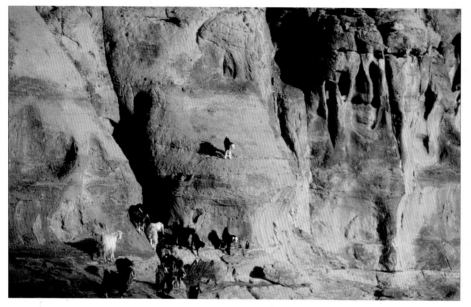

In Jordan, governmental pressure on the Howeitat to adapt and adopt a settled lifestyle was not as strong as that on other Bedouin tribes in other Arab countries. This was due to the image projected to the outside world by King Hussein, who greatly valued good press in the West. However, the Howeitat could not refuse the offer to build schools and drill wells. And so the village of Rum was set up in Wadi Rum. The rather small fragmented construction of the settlement, with each of its houses accommodating only a few inhabitants, was drawn up on a governmental drawing board. The social framework was changed this way, too. For the Howeitat, and for other Bedouin communities, the family has never been the nuclear family as is true in Europe and North America, almost to the exclusion of all other forms. However, urban lifestyle is initially felt here through the available living space. Bedouin families, too, are slowly changing. Today, small families are living in small houses. The Bedouin police may be able to prevent tourists dying of thirst, but they cannot arrest the pace of social change.

MAX ANNAS

Jordan is a modern country, as this communication in the desert shows ABOVE LEFT. *Tourists flock to festivals in the Wadi Rum, or take part in adventure sports, like mountain climbing* ABOVE RIGHT AND CENTER *Children collect stones that will be made into souvenirs inside the Bedouin tents* BELOW.

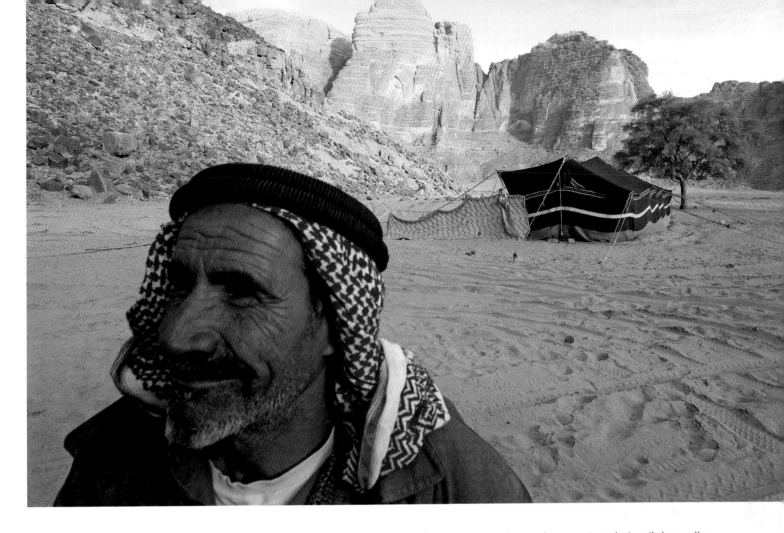

Bedouin houses in the Wadi Rum are, in principle, perfectly mobile. The tents can be pitched nearly everywhere in the approximately 60 mile long valley. Those who have found a particularly good site, and have a vehicle that can drive in the desert, are just as happy to settle down.

CELEB:
DISTANT HEAT

»The desert is alive; the earth quakes; the great dancing caravan uninhibitedly shakes its body,« writes Oliver Maria Schmitt of the weekly German newspaper »Die Zeit.« »Wafts of mist creep along the red-illuminated walls of the Wadi, engraved by robust basses.« »Distant Heat« is the name of the techno festival in southern Jordan, near the city of Aqaba on the Red Sea. »Voyage into Rum« is the subtitle of the annual spectacle; whereby Rum is not a reference to the well-known party intoxicant, but instead refers to the river, Rum, which, incidentally, no longer flows. The desert canyon is the scene of dancing for a whole night at the end of July in what may well be the hottest night of the year, not only due to the music. By day, the temperature can easily reach 122 degrees Fahrenheit (50 degrees Celsius); at night, when the sun disappears and the Wadi reflects the red and blue lights, it is normally just less than 86 degrees Fahrenheit (30 degrees Celsius). The hochos of the scene have had influence over the pick-up since the desert rave first took place in 2003, and apart from tourists, the public mainly consists of the children of rich parents from Arabian countries. The Jordanian government advertises group visits to Wadi Rum as an opportunity to get to know the culture of the Bedouin. Well, techno is not a part of it, but the international festival has, at any rate, improved the infrastructure of the Howeitat Bedouin. For the Jordanian government, the rave is proof of just how far Jordan is oriented toward the West. When the party is over, the guest all leave for Aqaba—to sleep, to carry on partying, or to simply not be alone after such a night.

www.distantheat.com

Trash

The deserts of southern Morocco are fascinating. At least for anyone who is capable of being captivated by landscapes that, despite a long journey, seem to vary only in their details. The Volkswagen van stops near the thorn bushes. Here is something resembling a parking area. Out of the overfilled minivan, the sound of the engine and the endless babble is still ringing in our ears. Peace and quiet at last and it is only then that the chirping of the crickets is heard, from the thorn bushes where they are hiding. Grey with dust, a thin rag of plastic hangs from a bush. Here, in the middle of the desert, flutters an inconspicuous scrap of those countless black

Plastic remains indestructible

or white plastic bags that one almost automatically acquires these days when buying fruit or vegetables. While a new bag makes a lot of noise, this one is already torn in many places and has become quite soft from the impact of sand and wind and other processes of decomposition. The rag flutters without a trace of sound in the desert wind.

This is what happens to a disposable product in areas where otherwise just about everything is recycled and no one thinks in terms of waste and its disposal. Plastic is and remains indestructible. The bag in the Moroccan desert is one of an estimated 600 billion manufactured and used worldwide every year. Americans alone use 50 to 80

billion per year, the Chinese 3 billion a day. Kenyans, whose annual consumption only reaches the millions, have no chance of keeping up. The fact remains – four centuries can pass before a product like that disintegrates on the ground. While national economies are stepping up their contact with the Western world, these nations are also increasingly swamped with industrial products from the »western paradise.« Meanwhile, the mountains of waste are growing, not only around Manila in the Philippines or Lagos in Nigeria. Wind and water carry plastic bags and sheets and bottles into the forest, the steppes and the desert.

At the same time, discarded cans are crunching under the tourists' hiking boots in the Masai Mara and the worn-out plastic bags are blowing in the wind among the acacias of the South African national parks. In areas where the population

The trash carpet circles quite undisturbed

density is almost zero, civilization allows its ugly excrescences to blossom all year round. The South Africans call the plastic blooms »roadside daisies« and cynically considered naming the bags their »national flower.« However, behind the flood of bags and bottles lies more than an organizational problem that displeases the eyes of tourists. Plastic waste blocks drains and sewers and leads to

serious flooding, according to a report of 2005 by UNEP, the »environmental conscience« of the United Nations, on the waste disposal situation in Kenya. The inhabitants of Bangladesh have had only too much experience with flooding disasters. Kenya's Nobel Peace Prize winner Wangari Maathai has pointed out a further problem of hygiene, based on the fact that damp plastic bags are a favorable biotope for egg-laying by malaria-carrying mosquitoes, and thus encourage the spread of this disease.

Proof has long been available that plastic waste is a serious threat to fauna. In the African steppes, birds and mammals consume bag after bag, year after year, and perish. If plastic waste floats in water, it becomes particularly prone to absorbing chemicals. In the Pacific, an astonishing number of albatrosses confuse such flotsam with food, and poison themselves. Altogether, plastic waste kills a million seabirds, 100,000 seals and other aquatic mammals as well as any amount of fish every year. Many are strangled in the attempt to free themselves from plastic nooses.

The current carries plastic bags as far as the Arctic. For almost twenty years, the British marine researcher David Barnes has observed, the bags have been found almost everywhere, from Spitsbergen in the North

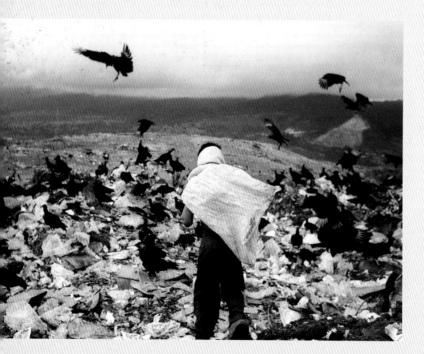

Not an isolated case. Over one hundred children live by sorting through the garbage in the main dump of the Honduran capital city of Tegucigalpa.

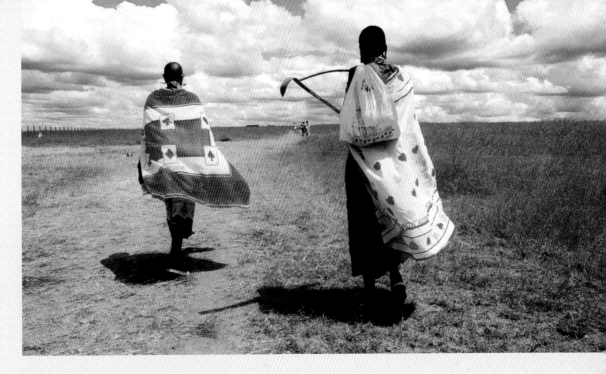

Atlantic to the Falkland Islands in the South Atlantic. However, the epicentre of the problem lies in the middle of the Pacific – a gigantic carpet of waste that has reached the size of central Europe. Thanks to a particular current, it circles quite undisturbed and stays roughly in the same area. An illegal deposit of waste far away from the nearest outpost of civilization. Here too, countless disposal activities have taken place on the high seas by ships' crews, in the seclusion of the deserts of water, from the cigarette lighter carelessly thrown overboard to the cost-saving emptying of entire containers. Out of sight, into the ocean, one might say. The problem is out of control, partly because the Marpol charter of the UN International Maritime Organization of 1978, which forbids the disposal of plastic on the high seas, is in practice ignored by seamen.

The tip of this mountain of waste can be approached only by the individual nations responsible. In China, for example, in January 2008, it was decided that the use of plastic bags should be significantly restricted. China thus joins the growing international trend to strike at the root of the problem. From Australia through Uganda as far as South Africa, the legislators are experimenting with raising taxes, fines and

The triumph of the throwaway culture. More and more people all around the world carry their shopping back home in plastic bags, like these women near Nairobi.

restrictions on production. In South Africa, for example, it is hoped that the annual consumption of eight billion bags per year can be reduced by half. In addition, there are plans to develop waste disposals inland, at the Cape, in the name of the creation of urgently needed jobs.

In the age of globalization, we are battling worldwide with the consequences of a culture that Mark Twain once characterized with the words »Civilization is the limitless multiplication of unnecessary necessities.« If people in Africa today less often go shopping with baskets and strong bags, and instead have their vegetables and bread packed in the cheap plastic bags mainly imported from Asia, this development may, from the perspective of the post-industrial society, which has learned its lesson with regard to lasting economies, be absolutely superfluous. However, the flood of bags is

The flood of bags is only a harbinger of things to come

only a harbinger of things to come. Soon these bags will contain the cheap Chinese products that are flooding the African market. The pocket flashlight, in the hands of the North African nomad who travels only once a year to the far-off city souk, may arouse huge enthusiasm. As soon as the light goes out, the blessing

of civilization will become waste in his hands. What can be done with a flashlight that does not work, if batteries or a new light bulb are prohibitively expensive or only to be obtained a very long distance away? The result is a flashlight case abandoned in the desert.

SÖREN KÖPPEN

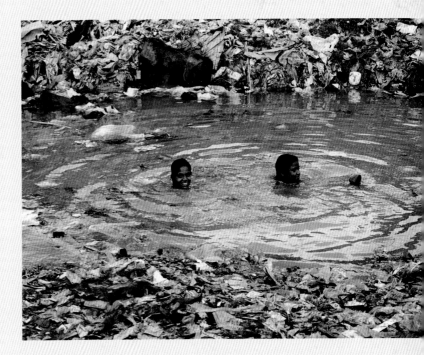

Garbage pollutes water. Slums like these in Dhaka, the capital of Bangladesh, appear to be smothered in garbage.

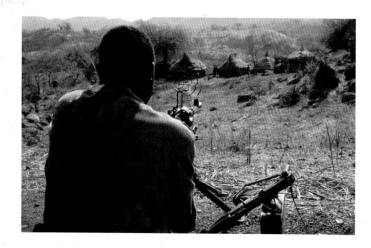 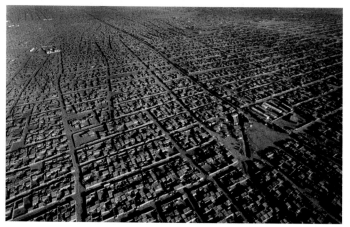

SPLA militia training in the Nuba Mountains LEFT. *Nuba and Dinka refugees gather in the mud buildings in the refuge Khartoum, on the southern outskirts of the city* RIGHT. *The Nuba maintain their traditions, like the wrestling shown* BELOW.

KHARTOUM 🌍 15°35'N 32°31'E

NUBA

In the clay megalopolis

Without a pause, the brown clay bricks are created. With the result of their work in front of their eyes, innumerable houses of the greatest simplicity, young men are shoveling clay out of the ground. They keep on digging. Water from a nearby stream is the second ingredient needed to produce building materials for the endless extension to the Sudanese capital, Khartoum, and its twin city, Omdurman, on the opposite shore of the Nile. Clay and water are mixed, and from the damp slurry, they form the rect-

angles which are taken out of the kilns as completed bricks.

The Nuba are already familiar with journeys of retreat in the course of their history, even before the Sudanese civil war reached their mountain region and once again set them in motion. Their settlement in the remote and somewhat barren Nuba Mountains, southwest of Khartoum, can be traced back to flight from war and fear of Arab slave hunters in the preceding centuries. The fact that many different languages have been preserved in these

mountains shows that the Nuba are a population group that originally derives from different ethnicities.

Perhaps it was here in the mountains that they first developed common traditions, such as the decorative scars that adorn the upper bodies of many Nuba, or the legendary Nuba wrestling matches, an important sport in Sudan. Exported from the mountains to the cities, it has lost its ceremonial character. Conversely, as a result of the lack of internal uniformity, there have repeatedly been individual Nuba who occupied high positions in the Sudanese army – and, thus, made themselves into outsiders, though powerful ones. Like the people from Darfur today, since the 1980s, the Nuba have fled in droves to the cities of the Nile plain, and with them the Dinka or the inhabitants of the desert steppes in the east of the country. The growing townships are today among the poorest in the world. The mountains can hardly be traversed on foot any more, for they extend over countless miles. Like many refugees worldwide, the Nuba will stay and not return.

MAX ANNAS

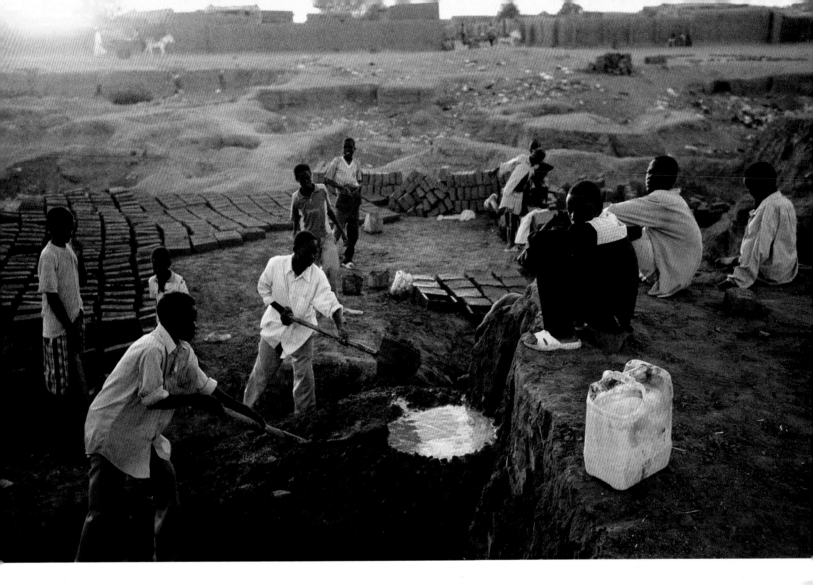

The manufacturing of mud bricks. The outskirts of Khartoum have been growing since the 1980's beginning of the civil war ABOVE. *It is estimated, that half a million Nuba still live in the Nuba Mountains in the province of Kordofan. The conflict, however, continues* BELOW.

HERE & NOW

Up to the present, Sudan has not been a country which knows freedom, but at least the situation in the Nuba mountains has somewhat improved in recent years. Since the nominal peace agreement of 2002, many Nuba, whose number is estimated at around a million people, have returned. However, they still live here in a state far removed from actual peace, although the Sudanese army since then has taken more interest in the western region of Darfur. Since the early 1980s, the Nuba have organized themselves into the south Sudanese freedom movement, SPLM, and its military arm, SPLA. This further determines their present day– for although the Nuba Mountains and their inhabitants belong geographically and culturally to the south of the country, their region of Kurdufar is politically linked to the larger and more powerful north, with the capital Khartoum. Here, the Nuba are now considered traitors. More significantly, however, are the tangible economic motives for Khartoum's interest in this high-lying and inhospitable area. Right through the Nuba settlement area runs the most important oil pipeline in the country, which links the sources in the southwest with Port Sudan on the Red Sea. Conflicts related to the most important natural resource in the country and the resulting income from it will continue for a long time to determine the lives of the Nuba.

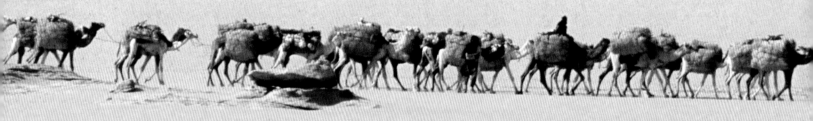

It is harvest time in Bilma in the eastern part of the West African country of Niger. The men mine salt out of deep holes cut into the hard, white soil. The holes, which are several yards across, fill slowly with water, and a salt crust forms on the surface. A small city with little more than 2000 inhabitants forms around this center of salt production in the sandy desert of Bilma, part of the southern Sahara. Between Bilma and the salt works many miles away, the camels of the Tuareg can be found along with their owners, encamped by the thousands.

The delicate crust of salt forming on the water's surface is skimmed off twice per day to allow the water to evaporate further and let more salt accumulate on the edges of the basin. Only the finest surface salt, called beza, will be sold for use in the kitchen. The rest will be hacked laboriously from the evaporation pit, stirred while moist, and pressed into the hollow stem of a date palm. There the mass will dry, after which it can be cut into salt cones. The cones are not destined for human consumption; they will be sold as salt licks for cattle, camels and sheep. Both man and beast need salt to survive the severe deprivations of life in the Sahara.

The Sahara has an area of more than 3.5 million square miles (9 million square kilometers), making it nearly as

TUAREG

The way of the desert

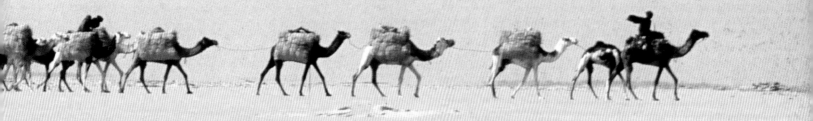

large as the continental United States. To the Tuareg, this unfathomably vast wasteland is home. It is thought that they have lived in the great desert since the 7th century. Until the 16th century, the Tuareg lived primarily in the Saharan interior, where they traded cattle and salt, and controlled the trade routes that crossed the continent. When the Songhai Empire collapsed, freeing up an enormous region in the valley of the Niger, Tuareg

nomads stormed into the south, entering the former Songhai cities of Timbuktu and Agadez. Despite their continuous presence in ancient, settled areas, the Tuareg have never succeeded in gaining the respect of the sedentary peoples who live there.

The Tuareg live in large tents made from the skins of sheep and goats. Up to 40 skins are needed to sew just one tent. Both men and women wear loose,

expansive robes for protection against sand and heat. The entire body is covered except for the eyes. Covering the mouth is not simply a practical measure. The Tuareg consider it impure to do otherwise.

Modernity has drastically changed the Tuareg's economic situation. Control of the Sahara trade is now only a small part of their subsistence strategy, at least from the point of view of the legal end of the business. There is some evidence of

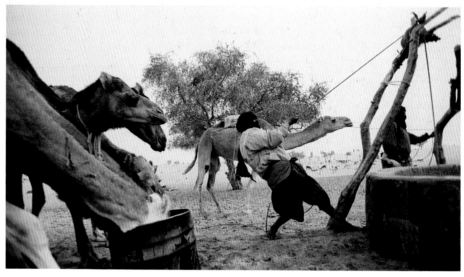

Salt caravans transport one of the few treasures the desert has to offer PREVIOUS PAGES. Oases usually exist wherever there is water, with international brands of soft drinks now on sale LEFT. Even the desert is looking forward to a tourist boom BELOW LEFT. The animals in a caravan need water like cars need gas BELOW RIGHT. The Festival du Desert in the north Malian city of Esskane is the cultural highpoint of the Tuareg season RIGHT.

Tuareg involvement in smaller, less well-established trade routes leading from the small, unstable country of Guinea-Bissau across Senegal and Guinea, and on though the desert to the Mediterranean coast. The trade goods in question are purportedly illegal drugs, an insinuation that the Tuareg vehemently deny.

Tourism may also be on the Tuareg economic horizon. The Festival in the Desert held inw Essakane in northern Mali is a step in this direction. It draws an audience from all over the world, giving Tuareg musicians and bands the opportunity to perform with international artists. Ever since Led Zeppelin singer Robert Plant took the stage there in 2003, the festival has had a place on

TINARIWEN
– THE ROCK OF THE DESERT

The comparison simply cannot be taken seriously. Tinariwen are not »the Rolling Stones of the desert.« Yet as a label, the analogy can only help, for this is exactly what the ever-hungry music press is looking for. The name »Tinariwen« means »empty place« in Tamashek, the Tuareg language. It may be meant as a joke. Ibrahim, the guitarist, lead singer, and image of the band most frequently seen in the publicity photos, has commented:

»The people in Europe always think that there is no life in the Sahara, that it is entirely uninhabited. This is false. One need only know how to live there.«

Tinariwen, while not the only Tuareg band, has become so well known in recent years that what its members say is taken seriously. Their sound really rocks. Up to five musicians play guitar and bass, producing a mixture of chants and guitar licks that quickly transports the listener to a distant world. Tinariwen's rock-and-roll casts a spell. The often polyphonic songs focus on questions of identity, but also on survival in the Ténéré, which is the Tuareg name for the Sahara. The music deals with the Tuareg's simmering conflicts with the nation states, where they are made to feel like second-class citizens. The lyrics also question whether or not the Tuareg should take up arms. The musicians of Tinariwen, have chosen to take up guitars instead. With them, they reach many more people than those Tuareg with weapons. Tinariwen has taken the present day situation and problems of the Tuareg and put them on the international map.

www.tinariwen.com

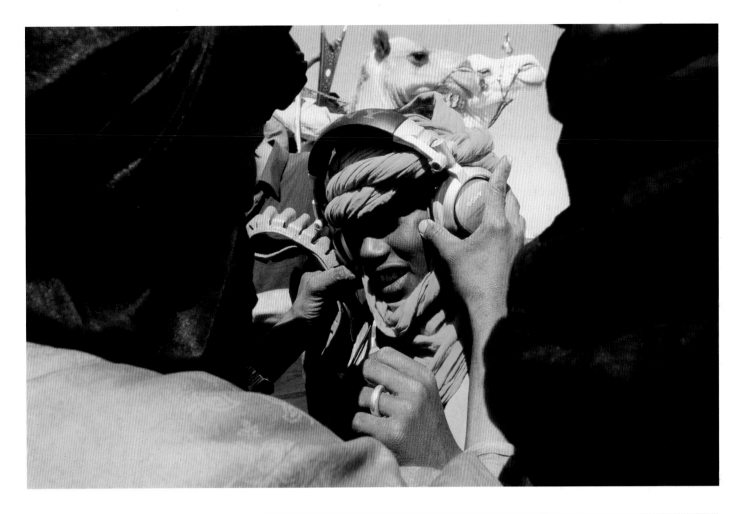

the agenda of most mainstream music magazines.

Tourism and the associated revenues may help the Tuareg achieve some measure of self-determination and self-government. Unfortunately, the war-like conditions in northern Niger and travel warnings issued by European states have worked against tourism's initial successes in the region. As a result, more and more Tuareg find themselves drawn back into the desert, to encampments on the edges of the cities of their Sahara neighbors. Others abandon traditional life alto-gether. In Balmi, the trade in salt and dates, which are also harvested nearby, continues as it always has. The dromedaries simply sit, waiting for their loads.

MAX ANNAS

HERE & NOW

Between 1.5 and 2 million Tuareg live nomadically in the enormous area of the central Sahara. Most live in the under-developed countries of Niger and Mali, while others live primarily in Algeria, Mauritania and Burkina Faso. Many Tuareg fled to Libya as a result of the armed conflicts of the past half-cen-tury. There, they live as second-class citizens, imprisoned in refugee camps. Currently, many Tuareg find themselves in conflict with the governments of Niger in Niamy and Mali in Bamako. The MNJ (Mouvement des Nigériens pour la Justice), a Tuareg rebel organization, has accused the government in Niamy of breaking their promise to pay the Tuareg ten to fifteen percent of profits from uranium production in the northern part of the country, which the Tuareg consider to be their territory. Uranium enrichment is taking place near the city of Agadez, the ancient trading capital of the Sahara and the unofficial capital of the Tuareg. As is often the case on the African continent, when mineral resources are exploited, local populations see none of the profits. In 2007, the Tuareg began an armed insurgency against the Niger military, killing many soldiers. As a tactical countermove, the military enforced a news blackout over the entire region. President Tandja of Niger remains in good standing with the USA, which supports Niger's efforts against the Tuareg with both financial and technical assistance. In Mali, the conflict continues to smolder at a lower level. The wandering Tuareg have yet to be treated as full citizens with equal rights in either country.

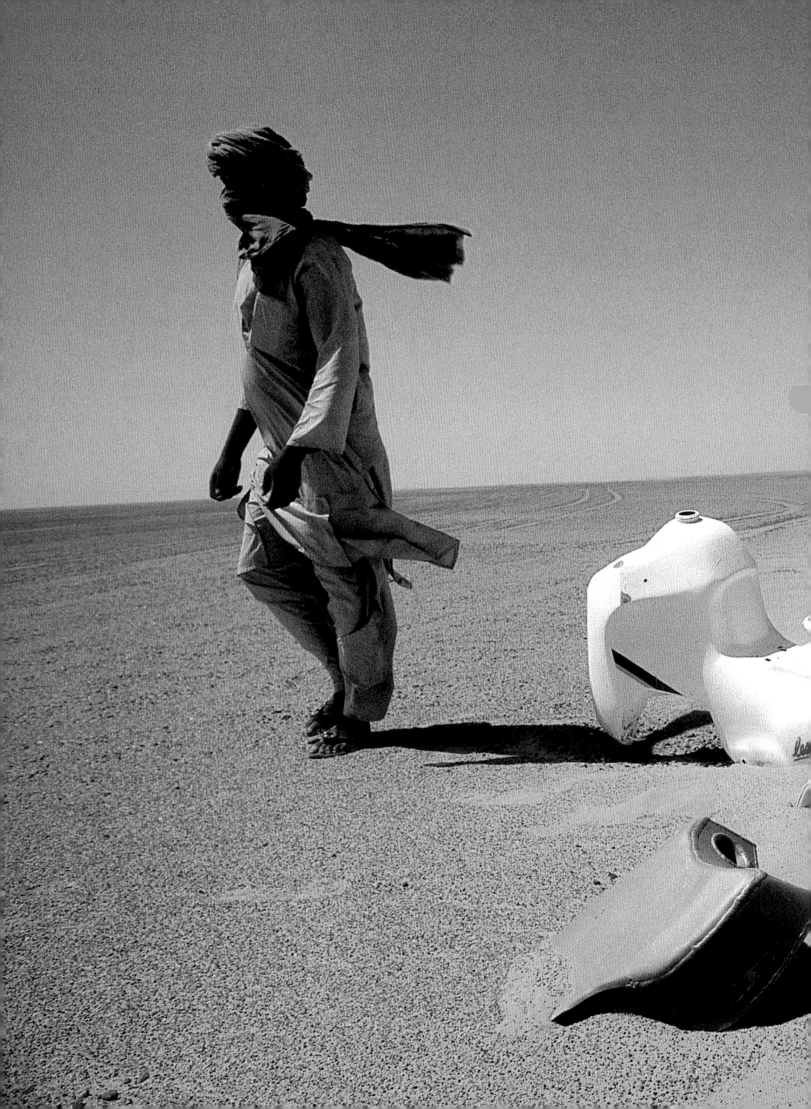

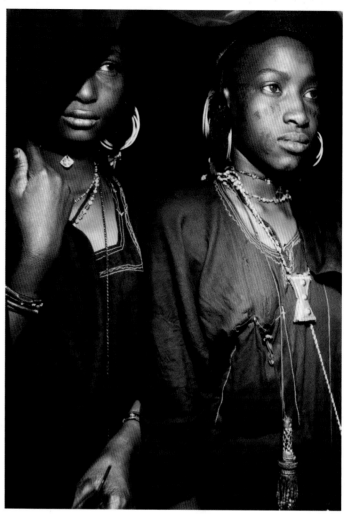

The salt mines of Bilma. Frequently, hundreds of camels can be found encamped between the salt lowlands and town, waiting for their loads ABOVE LEFT. *Fulbe nomads can be encountered all over the vast Sahara Deserts, as here in Kaedi, Maurentania* BELOW LEFT. *Fulbe women near the Nigerian salt baths* RIGHT.

IN-GALL 🌍 16°47'N 6°56'E

FULBE

Nomads with many names

On anthropological maps of Africa, one often sees very clearly demarcated spaces which are unequivocally identified. Some groups of people live here and others there. With the Fulbe, the case is very different. Their distribution can already be discerned from the many different designations they have been given. Depending on how their names have entered European languages they are called the Peul or Peulh, Massina, Fulani and Fula, or indeed Fulbe. They use the names of smaller groups which are understood to be part of the whole, such as Bororo, Toukouleur or Fuuta. They are represented in all West African countries, in Mali with about a million individuals, in the Ivory Coast with only a few thousand as a result of the civil war and racist displacement.

In September, there are still traces of the water left behind by the rainy season. Where otherwise hardly a blade of grass is to be seen, green islands briefly flourish in the Sahel. Among the Bororo, the Cure Salé, the salt cure, is celebrated, where the Fulbe, still living as nomads, gather near Ingall in Nigeria, where there are salt springs and water. Here, people come together from all points of the compass. They prepare for the colorful festival that is portrayed by corrupt politicians from the capital, Niamey, as a touristic high point in a poor country otherwise lacking in sensations –

sponsored by Coca Cola. This is gratefully accepted by tourists in the Sahara region; in recent years, the traditional festival has developed into a secret tip, although it had to be canceled a few times in the 1990s due to the wars between the government and the local Tuareg. During the Cure Salé, the young people are intent on marrying, and the old people on solving the problems of the community, and marrying off their offspring.

The Fulbe have moved far and often in the past millennia. According to some theories, their complex language is related

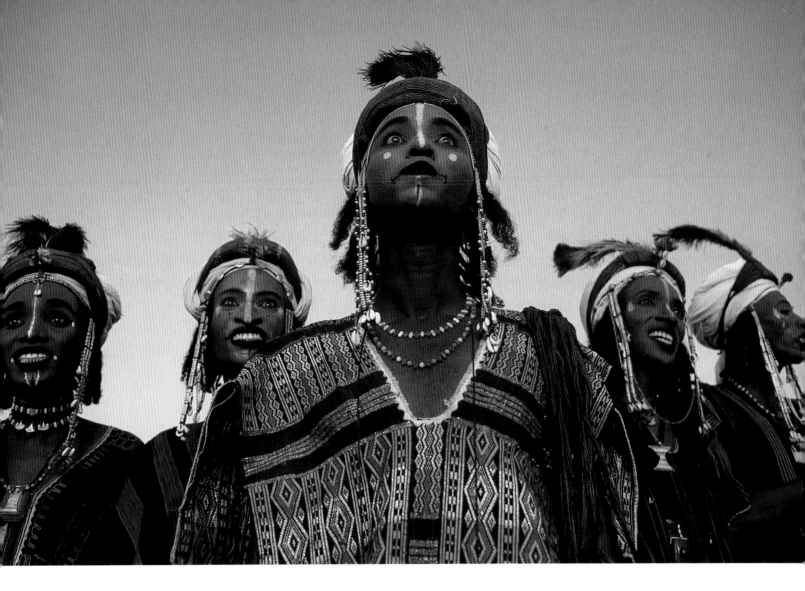

This is custom: young Fulbe men present themselves in all their beauty at the Cure Salé. It can take them hours to do their make-up for this community festival in the Nigerian town of Ingall. The Fulbe men continue to advertise themselves like this to the women in their group today, much to the joy of the visitors.

to that of the ancient Egyptians. Their first focal point for settlement was in the north of present-day Senegal. At an early stage, the Fulbe became dedicated to Islam; their wanderings are decisively responsible for the fact that the religion was able to spread south of the Sahara.

Africa demands much of its people. In the life of the Fulbe, they have always been expected to endure the severity of the Sahara. The hardest tests, however, have been imposed by the continent on those who have had to bow to the pressure of the societies in which they have settled. So the communities meeting at Ingall are the preservers of a very old culture, who understand stock breeding and the search for water. At the same time, the Fulbe stand for tradition and modernism. This is not situation of their choice.

MAX ANNAS

HERE & NOW

At present, it is estimated that eight million Fulbe live in up to twenty states in West and Central Africa, and more than 1.5 million in the diaspora. They have left their traces everywhere, particularly in Cameroon, where they put up the first national president after independence, Ahmadou Ahidjo, who led the country to dictatorship in the 1970s, and in Senegal, where Ahmadou Bamba (1853-1927) founded the Sufi brotherhood Muridiyya, a local variety of Islam. In Senegalese towns and villages, there is hardly a street where one does not see the hastily painted, shadowy features of Bamba on the wall of a house. Touba, the sacred city of the Muridiyya, located west of the capital Dakar, is today considered one of the most rapidly growing cities of the continent.

DOGON

Myths, masks, monuments

It can already be seen from afar. If one moves towards it along the red sand roads through the green plain, the rocky massif towers in front of one up to 984 feet (300 meters) high, a relic from primitive times, or as if placed there by extra-terrestrials. The »Falaise de Bandiagara« is 124 miles (200 kilometers) long, a sandstone plateau that was declared a World Cultural Heritage by UNESCO in 1989. This massif made the UNESCO list, not because of the impressive stature of this colossus that is gradually eroding away, but because of the settlements built up against its steeply towering walls.

The architecture is astonishing and spectacular, and one immediately asks why. The houses are built into the rock face; they are the same color as the rock, and look like a group of honeycombs. One thing is clear at first glance; no enemies can attack from behind. In front, there is an endless vista of the broad plain.

The history of the Dogon can be traced back to the 12th century, when they lived in the southwest corner of the present-day Mali and in the adjoining areas, which, today, belong to Burkina Faso. At that time, the Mossi, who today represent the majority in Burkina, moved through this part of the continent, in order to enslave people and disseminate Islam. The Dogon reacted by moving several miles to the east in order to avoid this threat, this departure from the threatened land thus creating the myth of their origins.

Tirelli is a settlement at the foot of the rock. Halfway between the plateau and the plain, a burial ritual is taking place.

Young men are dancing on tall stilts. They hold masks in front of their faces and wear fiber costumes, mainly in yellow and pink. Other dancers, without stilts, were similar clothes, but also carry on their heads a large figure resembling a cross. The dance takes place in order to take the soul of a dead person on its final journey. The Dogon have a complex system for using masks to set their ancestors on the right path. The ceremony sometimes takes place years after the death of the person in whose honor it is held. Detractors claim that this is the fault of tourism, for a major ceremony brings expectations of substantial sums from tourists.

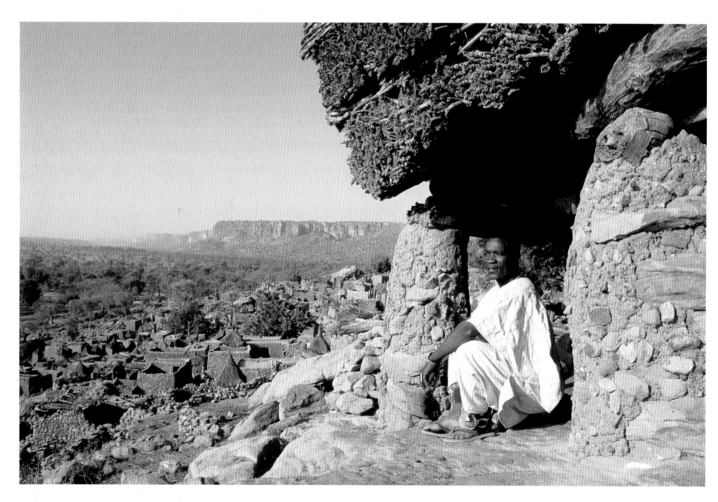

An initiate in the Toguna. Only men are allowed inside the assembly building, where the chief elder holds assemblies ABOVE. *The Dogon dance some of their ceremonies on stilts in order to be closer to the gods. They take consummately earthbound symbols like this photo along with them on their ritual journey* RIGHT.

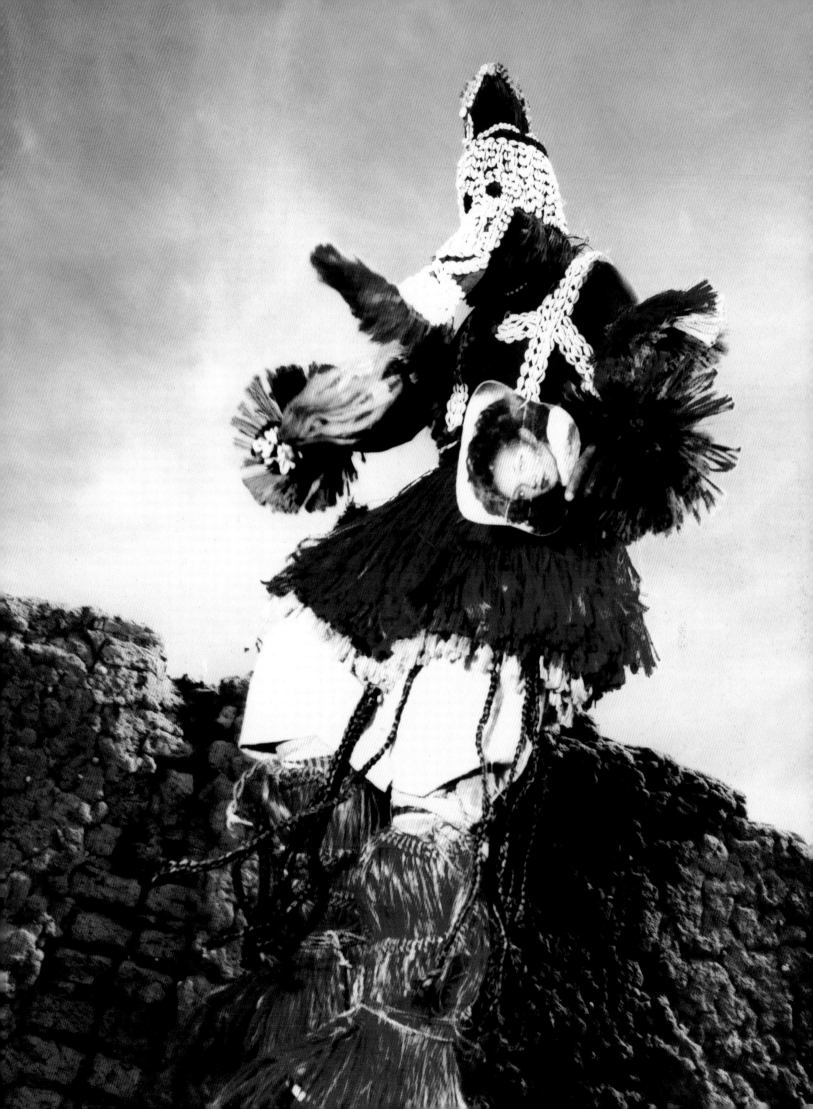

HERE & NOW

There are varying accounts as to how many Dogon live in the south of Mali and beyond the nearby borders with Burkina Faso and Niger. Certainly there are more than 300,000, but sometimes their number is up to 800,000. Their cultural center lies in the little town of Bandiagara, south of the river Niger, with its famous Falaise, a rocky massif, and the hamlet of Sangha, not far away. The Dogon live in small settlements and cultivate mainly millet on their land, which is not only a basic foodstuff, but also an article of merchandise for them. It is transported by car or by boat across the Niger to the markets and towns. The Dogon villages built on the rocky walls of the Falaise de Bandiagara are part of the World Cultural Heritage of UNESCO, and for years have been attracting ever more tourists, who are fascinated by the traditionally directed life of the Dogon and the spectacular architecture. Their arrival is beginning to make profound alterations to the local infrastructure. For European visitors to Dogon country, the way that people live there in a community may seem culturally and linguistically homogeneous. However, in this tract of land south of the Niger, the footprints of many centuries are to be traced. The Dogon live in peaceful coexistence with the Fulbe, Malinké, and Bambara, but regard the area as entirely their own, ancestral territory.

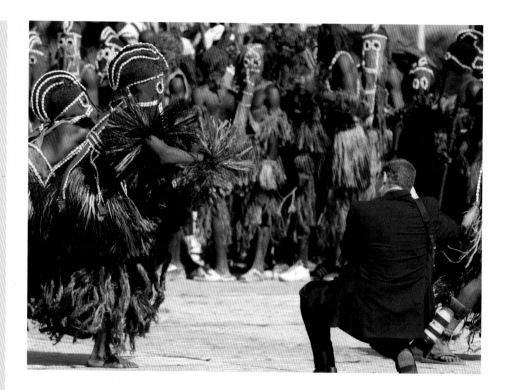

Dogon dancers in Bamako, Mali, at the opening of the 23rd France-Africa Summit in 2005.

The Dogon have evolved a legendary ceremony which takes place only every 65 years. Sigui is a festival of the dead, which honors the first deceased ancestors of the Dogon. For each Sigui, a mask is specially constructed, which is not carried as a facial adornment; it is much too big for that. The Great Mask, or Mother of all Masks, is carried in the hands and is several yards long. It is included in the dance.

The retreat of the Dogon from their old settlement area had consequences that could not have been foreseen at the time. Islam was aggressively on the march. Christianity had not yet discovered the continent; the missionaries were not to arrive until later. For many Africans, contact with the monotheistic religions, Islam or Christianity, was equivalent to their encounter with subjugation and

DÉNÉ ISSÉBÉRÉ– THE VOICE FROM DOGON COUNTRY

There are varying accounts as to how many Dogon live in the south of Mali and beyond the nearby borders with Burkina Faso and Niger. Certainly there are more than 300,000, but sometimes their number is up to 800,000. Their cultural center lies in the little town of Bandiagara, south of the river Niger, with its famous Falaise, a rocky massif, and the hamlet of Sangha, not far away. The Dogon live in small settlements and cultivate mainly millet on their land, which is not only a basic foodstuff, but also an article of merchandise for them. It is transported by car or by boat across the Niger to the markets and towns. The Dogon villages built on the rocky walls of the Falaise de Bandiagara are part of the World Cultural Heritage of UNESCO, and for years have been attracting ever more tourists, who are fascinated by the traditionally directed life of the Dogon and

the spectacular architecture. Their arrival is beginning to make profound alterations to the local infrastructure. The Dogon live in peaceful coexistence with the Fulbe, Malinké, and Bambara, but regard the area as entirely their own, ancestral territory."

www.deneissebere.net · www.mali-music.com

slavery. Nevertheless, the two great religions had a sweeping success in Africa, which could build on its own spiritual models. Today, there are countless peoples found throughout sub-Saharan Africa, which have converted to Islam or Christianity without having entirely given up their own religions. Thus, among many ethnicities, one finds both a traditional ancestor ritual on the one hand, and obedience to Mecca on the other.

The Dogon form one of the exceptions. Here, the expansion strategies of the world religions have not taken hold. For centuries, there were hardly any converts; only today do the numbers of conversions appear to be rising. This close connection with tradition continually made the Dogon interesting to Western researchers, who believed that here they were on the trail of the origins of the human race in its entire purity. The French ethnologists Marcel Griaule and Germaine Dieterlen claimed, in the 1930s, that the Dogon had secret knowledge about the star Sirius B, a neighbor star to the much brighter Sirius. Sirius B can indeed be observed only with highly developed equipment; but the French scientists' statement triggered a veritable storm of follow-up studies, one of which actually came to the conclusion that the Dogon had been visited by aliens. In the meantime, it is now accepted as fact that the methods of Griaule and Dieterlen were unscientific, and that they simply attributed their desired conclusions to statements by the Dogon. In the otherwise rich mythological treasury of the Dogon, extra-terrestrials quite simply do not occur.

MAX ANNAS

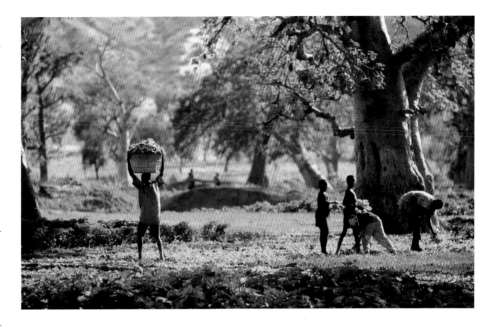

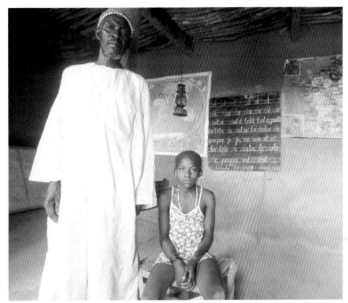

The Niger River is the lifeline of the Dogon. On its banks, they grow crops like onions, for which the Dogon are famous ABOVE. *A school in Bandiagara where ex-colonial ruler France has left its mark* CENTER. *Traders in piroques hoping for good business wait on the arrival of the ferryboats* BELOW.

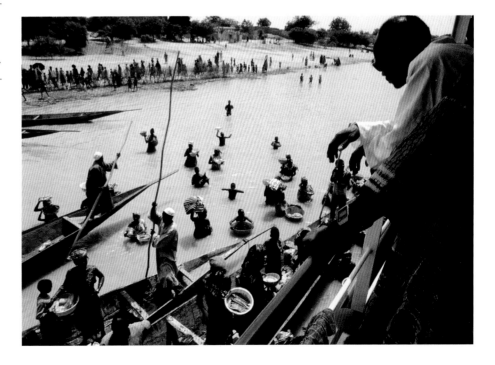

BERBER

The caravan moves on

With jackets and bags filled to bursting, the men and women shuffle through the border crossing. The Spanish men in uniform look away when the people push their way through the long barbwire cage that leads from Europe to Africa. However, the Moroccan border soldiers at the end of the route take a very close look at who has brought what from the other continent, and hold out their hands. It is usually small electrical appliances, household goods, candy, and hygiene articles that are imported here through the minor border traffic. Whether the border guards are levying duty on these goods or merely pocketing baksheesh is irrelevant.

Ceuta is a small Spanish exclave on the Moroccan mainland, a tiny remnant of a once gigantic Spanish colonial empire. The peninsula jutting out into the Mediterranean has been made a tax heaven to persuade its inhabitants to stay, so this place is one great duty-free shop. The retail dealers from Morocco fill their bags with goods for »personal use.« Barely do they have time to deliver the goods to their side of the border before the next round starts from the beginning.

Many of the border commuters in this traveling caravan do not speak Arabic. The women do not wear veils. This is easily explained: The area around Ceuta and along the Mediterranean coast between Tangiers and the Algerian border is a classical settlement area of the Amazigh. They have lived there since long before the Christian era, and have been successively attacked and conquered by the Phoenicians, the Romans, and the Byzantines. These were called Berber »Barbarians« by the Amazigh. In the early Middle Ages, the Arabs came with a more important mission than plundering. They carried the Koran

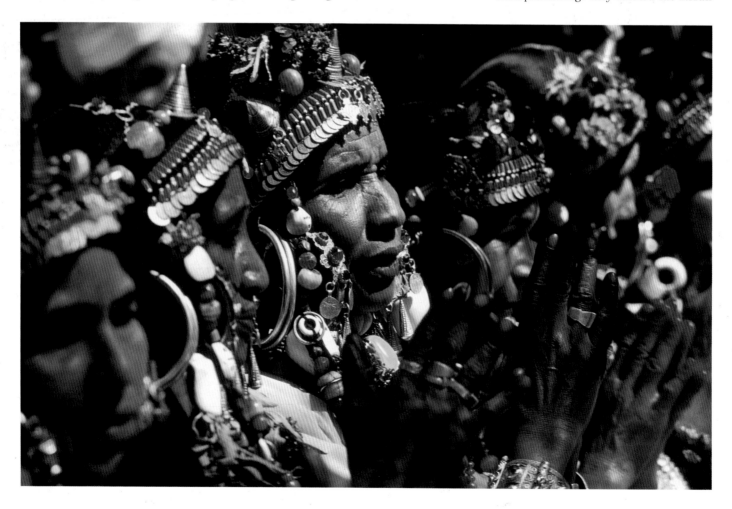

The Atlas Mountains go through Morocco, the Amazigh populate big parts of this mountain range. In these areas Moussem (markets) are held all year. These are more than big markets; they are also pilgrimages, political tribe meetings, places of tradition and public entertainment. Many villages have their own Moussem like the one for the almond blossom in February in Tafraoute RIGHT. Berber women celebrating in Tarhjijt ABOVE.

End of school in El-Kelaa-Mgouna in the valley of the Dades. Here in the province of Ouarzazate, primarily, roses are bred for the further processing in the perfume industry TOP.

Smith in a Ksur, the traditional refuge, in Goulmina RIGHT.

KHALID IZRI

Kahlid Izri is the rockstar among Amazigh musicians. He possesses an unbelievable range of styles, from soft and smoochy to up-tempo. Izri can pick up his guitar and croon away for a few minutes; but with his band he can also bring a hall to boiling point within minutes. Khalid Izri was born in 1969 in the small Spanish Mediterranean colony of Melilla in northeastern Morocco, and began to re-play the music of other Amazigh Combos at an early age. He had not quite reached the age of 20 when he brought out his first album "Tamwart Inu," which quickly made him a star among the young people of the Amazigh world. This was not only because of his music, but also due to the openness with which he addresses the problems of his people. His texts deal with themes such as identity and emigration, changing values in a traditional society and also the difficult position of women, who are decisively forcing the pace of such change. Khalid Izri is a superstar among Amazigh exiles in particular. His concerts in the Netherlands, where—after Spain but before France—the second largest community in Europe lives, are sold out well in advance. Whoever would like to see Khalid Izri live in Morocco, should ask when he is giving a concert in Nador, Mellila's twin city behind the gigantic barbwire border.

www.khalidizri.net

in their baggage, and more or less completely converted North Africa to Islam

The Amazigh either came to an arrangement with the Arabs or backed off into the inhospitable inland along the Atlas Mountains which reach all the way to the south of Morocco. Thus, there are oases such as Tafraoute in the western Anti Atlas. Tafraoute with its 5,000 inhabitants is shaped by the Berber group of the Ammel who populate the valley. When the almond trees bloom in February, the city is full of people who celebrate a Moussem for days. However, Tafraoute became famous for the land-art project of Jean Veram who realized his »painted rocks« in 1980 not far away from the city. The commotion about this artwork died away rather fast; today, the rocks are weathered from erosion, and the tourists who come by find that their charm is quite faded.

Like in Tafraoute, the common grounds with Berber native tongues are in areas with an Arabic speaking majority; the density of the Berber decreases from Morocco towards Libya. While most of these areas are economically under developed and culturally fallow, the area around Ceuta is different. Here, conflicts led to permanent tension between Morocco and Spain, which in principle still continues today. As recent as 2002, the two countries stood on the edge of armed conflict when Morocco installed a guard post on the uninhabited and 247 acre (1.5 square kilometers) large Isla Perejil off its coast. Spain reacted with the deployment of combat aircraft and infantry and was evidently greatly affronted.

The colonial status is officially ended, but the hierarchies still exist today. Spain prevailed in the clash over the Parsley Island, and the wealth of Ceuta is carried to Morocco in an absurd and humiliating procedure. All around the barbwire cage, the hands of young men grasp whatever will pass through the mesh. Every article that passes over the border this way is not only duty-free; it is also baksheesh-free.

MAX ANNAS

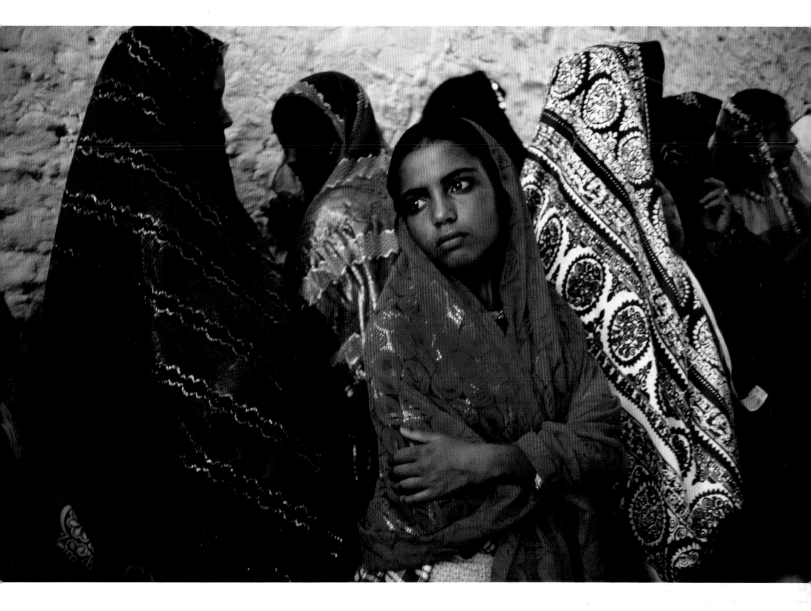

Marriage in the Atlas Mountains. Today, girls are not married anymore at the age of 12, but rather at the age of 15. The procedure remains the same, which also counts for the garments, even though the youth distinguish themselves from the older generation with their more western clothes in day to day life.

HERE & NOW

The Berber, in the broadest sense, speak a Berber language, descend from Berber, or at least have a Berber in a grandparent generation. Very different groups are combined under the notion Berber, the Tuareg among others. Historically, the notion means the non-Arabic population of North Africa, which was colonized over and over again by the Arabs pushing towards the west, and wanting to Islamize Africa since the middle of the first century. Amazigh is only a term for the many people who are still mostly called Berber outside their own world. Very diversified groups are assorted under the term »Berber,« including the nomads of the south Sahara—the Tuareg. In its widest sense, it embraces the non-Arab inhabitants of North Africa who experienced another of their many colonizations, this time by the Arabs pushing westward since the middle of the first millennium in order to convert the African continent to Islam.

Very different groups are combined under the notion Berber, the Tuareg among others. Historically, the notion means the non-Arabic population of North Africa, which was colonized over and over again by the Arabs pushing towards the west.

Amazigh is a term for the many people who are still mostly called Berber outside their own world. They often refer to themselves as Imazighen, which basically means »free people.« Some communities have names of their own; for example the Kabyle or the Chaoui in Algeria. The name Imazighen or Amazigh is primarily popular in Morocco where, at around 80 percent, the Amazigh form the majority in Morocco, as is the case in Algeria with approximately 60 percent. However, the Amazigh form the social elite in neither Morocco nor Algeria, which especially among the Kabyle in Algeria repeatedly led to bloody rebellions. More than two million of them live in Europe as migrants.

Migration

Sociologists define human migration as a long-term, permanent, change of residence by either individuals or entire groups of people. Mass migration describes the situation that results when whole societies and communities start out for a new territory at more or less the same time. The term can be applied to almost any era, but fits the fourth and sixth century movement of the Germanic tribes into Europe particularly well. In the English-speaking world, this great migration is known as the »Barbarian Invasions.«

Moderne Migration wird von Modern migrations are governed by several constants. Today, individuals and small groups are usually the ones underway, rather than entire communities or ethnic groups. The existence of the modern nation state regulates border crossings and residence rights like never before. Exceptions to the strict legal restrictions on immigrants are often lifted for war victims. Refugees from Darfur have crossed into Chad, where they scratch a meager existence in border camps in a country where few other options are available. Should the situation in the Sudan stabilize, a concerted effort to send them back is to be expected.

Brimfull boatloads of young men

There are many obstacles along the way for anyone trying to find their way to safety from a war zone, or anyone who simply wants to migrate in order to improve their economic circumstances. Europe protects itself with police boats off every coastline and strict immigration requirements for people from impoverished lands. Where Europe shares a border with poverty, as is the case with the Spanish autonomous cities near the coast of North Africa, the situation is particularly tense. People trying to scale the tall fences around these landlocked islands of the European Union are fired on by sharpshooters. The most familiar images of desperate immigrants trying to get to Europe are the brimfull boatloads of young men wrecked offshore of a South Italian island, or floating rudderless near the Canaries. The situation on the border between the United States and Mexico is similar. There as well, the waves of inmigrants trying to reach the border will never end. As in Europe, the proper way to deal with these uninvited immigrants is an emotionally charged political discussion.

They sought a better life

Officially, current immigration authority parlance refers to »migrants« as refugees, applicants for asylum, or makes some other specific reference to the situation at hand. This has led to the evolution of the pejorative term, »economic migrant,« or, even worse »fake asylum seeker,« both of which refer to people who try to immigrate as a means of escaping an economically disadvantaged situation at home. This has brought the world to the threshold of a new era of hermetically sealed borders. Traveling from place to place has never been easier. With airplanes, the distances between continents can be reduced to a few hours flying time. Getting there is easy, but getting in is nearly impossible.

The desire to flee bad situations and impoverished conditions has long been the most common motivation behind migrations. Man is conservative. People prefer to stay at home, and will stay where they are if it is at all possible. Instead of moving to a different climate, humans come up with all kinds of ideas and contraptions to help them endure the most dire weather conditions. Likewise, since the beginning of time, if a person is convinced that things in his or her present location are impossible, that person will attempt to continue life somewhere else. The forces behind the perceived need to migrate are varied. It could be a Force Majeure, in the form of drought, flood, plagues or epidemics. Perhaps there was conflict within a group, or with another community, that led to the decision to leave one area and start anew somewhere else. Of course, there will always be the occasional people who wander because they are born with a certain investigative spirit, or possess the will to conquer.

Without migrants and wanderers, the world would be a very different place. Nearly every state in the USA is inhabited by people whose ancestors left Europe to escape economic or political conditions, or for religious freedom. They sought a better life, and some generations later, most of them achieved it. At the same time, other Europeans enslaved

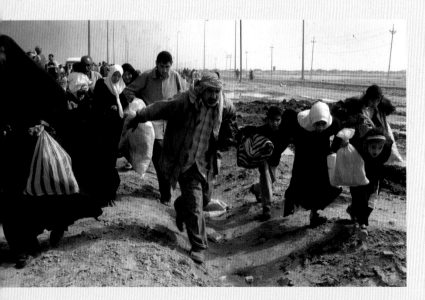

Iraqi war refugees in Basra in 2003. Millions of people are fleeing armed conflicts worldwide.

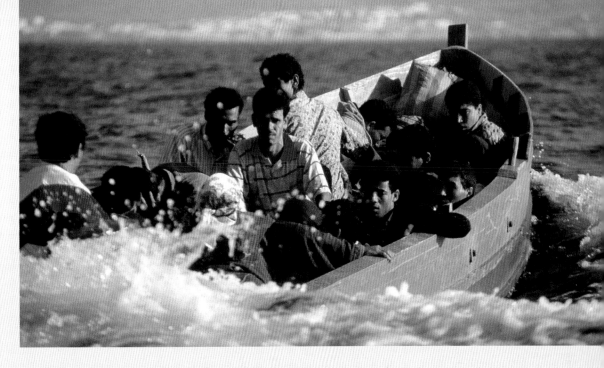

Migrants in the Strait of Gibraltar in 2005. African refugees are always seeking out new ways of getting to Europe. Europe, in contrast, is looking for ways to curb illegal immigration.

millions of Africans, who, in providing an essentially free labor force, contributed to the rise of those economic, political and religious refugees from Europe. In Australia and New Zealand, white elites, in this case, descendents of convicts, held all the power. Only in African states like Zimbabwe did the inherited colonial status quo turn out somewhat differently. Rich whites once had the power, while poor Africans worked in the fields. Then, the roles, while not reversed, changed radically. In South Africa, the transformation is still underway. Outside of Asia, there are few countries where a European language is not either the official language, or the lingua franca by which most citizens communicate with each other.

One of the largest and longest lasting migrations in history is the Bantu Expansion that began when groups that lived in what are today Southern Nigeria and Northern Cameroon began to spread throughout most of the African continent. Historians and ethnologists have recovered traces of this long process. They have determined that the Bantu migrations began some three to four thousand years ago in the rainforests of Central Africa, from where the linguistic group expanded whenever conditions allowed. When the Bantu-speakers themselves eventually crossed paths with other groups of migrants moving south, they

redirected their movements to the east and west. They slowly made their way as far as the western coast of Central Africa, to Kenya and Tanzania in the east, and to territories near present-day South Africa in the south. The entire series of migrations took place between the thirteenth and sixteenth centuries. The Bantu groups that wandered to the south in the eighteenth century are

A series of spoiled hopes

today known as the Zulu and Xhosa. The ongoing shifting of settlements into new areas was characterized by short-term sedentary periods that came to an end with each new departure. In the process, the Bantu developed technologies that enabled the societies of the African continent to confront a variety of challenging environments, and survive.

Things are not so simple in Africa anymore. It is not a matter of simply pushing on toward the south. While African borders are somewhat easier to cross than those in Europe, South African police regularly raid the immigrant camps that encircle Johannesburg. Those arrested are usually dumped back on the other side of the border. These are not the kinds of conditions that encourage relocation.

MAX ANNAS

Illegal immigrants from Zimbabwe are taken to Johannesburg in police vehicles in 2004. The Republic of South Africa is the destination of many refugees from neighboring states.

Fine grains of sand trickle down from the heights above. Red dust collects in the corner of the eye and accumulates in a camera's every nook and cranny. The sandstone walls of the cavern-like canyons are colored in shades ranging from light yellow and orange to the deepest red. On the border between Arizona and Utah, a mysterious, magical world surrounds visitors as Chief Tsosie leads them through Antelope Slot Canyon.

This is Navajo country, exactly like everyone expects it to be. In the scrub desert of Monument Valley, countless westerns have been filmed against the magnificent backdrop of towering mesas rising steeply to the sky. The nearby Canyon de Chelly rivals the Grand Canyon as a favorite destination for tourists from the rest of the United States, and, increasingly, from overseas as well. There is something spiritual about a journey through the endless red-tinged terrain, passing by the traditional Navajo hogans as well as the modern trailer parks where most Native Americans live. The region is known as Four Corners because it is where the states of Arizona, New Mexico, Utah and Colorado meet. Its development, or lack of the same, has been, until recently, ideal. In earlier centuries, this area was considered the end of the world, a worthless desert that the Spanish, and later, the Americans, were happy to leave to the aboriginal peoples. This remained true up until the day its mineral wealth was discovered.

Chief Tsosie runs a small travel business in the city of Page, located on the shore of the Lake Powell reservoir. He is one of many Navajo who make their living from tourism near this enormous body of water, which is now one of the region's most popular vacation destinations. In Chief Tsosie's store, each and everything to do with the Navajo culture is for sale. There are carpets, books, CDs and jewelry on display. He may perform a traditional dance for visitors between the shelves of craftwork and souvenirs. His wife is there too, in the narrow aisles and grottos of the shop, playing an Indian flute as the Chief tells tales of the history of the earth, and

NAVAJO

Beyond the scenery

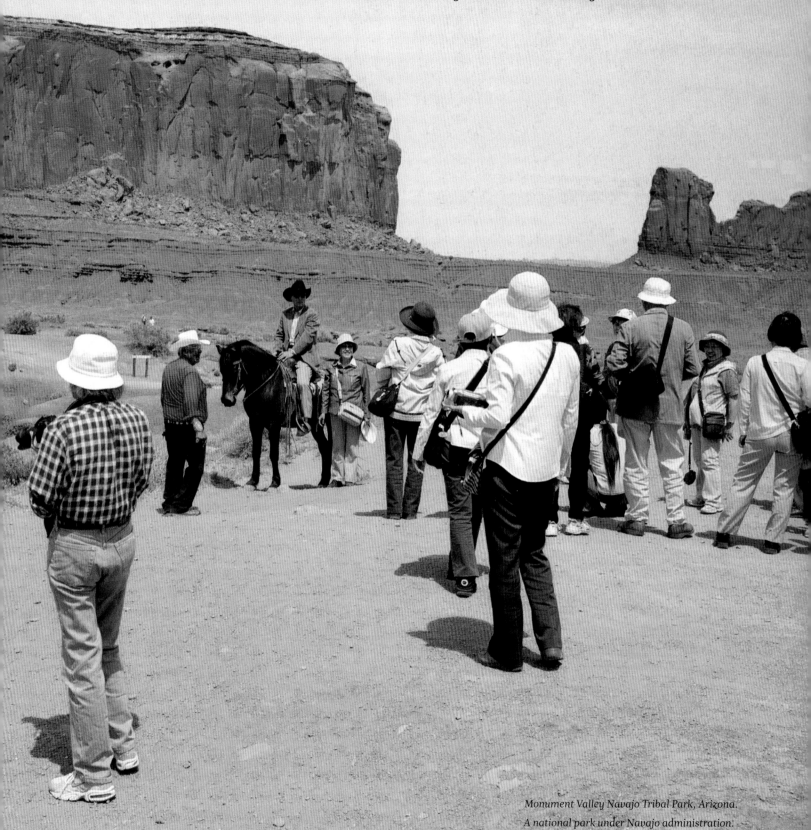

Monument Valley Navajo Tribal Park, Arizona.
A national park under Navajo administration.

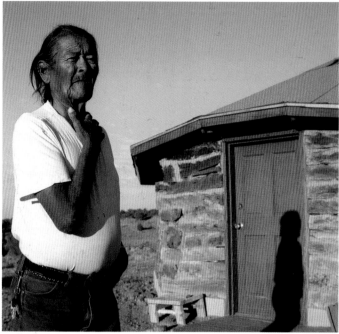

Navajo Tribal Park, Hogan in front of the mountain formation Three Sisters. The park can be seen on a 17 mile long stretch.

Retired Navajo, Black Mesa. When he was not working for the Santa-Fe-Southern-Railway, he took care of the flock of sheep.

Navajo myths and legends. At the end, if you like, you can request and »Indian massage« outside in the hot sand.

Chief Tsosie makes a living. Every year, he sells his canyon tours at international tourist fairs like the ITB in Berlin. Tsosie markets Navajo culture in quality and quantity from his nearly one hundred year old Cameron Trading Post on Highway 89, halfway between Page and Flagstaff. His business seems to be a gold mine. Many who drive along the tourist route easily get the impression that, economically, things are going very well for the Navajo indeed. The reality, however,

is somewhat different. Unemployment is high, as it the case with nearly all Native American peoples in North America, and many Navajo have little choice but to live in the most depressed neighborhoods of the big cities of the American Southwest. Only very few of them can afford to live the traditional lifestyle as sheep and cattle herders on their own land.

The land itself, the very ground, is of central importance to the Navajo. The Black Mesa in the Four Corners region is considered a holy site. Yet the Black Mesa has, in recent years, been the stage for a series of ongoing tragedies revolving

around land disputes, coal mining and forced relocation. In the 1950s, after the Peabody Coal Company discovered rich veins of anthracite in the middle of the Navajo reservation, outsider interest in Navajo and Hopi lands increased astronomically.

Conflict over land rights have flared up primarily over the so-called »joint use area,« which was used by both tribes. In the end, the area had to be divided. In 1974, the law ended the dispute by forcing 12,000 Navajo and 100 Hopi to resettle on either side of the new boundary. This led to many years of bitter protests by tradi-

HERE & NOW

With a population of around 350,000, the Navajo are the largest indigenous group in the United States. More than half live in the almost 70,000 square kilometers (27,000 square miles) Navajo reservation, which lies in Arizona, with parts of it crossing the border into Mexico, Utah and Colorado. The rest of the Navajo live dispersed throughout the United States, mostly on the edges of the big cities of the American Southwest.

The Navajo arrived in the Southwest some 600 to 700 years ago after a lengthy period of migration from the north that had begun as many as 300 years earlier. They soon settled down and began to raise cattle and sheep. The Navajo are related to the Apache, who,

like them, have northern origins and a language in the Athabaskan linguistic family. The split between the two groups is relatively recent in historical terms. The lives of the Navajo were defined by extended periods of warfare with the Spanish, Americans, and neighboring tribal groups. By the middle of the twentieth century, most of the conflicts were legal ones having to do with land rights and the division of mining profits

Today, tourism is the main source of income on the Navajo Reservation. Continued growth seems secure thanks to the magnificent handicrafts, along with the breathtaking scenery of canyons and scrub desert celebrated in countless Hollywood films.

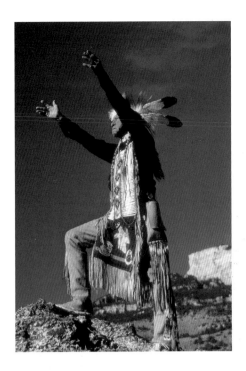
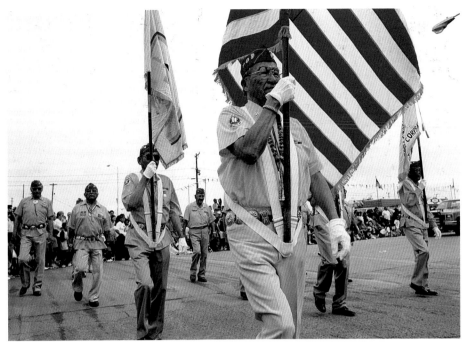

The tribal park is not a museum; Navajos live here LEFT. *Navajo Code Talker at a parade. The Navajo language was used with great success in World War II in encoding radio communication* RIGHT. *Road sign on Highway 89* BELOW.

tionalists from each group who did not want to leave their land.

There is more going on in Navajo country than just coal. The discovery of additional mineral deposits of oil and uranium has also attracted the interest of big business. Uranium for the use in the manufacture of atomic weapons was mined here from 1942 into the 1970s, with Navajos doing much of the hard labor. It was never explained to the miners that the extraction of uranium releases dangerous radioactivity. Many Navajo built their houses out of radioactive stone. Highly toxic radon gas was released in residential quarters and near children's playgrounds. The incidence of cancer skyrocketed, and thousands died.

In 1974, new land allotted to the Navajo south of the reservation on the banks of the Rio Puerco was accidentally contaminated by millions of gallons of radioactive wastewater. A broken dam released poisons into a river that was the only drinking water supply available to the Navajo and their herds of sheep. Extensive investigation and the support of international environmental organizations culminated in Joe Shirley, newly elected Navajo Nation President, declaring

that all reservation land would remain a nuclear-free zone forever. Uranium will never be mined there again.

There are other sources of income that are less dangerous to their health. Casinos pour gold into the cash box, and white Americans throng around the gambling tables. The production of traditional crafts plays an increasingly large economic role for many Navajo families. Woven blankets and carpets, ceramic wares, the famous sand paintings and turquoise-inlaid silver jewelry are in high demand. Paintings by the artist R.C. Gorman, who died in 2005, hang in museums and galleries around the world. Art lovers make pilgrimages to his studio in Taos, New Mexico. While tourists love to buy the colorful Navajo art and enjoy listening to tales told by their tour guides, many young Navajo have lost touch with their own culture. They no longer know anything about their religion, and may never have heard the myths of their ancestors. Most no longer understand the Navajo language, which is linguistically so complex that almost no outsiders have ever been able to learn it. The famous Navajo Code Talkers kept American radio signals safe during the Second World War.

Despite all their efforts, enemy forces never managed to break the »code« that is the Navajo language.

Offering some hope for the future are educational institutions like the Diné College in Tsaile, where Navajo culture, history and language are taught. And who knows, if tourist interest in the Navajo continues to grow, maybe the younger members of the Navajo nation will start to show more interest in their own culture.

BERNHARD MOGGE

Sometime between December 1930 and March 1931, Albert and Elsa Einstein set off from Princeton, NJ on a luxury tour to the Grand Canyon. The Fred Harvey Company offered an adventure travel package through the southwestern United States by train. Even at that time, the area was already nearly completely covered with hotels, restaurants and shops, most of them belonging to the travel company. Like everyone else, the Einsteins stopped at »Hopi House,« where the popular Kachina dolls of Hopi Indians were

HOPI

For Native Americans only

sold. Package tours to the Southwest flourished in the 1960s, establishing mass tourism throughout the region: tourism with Native American Art as its focal point.

A short time thereafter, it was no longer fashionable to travel by train. American

tourists had their own wheels now, and have since traveled on their own into every last corner of the desert. Anyone who drives by the gateway of the Hopi village of Old Oraibi, however, will be informed politely, but seriously, that photography and video cameras are strictly forbidden. When visiting the Pueblo-dwelling tribes of northeastern Arizona, everyone enters the community as a guest, or not at all.

As was the case earlier with hippies, the Hopi enjoy an almost cultic level of adulation among the New Age crowd. With a name that translates to »the peaceful ones,« the Hopi fascinate people who inhabit a more turbulent world. Living in almost complete isolation for hundreds of years, the Hopi have succeeded in preserving their ancient way of life as farmers, deliberately avoiding conflict while striving to live in harmony with all creation.

The tourists' desire to encounter the descendents of the original inhabitants of North America as up-close-and-personal as possible has, from the very beginning, had a dramatic effect on the native people's living conditions. Today, the approach to tourism is much more culturally sensitive, with the interests and needs of the tribal groups taken into account along with the visitors' expectations.

A tourist walking through a Hopi settlement comes across signs forbidding access to anyone but the Hopi. A few of the eleven autonomous Hopi villages still do not have electricity and running water, in part because that is the way the inhabitants like it. Old Oraibi, along with Walpi and Hotevilla, are veritable strongholds of Hopi tradition. Many of the elders hold on tight to traditions, attempting to pass the Hopi way of life down to younger members of the tribe and their children. The shops are full of skillfully carved and painted

Hopi House in the Grand Canyon National Park. The architect Mary Colter built this shop for the Fred Harvey Company in 1905. The building still functions as the business and gallery room.

Basketball in the Hopi reservation in Polacca, Arizona. North American Indians have not found their niche amongst the sports millionaires like other ethnic groups in the USA.

Hopi women near Tuba City. A Hopi chief named Toova from Oraibi gave the region its name. Hopi, Navajo and Paiute cherished the region for its many water sources. In 1900, the Mormons arrived and put down the foundation stone for Tuba City.

kachinas, which are dolls that incorporate good spirits. These popular items always make up a large part of the items offered for sale. Jewelry and ceramic goods are also sold.

Mysterious Hopi rituals conducted in subterranean kivas have long fascinated visitors. These ceremonial places, circular in layout and partially underground, can be entered only with a ladder through a hole in the roof, but as a rule, outsiders are forbidden entry altogether. For a fee the ceremonial dances that take place outdoors are visible. There are no hidden meanings in them. Most visitors accept these expressions of private enterprise as a sign of self-respect. On this point, at least, the Native Americans and visitors agree.

BERNHARD MOGGE

HERE & NOW

Hopi origins lie in the dark depths of history. The Hopis established their first pueblos in Arizona in the twelfth century, and Old Oraibi has been an important site ever since. In existence for 850 years, it is the oldest continuously inhabited permanent settlement in North America. The Hopi are a small group with a population of approximately 12,000 tribal members. Their tribal reserve of approximately 12,600 square kilometer (4,865 square miles) is completely enclosed by the much larger Navaho reservation. In addition to the pervasive problems of unemployment and poverty, the greatest cause of conflict among the Hopi today is the mining of coal and other minerals on the Black Mesa. Long battles with the Navajo over land rights are another important issue.

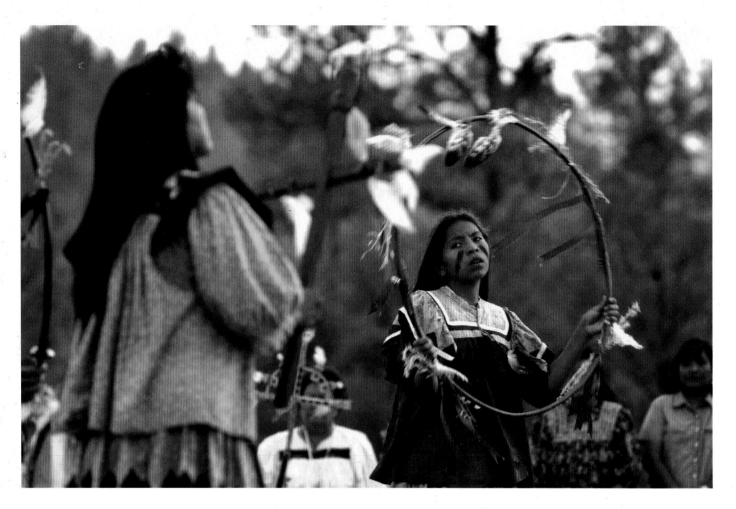

Red squirrels? Do the Apaches really go to war to protect red squirrels? This is how incorrectly and stereotypically a conflict in the southwest United States is sometimes represented: a conflict that is actually about something quite different than protecting an endangered species, even if the red squirrel is native only to Mount Graham in southeast Arizona.

Rising over 10,498 feet (3,200 meters) high, the mountain range has a special significance for many people. For the San Carlos Apaches, the Dzil Nchaa Si An, the Great Seated Mountain, is not only sacred, but also it is a living being. This is where traditional healers search for herbs, come to pray and receive instructions from mountain spirits; this is where their ancestors are buried.

For conservationists, Mount Graham is a unique ecosystem, the habitat of many rare species of plant and animal, including the Mount Graham red squirrel. If you climb from the foot of the mountain to its peak – a nature reserve – you pass through no fewer than five different cli-

MOUNT GRAHAM ⊕ 32°42'N 109°53'W

APACHES

The fight goes on

mate zones. For researchers, the mountains offer ideal conditions for exploring outer space. Three huge telescopes have already been erected here. The University of Arizona is in charge of the project, but German and Italian research institutes, as well as the Vatican, are also involved.

The San Carlos Apaches have vehemently and persistently opposed the observatory project since its foundation. They argue that the gigantic complex has desecrated their sacred mountain, destroyed the countryside and prevented them from practicing their traditional religious ceremonies. They know the law is on their side. However, the supporters of the observatory are familiar with all the legal tricks and the mountain is firmly in their hands.

The struggle for Mount Graham illustrates the contradiction between economic interests, on the one hand – investment in the telescopes cost many millions of dollars – and the preservation of an autonomous and endangered culture, on the other. The Apaches, though, are experienced fighters. Few other indigenous peoples in North America evoke so many memories of cruel wars with the white conquerors; famous leaders such as Geronimo, Cochise or Nana; or massacres and bitter defeats as the Apaches. In Germany, the name of this tribe is probably more famous than any other, thanks to Karl May's ficticious Apache chieftain Winnetou, who combined all the attributes of the »noble savage.«

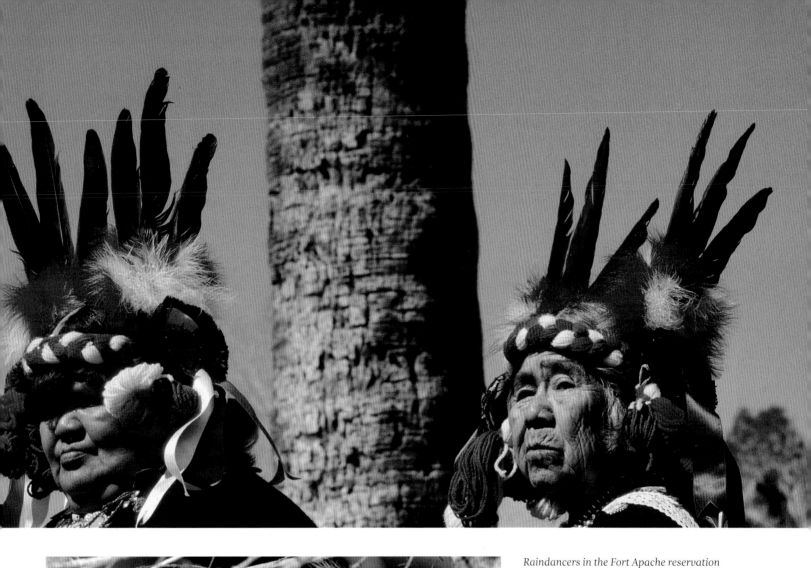

Raindancers in the Fort Apache reservation VERY LEFT. Western Apache near Phoenix TOP. Northern Amazon red squirrel at the Mount Graham, the holy mountain LEFT.

While the San Carlos Apaches campaign for the preservation of their sacred mountain, other Apache groups have come to terms with the situation. They run ski resorts and golf courses, organize tours of the area and to places of cultural interest. Taking photographs is acceptable if done with the necessary respect. However, even for these Apaches, freedom to pursue their religious ceremonies is of utmost importance. During impor-tant celebrations such as the female puberty rite, non-Indian visitors are excluded. Dance performances are put on for them instead, and sometimes, the clicking of cameras drowns out the sound of stomping feet.

BERNHARD MOGGE

HERE & NOW

The Apaches originally came from the north of the continent. They migrated southwest with the Diné (Navajo) 600 to 700 years ago, settling there as gatherers, hunters and farmers mainly in what are now the US American states of Arizona and New Mexico. The Apaches do not have »tribes,« they are divided into several main groups, the most famous being the Jicarilla, Mescaleros and Chiricahua. Like most indigenous peoples in North America, the Apaches living in the reservations struggle with unemployment and poverty, but an increasing number are working successfully in the tourist business, marketing their rich culture without exploiting it.

TARAHUMARA

Fast runners through the ravines

The women, dressed in colorful garb, stand up and shuffle to the platform where the train will come to a full halt in the coming seconds. Finally, the train comes to a slow stop at the small train station. The women lift their baskets high, to show the travelers their wares, even before the train has arrived, even though they know that the travelers are still too preoccupied with what was most likely the most spectacular train ride of their lives: through the Sierra Tarahumara with its countless ravines, courses of rivers and waterfalls. Eighty-six tunnels and thirty-seven bridges are all part of the adventure. The tourists can most likely still feel in their bones the chillingly steep ascent of almost 1.5 miles (2.5 kilometers) from the Pacific Ocean. The women here in the little city of Creel hardly stand a chance to peddle their baskets.

The Chihuahua Pacific Railway is one of the most exciting and picturesque train

Creel, with almost 6,000 inhabitants, is the trade center of the Tarahumara TOP. *Its train station brings local as well as international travellers into the highlands; the Ferrocarril Chihuahua al Pacifico is one of the picturesque line sections of the world* RIGHT. *The beauty of the Sierra Tarahumara is obvious, but the residents live in poverty* FAR RIGHT.

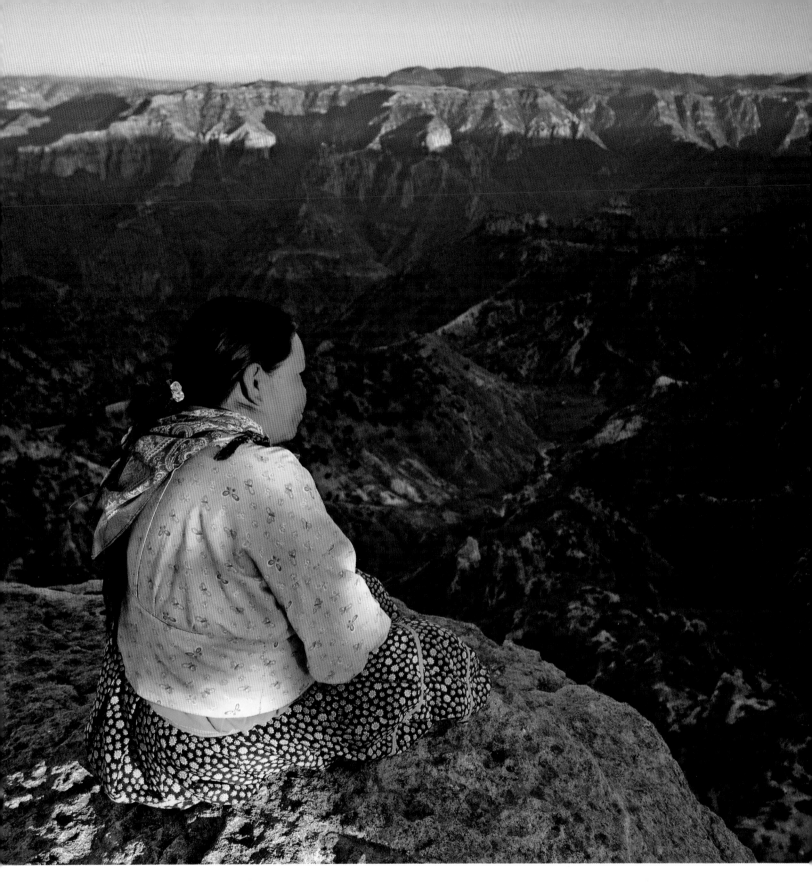

rides in world. It connects the coastal city Los Mochis, which borders on the Pacific, with the capital Chihuahua and crosses straight through the region where the Tarahumara have settled. One gapes in awe at the ravines of the mountainous landscape, the Copper Canyon and the even steeper and craggier neighboring canyons, the Barranca Urique, Barranca Sinforosa and Barranca Batopilas. While this makes for a thrilling trip for tourists, the Tarahumara call this place home. They did not even choose to live on this region, which is said to be one of the most spectacular in the South American continent– they fled here.

For at least 2000 years, the Tarahumara have lived in the area of what is today the state Chihuahua. With the Spanish invasion of their territory, the Tarahumara suffered extensive losses, through imported diseases and also with the lasting loss of their territory, which they used for cattle and agriculture. In the 19th century, gold and

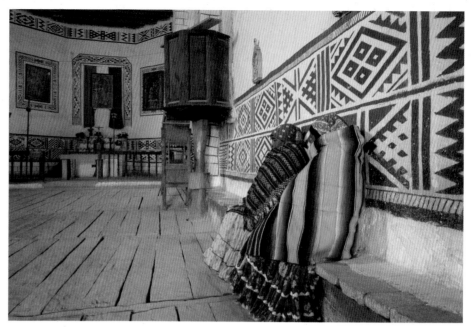

The men raise the livestock in the forested highlands of the Sierra Madre Occidental LEFT. *The mission church in Cusarare, near Creel. Despite the Tarahumara refusing the Christian belief, the province Chihuahua was opened up to missionaries when the railroad wasbuilt* RIGHT.

silver mines became increasingly important and the number of inhabitants of this region grew. As a consequence, the large communities of the Tarahumara moved west to the nearby mountains of the Sierra Madre. Yet, this was not a move made out of choice and resulted in the further loss of the best Tarahumara territory.

For a long time, Mexico has known about the exceptional skills of the Tarahumara.

Increasingly, even the rest of the world has come to realize that many Tarahumara are highly talented and enduring long-distance runners. They call themselves the rarámuri, which translates to »mean runner.« Their territory was once impressive; their refuge today is still enormously vast. The terrain is not easily accessible and the roads are long. Running even used to be of ritual importance, originating from the techniques the Tarahumara used during hunts. They would hunt on the run, exhausting their prey until they killed it. Even large-scale Mexican landowners used the Tarahumara as drivers for their own hunts. In the past years, more and more Tarahumara have been taking part in competitions and easily leave many marathon competitors in their dust – no wonder, for long runs of up to 105 miles (170 kilometers) are not unusual for the Tarahumara.

Missionaries, who came in hordes over the ocean on Spanish ships, despaired at the vehemence with which the Tarahumara refused to accept the blessing of Christian beliefs.

Yet, no society in Latin America is completely free from the pressure of the European conquerors. Some Christian rituals have been incorporated into the Tarahumara belief system, such as worship for Jesus Christ and Mary together with the lunar and solar deities, who are believed to be their parents. Indeed, this might even represent a necessary compromise taken to prevent angering the colonial powers. Yet, it remains to be seen how many more compromises will be necessary to withstand the growing tourism and the subsequent pressure to change.

MAX ANNAS

HERE & NOW

Around 70,000 Tarahumara currently live in the Mexican state Chihuahua and the neighboring states Sinaloa, Sonora and Durango. Originally in the plains, they moved up to the more inhospitable highlands after the Spaniards arrived, finally ending up in the remote region around the Copper Canyon. Little did they know back then that this part of the Sierra Madre would one day be called Sierra Tarahumara, and that the Parque Nacional Barranca del Cobre (Copper Canyon National Park) would become an important final destination for tourists in Mexico.

Nowadays, only half of the Tarahumara live in the mountains on a full-time basis: the other half has returned to the plateaus or the nearby urban areas, looking for work. Yet, even in the Sierra Tarahumara, the Yoruba are minorities. They merely represent a fraction of the 300,000 inhabitants of the mountainous region. Scientists, therefore, believe the Yoruba lifestyle and language to be endangered. While tourism has attracted increasingly more visitors, it does not represent the most important source of income for the Tarahumara – others benefit far more from tourism than they do. The economic basis is still one of subsistence agriculture and small trade – tourists are interested in their daily life and artisan wares – the baskets and colorful fabric, carved animals out of wood and jewelry.

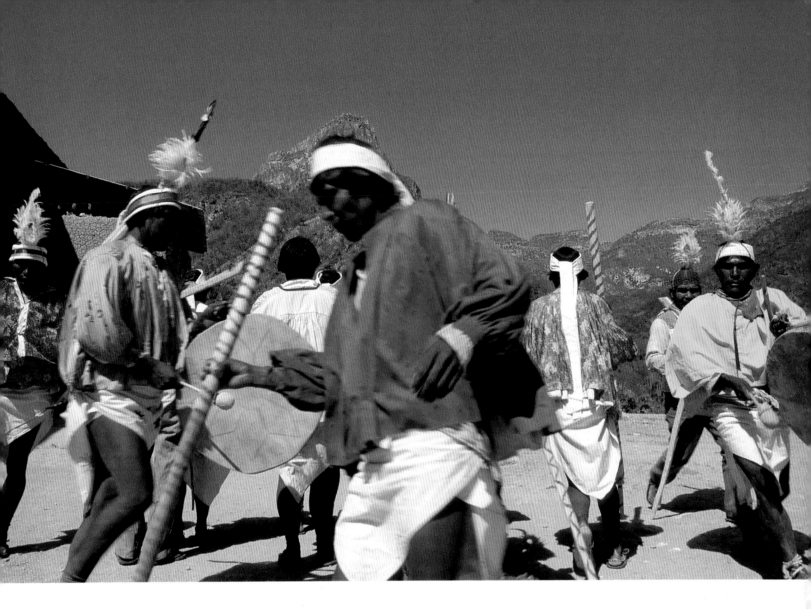

Tarahumara on the ritual square. At the spring festival, the men dance for up to three days, the drums put them into a kind of trance. The women operate the cooking area, supply the dancers or watch. The gender roles of everyday life regulate the festival culture as well.

HENRIETTA YURCHENKO

Even her name indicates that Henrietta Yurchenko is not a Tarahumara. Born as Henrietta Weiss, she did not marry an Aztec descendant, but instead Argentine-born artist Basil Yurchenco. Yet, she was to play a role in the Tarahumara life, and the Tarahumara in hers. Shortly after her wedding in 1936, the 20-year-old and her husband left for Mexico, where the pianist and music ethnologist used a stipend from the Library of Congress to conduct work. She accomplished in Mexico and in Guatemala what Hugh Tracey did in the same period in South Africa. Traveling on mules and laden down with recording devices, Henrietta Yurchenko conserved the traditional music of different groups, which originated from pre-Conquista times. In addition to the Tarahumara, Yurchenko also recorded the music of the Tzotzil and Tzeltal, the Cora, the Huichol or the Seri and the Yaqui, to name just a few of the peoples in Mexico. After traveling through Central America for five years, she expanded her travels and recorded music in Morocco and Spain.

The majority of her recordings are in the archives of the Library of Congress in Washington D.C.; Yurchenko recorded around 30 tapes of the Tarahumara in the state of Chihuahua. Only one cassette was released, and it can still be found in the collections of some of the archives. The entire treasure trove is still waiting to be discovered. Hugh Tracey's recordings were released, countless records and CDs sold, and today, his huge archive of recordings is accessible to scholars in the South African university, Grahamstown. Henrietta Yurchenko's recordings, however, are still waiting to be given the same respect and to be made accessible to all. This not only concerns her achievements as an ethnographer, but also the unique audio recordings of the Tarahumara and other communities. Henrietta Yurchenko died in 2007 at the age of 91.

www.henriettayurchenco.com

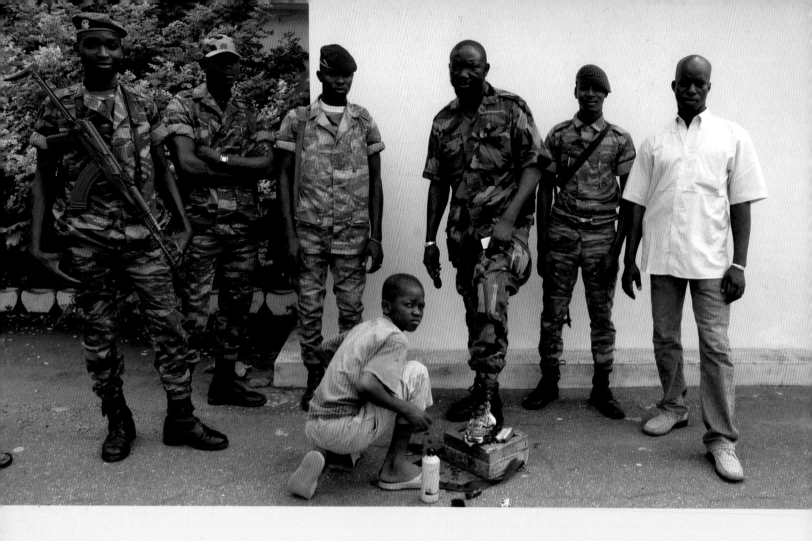

TROPICAL CLIMATE

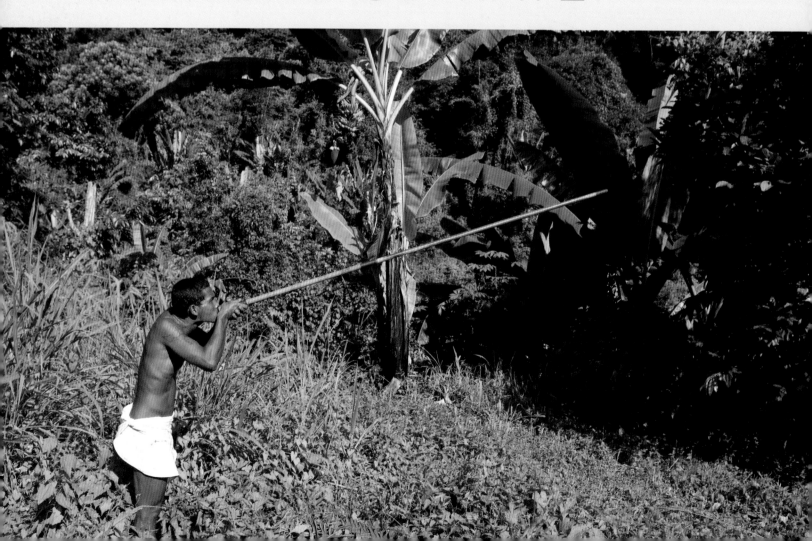

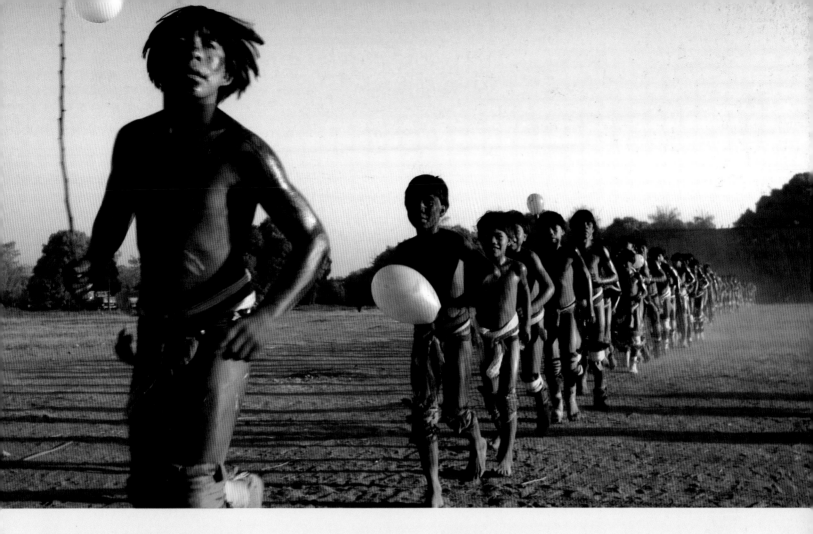

ALONG THE EQUATOR

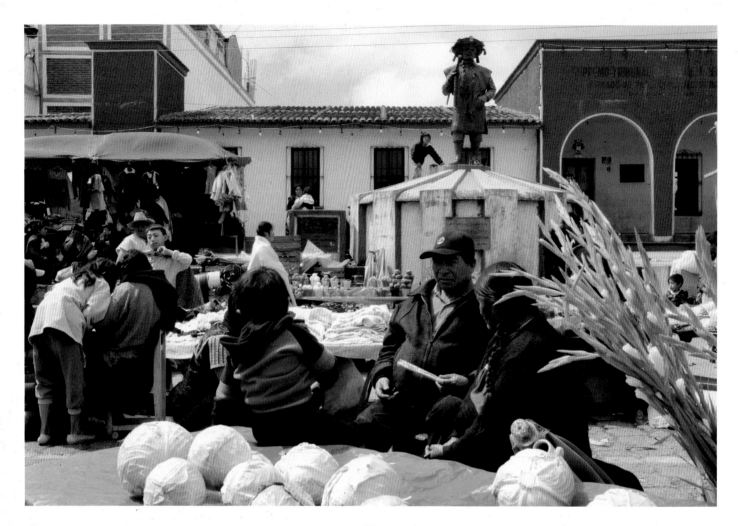

CHAMULA 🌐 16°47'N 92°41'W

TZOTZIL

A thoroughly modern uprising

It is market day in Chamula, and the vendors crowd the great plaza. Despite the noise and crowds, this is a relatively calm day in this small city in the Chiapas highlands. The stands are packed with neat mounds of produce and other foods. There are vegetables and fruit from local farms, and freshly-killed fowl for those who can afford it. The women wear colorful local costumes that they have woven themselves. It is pretty unlikely that these colorful clothes would be bought or sold. Here, only tourists hand out money for things, and tourists do not always come to shop here at the market. Still, every now and then, like today, a minibus drives slowly by. Look! A minibus for tourists only! Hopefully, they are in a generous mood!

It is usually calm in Chamula, the administrative city for both the district and the southern Mexican state of Chiapas. Most tourists prefer to travel to San Cristóbal de las Casas, a large city further south. It was there, on January 1, 1994, that the uprising of EZLN (Ejército Zapatista de Liberación Nacional = Zapatista Army of National Liberation) first began. Pictures of the native peoples the Mexicans call indigenas, heavily armed and keeping guard while chomping on bread and drinking coffee in the streets, were sent out around the world. Many of the photos were taken around Chamula – and many of the rebels were Tzotzil.

The ancestors of the Tzotzil, and the closely related Tseltal, entered the high-lands of Chiapas some two thousand years ago. There, they split into the two groups, each defined by linguistic differences so minimal that both groups understand each other very well. The first Spanish settlement was founded near San Cristóbal in 1523. The Spanish were the first to describe the Tzotzil and Tseltal as separate groups.

Almost five hundred years of colonial oppression lay before them. The Spanish and their successors saw the indigenous peoples as a source of cheap labor, best exploited in coffee and sugar plantations in the lowlands. The long process of land reform slowly brought the indigenous peoples back in touch with their origins. In 1940, revisions of the original reforms

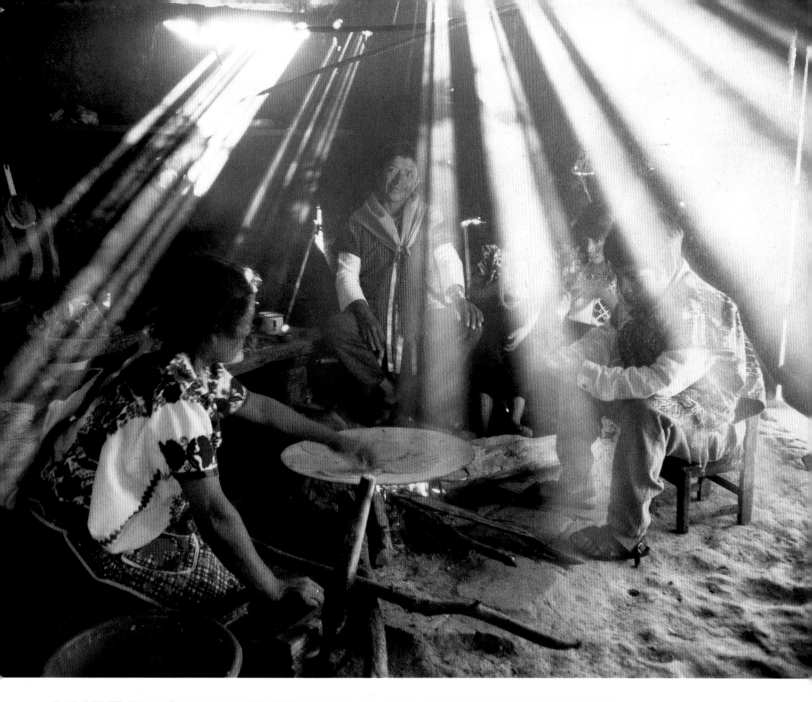

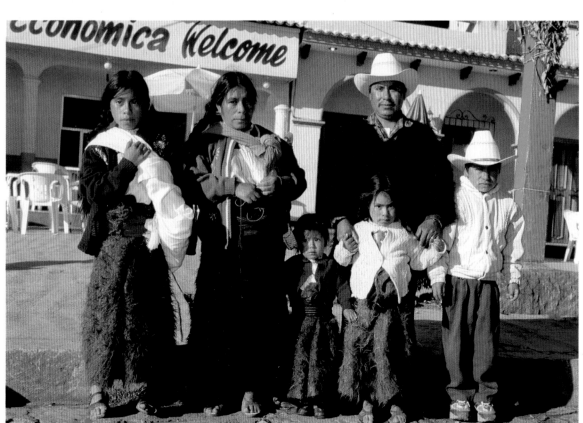

On the market in
Chamula
FAR LEFT.
The visiting of the
market is an event
for the whole family
from the hinterland
LEFT.
Housing conditions
far from running
water and electricity.
Chiapas was always
one of the poorest
regions of the
country TOP.

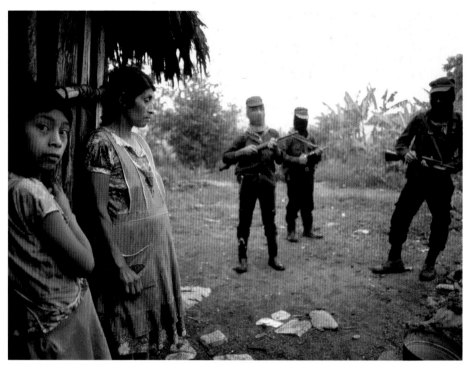

The rebellion of the Zapatists brought changes TOP LEFT AND RIGHT. Since then, Chiapas is a synonym for rebellion. One of the many murals in the village Taniperla BOTTOM. It was reproduced in the entire world and can be seen on house walls in a few cities.

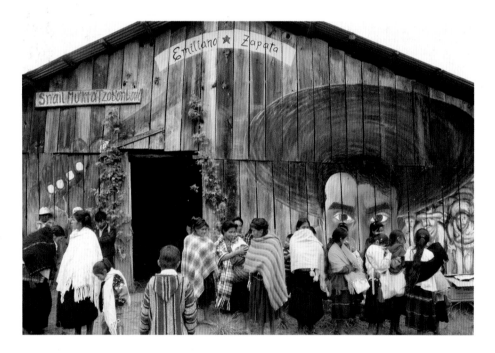

promised to return the Tzotzil to their original lands, which, however, were now much smaller in area than the natives claimed they should be.

January 1, 1994 was a decisive day for the Tzotzil, Tseltsal and other indigenous groups in Chiapas. For the first time, they were able to show Mexico and the entire world that they, too, had rights, and were prepared to take up arms to achieve them. Led by the polyglot Sub-Comandante Marcos, a man who only appeared in public with his face masked, the Chiapas region rose up. It was the first revolution that began twenty-first century uprisings, where the roar of guns is recorded as a sound file to be broadcast on the internet.

HERE & NOW

More than 300,000 people in Mexico and a few hundred more in Guatemala speak Tzotzil, a Mayan language. They make up the sixth largest linguistic group in Mexico. Most Tzotzil speakers live in the northern part of Chiapas, Mexico's southernmost state. Farming, poultry and sheep-herding make up most of the local economy. The Tzotzil trade eggs and meat, and weave wool from their sheep to make most of their clothing. Some fine woven goods are also offered for sale. Their traditional households have been to a large extent dissolved by the economic necessity that forces many Tzotzil men to work as itinerant laborers in the nearest big city, leaving their families behind for long periods of time. The Tzotzil have, for the most part, held on to their religion, despite enormous pressures from missionaries dating from the Spanish Conquest onward. Father sun and mother moon are the most important deities. Other indigenous groups that have managed to retain their own religion and myths have tended to live well away from the blessings of the modern world. Nowadays, Chamula and Zinacantán are easily reached via roads connecting with the Pan American Highway.

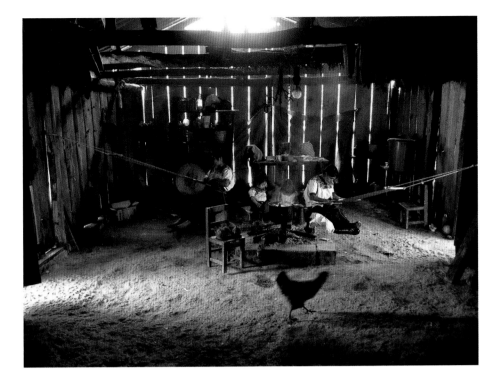

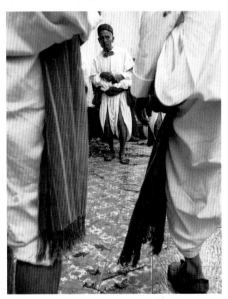

Weaving mill in prehistoric style in Oventic TOP. Tzotzil women in Zinacantan TOP LEFT. Dance of the eldest in San Miguel Huixtán RIGHT.

For weeks, the world's media trained their cameras on Chiapas.

At first, Mexico's reaction was unsettled. Over the next year, the government discarded their divide-and-conquer plan, deciding to focus instead just on »conquering.« The armed soldiers stormed deep into the Chiapas highlands and killed without rhyme or reason. The victims broadcast offers to negotiate via international news programs, but the government refused to comply. In 1998, Mexican paramilitary units slaughtered forty-five Tzotzil in a church near the village of Acteal. With his program of land reform and women's rights for indigenous peoples, Sub-Comandante Marcos was celebrated like a pop star around the world, without anyone ever having seen his face.

The Zapatista uprising did not result in justice for the indigenous communities of Chiapas. The Tzotzil are still as poor as ever, and Mexico's upper classes continue to look down on the southern states with pity and disgust. The Zapatistas did manage to light a beacon of hope. The uprising was a sign to the world that progress is not just something that comes from large organizations in big cities. Small steps along the way can lead to the same goal. Other indigenous groups have, since then, sat down with the Tzotzil to learn from them. The Sub-Comandante, who is neither Tzotzil nor Maya, has in the meantime become a walking advertisement for indigenous politics.

MAX ANNAS

SAK TZEVUL
– INDIGENOUS, WITH CATCHY TUNES

Rock Tzotzil is the buzzword when the band, Sak Tzevul, steps up on the stage. In 1996, the brothers Damián und Enrique Martínez, at the time just nineteen and seventeen years old respectively, formed Sak Tzevul in the Tzotzil city of Zinacantán just two years after the beginning of the Zapatista uprising. Their goal from the very beginning was to give voice to the indigenous peoples of Chiapas. Most of their songs are sung in Tzotzil, but they also sing in Spanish, so as to bring the problems of their people to a larger audience. The Martinez brothers believe that Mexicans should finally start taking notice of their battered fellow citizens in the South.

Sak Tzevul's music is contemporary guitar rock, influenced by the Seattle grunge sound popular in the United States in the 1990s. Sak Tzevul also gives indigenous melodies a place in the spotlight, a sound grounded in the village and city life of Mexico's southern states. Traditional instruments, including flutes and percussion, play an important role. The band often plays live in Chiapas, sometimes with other local bands that take a more traditional approach. In southern Mexicao, the Sak Tzevul musicians are superstars and teen idols. With their catchy songs and connection to the drama of the Chiapas uprising, one would think they would have little difficulty selling themselves to the rest of the world. Yet, the six CDs they have released so far sell outside of Mexico mainly as curiosities.

www.saktzevul.org · www.myspace.com/saktzevul

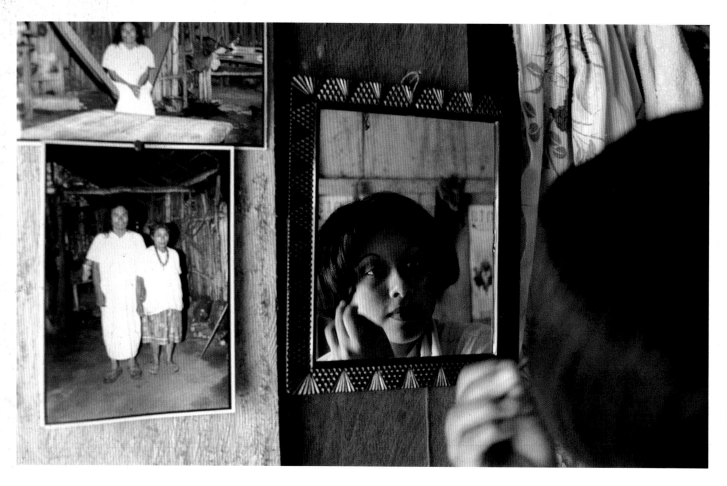

LACANDON

Among other peoples' ruins

Dressed completely in white, a man paddles across a quiet river. Large trees and thick fern growth cover the shores; and the kneeling man, using his oars to cut through the water, seems to be completely in his element. Obviously used to the movements, the man slowly, steadily pulls the oars, moving the boat forwards – it is apparent that he is no amateur. In some ways, Ricardo Chambor Kin resembles an ambassador. He represents the Lacandon people from Chiapas in Mexican television. The message of the exactly one-minute long commercial rings loud and clear – come visit the Lacandon Jungle.

Not many Lacandons exist nowadays; it is doubtful there were ever very many to begin with. While their number was unknown in earlier centuries, it is probable there were more than the current estimate

of 500 to 1,000 Lacandons alive today. They still live relatively remotely, either in the eastern part of the most southern Mexican state Chiapas, bordering Guatemala, or sometimes even on the other side of the border. The Lacandon Jungle is almost impenetrable, one of the densest and best-preserved jungles of Middle America; the Lacandons represent one of the most secluded communities in the whole land. Why would the Lacandons be involved in a television commercial? What is Ricardo Chambor Kin trying to sell?

He runs over a narrow wooden bridge, hides mischievously between two tree trunks, peeks out to share his message on tape, and stands tall in the dusky twilight of the jungle. Carefully rocking a small child in his arm, he poses with an indigenous family in front of a tree

trunk, so thick that ten people could barely encircle it. Ruins are briefly shown, before the camera sweeps over the lush dark green valleys. In the last five seconds of the commercial, an attractive woman in full Western attire appears, summing up the true message of this commercial – Come to Chiapas, come visit the Lacandon Jungle, come as an ecological tourist!

The Lacandons are true survivors. They fled the Spanish conquest and retreated in small units into the inhospitable mountainous region, known today as Chiapas and the Guatemalan province, El Petén. Up until the mid-20th century, they lived in complete seclusion, as far away from the Spanish invaders purporting divine and royal mercy as from successive Mexican governments. The Lacandons are, thus, the only Mayan community that

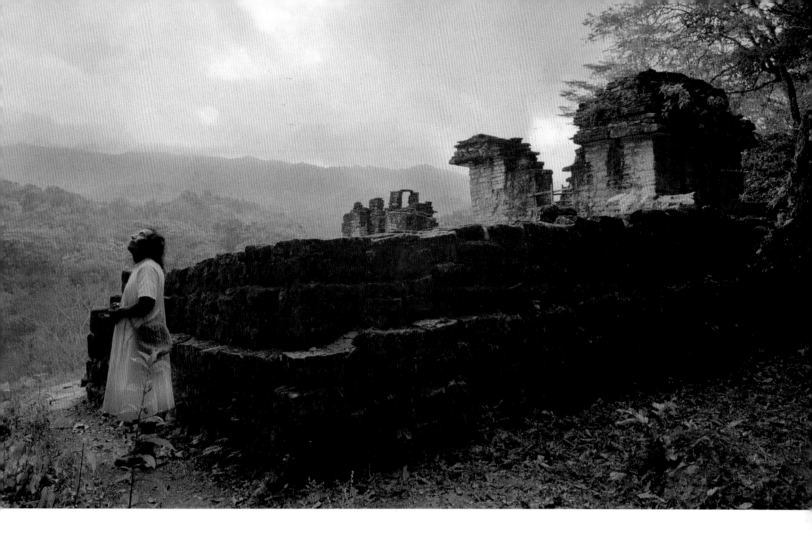

Teenie puts on make up. She admires the pictures of her ancestors and treasures soap operas LEFT. Maya is still a magic word. Near the ruins of the Maya temple of Bonampak, tourist offers have settled TOP. With the tourists, work, money and electricity arrive BELOW.

Lacandon couple. Many men promise their wives to avoid the temptations of the cantinas TOP. *Father and son in the campamento Lacanja* RIGHT.

can rightfully claim to have never been ruled by the Spanish conquerors.

In the latter half of the 20th century, the Lacandons were believed to be the direct descendants of classical Mayan culture. Several reasons were given. First, they live in proximity to the ruins of Bonampak, which, while not the most important of all historical Mayan sites, are significant for their unique murals. Second, some of the villages had never been exposed to Christianity in spite of

HERE & NOW

With 1,000 members at the most, the Lacandon population, while growing, remains quite small. Around 70 extended families live in several communities in Eastern Chiapas, the far most southern state of Mexico. Even though the Lacandons were still largely true to their own religion when the outer world became aware of their existence, great changes have taken place. Just like in other indigenous communities of Middle America, Christianity has left its mark. Not only evangelical branches, but also Catholics are gaining increasing influence. The Lacandon community has not succeeded in maintaining their secluded lifestyle over the past three decades. While their economic basis is more or less tied to nature, the outside interests are not, which has led to the exploitation of the natural habitat and,

has thus damaged Lacandon daily life. Lured by short-term financial benefits, the Mexican government gave woodworking companies permission to fell the woods. When oil prices rose, the government could afford to make reservations, where felling wood was prohibited. However, the principle reason therefore was the rain forest and the environment, not the Lacandon people and their habitat. At the same time, roads were built to make the Lacandon Jungle more accessible. Today, tourism is currently the most profitable sector in the land of the Lacandons. They themselves participate by making and selling handmade goods, hunting kits and woodcarvings to the usually Western tourists.

Salesman in a tourist shop. With the white garment of the Lacandon, he presents himself as the descendant of the Maya. He left the rainforest centuries ago. The shop is at the entrance of the national park Palenque, one of the most impressive places of worship of the Maya.

their relative distance from one another. In fact, the Lacandon religion did not even contain syncretist elements at that time. Lastly, the Lacandons were admired for their ability to survive in this remote forest region. The latter was ascribed to their Mayan roots and reinforced by the fact that the Lacandons still identify with the Mayan culture depicted on the walls of the ruins.

In reality, however, things are probably quite different. In fact, the Lacandons only became an ethnic group after their flight from the Spaniards. Their origins can be traced to various peoples from the regions that are now known as Mexico and Guatemala. The smallest common denominator is the dominant Mayan culture prevalent in that region. The variety of their cultural baggage dwindled in the high forests of Chiapas, merging into a completely unique culture, which was founded on the basis of their common roots.

The famed survival techniques of the jungle immigrants consisted of cautiously approaching the fairly inhospitable environment. For centuries, the principle of sustaining the environment determined how resources were used. For this very reason, the Lacandon Jungle contains countless rare species of flora and fauna. Indeed, it is a true jungle.

In 1996, the Zapatista revolt powerfully raised awareness of the region. During the first months of the revolt, the rebels' statements were always labeled as a declaration from the Lacandon Jungle. The Zapatistas, who actually inhabited the more populated regions near Chiapas, thus sided with the Lacandons, involving them in a battle for more rights for indigenous communities.

The Mayan ruins, which can be briefly seen in the commercial, are those at Bonampak. The famous murals are painted on over 470 square feet (144 square meters) and date back to the classical Maya period (300 to 900 C.E.). Aspects of Mayan life, the lives of Mayan nobility and blood and human sacrifices are depicted. The Campamento Rio Lacanja is located just a ten-minute stroll away. It is a role model for ecological tourism, and takes the needs of modern-day life into account, including a restaurant and current communication technology. Ricardo Chambor Kin is the owner of this establishment. With this commercial on Mexican television, he hopes to attract visitors to his environmentally friendly hotel.

MAX ANNAS

Natural Medicine

Samuel Hahnemann (1755-1843), the father of homeopathic medicine, silenced the critics of his novel treatments and healing methods with the memorable phrase: »Who heals, is right.« Although the envious quacks could say nothing in return, Hahnemann's insight was not at all new.

Who heals, is right

Life ends in death, but in between birth and death come injuries, wounds, disease, suffering, infirmity and lingering illness. These maladies have been mankind's companions since the beginning of time. At least as ancient are healing potions and treatments designed to heal or lessen the symptoms of those afflictions. All medicine originates in nature, with the world of plants the primary source. Today, in our technological world, almost 70 percent of all drugs available at the local pharmacy are in part or entirely of natural origin. The late twentieth century propensity for chemically synthesized medications is now well past its peak, and many of the most promising techniques like gene splicing, and other bio-technological innovations have failed to fulfill their potential. Today, the large pharmaceutical companies send scientific investigators into the rain forests of Africa, Asia and South America. There, scientists look over the shoulder of indigenous peoples when they are mixing up their medicines, and make the best use their knowledge.

The exploitation of medicinal plants by international pharmaceutical companies has raised protests from those who consider their actions nothing less than bio-piracy. Human rights organizations have accused the industry of applying for patents for naturally occurring plants, animals and genetic material in order to secure exclusive rights to both the raw materials and their therapeutic implementation. This monopoly on traditional healing knowledge could lead, in extreme cases, to the actual »inventors« of the drugs, the aboriginal peoples themselves, having to pay pharmaceutical companies to use their own medicines.

The medicines used by aboriginal peoples are effective on two different levels: the physical and the spiritual. While most indigenous peoples are familiar with a whole range of pharmaceutically active substances found in leaves, flowers, rinds, grasses, herbs, and fruits, not all illnesses can be cured by these elements alone. Of equal significance are the medicine men, shamans and other traditional healers. These are the people who administer natural medical treatments in the context of familiar rituals. With the ritual still an important part of the lives of traditional peoples all over the world, the medicine man or shaman serves as doctor, psychologist, and spiritual counselor, all at once.

There is no herb against AIDS

The traditional healers of the Sangoma in South Africa have an enormous task ahead, one from which they can also hope to profit: the disease HIV. Known in many parts of Africa as the much-feared »three letters disease,« the skyrocketing incidence of HIV/AIDS has halved the life expectancy in countries like Zimbabwe from 60 years to just 30. Just as Apartheid finally came to an end, Death, in the form of the HIV virus, rounded the Cape of Good Hope and settled in South Africa. Throughout the years of Apartheid, herbal cures had been scorned in favor of preventative medicine and hospital cures. As AIDS raged throughout the country, traditional tribal healers found themselves called on once again, in part because only they could promise the impossible. They also caused many of their patients to doubt that AIDS was the cause of so much death. As the medicine men saw it, an evil spell brought on the symptoms, not a virus. Many traditional healers live by the motto: »You cannot escape danger, but only pray and go on doing what you always have done.«

In many African states, the governing philosophy is too often »the politics of the stomach,« a phrase used to describe the endlessly irresponsible cycle of self-enrichment controlled by the elite ruling classes. To exert pressure on the opposition, many politicians turn to black magic, which most Africans refer to as witchcraft. In practice and reality, African witchcraft goes hand in hand with the healing, or white, magic. Healing and curing are culturally

Cataloguing medicinal plants. Natural healers, specifically in India, increasingly are moving from rural regions into the cities, where they practice their profession in modern medical offices.

related to an individual group's concept of nature. As such, attitudes toward healing are profoundly ambivalent. For example, the Maka in southeast Cameroon believe that the power of witchcraft, which they call djambe, resides in the belly. It is djambe that gives witches the power to cast spells. At the same time, djambe, when directed by a traditional healer called a Nganga, can also cure disease. With this kind of worldview, good and evil are explained as having the same source. Depression and disease, epidemics and civil wars; djambe lies at the root of everything. In extreme cases, a vicious cycle ensues. Anyone can call on black magic and cast a spell, which those, who suspect a spell has been cast on them, will try to counteract by going to the Nganga for another spell.

In societies like this, a group's traditional healing customs continue to play a major role in their belief systems. The healer's special abilities rest on the solid foundation of his or her deep knowledge of local plants and animals. The healer also knows his patients well. A responsible healer mingles with his potential clients daily, and is therefore well aware of the stresses and recent events in their lives. The local community is usually all too ready to confess their transgressions and violations of taboo to the medicine man. The patient can expect a straightforward diagnosis like: »It is obvious that you have upset your ancestors in some

The healer has special knowledge

way.« In practice, the healer not only prescribes natural medical preparations, but also the appropriate accompanying rituals. These might involve sacrificing a pig, or chicken, or paying out some kind of a settlement. Traditional healers also take care to mend uneasy or disruptive relationships, thereby restoring harmony to the community at large.

What can a healer do if social inequality and envy are threats within the community? Are medicinal plants and magic hands up to the job of curing these diseases of civilization? The Yoruba living in the Nigerian capital of Lagos rarely venture back to their tribal homeland out of fear of awakening envy in their former community. At the same time, if they do not return, they can be subjected to curses sent their way either because they have chosen to stay away too long, or because they have not taken care to send back adequate gifts. In order to

Thonga natural healers in South Africa. This sangoma and his helpers are sacrificing a goat. Ritual animal sacrifice in the presence of the community can be an indispensable part of cures for individual patients.

protect themselves, the Lagos Yoruba purchase expensive fetishes and, for advice, visit an entirely new generation of urbanized healers. These men and women work in modern offices adorned with academic certificates. A prospective patient might find them paging through western scientific magazines. In principle though, both the urban healers and their patients are following in the same tradition as the healers on the global periphery.

CHRISTAN ROLFS

Healer in Salvador, Brazil. Receptive music therapy was already known in antiquity. All the patient has to do is listen. The magic and mystique of music can cure by calming the patient, or by sending the patient into a trance.

KAQCHIKEL

Simply modest

A Kaqchikel woman highly advanced in pregnancy, in Santa Maria Cauque, Sacatepéquez. The direct descendants of the Maya distribute over several departementos in the central highlands of Guatemala. They mostly rank among the social marginal groups.

There is barely room to move at the market in Sololá. Like every Tuesday and Friday, traders have laid out their produce: tomatoes, onions, bananas, mangos and citrus fruit. However, several funfair attractions have drawn more visitors today than usual to Sololá. The little merry-go-rounds are half empty because most of the children want to try out the mini Ferris wheel. Barely 13 feet (4 meters) high, it is not driven by complicated technology but by the muscle power of two young men who keep it turning slowly but surely. The children are delighted: this is the biggest Ferris wheel they have ever seen.

The small town of Sololá is the capital of the Kaqchikel, situated high above the deep and icy Lake Atitlán in the Guatemalan highlands. Most of its 20,000 inhabitants are Kaqchikel Indians, a group of people that goes back many thousands of years. In the 8th century, the Mayan culture, from which the Kaqchikel descend, was at its prime. Numerous small states between the south of what is now Mexico and present-day Honduras had contact with each other; they traded together or waged war against each other. The Mayan kingdom was already declining when the Spanish landed there at the beginning of the 16th century; only the community of the Kaqchikel and that of the rival Quiché maintained their status. The Spanish played the two groups off against each other and soon had the region under their control.

The number of Kaqchikel at the time of the Spanish conquest can only be estimated. However large the population once was, contact with the Spanish not only robbed them of their independence. The diseases they introduced into the country seriously decimated the population of the Atitlán Lake region. A modernization wave in what was already known as Guatemala in the 1930s connected the region and its people with the rest of the world thanks to the construction of a network of roads. However, the roads promoted the interests of big landowners who were able to sell their products more successfully and exploit the Kaqchikel, like all the indigenous groups in the country, as a cheap and powerless source of labor. The poverty of the indigenous inhabitants is clearly apparent at the market in Sololá; the people wearing traditional Mayan dress are still waiting to participate in the politics of their country.

MAX ANNAS

All Hallows. Cities like Sololá have a market twice per week during holidays. For the indigenous population of the hinterland, the market is not only a possibility to trade; booths and fairground rides are a get away from day to day life.

HERE & NOW

There are fewer than a half a million Kaqchikel Indians today; they live almost exclusively in the small west-Guatemalan department of Sololá whose capital has the same name. The soil in the region is extremely fertile, which is why extensive areas of mountain forests have fallen victim to progressive erosion in the last few years. Apart from produce grown for their personal consumption, the Kaqchikel grow coffee. Revenue from tourism is also gaining importance as Lake Atitlán and its three neighboring volcanoes become increasingly popular with individual tourists. The town with the largest number of hotels, Panajachel, is known colloquially as Gringotenanga.

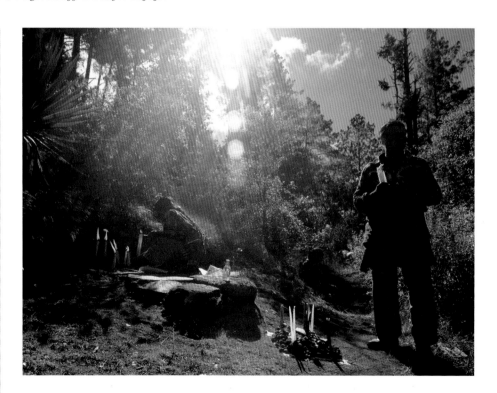

Ancestral rites of the Kaqchikel in the high forest near Sololá. The natural religion influenced by the Maya is still practiced in the high lands, even at rising competition to the Christian church.

The two men pull their boat onto the shore and unload their catch. Lobster, crab, small shellfish of all kinds and fish of various sizes. The haul from their fishing trip is spectacular only in the eyes of people who normally buy their fish at the store. On Wichub Wala, one of the larger of the otherwise very small islands of the San Blas archipelago, this splendor is mere everyday stuff. There is hardly anything to eat with ones coconut rice other than fried, boiled or grilled fish or seafood. But the men can make as

KUNA

Fresh fish versus fine handwork

much effort as they like. The daily catch does not make them the chief breadwinners of their families. Here, they are outwitted by the women.

The Kuna reacted very early to the colonization of wide areas of Latin America by the Spaniards, and retreated from what was their territory in the north of Colombia to the Caribbean coast of present-day Panama. According to other sources, wars with other indigenous groups were the cause of their retreat. Then again, it was the fault of the countless mosquitoes that the Kuna once again resettled collectively, on the archipelago near the coast.

Early on, the Kuna had struggled hard to gain minority status within Panama, which itself was fighting on several fronts for its independence: in 1821, it split from Spain, in 1903 from Colombia and in 1999, at last, definitively

from the USA. As early as the mid-19th century, a certain degree of self-administration by the Kuna was tolerated; in the 1920s, they tried with the support of the USA to attain total independence, and since 1953, they have enjoyed wide-ranging autonomy in their region. For the Kuna, land is common property, social conflicts are also communally resolved, and they are famous beyond Panama for their success with traditional healing methods. In material terms, the women have already gained the edge where equality of the sexes is concerned, for it is they, with their molas, the colorful cotton fabrics with appliqué embroideries, who generate the major part of the family income. Not only do they do business with tourists on the spot; their needlework skills have long been on offer on the internet.

MAX ANNAS

HERE & NOW

There are some 50,000 Kuna in eastern Panama, while a small group lives in nearby Colombia. More than 35,000 Kuna are settled in the autonomous region Kuna Yala on the Caribbean coast, and the majority live on the offshore archipelago of San Blas, which consists of 365 mostly small islands, some so small that only about 10 percent of these islets are permanently inhabited. The Kuna economy is based on self-sufficiency and traditionally on trade in fish and fruit, of which there is abundance. The Kuna women's molas however have become the important commodity in recent years, an export hit. Despite their relative seclusion, the Kuna have always been open to trade relationships; they have also been notorious for their alliances with Caribbean pirates against partly common enemies on the mainland. The developing eco-tourism seems to be secure, since their land can be neither sold nor leased, and through their autonomy, they are able to retain sovereignty over this economic sector. Nevertheless, there are still conflicts in this paradise, particularly confrontations with the many landless people of Panama who are crowding into the sparsely settled Kuna Yala.

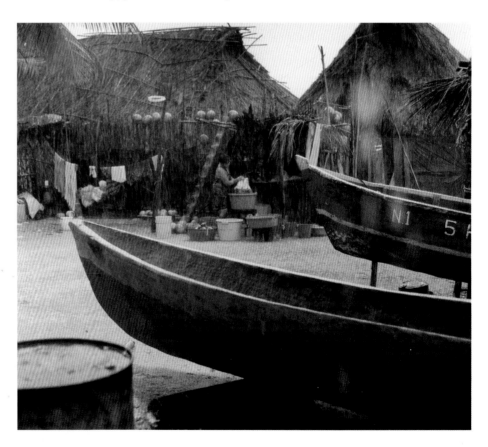

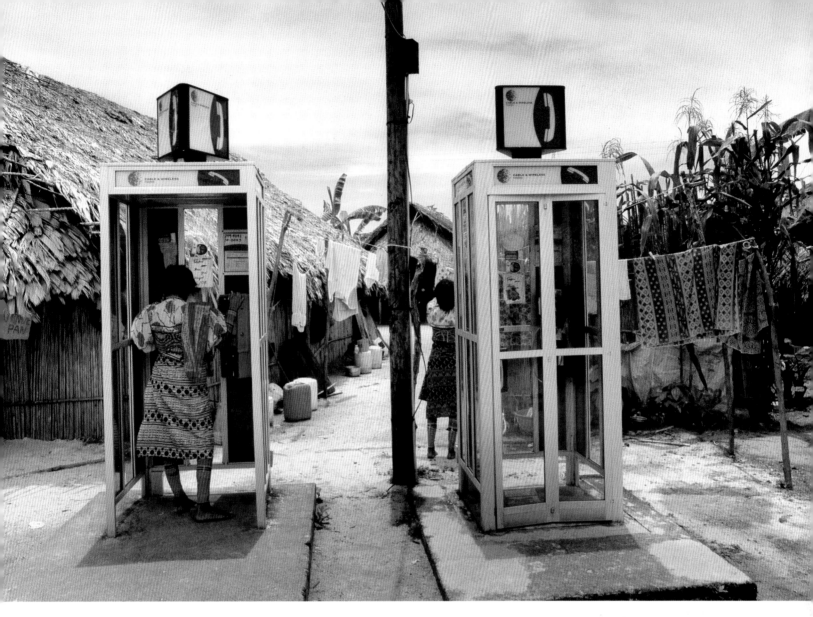

Boats are part of
the farm on the
San Blas Islands
like automobiles
elsewhere LEFT.
The numerous small
islands belonging
to Panama and
situated in the
Caribbean, are quite
secluded, but they
are not cut off from
the world TOP.
The women of the
Kuna actually wear
the fabric, which
they sell to tourists
RIGHT.

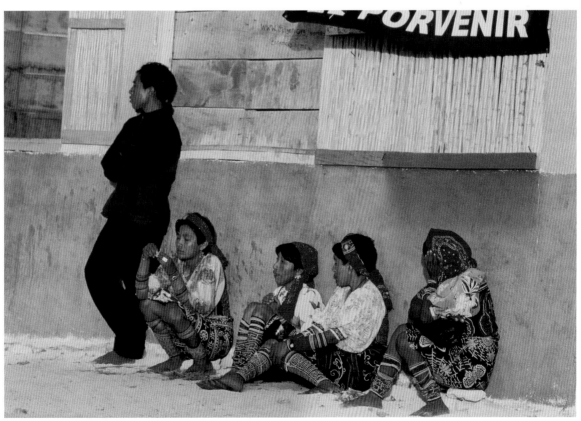

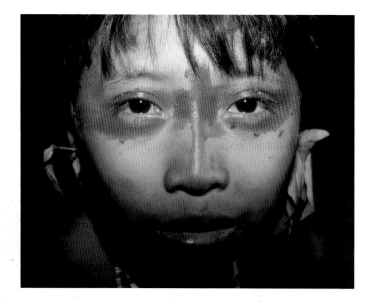

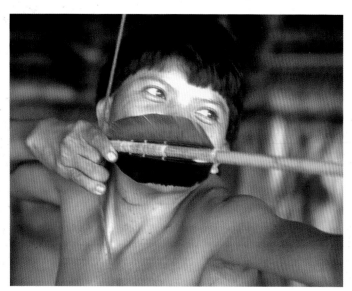

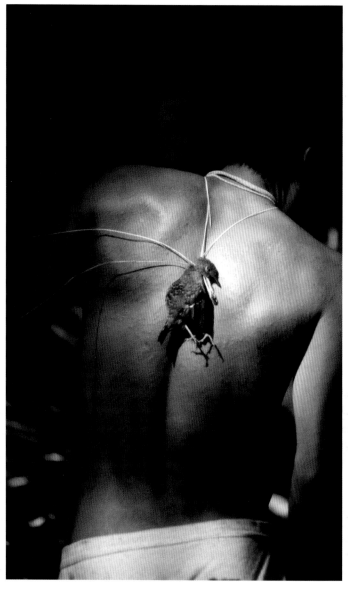

Yanomami in Tootobi. The red color as well as the foliage jewelry symbolize life while black is used in martial matters and mourning LEFT TOP. *Bow and arrow are tested in the Shabono* LEFT BOTTOM. *Hunter with prey. A broad road and path network opens up the hunting grounds* RIGHT.

YANOMAMI

Back and forth from perspective to interest

One of the oldest members of the tribe has died. The community is in mourning; all of the Yanomami have decorated themselves with Genipapo or soot. Mourning songs resound through the village. The shaman moves lightly; dancing through the rows, he is easily recognizable as the ceremonial master. The Yanomami death ritual is astonishing. When a member of the tribe dies, his or her corpse is burned. The bone remains are crushed into a powder, which is mashed with bananas and then eaten by the family members. Only this way, according to Yanomami belief, can the soul of the deceased be set free and begin the last trip to the other side.

With this ritual dinner, ethnologists even speak of endo-cannibalism, the former powers of the deceased are also assimilated into the community. Nowadays, the Yanomami territory is around the size of Switzerland. The Venezuelan side counts around 12,000 members, the Brazilian around 9,000. On both sides of the border, large family communities can be found; their lifestyle has remained the same for centuries. Up to one hundred clan members live in the round houses, known as maloca or shabono. This is the case, for example in Tootobi, in the Roraima region. All families live with their possessions under a huge lean-to roof, which is covered with big palm leaves. The walls consist of a woven construction of branches and green plants. Families usually group their hammocks around a single fire pit.

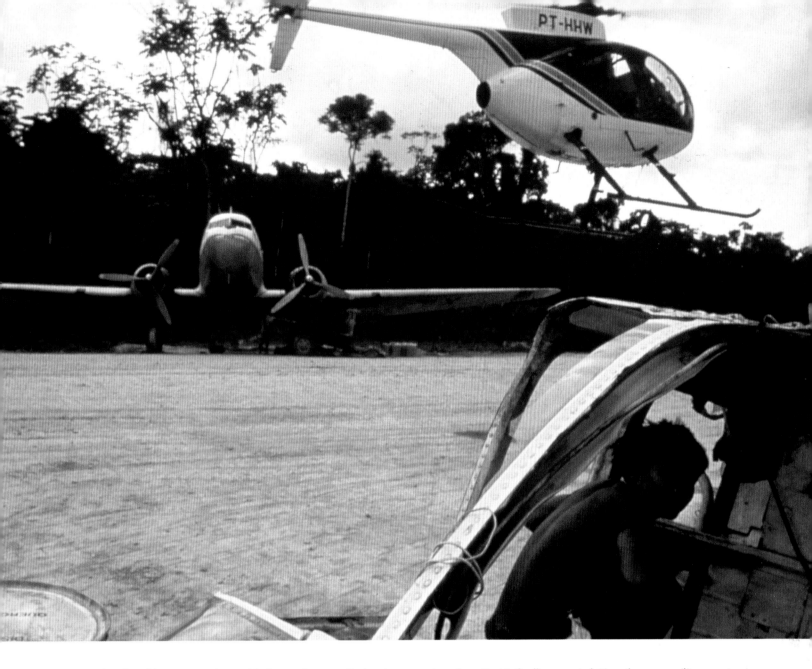

Runway at the edge of the Yanomami area. A helicopter has a medical assignment where the patient is finally evacuated. Since the 1970s, military posts, streets and runways move closer to the rainforest at the equator, with all advantages and disadvantages.

Should there be tension among the neighbors, the hammocks are simply pushed a little apart. Community life is, however, generally determined by a large amount of social justice and equality. Personal property and achieved wealth serve the community.

From the center of the shabono outwards, concentric circles extend into the forest area. In the first area, with a circumference of around 3 miles (5 kilometers), the women regularly gather fruits and berries from the forest. Plantains, sugar cane and manioc are also cultivated. Manioc is an important, starchy source of nutrition and also a medicinal plant – the young bulbs help

with all types of infection. At sunset and sunrise, small animals are also hunted here. In the second area, hunters/stake out their individual territory and gatherers will hike up to 6 miles (10 kilometers) through the woods looking for suitable roots, berries and other plants. The third area is reserved for the groups of hunters, whose hunting tours can last one to two weeks. Depending on the season, when certain plants bear fruits, entire families can go on hunting and gathering tours through the woods, which can span several weeks. These forays used to last several months and lead the Yanomami far away from the shabono. After increased contact with European and Western

civilization, however, the Yanomami slowly ceased these trips. They have become obsolete since the neighboring outpost of the FUNAI, the National Amerindian Foundation, have begun supplying the Yanomami with medicine and offered the possibility to conduct trade.

When a hundred people live in a part of the forest as described above, the game population needs time to recuperate. Even the soil, replete with nutrients in the Amazon region, needs time to regenerate. Generally, this is the case every four years. The Yanomami are role models in sustainable development in the jungle. After four years, they abandon the shabono. The Yanomami trek onwards, building a

village as far away as possible, establishing new concentric circles.

For the longest time, the Yanomami and their lifestyle remained undiscovered. The impenetrable and economically unattractive forest protected them from greedy gold-hungry Conquistadores, the conquerors, who left the Old World to raid the new one. Only in the first half of the 20th century did missionaries first arrive, followed by ethnologists and journalists.

The first ethnic pictures to go around the world show the natives, naked, staring into the camera. Ethnologists sometimes refer to the ›foreigner's first footprint,‹ which provokes long-term changes for the respectively ›discovered‹ ethnic indigenous group. The personal contribution to these changes often goes unmentioned.

In the case of the Yanomami tribe, it became evident that scholars directly affected communities by their work.

World-renowned scientists visited the Yanomami repeatedly, including Napoleon Chagnon, eminent geneticist James Neel, and Frenchman Jacques Lizot, a former student of the anthropologist Claude Lévi-Strauss. In all of Napoleon Chagnon's books and movies, the Yanomami tribe's societal behavior is marked by unbridled savagery. Lizot focused on the Yanomami's sexual activity. Are the Yanomami violent and sex-obsessed survivors from the Stone

Yanomami live in community houses offering room for up to 400 people. LEFT *A family hangs up their hammocks around their own fireplace and thus segregates themselves from their neighbors* VERY LEFT BOTTOM. *Mass in an outskirt settlement of the Yanomami* LEFT BOTTOM. *Mother with child after field work* RIGHT. *Every community builds their own Shabono* VERY RIGHT.

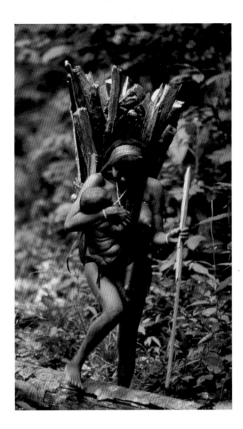

Age, willing to slaughter one another for women? When answering this question, one must keep in mind that each depiction and description includes the observer's position. No world exists independently from the pair of glasses through which it is seen.

In the 1990s, scientific journalist Patrick Tiemey disappeared into the jungle, following the traces of these hitherto acclaimed scientists and scholars. He visited the Yanomami and interviewed in addition to the Amerindians, missionaries and anthropologists in the surrounding regions. His research focused above all on the working methods of field scholars in the rainforest – and provoked a scandal long before his findings were published in 2000, with the title Darkness in Eldorado. Tierney claims that the indigenous population was horrifically abused. Earlier research had been falsified; depictions of the savagely violent Yanomami had been staged. In addition, he accused Chagnon and Neel of exacerbating a measles epidemic, from which hundreds died, in order to observe the principle of ›survival of the fittest‹ in a ›primitive‹ population. Shortly after the book was released in the United States

of America, a Task Force commissioned by the American Anthropological Association conducted an inquiry to examine the validity of Tierney's claims. Their findings supported that, indeed, the Yanomami are not brutal murderers, as has been claimed by some anthropologists since Chagnon, but also contradicted Thierney's accusation. The scholars were not held responsible for the outbreak of measles and ensuing epidemic. Were both sides thus truly rehabilitated?

Regardless of whether it is the initial contact with the scientists or the ensuing violent debates for or against this initial contact, they cause the spiritual balance of this forest community to tip. Yet, according to the Yanomami, it is this state of equilibrium, which is crucial as the source of survival and its drive here in the rainforest.

ALFRIED SCHMITZ

HERE & NOW

Up until 1973, when the Brazilian government began with the construction of the road Perimetral Norte, the indigenous people of the rain forest lived unthreatened, as they had for the past 300 years. From 1980 onwards, Yanomami life was marked by blood and death. When gold and uranium were found in a neighboring region between Venezuela and Brazil, unadulterated gold fever broke out, bringing murder and death to the tribe. In 1993, a full-blown massacre provoked worldwide protest and shock. Up until then, gold hunters could easily invade the rain forest territory between Orinoco and the Amazon, lay forest fires, persecute and kill the Yanomami, import diseases of civilization and pollute the rivers with mercury and other chemicals. The Brazilian government finally took action. Gold digging was restricted by law, the Yanomami were given around 37,300 square miles (60,000 square kilometers), where they have lived since 1996, under the protection of the FUNAI. Around 20,000 indigenous people live scattered in 350 village communities.

Shamanism

In 2004, the agendas of a total of 14 shamans marked the date of the International Congress for Shamanism und Healing, in Mondsee, Austria. In all, over 400 participants attended the congress. Doctors, healing practitioners, psychologists, psychotherapists and open-minded alternative healers hosted shamans from five different continents. The main participants came from Korea, New Mexico, Norway, the Swaziland steppe, the Delhi Moloch and the Guatemalan rainforest. Human beings get sick; their souls hurt. They look for help. Someone from the community can talk to spirits and the gods; he or she knows how deal with herbs and look deeply into the patients' souls. Seen from outside, shamans comment on things they have no way of knowing. Held in ecstatic thrall, they commit acts that seem like wonders and defy conventional medicine. Shamanic success is usually due to shamans and patients agreeing with each other. They live in unspoiled nature; their village or camp is far from the next city or hospital. They speak the same language, the same dialect that few understand. Above all, they work together during the healing ceremony, in a way that their brothers and sisters agreed upon centuries ago.

They do this free of charge, for, according to custom, it would be immoral to gain profit from divine gifts.

Shamans and patients agree with each other

Nadja Stepanova traveled to the congress in Mondsee, Austria. Born in Buratia on the Lake Baikal during the time of Soviet communism, she has been aware of her ability to contact gods and spirits from a very early age. During the Communist rule, atheism was the norm. Shamanism was prohibited in Siberia and Inner Asia. After Perestroika, the long-lost culture experienced a revival. Today, Nadja Stepanova is president of the Association of Shamans and member of the Council on Religions in Buratia. In addition, as an anthropological scholar, she now chairs the Department of Shamanism at the Cultural University of Ulan Ude.

Stepanova is not an individual case. In addition to the original typical representative in rural areas, shamans are now found in cities, usually well trained, many even with academic degrees. Shamanic and healing services are no longer free of charge. In Siberia, in particular, shamans have become stylized symbols of the post-Communist identity and ethnically fill the ideological gap left by the demise of the Soviet Union.

Even if the circumstances differ, Middle and South America have noticed a revival in shaman practices as well. Tourists traveling to Ecuador receive ›invitations‹ every step of the way. Shamans advertise ritual one-to-one sessions, loud and garish colors are used for the posters hung up in villages and cities. Indigenous organizations invite tourists to participate in a celebration of the Indian Solstice, Inti Raymi. The main attraction is the ritual washing in sacred springs, the pugyos. Several shamans are needed for the procedure, which takes place in front of an interested and well-paying audience. Strangely enough, the cleansing rituals correspond to traditional healing rituals, both in regards to the sequence and the elements. Ethnologists discovered this when comparing these tourist attractions with the shamanic and ethno-medicinal practices of the indigenous communities. In the entire Andes area, different schools of shamanism could be found, whose cosmologies and worldviews differ considerably.

House of a Shaman of the Nganasan in Ust Avam in Siberia. In Soviet times, Shamanism was criminal; due to the isolation of the island Tamyr, the Nganasan did not really mind.

In her main work, the Mundo Ankari, comprising two cycles and six volumes, the Andes scholar Ina Rösing documented the Kallawaya rituals. Often, el susto – the great fear – is mentioned. This phenomenon is only known in South America. Patients suffer from sleeplessness, anemia, and diarrhea; often they are overly sensitive to sounds and are in the full throes of depression and lethargy. The Kallawaya see el susto as a loss of the soul. Their ›large soul‹ is their life; the ›small‹ one could be compared in Western cultures to the psyche. The small soul needs particular care and can be easily lost when humans are scared, such as at the sight of a wild animal, when lightning hits or, quite simply, when meeting an evil spirit. Often the soul remains frozen where the individual was frightened. Both the patient and the healer work through the history and go on a journey together. Ultimately, the shaman tries to convince the soul to return through a sacrifice. Conventional doctors ungrudgingly admit that shamans show great healing success, in particular, for emotional suffering and chronic illnesses, such as rheumatism and migraines. Often, the traditional medicinal explanation, therefore, is the Placebo effect, a form of healing that is based on the imagination instead of chemistry. Even how the healing is staged seems to play a role.

Even tourists become patients

Shamans have always taken on several roles: not only that of a healer, but also one as a cultural mediator. The latter has become of increasing importance in the era of globalization. Shamans continue to be medicinal experts, yet perform their rituals to the public as well. When their services are required in the United States, they travel gladly to South American immigrants, who honor them as healing experts and remunerate them accordingly. Many shamans are active in indigenous organizations; quite a few even attend the General Assembly of the United Nations. Sometimes, others merely become spokesmen for other organizations or events, such as the Ecuadorian campaign Shaman on Tour. Before the world tour in 2006, one shaman blessed the German soccer stadiums – ultimately attempting to tempt tourists to Ecuador. The yellow press complained, stating ›Now he has cursed our stadiums!‹ Whether those responsible had foreseen this form of interpretation remains to be seen. For in the world of soccer, a competent and cosmopolitan medicine man from the rain forest is reduced to a simple sorcerer.

»Shaman on tour«

HENDRIK NEUBAUER

»Shaman on tour« in Frankfurt on the Main, Germany before the European Soccer Championship in 2006. The Ecuadorian Tzamarenda Naychapi sanctifies the stadium with the ritual of the waterfalls and the sounds of the sky.

Market in Otavalo in Ecuador. The man from Yantzaza in the rainforest calls himself a Shaman and advertises his »miracle cures.« The true medicine proves itself in the work with the patient.

ZOÉ

Trustingly defying death and the devil

When the surveyors get up in the morning, they suspect nothing. It is the summer of 1976 and they are preparing for the building of the federal highway BR 210, which is to be built straight through the federal state of Pará in the north of Brazil. In the course of the day they come across longhouses of open construction. A moment later, arrows hail down on them from the forest. They flee in their helicopter and observe the scene from the air: Indians, all with a strange sort of peg in the middle of their faces, battering a bag of equipment that had been left behind.

This was the first documented contact of the Zoé with the outside world. What had immediately caught the attention of their discoverers was the striking feature called a poturu, a lip-plug up to 6 inches (15 centimeters) long. Women, men, and even children from their eighth year on wear the plug, made of light-colored wood, with which the lower lip is pierced. Only someone who wears the plug is a Zoé, and thus, in their view of the world, a human being, created by a god of the forest. This tradition probably developed out of the desire to frighten their neigh-

bors and keep them at a distance. At any rate, that is what ethnologists presume.

It was not long before the existence of the Zoé was put on record. The National Foundation for Indians, FUNAI, got wind of the encounter and sent forest rangers out to search for them. They reported that any further contact would be too dangerous for the Zoé. The Zoé withdrew back into the primeval forest. The authorities declined to allow mineral oil companies who had already obtained concessions for the area to carry out further work. The road was never completed.

The enclave had fended off the first attack, thanks to FUNAI, although the Zoé gave the credit to their forest god. Their living area remained, for the time being, untouched. This corresponds entirely to their world picture: such a thing as a concession which grants rights to their land is

an absurdity to them, for the land belongs to no one. Their clans are divided among villages, which lie many days' marches apart. They gather fruit and honey, and live mainly on the manioc that they cultivate themselves. Ground into flour, the otherwise poisonous tubers can be made into nutritious flatbread.

In the dry season, almost without clothing, the men set off on the hunt. Each of them claims his personal hunting path. With deadly precision, the homemade arrows hit a monkey, their preferred target, which abound in the densely crowded treetops. The dead monkey is a mother animal, with a baby still clinging to it. Carefully, the hunters capture it and take it with them into the village. There, it will later be kept as a family pet. Often, a Zoé woman will suckle a baby monkey along with her own baby. If an area is used

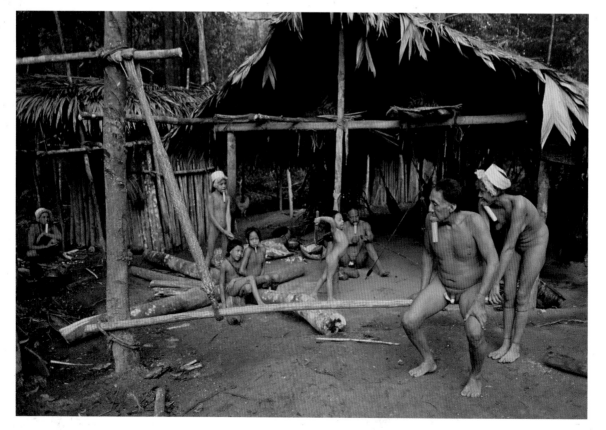

Zoé are hunters and gatherers. Their villages are in the middle of the rainforest; the societies consist of roughly a dozen families, who all live in individual huts. The forest is the stomping ground of the men RIGHT. The women collect plants of the forest and cultivate tapioca. Here, the tapioca is worked with a press in order to get the juice out LEFT.

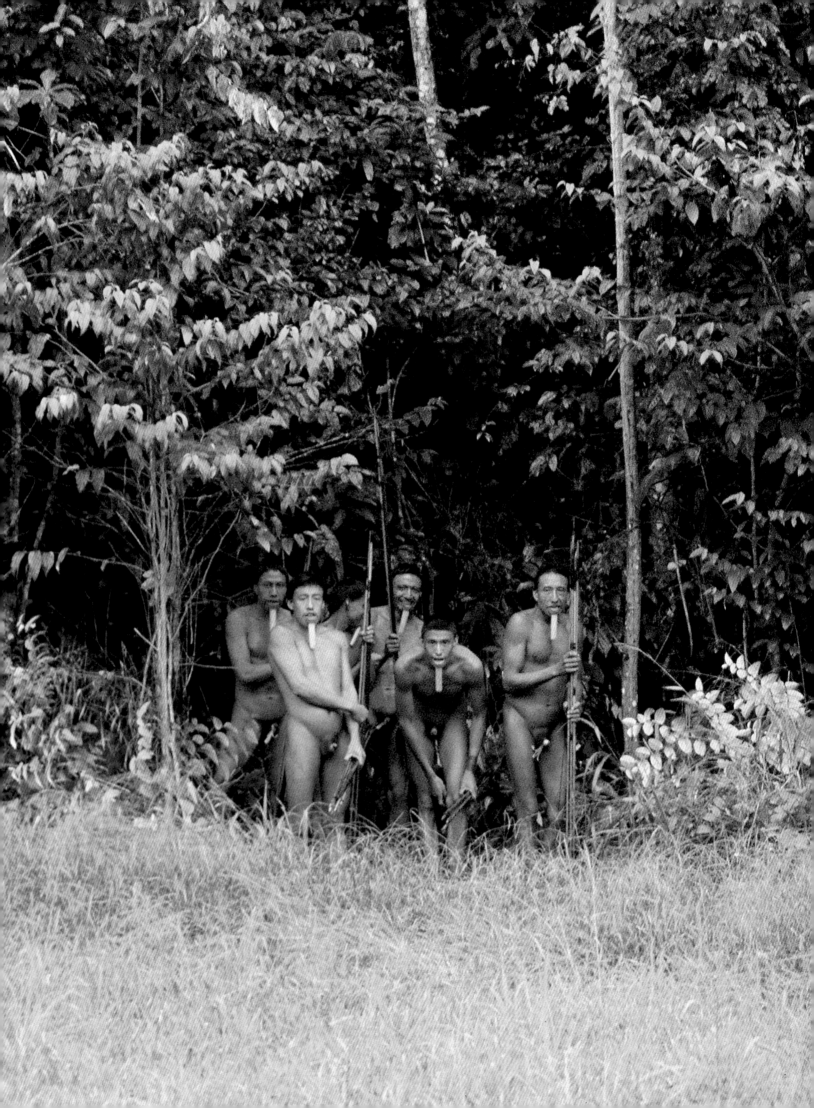

The Zoé are considered Isolados. Contact with them is highly regulated by the FUNAI since 2000 LEFT TOP. *Men and women carry out mutual personal hygiene* RIGHT TOP. *The Zoé, whether young or old, bathe in the river several times a day* RIGHT.

up in the truest sense, the semi-nomads will give up their terrain and move on. Continual management is in any case a law to them.

Despite the peace of the forest, the Zoé would have made the headlines. And in Belem and Santarem every new discovery of these retiring people in the expanses of the jungle is a subject for discussion. Here, not only engineers and gold prospectors gather, but also missionaries from overseas. From here, they plan their forays in the name of the Lord. In 1982 they were ready. Missionaries from the »New Tribes Mission« penetrated as far as the Zoé, with the firm intention of converting them. With small aircraft, they circled over their villages and threw gifts to them, until the Zoé became curious. A commando-style mission station had already been set up nearby. This second contact of the Zoé with white people had devastating consequences: 46 Zoé died of influenza and malaria. In the seclusion of the rainforest, their immune systems had not developed any defenses against these illnesses. In order to uproot the nomadic groups, the intruders resettled the Zoé – in the direction of the river, in order to link the mission station more easily with civilization. Further epidemics broke out and spread rapidly. The missionaries could only watch helplessly as the number of the Zoé shrank to 130 members, who could in the end not look after themselves any more and became dependent on the alms of the missionaries.

Sidney Possuelo, the department head responsible for the isolados (uncontacted peoples) is said to have been furious when the events on the Rio Cuminapanema reached his ears. In Brasilia, it was thought that these isolados had been unmolested by trespass. Possuelo immediately took measures against the missionaries, and in the course of months and years almost hermetically sealed off the area of the Zoé for their protection. Now he was faced with the task of resettling a thoroughly sick ethnic group in the primeval forest. For a start, they were gathered together in fifteen longhouses and their medical care was secured. Today, first-class outposts and medical stations ensure that the Zoé, even if severely ill, need not leave the forest. The missionaries had not only brought diseases, but their alimentation meant that the families could no longer

HERE & NOW

Today some 240 Zoé live in relative isolation in the federal state of Pará in northern Brazil. Their language belongs to the Tupi-Guarani family, which is the origin of words such as »jaguar« and »Carioca,« the name generally given to the inhabitants of Rio de Janeiro.

Officially, no one is allowed to enter the 624,000 hectare area, since 2001 designated as an Indian protected area. They belong to the four indigenous groups that are still considered as isolados or uncontacted people by the Brazilian National Foundation for Indians, FUNAI. Apart from other indigenous groups, they have contact almost exclusively with the staff of the authority, which ensures that their medical needs are met, and supply them with machetes and flashlights. They themselves produce all other objects that they need to survive in the forest. Mining entrepreneurs, woodcutters, and missionaries are to this day forbidden to enter their protected zone. Their future is entirely dependent on the security of these areas.

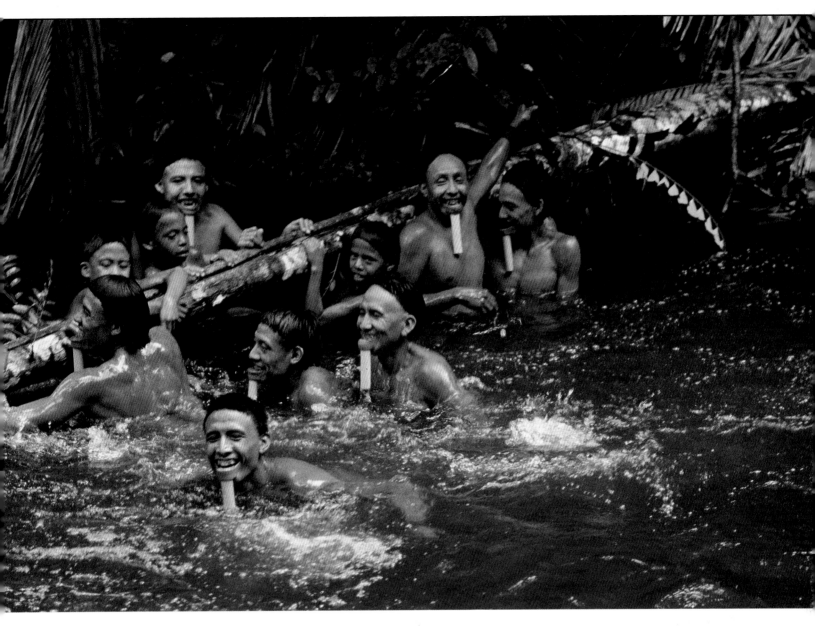

easily look after themselves. They had to relearn hunting, but the over-large population in too small an area soon led to a shortage of game. Such a large village could not live on berries and fruits alone; they needed enough protein to get well. Only slowly could they return to their old life and recover from their contact with the missionaries – always under the watchful eyes of the FUNAI officials.

In 1993 Chief Waiwai of the Waiapi Indians, who had been first contacted some 20 years earlier, traveled to the Zoé bringing videos which demonstrated the decline of their own culture through the contact with white people. For the Waiapi, who also speak a Tupi-Guarani language, the visit to the Zoé was like a journey in time back to their past, now forever lost.

The resulting documentary film Meeting Ancestors by Vincent Carelli documents the suffering of the one group, while demonstrating the potential of the other.

Why should the Zoé not stay in the rainforest? After all, today, it still offers the Zoé everything they need for survival. Not even a trace of resignation or even xenophobic traits are to be found in them, despite all the hardships they have endured. Roland Garve, a German physician, who has made more than 60 expeditions to indigenous ethnic groups, sums up his two visits to the Zoé: »I can say today that the Zoé are the most likable people I have met anywhere in the world.« This is generally confirmed by the few visitors who are allowed by the authorities to travel to their region, today only

after a careful medical checkup. They report on the openness and cordiality of the Zoé, and their great interest in touching the strangers and seeking physical contact with them. Yes, indeed, the Zoé are trusting, in the best sense of the word. For that they need their own space – their forest.

LAURA ENGEL, HENDRIK NEUBAUER

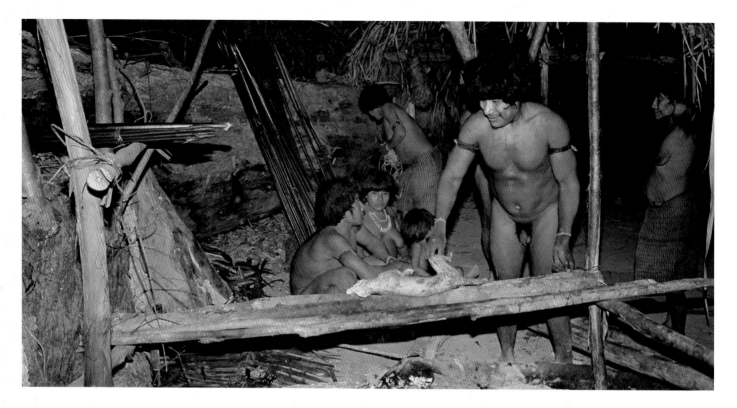

MARANHÃO ⊕ 2°46'S 46°28'W

AWÁ GUAJÁ

In the forest of smiles

When the Portuguese sailor, Pedro Alvares Cabral, set foot on the land later to be known as Brazil on April 22, 1500, north of the present port of Porto Seguro, the world of the native inhabitants, who at that time numbered some 5 million, was still in good order. Today, their descendants number barely 250,000, and their environment is in far from good order. Among the remaining ethnicities are some 300 members of the Awa Guaja still living in the northeast Brazilian federal state of Maranhão, one of the smallest and least researched groups of the rainforest.

Before colonization and deforestation deprived the Awa Guaja of their familiar lifestyle, they were settled, as they had been for centuries, in small village communities in the primeval forest. With the beginning of the destruction of their environment and lifestyle by the advance of the Europeans and their descendants into their areas, the days of their traditional village life were numbered. In the early 19th century, the Awa Guaja gradually became nomads. Today, the last survivors, consisting of 40 to 50 families of five or six members, wander through the forests, at most sparsely building a few simple huts in which they find sporadic refuge for a short time. They live on bananas, roots, berries, meat or fish – and fear white people so much, that for fear of discovery, they converse only in murmurs, constantly on the alert in the shelter of the thicket.

While the woman gather fruit, the men devote themselves to hunting, climb up to the top of a tree armed with bow and arrows in pursuit of a monkey, seek a good position high up for shooting and send two or three arrows into the almost impenetrable foliage. If this is followed by the sound of a body breaking through branches and twigs and a dull thud on the ground, their protein needs for the next few days are covered. Apart from monkeys, porcupines and turtles are on the Awa Guaja menu; but, in recent times, the hunt for game has increasingly been unsuccessful. Even the animals of the region are disappearing along with the rainforest, or retreating even further due to the noise of the freight trains clattering incessantly through Awa Guaja country. Since 1984, these trains have been transporting iron ore, copper, nickel, gold, and other natural resources from the gigantic strip mining area of Carajas to the port of shipment of São Luís, 559 miles (900 kilometers) away

In view of their history of suffering and the hard conditions of their life today, it is all the more surprising that the most striking characteristic of the Awa Guaja is their smile.

CHRISTIAN ROLFS

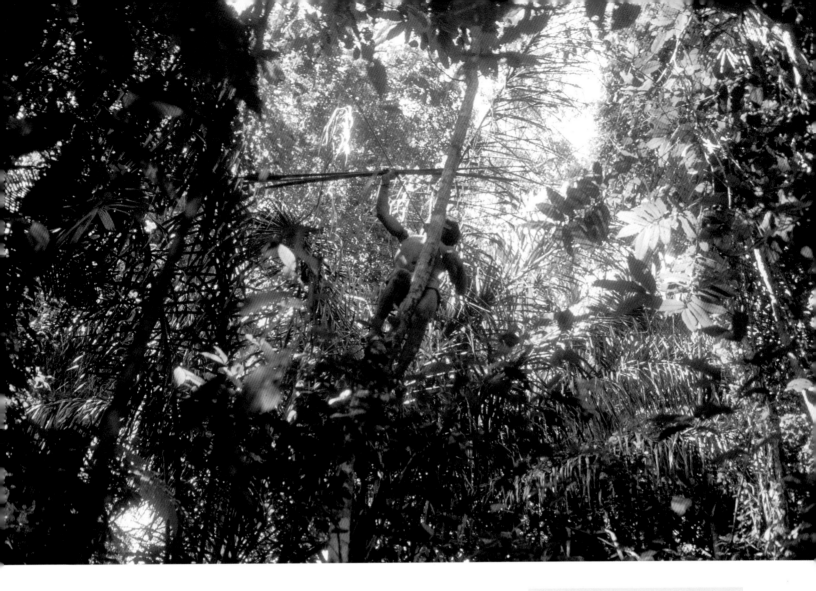

The days in which the Awa Guaja could regulary roast a wild pig on the fire LEFT, or shoot a monkey out of the treetops RIGHT, are surely gone. Land seizures and the iron ore trains that rumble through their territory have decimated local populations of rainforest animals ABOVE.

It is still not long ago that colonists, speculators, and mine operators used to send out headhunters, to whom they paid 60 US dollars for every Awa Guaja who had been killed. As yet, it is not known whether any of these murderers or their employers were ever called to account for their crimes. However, on account of massive pressure on the part of the World Bank, measures have been taken nationally to ensure that the Awa Guaja are no longer persecuted. Instead, they have become increasingly subject to illness such as influenza, measles, whooping cough, and tuberculosis, against which their immune systems are defenseless.

Since 2003, a reservation dedicated solely to the Awa Guaja has defined their borders, and guarantees them state protection at least within those borders.

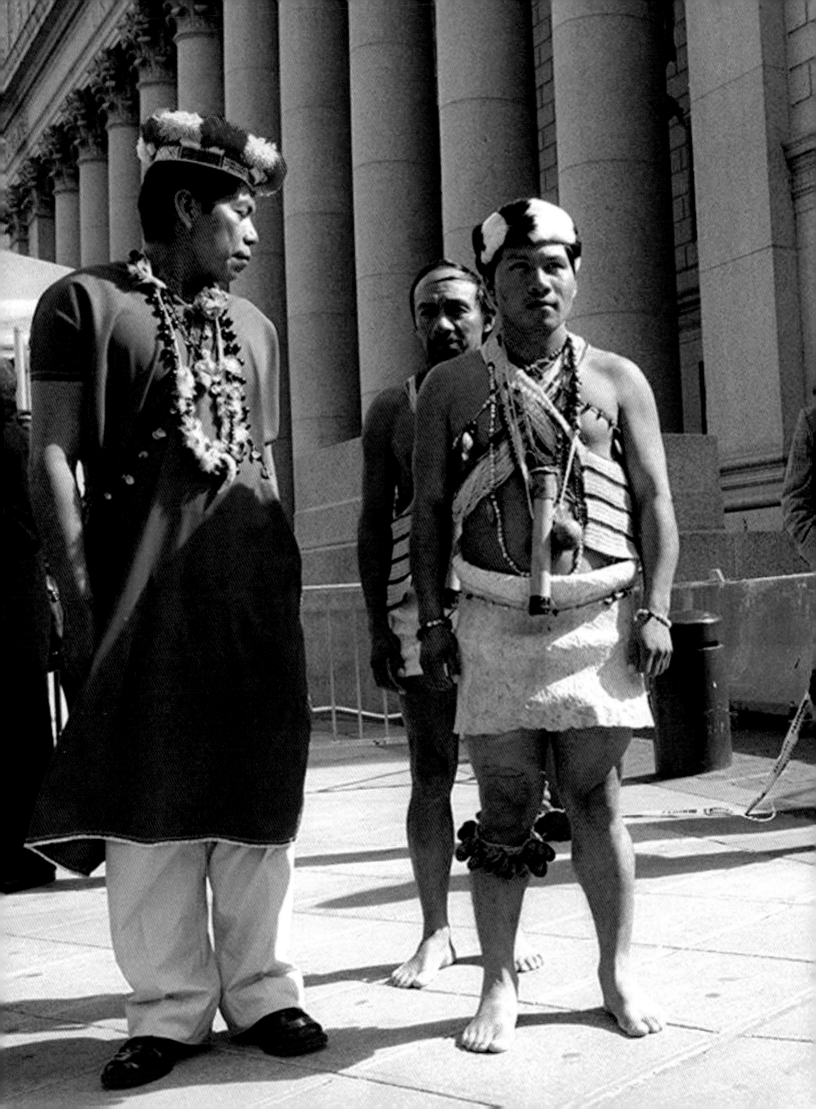

SHUAR

Shrunken heads, disappearing woods

Both of the old dancers approach each other shakily. The woman places each foot down, one after the other, and moves her shoulders in rhythm to the rattle. The man, to whom she has been married for decades, is less exposed. He walks, rather than dances, towards his wife, often missing the beat of the rattle. He carries a long gun in his extended right hand, holding it cautiously, as if it were the most important part of his dance. He does not put it out of his hand until the dance is over. Both sit back down without further ado, next to the children who remain silent in the dusky hut.

The old man's gun is a true relic. Here, in the Ecuadorian rainforest, miles away from the increasingly fast-growing city of Puyo, such weapons are no longer needed. Once referred to as the Jivaro by the Spanish, the Shuar were feared warriors; their hunting skills were legendary. Wars, however, are no longer waged in this region and the large animals that could be shot are no longer to be found here where the Shuar have settled. The old man's father still knew how to make shrunken heads, he knew the necessary secrets for the preparation and even had quite a few opportunities to conserve the heads of vanquished opponents. But today? Not

even small animals merit being shot, as the traps are more than sufficient.

The classic Shuar region corresponds more or less to the current Eastern Ecuadorian province of Morona Santiago, bordering Peru. The rainforest is rife with lush vegetation, the Andes and all rivers along the shore flow towards one goal – the Amazon Basin. The Incas were not very powerful in this region; in fact, they probably did not even seriously attempt to put down roots here. Various Shuar communities could thus lead their own lives; even the Spaniards seem to have largely ignored them. It is, however, possible that Shuar themselves forced both invaders to

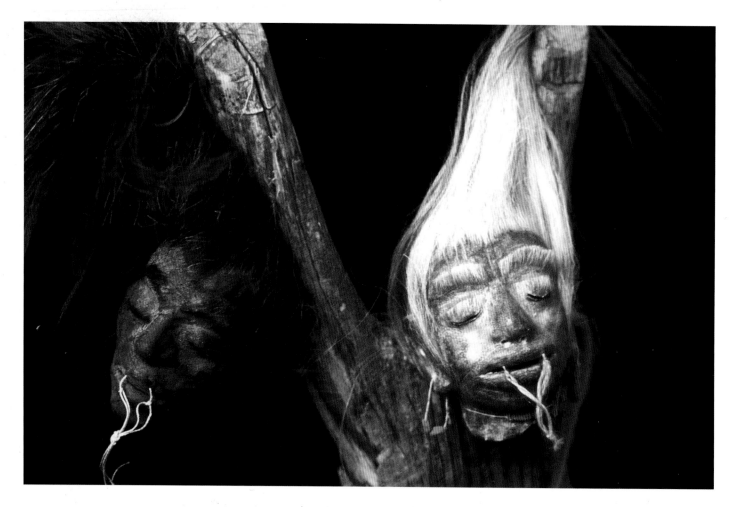

The shrunken heads of the Shuar are no legend. The community preserved their opponents this way until the 1950's TOP. *The mythic past lives on in ritual feasts. A hunter who still enjoys a high reputation in the Amazon cultures* RIGHT.

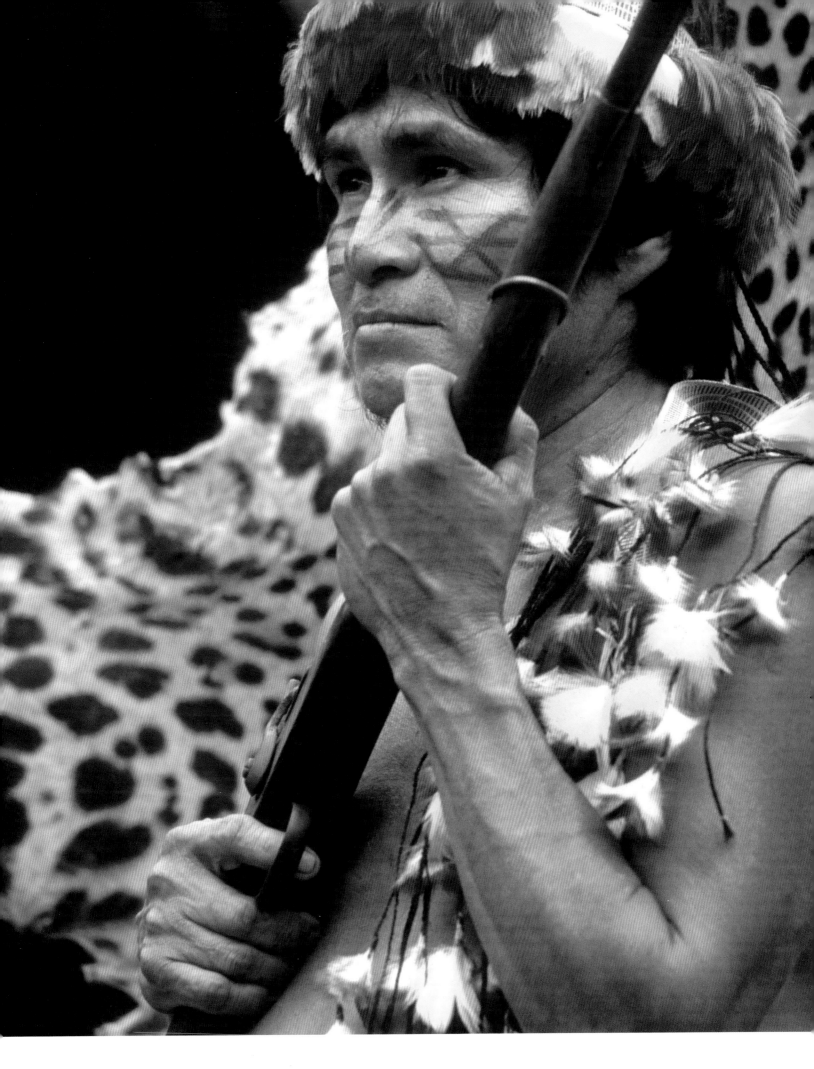

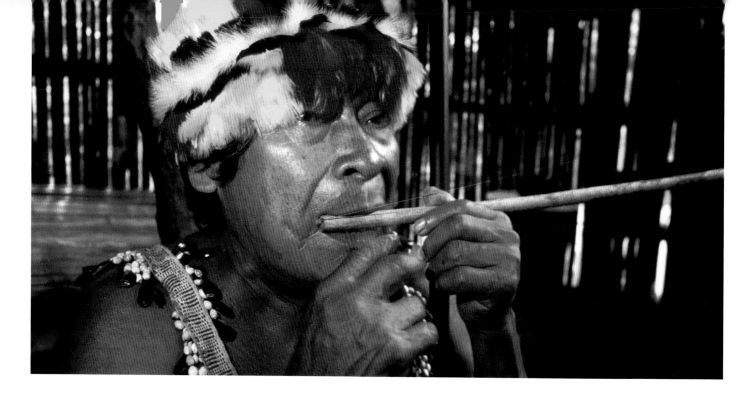

retreat. The only documentation in existence shows attempts to invade Shuar territory made by the Inca briefly before the Spaniards' arrival, and later, in the mid-sixteenth century, by the Spaniards themselves.

Having a reputation of being particularly brutal might have offered some protection to the Shuar. Heads of opponents killed in battle were shrunk, for the Shuar believe the souls of the dead can thus be controlled. Of course, this was interpreted differently outside of the Shuar culture. Even today, shrunken heads are seen as trophies, which only wild barbaric savages could create. Some contemporary articles still support this position. At any rate, the old dancer's father still practiced this type of soul possession. Nowadays, shrunken heads are only created for the tourists. Heads of captured sloths are usually used for this purpose.

MAX ANNAS

MOSES ASCH.
LISTEN, BE THERE

Moses Asch was not a Shuar, even though his name might seem to indicate the opposite. Born in Warsaw in 1905, he saw quite a bit of the world in his youth. Sholem Asch, his father – an author and one of the pioneers of Zion – journeyed with his family to Palestine, the USA and many other countries. Moe Asch, as his friends called him, founded the legendary Folkways Label together with Marian Distler in 1948. Until Asch's death in 1986, Folkways published more than 2000 albums, which initially covered the history of North American folk music and, in the 1950s, led to an unexpected revival from which musicians like Woody Guthrie and Pete Seeger greatly benefited. Asch was dedicated to bringing folk music back to the people. Increasingly, music from other parts of the world and not only from the USA, was included in the albums. No continent was too big, no corner of the world too far for people to refrain from recording music. In 1973, the Shuar were featured, under their colonial name Jivaro. The ensuing album was simply called Music of the Jivaro of Ecuador. Twenty tracks play music from daily life, as well as shaman songs. One track, Shaman Curing a Bewitched Patient (Male Solo, Whistling, Singing, Sucking, Leaf »Rattle«), includes sounds from a man who is obviously in an altered state of mind, humming monotonously to himself, with a little bit of rhythm and a few whistling sounds, which, strangely enough, resemble sucking sounds. Indeed, the shaman could be heard sucking out the curse, or better the person who had made the curse, from the ailing patient. The healer achieves his altered state of consciousness through a hallucinogenic drink he concocts out of herbs called Natema. The whistles are used to signal to the spiritual helpers that their aid is needed. Even David L. Mayers, a man who is not known for his verbal reticence, could only review the album on www.allmusic.com with the following words: »This is the music of a very interesting jungle tribe.« There are many ways to experience things unseen. Today, ultra-compact digital cameras have ensured that virtually all villages around the world are accessible to everybody. Nonetheless, this soundtrack from 1973 of a shaman at work is almost sacred. It becomes tangibly obvious that this music is not a game, but instead a spiritual ritual conducted by the Shuar. This was certainly a magical experience unlike any other before the computerized era. Nobody in those days, with the exception of plantation owners, anthropologists and the few brave souls working for Moe Asch, had any contact with the Shuar. Moe Asch fulfilled his personal mission by making the world accessible through music. Through music and through listening to music he proved that all men are equal – a truly noble mission.

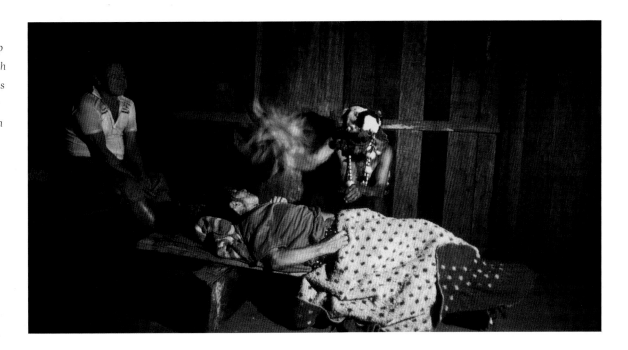

Archaic: the Shuar play the mouth harp LEFT*; they heal with established remedies* RIGHT. *Aggressive: 2002 demonstration in Nueva Loja. They demanded more security and social investments when building an oil pipeline* LEFT BOTTOM. *Ritualized roles: a woman offers the man Chicha beer* RIGHT BOTTOM.

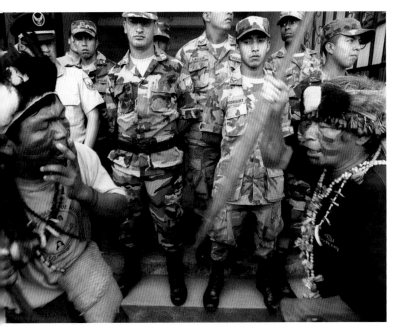

HERE & NOW

More than 100,000 Shuar are currently living in the tri-border region of Ecuador, Peru and Columbia. Ecuador probably has the largest number of Shuar inhabitants, at least 40,000 people. Shuar associations have counted 668 village communities in these three countries. Hunting does not play the large role it used to, mainly as the outer world is increasingly penetrating the jungle. Another reason might be that the Shuar have cultivated a significant amount of farmland. The rainforest was destroyed through slash-and-burn land clearance, destroying the natural habitat of larger animals. Grazing land was thus created. Raising cattle and tilling the land have transformed the lives of the formerly semi-nomadic Shuar to a more sedentary lifestyle. Urban areas in the Andes are springing up fast as a direct consequence. Of around 2,224,000 acres (900,000 hectares) that the Shuar see as their land, only 1,780,000 acres (720,000 hectares) officially belongs to them. Conflicts have been brewing for several decades with companies who drill for oil and contaminate the land of the Shuar. Oil makes up a considerable amount of South America's income. In 2000, a court in Macas, the capital of Morona Santiago, made the sensational ruling that the collective land rights of the Shuar were being violated by oil production. When contested, the original verdict was upheld. The battle, however, is not won yet. Each company which loses, sells the claims to another company, which then sues for the rights. In April 2005, Enrique Cunambi, the head of the largest Shuar organization, the FICSH, declared he had reached a settlement with oil production companies. This was, however, immediately contested, as he had acted in his best interests and not in those of the community.

QUECHUA

Listen up! Who is doing the talking here!

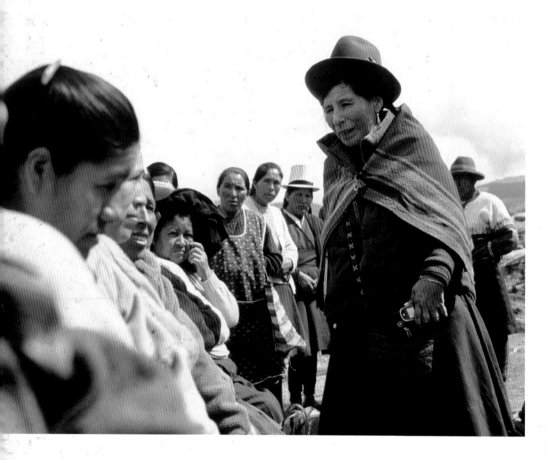

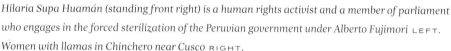

Hilaria Supa Huamán (standing front right) is a human rights activist and a member of parliament who engages in the forced sterilization of the Peruvian government under Alberto Fujimori LEFT. *Women with llamas in Chinchero near Cusco* RIGHT.

The highlands surrounding the Peruvian city of Cuzco are the former homeland of the Inca. The river rushes through the Izcuchaca district like it always has, but today is a very special day. Hilaria Supa Huamán is coming to this isolated valley with her committee members to hear what the Quechua women have to say. The women's accounts and experiences are similar, but it is the individual stories in which she is most interested. Supa Huamán is more than just a human rights activist; she is a good listener as well. A Quechua-speaker herself from the humblest of backgrounds, Supa Huamán not only speaks the language, but understands how the women feel. Now a parliamentary delegate in Lima, she leads the fight against programs that have led to the forced sterilization of hundreds of thousands of indigenous women in Peru.

The Quechua are the product of the intra-continental colonization of South America. By the sixteenth century, the Inca ruled an area larger than the northern half of the continent. Little by little, they conquered or exterminated other groups of peoples not as populous or powerful as themselves. This led to Quechua, the Inca language, becoming the lingua franca of the day. Most groups adopted the Inca language, but retained bits and pieces of their native tongue. This led to considerable variation in Quechua dialects, to the point that many Quechua-speakers still have difficulty understanding each other today.

There is as much variation in lifestyle as there is between Quechua dialects. Many Quechua groups practice collective

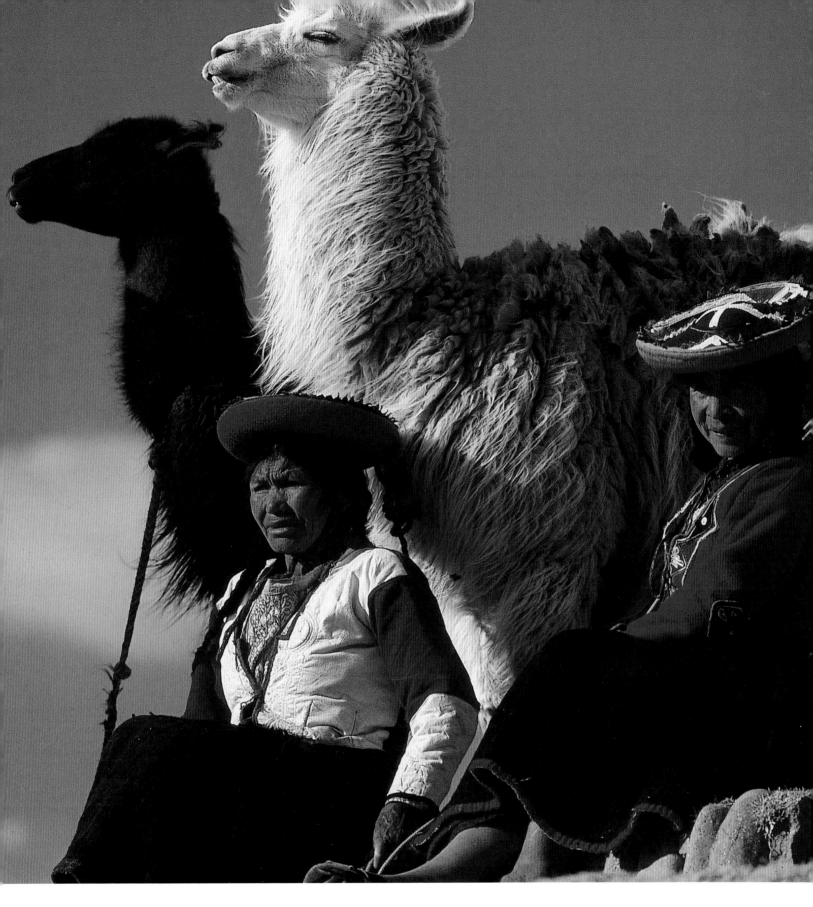

agriculture, much like the neighboring Aymara. Following hundreds of years of tradition, the community works together to farm the hillside terraces, valley floors and high mountain plains. Unsurprisingly, this lifestyle and the social structure that supports it collided with the economic and political aspirations of the Spanish conquistadors, and continue to clash with the economic policies of their successors, the South American nation states.

The struggle for some measure of autonomy and increased rights to their traditional lands remains at the center of the Quechua situation today. In the second half of the eighteenth century, the legendary rebel leader Tupac Amaru II tried to turn back the economic clock by discarding the monetary system in favor of a return to the traditional practice of exchange. The rebellion he led demanded

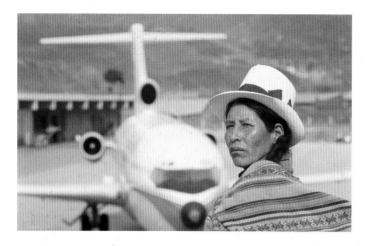
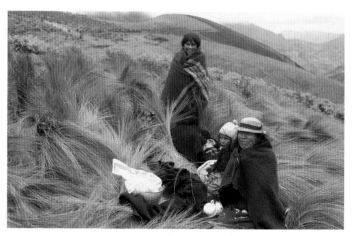
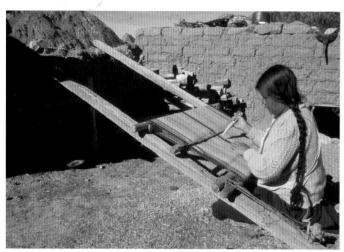
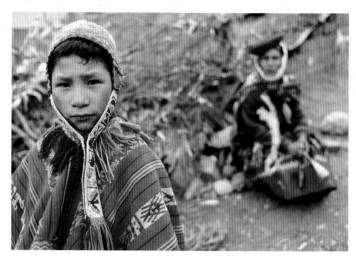

HERE & NOW

At least 8 million Quechua speakers live in Bolivia, Ecuador and Columbia today, with isolated groups in Argentina. Whatever the country, Quechua-speakers almost always live in the Andean highlands. There may be millions more. Population estimates are uncertain, with some giving a figure as high as 14 million. The term »Quechua« takes in a number of different groups, all of which speak the Quechua language in one of its many variants. At present, neither the experts nor Quechua themselves can agree on which dialect should be the mother tongue. There are numerous ethnic subgroups as well. Some have fewer than one hundred members, while others have a population of more than a million. One of the many effects of colonization by the Spanish is the near complete disappearance of the traditional religion in the wake of the Spanish conquest and its onslaught of Catholicism. Evangelical Protestant sects have also had some success in the region.

The oppression of the Quechua is not limited to the colonial period. During his 1990-2000 term as President of Peru, Alberto Fujimori instituted a sterilization program that made 363,000 Quechua and Aymara women infertile. In 2006, Hilaria Supa Huamán, a persistent opponent of these programs, was elected to the Peruvian parliament. She insisted on taking her oath of office in the Quechua language. The Speaker of the House, Martha Hildebrandt, a former Fujimori partisan, stood up in protest. While Quechua is one of Peru's administrative languages, it is only an official language in areas where Quechua speakers are in the majority. This means, of course, that it cannot be used in Parliament.

The airport in Cusco TOP LEFT. *Quechua family in the step of the Bolivian high Andes* TOP RIGHT. *Woman at a loom in Potosi, Bolivia* BOTTOM LEFT. *On the path of the weavers in the Patacancha River valley, Peru* BOTTOM RIGHT. *Market day in the Peruvian Apurimac* VERY RIGHT.

a halt to forced labor and the reunification of the Inca nation, which was cut in two by state borders. The tolls and tariffs applied as a result had ruined traditional trading relationships. Despite his failure, Tupac Amaru II (the name means »noble serpent«) is glorified to this day, in the Quechua region and elsewhere. The Uruguayan Tupamaro movement was named after him, and the rapper Tupac Shakur, murdered in 1996, also carried his name.

By the early nineteenth century, most South American countries had gained independence when Spain proved unable to control over its colonies. The elite classes of the newly formed nations quickly gobbled up all the land. Indige-

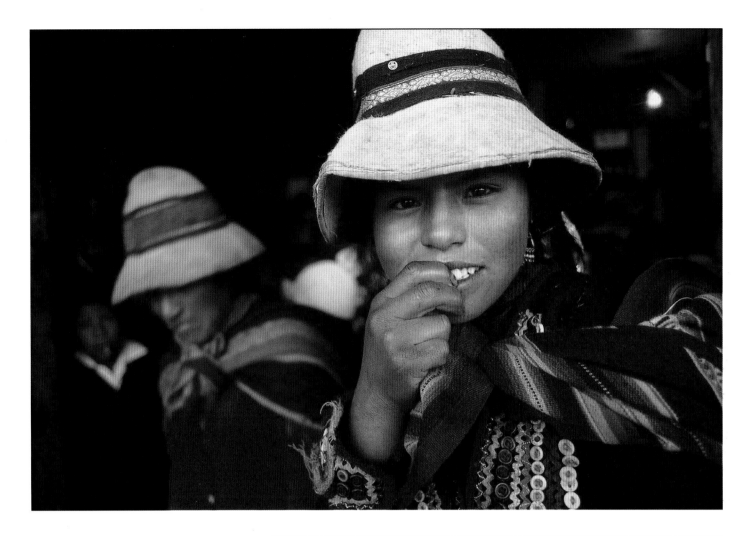

nous peoples were forced into positions of servitude as bonded laborers. In the late twentieth century, land rights were again dealt with from above, following the victory of military juntas in Bolivia in 1952, and Peru in 1968. The Quechua and other indigenous groups had next to no role in the decision process.

Despite worldwide attention and the efforts of definitive personalities like Hilaria Supa Huamán, the nations of South American are still not ready to answer questions regarding justice for indigenous peoples. The return of confiscated landholdings has been propelled to the forefront of the discussion by Quechua interest organizations like Ecuarunari, but new questions have been raised with the discovery of mineral wealth. The Quechua community of Sarayacu fought companies wanting to drill for oil on their land for many years, recently with some success. This will not be the last case of this kind.

MAX ANNAS

YMA SUMAC

Yma Sumac counts as one of the most mysterious of all show business phenomena. All that is certain is that she was born in 1922. Her childhood and youth remain shrouded in darkness. In the Quechua language yma sumac means something like »how beautiful.« A widespread legend says she is the offspring of a native Peruvian and a Spaniard, and that she grew up as a Quechua. Other stories claim she is an Inca princess.

In the 1940s, Yma Sumac's fame as performer in Lima was so great that people outside of Peru began to take notice. The inevitable trip to the United States followed. Upon her arrival, she established herself quickly with her memorable mixture of Andean folk music and complex orchestrations, usually arranged by Lex Baxter. Her band had a Latino-style brass section and lots of drumming. Very much in the foreground were Sumac's unique vocal talents, including, in her early years, a six-octave range. Later, she could sing around four and a half at her best. In the 1950s, she served the growing appetite for exoticism with a string of hit singles and sold-out performances. It wasn't long before Hollywood called. Yma Sumac starred in several B-movie classics like Secrets of the Inca. As her star dimmed later in the decade, she abruptly disappeared from sight. Her aura of mystery was preserved, with the only signs of life her increasingly rare performances and, later, CD releases. In 1998, her music rang out from the Coen Brothers film The Big Lebowski, and her most recent CDs uses beats from a mix tape. Once again, Yma Sumac has satisfied the tastes of the masses, whatever one thinks of her music.

www.yma-sumac.com

Fair Trade

Aboriginal people require more land proportionately than their fellow humans in the emerging and industrial regions and country. In fact, they use from ten to fifteen percent of the land surface area, but only account for four percent of the world's population.

This disparity is soon resolved when it becomes clear that the habitat in which they live is mostly in ecologically sensitive regions of the world: deserts or other arid regions, mountainous areas, cold polar regions, and rain forests. People from industrialized areas may well often find these regions extremely hostile, but they nevertheless greatly covet their mineral deposits or potential for harvesting primary renewable resources. International companies pounce on their extraction, mostly without respect for existing land rights and the environment, whereas the aboriginal inhabitants survive by adapting to the regions' specific conditions,

Aborigines stay, companies wander

and only take as much from this primal natural world as it can possibly give at the time. In addition, many of these regions are not only significant as habitats, but are also of considerable global climatic importance.

What is the situation, for instance, in the economic zones around the equator? Ethiopia's cultivated regions are well-known among coffee experts for producing excellent coffee. Arabica highland coffee with its aroma of berries, citrus, and spices is held in high esteem worldwide. The various coffee types bear names such as Harar, Sidamo, and Yirgacheffe. Coffee is Ethiopia's most important resource. Around 40 percent of the country's export income is obtained through coffee. About 15 million of Ethiopia's 71 million inhabitants live from the cultivation of coffee. Nevertheless, it is not a mass product but a specialty coffee.

Such cases call for Fair Trade concepts. They assist small businesses and farmers on the outlying areas that cannot produce on the same terms as large estate owners. If market forces

Some cases call for Fair Trade concepts

alone are allowed to prevail—the global market encourages the cheapest method of production and penalizes every more expensive one—then free reign is given to the depopulation of entire swathes of land and economic migration. It is for this reason that the International Labour Organization (ILO) promotes global strategies such as »Empowerment,« which means nothing more than providing the capability for economic self-determination.

In practical terms, this means small farmers joining together, as 86,000 of them in the Ethiopian province of Sidamo have done. Transactions are carried out by well-trained business economists. They ensure that growing areas become better known, create brand names, and—at best—curtail the amount on offer as demand increases, thereby ultimately achieving an appropriate price for a premium product. The cooperatives have to be able to deal on commodity exchanges on an equal footing with larger concerns. The new structures are beginning to have an effect, as recently, a cooperative from Sidamo gained the upper hand in a brand dispute with a North American chain of coffee houses.

Fair Trade not only serves to ensure the existence of indigenous peoples, it is sensible in ecological terms to emphasize this economic concept from an economist's point of view. Fair Trade is often accompanied by the reduced use of pesticides, maintenance of biodiversity, and sustenance of soil fertility. Technology is here a key factor: the approach combines both traditional and modern technologies, whereby the potential and interests of aboriginal peoples are fused together with those of the modern economy.

Where do we stand today? Worldwide, more than 1.6 billion Euros were spent on certified Fair Trade products in 2006, an increase of 42 percent from 2005. In the meantime, 632 businesses in 58 countries and 1.4 million farmers are participating. Today, Fair Trade is a steadily growing, although marginalized, factor (still accounting for less than 0.1 percent of world trade).

Are opinions changing? The holder of the Nobel Prize

Coffee roasting facility in Varginha in the Brazilian state Minas Gerais which operates under the Fair-Trade principles.

Fashion parade for ethically traded and ethnically influenced peachiness on the Parisian forum for fair trade in 2005. LEFT *Tea plantation in Makaibari, India. The teas of this plantation are produced ecologically sustainable and carry the Fair-Trade label since 1994.*

for Economics, Joseph Stiglitz, demands »Fair Trade for all,« instead of abandoning trade to market forces alone. It is becoming clear: the world has a problem with apportionment and not a resources problem. Perhaps this is the core on which everyone can agree. An increasing number of experts see balanced conditions for world trade through an institutional rearrangement as a decisive component of the strategy to shape ecological, social, political, and economic living conditions in a sustainable way. They see the alternative as being global, ecological collapse or increased inequality whereby the rich buy or extort access to resources; they call this Eco-Dictatorship or »Brazilianization.« Fair Trade is thereby not a raised moral index finger, but the only practical way forward. Global

economic currents require partners on the periphery. Unless, that is, we want to support half of the steadily increasing world population in the future.

Hardly any holder of public office on the international political stage dares risk such words as clear as those the former IMF director and President of Germany, Horst Köhler. He describes the grim alternative to global Fair Trade: „If Africa does not succeed in achieving development of its own, the results will hit us in the form of migration, diseases, and environmental problems, whether we want them to or not. We should realize that positive development there is in our own interest.« Perhaps the appeal to wealthy countries' selfishness will feed the determination to practice and

Partners on the periphery

support sustainable trade in the future. Obvious interaction between politics, environment, society, and Fair Trade make the work of advocates of Fair Trade increasingly easier. The Aboriginal peoples of today have a decisive advantage over those of the last century:

they have non-governmental organizations (NGOs) from Hammerfest to Cape Town on their side, loudly demanding the protection of the wilderness. They do so in their own interest, to prevent a climatic catastrophe.

SÖREN KÖPPEN

Peasants peeling coffee beans in Moshi, Tansania. In this region, small scale producers are offered the Fair-Trade program.

KAYAPO

Raoni – One for All

Kayapo at a ceremony in Pira. The villages are built extensively around a fairground such as this TOP. *Kayapo at a gathering. Still traditionally dressed, they act politically and economically over the Xingu region* BOTTOM.

Raoni is one of the chiefs of the Kayapo tribe, an original Brazilian tribe comprising around 7,000 members. Raoni is very much a man of the 21st century, of considerable intellect; his eyes are bright, his thoughts are clear. In order to represent the rights and issues of his people and make them public, he uses modern communication methods and maintains close contact with journalists. Yet, he can only be compared to a political manager of the western world in his words and actions. For in his heart and soul, he remains true to the Kayapo tradition.

A large disc in his stretched lower lip commands attention. Heavy jewelry dangles from his extended earlobes and several colorful necklaces hang down on his bare chest. His dark hair is adorned with stunning feather decorations. Most of his body is painted in decorative colors. When asked about the history of his people, Raoni tells an old legend that has been handed down from generation to generation. The Kayapo are said to have once lived in the heavens. One day, so the story goes, one of the hunters found a mysterious cave leading downwards. The Kayapo looked down into the cave and saw a large beautiful forest. They climbed down a rope and decided, from then on, to live on earth instead of in the heavens.

»At that time,« Raoni continues the story, »there was no Yesterday, nor Tomorrow. Only Today existed. We did not even know how to make fire until one of the Jaguar people showed us how to do so.«

For a long time, the tribe of this imaginative creation myth was believed to be the most dangerous of the entire Amazon region. This was unjustifiably so, as was later determined. The Kayapo were said to kill any white rubber tappers or gold hunters who dared trespass into their territory. These horror stories, however, only gave avaricious adventurers a pretense to drive the Kayapo away from their territory or killing them, in order to fully exploit the land's riches.

Luckily, the ethnic group of the Kayapo survived these brutal invasions;

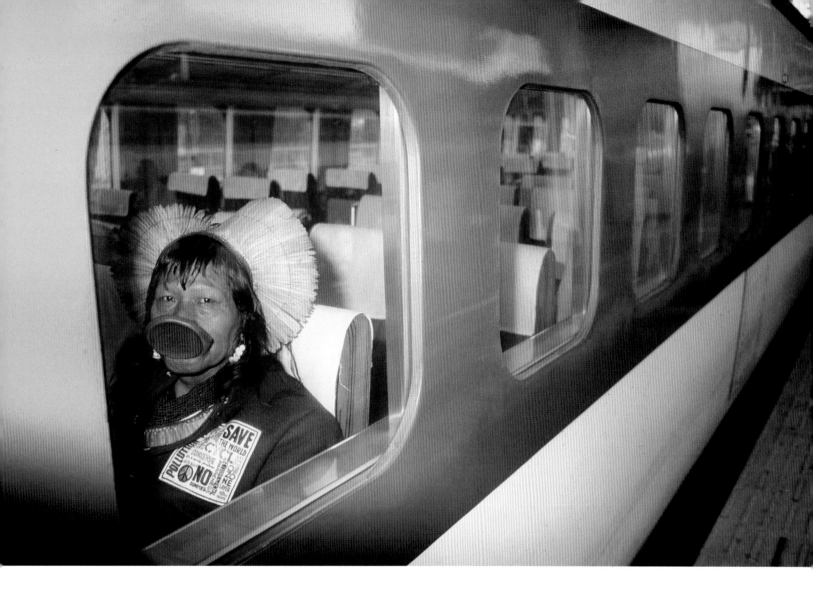

Raoni in Tokyo in 1989. One year before, the Kayapo were visited by the English Rockstar Sting. He was shocked by the degree of the subversion of the rainforest. Sting and Raoni went on a world tour through seventeen countries, in order to make the problem public.

the Kayapo now live in one of the largest protected tribal reservations of Brazil. The villages of the Kayapo are situated along the Xingu River, an estuary of the Amazon River. Men go hunting and fishing with their seemingly outdated equipment. The settlements consist of round huts, which surround the village center. Yet, even though the Kayapo seem to live as if progress had bypassed them completely, many own televisions and radios. They use cell phones, drive Jeeps and Land Rovers. More and more Kayapo are turning their back on the traditional way of life and moving far away from the settlements. Contact with the Western world seems to be threatening their traditions, rendering them slowly obsolete.

In order to keep these old rituals and traditions alive, the farsighted Kayapo chief Raoni erected a school a few years ago, wherein the knowledge of the Kayapo traditions are to be passed down to the younger generation and thus preserved. Yet, it remains to be seen whether these traditions and the Kayapo will survive. Toxins have heavily polluted their living area, leaving the Kayapo with an expected life span of 45 years. Increasingly, more native Kayapo are seduced

HERE & NOW

Around 7,000 members of the Kayapo live in the Brazilian state Para. Raoni, their chief, has succeeded in building a bridge between the past and the present, between prehistoric lifestyles and the 21st century. Kayapo people currently have the power to speak up for their future and their rights, even though the illegal exploitation of the rain forest continues. They defend themselves and protest through television and Internet platforms, controlling the editorial content themselves. In addition, the Kayapo have created a forum to unite Brazilian indigenous ethnic groups – www.cdi.org.br. Solar satellites enable those living in even the most remote parts of the Amazon region the possibility to use the Internet to become informed and educated.

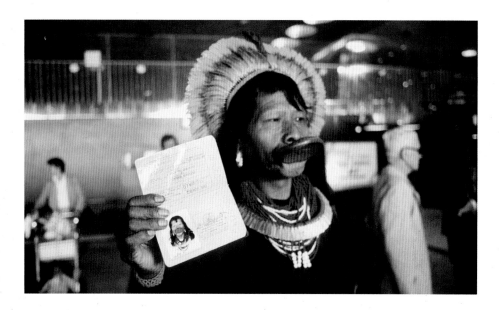

Raoni in Rio before his entrance upon his world tour, with his freshly issued passport, in 1989. He was the first indigenous Brazilian who applied for a passport ABOVE.

by the prospect of fast money by selling their land to mining companies and moving to neighboring cities. The rain forest is gradually decreasing around the villages, destroyed by slash-and-burn land clearance.

In 1989, the existence of this native tribe was gravely endangered by a construction project of gigantic proportions. The Brazilian government planned on building no less than 136 dams on the headwaters of the Xingu River. Chief Raoni fought back – using pop culture to his advantage. One of the most popular supporters of the Kayapo Indians is British musician Sting. He was appalled and angered by the devastation and pillaging of nature. Sting likened the experience to observing a rape, mentioning that indeed, the land was being raped and destroyed.

Together with Raoni, Sting planned an extensive PR-tour, which led through many countries and countless television shows. Together, they founded the Rainforest Foundation.

Under such public pressure, the World Bank of Brazil cancelled the initially pledged loan of 500 million US dollars.

The project was no longer financially viable and temporarily suspended.

Chief Raoni, with the support of his nephew Paulinho Paiakan, won a brief victory in this poker game with millions at stake. Yet Raoni would not be Raoni, if he did not keep on planning for future developments. In order to keep his endangered tribe and his people's interests in the public eye, in 2008, he created a television channel and a corresponding Internet platform. Aldeia Virtual, virtual village, is the name of this progressive bi-medial project. According to Raoni, the Internet grants even the poorest of the poor a marvelous chance to increase their level of education. Even minority groups deserve to benefit from this digital age. In early 2008, only four percent of Brazilian population had Internet access, eighty percent thereof belonged to the upper class. Raoni and other supporters of his campaign dream of »information technology for all.« The principles of civil and human rights could thus be communicated, understood and applied. Raoni hopes that in this way he will be able to achieve more understanding for his people, the Kayapo's needs, desires, worries and problems.

ALFRIED SCHMITZ

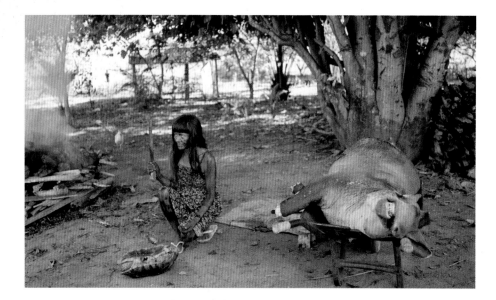

Everyday life in Pira. A woman prepares a big meal. The menu contains turtle and tapir.

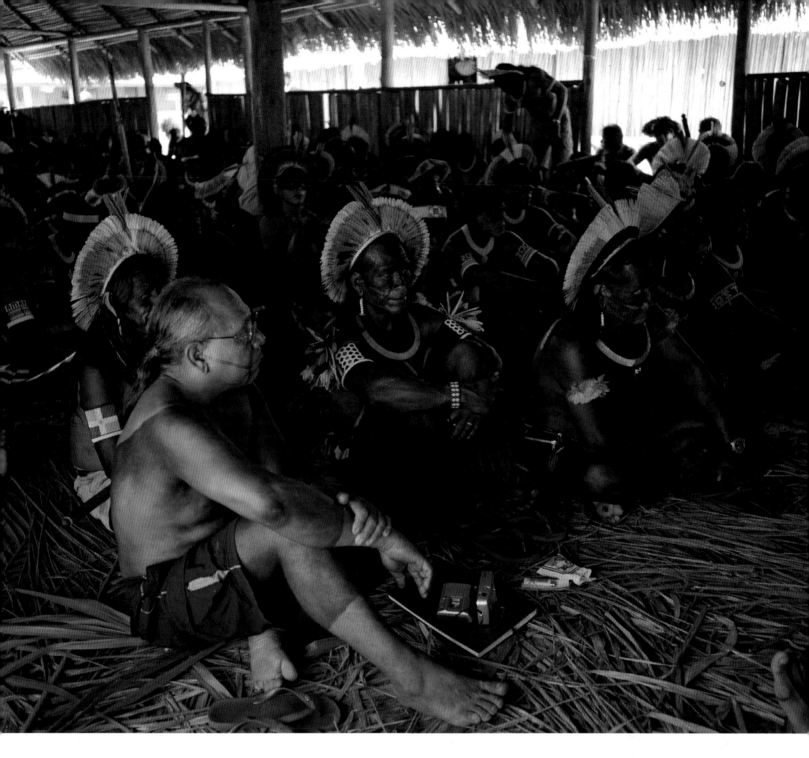

Renewal of the protests. After the plans for the Belo–Monte–Dam were off the table in 1989, they were pending for implementation again in 2006. Here, the indigenous of the region gathered; the Kayapo had a leadership role back then as well as today.

THE MUSIC
– DANCED HISTORY

The language of the Kayapo is colorful and full of images. In many stories, resembling both in form and structure fables, legends and myths, the Kayapo have succeeded in keeping their history alive for hundreds of years. In the evening and at night when the oldest share the stories with the youngest, often in song, oral tradition is at its strongest. The older members of the tribe also take on the organization of the parties and ceremonies. The chief begins the songs, which are repeated in concerted song by the women and men of the village. The Kayapo also conduct musical rituals during religious services, which are also often accompanied by dance. The sequences of the moves are often modeled on nature and strive to imitate the solar and lunar orbits. In 1995, the American Smithsonian Museum published an album with the music of the Kayapo. It is based on the recordings of the musician and ethnologist Max Peter Baumann, who visited the Xikrin do Catete village in 1988 and is called »Ritual Music of the Kayapo Xikrin, Brazil.«

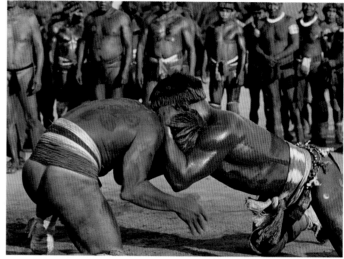

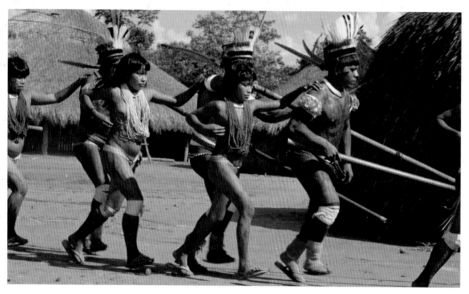

The Kamayurá have issued invitations to the two-day Kuarup festival. From the surrounding villages of the Xingú reservation, some Yawalipti, Kalapalo and Kuikoro have arrived as well: as often, the ceremonies in honor of their ancestors begin with uka uka, a wrestling match. The young men compete in the fight and contend for rank and esteem within their clan and the neighboring groups.

The Brazilian federal state Mato Grosso, in terms of surface area about as large as Germany and France together, in its impenetrability is among the least explored areas of South America. Here, at the headstreams of the Rio Xingú, south of Lake Ipavu, in numerous villages, live the Kamayurá. They are in touch with about a dozen more ethnicities in the region, which speak other languages but are otherwise very similar to them in appearance and lifestyle.

KAMAYURÁ

Defensively peaceable

Numbering about 350 individuals, the Kamayurá are known as skilled archers. They hunt and gather; they eat what can be obtained from the primeval forest, the rivers and lakes: game, fish, bananas, and tubers. They deal in belts that they make from snail shells, in fishing nets, canoes, hammocks and flutes. Part of the Kuarup ceremony is the reception of the new generation into the polygamous community, where divorce is possible. For young people who will later be entrusted with leading roles, the initiation is preceded by a three-year period of training. Girls

are prepared for six months for their new social status. At the Kuarup festival, the chief cuts the girls' long hair, which has grown over their faces. From this day they are considered to be women, and may seek out a man of their choice and marry. After the wedding, the husband moves into the house of his bride's parents.

The second day of the Kuarup is drawing to a close. Smartened up and with a measured step, the Kamayurá stride across the area, followed by the newly initiated girls, and playing the urua. These flutes, up to nearly 10 feet

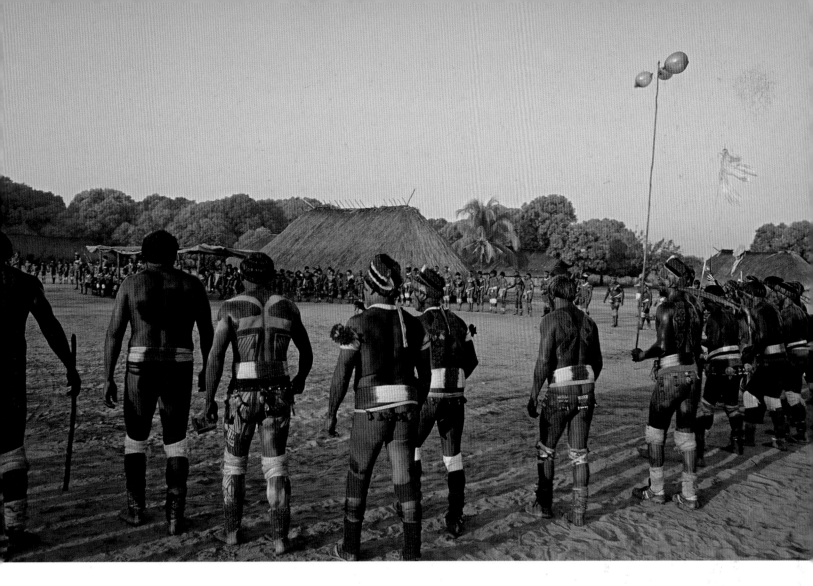

At the Kuarup festival, the elders solemnly take their places before the sacred tree trunks. The ceremony can now begin. The Uka–Uka wrestling matches are ready to start, the flute players bring the girls out of their huts, and the warriors wake the gods with the rhythmic stomping of their feet.

(3 meters) long, only played by men, go back to legends of water spirits. Once, it is said, a Kamayurá observed the water spirits at their song and made a wooden image of them, which was the urua flute. But neither he nor anyone else after that was ever able to match the unique sound of the spirit voices. The deep tones of the flute tirelessly accentuate the celebrations of the Kamayurá's ancestors and creator. Kuarup today revitalizes the myth of the Demiurge. When the first humans died, their creator god told their offspring to carve wooden images of their parents. But when the attempt to bring them back to life failed, and death inevitably entered life on earth, their ancestors were commemorated from then on in the Kuarup ceremony.

CHRISTIAN ROLFS

HERE & NOW

The first lasting contact between the Kamayurá and white people was in 1946. The Villas-Bôas brothers set up a trading post there and later campaigned for legal protection for indigenous peoples, which they achieved in 1961 with the foundation of the Xingú National Park. But the discoverer of this small nation is considered to be Karl von den Steinen, who led the first expedition into the Xingú region in 1884. With the white people came disease.

Influenza viruses and measles above all carried off so many members of the tribe that in 1954, the Kamayurá numbered only 94. Malaria became a deadly problem for their weakened bodies. But then a gradual recovery began, and by 2002 the numbers had again increased to 350. Thanks to the achievement of the Villas Boas brothers in creating a protected area, the prognosis for the survival of the Kamayurá today is an optimistic one.

Rites of Passage

Rites of passage are based on the basic patterns of life, which are the same the world over. At birth, newborns have left the world of the unborn and are introduced into the world of the living; youth are separated from the group of children through initiation rites and integrated into the world of the living. Those who have died are released from the world of the living through funerals and ceremonies and led into the community of the dead.

Rites that accompany such passages aim primarily to achieve control over the processes of social dynamics. Above all, the phase of youth is more or less marked in all cultures by feelings of rebellion, fear and weakness. We know this phenomenon better from metropolises like New York, than from East African villages of the Massai. The decisive difference, however, is that traditional societies are more rigid when it comes to restricting youth. Individuals mean little in natural religious societies; community, however, means everything. This strict order is based on the notion that gods and demons are not generally good and benevolent, but instead often moody or angry. They need to be wooed by good behavior, and also by sacrifices, magic and taboos. Even daily communication with ancestors is marked by fear, regardless of the degree of familiarity. When the members of society enter a new period of life, the novice is required to pass hurdles, which can vary greatly.

Frenchman Arnold van Gennep (1873-1957) presented these cultural differences across the globe in his main work Rites of passage (Les rites de passage, Paris 1909)

»Life itself makes it necessary for the passage from one group to another, from one social situation to another.«

Gods and demons need to be wooed

This ethnologist focused primarily on the societal importance of rites. He found that all rites of passage are structured analogically to rites of space or of crossing of boundaries. A society can thus be imagined as a house with many rooms, when moving from one room to another, the passage could be imagined as going through a doorway. Van Gennep discovered that rites of passage always followed three successive phases: separation, liminality and incorporation.

In the separation phase, the old place or state is dissolved; in the liminality phase, one seems to be floating between two worlds, being in neither. Finally, in the incorporation phase, one is fully integrated in the new place or state.

Of crucial importance is Van Gennep's statement that rites of natural passage, such as puberty, cannot simply be represented or reconstructed. Instead, rites of passage mark societal transitions, which do not necessarily have to coincide with physical changes. Initiation rites do not truly mark the arrival of sexual maturity, but instead define societal maturity, or the fact that the youth has reached majority. From then on, youth are fully integrated in the duties of the community.

Circumcision ceremonies orchestrate the transition between generations in a conflict-free manner, as here in with the Luhia, where circumcision is but one of several inititiation practices.

The circumcision of young girls, a practice banned in many countries, is still a common cultural practice, as here in the Kenyan Sambalat region. Immediately after the procedure, the girls are separated from the group.

The Uighur, one of China's Muslim minorities, circumcize their boys for religious reasons. For the majority of Chinese, the pratice has no religious basis and as such is rarely practiced.

In accordance with societal changes, rites of passage have changed in rural structures in Americas, Africa and Asia. Men leave the villages for years in order to work on plantations or for labor in the cities, and thus, cannot return to the village in time for the festivities. Mandatory schooling prevents many children and youth at boarding schools from returning to their home region. As children between twelve and fourteen years old no longer live at home, they can only be initiated into village life at their return. The ritual initiation into society only occurs when there are sufficient candidates in the village. The frequency of celebrations is decreasing and the average age of the novices increasing.

Initiation rites define societal maturity

This process, however, has not caused the initiation celebrations to cease, only for them to be adapted to new conditions.

In traditional societies, rites of passage are usually very different for women and men. One of the most important rituals of the Massai community is the Eunuto Ceremony, the rite of passage marking the transition from junior warrior to elder. It takes place every few years and occurs in the region between Kenya and Tanzania. Shearing off the participants' hair marks the climax of the four-day ceremony. For mothers, this moment is incredibly moving, as it ultimately represents the final separation from their sons. Even today, the Eunoto Ceremony is an impressive demonstration of force. Up to 1,500 Massai between 30 and 40 years old participate therein, before they return to their villages as elders and attempt to ensure their people's well-being and the continuation of the Massai tribe itself. At least, this would be the ideal situation. However, other Massai also participate. One example could be Massai who work outside of the villages, on private farms as gamekeepers. They also take the ceremony master's advice: ›Now, that you are the eldest, put down your weapons and use your heads and your wisdom instead!‹

Sage advice, especially for men, who increasingly need to prove themselves in globalized societal structures. These structures are moving farther and farther away from the idealized image of masculinity, anchored in traditionally and ritually organized societies. Indeed, the question arises as to whether traditional rites of passage could be seen as a guarantee for successful crossing of boundaries, a bridge between traditional and modern times.

HENDRIK NEUBAUER

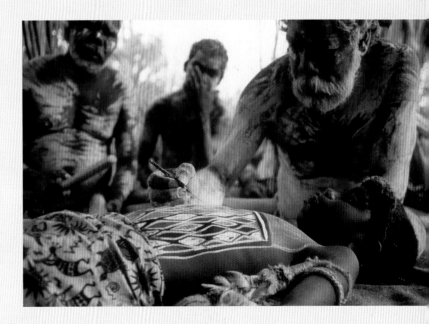

In an act of rebirth, the Yolngu of Australia's Arnhem Land let the child within the man die. During the Dhapi initiation ceremony, the youth »receives« family history motifs so that he can be taken up into the circle of men.

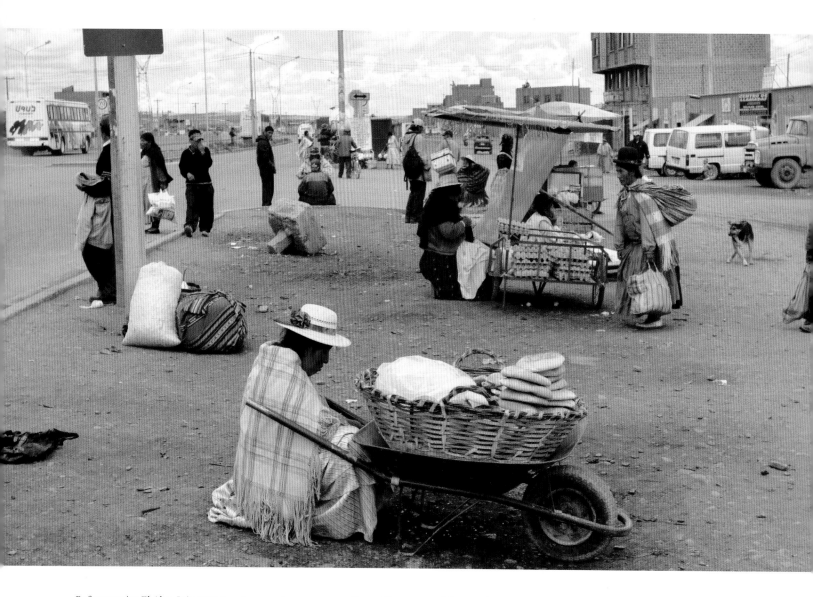

Refugee point El Alto. It is a young city, growing every year. Almost 80 percent of the population are Aymara, 6 percent are Quechua. Up here, poverty is dominant; wealth is found in the European sister city La Paz, roughly 1,200 feet (400 meters) lower in the valley.

EL ALTO 🌐 16°30'S 68°9'W

AYMARA

One of us

It is chaos on the central Avenida in El Alto. It is still early in the morning, but people are already crowding excitedly into the minibuses. All around them, newspaper sellers and other itinerant dealers are swarming; for where many people are on the move, there is always a little money to be made. The people just getting onto the buses are not traveling for pleasure either. They are making a short trip that will take them to La Paz, the capital of Bolivia, situated some 1640 feet (500 meters) lower. Work can be found there that many cannot find in El Alto.

La Paz is rich, and El Alto is poor. The two cities are unequal sisters, neither of which can survive without its unloved counterpart. La Paz has existed for 500 years, and is the old trading city, lying deep in the valley and in the shade, but also protected from the violent winds of the Altiplano, a gigantic plateau. El Alto was once a suburb of La Paz. Since 1985, with approximately 750,000 inhabitants, it is an independent city, which easily could be the capital; no other city in Bolivia is growing as fast as windy El Alto, where even in summer the temperature barely reaches 20 degrees.

The Aymara represent the majority of the inhabitants, estimated as at least three-quarters. The gulf between the two cities has never been as great as in 2003, when the Bolivian state granted US companies the permission to exploit large parts of its rich gas resources. This development led to mass protests. They came to a head in El Alto. At this time, Evo Morales, leader of the country workers, became a spokesman for the movement; when President Sánchez de Lozada ordered the shooting of 60 people by the army, the whole town of El Alto leapt to

View from El Alto to the seat of government La Paz. Those who have work, has to go down in the valley. Up here, 50 percent of the population are 19 years old and younger; only 18 percent of the population are older than 39 years. More than every second inhabitant is illiterate. The majority lives below the poverty line.

its feet to blockade the capital La Paz. When major bottlenecks had been created in the supply of gasoline and foodstuffs, Sánchez de Lozada threw in the towel and went into exile. The Aymara had defeated him.

The area around La Paz had, for a long time, been a focus for Aymara settlement. They are said to have come to the Altiplano from the north, and it was here, on the cliff between El Alto and La Paz, that their striking clothing practices are believed to have developed. The heavy poncho; the shawl; a great deal of jewelry; the whip as the symbol for the leader of a community; and the bowler hat as headgear, which certainly did not originate in the Andes, are seen as proofs that the Aymara had contact with many other groups.

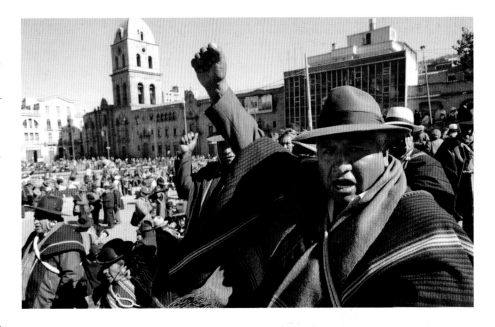

Demonstration on the Plaza San Franxiso in La Paz in 2005. The protest of the Aymara finally led to an Aymara, Evo Morales, being president.

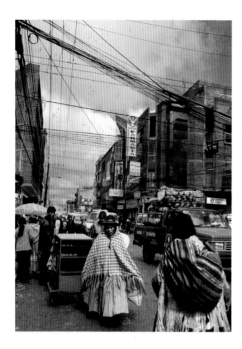

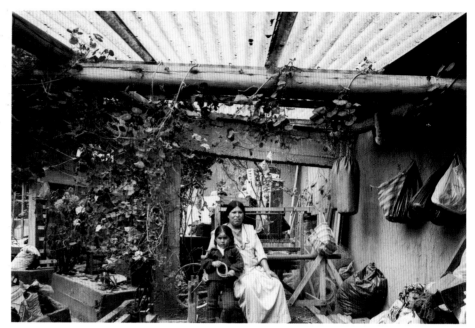

Even in the summer, it is hardly ever warmer than 68 degrees Fahrenheit (20 degrees Celsius). The apparel of the Aymara with poncho and hat has developed here and is not traditional in the classical sense LEFT. *many inhabitants live in simple and improvised houses* RIGHT.

WAYNA RAP

Hip-hop arrived everywhere long ago. In El Alto, it has dominated the streets since 2006. Wayna Rap is the name of the best-known band, one of many bands making use of break beats. Hip Hop Andino and Aymara Rap are the two current labels on which Wayna Rap are represented. This is not just idle talk: above the beats and the voices, the sound of the panpipes is heard, the sacred instrument of the primeval inhabitants of the Andes. The five boys write lyrics dealing with the country's current politics. In an interview with the New York Times, Abraham Bojórquez refers first of all to »Black October,« by which he means the October of 2003, when the Bolivian population sent the previous president Lozada packing in the so-called Gas War. Wayna Rap mixes Aymara and Spanish, and Bojórquez told the online magazine Wiretap that hip-hop was a means of struggle

for him and his colleagues. Thus, Wayna Rap seamlessly fits into the present day of the Aymara, who have so durably influenced Bolivia with their struggle in recent years.

www.myspace.com/waynarap

Many were shocked by the severity of the clashes, and the government had certainly not taken into account the Aymara's powers of self-assertion. However, during the preceding years, the tone had already fundamentally altered. The inhabitants of the fourth largest city in the country, Cochabamba, had unexpectedly changed the contracts for water supply when it was made a punishable offense to collect rainwater in order to remain self-sufficient. When Sánchez de Lozada's successor Mesa made the decision to nationalize gas reserves, but made no attempt to use the proceeds for the common good, the Aymara once again blockaded La Paz. Mesa too resigned.

During the next presidential elections in December 2005, Evo Morales became the first indigenous individual to be elected as president of a South American country. He immediately reduced the salary of the president, his own salary for that matter, by 58 percent, and in May 2006, he enacted a law to nationalize the natural gas industry. Morales was an Aymara farmer living for years from the sale of coca. Now, he was a new president as accustomed to the bitterest poverty as those who had now elected him. In spite of its great natural resources, Bolivia is the poorhouse of South America. Morales took office with the promise to transform the life of the poor on a long-term basis.

MAX ANNAS

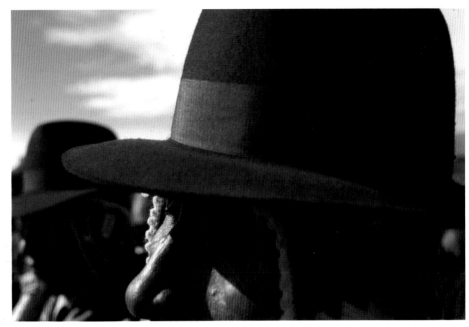

Aymara festival in El Alto TOP LEFT. Hats from Europe and the poncho; the men prefer the bowler hat, the women the borsalino TOP RIGHT. Platoon in La Paz in 2005. Whether unsatisfied mine workers or farmers, they always block arterial road over the high plateau near El Alto first LEFT.

HERE & NOW

Fewer than 2.5 million Aymara live in the High Andes today; of these, about three-quarters are in Bolivia, others in Peru and Ecuador, still fewer in Argentina and Chile. Lake Titicaca, the largest high-level lake on earth, is at the heart of the Altiplano, a plateau higher than 3500 meters above sea level and situated between Bolivia and Peru. Altiplano forms the core settlement area of the Aymara. The Atacama, the driest desert on earth, is also part of the Altiplano. It is due to these locations that the Aymara are used to tough environmental conditions. Many of them have, for a long time, been living from the cultivation of coca. The leaves of the plant serve the Aymara for cult

and medicinal purposes, and they have a significant effect on altitude sickness, a kind of advanced migraine which affects many Aymara. As the raw material can, of course, also be used to manufacture cocaine, various US governments have tried to put pressure on the Bolivian state to prohibit its cultivation by the Aymara and other indigenous groups, where necessary with the help of the military. In Bolivia, the discussions between the coca farmers and the new president Evo Morales ended in compromise. Even in the Chapare region, where coca is known to be cultivated illegally, a limited quantity may now be grown and harvested annually.

Ethno-Tourism

Long before the invention of mass tourism, exotic peoples were brought from America to Europe, where they went on tour. The wars between Americans and the continent's native inhabitants had not yet ended when, in 1880, Buffalo Bill Cody first put together his Wild West Show. He recreated both cavalry charges and Indian attacks using, as his posters proclaimed, »the original performers.« Cody's show toured all of Europe. Audiences could not get enough of shows like it. Unashamedly, racist Europeans enthusiastically flocked to ethnographic exhibitions that made the populace of the colonial powers feel secure in their superiority. »Stone Age humans, recognizable by their simplicity, savagery, and by their ferocity,« wrote Journalist and Zionist pioneer, Theodor Herzl, after visiting in 1897 what he called a »Human Zoo« (Menschengarten) in Vienna.

The booming business of importing aboriginal peoples for dancing, hunting and craftwork exhibitions lasted until the outbreak of World War I. After 1919, the choice of which strange people would be brought in to perform in Europe's great metropolises was dependent on several basic principles of showmanship. They had to be unusual and as extraordinary-looking as possible, with colorful costumes and primitive weapons. A cross-section of age and genders had to be

Human Zoos

exhibited, and they all had to be ready to engage in their typical native customs without shame in front of a large audience. Their recruitment took place under the auspices of strict government regulations. The European governments issued entry permits to the aboriginal performers, often requiring that they or their representatives deposit a large sum of money to guarantee that all fees would be paid, and that the native performers would return to their home countries at the end of the tour. As many as four hundred of these ethnographic shows could be touring Europe at any time.

Much later, in 1970, Americans and Europeans began to travel in hordes on long and arduous journeys to exotic lands in the hope that they would get to see natives performing their genuine rituals in their natural environment. This first wave of alternative tourists was not, for the most part, made up of particularly sensitive travelers. It was irrelevant to the tourists whether they traveled to The Algarve, Kenya or Goa.

Tourism today, in all its varied manifestations, is one of the biggest sources of employment in modern economy. For developing nations and emerging market states, the opportunities offered by tourism are impossible to ignore. When everything is going well, the local indigenous population can profit from

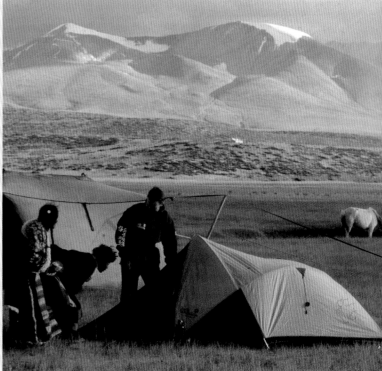

Moko Jumbies of the stilt school in Port of Spain, Trinidad. The school maintains the West African tradition of stilt dancing, an attraction at carnival. The children also have a home here.

Meeting at the Manasarowar Lake in Tibet. A tourist on a trekking tour attracts the attention of the locals.

tourism's positive side effects: increased prosperity, improved health care, a modern infrastructure, and the protection of the environment and its natural resources.

What about when everything is going badly? Have we really improved on the racism that characterized the early twentieth century? Is there really that much difference between going to see exotic groups of people on exhibit, and traveling to »observe« exotic peoples? Ethnographer Corinne Neudorfer has looked at these questions from the point of view of the Akha, an indigenous group native to Laos. In answer to what, at first glance, seems a rather silly question: »What is a tourist,« an Akha tour guide crisply replied, »a falang,« using a word that literally means »Frenchman,« but can also mean »European,« or »foreigner from a western land.« Some Akha, replying in English, translated the word as »an American person.« The language conventions of the Akha make no distinction between foreigners visiting the country as international aid workers, and those who are only there on vacation. Why foreigners enjoyed traveling so much was a question the Akha could not so easily answer. Their language has no word comparable to »tourist.« The closest the Akha could come was the phrase »nak tong tiao,« which translates literally as »person who wanders here and there.«

In this context, indigenous groups that are involved in the tourist industry must be sure as

Search for authenticity

to which part of their identity they are willing to expose to visitors. Likewise, tourists should make their own expectations clear. The tour companies can serve as mediators in this process. Unfortunately, those tour companies that would like to be fair to all often run into all but immovable political barriers along the way. Anyone wanting to visit the Kalasha minority group in their refuge in Pakistan will find be stopped at the border by officials from the primarily Muslim local government. Entering or leaving the valley of the Kalasha has to be done strictly by the book. In order to approach the Kalasha from Pakistan, visitors must be driven over the border by a Pakistani, and checked into a hotel that is run by Pakistani service workers who have been brought in to work. What is left for the indigenous people to do? When political conditions such as these are in place, as they are for ethnic minorities all over the world, what remains is very little. Perhaps the natives can dance, hunt, or demonstrate their native crafts. The tourist hands out little more than pocket change in return for all these riches. Often, having already paid top dollar for transport, hotel and guide services, the tourists are not ready to pay out much more.

A further point has to do with infrastructure. In Kalasha, no one really pays attention to air pollution, but the poisoning of the mountain rivers with sewage from the hotel cannot be overlooked. There has never been a garbage removal service in the

Poster of the »Exposition Coloniale Nationale de Marseille« from April 14 to November 18 in 1906. This was the first official colonial exhibition in France. 1.8 million people visited the pavilions.

valley, and since there still is not any means of clearing out the detritus of prosperity, it piles up, uncollected.

Thus, it is obvious that the principles governing adventure tourism have not changed. Vacationers from industrialized countries want their experience to be authentic, at least in name, and as lively as possible. The process of selecting actors for these performances is really pretty much the same, be it for brutal human zoos or gentle, environment-friendly tourism. The indigenous peoples need to be unusual and as extraordinary-looking as possible, with colorful costumes and primitive

weapons. A cross-section of age and genders should be exhibited, and everybody should be ready to engage in typical native customs without shame in front of a large audience. A critical difference between the past and present is that, today, many of the performers decide for themselves if they want to participate. If they see no profit in it for themselves or their families, they may choose to opt out. Today, tourists increasingly find themselves standing outside a closed door with a sign saying »Private« prominently displayed. This, too, is something new and deserving of our respect.

HENDRIK NEUBAUER

A high school in Korhogo, Ivory Coast. The sign on the school's administrative building promotes AIDS awareness ABOVE. Ceremony in Loulouni, Mali. The masks and balafon (African xylophone) are typical features of Senufo dances and festivals RIGHT.

KORHOGO 🌍 9°27'N 5°38'W

SENUFO

Dance of the hunters

The men with the old guns over their shoulders dance in a circle around a large tree. The tempo is leisurely; after all, it is not only the youths among the male village inhabitants who are represented here. Stepping lightly one behind the other, they move around the tree a couple of times before they form a new circle. Outside the circle, another man is moving, wearing a fringed costume. He looks like something out of The Wizard of Oz and represents the animals that are being hunted by the men in the circle, for they are the hunters, an important element in Senufo society.

The band also sits outside the circle. Their leader is playing a donzo ngoni, a large lute or small harp with eleven strings. The bandleader is also the singer and composer of the music to which the hunters are moving. The songs praise the courage and readiness to take risks needed for a successful hunt. Another repeated theme is the ancestors and their deeds of heroism.

The Senufo mostly live in small villages in southern Mali, in south-west Burkina Faso, and in the north of the Ivory Coast. It is a very uniform settlement area; only a few smaller groups live outside it, a few thousand people in northern Ghana, for example. Since settling here, coming from the north in the 15th to 16th century, the Senufo have always been concerned to preserve their cultural independence. Many of their rituals and ceremonies, such as the dance of the hunters, have survived, even though dominant cultures in their vicinity, such as the Songhai, have repeatedly attempted to Islamize whole Senufo villages. How appropriate it is that the lead instrument in their music in their new home practically fell from heaven.

The legend is as such: a hunter was in despair because he had been traveling for a long time but had had little success. His despair came from the fact that he had not achieved his task of obtaining food. Exhausted, he sat down under a tree. From its top, he heard a sound that was totally unknown to him. Above him he saw a spirit playing a ngoni. Suddenly, the being above him let the instrument fall, and the hunter caught it. He immediately mastered the instrument and began to sing songs about the hunters and to praise them. From that day on, the instrument was called dongo ngoni, the hunter's ngoni.

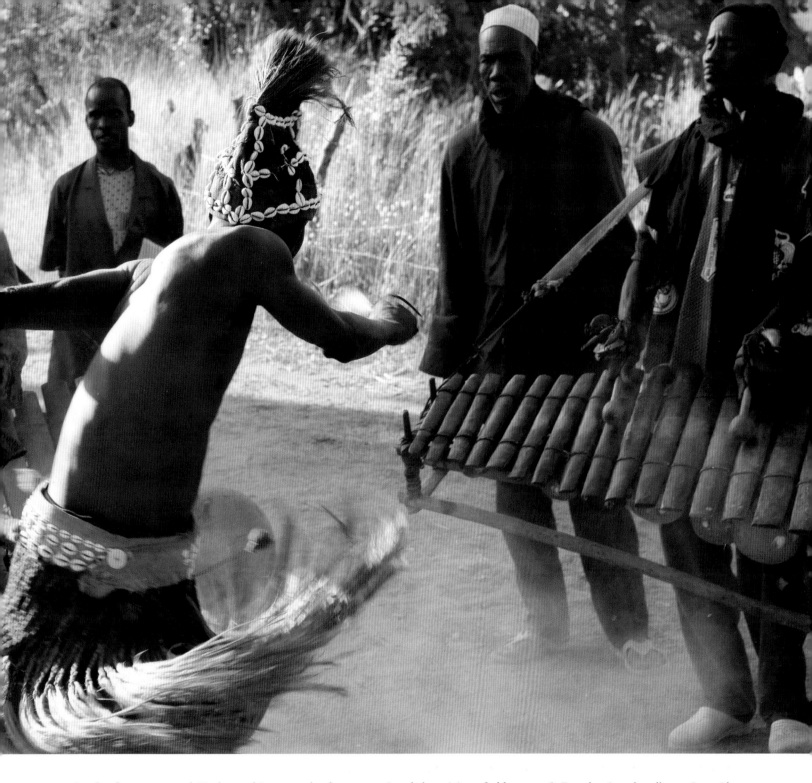

In the forests around Korhogo, big game has become rare. Therefore, today, the Senufo shoot small animals and birds. When they go hunting, they still wear the bogolan. This fabric is painted with a compound of clay, wood bark and herbs, which gives it its natural colors, yellowish beige or warm brown. Well camouflaged, the hunters go about their daily work. At the same time, they have often sufficiently proved that as skilled hunters they can defend their villages against attack in the case of economic and ethnic tensions. The songs of praise resounding

to the donzo ngoni and the raising of old firearms to the sky illustrate an important part of their survival strategy: Senufo culture lives. The music of the Senufo has long become part of the pop business, beyond the village culture, showing that the music is a living trasition, and not a museum-like administration of ancient ritual. Its protagonists are the internationally known balafon player Neba Solo, but also the ngoni player, Bassekou Kouyate, who does not come from Senufo country, but nonetheless has attracted unprecedented attention to the ngoni since

2006. By releasing the album, Segu Blue, with his band Ngoni Ba, Kouyate brought the ngoni to the whole world. In Britain, the daily papers have competed to publish page-long stories about Kouyate. He has even appeared at rock festivals there, and has been compared to Jimi Hendrix, because he plays his electrically amplified instrument in such a pungent style.

The ngoni rocks the scene in London and it rocks the village of Korhogo. The same instrument serves the various needs of groups separated by thousands of miles. In the European metropolises,

A clinic in Sindou, Burkina Faso. Senufo healers working together with a nurse and ethnobotanist ABOVE. Senufo instrument makers are highly skilled RIGHT.

music fans spend a lively evening, while in West Africa, the music continues to be the pulse of the village. Each new song is an interpretation of the here and now, if not a practical orientation, at least an encouragement to carry on. It is only in this context that the songs of Bassekou Kouyate, as well as those of the band that accompanies the dance of the hunters in the village, can be heard and understood.

MAX ANNAS

NEBA SOLO:

The Senufo call it djegele or cekiw; in West Africa, it is widely known as the balafon, a wooden xylophone with resonators made from gourds. At festivals in the villages and towns, two cekiws are often played together, supported by percussionist. Neba Solo, born in 1969 as Souleymane Traoré, is the son of an old balafon master and grew up with the instrument. His stage name is composed of the abbreviation of his birthplace, Nebadougou, and that of his forename. In the late 1980s, Neba built a balafon with a larger number of bass keys, inspired by the reggae sound of the Ivorian Alpha Blondy. He quickly swept away the initial doubts of his father and conservative Senufo people with a performance, and from then on, toured with a band in which his younger brother, Siaka, is in charge of the second balafon.

The brothers are supported by a whole flock of percussionists – the touring band consists of eight members. Since his CD Kenedougou Foly came out in 1997, Neba Solo has also been represented internationally. In Mali, he has the reputation of a traditionalist as well as of a musical revolutionary. Anyone who listens on his homepage to his hymn for the Africa Cup of 2002 (»Can 2002«), which took place in Mali, will quickly understand how infectious and stirring Senufo tradition can be, when supported by canned beat music. Neba Solo's songs have several times been used for remixes. The best known are those of the Frenchman Frédéric Galliano.

www.nebasolo.net
www.mali-music.com/Cat/CatN/NebaSolo.htm

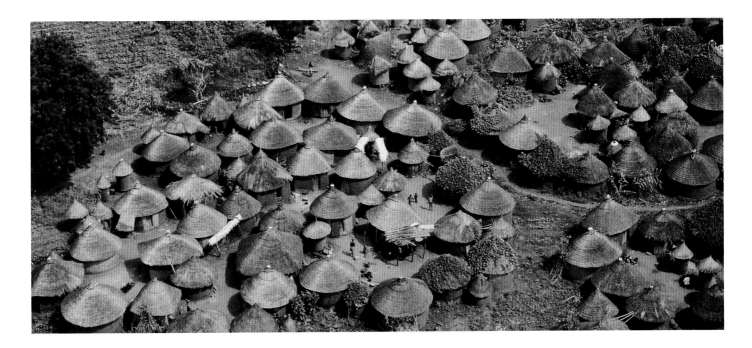

A Senufo village is organized into courtyards ABOVE. The hunters have a special position in society. According to legend, they founded new settlements and developed land for agriculture BELOW. In action: spirit and antelope masks CENTER.

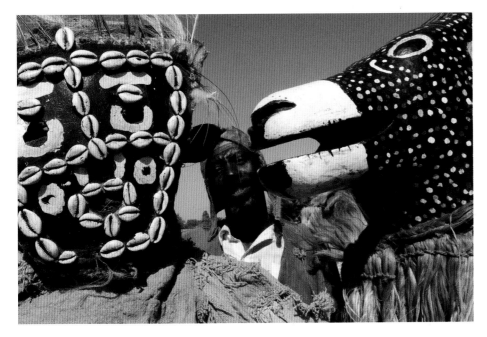

HERE & NOW

Between 600,000 and 800,000 Senufo live in southern Mali, in the north of the Ivory Coast, in southwestern Burkina Faso and in an exclave in a small spot in the north of Ghana. Wide areas of Senufo country are very fertile, and there, rice, corn, sorghum and all imaginable fruits and vegetables are harvested. There is animal husbandry, although the Senufo do not keep cattle. The cultural capital of the Senufo is their »big city« of Korhogo in the Ivorian north. It was an important staging post in precolonial trade and lay on the route that linked a number of areas in the interior of West Africa to the Atlantic. In the first year of the civil war in the Ivory Coast, which began in September 2002, Korhogo was hit several times by major clashes between rebels and government forces. Even after the cease-fire and the formal division of the country there were repeated clashes. In June 2004, at least 22 people were killed in shootings. In August of the same year, mass graves were discovered containing 99 dead bodies. The mood in Korhogo continued to be tense after these events.

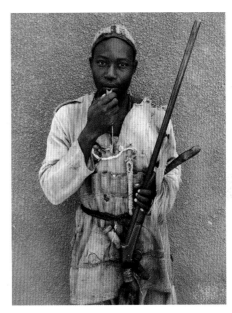

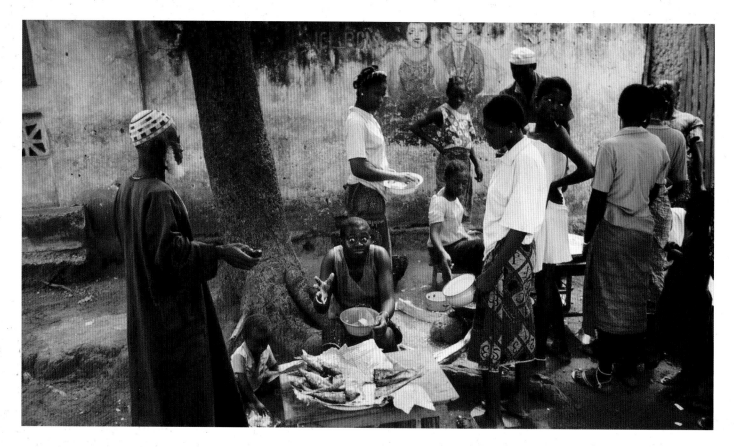

AGNI

The world of the fetish priestesses

Yam festival in Tenguelan. The fetish priestesses dance for hours, despite the parching heat. They swiftly spin around in their white dresses; only they are allowed to wear the red hats. To a persistent drum beat, they enter a trance; now their movements seem directed by remote control. They have made contact with their ancestors. Faith in the presence of their ancestors

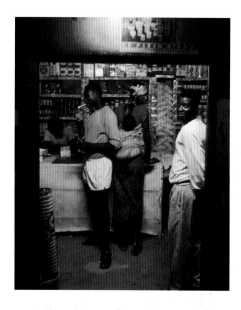

Market day in Tenguelan ABOVE.

A Fulbe merchant sells staple foods BELOW.

is the most important spiritual message for the Agni. It is by no means a simple task that these women have undertaken, and reception into the ranks of the fetish priestesses seldom rests on a free decision. If a girl falls into a trance for no obvious reason, she is taken out of the community and trained as a priestess. Resistance against this tradition is not tolerated.

Tenguelan is the home of the oldest Ivory Coast school for fetish priestesses. The little town of Tenguelan sits at the most eastern point of the Ivory Coast. Ghana is not far away. At the moment, the Agni have a great deal to celebrate. Every year in October the noblest fruit of the earth is honored. It is not simple basic fare like millet or rice. The yam root unites many advantages: it has an exceptionally pleasant taste; it can be stored for half a year, which is of

great importance in a society which lives largely without electricity; it can be fried, boiled, deep-fried, or used to make fufu, a firm dumpling eaten with spicy soup; and it is a desirable commodity which is transported across long distances, since one can make comparatively large sums of money with it.

The yam festival is much more than homage to the tasty root, however. It is also the beginning of the initiation of the growing girls into the community. The women and girls cover themselves with kaolin, the white powder of porcelain clay, which makes them look like creatures in transit between life and death. Keeping in contact with the dead is the duty of every member of the community. It is also the aim of a fulfilled life to be accepted as a valued member into the ranks of the ancestors one day.

MAX ANNAS

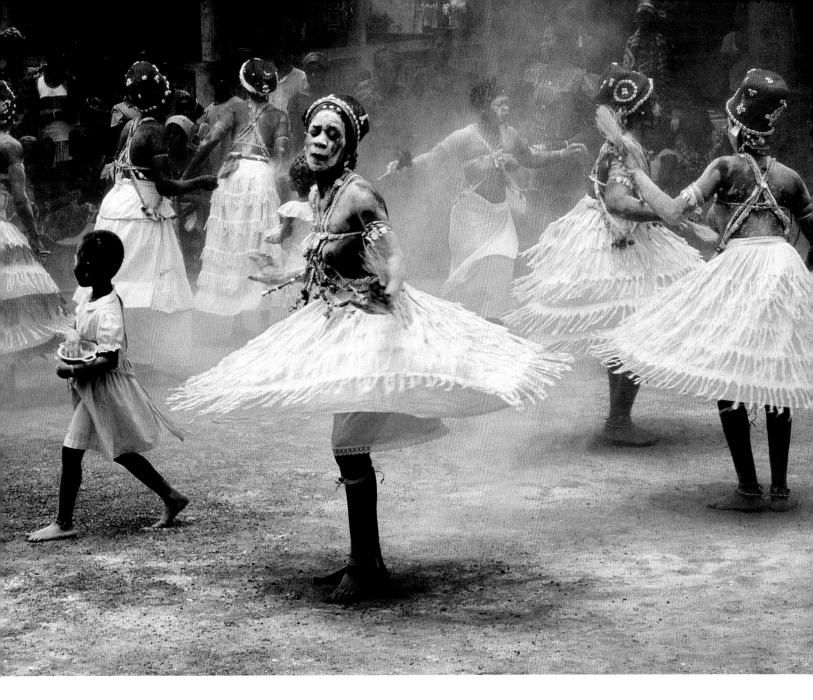

The fetish priestesses celebrate the annual Yam Festival. Priestesses and healers trained here in Tenguelan serve as mediums between believers, gods, and ancestral spirits. Only initiates wear red hats.

HERE & NOW

Ghana, however. The Ivory part is dominated by the gigantic Aby Lagoon. An extremely attractive beach landscape extends over more than 18 miles (30 kilometers) down to the Gulf of Guinea, which is, however, not intensely used for touristy purposes. The civil war at the Ivory Coast has thwarted further plans. Most of the Agni live in village communities of manageable size. Predominantly they live by subsistence farming; anyone who has access to the lagoon for fishing or catching crabs has the opportunity to earn additional cash. The largest Agni town, in the southeast of the Ivory Coast, is Abengourou, with more than 100,000 inhabitants. The name Abengourou comes from the Ashanti sentence »n'pé kro,« which means something

like »I don't like big words.« Although the Agni are related to the Ashanti, they have not had a great share of their wealth and power, but remain marginalized. This is one of the reasons why they have been divided geographically between the two great colonial powers, France and Britain.

Abengourou is the seat of the king of the Agni, Boa-Kouassi III; his kingdom is called Indénié. While the reign of kings and chiefs has no legal or constitutional basis, their moral influence on the Agni society shouldn't be undervalued ; king Boa-Kouassi played an important peace-making role during the civil war at the Ivory Coast.

Voodoo

Benin, in the middle of West Africa, is the cradle of the animist religion known as voodoo. Many gods reign in the apparently limitless cosmos of this faith. All that happens on earth is interpreted in its entirety as the divine will. In this world that is becoming ever more complex, for Africans too, voodoo serves more than ever as a daily explanation of the world. The world of voodoo is an enchanted one and the initiates live from the aura of the wise ones. This wisdom lends voodoo its centuries-old power over the psyche and physicality of man, and not only in West Africa. For the African slaves of the 18th and 19th century came mainly from West Africa and, despite all repressions, they preserved their faith on the American continent. Today, voodoo, with 60 million adherents in Africa and Latin America, is a world religion. If you search for it, you will find voodoo communities even in New York or Paris.

Voodoo adherents have no faith in the sense of a passive understanding of the concept in today's European Christendom. Voodoo is a daily religious activity. Always and everywhere, the principle is one of »here and now.« The everyday is not a permanent ecstatic celebration, but is interrupted by religious festivals, which however take place considerably more frequently than, for example, in religious communities in Europe. Daily religious practice is restricted to the little rituals. Prayer.

Voodoo is a daily religious activity

The regular sacrifice to the ancestors or for personal protection. Visits to the temple. Spectacular highlights in this long tranquil flow of the religion are the collective rituals and ceremonies. In the trance conditions of the voodoo initiates, the relationship between gods and men reach a peak. Initiates describe the condition of trance with the words: »We pray with our whole bodies.«

In the voodoo pantheon, the assembly of gods includes Mami Wata, goddess of water, and Shango, god of lightning and thunder. How many of them are there? A hundred, two hundred? Only the initiates know. According to their areas of responsibility and influence, they form cults led by priests, who also often take on tasks as natural healers. The individual's family and the priest decide who is to be accepted into the cult as a voodoosi. They follow protracted rites and a stay in a voodoo monastery. Some cults practice the ritual death of the applicant, whom the voodoosi, born again into the community, leaves behind.

Anyone who has been accepted into the cult has little interest in the understanding of outsiders. Questioning results in statements by initiates such as this: »Even if you spend your whole life with voodoo, whether you are local or a stranger, you understand or know only as much as can be seen between two twinklings of an eye.« Voodoo is the wisdom of masters. This wisdom was and is given to this religion by its centuries-long power over the psyche and physicality in West Africa. In the 17th century, the kings of Dahomey, with the assistance of the voodoo priests, legitimized their position of power in the newly conquered kingdom with the introduction of the ancestor cult. In the 19th century, voodoo gave the Amazon army almost inexhaustible fighting strength against the soldiers of the colonial powers. After incorporation in the French colonial kingdom, regionally powerful voodoo priests came to an arrangement with their new masters and achieved religious tolerance. Voodoo adherents took an active part in the political chaos of the postcolonial period throughout the region. The Marxist dictator Kérékou could not survive in Benin, simply because, on account of his dogmatic atheism, he could find no modus vivendi with voodoo.

This short historical look back at West Africa shows that voodoo has never feared contact with the wielders of power. Voodoo adapts itself to social circumstances and uses these according to the possibilities available. This also becomes clear in the relationship between voodoo and rival religions. Hare Krishna figures or images of the Virgin Mary are adapted

Voodoo is the wisdom of masters.

Benin. An adept is taken up into the Mami Wata Cult. The goddess of water is also the goddess of destiny responsible for all the good things in life.

Candomble priestesses in Brazil's Salvador do Bahia, the city with the highest concentration of descendants of African slaves in the Americas.

and reinterpreted in the spirit of voodoo. The voodoo religion works like a sponge. It soaks up all divergent cultural and life statements into its world picture. Thus, a secular engine block becomes a sacrificial site for Gu, the god of iron. To this extent, voodoo also employs a form of syncretism.

While voodoo is open to outside influences, the religion is equally closed within the ranks of its community. The inner circle of initiates forms a closed system that does not shrink from asserting its values and moral principles by means of social pressure and force. The loosely knotted circle of ordinary cult followers is repeatedly brought to heel by the public rituals, the demonstrations of power.

The voodoo religion works like a sponge

In West Africa voodoo is omnipresent. In the Diaspora, whether on Haiti or in Salvador do Bahia in Brazil, it includes the most various syncretistic cults. As a general rule, its followers place themselves under the protection of deities by means of rituals and sacrifices. Thus a centre of this African American religion has come into being in Salvador do Bahia, where, as in its original home, the trance of possession plays a large part. However, in the Caribbean too, the influence of voodoo is not to be underestimated. In Haiti, for example, where the descendants of slaves can practice their religion undisturbed today, it is said in the streets of Port-au-Prince that 100 per cent of the inhabitants profess Catholicism, and 90 per cent

voodoo. Is this a paradox? From Abomey to Salvador, the so-called Fifty-Fifties call themselves Christians by day, but at night they become voodoosi.

HENDRIK NEUBAUER

Screamin' Jay Hawkins (d.2000) is considered one of the founding fathers of rhythm and blues music. He conquered the world with his hit song, »I Put a Spell on You,« and his eccentric stage show, which included voodoo elements.

KUMASI ⊕ 6°41'N 1°37'W

ASHANTI

Imperial heritage

A flurry of activity among the crowds gathering in the center of Kumasi. The Asantehene, the king of Ashanti, is being carried through the city in a litter. With his subjects, he is celebrating the Akwasidae festival, which takes place every six weeks. The people are carrying enormous colorful umbrellas and raising wooden chairs aloft. These are all more or less successful copies of the Golden Stool of the Ashanti. The Golden Stool represents the power of the ruling Asantehene, Otumfuo Nana Osei Tutu II, but it also stands for the spirit of the Ashanti nation, which according to their faith is composed of all those alive, who have lived and who are still to be born.

The Otumfuo, a title which means something like warlord, is the current representative of a ruling line that can be traced back into the 17th century. Osei Tutu I, the founder of the state, united the Ashanti and created a national army. This in its turn succeeded within a few years in extending the dominion of the state considerably and forcing a path to the coast, which enabled direct contact with the Europeans. This initially meant the Dutch in the huge Fort Elmina at the Gulf of Guinea.

After them, the British attempted to extend their influence deep into the African interior. For this reason, from the early 19th century on, there were constant wars and battles, many of which were at first won by the Ashanti. However, when the British made alliances with the Ashanti's neighbor nations, Ashanti independence gradually came to an end. Today the Asantehene is officially only the spiritual leader of the nation. Nevertheless, keeping old tradition, he regularly intervenes in the daily business of politics. A critical remark about a Ghanaian politician will guarantee the Asantehene headlines in all national daily newspapers.

MAX ANNAS

HERE & NOW

Over a million Ashanti live in the heartland of Ghana in West Africa. Their wealth was once legendary; their great power was built up from trade, in gold and in slaves. In 1900, after bitterly conducted wars, the Ashanti were defeated and assimilated into the British Empire.

In 1957, when the modern state of Ghana was founded, the Asantehene kept his position as traditional chief. Until today, the Ashanti king has his seat in Kumasi, the traditional political, economic and cultural center. Today gold is still the top export item in the Ashanti area, ahead of resources such as rare woods and cocoa. Gold is mined in great quantities around the rapidly growing town of Obuasi south of the Ashanti capital Kumasi. Ashanti Goldfields Limited, which mines there without competition, was the first African enterprise to be listed on the New York Stock Exchange, in 1996. The company, now linked with South African capital as AngloGold Ashanti, is today the second largest gold company in the world. In the Obuasi district, where one of the ten most productive goldfields is located, everything depends on the noble metal. AngloGold Ashanti has far-reaching powers to expropriate land where gold is believed to exist, and to exploit the raw materials. This means that the town and its surroundings are in a state of constant reconstruction and redesign. Social connections are permanently destroyed, and so the great value of gold, which is transported to Switzerland in small special jets, is counterbalanced by the impoverishment, which cannot be overlooked, of individual strata of the population. Wide areas of land give the impression of being destroyed, and the pollution of drinking water with arsenic, which is released by the washing of the gold, is very severe.

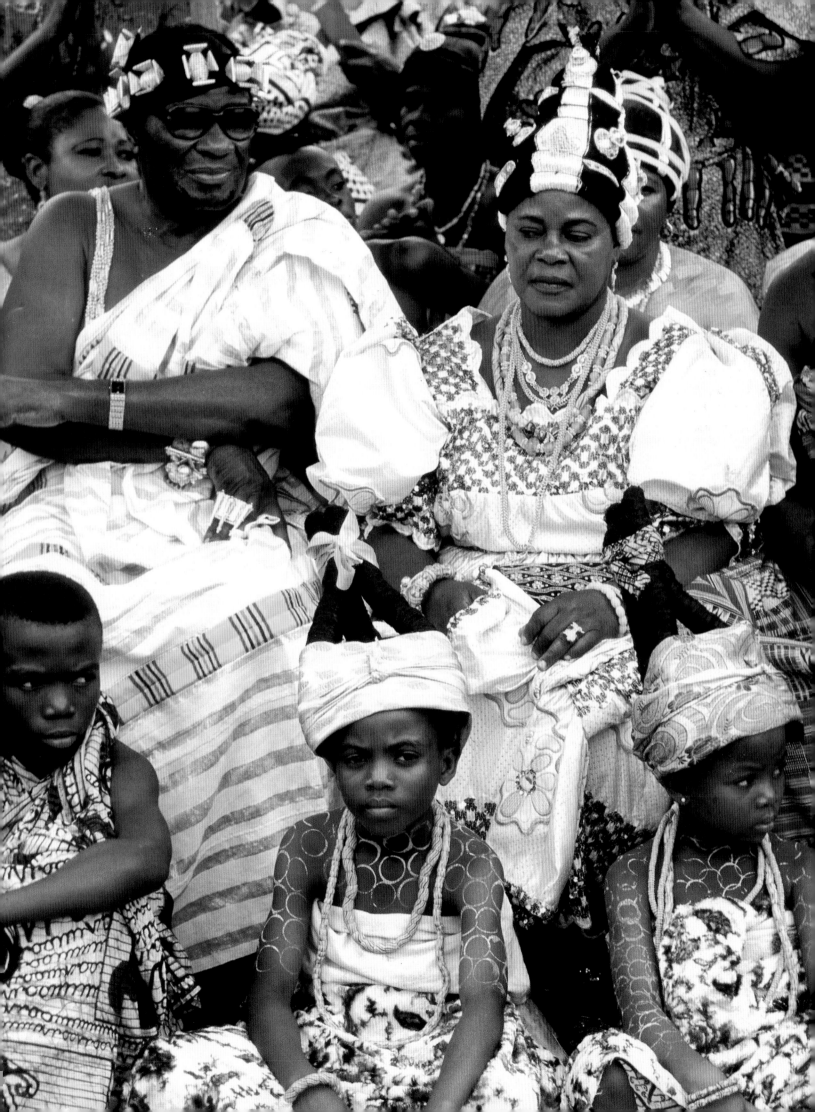

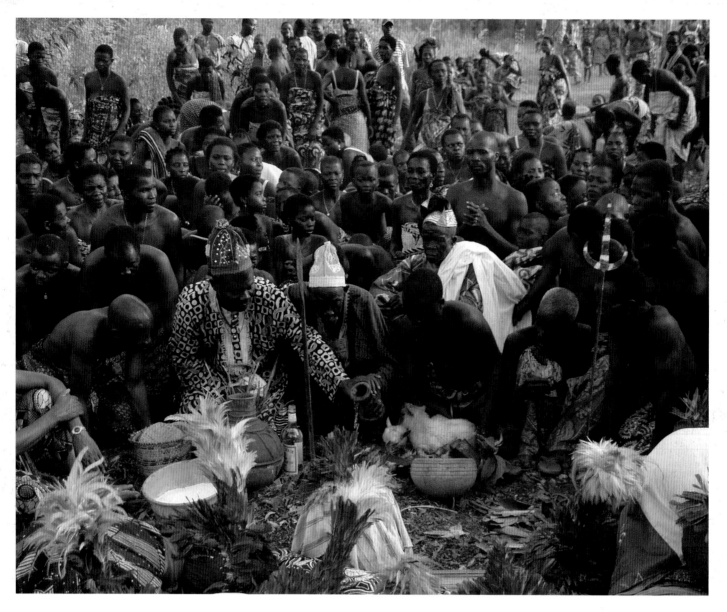

HÉVÉ 🌍 6°17'N 1°51'E

YORUBA

Held by the night

Dancing frenetically, the figure moves in a small circle, whirling around with increasing speed. The head wobbles a little and the body shakes, but neither head nor body are recognizable under the conical straw mask. The people of Heve stand at an appropriate distance from the circle. Red-dyed straw covers the head and face; underneath the throat, the colors continue – yellow, green and red again. These are the pan-African colors, which represent the sun and mineral deposits, the fertile soil and the

blood spilled in the battle for independence. This, however, is the funnel shape of the Zangbeto fetish.

In Heve, in the south of Benin along the Gulf of Guinea, the fetish twirls around as representation for non-human gods. The fetish stands for nature and its horrors and for the evil of the night that reigned on earth before the humans seized control. Nobody knows who is hiding underneath the disguise, for Zangbeto dancers are part of a secret society and a voodoo cult. The colored straw bestows

them with a second identity, in addition to their terrestrial existence.

For over several thousand years now, the Yoruba have lived in the outer region around the lagoon of Laos in southwestern Nigeria. Presently, they are quite close to the borders of the neighboring state Benin, where many other Yoruba live in the south. In the 11th century C.E., Yorubaland was given a unified leadership, probably through a king who had come from the northeast of the African continent. The kingdom of the Yoruba reached its cultural

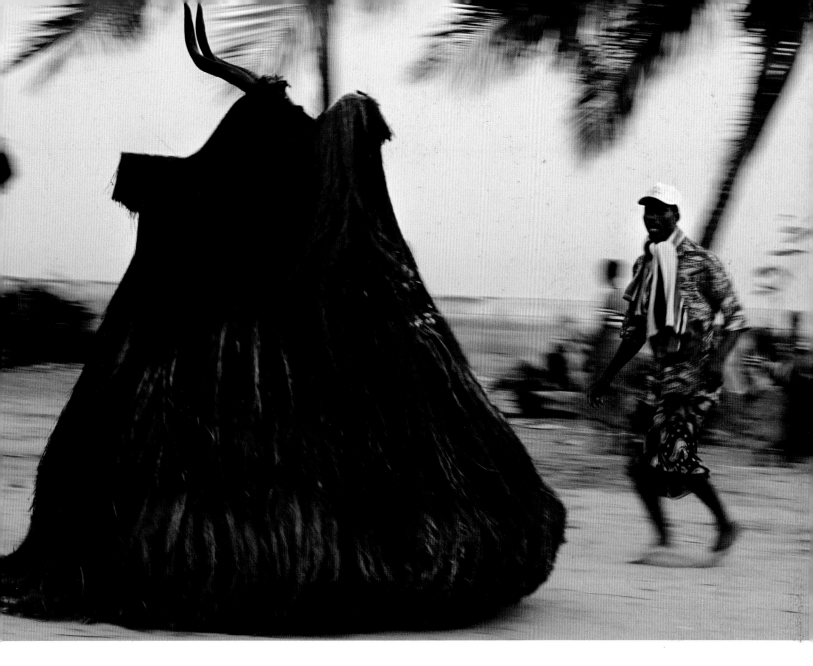

Zangbeto in Heve. The ceremonial night watchmen gyrate through the streets punishing thieves RIGHT. Libations for the voodoo god, Aglobe-Vedo LEFT. Spiritual Christians speak words of blessing in Cotonou on Lake Nokoue BELOW.

peak over the next centuries; rich cities sprung up with the subsequent large-scale agriculture. Only in the 16th century, when the European powers began to conquer Africa from the coast, did it begin to decline. Just like everywhere else, the invaders looked for mineral deposits and began to persecute the indigenous people. Slave hunters were abundant.

Romuald Hazoumé is currently one of the most famed artists around the globe. A participant in documenta in 2007, he has been awarded countless prizes; his

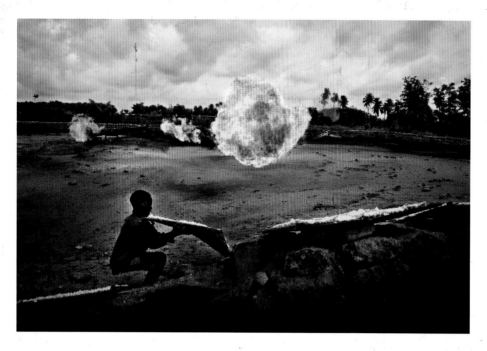

An oil field in Warri, Nigeria. When propane gas is scarce, the heat of the pipeline is used for cooking ABOVE. *Romuald Hazoumé at the »documenta 12« exhibition. His sculptures fashioned from discarded gasoline cans are internationally famous* RIGHT.

art has been exhibited in all parts of the world. His installation, La Bouche du Roi, which translates into The Mouth of the King, exhibited between 1997 and 2005, is one of the most-discussed artworks of the decade. Hazoumé gained fame through his works with oil canisters, such as the ones that can be seen everywhere in his home city, Porto Navo, the capital of Benin. There, these canisters, filled with black-market petrol are transported to nearby Nigeria. Images of Porto Novo often depict motorcycles laden down by a whole freight of these canisters. This is a terrible risk, given the highly explosive content. Hazoumé sees these canisters as a metaphor for the connection to past and present, using them to draw a comparison to the age of slavery and the living conditions of modern-day Africa, which is still suffering from the direct consequences of centuries of unbridled exploitation.

La Bouche du Roi uses this type of canisters, as well as material from the Brookes slave ship plan; material used by abolitionists in the early nineteenth century. These papers showed the structure and storage facilities of a slave ship, clearly depicting the inhumanity of the slavery system. Great Britain reacted to these papers and slavery was abolished in 1807. Using the canisters, Hazoumé built the ground structure of this slave ship and arranged the canisters' handles and outflows to resemble lifeless masks. La Bouche du Roi is now a fixed exhibit at the British Museum; Hazoumé has since also taken part in the worldwide exhibition ›Africa Remix.‹

No African culture has survived slavery as uninterrupted as the Yoruba. This is easily understandable, for compared to other tribes and given the considerable size of the Yoruba communities, relatively few younger Yoruba were kidnapped and hauled across the Atlantic Ocean.

Nonetheless, in many countries of the Caribbean, especially in Haiti, Cuba and Trinidad, as well as in Brazil, many elements of Yoruba culture can be found in religions and popular music. Classi-

HERE & NOW

At least 30 million Yoruba live predominantly in the large western African state, Nigeria, and the smaller neighboring state to the west, Benin. In both states, the Yoruba represent the second-largest group. They are also spread out across countless other states, many Yoruba families even live in the neighboring coastal states, Togo and Ghana. Their language unites them. Many are also linked to each other through Itan, the leading force behind the religion and myths of the Yoruba. Itan is the best-known spiritual model of African origins and has not only shaped voodoo, but also Santeria and Candomblé in the Caribbean and in Brazil. In addition to the metropolis Lagos, with Ibadan and Benin City, other large cities in Nigeria are in the Yoruba region; the Yoruba have also greatly marked the two most important metropolises of Benin, the capital Porto Novo and the economic capital Cotonou, which houses the government and many diplomatic services. In spite of their common language, the Yoruba have never seen themselves as a separate ethnic group or people, because the settlement territory was too big for a homogenous organization and the Yoruba, who define themselves as such, differ greatly. In Nigeria, for example, the community is divided in the middle. To the north, Muslim faith is predominant and to the south, indigenous religions and also Christianity are more prevalent.

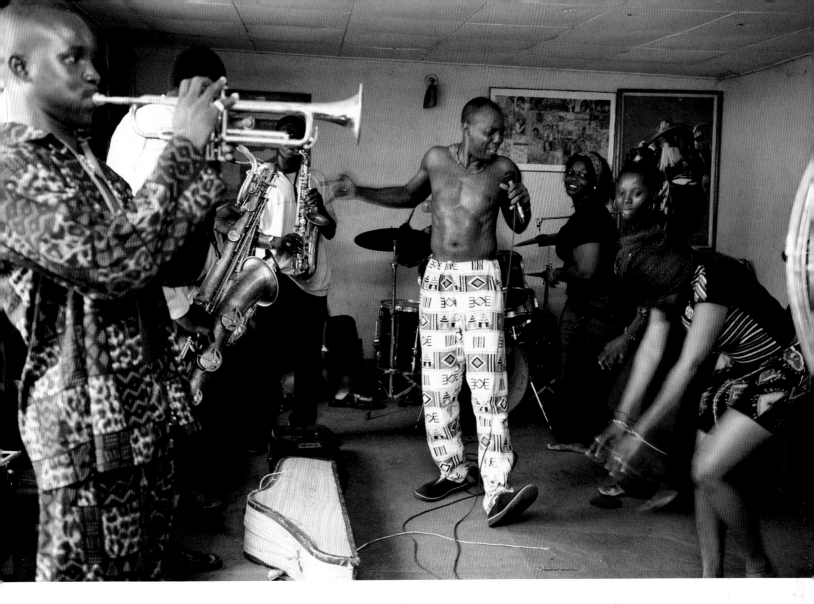

Dede (center of picture) at a rehearsal in Lagos. For ten years, he played in the band of Fela Kuti, the most famous Afrobeat musician. In Lagos itself, Kuti was notorious for speaking out against government abuses. His Kalakuta Republic, a sort of commune, was frequently raided by the police.

cal Yorubaland was also the destination for a large number of former slaves, who, after the official abolition of slavery from the mid-nineteenth century onwards, returned to Africa through the Caribbean and Brazil. This type of return was the alternative to the model of repatriation, designed by the United States of America, which resulted in the founding of Liberia, several thousand miles farther west, in 1847.

MAX ANNAS

LAGOS

Lagos, located in the heart of Yorubaland, has become one of the most fascinating metropolises in the world. With around 13 million inhabitants, it is both the largest city and the largest megalopolis in Africa, seen by many as an uninhabitable and intolerable Moloch. Yet, Lagos is also a cultural melting pot, and no other city in Africa has produced such a large number of recordings. The epic beat of Yoruba drums and the influential styles from colonial Europeans, north-African Muslims and those returning from Brazil have resulted in musical styles that inspire dance all around the world, such as Juju, Fuji, Waka and Sakara. Even Fela Kutis' Kalakuta Republic was situated in Lagos, placed by the musician and activist as a living sign against Nigeria's political stagnation. Kalakuta Republic had a health center and a recording studio, and was also the home to Fela's large family and those of his musicians. In 1970, he symbolically declared it independent. Seven years later, it was raided by the Nigerian military and burned to the ground. For two long decades, these nocturnal forces held Yorubaland, and, indeed all of Nigeria, in a stranglehold.

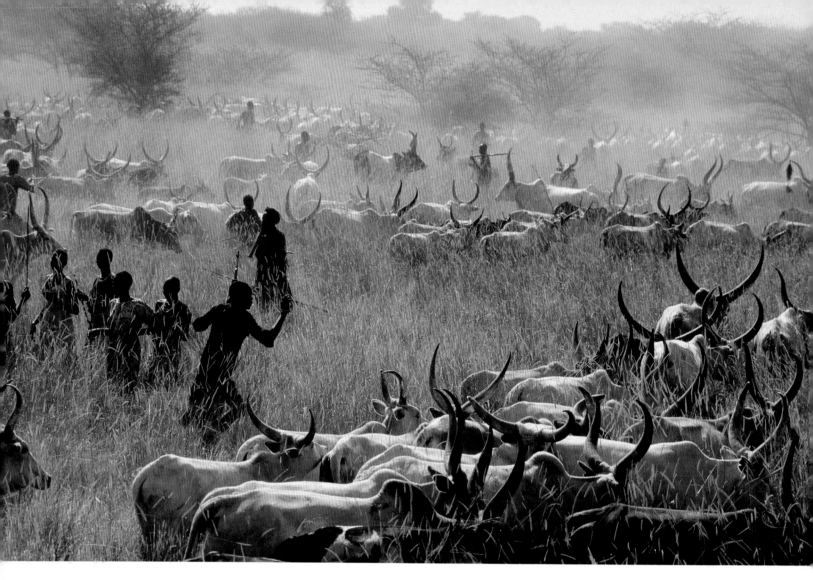

DINKA

The Cattle Cycle

The cattle cause aural mayhem. Hundreds, if not thousands, of them disorderly wander, mooing vigorously, in no recognizable pattern. It is market day in the small southern Sudanese town of Bor, on the eastern bank of the Nile. Isolated young, strong men wander between the cattle, trying to haul forward one or the other animal for presentation. The cattle are the Dinka's most precious possessions. Hardly anyone invests his wealth in money in a bank, for the cattle are the securest possession anyone of them can imagine.

The wealth of a man or a family can easily be measured by the number of cattle they own. One who calls several hundred of them his own is considered wealthy. The price of a bride is also paid in cattle. Poor people give perhaps ten animals; rich people, by contrast, many times more. However, not everything can be bought with cattle. Therefore, the word of the daughter also counts in

choosing a prospective husband, and not just the father's eye on a future herd.

No one knows how long the Dinka have been settled in this area, but it has certainly been several centuries. Pictograms have been discovered in ancient Egyptian temples showing large stocks of cattle that were not tended by the Egyptians. Were these the herds of the Dinka?

The land of the Dinka had practically no urban structures upon it until the beginning of colonization at the end of the 19th century. The British first attempted to establish administrative centers in order to systemize their rule in southern Sudan. This was enough of

an inducement for a small number of Dinka to change their lifestyle. Since then, these towns have slowly, but steadily grown.

However, civil war did more to change the world of the Dinka than the during the Colonial Era. After the then president of Sudan, Nimeiri, converted from Socialism to Islam and, in 1983, extended the Sharia to cover all of Sudan, the newly founded SPLA (Sudan's People Liberation Army) took up arms, because the majority of people living in southern Sudan are not Muslims. The war intensified when Nimeiri's rule was replaced by an elected government in Khartoum, which, in turn, was swept aside in a coup

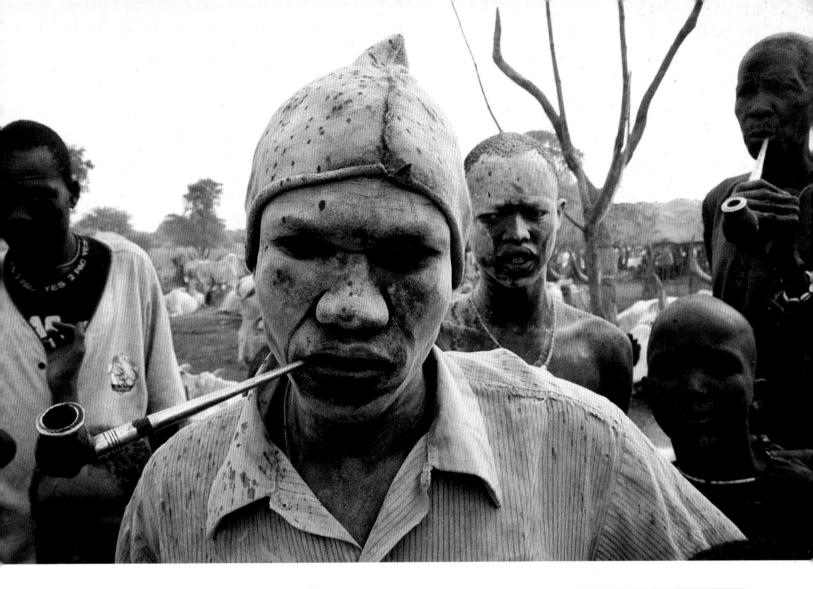

The swampy lowlands of the Bahr el Gazal province are only suitable for cattle herding LEFT. With an average height of 5 feet 9 inches (1.80 meters), Dinka men are among the tallest people on earth RIGHT.

by the notorious duo, al-Turabi and al-Bashir. These two tyrants tightened the screws and waged the war aggressively. Their interests were in the rich deposits of crude oil on the border between northern and southern Sudan. Many Dinka were especially among the war's two million dead and four million displaced refugees.

The Dinka lifestyle has always been characterized by a generous use of space for their cattle, tended by the young men, and the cultivation of the farm by the women. The Dinka have always subordinated the rhythm of their lives to the needs of the cattle. When wealth is invested in animals, then this wealth must also be well cared

HERE & NOW

It is not quite clear how many Dinka live in the Sudan today. The last census dates from 2001 and was certainly very imprecise due to the war. Since then, much has happened in Africa's largest country. Population estimates differ widely; the Dinka probably number between 2.5 and 4.5 million people. The same is true when estimating the population of the Sudan as a whole; here, the figures also vary between 35 and 42 million. The Dinka predominantly live in the south-western region of Bahr-el Ghazal, which borders on the Central African Republic, but also in the regions of Jonglei and Kordofan.

Bahr el-Ghazal was a center of the civil war in southern Sudan for more than twenty years; the leader over many years of the SPLA freedom movement, John Garang, who died 2005 in an unexplained plane crash, and his successor, Salva Kiir, are both Dinka. Many Dinka fled to more peaceful regions of Sudan or abroad during the civil war, which officially ended in 2005. The Dinka believe in a strong god, Nhialic, who created the first man and woman. Christian missionaries attempted to use this template for their own purposes. Nevertheless, only some of the Dinka have to date been Christianized. There are ten groups of Dinka, of which the Malual, with more than a million members, is the largest. The five Dinka languages are very similar and can be mutually understood with ease. The Dinka live, in part, as nomads and adapt their rhythm to the needs of cattle breeding.

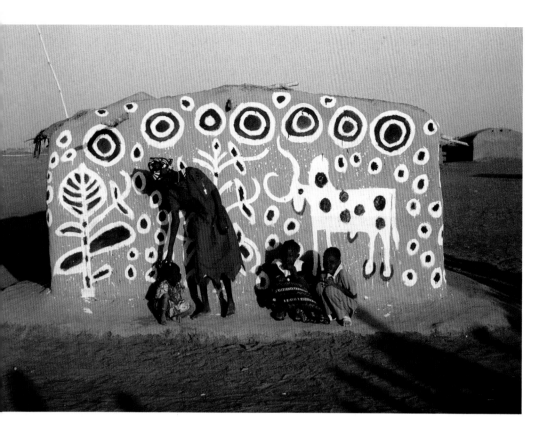
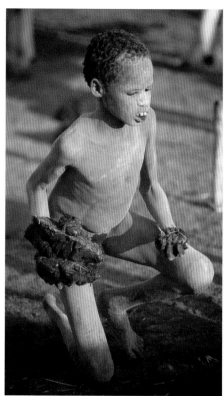

During the civil war, many Dinka fled to the outskirts of Khartoum. In the townships, Dinka traditions live on in the red mud brick buildings. Zebu cattle provide the Dinka with not only meat, milk, butter, cheese and leather, but also dung, which can be burned for fuel.

for. The Dinka have more than 400 words that describe the livestock and the various movements of the cattle. The horns of the young animals are shortened and shaped, serving as a unique identification marker, similar to the branding of animals in the West. Inexperienced observers do not know how to spot the differences, but whoever has to gather together his 30 animals from among the hundreds here, will only need a few minutes to do so.

MAX ANNAS

EMMANUEL JAL

There were two reasons why Emmanuel Jal began his career in Kenya. First of all, the east African country is one of the continent's biggest markets for music, and for decades, has consistently attracted musicians from all over Africa. Secondly, the chances of a young rapper from southern Sudan to be noticed at all in his home country are not particularly good. There was simply no chance for this in the war-torn country. No one knew that better than Jal, who was deployed as a child soldier.

It was the track on the sampler in the »Rough Guide« series, devoted to various scenes in the Sudan, which unexpectedly brought him to international attention. »Gua« is the name of the song that Jal calls a »cry for freedom« and was a number one hit in Kenya. With its combination of Jal's narrative tone and an enchanting female choir in the background, »Gua« was initially seen as a promise of a great future album for the young newcomer. However, things

turned out very differently than everyone had expected. »Ceasefire« was a cooperative work with Abdel Gadir Salim, the grand old man of Sudanese music. Up until then, Salim had never interfered in politics. Instead, his band focused on the small problems of everyday life. »Ceasefire« was the turning point.

Jal, the young man from the south, and Salim, the old man who had primarily played for the inhabitants of the north, showed the Sudan and the world that people must be united. »Music can do things that other media cannot. Music can transport things that cannot stand in the newspapers or that no one is allowed to explain on the radio.« It was then not much longer until the peace treaty between north and south, which, unfortunately, has been undermined by the following terror in Darfur.

www.emmanueljalonline.net · www.myspace.com/emmanueljal

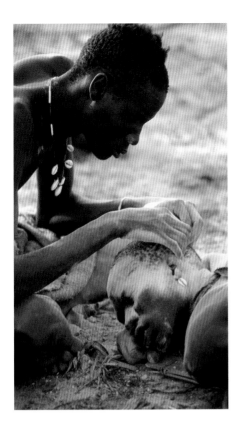 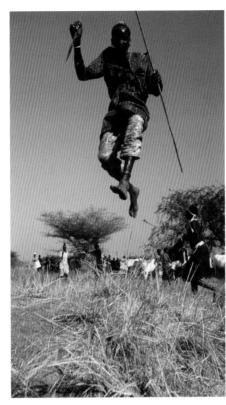 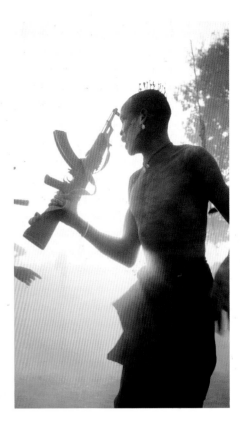

The ash of burnt cow dung offers protection against insects LEFT. The lifestyle of the cowherds has not changed CENTER. Many Dinka have joined the SPLA militias and taken up arms RIGHT. Others have fled in the direction of Khartoum, such as these Dinka holding a ceremony in a township BELOW.

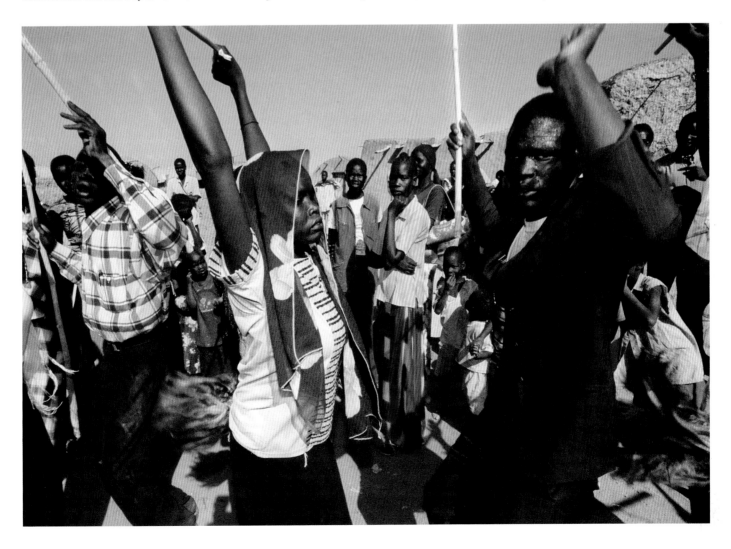

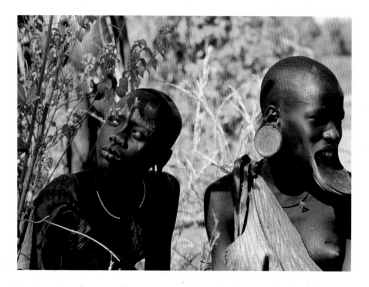

Mursi women are well known for their lip plates. They decorate their earlobes in the same way ABOVE LEFT. *Millet is pounded with a heavy stick* ABOVE RIGHT. *Mursi women in a temporary camp* BELOW LEFT. *These men are painting their bodies with clay* BELOW RIGHT.

OMO 🌐 5°53'N 35°44'E

MURSI

Caught in the crossfire

The river rushes along, and on its banks, the grass stands tall and thick. The trees that edge the valley are rich with green foliage, and the herds of cattle stand idly in the water. Every single animal enjoys the wet this September, for after the monsoon comes the dry season. The river Omo runs through the southwest of Ethiopia, along the border with Sudan, branches out into a kind of delta, and flows into Lake Turkana, part of the great East African rift, which extends far into Kenya and is considered to be the world's largest desert lake.

On the banks of the Omo stand slender, lanky men, attentively watching the movements of the cattle. These oxen are the most valuable possession of the Mursi, and unlike many other cattle herders in Africa, they live in a manageable area and, as nomads, have a relatively small radius of movement. Since the end of the 19th century they have – rather unwillingly, and certainly without being consulted – become part of the population of Ethiopia. At that time the power-hungry Emperor Menelik II had extended his sphere of influence through the conquest of »independent« areas. The Mursi live according to their own devices on the periphery of the national state up to today. Since their naturalization as citizens of the gigantic Ethiopian nation, they have even collectively withdrawn three times, wishing not to be involved in the conflicts between neighboring states, but to preserve their own identity.

This is something they are likely to find increasingly difficult. Countless films and photographs are made about the Mursi, who call themselves Mun. Above all, the girls and women have repeatedly become the subjects of

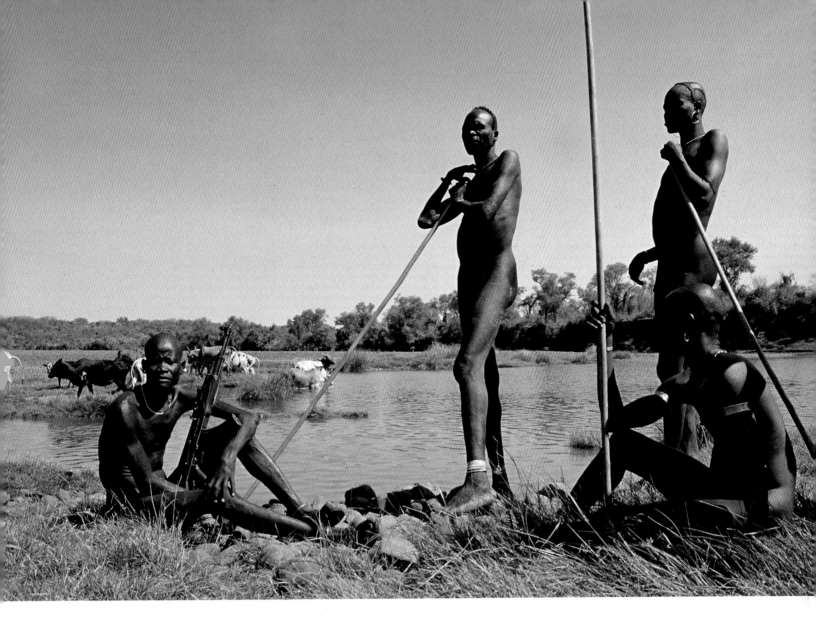

Along the Omo River, Mursi nomads guard their herds of cattle with spears and guns. Wandering according to the rainy and dry seasons, the Mursi occupy only temporary quarters.

a partly voyeuristic curiosity. Their lip-plates are part of their ideal of beauty, and the larger the fired clay plate in a girl's lower lip, the higher is the bride price, valued in head of cattle. However, it is not only the media that take up presumably spectacular motifs and break up the privacy of the Mursi. There are also everyday phenomena such as the contact, now an everyday matter, with the outside world; there are the girls who manage to access the country's rudimentary school system, who stand for change, and not only because they refuse to wear the lip plates. As long as tourists are prepared to pay two birr to be allowed to take a photograph of a woman with a lip plate, business will continue as usual.

MAX ANNAS

HERE & NOW

Today the Mursi number fewer than 10,000. They live in an area of unique historical importance by the lower Omo river, where remains of the first Homo sapiens have been found. The Mursi live in five large groups that cannot be precisely distinguished from each other. In addition, neighboring groups of herdsmen with their cattle complicate the picture. However, for a long time this did not lead to major conflicts. Only since the Kalashnikov has replaced the spear here and there, more skirmishes which arise over land disputes are heard of. In 2006, violent rainfall led to the Omo flooding its banks, with several hundred lives lost as a result. One danger for the Mursi also lies in the African Parks Foundation, a commercial organization which is responsible for the maintenance of several national parks between Sudan and Zambia. At the end of 2005, nearly 500 Mursi houses were burnt down as the result of an agreement between the Ethiopian state and this »foundation.« Documents had been presented in which the Mursi had allegedly declared themselves ready to give up part of their area – without any compensation. The Mursi respond that they could not even have read such documents, let alone sign them.

Slavery

In 1807, Great Britain banned the slave trade throughout its empire. The decision was preceded by decades of political wrangling. Other nations, like Prussia, were already ahead of London in this regard.

One result of the new policy was the willingness of the British Navy to board all slave ships en route from West Africa, break open the holds and escort the imprisoned Africans back to the mother continent. In 2007, the two-hundredth anniversary of the abolition of slavery was celebrated in the British Isles with great fanfare.

Unfortunately, in many ways, things have not changed all that much. Slavery lies at the very foundation of human relationships. Wherever there is work to be performed or money to earn, if the situation is more or less exploitative, it can often be fittingly described as slavery, in one form or another. Slavery has, of course, adapted to the times. Just as messages are no longer written on papyrus or delivered by Pony Express, young Africans are no longer thrown into chains and shipped to the Americas.

The forms of slavery have changed

Slavery means treating other people as property. In the process, the slaves are derogated, with their status reduced to that of any other merchandise. Today, two types of slavery are recognized. One kind controls the lives of people within a regime governed by the threat of physical violence, where running away to freedom is punishable by death. The other form is much more subtle. It exists as a form of trade in which (almost) all the participants are in agreement. An example is when impoverished parents give away their children to a different, more prosperous family. Calling this a sale, or calling the children a possession, is difficult in situations like this. In some cultures, few would blink an eye if hardworking parents, who were already working hard as children, handed their children over to the plantation next door in exchange for a sum of money. There can be little doubt that forced marriage also belongs in this category, even if the families involved see it somewhat differently.

Reports are emerging from the Ivory Coast that children are being forced to work on cacao plantations. It makes little difference to the children how they got there, be it via direct sale to the plantation owner or through some other kind of business arrangement. Child labor, as such, is not slavery, although it treats children like commodities. No one is really sure how many of the more than 200 million working children between the ages of five and fourteen years old live under slave-like conditions. In 2006, the child advocacy group, Terre des Hommes, put the number of enslaved workers around the world at 12 million, one-half of which are children.

All the high-achieving societies in the history of world civilization were slaveholding societies. This is as true of the ancient Orient as it is of Greece and Rome. Military expeditions were a good way to capture prisoners, who were then enslaved. The slave trade was part of everyday life all over the world for nearly every

The slave trade was part of everyday life

culture in every time period. Only the biblical Hebrews in Israel and Palestine explicitly forbade the buying and selling of slaves. Possession of a slave was legal in Israel, where most slaves belonged to the clan chiefs. Although not free workers, Israel's slaves had rights, which they could demand at any time. While slaves in many other slaveholding societies were not completely without rights, most were entirely subject to the will of their owners.

Improvements in technology changed the nature of slavery forever. Once ships could cross the Atlantic, plantations were founded in the New World. To make these economically successful, enormous quantities of workers were required. From the early sixteenth through the mid-nineteenth century some 30 million West and Central Africans were carried off to the

Slave fort Elima in Ghana. An African American family from the USA seeking traces of their ancestors from Africa.

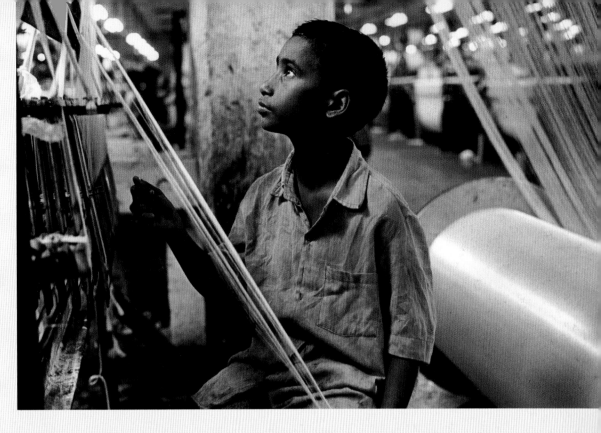

Caribbean, South America and North America. Their labor on sugar and cotton plantations was the fuel that revived a European continent torn by war and ravaged by epidemics. The American Empire would not have developed as it did without the blood, sweat and tears of slaves. The so-called Trans-Atlantic Triangle that brought slaves to the Americas was the first step toward globalization. The »middle passage« was its central element. Ships departed for Africa from European harbors loaded with trade goods, missionaries and soldiers. The middle arm of Triangle-transported slaves from Africa to the Americas to work for life. Finally, raw materials from the colonies would be shipped back to Europe, where they would be used to produce more goods.

After the slave trade ban of 1807, it was still many years before slavery itself was forbidden in most parts of the world. The sale of slaves might have been banned, but ownership of slaves remained legal. It was not until the early 20th century before most of the world's nations included a prohibition against slavery in their legal canons, but many Islamic lands did not ban the practice until the 1960s and 1970s. In 1980, the northwest African nation of Mauritania became the last country in the world to outlaw slavery.

Today, slavery has many faces. The recruitment of

Child laborers in a textile factory in Surat, India. Even with the public pressure rising for the companies, child labor still exists, and there are even orders from Western foreign countries.

Today, slavery has many faces

child soldiers is now officially recognized as a form of slavery. Trafficking in human beings for the purpose of forced labor and forced prostitution is usually considered slavery-like, in that it degrades men and women by treating them as merchandise. There is still no clear definition of the term. Many human rights organizations have declared that forced prostitution is a form of slavery. This is difficult for western-oriented states to accept. No nation wants to admit that there is slavery within its borders. In the vast northeast of Brazil, many workers live in poverty and labor in de facto bondage, guarded by armed personnel. The large landowners who exploit them live far away from the reach of the state. The ban on slavery has not made it this far yet.

MAX ANNAS

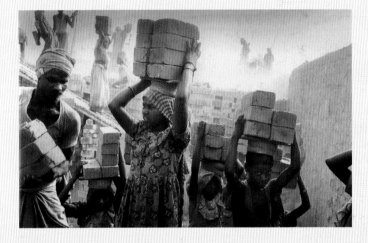

Clay brick factory in India. Child labor is a fact in many economies TOP. *Children soldiers of the SLA near Kutum in the Sudan. Many children are robbed at gunpoint and drilled to kill* BOTTOM.

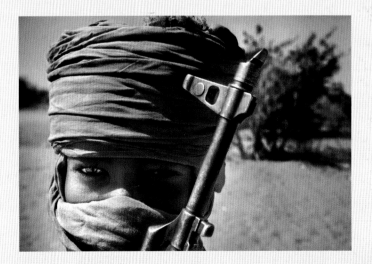

The Congo River, the second largest river in the world, drains the rain forest of Central Africa with its network of tributaries.

Forest clearance continues. The settlers who arrive in its wake of deforestation drive the Aka out of their homes.

AKA

A Long-Distance Network

The Ubangi River flows swiftly just a few miles away from the small town of Mongoumba. The river is very wide here as it roars its way south. Along its central axis, a long, thin island divides it into two channels. The city of Libenge lies on the east bank of the narrower of the two. The city behind the island, once part of the Central African Republic (CAR), today belongs to the Democratic Republic of the Congo (DRC). Within a few hundred miles the Ubangi empties into the Congo River, forming part of the gigantic river system that supplies all of central Africa and its people with water and life.

The first Aka settlements can be found a mere stone's throw away from the opposite bank of the river. There are at least 20,000 Aka living in the southwestern corner of the CAR, in part due to an influx of refugees from the neighboring DRC, where the Aka were subject to violent attacks and persecution. They are more secure in the impoverished CAR, where even ongoing civil war between the government and rebel forces barely touches them. The fighting has to do with the struggle for power in the capital city of Bangui and control of military installations. This is all very far away from the lives of the Aka.

The Aka are pygmies. There are many different groups of pygmies in Africa, with a total population of not more than 150,000. Pygmy is a term that is destined to fall

out of use. From antiquity onward it has been used as a pejorative description for a debased class of people who were markedly smaller in stature than larger people thought was normal. If the term is still in use around the world it is because no one

has made the effort to come up with a more suitable substitute. The Aka call themselves and other local groups bayaka.

Throughout history, the Aka have always managed to stay out of the way, whether by voluntarily making way for other wandering

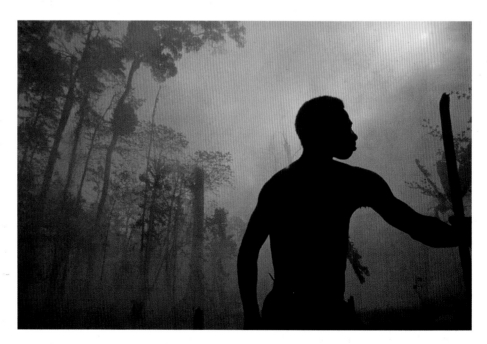

Aka pygmies are a forest people living scattered over a vast area of Western and Central Africa FAR RIGHT. *Widespread slash-and-burn land clearance threatens the rainforest* ABOVE.

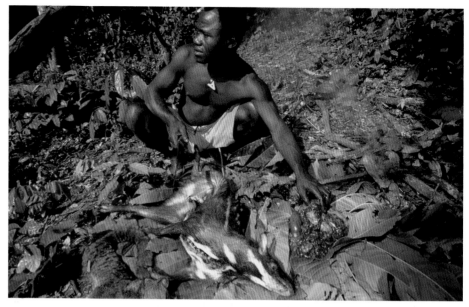

Families in a settlement in the Likouala region. The man has a fake telephone on his belt LEFT. The Aka still hunt animals like antelope, wild pigs and apes RIGHT. For the Aka, ideal beauty is expressed by decorative scars and teeth filed to a point.

groups or by being compelled to do so. Here and there one reads that their lifestyle descends directly from Stone Age hunter-gatherers, although there is considerable dispute about this. The Aka neither farm nor raise domestic animals. Instead, their economy depends on the exchange of food and crafted goods with neighboring settled farming communities. The languages of these related nomadic groups can vary widely from each other. While many indigenous groups have abandoned their native tongues for the languages of their sedentary neighbors, the Aka still speak their own Bantu-family language.

The Aka have long supplied local settled communities with meat, even during the colonial period. When the French were searching for cheap labor to work on colonial rubber plantations, many refugees, mostly male, fled the ruinous work conditions, hiding away in the deep rainforest with the Aka. The Aka had already upended Paris's best-laid plans by refusing to take part in the new society organized by the French. As long as the Ubangi continues to flow south, the Aka will also continue on as they always have, keeping their distance from modern society.

MAX ANNAS

HERE & NOW

The Aka of the Central African Republic live in one of the poorest and least secure countries in the world. This now-independent nation in the center of tropical Africa has freed itself from colonial economic intervention and military aid. As such, it can offer the Aka only a relatively secure refuge, far away from the centers of power, where they can live as one with nature in an environment too harsh for most outsiders. In contrast, related groups still living in the Democratic Republic of the Congo are regularly hunted and murdered by war parties, whose participants treat them as less than human because of their small body size. According to the United Nationals Commission on Human Rights, they are sometimes even eaten.

The Aka's rainforest home, of course, is also threatened by logging. They live in the rainforest nomadically, sustaining themselves by hunting, but also by gathering roots, fruit, and small creatures including insects. The Aka are monogamous, living in small groups of up to twenty families. Aka men made headlines a few years ago when they were called »the best dads in the world.« American anthropologist Barry Hewlett observed that Aka fathers spend more time in the immediate vicinity of their children than fathers in any other society. In the process, the ethnographer found an answer to one of nature's most puzzling anatomical mysteries: why men have nipples. Hewlett saw the Aka fathers calming infants by letting them suck on their chests until their mothers could take over.

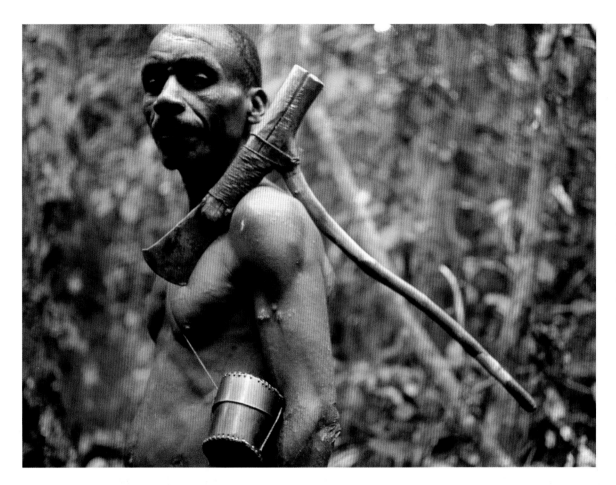

In addition to hunting, the Aka catch fish, and also gather honey, wild sweet potatoes, berries and other plants. All Pygmy groups also keep in close contact with neighboring farmers, for whom they work, or provide with wild game and forest products in exchange for crops and other goods.

THE MUSIC OF THE AKA:
THE COLLECTIVE IS THE STAR

When we think of African music, great stars like Senegal's Youssou N'Dour, Manu Dibango from Cameroon or Mali's Habib Koité, come to mind. It is always the individual who comes to the fore in pop music, to be marketed worldwide like any other band or artist. Anything that does not fall under the category of World Music is sold under the label »tribal,« a category that comes across as more than a little disparaging. Most of the time, the uninformed western listener expects little more than drumbeats. Labeling music as tribal or traditional makes it difficult to recognize two important realities. Firstly, the music in question is already an integral part of African pop music. Secondly, the musical pieces played far away from the big cities are often magnificent, thrilling works of art in their own right. For the Aka, as is the case with other groups with a similar lifestyle, music has always been, and remains, a collective experience to be celebrated within the community, for the community. The emphasis is on songs that are repeated in tightly ordered cyclical rounds. The songs are so complex that they can be analyzed mathematically. To anyone who grew up listening to rock music, Aka songs come across as hermetic and impenetrable. Naturally, the Aka themselves do not find their music at all complicated because they grew up with it. Aka music has long fascinated ethnomusicologists. For over half a century they have collected, diagrammed, systematized, and notated Aka songs. Musicologists have put down on paper music that had

never before existed in that form. Serious musicians have also shown interest in the Aka. The Hungarian composer György Ligeti has worked with their music for many years in an attempt to understand its polyrhythmic character for use his own compositions. His works for the piano experiment with the metrical freedom of Aka songs.

The music of other ethnic groups from the rainforest has also left its mark on the western world. In a 1973 remix of Herbie Hancock's famous hit single »Watermelon Man,« Hancock's percussionist Bill Summers played a beer bottle and imitated the sound of a pitch whistle in the Hindwhu style of the BaBanzéle, a group from the northern Congo. In 2003, UNESCO declared the polyphonic songs of the Aka to be Masterpieces of the Oral and Intangible Heritage of Humanity.

Fertile fields dominate the landscape along the road between Nairobi and Nanyuki ABOVE. *A Kikuyu man flees his Luo pursuers in Kibera, a Nairobi slum. In the wake of the 2007 elections, Kenya stood on the brink of civil war* BELOW.

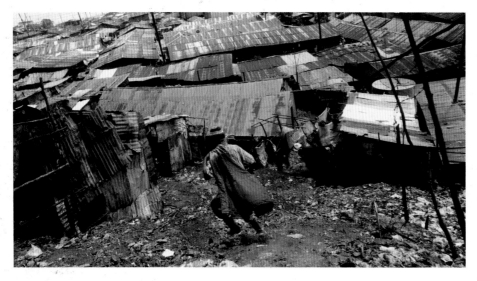

NANYUKI 🌍 1'N 37°4'E

KIKUYU

Good fruit on good land

The plump woman in the snack bar in Nanyuki gives the large silver-grey pot another stir before dipping the ladle down deep to its base and scooping a portion of githeri onto the plastic plate. She serves the stew together with a drink of lemonade on the small wooden table in front of her snack bar, which is still just in the shade. Then, she places a few pieces of roast meat on a wooden board, and puts it in front of the hungry young man at the table, who has already begun to eat. Githeri is the daily dish in Kikuyu country – a mixture of corn and beans, with a few leaves of cabbage and a sprinkling of spice.

The heartland of the Kikuyu extends around Mount Kenya, the highest mountain in the country. The region is fertile, and the Kikuyu harvest the best vegetables and fruit far and wide. However, the area is legendary for quite different reasons. Muingi was the name given by the Kikuyu to their armed rebellion, which was famous worldwide as the Mau Mau rising. Beginning in 1952, they forced the army of the British Empire into bloody confrontations which continued for several years. Although the revolt was definitively put down in 1956 by the British, it is considered only the beginning of a development with the independence of Kenya as its ultimate goal.

The Kikuyu were agricultural farmers who, from the 16th century onward, began slowly to move north from present-day Tanzania in search of better land. The quality of the soil and the work of the Kikuyu were recognized by the British settlers in the late 19th century and forced the indigenous farmers into humiliating dependence. The colonists demanded ever more work for ever decreasing reward, mostly in the form of small parcels of land conceded to the Kikuyu to cultivate for themselves. More than 50,000 dead on the side of the insurgents was the death toll of the Mau Mau uprising, mostly to be borne by the Kikuyu.

MAX ANNAS

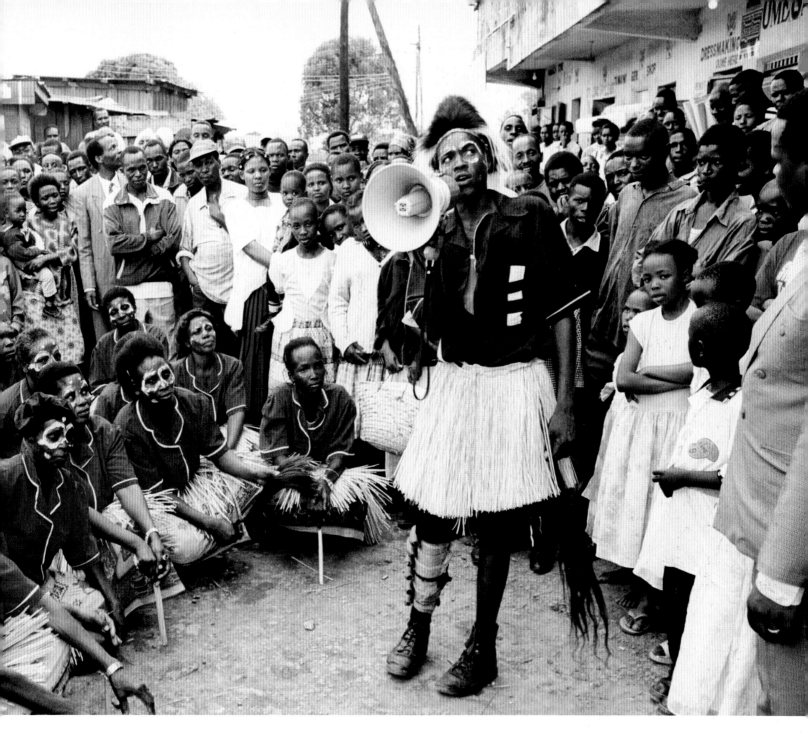

AIDS education in Chogoria. The culture of the Kikyu is alive, insofar as it accepts such pressing problems such as AIDS.

HERE & NOW

The Kikuyu represent more than a fifth of the Kenyan population, and thus, are the largest ethnic group in the country, above the Luhya, the Luo and the Kalenjin. They live in large part in the central province north of Nairobi, a mountainous region with fertile plateaus. As traders, they handle a significant proportion of goods transactions in the East African country, and accumulate a comparatively large amount of material wealth. The Kikuyu see their origin in Ngai, a strong, monotheistic god, who is said to have had nine married daughters, and thus, to have founded nine Kikuyu clans. Today, about three-quarters of the Kikuyu are members of Christian churches. Kenyan politics and the everyday life of the country are strongly characterized by ethnic allegiances,

and therefore, a claim to leadership has evolved among the Kikuyu, no just due to their large share of the population. Like Jomo Kenyatta, the first president of independent Kenya, the third president, Mwai Kibaki, is also a Kikuyu. As a result of their power and their property, other groups of the population adopt a mistrustful stance toward them. After the presidential election in 2007, the current holder of the office, Kibaki, declared himself the winner. His opposing candidate, Odinga, claimed that there was a manipulation of the vote. Mainly in the western part, it led to ethnically motivated riots and assassinations. In Febuary 2008, the parties agreed on a formation of a coalition government, and on a retrenchment of the presidential powers.

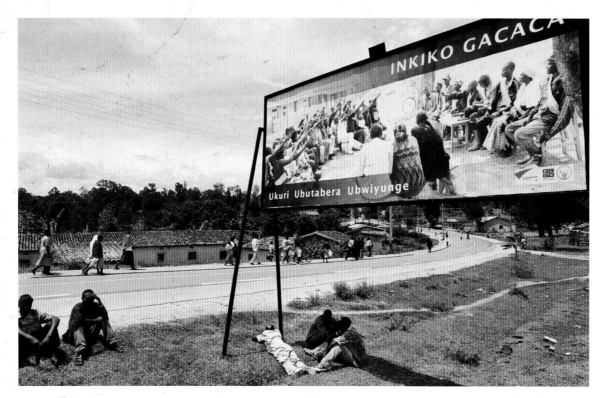

KIGALI 🌐 1°57'S 30°3'E

HUTU AND TUTSI

Racism on trial

It is April. The rainy season is beginning. The radio broadcasts reports on the trials that are beginning these days. It has been exactly ten years. Back then, it was the beginning of the rainy season, like today, when the Radio Milles Collines in Kigali began to read the lists.

These are the opening lines of Raoul Peck's film, Sometimes in April, about the Rwandan genocide. It all began in 1994 when the most popular radio program in the country transmitted coded words to the Hutu troops, sending out a call to murder through the airwaves. Not for the first time since those dark days, the Hutu and Tutsi are once again expressing hostility. The peace treaty in place since the victory of the Tutsi troops led by Paul Kagane has not been sufficient to transform Rwanda into a country ready to turn and face the future.

Hutus and Tutsis do not really exist, or at least there is no ethnic difference between them. They have a common culture and a common language, Kinyar-wanda. Ethnologists theorize that the difference, which goes back to pre-colonial times, is social rather than ethnic. The barrier between Hutu and Tutsi is the difference between poverty and wealth. Group identity is defined by the degree of social advancement or decline.

The nineteenth-century consolidation of the Kingdom of Rwanda was based on social factors as well as political power. People began to use the term Tutsi to describe people who had power, while the Hutu were referred to as »the ones who are ruled.« Attributes such as industriousness, marriage, happiness and employment were subverted by the desire for power and cliquishness. While this was going on, the increasingly divisive society came under attack by Germany. During the brief period of colonial rule (between (1885 and 1918), the divisions between the two classes of Rwandans were amplified. The Germans, needing administrators and governors, set themselves the task of figuring out what

was causing the increasingly evident divide between the Hutu and Tutsi. German specialists concluded that the 20 percent of the population that was Tutsi ruled over the majority population of Hutu, who were therefore necessarily their subordinates.

Belgium took over Rwanda and neighboring Burundi after the Allied defeat of Germany in the First World War. The Tutsis, acting as colonial deputies, became the indirect rulers of the country, carrying on much as their forefathers had done. The ethnological split remained in place when colonialism came to an end. Hutu and Tutsi fought against each other with everything they had during the early days of independence. The first government of Rwanda was organized under Hutu leadership in 1962. Thirty-two years of politics later, the genocide of approximately one million people was carried out under the banner of hate, while the world stood by, watching.

MAX ANNAS

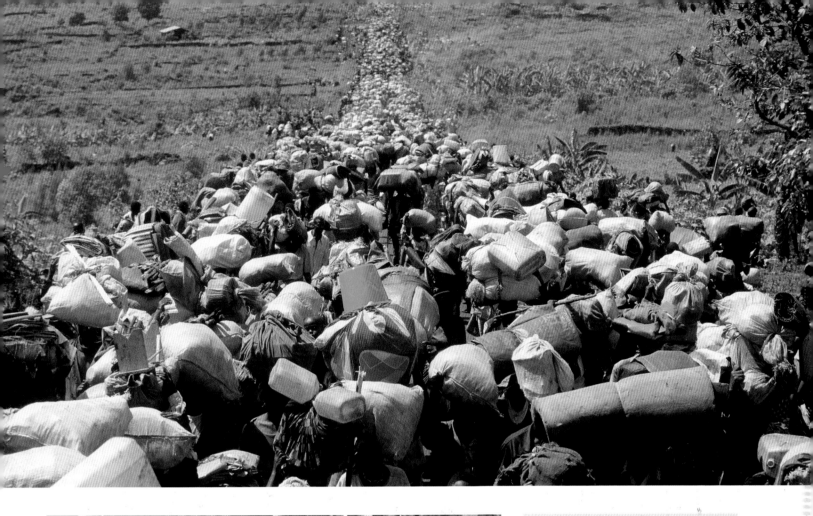

Rwanda, 1996. A massive return of some 600,000 people meant that the population increased by 25 percent within a short period of time ABOVE. October 2000. A Hutu couple at their wedding celebration in a refugee camp near Ngara, Tanzania BELOW.

HERE & NOW

The 1994 victory of the Rwandan Patriotic Front led by Paul Kagane promised reconciliation and a tally with the past. Questions remain as to how to bring about a common future under democratic conditions. There are several factors interfering with the prospect of peaceful coexistence. Mistrust still governs relations between the two groups, and densely populated Rwanda cannot provide enough gainful employment to keep troublemakers off the streets. There is also simply not enough drive to support a meaningful recovery program. In addition, the economy is focused on the production of cash crops like coffee and tea, which comprise over half of Rwanda's foreign trade. This is too insecure an economic basis given the wide variations in prices for these commodities from year to year, as well as their being controlled by the importing nations. One thing has, in fact, changed. The Hutu and Tutsi, while still separated, are no longer killing each other.

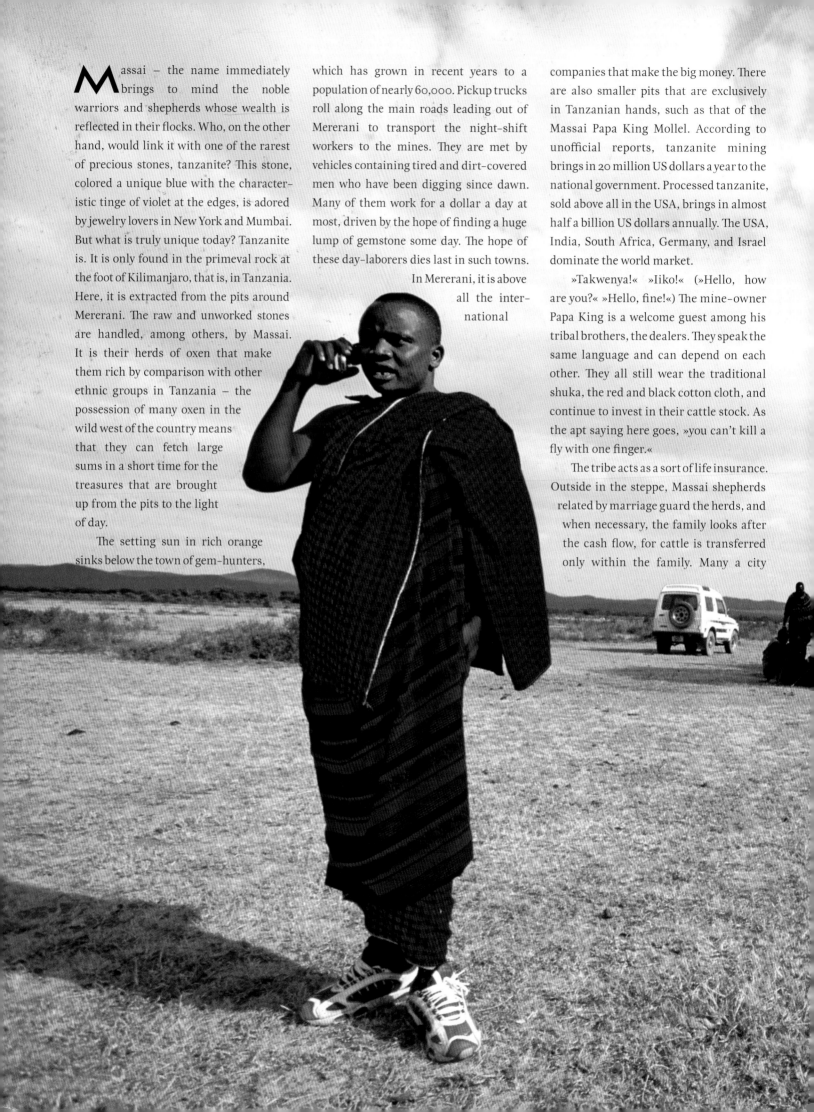

Massai – the name immediately brings to mind the noble warriors and shepherds whose wealth is reflected in their flocks. Who, on the other hand, would link it with one of the rarest of precious stones, tanzanite? This stone, colored a unique blue with the characteristic tinge of violet at the edges, is adored by jewelry lovers in New York and Mumbai. But what is truly unique today? Tanzanite is. It is only found in the primeval rock at the foot of Kilimanjaro, that is, in Tanzania. Here, it is extracted from the pits around Mererani. The raw and unworked stones are handled, among others, by Massai. It is their herds of oxen that make them rich by comparison with other ethnic groups in Tanzania – the possession of many oxen in the wild west of the country means that they can fetch large sums in a short time for the treasures that are brought up from the pits to the light of day.

The setting sun in rich orange sinks below the town of gem-hunters, which has grown in recent years to a population of nearly 60,000. Pickup trucks roll along the main roads leading out of Mererani to transport the night-shift workers to the mines. They are met by vehicles containing tired and dirt-covered men who have been digging since dawn. Many of them work for a dollar a day at most, driven by the hope of finding a huge lump of gemstone some day. The hope of these day-laborers dies last in such towns.

In Mererani, it is above all the international companies that make the big money. There are also smaller pits that are exclusively in Tanzanian hands, such as that of the Massai Papa King Mollel. According to unofficial reports, tanzanite mining brings in 20 million US dollars a year to the national government. Processed tanzanite, sold above all in the USA, brings in almost half a billion US dollars annually. The USA, India, South Africa, Germany, and Israel dominate the world market.

»Takwenya!« »Iiko!« (»Hello, how are you?« »Hello, fine!«) The mine-owner Papa King is a welcome guest among his tribal brothers, the dealers. They speak the same language and can depend on each other. They all still wear the traditional shuka, the red and black cotton cloth, and continue to invest in their cattle stock. As the apt saying here goes, »you can't kill a fly with one finger.«

The tribe acts as a sort of life insurance. Outside in the steppe, Massai shepherds related by marriage guard the herds, and when necessary, the family looks after the cash flow, for cattle is transferred only within the family. Many a city

MASSAI

Of shepherd warriors and dealers in precious stones

Massai in Mererani attains substantial prosperity in this way. However, the unpleasant rumor that up to 4,000 children work in the pits in inhumane conditions is rejected in these circles, as being bad for business. The Massai dealers observe the hard, dusty activity by day from the distance of their desks with reading lamps, magnifying glasses and micro scales.

The Massai have always been considered a proud and defensive tribe. Three or four hundred years ago they came from the region of the middle reaches of the Nile, the Sudan of today, to the area east of Lake Victoria. In the years that followed, they marked their territory, large parts of which are known today as the Massai steppes, and which extend beyond the border between Kenya and Tanzania. In the course of history, the Massai repeatedly had to defend »their« savannah landscape and assert themselves against other intruding tribes. Their success enabled them to live in their traditional way for a long time, unmolested by outside influences.

Papa King Mollel, mine operator and herd owner, on the savannah in consultation with an elder.

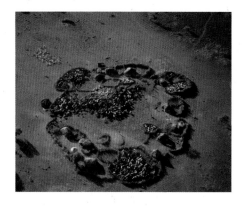
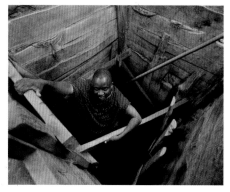
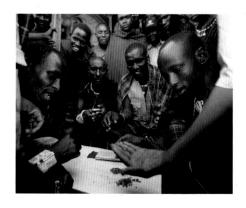

Man and beast. A typical boma enclosure on the savannah between Tanzania and Kenya ABOVE LEFT. Shaft D in the gem mining area of Mererani. The mineworkers have to dig shafts at least 3,000 ft (1000 m) deep to reach deposits of tanzanite ABOVE CENTER. Massai traders with raw gems in Mererani ABOVE RIGHT. Papa King with his youngest wife and their two children in front of his estate in Mtakuja, his home-

land BELOW LEFT. The Massai and their herds are barred from Serengeti National Park. They are left with barren wasteland in the nature preserve near Ngorongoro Krater BELOW RIGHT. The dance of warrior herdsmen. In earlier days, warriors guarded the savannah against incursions by other tribes, or went off on raids. Today, they protect both the boma and grazing cattle from wild beasts RIGHT.

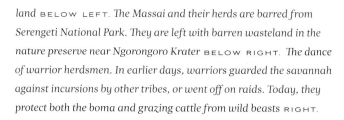

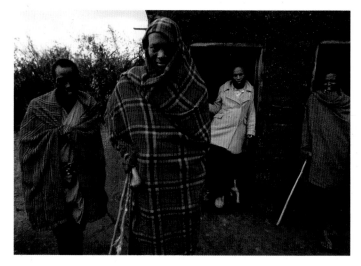

At the beginning of the 21st century there are only a few enclaves left in the region, where the Massai, far from all civilization, move from pasture to pasture and build their kraals. Increasing overdevelopment restricts their freedom of movement, and the nature reserves of Masai Mara and Serengeti restrict it even further. Where can the moran, the Massai warriors, go to hunt lions without being prosecuted for poaching? How is the carrying of spears or short swords viewed by one's neighbor in an urban environment? Would it not have been better to choose a school scholarship rather than continuing to roam around with the cattle?

The tradition of the shepherd warriors lives on. The initiation rites, where young men are circumcised and accepted in the ranks of the warriors, still exist. Though

for a long time, the Massai have been treated with hostility for putting their cultural practices so openly on show to paying tourists. By now, there are various projects in Tanzania, which on the one hand direct the streams of tourists into orderly channels and on the other hand have taken up the cause of sympathetic participation in the life of the Massai. This keeps the rank growth of tourism in check, and some villages remain undisturbed by visitors, but through redistribution all profit from this income.

For most people, the journey is an adventure in itself. Instead of an air-conditioned coach, they travel by shared taxi or crowded minibus into the bush. One of the routes ends up in Ngaramtoni, where on Thursdays and Sundays a large cattle market lures people from all over the

area. From here, one goes on foot through maize and potato fields, past banana and coffee plantations and innumerable small villages of huts. Always in view is Mount Meru, at 14,980 feet (4,566 meters) the second highest mountain in Tanzania, after the Kilimanjaro.

On arrival in one of the project villages, the visitors are invited to enter a boma, the traditional fenced courtyard. The friendly greeting »Takwenya!« can be heard everywhere. The reply, »Iiko,« already slips easily off the tongue. On request, a visit to a healer will be scheduled. Even when a special festival or ceremony is taking place in the village, guests are welcome. They are invited to enjoy a meal of grilled goat meat with rice and spicy pepperoni sauce. If they wish, they can have lessons in craft work such as threading beads. One

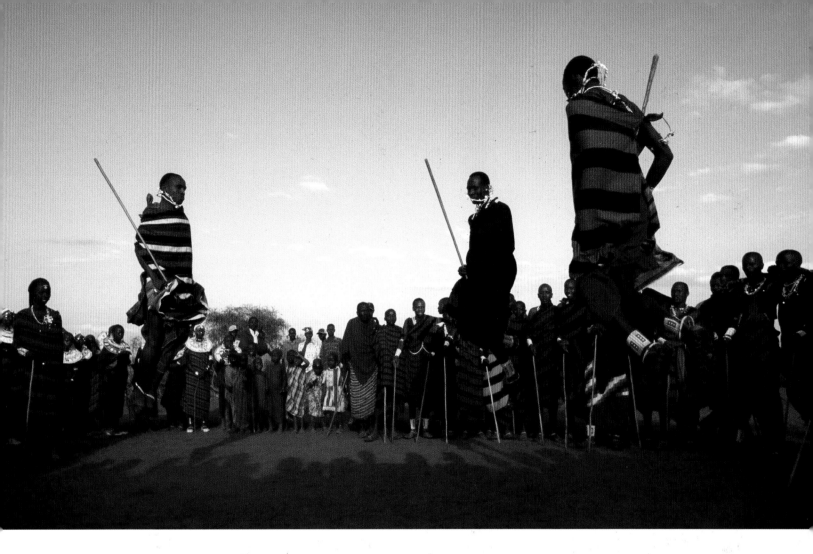

might almost forget that all these friendly services are given in exchange for the appropriate fee. But the tourists comfort themselves with the thought that an initiated and staged cultural program has finally put an end to the charity culture and that hosts and guests are profiting equally and consciously from this exchange.

Whether at the foot of the Kilimanjaro or at Mount Meru, time has changed for the Massai. Though in both cases they have developed survival strategies. And when the sun goes down behind the mountains, they remember the old myth, according to which the rain god Ngai promised the Massai all the oxen on earth. This gives the »shepherd warriors« of the 21st century hope for the land allocation battles of the decades to come.

HENDRIK NEUBAUER

HERE & NOW

The settlement area of the Massai, who number approximately 400,000, extends over the savannahs of southern Kenya and northern Tanzania. Among the 120 ethnic groups of the United Republic of Tanzania, the Massai form the second largest population group after the Bantu tribes.

The challenge to the Massai lifestyle consists in the increasing reduction of their habitat. Environmental changes resulting from human intervention intensify the situation. With the progressive deforestation of the already sparse woodland, the area of steppe land grows, and devastation and soil erosion increase. In addition, new,

modern transport networks continue to cut through the savannah. Climatic changes noticeably lead to ever longer dry seasons between the monsoons. The Massai find themselves exposed to political pressure to settle down and take up agriculture as well as cattle-rearing, in order to make more intensive use of the areas assigned to them. Consequently, in the long term they are faced with the choice of using their living space more productively or moving to less fertile regions. Even worse, the Massai possess hardly any rights to the land, and those that they have are increasingly disputed.

Men's and Woman's Societies

Early twentieth century anthropologists and sociologists were the first to describe men's societies, based on male initiation rites observed in Africa. Many of them, but in particular, Georges Dumézil, utilized the term in their conceptualization of »Indo-Germanic men's societies.« Dumézil's best known thesis identified this behavioral pattern in the ancient societies of the Romans, Germans, Aryans and Indo-Europeans. He saw all these groups as related, nurturing the same idealistic, mythological dream of an ideal society with kings and priests at the top, and peasants and laborers at the bottom. Many of Dumézil's colleagues were more than a little leery of his conclusions. To this day, there is no evidence of men's societies among the early Germanic tribes.

It is, of course, not uncommon for men to band together in a gender-specific group, but not every Friday night poker game qualifies as a men's society. Men's societies can be identified by their uniformity, secretiveness, their particular, often strange, rituals, and, of course, the exclusion of women as well as other men. These criteria describe college organizations, like fraternities, as well as groups found inside the military, mafia families, and political circles. All share at least some of the characteristics and functions

Representation of social power

of a men's society. A man is accepted for membership, and sworn in, usually by promising never to reveal what he has sworn to do. This makes him a member of a lodge, band, club, or secret society. Members of all-male associations often consider themselves an elite group, leading outsiders to wonder whether the secrecy is not simply an end unto itself. The representation of social power and pure, unadulterated male superiority is often part and parcel of the program.

A great many men's societies have been identified throughout the course of human history, and they are found all around the world. They still exist today in great numbers. Many stay well below the media radar, in part due to their exclusivity. Journalists are rarely granted access. The African nation of Liberia's Poro Liberias came to the attention of the international media after it came up in testimony against former president Charles Taylor during his trial for war crimes. As member of the Poro, Zigzag Marzah claimed in his 2008 testimony at the European Court of Human Rights in Den Haag that he and his companions had killed their enemies, including Nigerian soldiers who were in Liberia as part of an African peacekeeping force. After killing them, Marzah continued, they ate them. Due to his high rank, Taylor and others at his level within the Poro society consumed the hearts of the dead. Marzah went on to describe other rituals, such as burying a pregnant woman alive, and tearing apart a living sheep.

The Poro is a special kind of men's society. The mere fact that nearly all the men in Liberia are members places it outside the standard definition. The Poro society has a long history, one that probably goes back at least to the sixteenth century. Today, it operates in all realms of Liberian society, secular and sacred alike. Poro members are responsible for both the initiation of young men, as well as a portion of their education and training. It is the Poro that decides what each man will do in civilian life, and whether or not a man will go to war. None of its members speak about the Poro

Taylor and the Poro society

directly. Marzah may well be the first who has been willing to do so in a big courtroom with the television cameras rolling. It was Marzah's testimony that first revealed that Charles Taylor was not only the President of Liberia, but a high-ranking leader of the Poro society, as well.

Women's societies, whether entirely secret or relying on some level of secretive behavior, function in a completely different way from men's societies. The difference lies in the balance of power. With much less power, and less money, the need to conceal activities from outsiders becomes much less important, making the

Charles Taylor, former President of Liberia and member of the Poro society, in Monrovia in 2003. Taylor has been on trial for war crimes before the International Court of Justice in Den Haag since 2007.

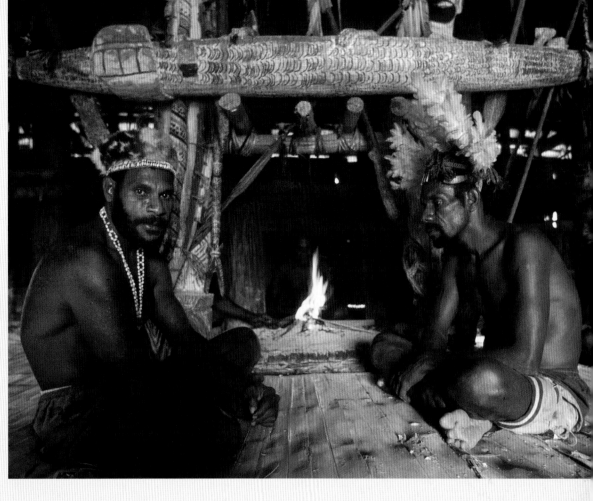

pressures within the societies much less extreme.

Among the Balobedu in northern South Africa, the »Rain Queen« rules over a tribal society with some 40,000 members. She is believed to have mystical powers, which are the source of her dominance. It is said that she can conjure up the rains. What is certain is the great respect she commands, surrounded, as she is, by a bevy of women known as her »brides.« Her power makes her socially a man, which means that, like men, she is entitled to take wives. Traditionally, these wives come from the most important local families, who, in giving their daughters in marriage to the Rain Queen, hope to gain influence in her »court.«

The effect of all this is not to be underestimated. Shaka Zulu himself, a conqueror of lands and peoples who is honored by the Zulus to this day, was afraid of this female power clique. In the course of his never-ending nineteenth century expansionist wars, he took care to avoid the Rain Queen's territories.

Upon the death of the former Rain Queen in 2001, it was remarked that, with the exception of Congolese President Laurent Kabila, she was the only person who ever made South African President Nelson Mandela wait for an audience. She needed first to be propitiated with valuable gifts. Her successor, a

Asmat men's society in Western New Guinea. Each society has its own long house. In contrast to exclusive secret societies, every initiated male in the community is a member of his village's men's society.

granddaughter, has also since died. As her only daughter was born of a relationship with someone not chosen by the court, the tradition of the Rain Queen is currently unsettled, and possibly at an end.

Men do it, and women do it too. In all cultures, they take on duties and responsibilities, enter into affiliations and make vows. Needless to say, Liberia also has a women's society. With nearly all the men in Liberia members of the Poro, there has to be some kind of counterpoint. Called the Sande, the Liberian women's society is the extra-governmental, parallel organization that makes the country complete. Like the Poro, the Sande is responsible for initiation, education and maintaining the social order. War and peace,

however, are not the Sande's business. Sande women make masks that they alone are allowed to wear during ritual ceremonies. There is nothing like this in all the rest of West Africa.

MAX ANNAS

Men do it, and women do it too

Funeral of the Rain Queen in 2005 in Ga-Modjadki, South Africa. Balobedu women like these have maintained their women's society as regents of the Rain Queen ever since.

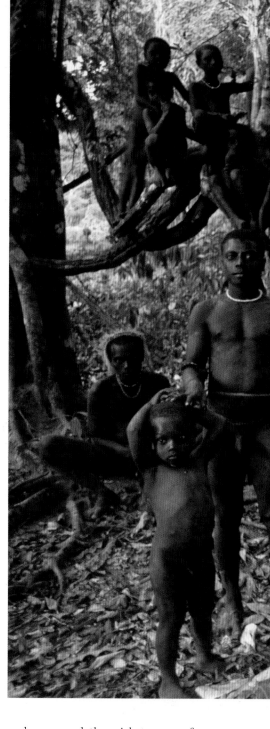

The hunting techniques of the Jarawa include catching fish using a bow and arrow. Jarawa senses are so sharpened by their close contact with nature that they can discern the slightest seismic variations long before a disaster, like the 2004 tsunami, strikes.

ANDAMAN ISLANDS 12°6'N 92°40'E

JARAWA

Short, strong and unyielding

On December 26th, 2004, a seaquake of horrendous proportions shook the Indian Ocean, causing a gigantic Tsunami wave to bring death and devastation to the coasts of countless islands and neighboring regions. In all, 230,000 people lost their lives. Even the Andaman Islands, an island group 185 miles (300 kilometers) southwest of Myanmar were not spared. This natural catastrophe took the lives of around 5,000 of the 250,000 inhabitants. Currently, around 500 to 600 native inhabitants live on the Andaman Islands, comprising four different Negrito peoples: Jarawa, Great-Andamanese, Onge und Sentinelese. All of them survived the Tsunami. They had foreseen the impending disaster and escaped to higher regions of the island. Ethnologists believe that these peoples have lived on the Andaman Islands for at least 30,000 years and seem to have developed abilities that others do not have. One example might be correctly interpreting the restless and frightened behavior of the animals or the unusually strong retreat of the sea before the gigantic wave hit; which they did on December 26th, 2004.

The Jarawa are some of the most enigmatic and least researched ethnic groups on this planet. Even today, they still lead a virtually pre-historic existence. Jungle nomads, they roam through the woods in groups of forty or fifty, hunting wild boar, turtles, birds, fish, shrimp, fruits, roots and honey. Short, with stocky, muscular body build, dark, almost black skin and curly hair, they are highly defensive and still hunt with bow and arrow. In fact, it was with this weapon that they defended themselves doggedly up until 1998, when a new transit road was to be built through their territory.

For over forty years, the government had continuously made attempts, albeit unsuccessfully, to initiate communication through small, simple presents. Yet, one day in 1998, some Jarawa left the forest voluntarily, strolled completely naked through the neighboring Indian villages, and expressed the wish to cease former hostility and even become friendly. This ultimately resulted in the increased exploitation of resources from the Jarawa forest reserve and a change in their nomadic lifestyle.

Just as unexpectedly, in 2004, they disappeared, having however, clearly indicated that they would no longer accept gifts and wished to be left alone. Maybe they had realized that contact with the settlers would hurt them even more. For in 2001, a mass epidemic of measles caused the deaths of many of the tribe and weakened

even more. In addition, hundreds of poachers have decimated crucially important fish and game along the transit road and coast. Prostitution and alcoholism, and all the consequences associated therewith, also play a role in the destruction of this unique ethnic group.

CHRISTIAN ROLFS

HERE & NOW

During the 1950s and 1970s of the of the 20th century, tens of thousands of refugees fled from Bangladesh to the Andaman Islands, which provoked increasing tension between the natives on the one hand and the British and Indian settlers on the other. Attempts made by the government to forcefully resettle the Jarawa in 1991 were finally given up in 2001. The cessation of hostility in 1998 ultimately led to the Jarawa stopping cars driving on the transit road through the Jarawa territory to beg for food, clothing and other goods. As the road attracted a growing number of settlers, lumberjacks and poachers in the Jarawa territory, the Supreme Court ordered the closure of the road in 2002. This has not been put into practice completely. Drivers are now only permitted to drive through in a convoy of cars. Stopping and taking pictures is, however, completely prohibited.

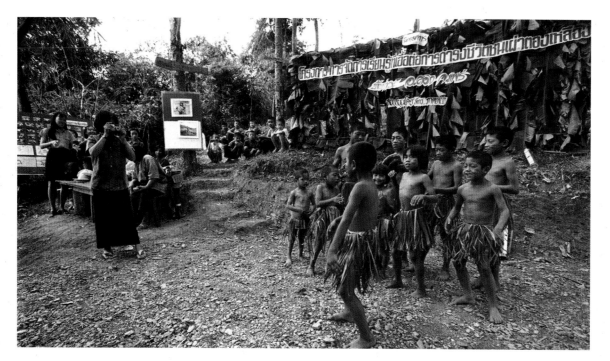

BAN RAI PHAN 🌐 18°47'N 98°54'E

HMONG

Luckily There Are Traditions

They are very enterprising, the women of the Hmong Njua, the so-called Blue Hmong. When the first »day-trippers,« with cameras adventurously dangling around their necks, make their appearance in the Thai mountain village near Chiang Mai in the morning, the Hmong women are already standing in pose at the invitingly open doors of their straw-thatched huts. The children run around smiling. The men, however, are nowhere to be seen. Click click click - only the digital cameras no longer make a sound. A perfect idyllic scene?

Cultures change. The Blue Hmong put their culture on display. The inhabitants of Ban Rai Phan village wear traditional clothing, but at the same time they also offer it for sale. The tourists spread out among the huts. Large, steaming cauldrons of cloth dye simmer over the hearths. This is where the indigo-blue pleated skirts originate; they are coveted souvenirs. The Hmong fulfill the needs of the tourists, and they are obviously good at it. Day after day, the buses stop in Ban.

The process of modernization is far advanced in Thailand. The villages of the mountain tribes also have a share in it. A school education is normal here. A modest degree of prosperity has developed. Economic success can be measured on the basis of consumer goods such as cell phones and computers, but these are not necessarily on show. The time-honored symbol of wealth is still jewelry made from silver. Today, the Hmong do not only wear silver jewelry only on feast days. The celebration of the crossover from the spirit world to the human world is becoming an everyday business and contributes to maintaining the Hmong illusion. The precious, handworked clothing with its embroidery and silver applications simply has to be seen, just as the artistically produced crossbows and musical instruments simply have to be demonstrated. It is the living tradition and not the museum shop that is so attractive.

At the market in Chiang Mai, between the vegetable and fish traders, the Hmong women, in traditional costume of course, offer their high-quality artistic hand-

icrafts made from cotton, hemp, wood, bamboo, and rattan for sale. Here, at the foot of Doi Pui Mountain, between the metropolis' concrete buildings, the culture of the mountain people seems out of place. High above the city, at an altitude of 1,000 to 1,200 meters, the effect is much better.

There, in Ban Rai, a daily ritual takes place during the tourist season. Before the first bus doors open, the huts of the Hmong come to life and the cauldron fires are lit. The women sort the goods for sale. The men, on the other hand, disappear to the livestock or the rice fields, distancing themselves from the whole hustle and bustle. What exactly they are cultivating is best left vague. Opium cultivation, sale, and consumption are not for the eyes of the tourists. In order to come to grips with the drug problem, the Thai government puts more emphasis on measures to assist agricultural development than on harsh penalties. The process of modernization is indeed far advanced in Thailand.

ALFRIED SCHMITZ

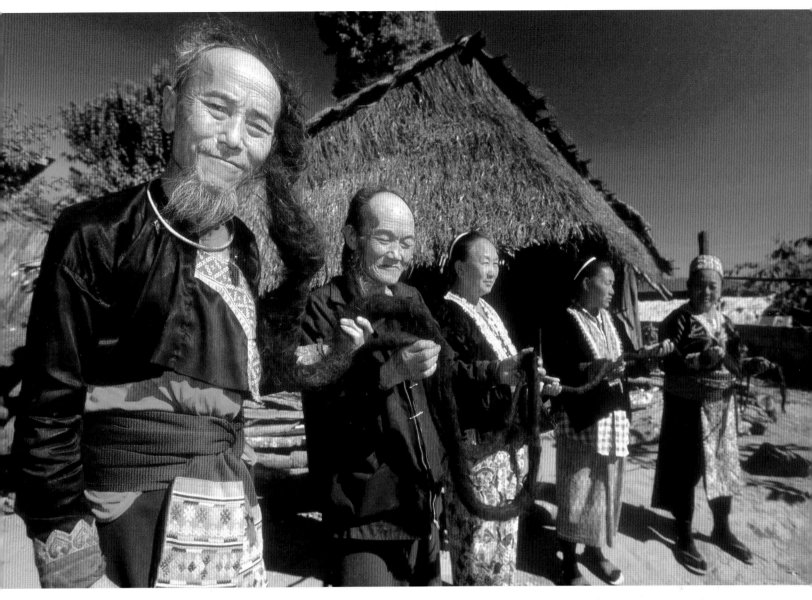

HERE & NOW

The Hmong are a people without a traditional homeland. Apart from Thailand, populations of Hmong can today be found in Laos, Vietnam, and also in several provinces in southern China. The Hmong is one of the world's most scattered minorities, with a total population of over 5 million. More than 80,000 members of the tribe still live Thailand, in three different groups – the Hmong Njua, Hmong Dao, and Hmong Gua M'ba.

Their ancestors presumably originally came from the high steppes of Tibet, Siberia, and Mongolia. They are said to have been a wild people who rebelled against the powerful Chinese and were driven south during the mid-19th century. Belief in natural religion is still very widespread. The social structure of the Hmong in Thailand is provided by the extended family. The oldest male member of the clan is in charge. Although some families profit from the general economic situation, the over-whelming majority can be said to be poor despite the obvious progress made.

Nothing escapes Agta arrows. Somewhere in the mountains of the Philippine island of Luzon, a smiling Agta man steps out from under the dense understory of the rainforest carrying a wild pig, monkey or python on his back. This will satisfy his family's hunger for two weeks or more. So it was, day in and day out, for a thousand years, and so it still is today – at least every now and then. Whether life for the Agta will still be this way tomorrow is considerably more doubtful.

Wild animal populations and the Agta hunting grounds themselves are rapidly shrinking. This is true throughout the Philippines, where mining and clear-cutting of the rainforest have driven the indigenous peoples out of their native lands. The island of Luzon, the largest in the Philippines and home to the majority of the Agta, is also subject to natural disasters, such as earthquakes and landslides. Recent volcanic activity has included the eruption of Mount Pinatubo on June 12, 1991. The areas where indigenous peoples are able to survive have become smaller, leading to a dramatic decline in their population. Today, only a few thousand Agta remain, and of these, no more than a few hundred who live deep in the island's

AGTA

People in upheaval

interior carry on the nomadic hunter-gatherer lifestyle of their forefathers. The Agtas are counted among the Philippines's negritos, a pejorative term used to describe the few surviving representatives of the most ancient races on the earth. They are thought to have crossed over from the Asiatic mainland to the islands some 30,000 years ago.

The Agta have crinkly hair and dark, often almost black, skin. With an average height of 4 feet 6 inches to 5 feet 1 inch (1.40 to 1.55 meters), they are notably short in stature, similar to the pygmies of Africa. With a lifestyle that revolves around the ability to move quickly from place to place, the Agta build only simple, temporary huts. Two wooden poles are set parallel to each other with one end thrust diagonally into the earth, and the other leaning against a tree trunk or rocky outcrop. They have highly developed orientation abilities and an unusually strong sense of smell. They can locate a snake based on its scent alone. The Agta

are also exceptionally skillful craftsmen, weaving mats and baskets and producing most of their household objects by hand.

Despite being highly adapted to their environment, Agta life expectancy is remarkably short. Only one in three Agta children will survive into his or her fifteenth year. Those who manage to pass this hurdle can expect to live, on average, to the age of 27. Recent research from England suggests a direct correlation between body size and life expectancy. According to this theory, the Agta stop growing by their twelfth year so as to make more efficient use of an accelerated lifespan. There is also some evidence that the small body size alone conveys no particular evolutionary advantage. People who live for a shorter period of time must necessarily reach adulthood earlier to ensure the survival of the group.

CHRISTIAN ROLFS

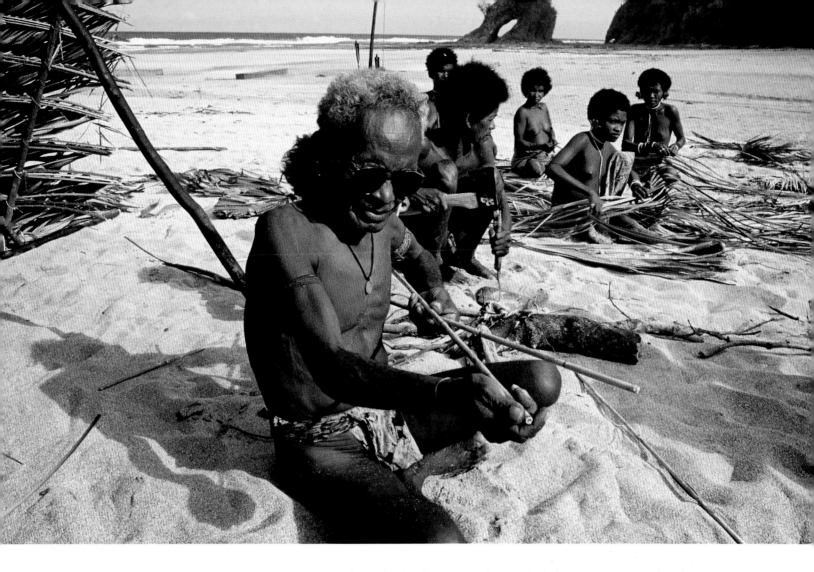

Nomads like the Agta live in rock-cut caves near water LEFT, or in huts on the beach ABOVE. The hunt for food takes up the majority of their day BELOW LEFT. A wild pig LEFT can only be brought down by someone who has been extensively trained by elders in the art of the bow and arrow BELOW RIGHT.

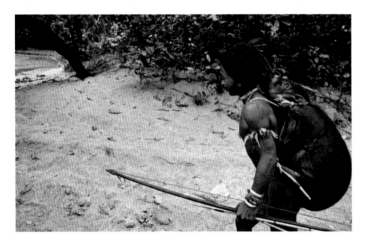

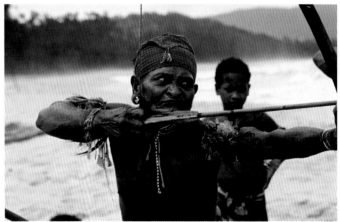

HERE & NOW

An aboriginal group on the brink of extinction, the Agta could finally breathe a sigh of relief in 2004 after a half-century of continuous decline. In response to the incursion of Filipino settlers into Agta lands and the continued destruction of the forest, the government of the Philippines granted the Agta an area of 31 square miles (50 square kilometers) so that they can continue to practice their traditional way of life. Over the years, more Agta have learned how to use a computer rather than the bow and arrow, and increasing numbers of Agta now choose to live in permanent settlements. Yet one thing has not changed: the Agta continue to occupy the lowest rung of Philippine society.

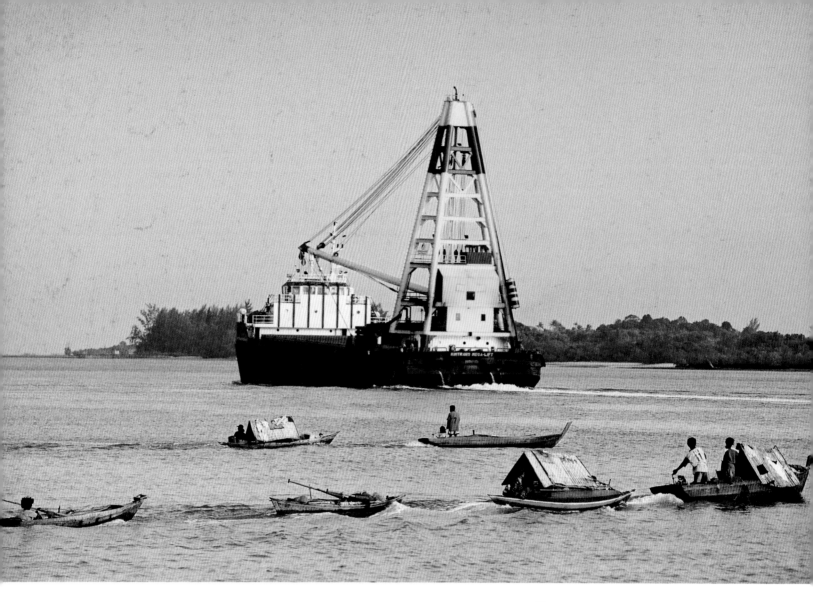

They do not own land, houses, or apartments. They are everywhere and nowhere; they need no money; they know no clocks; they are indebted to no one, aside from Allah and themselves. No one knows when they are coming, where they are coming from, and where they are headed. Their rhythm is determined by day and night, ebb and flow, rainy season and dry season: the Bajau are an enigmatic people of sea nomads with their own language who, for centuries, have been spending their entire lives on the water. Their children are born on the water, grow up on the water, marry on the water, have children on the water, and finally die on the water.

In Southeast Asia, on an Indonesian archipelago with its more than 17,000 islands, their homes float where the Indian and Pacific Oceans join. The lepa is a simple wooden boat, barely 20 feet (six meters) long and, perhaps, 5 feet

BADJO

With the Pacific Nomads of the Sea

(1.5 meters) wide, built from a few planks with booms to the left and right, on the cross-beams of which spear, harpoon, paddle and fishing equipment are stored, a blue-and-white triangular sail, and a roof of palm leaves that keeps the midsection dry when the sluice gates of the tropical heavens open. There is just enough space for an entire family. They do not have the opportunity to stretch out; they must crouch, squat, or duck down.

The hearth is a sand-filled bowl with three or four pieces of coral on which the wok and the water cauldron alternately find a secure hold. Their diet: fish. Time and again fish, every now and then shrimp,

fried in coconut fat, and augmented by sago, the nutritious flour of the sago palm, and occasionally rice.

The Bajau avoid the mainland, islands, and everything that does not float. They are met with contempt by the Indonesians living on land, who consider them to be dirty and inferior, and sometimes treat them as pariahs. They only leave their lepa when unavoidable: when they require drinking water, wood for fuel, bananas, or something to smoke. Matches, sewing equipment, canvas, or sarong can only be obtained at a market or shop and not out at sea. When a child falls seriously ill and a shaman is its only hope, or when they

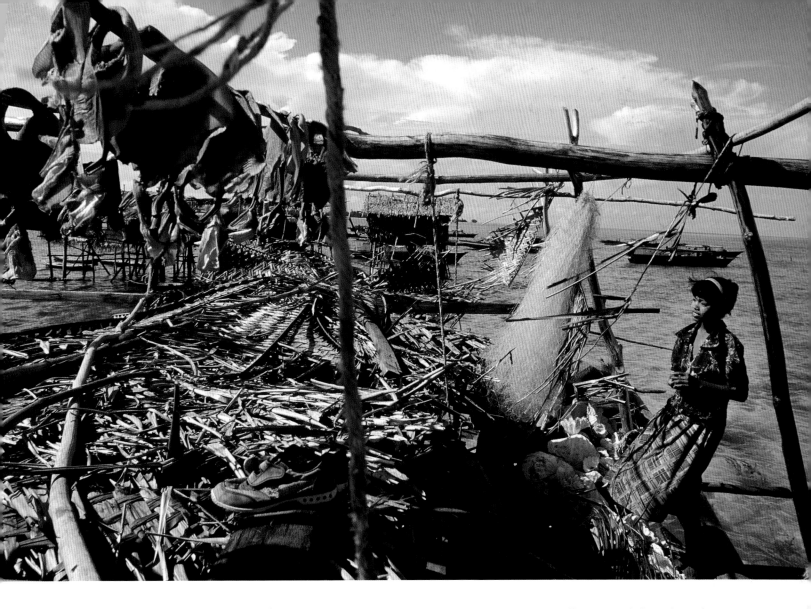

The Badjo carry on their traditional way of life on the Sulu Sea, unfazed by pirates and international shipping traffic LEFT. Fish dry in the sea breeze ABOVE. A fisherman locates schools of fish acoustically through a hole in the bottom of his boat BELOW.

wish to do a bit of trading, must they go to the land; the sea gives them much, but not everything.

Their goods bring the Bajau only a few meager Rupiah, although they cost a small fortune for the end consumer: fish and sea cucumbers. Captured and shipped alive to Taiwan, China or Singapore, the Hump-head wrasse lands on the plates of spoiled gourmets at horrendous prices, as do the slices of dried sea cucumber as a delicacy in the Trapang soup of expensive noble restaurants. While they get fish in their nets or on their hooks at all times of day or night, the Bajau have to wait until the evening and night hours before diving for sea cucumbers. These echinoderms, which resemble salad cucumbers in form and can grow up to 3.2 feet (one meter) in length, remain in hiding during the day and only

come out to forage for food on the seabed when night falls. There, they graze on the floor sediment and digest the organic substances attached to it. It is for this reason that sea cucumbers are kept in the aquariums of some zoos as living vacuum cleaners that constantly keep the tank floors clean in a natural way.

The Bajau often have to dive 23 to 26 feet (7 to 8 meters) into the depths to catch sea cucumbers; something they accomplish with playful ease, for they are skilful and resilient divers. So resilient that the first Europeans to come into contact with them initially believed in wonder that the Bajau possessed gills just like fish. The Bajau dive with self-made harpoons, but swim without flippers or oxygen tanks. At best, they wear diving goggles carved from wood with lenses skillfully sealed with natural

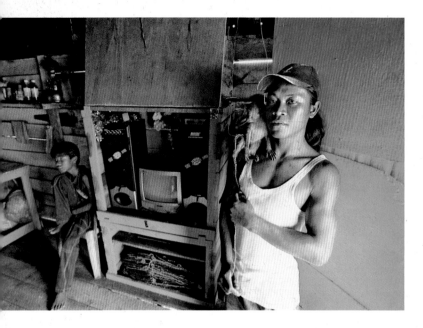

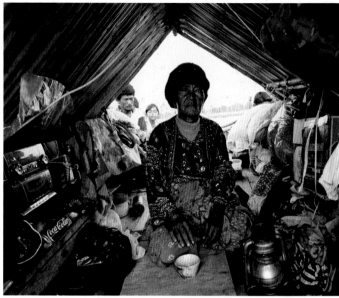

There are no schools on the water. Great efforts have been made to make the sea nomads settle down in order to give Badjo children educational and training opportunities. The Badjo build their houses on stilts because of the proximity to water ABOVE LEFT, BELOW LEFT, BELOW RIGHT. Entire families still live on boats, most with petroleum for lamps and batteries to keep contact with the outside world.

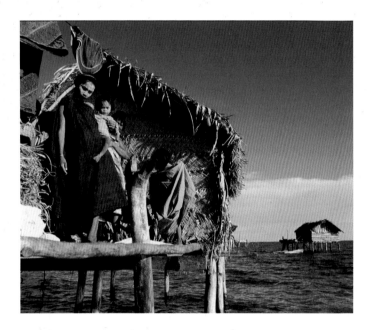

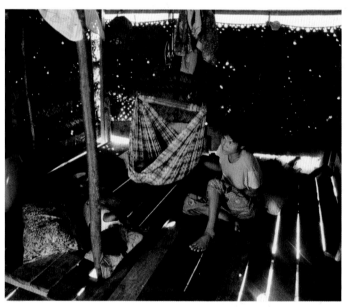

rubber to make them water-tight. The Bajau are considered peaceful, shy, courteous, and friendly. They know no fear. They even remain out at sea during storms, at most seeking protection between the bizarre stilt roots of the mangroves when things really get rough, for the freeboard of their lepa is scarcely 12 inches (30 centimeters) high and the boats quickly become waterlogged in adverse sea conditions.

When mata hari, the sun, sinks into the mirror-like surface of the sea at dusk, groups of sometimes seven, sometimes eight, lepa can be found closely packed together at anchor in the bays of deserted islands. No one knows where they have come from, but they are there. Soon, the murmur of hushed words waft over the water, news is exchanged in a relaxed manner, goods are exchanged, and gifts are given. Those who no longer have any sugar are given sugar; those who have had no luck in fishing are given fish; those who no longer have anything to smoke are given some tobacco. A Bajau needs nothing more in order to be happy. Paradise has many faces.

CHRISTIAN ROLFS

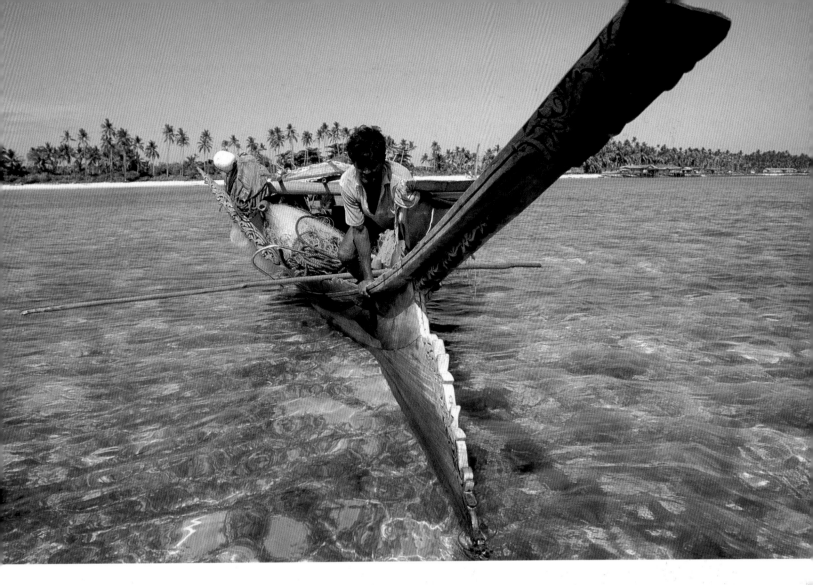

A Badjo is born on the water, spends his or her live on the water and dies on the water ABOVE. Badjo only go on land when it is absolutely necessary, when drinking water or other essentials are running low, or to bury relatives BELOW.

HERE & NOW

The origins of the Bajau are obscure. The sea nomads were first mentioned in reports by Portuguese sailors in the 16th century, which described natives living in house boats. There is no conclusive evidence to substantiate later speculation that the Bajau were, in fact, inhabitants of the Malayan coast later driven out onto the sea by other tribes. For years, the Indonesian government has been attempting for years to settle the Bajau in permanent housing, thereby, turning the sea nomads into settled inhabitants of the land. This way, they also wish to ensure that Bajau children go to school, something that they have never done before. This attempt can, meanwhile, be considered a failure, for almost all the Bajau left the permanent housing after a short period; many returned to their old life on the water. This comes as no surprise, for the booting-out method of radical change to century-old lifestyles is seldom crowned with success. At least, they have succeeded in getting some of the unwilling Bajau used to the idea of living in settlements built on wooden stilts and erected directly on the beach, which have a much less restrictive effect on them than stone buildings, thanks to their airy open construction. Here, they remain close to the water, while at the same time, their children can be educated at nearby schools. The Bajau know perfectly well that their children no longer have any major future without an education.

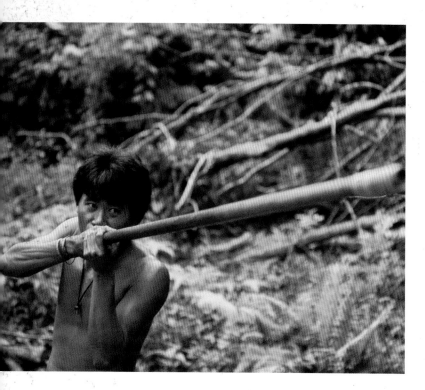

These Penan live as nomads. They hunt with a blow pipe and gather food. After months, when the harvests at one location in the rainforest reduce, they migrate to other places LEFT. *Bulldozers and power saws cut new stretches all the time* RIGHT.

BARAM RIVER ⊕ 4°11'N 114°19'E

PENAN

Demonstrators in the rain forest

The logging roads eat their way through the thick forests of Borneo like greedy caterpillars. The constant sound of chainsaws comes from a distance. Every few hours, a cloud of dust swirls down the muddy track, as another truck full of tree trunks drives by. The wood will be shipped to Asia and Europe within a few days.

One of the trucks has stopped because the road is blocked. Two enormous trees lie across the highway, overlaid by smaller trunks to form an impenetrable barrier. A dozen men stand around it, holding signs that read: »this is our land« and »stop cutting down trees.« The protesters are the Penan, an aboriginal people whose way of life is dependent on an intact rain forest, where they hunt forest animals like the bearded pig, and gather wild plants and tubers. The nomadic Penan trade with their sedentary neighbors living in nearby long

house communities. They provide them with forest products like rattan and the edible bird nests. The latter will find their way to the markets of Asia, where they sell like hotcakes.

Although the numbers of incoming tree cutters continues to grow, the number of Penan protests against them is decreasing. There are reasons for this. The first logging road blockade by the Penan took place in 1987, in Sarawak, a Malaysian city on the island of Borneo. Media coverage led to a massive wave of support, funded by, and in part directed by, western environmental activist organizations. The first blockade lasted for eight months. The government, which legally had its hands tied, promptly passed a new law that punished the erecting of a blockade with two years in prison and a hefty fine. In addition, the Malaysian police began taking down the barricades routinely. The logging roads

are still subject to regular blockading, but now the activists are usually arrested right away, after which they disappear as the world looks the other way.

The results of cutting down the rainforest, and with it, the Penan, have been devastating. Formerly clear streams are now cloudy, and fish stocks are declining. Animals are driven to extinction, and plant life is no longer abundant, making these traditional foodstuffs and trade products increasingly difficult for the Penan to find. They are more and more forced to give up their nomadic lifestyle. The Penan regret in particular the loss of the Sago palm, a staple of their diet. The slopes where it grows are regularly destroyed by logging roads, which also do not stop for their ancestors' graves.

Many Penan now live in settlements, where they build simple huts that bear no comparison to the fortress-like long houses of neighboring ethnic groups. The poverty

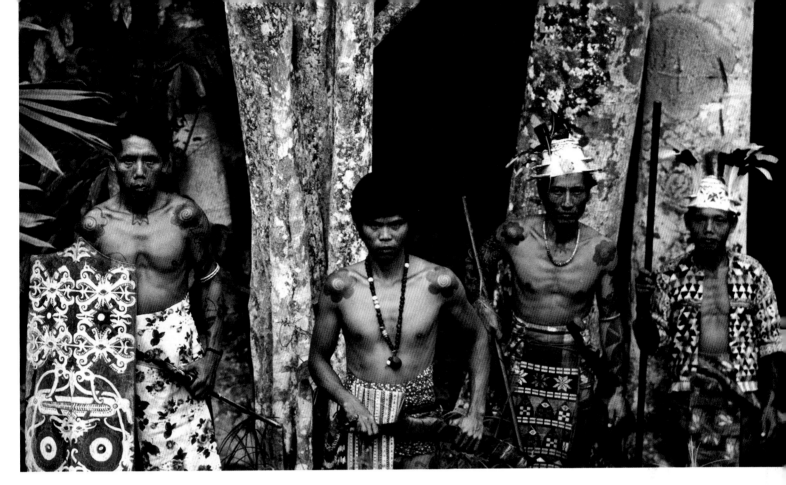

Penan are the original people in the jungle of Sarawak. Some present themselves as martial head hunters TOP. Newly built longhouses are the exception; many of the settled Penan live in barracks nowadays RIGHT.

of the Penan is palpable. In the shadows, a young man smokes a cigarette. Indigenous rights are protected in Sarawak's regional constitution, he says, but when these rights conflict with »development,« or the lumber industry, they are simply not upheld. Penan tribal territories are easily reclassified as land belonging to the state, often from one day to the next, he grumbles. The young man looks off into the distance to the southwest of the village, where the land begins to rise. That is where they once lived, he says, or so the elders have told him. They are not allowed to go there anymore, because it is now a protected forest preserve. The government threatens to punish the Penan who hunt there, but the young man still hunts there neverthe-less. He will take the risk. When asked if he still hunts with a blowpipe, the answer is: »No, now I have a gun.«

LAURA ENGEL

HERE & NOW

The Penan are a nomadic group living primarily in the Malaysian state of Sarawak. They are also found in the Sultanate of Brunei and in Kalimantan, the Indonesian half of Borneo. There are western and eastern branches of the Penan, separated by the Baram River. Both are subdivided into smaller groups. Around 300 Penan continue their nomadic lifestyle in the Baram region today. Many more Penan are now settled, but most continue, for the most part, to earn their living from forest products. Events like the disappearance of the Swiss Bruno Manser, who had fought for Penan rights, as well as the unexplained death of a Penan chief in 2008, continue to haunt the headlines.

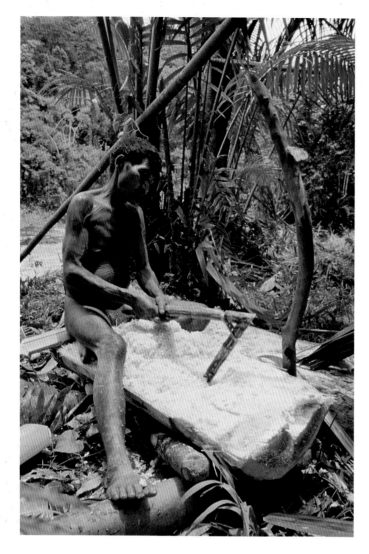

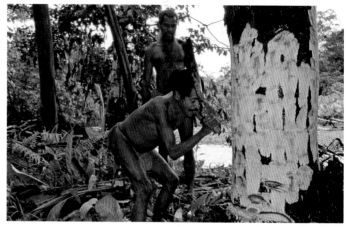

Before the pulp of the sago palm can be scraped from the trunk LEFT, *the tree's age needs to be determined and it has to be cut down* ABOVE.

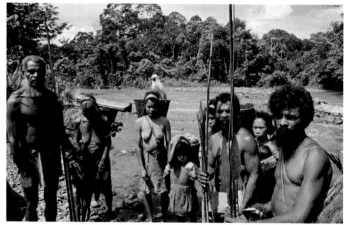

MASUANE

The Blessing of the Sago Palm

Sago is the starch that stems from the tropical swamp. Initially tasteless, palm marrow takes on the taste of those ingredients added to its preparation. Sago is one of the main staples of the Masuane, who, as foragers, ceaselessly roam the mountainous region, Ceram, hunting and gathering. Fortunately, the mountains and forests of the heart of the Moluccus archipelago are still spacious enough for this type of lifestyle.

The rainforest reaches right up to the settlements on the island of Ceram. Often, Sago palm tree groves are cultivated. In the depths of the jungle, these wild palms grow abundantly. With the Sago palm trees in mind, the Masuane make good use of the expansive space.

Sago palm trees only bloom once in their lives, when they are between ten and fifteen years old. Until then, they create and store enormous amounts of the marrow, which is needed to nourish the blossoms. After blooming, all marrow has been used and the tree trunk is hollow. The Masuane test the maturity level of the palm tree by drilling into the tree trunk. If the tree is sufficiently mature, they cut down the tree, remove the bark and split the wood into smaller pieces.

After the Masuane men have accomplished the initial part of the harvesting process, the women now begin to remove the marrow – they pound and crush it in a trough. Because it still contains inedible wooden fibrous elements, which need to be removed, the women add water and stir everything together.

This viscous mash is filtered multiple times through sieves, which results in the wooden parts being separated from the filtered liquid extract. This extract is then caught in containers. After a while, the starch settles on the bottom of the container and the Masuane merely need to scoop out the water, for the filtered Sago lies below. The last step is drying the Sago, either by leaving it out to dry or deliberately drying it over a fire.

The Sago can now be used as flour for bread, flatbread or porridge. The rest of the plant is used as construction material. Palm leaves are superior construction material for roofs, compared

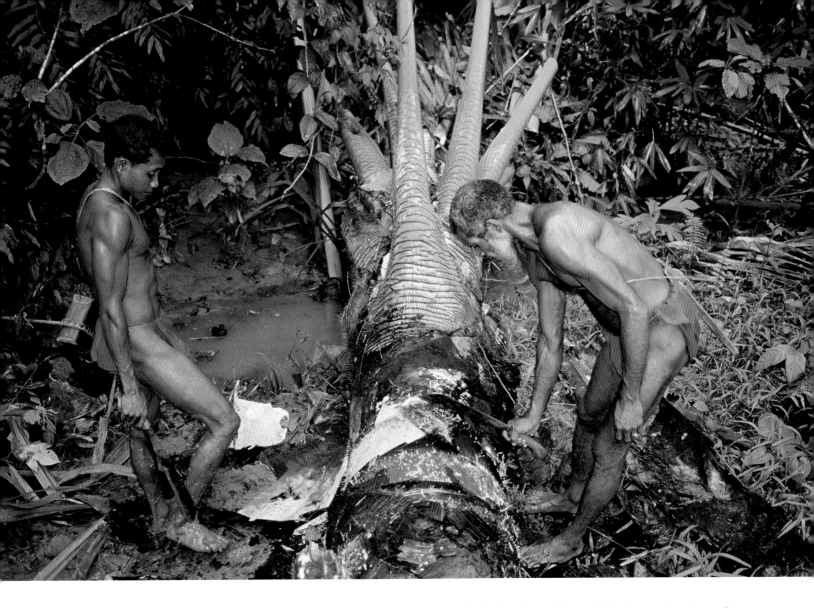

The sago palm is highly valued. In addition to other sago products, the Masuane use the leafstalks for walls and the sturdy fronds to make waterproof roofs for their huts. In some places, sago seeds are used to make buttons.

to, for example, corrugated iron. Indeed, the rainproof leaves protect from the impact of the tropical rain better than any other material.

No other useful plant in all of south eastern Asia has an even similar ratio of yield to input of effort as the Sago tree. A fully-grown Sago tree yields around 0.6 to 0.8 tons of Sago. That is more than enough to feed a Masuane for an entire year, yet it only requires around one and a half weeks of hard work.

Sago is also used in the Western world to make desserts and soups; in Ceram and other Moluccus islands, it is one of the more important articles exported, next to coconuts, cloves, rice, tobacco, cocoa and peanut oil. The Indonesian government, however, has other plans and is eager to chop down the rain forest in Ceram in order to cultivate rice plantations. Rice paddies offer more immediate profit. Will the wild Sago palm tree be able to compete?

CHRISTIAN ROLFS

HERE & NOW

With just over 1553 square miles (17,000 square kilometers), Ceram is around half the size of Belgium and the second-largest island of the Moluccus archipelago, situated between Borneo and New Guinea. This island, as well, suffers from transmigration problems, partially due to new immigrants' disappointment concerning the living conditions on the island. The main issue, however, seems to be the recurring conflicts with the predominantly Muslim immigrant population and the native inhabitants of the island, whose Christianity dates back to colonial times. The Protestant inhabitants are now no longer in the majority – a development, which is most likely encouraged by the central government. Over 4,000 people have lost their lives in this conflict – a high price to pay. Nonetheless, Ceram seems to have been somewhat spared, with only 24 deaths in 2000.

ASMAT

Sensed Boundaries, Precise Maps

Ahandful of men sit in a narrow dugout canoe, some splendidly decorated with painted faces and bird-of-paradise feathers in their hair, others in simple, western clothes. Among them is also a reporter from National Geographic, who is recording the remarkable scene for the readers of her magazine. The men are paddling up the Sor River in the humid heat of the malaria-ridden lowlands of New Guinea. The canoe halts at every tributary, and a man with a global positioning satellite device determines the coordinates of the river. The small group is undertaking the trip on behalf of the Asmat council of elders, in order to document ancient rights with the help of the most modern technology: the right of every Asmat family to the land and the forest, in which they have lived for thousands of years. The tributaries mark the natural boundaries between the living spaces of individual Asmat families. Here, they hunt and fish, and harvest the pith of the sago palm. Here, they erect their settlements—traditionally around the men's house as the cultural center. Here, the ancestors live in their sacred places.

So far, the Asmat have transferred the rights to use the land from generation to generation by word of mouth. They have not known the Western concept of landownership. This is now changing. It is a question of survival for the Asmat, as well as for many other Papuan peoples, for the Indonesian government will only recognize their ancestral rights of use to their forest when they can prove those rights. Time is short! The international interest in Asia's largest, still connected rain forest and its coastal waters is immense: logging is allowed in a third of West Papua. West Papua is already the world's biggest supplier of the valuable tropical timber Merbau, of which 90 percent is illegally felled. Oil companies have discovered large deposits of crude oil in the Asmat region, and settlers from other regions of Indonesia are increasingly encroaching on their living space.

»When we have finished surveying and mapping, then local, regional, national, and even international governments will have to recognize the rights to our land,« hopes Ernest Dicim, a leader of the Asmat. »That is our battle.« The battle is being financed and supported by the environmental protection organiza-

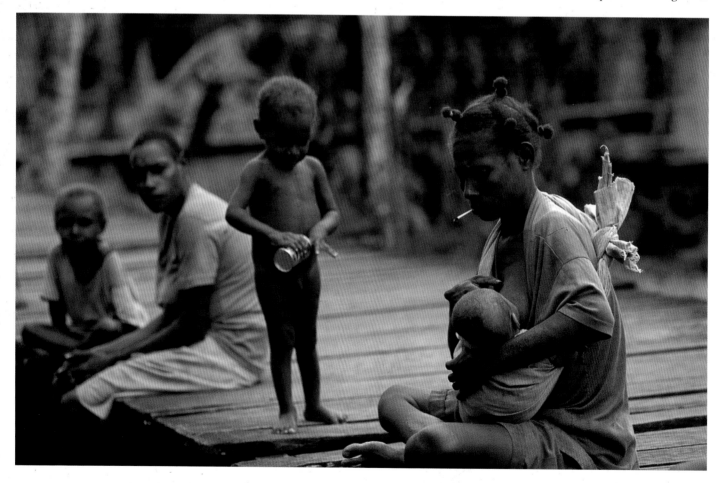

Life on the River Sor. The living conditions in the highlands are difficult and full of uncertainty ABOVE. *A football match between Asmat and Indonesian teams. The Indonesian government's transmigration project has brought many new neighbors to the Asmat* RIGHT.

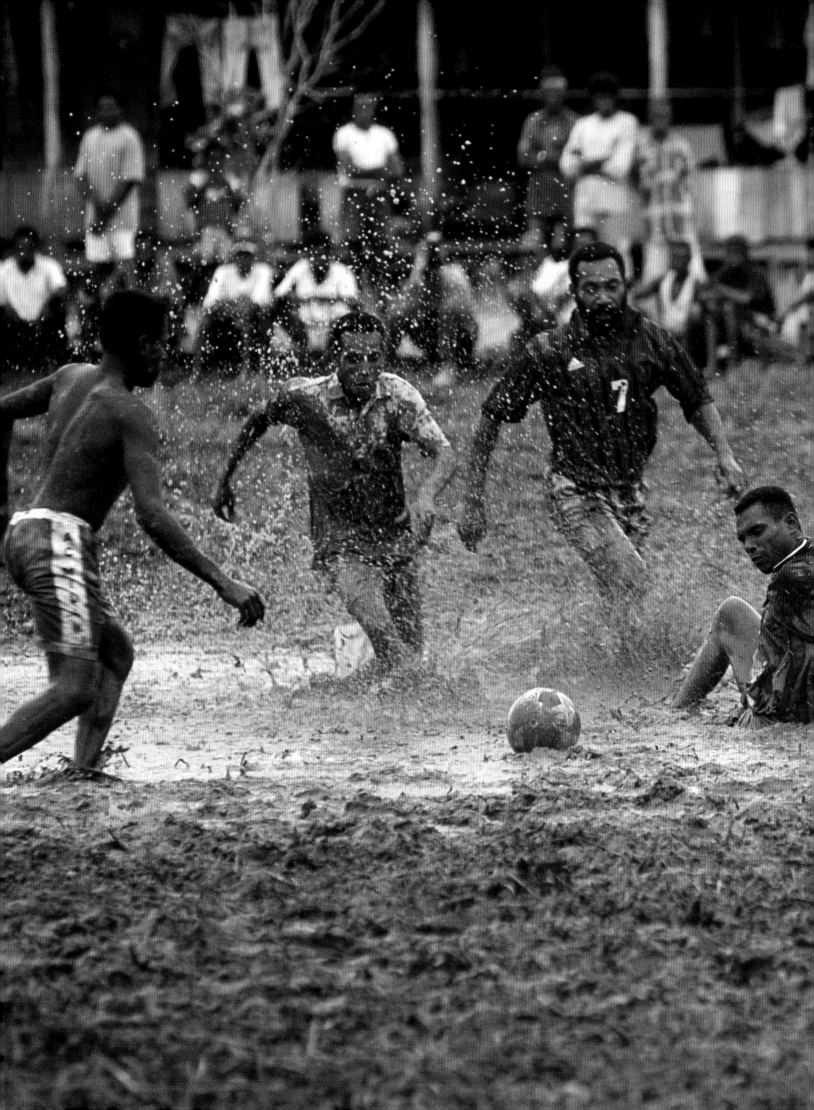

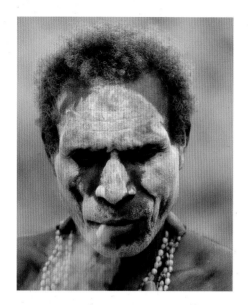

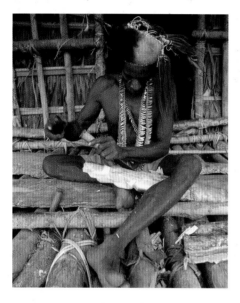

The Asmat are famous for their artistic woodcarvings, which are highly valued and sold worldwide ABOVE.

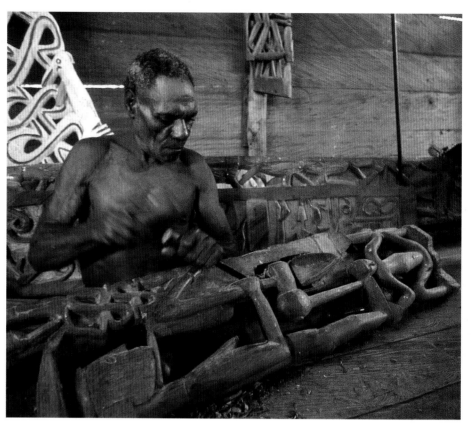

This man is carving a sculpture out of a tree trunk ABOVE. Doroe mask costume. A myth tells of ancestral spirits wearing these masks when they come to down to visit their earthly friends. The story of the legend is still danced today RIGHT.

HERE & NOW

Around 70,000 Asmat live in the lowlands of West Papua over an area the size of Belgium that, in part, overlaps with the Lorentz National Park. Their region is pervaded by rivers and swamps. The dugout canoe is the main means of transport. Up until the 1960s, the Asmat were feared as head hunters. They became known worldwide through their wood craft, which today can be admired in many ethnological museums and private galleries.

tion, Indo-Pacific Conservation Alliance, based in Washington, D.C., though the organization wants to go a step further with the precise mapping of the living space of the Asmat. The organization wants to help them combine their »adat,« unwritten rules for using the forest, for religious concepts such as taboo zones and for cultural rituals, with biological knowledge about the region's biodiversity, in order to improve protection of the natural resources with this documentation.

»Their culture and their natural surrounding are two sides of the same coin,« according to John Burke Burnett, the organization's founder and director. »When the one is destroyed, then the other is also endangered.« The Asmat have long felt what this means. Strangers came to their villages a few years ago and offered money for Gharu, the resin of the Aquilaria that the Asmat traditionally burn in order to contact the ancestors.

The perfumed resin is extremely rare and is traded on world markets at the price of gold. As a result, many Asmat resorted to searching for the precious trees, which are traditionally protected by taboos, and felled every tree they could find. This new source of income comes at a high price. The Gharu traders brought alcohol, prostitution, syphilis, and HIV infections with them to the Asmat, who did not know how to protect themselves from these threats. Communal tasks were neglected and the trees have now become rare. Many Asmat are convinced that this is a punishment for breaking the taboos. Asmat leader, Wiro Birif, hopes that the project will help the Asmat to sharpen their awareness of the vulnerability of their nature and culture: »We thought that our land was almost infinite. Through the mapping, we recognize that our resources are limited and we must handle them with care.«

CLAUDIA BIEHAHN

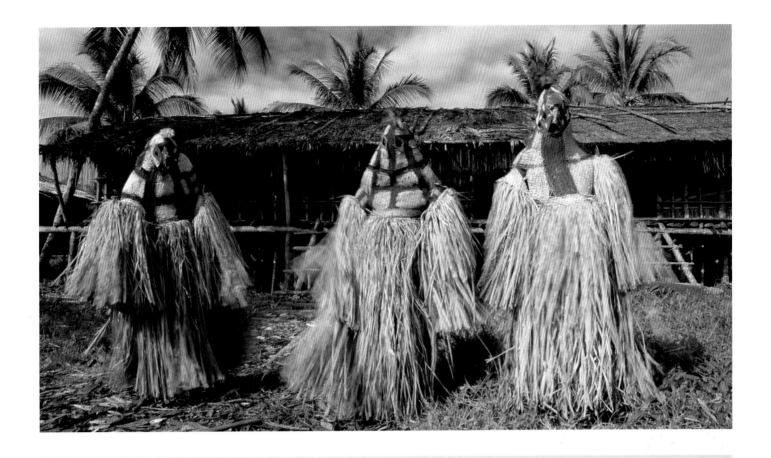

MUSIC OF THE ASMAT:
THE DRUMS OF THE
TREE PEOPLE

Before the Asmat came into the world, the drum was already there—according to the creation myth of these inhabitants of the rain forest. Once, Fumeripits, the »Wind Man,« disappeared into the forest and built a feast house. There were animals everywhere, but no human soul to be seen. And so he began to fell trees, and carved figure after figure. Some like this, some like that; both male and female. Alas, he was still alone among the figures in the feast house. They simply did not come to life. Then, he felled another tree, hollowed out a piece of the trunk, and carved a drum out of it. Over the body, he stretched a lizard skin and tightened the drumhead. Then Fumeripits began to drum. The beat of the drum brought the wooden figures to vibrate, which at first looked very clumsy but a little later turned out to be a very unique dance. The first Asmat had come to life.

That, though, was not enough. Fumeripits later came across a crocodile that wanted to devour him. However, he slew the beast, cut it up into many pieces and threw them high into the wind toward the sky. These pieces scattered to all directions of the compass and turned into other people. From now on, the Asmat also had neighbors.

The Asmat differ from neighboring groups through this mythical origin from wood—the myth creates their group identity. The Asmat's own term for themselves, Asmat-ow, can be translated as »we, the tree people.« Drums are still their sacred objects, they still provide the beat for their ceremonies and public rituals, and bring the Asmat in harmony with the gods of the forest. For that reason, they do not consider their very own dances and songs to be music, but rather religious services, political statements, psychotherapy, cultural tradition, and recreation and relaxation within the group.

The carving of everyday objects is not considered to be art; ready-made objects for the tourist industry are produced in the longhouses in Amborep, Atsj or Warse. Totem poles or even drums, however, are carved by Wow-ipits, specialists who are highly regarded socially, and should not leave the villages. At most, they find their way into the Asmat Museum for Culture and Progress in Agats.

tribes.calabashmusic.com

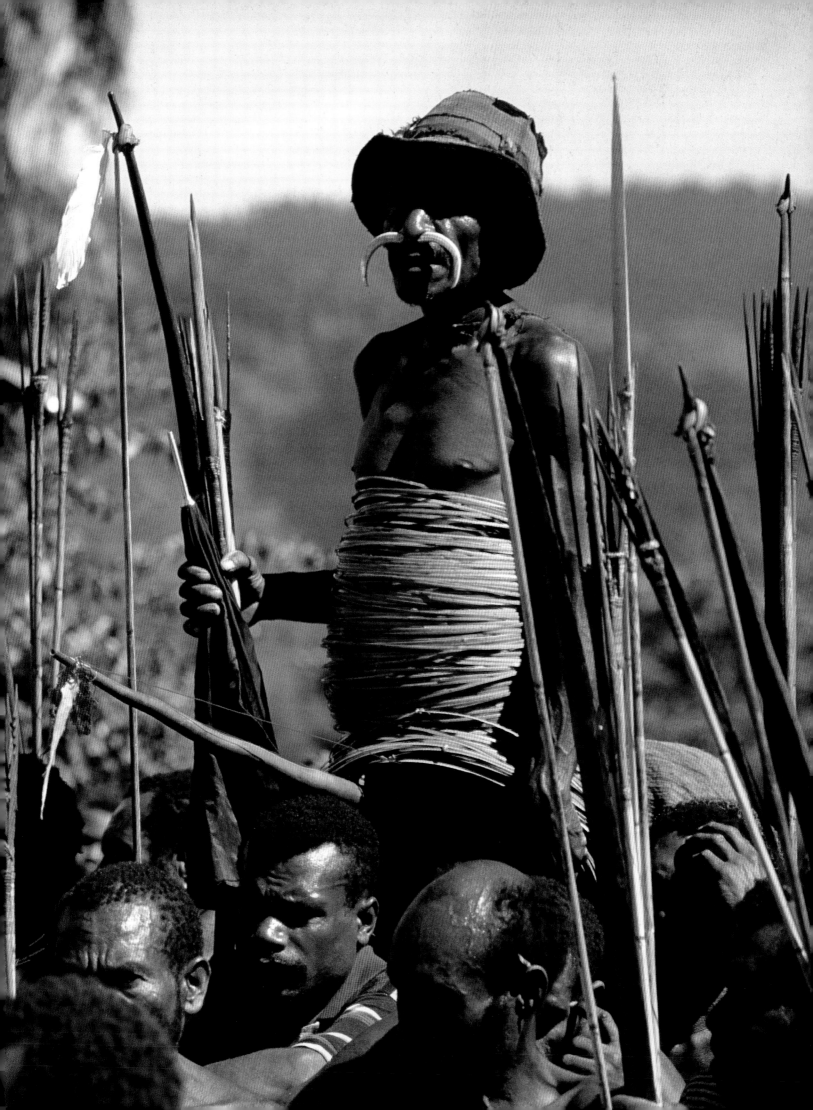

A penis gourd, called a koteka, is characteristic of the Dani. It is made by carving a bottle gourd, also known as a calabash. The koteka is omnipresent in the area around Wanemas, the administrative capital of the Baliem Valley RIGHT. *It is somewhat rarer inside the city itself* ABOVE.

WAMENA 🌐 4°3'S 138°53'E

DANI

Clash of Cultures in the Baliem Valley

A man has died among the Dani in the Baliem Valley of West Papua. It is quiet in the village, no one is working on the fields. Only the wailing of the relatives can be heard. Several of them have rubbed themselves from head to foot with mud as the greatest expression of sympathy with the deceased. Some wear the mud layer for months. The mud symbolizes the bursting skin of the deceased. The mourners thereby show just how much they share in spirit the fate of the dead person.

It is an impressive ritual, not only for ethnologists, but also for tourists from all over the world who are prepared to hand out a great deal of money to explore the «last wild men« in all their primal nativeness. What is left at all of the archaic culture of the Dani, the largest indigenous ethnic group on West Papua, after decades of Christian missionary work and violent Indonesian rule?

West Papua is far away from the government in Jakarta and even further away from the rest of the world, in geography, time, and culture. A visit to the Dani is an journey to another time and another world, in which a Stone Age life exists in parallel to the Computer Age, in which traveling is still a challenge – and in which two cultures collide that have nothing in common. There are the indigenous people; next to them live more and more Muslim immigrants who have been moved here from the overpopulated islands of Java and Sulawesi by the Indonesian government, or are trying their luck in the country's Wild East.

Wamena was just a small hamlet in the 1980s, today it is a town of more than 10,000 inhabitants. Here it can be clearly seen who is at the top of Papua's new

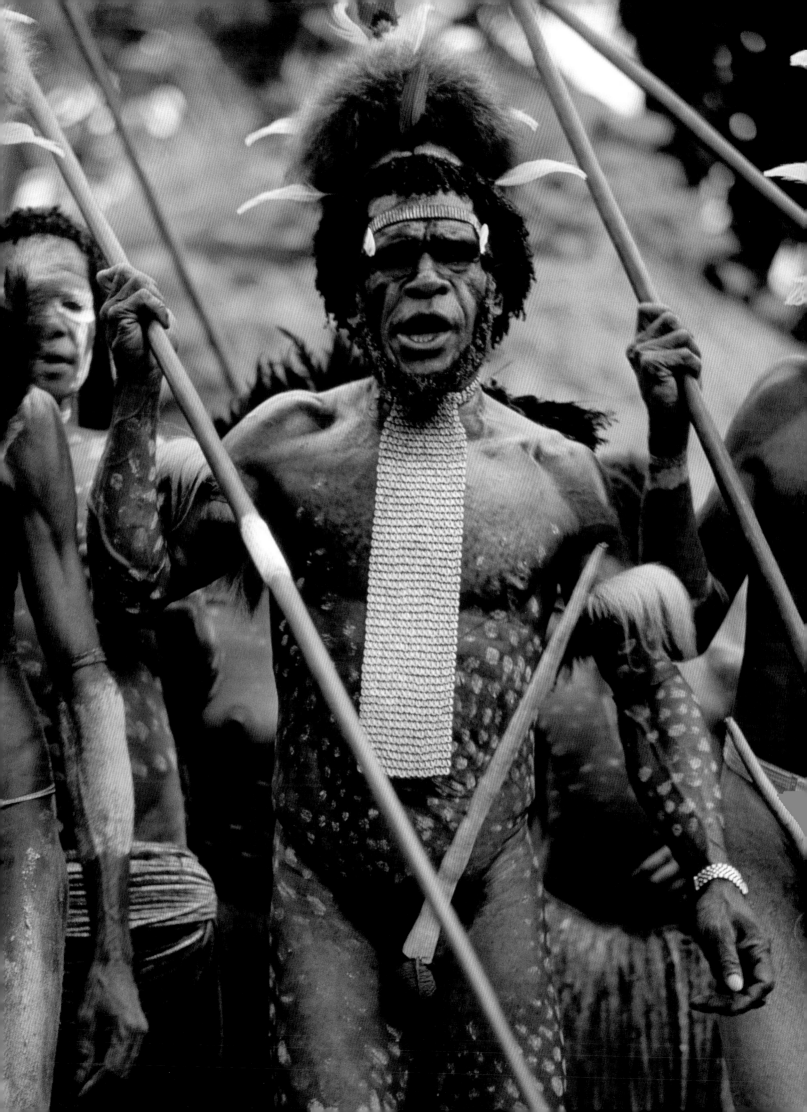

For a couple of Indonesian rupiahs, this Dani takes the mummified corpse of an ancestor out of the cult house LEFT. *Tourism in the Baliem Valley is often directed by Indonesian tour guides, with Dani participation limited to following in their wake* RIGHT.

society, and who is at the bottom: Dani women with their sweet potatoes, carrots, and tomatoes sit on the ground of the market, in the dust. Market stalls, shops, and the entire trade with imported goods are all in the hands of the immigrants.

Both groups eye each other with mistrust. The Indonesians, light-skinned, Muslims, mostly better educated that the Papuans and savvy traders, have no time for the black, curly-haired people who, only a few decades ago, were still active as head hunters and alleged cannibals; who exude a strong smell because they gladly grease their skin and hair with pork fat to protect themselves from the cold at night; and who sometimes still pull a boar's tusk through their nasal cartilage and traditionally insert their penis into a 12 inch (30 centimeter) long gourd, or – in the case of the women – wear nothing but a raffia skirt around the hips. They let the Dani feel their contempt. For their part, the Dani feel – as do most other Papuan ethnic groups – culturally swamped by the immigrants and politically disenfranchised by the government in Jakarta. They are tired of being labeled as primitive, and sometimes the pent–up anger is released in bloody uprisings that are put down by the Indonesian army with even more violence.

HERE & NOW

The island of New Guinea, the western part of which has belonged to Indonesia since 1963, is the world's second largest island: a green wilderness of dense tropical rainforest and swamps, hard to penetrate and until now crossed by only a few roads. A craggy mountain range crosses the island from east to west, crowned by the icecap of the almost 16,404 feet (5,000 meters) high Puncak Jaya (victory peak), the world's only ice field near the equator. The landscape is so impenetrable that until recently New Guinea's approximately 1,000 ethnic groups lived largely isolated from one another, resulting in a Babylonian diversity of languages. Only around 2.5 million people live in West Papua, half of them are today immigrants from other parts of Indonesia.

But West Papua is unbelievably rich in mineral resources, which makes the wildness so interesting for the government in Jakarta: among other resources, enormous deposits of copper, gold, silver, bauxite, crude oil, and precious woods are very enticing. And the Indonesian government tries to maintain its hold on these sources of income at any price. It therefore fights with all the means at its disposal the Papuans efforts to gain independence, who have been trying to get rid of the unloved rulers since their land was handed over to Indonesia. The independence movement Organisasi Papua Merdeka (OPM) was founded for this purpose in 1964. However, the rebels still overwhelmingly armed with bows and arrows met with little success against the soldiers sent by Jakarta. Up until now, the Indonesian armed forces have crushed every attempt at autonomy, making no distinction between rebels and civilian population in the process: 100,000 Papuans are said to have met violent deaths since the 1960s. Human rights abuses such as torture, murder, and the „disappearance« of opponents are the order of the day. They are largely perpetrated free from gaze of the world because journalists, UN and human rights organization are not allowed to enter West Papua.

The government has built schools, health clinics, and hospitals, and introduced new crops and methods of cultivation, but the valley is still heavily underdeveloped by Western standards. The Dani still live from subsistence farming and a few crumbs from the tourist business, for which they are the main attraction. The proceeds of the rudimentary farmers are slender. Often the women still till the small, carefully terraced fields in the Baliem Valley with the digging stick as was the practice 8,000 years ago, and tend the family's greatest treasure: the pigs. Pigs are raised by the Dani as members of the family and traditionally only slaughtered for special occasions. They are a status symbol and the currency for paying compensation when conflicts between villages or clans are reconciled. The traditional feast of cooking a pig is a must for every tourist expedition: it is the highlight of many trips to Papua when extremely colorfully decorated Dani men dispatch a pig with bow and arrows and cook it between heated stones in an earth oven.

Today, 90 percent of the Dani profess to be members of the Protestant churches that have being carrying out missionary work in the Baliem Valley since the 1950s. However, even decades of Christian missionaries have not succeeded in completely banishing the belief in ancestral spirits and fear of black magic. Young girls still have their finger tips amputated as a sign of deference and to appease the ancestors. The mummies of dead clan chiefs, blackened by smoke, still hang from the rafters of many windowless Dani huts – also a welcome but scary attraction for tourist groups.

Just like other Papuan peoples, the Dani are forced to perform the balancing act between the Stone Age and modern life. How the experiment will end is uncertain. Many young Dani are turning their backs on their people's archaic way of life and moving to the towns. Others are clinging on to traditions all the more intensely – perhaps as a defiant avowal of a culture that the civilized world scorns as primitive; perhaps also because the traditions are

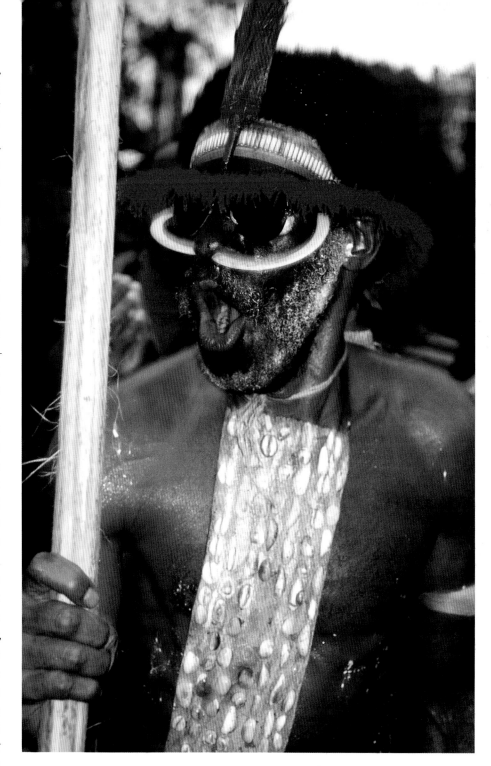

A demonstration in Jayapura. Just as a percentage of Dani have resigned themselves to political conditions in West Papua, another part of the population has acted constructively, clamoring more and more for the preservation of their roots.

so strong. The government tried to lure the Dani away from their heavily smoked round huts and get them accustomed to blockhouses. Only with modest success. Many families have moved out of the solid houses and returned to grass-covered huts because their new homes were too hot for them in the daytime and too cold at night. Now sometimes only the pigs inhabit them. The government's attempt to break the Dani's habit of using penis tubes, a tradition abhorred by Christian missionaries and Islamic immigrants alike, was also a failure. The penis quiver has instead advanced to become a political symbol against Indonesian rule and cultural paternalism: a unit of the rebel army OPM calls itself Satgas Koteka, the Penis Quiver Militia.

CLAUDIA BIEHAHN

AMUNGME

Every Man for Himself

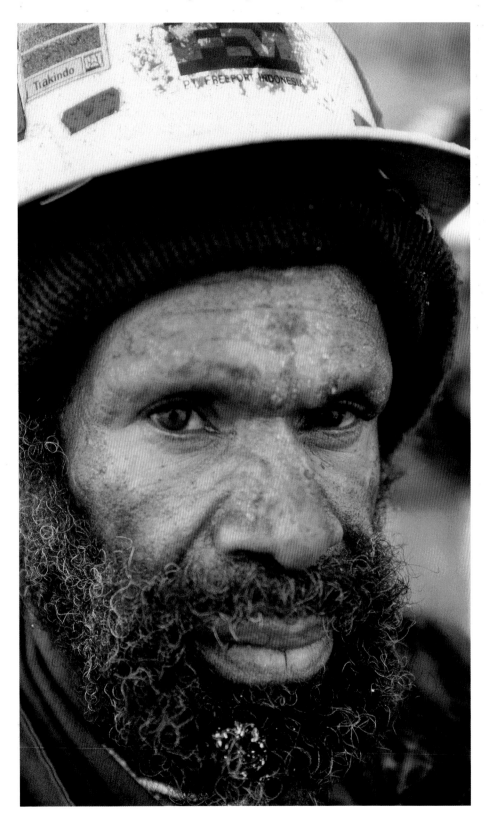

In the eyes of his people, this Amungme is privileged because he works in the Grasberg mine. Up until 1996, the mining company Freeport McMoRan did not employ a single Papua.

They went after each other with poisoned arrows in October 2007: members of the Amungme, Dani, Damal, and Moni Papuan ethnic groups. Three days of bloody confrontation left eight men dead and at least 19 injured. The government in Jakarta was forced to deploy more than 100 police officers to the troubled region immediately. No one outside the Indonesian region of West Papua would have found out about the trouble if the village of Banti, the scene of the fighting, had not been situated less than 3.7 miles (6 kilometers) away from the Grasberg mine. However this time, the international media picked up the reports and revealed the background of the confrontation: the fight for work and living space.

There have always been bloody tribal fights in West Papau, the Indonesian part of the island of New Guinea. However this time, it was not over a kidnapped woman; it was about money, about a tiny crumb falling from a big cake. For here in the central mountainous region of New Guinea, in one of the most remote corners of the world, at an altitude of more than 13,123 feet (4,000 meters), an American company called Freeport McMoran runs the world's largest gold mine and third largest copper mine. The company makes a profit of well over a billion US dollars from the mines every year. It pays exactly the same amount in tax into the state coffers of the Indonesian government. This is, therefore, a thriving business for both Freeport and the government in Jakarta, which heavily guards the site of the mines. However, it is also an ecological and social catastrophe for the ethnic groups that traditionally live in the region, most of all for the Amungme.

If someone had told the Amungme that it is possible to lose an entire mountain, that one day they would have to look on while a sacred sanctuary vanishes, leaving behind nothing but destruction – they would not have believed him. The ore of the Grasberg mines is removed from the earth by strip mining. More than 200,000 tons of stone and soil are mined every day into raw ore sludge. The sludge

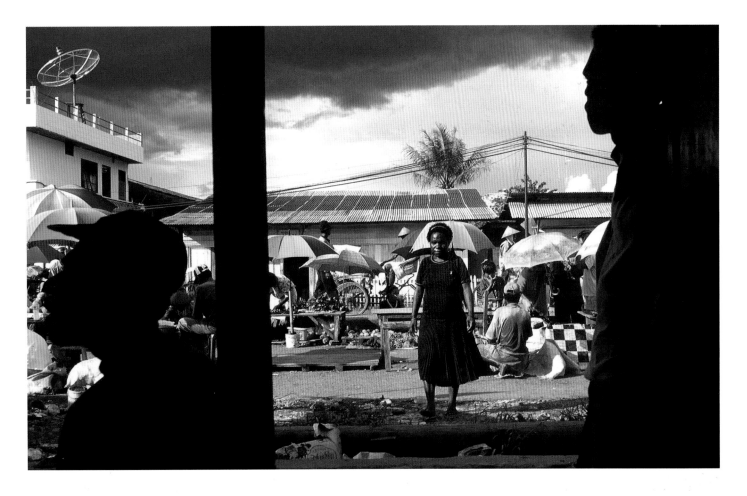

Light and shadow in Timika. The anger of the indigenous peoples toward the Indonesians can still be felt today. A murderous campaign by Indonesian troops, in response to the blowing up of a mine pipeline in 1977, wiped out entire villages. It has left deep wounds today.

is then pumped to a harbor through a pipeline and shipped by freighters to international smelters. The mining waste stays in Papua. The former holy mountain of the Amungme slides down to the plain of the Aikawa River in gigantic mudslides. The mouth of the river has become a grey plain on which nothing grows. Copper and other heavy metals enter the sea and have also been found in the ground water of the nearby Lorentz National Park, a park that UNESCO designated a World Heritage Site in 1999 due to the richness of its species, many of which have not yet been discovered.

In order to mine the ore, the Amungme and other Papuan peoples, such as the Kamoro, were driven down to the Malaria-ridden lowlands. The company built towns from scratch out in the jungle for the Indonesian workers who poured into Papua from the overpopulated islands of Java and Sulawesi. A new mining world was created, to which the Amungme

were denied access to the new job miracle; the company initially employed only immigrants. However, the Amungme did not endure the destruction of their land without a fight. As early as 1977, members of the Amungme people, together

with fighters of the OPM (Organisasi Papua Merdeka) freedom movement were responsible for blowing up a pipeline that carried ore sludge to the coast. One of the freedom fighters was Yosepha Alomang, a mother of five, who, in 2001, was awarded

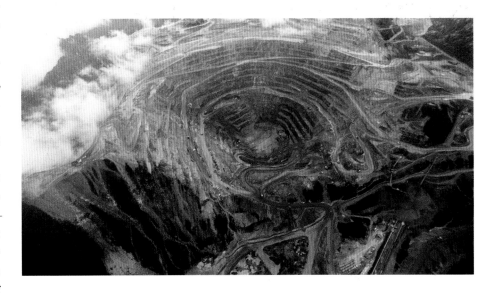

The Freeport Mine lies at an elevation of 13,100 ft (4000 m) above sea level. It is the largest gold mine and third largest copper mine in the world.

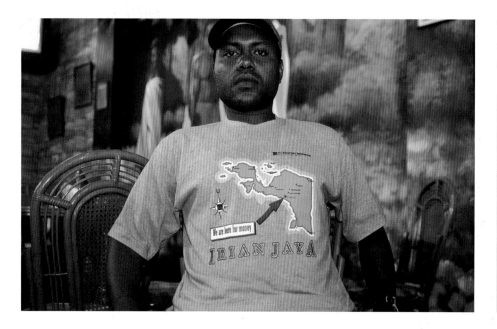

HERE & NOW

The Amungme (also called Amung, Hamung or Ohundine) are closely related to the Damal with whom they share their language, Damal, and who also live in the Lorentz National Park. Taken together, both ethnic groups number around 12,000 people; no exact survey exists.

the Goldman Environmental Prize, the world's most prestigious environmental award.

The Indonesian armed forces answered this act of sabotage by bombarding villages, torturing and murdering several thousand people. In 1996, the long-suppressed anger of the local population was vented in a storm on the mining company that brought the mine to a standstill for three days. Thereafter, the company changed its policy.

Freeport now employed workers from Papua. It built schools, hospitals and roads in the Amungme villages to fight malaria, and for the first time, paid compensation to the Amungme and another Papuan people, the Kamoro, for the use of land. However, the region is still far from being a positive model of economic development. The company still does not attend to the results of its catastrophic destruction of the environment, and is still in league with the local armed forces, who severely abuse human rights in their attempts to suppress protests against the mine; protests that again erupted in 2006.

In addition to Indonesian immigrants, thousands of Papuans have also followed the lure of the mines and attempt to participate in the work and the millions from Freeport's development funds. Where earlier only a few hundred people lived scattered in the jungle, now more than 100,000 have settled »in a Wild-West atmosphere of too much alcohol, prostitution, shootings, and AIDS, the abundance of money has ruined the lives of the Papuans. And we are nevertheless still marginalized,« says Tom Beneal, a political leader of the Amungme in an interview with the New York Times.

CLAUDIA BIEHAHN

Mineworkers at a hotel pool in Timika ABOVE. *Indonesians sell Christian devotional items* RIGHT.

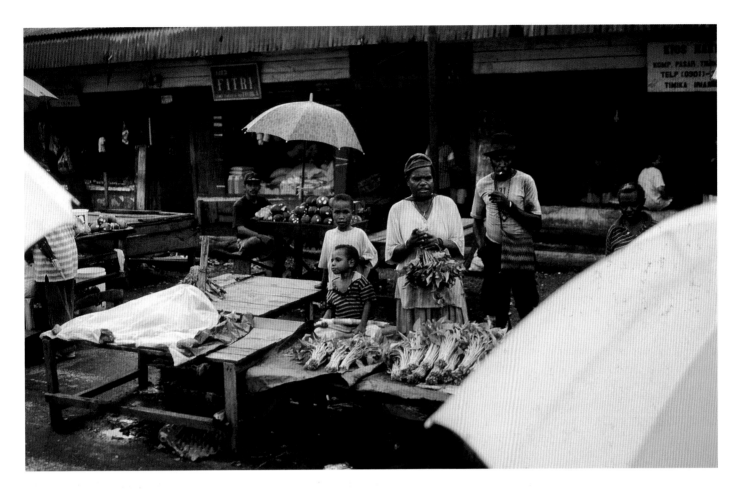

At the Timika market. Some percentage of the indigenous population around the town is employed by the Freeport Mine; this has significantly altered the economic structure of the region. Most indigenous people, however, have not profited from this development.

TELEK:
TIME AND AGAIN – »BACK TO THE ROOTS!«

The musician George Telek is a legend in West Papua. Even as a small boy, he devotedly listened to the stringband in which his grandfather and uncle played guitar and ukulele. When he was old enough, his relatives took him in as a member of the Moab Stringband.

The music of the stringband is a mixed form that can only be found in the Pacific. The missionaries brought the »poor souls« guitars and hymnbooks, but most of all, they brought their church harmonies. However, right up to the present day, Polynesian rhythm has provided the swing that makes all the difference; it mixes the chorals that have also developed a style of their own. This technique, in which the third voice often winds its way through the frame provided by the first two, is known as »snaking the vocal.« The stringbands still sing in their own language, which is anathema to the Indonesians. Independent and critical tones are at best registered with gritted teeth. And so, in 1984, the founder of the political music scene in West Papua, Arnold Ap, landed in prison, later dying there under unexplained circumstances.

Telek alternately sings in Tolai, the idiom of his home province, and in Tok Pisin, a language based on English, which conveys an idea of the attitude to life on Papua, a mixture of melancholy, dolefulness, and merriment. In addition, the bass drums pound and belt out ecstatic drum roll, time and time again, that interrupts the groove. Whoever listens to the works of Telek not only finds his more traditional side, but also encounters him as a rocker in his role as front man of the band »Painim Wok.« The Papuans also listen to Johnny Cash, the Beatles, or Nirvana on radio stations such as ABC. Telek still plays with these influences.

Traditional percussion instruments mix with drums, acoustic and electric guitars on »Serious Tam« (2000), which very clearly bears the signature of the Peter Gabriel label »Real World,« a wonderful album that nevertheless failed to gain success internationally. Telek is still on the move and is again touring the Pacific region with the umpteenth generation of the Moab Stringband

www.telek.com

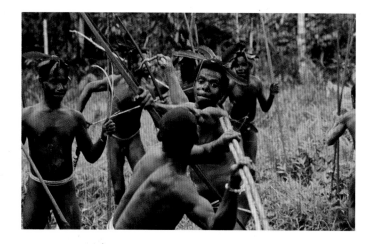

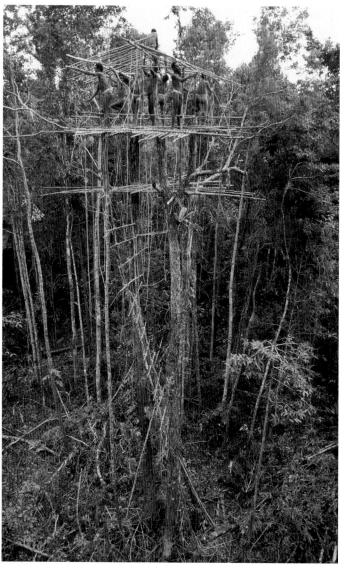

Fencing practice in the primeval forest. Korowai warriors practice self-defense ABOVE. *Indonesian clergymen carry out missionary work* BELOW. *The Korowai build a fresh tree house for a newly married couple* RIGHT.

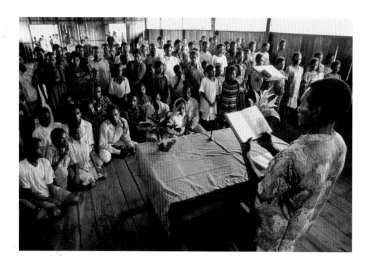

DAIRAM KABUR 🌐 5°40'S 139°41'E

KOROWAI

Visiting the forest's roof

Living between the skies and earth, the Korowai build tree houses with several rooms, from 16 to 160 feet (5 to 50 meters) high. During peaceful times, they inhabit the lower floors of these ›skyscrapers;‹ when danger approaches, they quickly move to the highest floors of their tree houses, high up at the top of the huge jungle vegetation. One might wonder what kind of danger these people could face, here in the thick jungle of West Papua. Yet, the ethnic groups live in proximity to each other: the Asmat are extremely close and during their foray through the jungle, it is best to avoid the villages of the Kapayap tribe altogether; and the Korowai, who support polygamy, report of inflated bride prices, of internal feuding and attacks from other tribes. Sometimes they steal women and torch the neighboring settlement; sometimes the neighbors kidnap pigs or burn down their enemies' housing. Cannibalism is also not unheard of.

Only in the 1970s did the rest of the world learn of the Korowai's existence. Even anthropologists still disagree on whether this tribe, also known as the Kolufo, still practices cannibalistic rituals or not. One thing, however, is certain – their lives have changed radically. Indonesian colonial powers penetrated farther and farther into the woods. Missionaries soon followed. In order to regulate and convert these ›wild creatures,‹ shacks with corrugated iron roofs were neatly built along the shoreline. Yet, even if the mission church fills regularly, most of the little huts have become decrepit. Korowai families do not like to live along a river, instead preferring a small clearing near a stream, where, if they feel threatened, they can flee up into the protection of the leafy treetops.

These native inhabitants still cling to their cherished traditions – they live in their tree houses, they gather their food from the woods, where they also hunt. An important element of their nutritional intake is flour made from the Sago palm

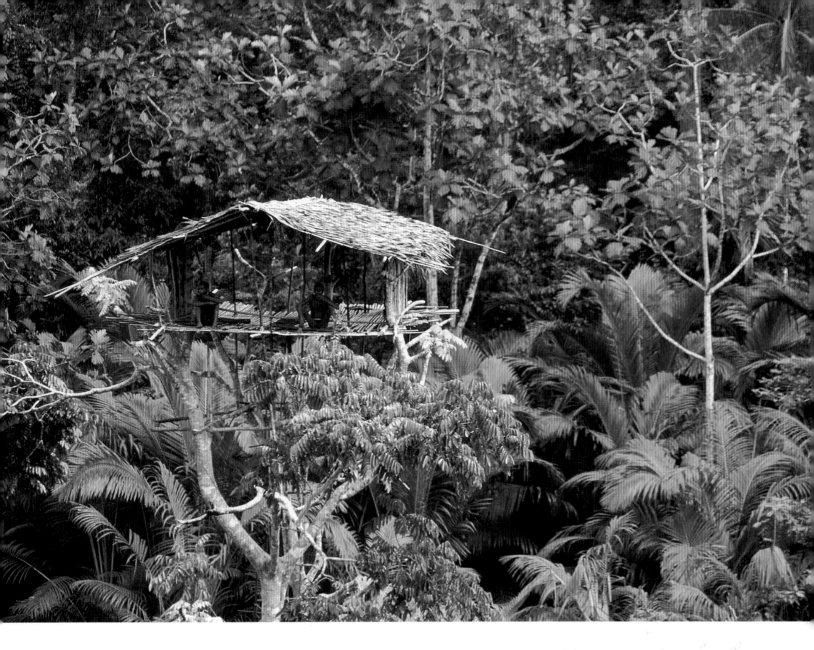

The Korowai build tree houses at a height of up to 80 ft (25 m). They are occupied by up to eight family members who live together. However, due to the Korowai custom of strict segregation of the sexes, men and women live apart.

tree, which they cultivate. Their religious acts are tied to strong beliefs in spirits; only the men, however, play a role in the respective ceremonies. In fact, tribal life seems to be largely dominated by men. The community's leader is the strongest and most powerful, not a man elected by the community.

In trading stations, Korowai usually wear typical Indonesian dress. In their teachings to the Korowai, the missionaries insisted they desist from burning houses, stealing women and, most definitely, murdering the neighbors. Some Korowai have been said to eat the still-warm brains of those tribal members who have been accused of sorcery. Tour guides have exploited these types of legends in order to market the Korowai as the last cannibals on the planet. The natives are wooed to behave like savages and encouraged to perform for tourists on a large ceremonial clearing in tree house settlements, which were specifically built for this purpose. Even though the steps have been reinforced for safety, every now and then tourists have been known to fall. Not all Korowai are friendly towards these strange creatures – some shoot arrows up into the leafy treetops of the tree house settlements – one tourist was flown back from the settlement because a stray arrow cleanly pierced his hand.

ALFRIED SCHMITZ

HULI

Once a Warrior, Always a Warrior

Huli warriors on Papua New Guinea mostly regard their women as weakening their male potency. A woman may never look a man in the eyes during sexual intercourse; if she does, his courage as a warrior will be weakened. Tenderness and shows of affection were completely unknown until the Whites arrived. The two sexes do not sleep together, and most definitely not in the same room. Therefore, it comes as no surprise that the Papuans of this region care little for the looks of their partners;it is much more important that she has a good reputation as a diligent worker and will reliably tend her husband's garden.

The warring males of the southern mountain region still battle away. The Huli were never disposed to long discussions of their differences. For example, when a stray pig from a neighboring tribe falls upon their carefully laid-out fields and fills its belly with their produce, the result is war. These conflicts are no longer fought only with bows and arrows, today, firearms are used as well. A more recent ethnological field study retrospectively reported attacks by the Huli on the bank and supermarket in Tari, the center of the Huli region. Automobiles were also stolen, and revenge attacks on neighbors led to the only access road to Mendi being blocked off, as well. The only remaining contact with the outside world was a landing strip. Here, the curious press their noses flat up against the wire fence every market day and pay day. Who is coming? What is being unloaded?

The Huli were discovered by two gold prospectors in 1935. Today, a goldmine digs its way through the earth in the region around Porgera, the neighboring town. The mining company is also taking the spade to the land of the Huli, paying them compensation and employing many Huli men. Helicopters flying shift workers in

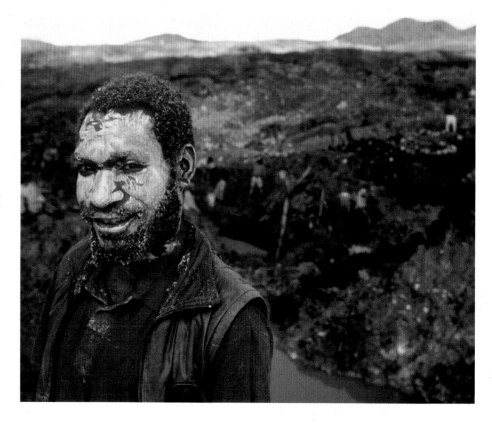

The gold mine has changed life around Porgera. Even the Huli have been digging up the landscape to serve the mining company ABOVE. *Huli at Sing-Sing, the assembly of the island's ethnic groups* BELOW.

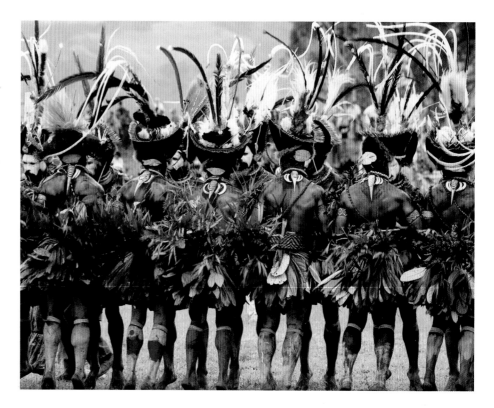

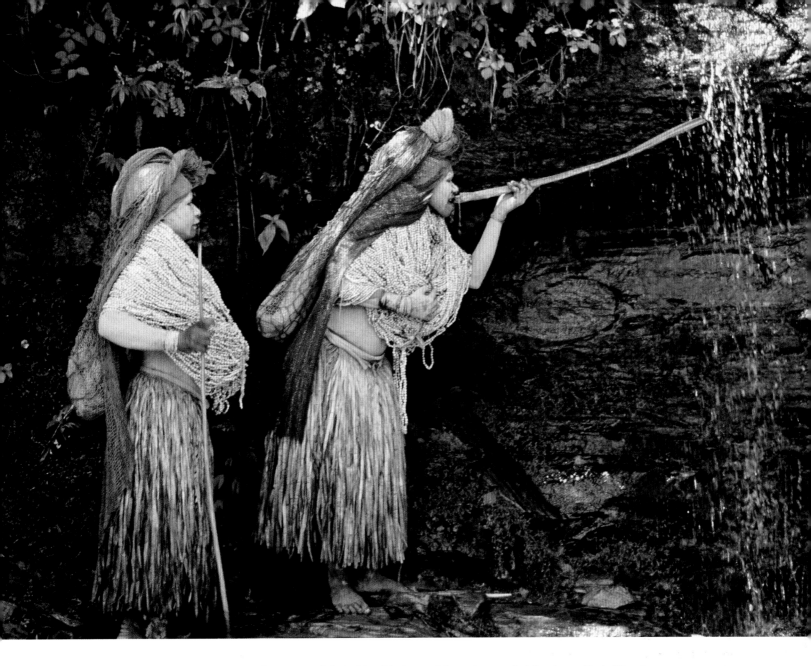

Huli widows wear mourning outfits for ninety days. They rub their skin with clay, and don a characteristic head net with shell jewelry.

and out regularly land at the airport. The welcoming committee at the wire fence reflects the diversity of the population. On feast days, many Papuans can be seen wearing jeans, and just as many men can be found with rich yellow, red, and white painted faces and wearing their typical wigs; around the lower body they wear nothing but a penis sheath. Naked men with sheaths and women in grass skirts are not unusual sights in everyday life in Tari, alongside workers in blue overalls.

Tradition lives on. When two Huli marry, they stay awake for four nights. On the morning of the fifth day, they celebrate a fertility rite in the garden. A magic potion is mixed and the man slaughters a pig. Before he takes his wife's virginity in the privacy of his own four walls, he pours scented tree oil in her vagina to protect his penis from her virginal blood. From now on, the two are a couple, although the man is free to enter into other marriages.

This concept of sexuality has snared many a warrior in area around the mine into a previously unknown and invisible trap. Tari registered its first cases of AIDS in 1997, and since then many more Huli from the surrounding area have fallen ill. In the beginning, it was still only the migrant workers from Port Moresby who began their last journey in Huli land in wooden boxes. The blows are now falling ever nearer. The warriors of the Huli still seem unimpressed by such dangers.

CHRISTIAN ROLFS

HERE & NOW

The Huli, an ethnic group with around 30,000 members, is at home in the fertile Tari basin of Papua New Guinea's »Southern Highlands« province. Their proximity to the goldmine in Porgera has permanently influenced their lives; around 2,000 people work there, including members of various Papuan ethnic groups. Tari has developed the infrastructure of a modern small town, but this means that its problems, such as inflation, also affect the periphery. However, subsistence farming is still to an extent the order of the day in the wide valley's villages.

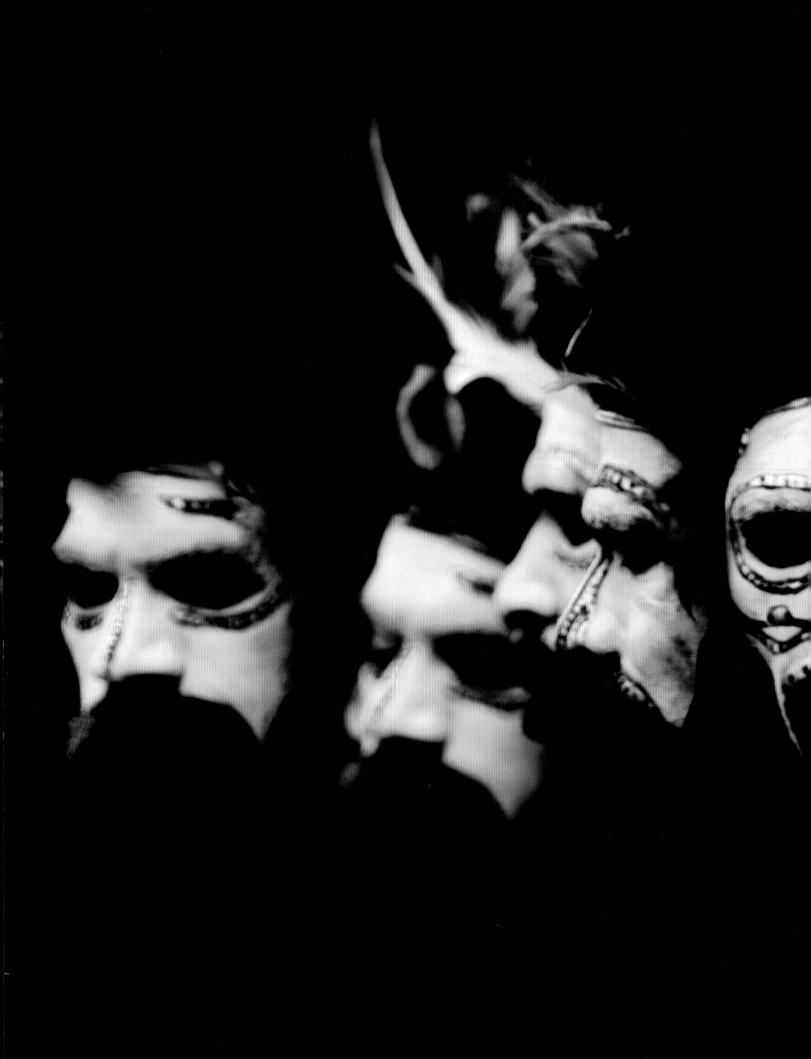

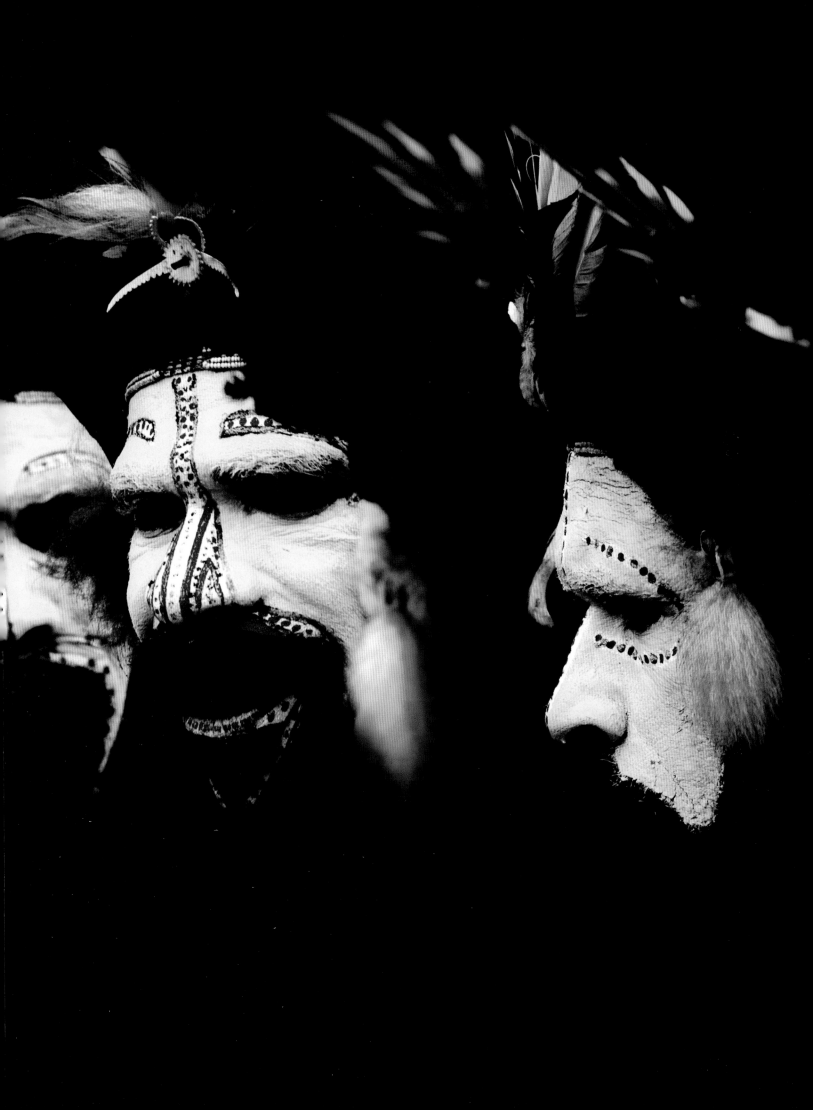

The Papua Phenomenon

It is sing-sing season. In the west as well as the east of the second largest island in the world, jungles steam and highlands shake. New Guinea's ghosts, mud men, moss men and birds of paradise have come together at a sing-sing. This annual conference is danced. One could translate the term as »confrontation,« or better, as a »settling of old accounts,« but this is not an afternoon tea party. The sing-sing festival resonates with notes of aggression.

There are roughly 1090 different tribal groups living in the New Guinea archipelago. More than two thirds are Papuan, while the rest are Austronesian. The indigenous peoples speak more than 750 individual

1090 tribal groups, 750 individual languages

languages, as well as Pidgin English with strangers. West Papua belongs to Indonesia since 1963. The eastern half became the independent state of Papua New Guinea in 1975, and remains a full member of the British Commonwealth. With 826 different races and regional cultures identified so far, there is more ethno-cultural variety in the eastern part of New Guinea than anywhere else in the world.

The jungles of Papua New Guinea grow rampant and wild. The capital city of Port Moresby can only conveniently be reached by sea or air, with the alternative being a march on foot that lasts several days through very inhospitable territory. This island state north of Australia has roughly

450 km (280 mi) of runways. The skies belong to the island's pilots. There are more runways and airways here than anywhere else on earth, but the tickets are sinfully expensive and the land routes in a pitiful state. Flying across the country is the only profitable option. Were it not for the mission air carriers, most New Guineans would probably never see their capital city unless they traveled overland.

Port Moresby's crime statistics cause many a brow to furrow in consternation. Murder, rape and corruption are everyday events. Those unfamiliar with the city are advised to retreat to a hotel room when night falls. Pilots remind their passengers that it is custom in these parts to turn in weapons prior to take-off. There have been instances where sixteen out of eighteen passengers had to leave their gear in the cockpit. Elsewhere in the country, things are not much better. Officials report staggering statistics not only for violent deaths and sex crimes, but also high rates of robbery, burglary and car theft. In a survey of international security, the most recent data ranks Port Moresby on the last place, behind the Nigerian capital of Lagos and the city of Karachi in Pakistan.

Officials work year in and year out, from election to election, trying to strengthen the police presence, although it is not at all easy to extend the long arm of the law into New

Guinea's distant mountains and valleys. It goes without saying that sing-sings, like the one in Goroka, require the presence of special security forces. Things are generally calm at these festivals, with any conflicts between the Huli, Mendi and Chumba groups dissipating after everyone has danced through the night. The Huli remove their wigs. Their thick makeup peels off in layers. The sing-sing will continue on the following night. By the end of the festival, many of them seem reasonably content. Conflicts are, at the very least, talked out, marriages are arranged, debts are put in writing, and exchanges scheduled. All of these forge bonds across Papua that go beyond blood relationships. If there happen to be a lot of tourists at a sing-sing, they can merely rubberneck.

In New Guinea's patriarchal societies it is the Big Men who come out on top. Every man in every New Guinea village has but one wish: to be one of the great ones. Only a few will earn the honor. Many benefits fall to the rich Big Man, such as nearly unlimited access to women,

It is the Big Men who come out on top

black pigs, sweet potatoes, and, in coastal areas, mussels. In principle, a Big Man achieves his position morally, by forging a network of responsibilities and obligations. A precondition for men desiring this social

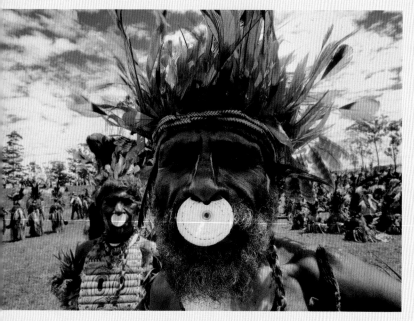

Sing-Sing on Mount Hagen. Despite all the militaristic elements, Sing-Sing is first and foremost a dance festival.

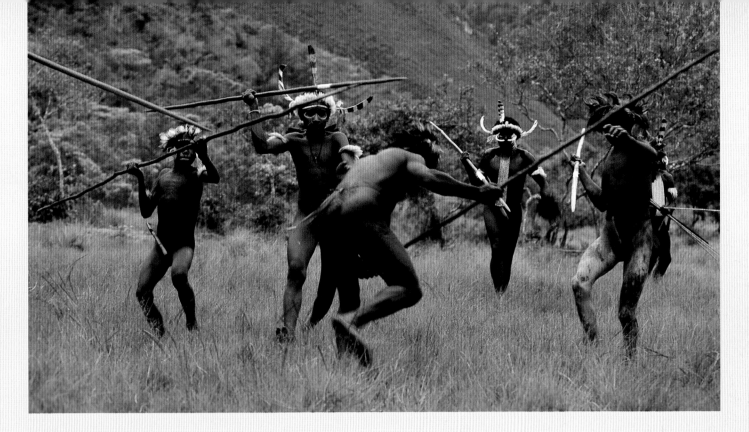

Dani from the Baliem Valley in Western Papua. For the benefit of outsiders, the warriors work out their aggressions in mock battles at festivals and ceremonies.

career is an extended period of ascetic initiation. This is the background against which all the highland communities developed their traditional conflict resolution mechanisms.

Neighboring races are terrorized. Blood feuds, sexual attacks, witchcraft and other forms of revenge govern all relationships outside the group. Over time, the Papua have exchanged their bows and arrows for firearms.

Government regulations have little relevance inside the village societies. Punishment for a crime like adultery is left to the villagers. Women have a particularly hard time. Should they manage to have a law enforced, and receive compensation for a crime against them, it is the victim's family that receives the fine, not the victim herself. In general, it can be concluded that values like respect and tolerance are

downright underdeveloped in these communities. In the highland villages in particular, the traditional values of disposition to violence, hierarchy, authority, discipline, subordination and punishment rule the day.

It is nevertheless tricky to derive the culture of violence in New Guinea from just these highland village cultures. The differences in behavior between clans, ethnic groups and regions can be great. Traveling in Papua New Guinea is like stepping into a time tunnel that passes through the Stone Age and medieval period on through to the age of plastic. The first few decades following independence, when ethnic conflicts flared up anew, show that the days of deceptive peace and tranquility are over. Out there in the jungle, warriors are once more en route, armed to the teeth. Tracking them down and

A tradition that lives on

disarming them is a hopeless enterprise.

It is sing-sing time once again, a tradition that lives on, in the east as well as the west of the island. Today, the halves of the island remain culturally connected, although politically divided. The Indonesians controlling the

western half have put severe pressure on the indigenous peoples to integrate. This has led to more and more fleeing to the east. The Papua are much better equipped to deal with their homebrew civil wars than oppression by colonial powers like Indonesia.

HENDRIK NEUBAUER

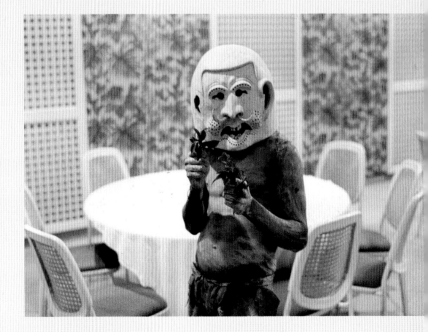

A tourist hotel in Goroka. One of the Mudmen, a tribe famous for masks made of mud, performs for the guests.

Air Vanuatu hops between the 83 islands that make up the archipelago. The in-flight magazine tells the passengers of a very special custom:

»Pentecost Island is famous for the custom of gol, or land diving. The ritual takes place as a rule on Saturdays in April and May. Its purpose is to guarantee a rich yam harvest in the coming year.«

Television teams and journalists have been visiting the Sa people on the southeast coast of the island for many years, hoping to see the tower jumping live. Ethnologists have known about the nanggol, another name for the practice, for even longer, but still do not know quite what to make of it.

Every year, the men from Bunlap build a wooden tower 98 feet (30 meters)

SA

The original jumpers

high, using the trunks of palm trees for the foundation of the tower. The day on which the tower is dedicated has been set for a long time. Ten to fifty youths and men jump from the tower, falling head over heels. Platforms erected at different heights determine the degree of difficulty. The jumpers have two long liana vines tied just above the ankles to keep them from smashing into the ground. Life-threatening disaster can result if the vines are not precisely measured and

cut to exactly the right length. After the jump, the jumpers are caught by a group of specially chosen men and cut free of the vines.

It is time. The day of the festival is finally here. The audience has assembled in the hot and humid air. People from all over the region, as well as tourists and reporters, impatiently wait for the moment when the first jumper falls to earth. The crowd raises the temperature with songs and whistles. The mood

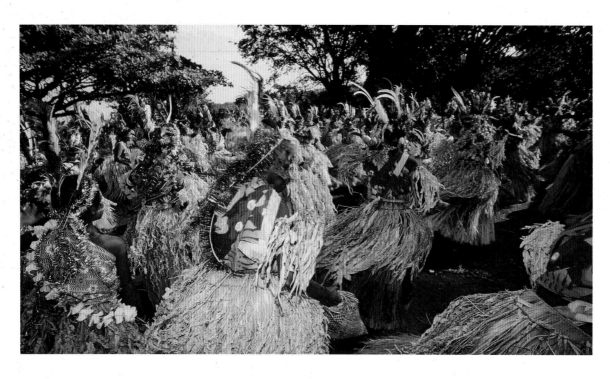

The cradle of bungee jumping is on the island Pentecost. Tower jumper in Bunlap RIGHT. *The Toka or Nekovia dance used to be celebrated, when a feud between neighboring ethnic groups could be ended. Nowadays, it is a sign of friendship and solidarity between two different groups* LEFT.

HERE & NOW

Melanesians, like the Polynesian, are of Austonesian descent. Most of the 550 ethnic groups of Melanesians are small, with a few hundred to one thousand members. The groups on Vanuatu include the Hano (pop. 7000), Apma (pop. 4500) and Sowa (pop. 20). The nation consists of 12 main islands and 70 smaller islands, most uninhabited. The total population is 206,000, of which 90 percent are Melanesian, and three percent Polynesian or Micronesian, with small groups of Europeans making up the rest.

The Sa live in the southeast of Pentecost Island, a thinly settled region overrun with wild, impenetrable jungles. The total population

on Pentecost is just 21,000, of which the Sa are a group of just a few hundred villagers. In 1980, the French-British protectorate of the New Hebrides gained its independence under the name Vanuatu, with its capital of Port Vila. The Republic of Vanuatu remains a member of the British Commonwealth. The island is heavily Christianized, but with nature religions and syncretic cults still widespread. Most of the Pentecost Islanders grow crops such as yams. Exports include lumber and copra, the dry flesh of the coconut.

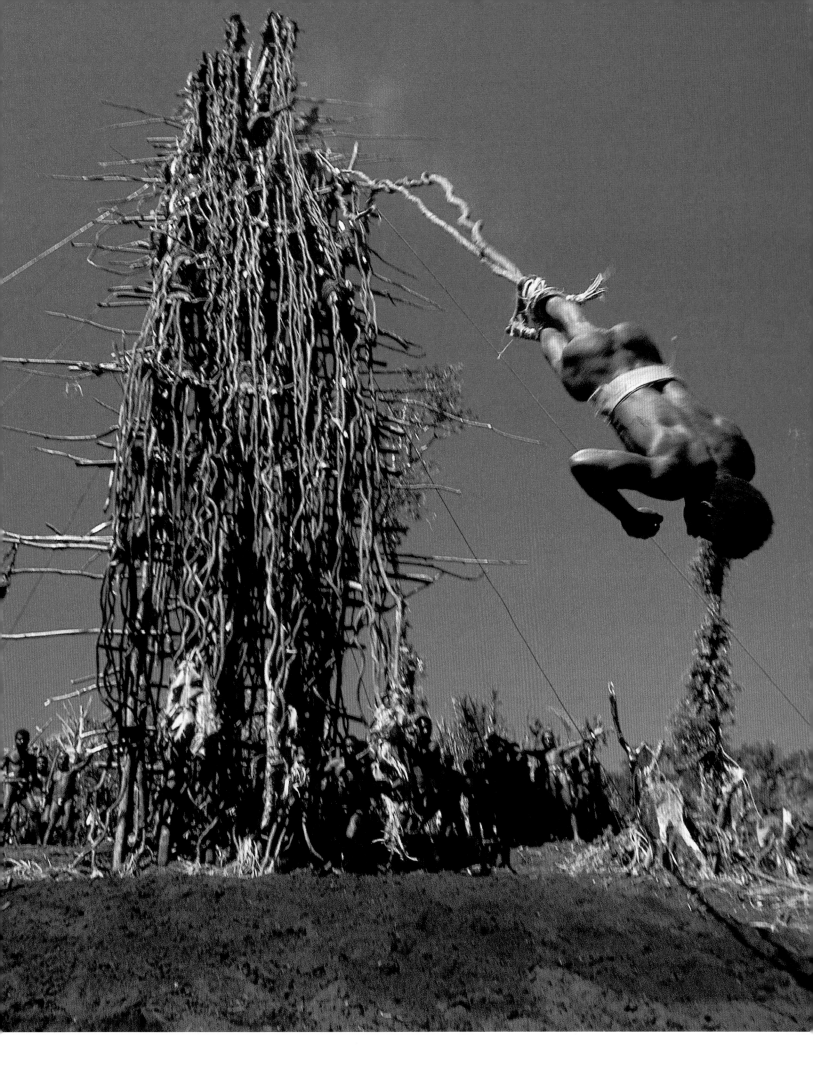

Flag ceremony on the island Tanna. Tribute is paid by flying the foreign flags of the US Americans, the British, and the French. Since 1980, Vanuatu is a sovereign nation.

SUNSHINERS:
POP, BUT IN A PACIFIC REGGAE MODE

In Vanuatu, music is what binds nature and culture together. As is the case in other parts of Oceania, the natives in Vanuatu are always open to musical influences. There are string bands with instruments and songs adapted from missionaries. Today, influences come primarily from music videos that arrive from all over the world. The Sunshiners are a band that grooves through the repertoire of British rock and pop music of the 1980s. Songs like the Fine Young Cannibals' »She Drives Me Crazy« are sung with refreshing naivety. U2's »I Still Haven't Found What I'm Looking For« is revived with the bass and guitar, but also with instruments like the ukulele and a beer bottle drum. Classic songs by The Cure, Depeche Mode and Rod Stewart are celebrated in a joyous reggae fashion. If there is one all-star band on Vanuatu, the Sunshiners are it. Four Melanesians sing the lead vocals: Gero Iaviniau from Nayo, the most famous band in the islands; John Kapala from Krosroad; Ben Siro from Huarere; and Jake Moses from Torotua and XX Squad. Four Frenchmen accompany them, having fled the gray skies of Europe for the South Seas. The Sunshiners audience is decidedly split. Some of their fans sing along in ecstasy from the first chord onward, while the hardcore reggae fans make themselves scarce. Even they cannot begrudge the Sunshiners their great success. www.sunshiners.net

is similar to a folk festival, with individual competitors celebrated by their fans. Here and there, one hears a few insults as well. They are off! Cheers are made for competitors based on the elegance of their jumps, and which platform they chose as a launching pad. The highest platform is reserved for the final jumper of the day, whose jump will be the highlight of the event. The audience holds its breath. If successful, the victor will be loudly celebrated. From time to time, there are accidents involving unskilled jumpers, weak spring boards or fraying lianas. Some mishaps end in death.

People lose all interest in the tower once the festival is over. The wooden edifice might be dismantled over time, piece by piece, perhaps for use as fuel, or to build a house. Often the tower is simply left to rot where it stands. Next year, another tower will be built for the celebration of a new festival. All in all, it is an extremely unusual custom. Can bungee jumping, the extreme sport which took off in America and Europe in the 1990s, have its origins on Pentecost Island?

German ethnologist Thorolf Lipp began working with the Pentecost Island nanggol in the 1990s. He has come across a number of bizarre opinions as to what the jumping custom really means. In 2002, during a study trip, he wrote down the comments of one tourist, who said:

»The nanggol did not originate on Pentecost. During the Second World War, there were a couple of clever chaps who saw American paratroopers training in Santo during the Second World War.«

It would all be very simple if that were the explanation, but as Lipp has shown in his research, things are seldom so clear-cut. He has demonstrated that this »interesting« phenomenon has, to some extent, taken on a life of its own, thanks to media interest and professional reporting. Due to difficulties in communicating with the locals, every report cites the same guidebook, where the jumping is described side-by-side with useful information and touristy brochures. This leads to a rather free

Volcano-boarding at the Mount Yasur, Tanna. A reporter from National Geographic supposedly tried it the first time; the children of the original inhabitants are no different than children all over the world. Everything that is new and promises to be fun is intriguingly absorbed and tried out.

interpretation of the custom, to put it mildly. This text below is cited by Lipp, as an example of one ethnologist commenting on the remarks of another:

»The ritual is a reflection of culture, a dimension of what it means to be human, one that seemingly embodies what it is assumed enlightened western people have somehow lost. Concepts like homo religious, the myth of the eternal return, and the submerging of the self in religion are no longer present in western society.«

Lipp's own scientific opinion of the nanggol is surprisingly sober. He sees it as an example of »risky spectacle,« one that servers as a spiritual anchor for the Sa, perhaps a remnant of the island's transition from matrilineal to a patrilineal social structure. This would explain why the jumping is restricted to males. Perhaps, it only exists as a means of impressing women. In the details however, the ritual comes across as considerably more complex and more ethnologically difficult to understand. Lipp came to the conclusion, by analyzing myths and symbols, that the process was a metaphor, or perhaps the played-out birth of the collective patriarchy. He also discovered that, remarkably, tower jumping has no initiation aspect at all. In a correction to the media, Lipp noted that the jumping also has nothing to do with ensuring a rich yam harvest.

The Sa men will continue jumping off towers, a practice that, over the last decade, has been a bubbling fountain of gold for villages like Bunlap. Do the jumpers continue out of community interest, or self-interest? Lipp has shown that, ever since gol tourism began, most of the money earned has been carelessly squandered. The Sa community has no one capable of running a business like this. The chief responsible for bringing in the tourist trade left Bunlap in the mid-1990s, but still controls outsider access to the festival. Anyone who wants to see or film the nanggol in Bunlap has to see him first. In 2006, the island's capital city of Port Vila instituted measures to break up the monopoly. This was not necessarily altruistic. There are plans afoot in Port Vila to declare the nanggol a national festival.

HENDRIK NEUBAUER

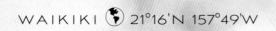

HAWAIIANS

The Original Beach Boys

A resident defends his private property against tourists who are looking for a shortcut to the Blue Pool Waterfalls near Hana on the island Maui ABOVE. *Surfing was invented here: young tourists at the beach of Waikiki taking a surfing course* LEFT.

The Duke watches over the activities of the surfers on Waikiki Beach. This is where his monument stands, this is where he grew up a like a Polynesian of old around 1900. His parents baptized him in the sea, in accordance with the old tradition. After high school, Duke regularly met up with his friends and family under the »Hau« tree on the beach; they swam, repaired nets, and, most of all, they made surfboards from tree trunks and rode the waves. Giant breakers, many as high as 32.8 feet (10 meters), rise up from the reefs before Hawaii, providing a unique kick for surfers.

Riding the waves is an old Hawaiian tradition. When Captain James Cook landed on Hawaii in 1778, he saw local inhabitants gliding over the sea on boards – and just for pleasure, as the

seafarers noted with astonishment. The sport was initially the prerogative of chiefs, which prevented their subjects from emulating them and gliding over the water in secret.

The Christian missionaries of the 19th century would only too gladly have put an end to this pleasure, for they considered naked people on surfboards simply indecent. It was, however, impossible to enforce the ban. Riding the waves is more than just pleasure for the Hawaiians; it is a tradition, a feeling for life. Today, surfing is a »fun sport« worldwide and an important economic factor for the Hawaiian Islands. The waves of Hawaii are second to none.

Duke Kahanamoku and his friends coined the term »Beach Boy.« In January 1968, all of Hawaii bid its most famous son, who also won Olympic gold

as a swimmer, »Aloha« for the last time. Duke was proclaimed Surfer of the Century by Surfer Magazine in 1999. A monument to him was erected in Waikiki, the beach suburb of Honolulu, right next to the police precinct. However, today one rarely meets real Polynesians in the tourist mecca for Aloha, Hula, and suntan cream. They might distribute flower garlands, dance, or play the guitar – and sweep the sidewalks. At best, they provide the backdrop for today's vacation industry. Whoever makes his way, though, parallel to the white-crested waves, along the fine-sand beach toward Waiane, soon leaves behind the bath towels, the surfers, and the playing children. The tent settlement on the horizon already makes a confused, disorderly impression from afar, and whoever dares a closer look then sees the tarpau-

Hana Bay developed to be a counter model to the over-heated tourism Waikiki style to down shifters and grand children of the islander Hawaiians.

opposite to that of overheated Waikiki – to stay cool.

At first, this is irritating to the Aloha-cliché-smitten tourists who are indispensible even here. Strangers virtually always wander through the place and surrounding area: »They don't even notice they are surrounded by Aloha all the time, everywhere here,« is what you're told over the garden fence. The locals spend the afternoon on the veranda; a barbeque sizzles away in a front garden for anyone who wants some – and is willing to pay. Hawaii's best-known export item, Aloha, is a feeling for life and at first, sounds a bit strange to those who do not make their way to the bamboo woods, enjoy the waves, or journey to the waterfalls in the mountains: »We live in unison with the environment, which we regard as a big brother who provides for us and protects us, as long as we care for him and respect him.«

The old men in the fishing hut on the beach have the daily »holo holo,« the fishing, behind them forever, but there is nothing like their experience; one of them, nick-named Blondie, keeps a look out for mackerel. When he discovers a shoal of them with the binoculars he gives a call. Aloha seems much more concrete and practical here in the fishing hut: the sea is their »icebox,« Taro roots become their ancestors. »Be friendly to strangers,« »never you're your back on the sea,« and »spring floods also come on Sundays« are the worldly wisdoms they convey with almost holy earnest. Slowly, one begins to

lins and wind-swept paperboard huts. Thousands of homeless people live here right beside the sea.

Jumping islands to Maui shows where the indigenous inhabitants of the American island state survive with more human dignity. With 56 bridges and 600 bends, the endless serpentines snake their way eastward to Hana, a modest settlement beside the sea with »Food-Gas-Lodging.« Half the inhabitants are, more or less, full-blooded Hawaiians who speak Pidgin English, and often still also speak Polynesian, and scrape a subsistent living from their gardens. Everyone cultivates at least Taro, a cassava-like plant. Most of them have no exact idea to which nations their ancestors belonged: »but my parents brought me up to be a Hawaiian.« The rest of the community in Hana consists of a mixture of Filipino, Japanese, Portuguese, and American immigrants. Primarily, celebrities and neo-hippies come from the USA. Whether Hawaiian or immigrant: the primary goal of all of them is the direct

HERE & NOW

Only 240,000 of Hawaii's 1,283,000 inhabitants today are of Polynesian origin. The population's multicultural composition is one reason why Hawaii became the 50th State of the USA only as recently as 1959. The request was turned down repeatedly because the members of the American Congress considered its mixed population of peoples too »un-American.« Tourism is by far the most important economic factor. Almost seven million tourists visited Hawaii in the year 2000. Roughly, one job in three depends on this industry. Food production on Hawaii cannot cover the islands' needs. A large proportion of the islands' food is imported, which means the

cost of living on the islands is relatively high. Hawaii has been trying to attract other industries for several years: the film industry now brings in almost as much as the cultivation of pineapples (around 100 million dollars annually).

English and Hawaiian are the two official languages. »Olelo Hawaii« was originally a Polynesian dialect and consists of only twelve letters – five vowels and seven consonants. However, only about 1,000 people speak it. But it is again on the rise, and there is even software available for the internet that can express the idiom of the language correctly.

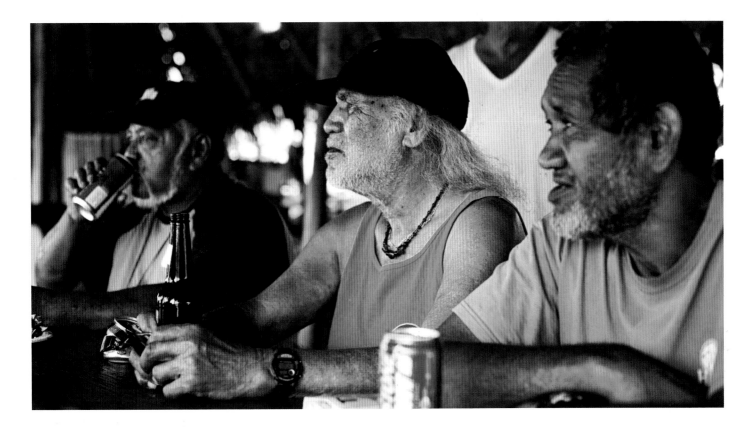

Hawaiians in a typical thatched fisher's hut in open, windowless wooden construction in Hana Bay; the retired fishermen practice fish spotting since the early morning, the eyes still on the horizon with their morning beer.

JACK JOHNSON: »GOOD PEOPLE«

Jack Johnson has just got into the water and is waiting for the next wave when a buddy waylays him: »Hey, man! Like your new album!« His recently produced demo tape was just being circulated. His surfing career was already failing, so after studying filmography on the mainland and making two successful surfing films, he took out his guitar and made his way to the sound studio. He was just 23 at the time and already married.

Johnson's singing is laid back, his guitar playing is relaxed, and his songs filled with an almost merciless optimism. Anyway, the entire pop business loved Johnson, who had never planned to be a pop star. In any event, he is a very suitable counter draft. Respect for nature is right at the top of his agenda. As an activist for the environmental organization »One Percent for the Planet,« he brings his albums on the market in paperboard sleeves and lectures school classes on the subject of recycling. Johnson assures that at least one percent of the profit he makes with his label Brushfire Records is invested in ecological projects.

But Jack Johnson is still primarily a surfer; he will always stay one thing: a born Hawaiian. He leaves the ukulele in the cupboard and translates Aloha for the rest of the world with wonderfully relaxed music.

www.jackjohnsonmusic.com

understand why in Hana the villas of the Hollywood stars who reside here never reach the ostentatious size of those on the other islands. One also discovers that there are Kahunu here who stand above the mayor and personify something akin to the spirit of the community: Hana gives, and Hana takes away.

Hana lies on the approach path to the »Blue Pools,« fed by the streams that swish down the densely-vegetated flanks of the Pohakupalàha volcano. It is possible to swim in the rock pools and dive through the waterfalls. This is simply Mother Nature. In the evening, these impressions are brought back to mind when the teacher of the Hula course in Hana sways like a palm tree in the wind. Her delicate hands explain the stories of princesses, ancestors, and forest gods; her smile bewitches her students.

Aloha Hana. Hula Honolulu – good bye. Of course, there is surfing in Hana, too. The beach is magnificent, as are the waves. They are ridden by the Beach Boys and Girls of today.

HENDRIK NEUBAUER

Public Health

American journalist Thomas L. Friedman once commented, »No two countries that both have McDonald's have fought a war against each other since each got its McDonald's.« He may be absolutely right, but only if he means war in the classical sense of the word, with armies massing along the border with a goal of mutual eradication. These days where armed combat in which nations literally exchange fire becomes less common, it may be necessary to broaden the definition of war. Looked at from this wider perspective, needless to say, Friedman's observation is no longer valid. When the NATO states pounced on what was left of Yugoslavia in 1999, there were only a few of the recently divided states in which fast food restaurants were not easily

found. Belgrade opened its first burger restaurant under the famous golden arches in March 1988.

Wars have long been fought on a very different battling ground. Paul Zimmet, director of the International Diabetes Institute (IDI) in Australia, has called the spread of obesity and diabetes »the greatest epidemic in the history of the world.« He is

Obesity and diabetes

not alone in this belief, allowing for the fact that it is anything but easy to compare the various epidemics that have afflicted humankind in different time periods and under widely varying conditions.

An epidemic is like popular culture. Hip hop music has spread into very nearly every corner of the earth over the course of the last twenty years. Most young people are not ready to settle

for listening to nothing but Snoop Dogg or 50 Cent or Eminem. From Dakar to Manila to El Alto, hip hop has become a means of self-expression, and it is this aspect of it that appeals to them. Yet hip hop is not the only cultural package that made its way around the globe in the late twentieth century. Movies have done this also, as well as soft drinks, white bread, and meatballs, preferably served and consumed together.

Globalization of world markets did not begin in the second half of the last century, but rather much earlier with the colonial conquest of the American continents. It led to the export of culture. Food preferences are part of this, as shown by the prevalence of Spanish and Portuguese dishes in South America, for

Export of food preferences

example. It is not at all unusual for the arrival of a new power to change not only the government, but also the meal plan. New is the power of advertising to travel around the world, as well as the existence of international businesses. Both are capable of penetrating any society or market, or at least giving it a try. The result is the transformation of a number of simple dishes into a kind of »world food« that can be found almost anywhere. Most children around the world do not think of hamburgers as American food, nor do they think of pizza as particularly Italian. Instead, these are just

meals that are available right around the corner.

Every ten seconds, someone in the world dies of a diabetes-related disease. Diabetes is no longer a disease limited to the inhabitants of big cities, or to those who live unhealthy lives detached from nature, isolated from the culture of their ancestors. Obesity and related conditions that were once described as diseases of western civilizations are now widespread among the indigenous peoples of the world, right down to Native Americans and Australian aborigines. All indigenous groups and societies that settle in major urban areas start out with a food culture that developed independently from their new surroundings. They all arrive with knowledge of a traditional diet that kept them well fed and healthy, provided there were no catastrophes to interfere, such as droughts or floods. Many indigenous peoples ate primarily grains, while others had more meat in their diets, and some subsisted essentially on roots and tubers. Only few would have faced the agony of too many choices. Their intimate knowledge of their environment had provided them with the means to feed themselves instead of dying of hunger; but this traditional knowledge does not provide much guidance for dealing with excess and abundance. It also does not help newly

A Himba woman in a supermarket in Opuwo. With a population of 5000, Opuwo is the capital of the Kuene region in northwestern Namibia.

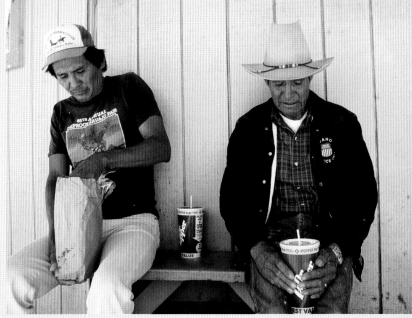

A diabetic Navajo in a wheelchair. The disease strikes one in four Native Americans in the USA, with the rate highest among the Navajo LEFT.
Fast food customers on an Indian reservation. American scientists determined long ago that a diet of fast food increases the risk of diabetes RIGHT.

arrived indigenous people deal with food that has basically no nutritional value.

In the course of indigenous people encountering what we call civilization, there were other factors that caused problems at first. Entire South and Central American societies died off after encountering the Spanish conquistadors. The Spanish brought diseases the indigenous peoples had never heard of, and which they had never suffered. Influenza, whooping cough, and measles killed off hundreds of thousands of natives in the sixteenth and seventeenth centuries. There was no natural medicine that could help the Aztecs and Maya, because their natural environment was totally unprepared for the new viruses. In the sixteenth century alone, the indigenous population of the Americas plunged from 70 million to 10 million.

Even today, a person infected with the influenza virus in Rio de Janeiro can endanger an entire clan of native peoples living in the isolation of the Amazon basin. If that person, despite his or her illness, comes into contact with the isolados, a simple handshake is all it may take to spread the disease. An influenza epidemic in Manhattan will send people running to their doctors for a vaccination, but natives in the Amazon are more likely to drop like flies as their immune systems quickly collapse. Another question is whether that visit to the doctor's office really helps matters. Viruses are difficult to fight off. One can really only build up individual resistance through vaccination or by exposure to the disease over time. Antibiotics are only effective against bacterial diseases, and even then, the transmission of infectious agents between people or via infected food happens extremely fast. The mobility of the modern world brings disease from one end of the planet to another in no time. Looked at globally, the numbers are disillusioning: two million people die every year from malaria, 240,000

Helpless in dealing with abundance

people per month from AIDS, and 136,000 per month from diarrhea.

Viruses threaten us in one way, and poor nutrition in another. The inhabitants of the Torres Strait Islands, located between the Australian mainland and Papua New Guinea, live on just seventeen of the 250 or so islands that make up the archipelago. Related to the mainland aborigines, only 6,000 of them remain on the islands today. Most, probably more than 40,000 have left their homeland and moved to Australia. Their native subsistence traditions were based on farming, hunting, and gathering. Until World War II, no Torres Straits islander had ever had diabetes. Since that time, however, they have been mentioned in frequent citations in international scientific publications discussing indigenous peoples and this disease. Incidentally, there is still no McDonald's on the Torres Straits Islands.

MAX ANNAS

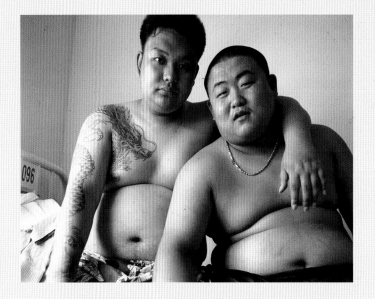

Morbid obesity has already taken hold in China. Patients at a diet clinic wait for their appointment.

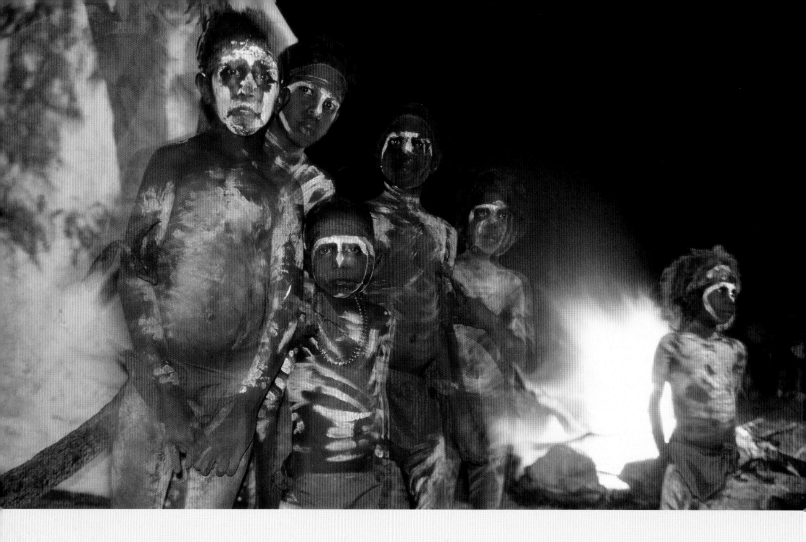

ARID CLIMATE

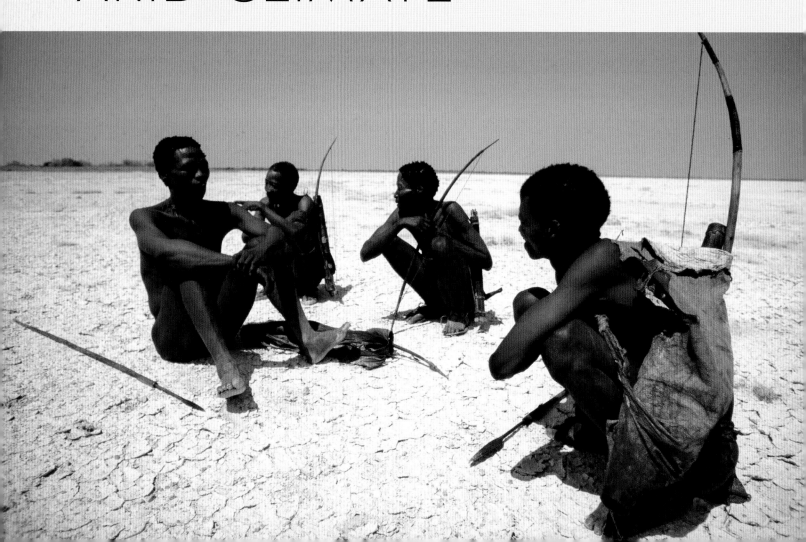

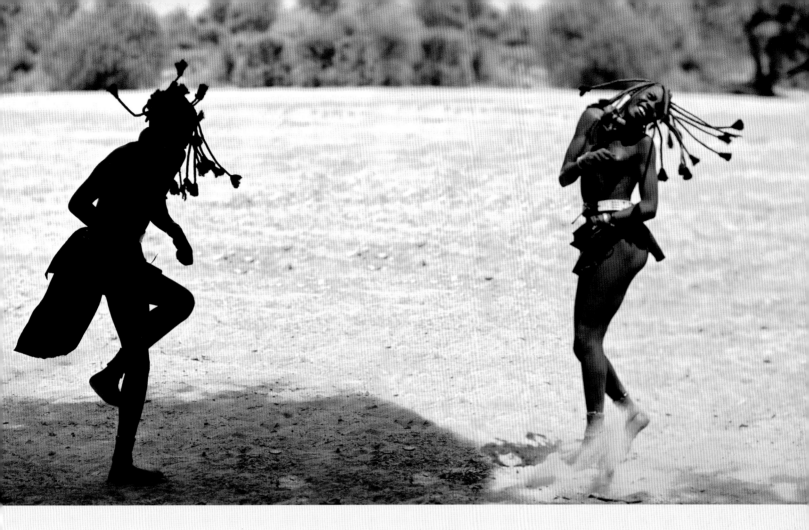

WIDE WORLD

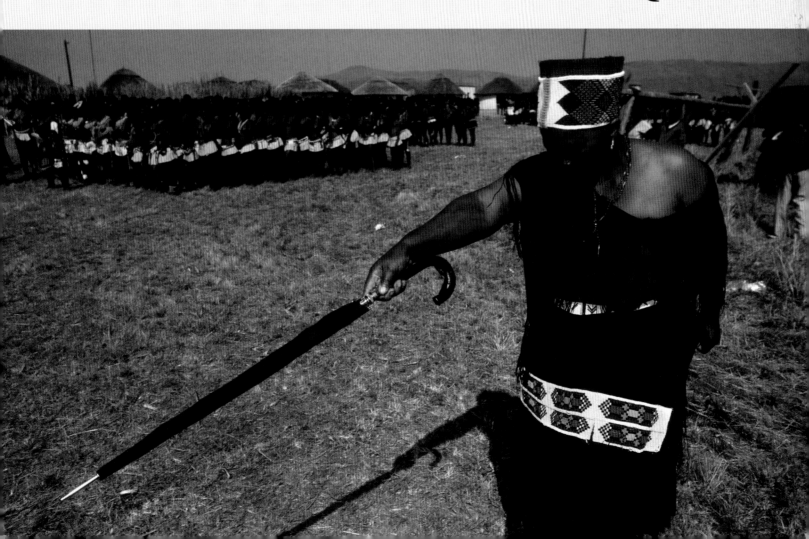

ABORIGINES

The Yolngu of Arnhem Land

When one enters Yolngu territory, one is worlds away from the Australia of Sydney's skyscrapers and economic boom – and yet one has arrived at the continent's origins. Arnhem Land is populated only at its edges, and its interior is as impenetrable as it is empty of human life. Despite the vociferous protests of the Yolngu, who fought for their land rights, bauxite mines were established on the coast in the 1960s. A sandstone plateau extends over 30,888 square miles (80,000 square kilometers); countless rainy seasons have carved deep ravines in the clay and the rocks; the area is traversed by rock drawings, caves and sacred places, thousands of years old. It is a world of its own in which the visitor feels lost.

Since 1976, some 20,000 Yolngu live here once again, when the Australian government recognized them as owners of the land. Many of them are »sick of town.« Instead of sleeping off the effects of drink on the central reservation of six-lane expressways like many of their fellow-tribesmen, they are returning from the cities and the cattle farms where they had been taken for work as cheap labor. Arnhem Land is the largest uninterrupted area in Aboriginal possession. Here, no outsider may enter without permission. The inhabitants keep to themselves and are not bothered by anything that calls itself civilization. This does not mean that they are completely cut off from the outside world. In outposts such as Korlobidahdah, Tom Noytuna uses the telephone to invite clan members to the next ceremony or to summon medical help.

Before the British invasion at the end of the 18th century, most Aborigines lived in semi-nomadic communities on the Australian coast, pursuing farming, fishing and herding. Hunters and gatherers lived in the interior of the country. By burning the undergrowth, they encouraged the growth of plants preferred by game animals. They were also experts at finding water. The invaders brought diseases with them when they came, which became rife among the indigenous population, and did not shrink from mass murder. The population was reduced from one million to 60,000 within a century. Today's history books are full of stories of genocide and the further persecution of the Aborigines. Some white Australians speak openly of their historic guilt, while others still retain their prejudices against the »bloody black riff-raff.«

Today, they are faced again by a self-confident and belligerent people, above all, in the provinces. Many Aborigines, particularly in the northern half of the continent, have kept their land, hunting, and gathering bush tucker, the food of the Bushland. Eucalyptus trees, palms and acacias stand closely ranked, while between their trunks the grass has grown to head height. In this region, one may encounter geckos, snakes, kangaroos and tortoises. Now and again, hunters wander through the undergrowth; by evening, they have gathered around the campfire.

Meanwhile, tourism plays an existential role in this secluded region. The sacred mountain Uhuru, known worldwide as Ayers Rock, is the region's primary magnet for tourists, based on a contradiction. The Aborigines themselves, out of respect for this shrine to nature, never set foot on the mountain and warn visitors against doing so. At the same time, the path has been made safe so that the »intruders« can safely climb. An accident would enrage the spirits even more than the daily and persistent offense against their honor. In the context of these natural spectacles, a commercial

YOTHU YINDI: »GET UP AND FIGHT FOR YOUR RIGHT!«

In the language of the Yolngu, Yothu Yindi stands for closeness to the land and peoples of Arnhem Land. This band, founded in 1986 by the bandleader, lead singer and songwriter Mandawuy Yunupingu, includes white Australian members and combines the musical origins of the Aborigines with Rock 'n' Roll. Clapsticks and didgeridoos encounter drums and electric guitars. Their stage show is supported by Yolngu dances. In 1993, Yunupingu was elected Australian of the year, and in 2000, the band appeared before an international audience at the Sydney Olympics. Worldwide album sales and world tours supported by Neil Young, Simple Minds, INXS and Peter Maffay, made Yothu Yindi probably the best-known Australian Aborigines.

From the beginning, they stood up for the rights of the indigenous inhabitants of Australia. Like other Aborigine artists, Yothu Yindi has become a mouthpiece for its generation. With the hit, »Treaty,« Yothu Yindi supported the demand for a self-determination treaty and ensured worldwide publicity. The foundation created by it has been organizing the Garma festival since 1999 and thus substantially contributes to the preservation of cultural practices and the identity of the Yolngu.

www.yothuyindi.com · www.garma.telstra.com

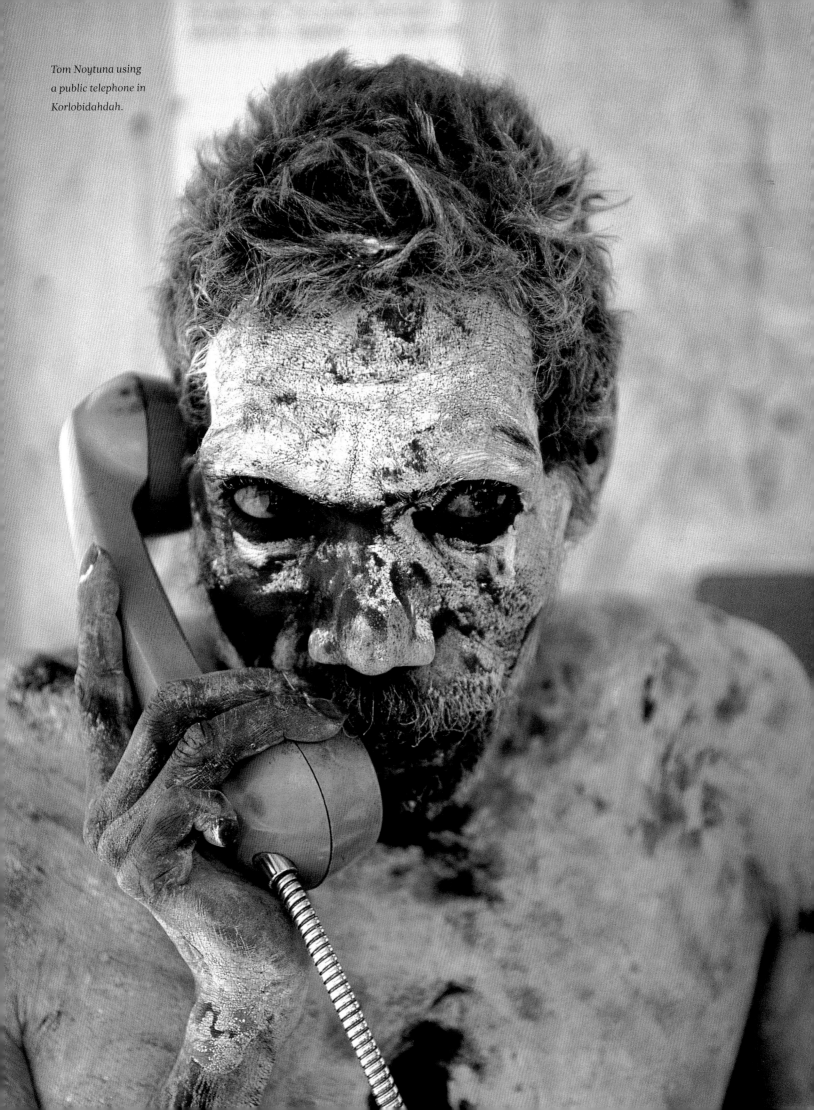

Tom Noytuna using a public telephone in Korlobidahdah.

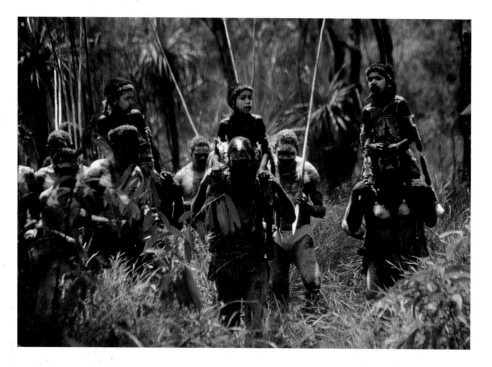

business emerges, for dance performances and craftwork are frequently offered at a price.

In order to prevent the community's culture from deteriorating into folklore, the Yothu Yindi Foundation has founded the annual Garma cultural festival. The primary participants are up to 1,000 members of the clans of Arnhem Land who come to attend a family gathering. Local and foreign guests are also welcome, as long as they are able to undertake the tedious journey to Gulkura. The festival combines a camping holiday, a marriage market, and a hotbed of rumors. The men make use of the opportunity to make trips to the ocean to hunt stingrays with spears. For the women, Garma is an occasion to form a huge circle where they paint their traditional pictures. Internationally acclaimed female artists join them in the painting hut. Gulumbu Yunupingu has exhibited her tree-bark work at the Expo 2000 in Hanover, and in 2004, she was awarded first prize in Aboriginal art for a series of decorative stakes for graves.

HERE & NOW

Many Aborigines live in the urban milieu of the white-dominated society. Their social situation is generally alarming. The life expectancy of the original inhabitants is 17 years below that of the majority of the population.

The central social conflict is reflected in the question of land. Until 1992, the British and Australian legal principle regarded the Aborigine regions as terra nullius, thus legitimizing the takeover. A final clarification of this question has still to be reached. Since 2000, the question of the »stolen generation« is also being discussed. In the 1970s, it was the practice to tear Aborigine families apart and place the children in white foster families and educational establishments. Today, it is a question of compensation regulations. A decisive event was Prime Minister Kevin Rudd's »We say sorry.« On February 13, 2008, after only eleven weeks in office, he issued an official apology for the »indignity and degradation« suffered by Aborigines in Australia.

Traditions live on in Arnhem Land. The Yolngu take the novices to the initiation ceremony. Circumcision is a part of this multi-day event ABOVE. Aborigine at a train station in Cairns. It is the starting point of the Great South Pacific Express railway to Brisbane and Sydney. The luxury journey includes excursions to the Great Barrier Reef and tropical rain forest BELOW.

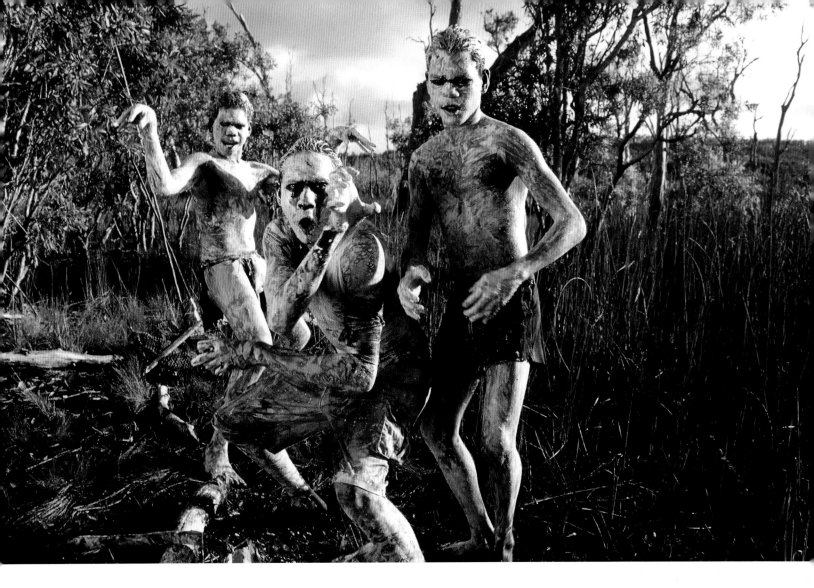

The rich, reverberating sound of the didgeridoo summons the participants every festival evening to the bunggul, the great sunset dance. The myths of the dreamtime are expressed in song and dance. The spiritual center of life is the landscape, which keeps the Aborigine both mentally and physically alive. The flora and fauna are sacred to the Aborigine, and they derive their being from the development of such flora and fauna. The Aborigine approach primeval times with dream and trance, drawing from them rules for their community, and gaze into the past and thus into the future. However, the sacred knowledge can be passed on only to the initiated; the Yolngu politely deflect curious questioning. For this reason too, the worlds that separate visitors from the indigenous people rarely merge. While they may greet the sun together in the morning, at the end of the festival program in the evening the Yolngu

and the whites sit separately around the camp fires.

Tradition and modernity are constantly clashing in Arnhem Land. Our man with the telephone, Tom, picks up a hammered stone in one hand. His fingers pass very lightly over one side of the stone, which has been beaten into a knife-sharp edge. He says goodbye to us, saying: »The knife shows the change that the Aborigines had to go through.« Only three generations ago, they still made their own clothes and lived on kangaroo meat and berries, with a highly developed culture, but behind the times in technological terms. »The Stone Age ended here only 80 years ago.«

HENDRIK NEUBAUER

On the dance floor. The dream-time comes alive in rituals. »Law songs« pass on social rules and recount tribal hierarchies ABOVE. *The totems on the faces of the Yolngu women are expressions of their spiritual souls. They come closer to their creator in the water, for »without him nothing exists, he is the water...«* BELOW.

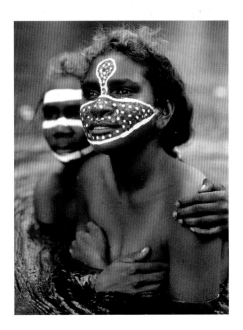

Belief is Rhythm

In West Papua, the end of the rainy season approaches and the day draws to a close. The sound of the rain forest is phenomenal, as if a wild orchestra is practicing. Cicadas set the tone, syncopated by bird calls. A little later, as if at the press of a button, the rain starts to fall. It drums on the roof of the forest; nature providing the measure in advance. The rain has scarcely abated, and the singing of the frog's choir is not the only sound that can be heard. The drums of the Asmat settlement echo through the forest. For the next few hours, they provide the sound backdrop, and set the village in a trance-like state. A feast is taking place which most likely does not have a spiritual background.

The same is true for all indigenous peoples: music is not played for enjoyment or relaxation, but is rather an element of belief and spirituality. Belief is all-embracing. It offers an explanation for phenomena in the outside world and, at the same time, provides the measure governing the lives of the individual and the group.

Take a look at an indigenous community that has such a rhythm, that lives in such rhythm. Can it be that what makes such a community indigenous is that it has not yet lost its tact; has not yet succumbed to the temptation of Western rationale and consumerism, or Islam's promise of salvation?

As already stated, music, like all other activities, has a context. This context enables the people to survive. Whoever digresses from this music, breaking the rhythm, sets himself apart from the community, with all the possible consequences that may follow, even including the loss of his life. Whoever breaks the binding taboos also breaks with the community.

Music is an element of belief and spirituality

All activities that may not be carried out under any circumstances are covered by a taboo. These may be the prohibition of specific foods, which often has a very practical background, such as the taboo against slaying game during specific times of the year. If man is to make demands on nature, he must also give it time to replenish itself. At the same time, taboos serve to self-insure the community and to distance it from others.

Taboos, and therewith their related traditions, are maintained, overseen, and passed on by privileged persons who may well be the chief, the oldest woman, the shaman, or the medicine man. They provide the rhythm in which the community lives. However, they also provide the link to the supernatural, to that which threatens or protects. In contrast to the scientific methodology that has explained our world down to the last nanometer and the bending of time and space, thereby creating more confusion than solving

it, natural religions offer a holistic explanatory model. The boundaries between animate and inanimate material, between microcosm and macrocosm, are transcended with ease. This approach allows natural religions to appear attractive to many people who live in the West and who find science »soulless« and cold. We need only think of Jean-Jacques Rousseau and his concept of the »noble savage,« which should be understood as a direct reaction to the Enlightenment Age of the 18th century.

Rousseau's successors in spirit can also be found today, usually among esoterics, otherwise known as the New Age Movement. They gladly but selectively borrow from natural religions. Adherents of esotericism are glad to put out of their minds that natural religions are truly holistic for the peoples who practice them; religions that embrace all aspects of life. It is the group that strikes the beat, from birth to death, and

The drum calls the community together

usually in a highly regulated fashion. The seasons of the year have their own rituals and music. The various stages of a human life are also subdivided; one need only to bear in mind the great importance of initiation rites that almost all cultures have in common. Here too, the pace is given by the beat of

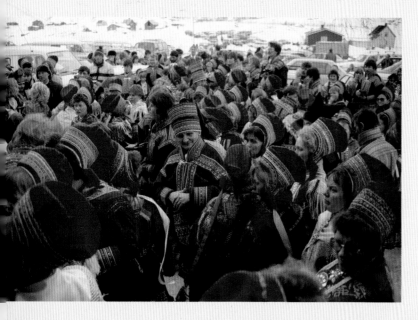

Kautokeino. Where the Sami are, the original religious singings will eventually sound. Yoki is once again synonymous with Samic culture.

Petro cult on Haiti. The drums are calling, the dancers bring the voodoo community close together, and the singings call the familiar spirits. Voodoo almost builds a protective barrier around the circle of those gathered here.

the drum. It appears to be an element that links together the various types of natural religions. The drum calls the community together, and even within the groove of gospel songs, it sets the mood to the point of trance.

Just as natural religions have a certain attraction and many gladly find inspiration in them, so has the music of these religions gained its own fan club in the »global village.«

The Fans of the Yoik dance to the beat and magical songs of Mari Boine. Is it Ethno-Techno, is it Techno-Folk? They need only bother themselves with such questions and not delve deeper into the religious background of the music: the Sami continue to preserve the Yoik. This singing is an expression of emotions, of grief or happiness. It is the spiritual fingerprint of its singer, his whole identity. Even animals have their Yoik. The Yoik is considered spiritual music. Sometimes it can work like medicine. The rhythm,

together with the singing, can set one in trance. Then a door opens from this world into another.

Sami at retirement age, who have probably still perceived the world as a spiritual whole, are confused by the sound of contemporary Yoik with its elements of rock music or break beat when they encounter it on the radio. The young, however, are proud that a part of the culture is being noticed by the outside world, and can follow on the Internet where the musicians have just been playing and what the fans have to say on music weblogs. World music is also a link between New York, New Wales, and Hammerfest.

On February 6, the Sami flag is flown all over Norway. The Sami celebrate their national day in Norway, Sweden, Finland, and Russia. The day is celebrated differently in different places; in a more secular way in the towns and cities, but in the traditional way high up in the north. There, in many places, the religious singing of the

shamans can be heard as they beat the drumThis feast must certainly have a spiritual background.

HENDRIK NEUBAUER

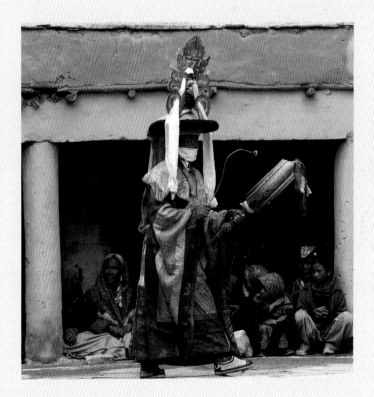

Festival at the Tsomoriri Lake in Ladakh. The priest strides through a cloister, recites verses, beats the hand drum; tinker bells jingle.

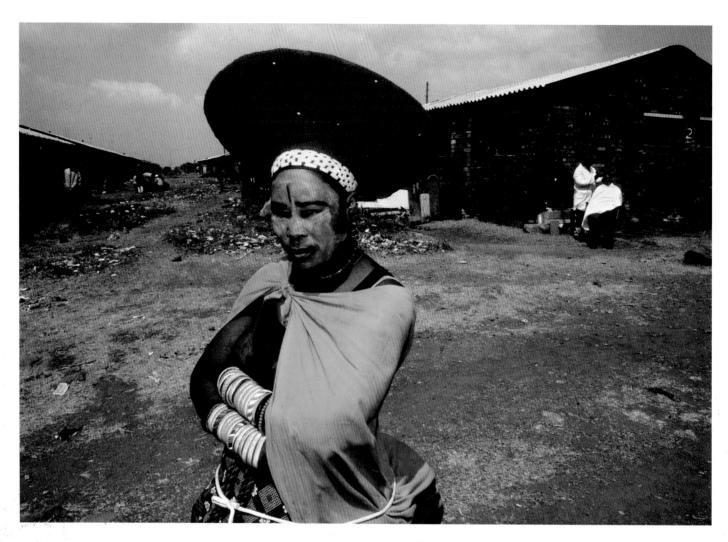

ZULU

Identity and power

There are people everywhere. The streets of Polokwane are bursting with people. The city in the Limpopo province of northernmost South Africa was formerly known as Pietersburg, and is not really located in Zululand. It was, however, the site of South Africa's most significant political shift since the end of apartheid in 1994. In December 2007, Jacob Zuma's campaign was well underway, his supporters in place, waving flags. Zuma is a Zulu, as are the majority of his followers. They have forgone the war insignia of the spear and cowhide shield that were very much a part of earlier Zulu demonstrations. Here, they want to avoid giving the impression that the campaign is only about electing a Zulu to lead the African National Congress (ANC).

The spear and shield are emblems of Zulu self-consciousness. Zulu history was marked by a lust for conquest and merciless sublimation. Had South Africa

not been the stage for the first serious attempt to colonize the African bush, the Zulu would have had several more decades in which to consolidate their power and expand their empire. Arriving as a small immigrant band of Bantu speakers from the north, the Zulus formed under their current name at the beginning of the eighteenth century, with their rise to prominence beginning a century later.

Shaka ka Senzangakhnona, known as Shaka Zulu, was king of his people for only a few years. His legendary deeds, however, have elevated him to the rank of ancestors who the Zulu will honor forever. Shaka Zulu is famous for his territorial gains and clever military

tactics, but also for massacring his subjects and betraying his allies.

Military drills were the totality of the education of a Zulu youth. Even very young children were enlisted in the military as messengers and porters. All Zulu males lived in barracks year round. They were only allowed to marry once they turned 30. In 1816, Shaka was a young king ruling over 1500 people. Some ten years later, after the incorporation of entire ethnic groups and tribes under the Zulu name and under Zulu control, that number would be more than a quarter million.

Shaka Zulu was murdered by his half brother in 1826, possibly after he ordered

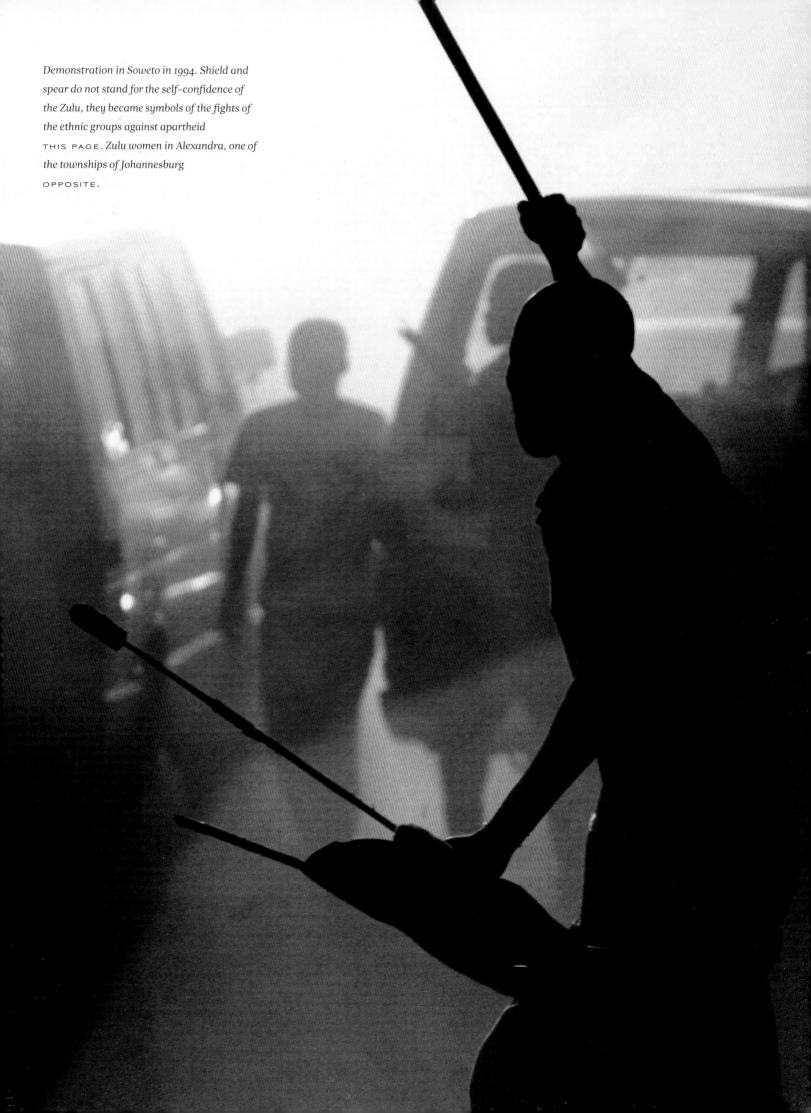

Demonstration in Soweto in 1994. Shield and spear do not stand for the self-confidence of the Zulu, they became symbols of the fights of the ethnic groups against apartheid
THIS PAGE. Zulu women in Alexandra, one of the townships of Johannesburg
OPPOSITE.

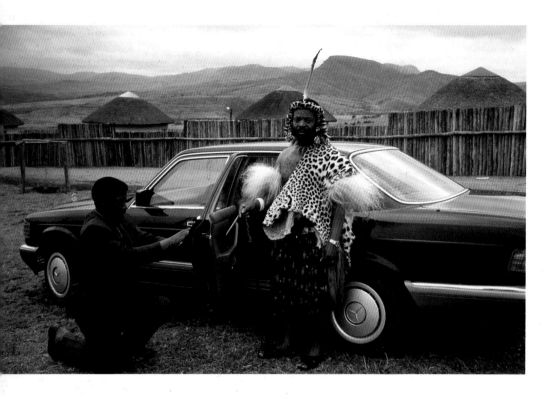

Goodwill Zwelithini, king of the Zulu nation, in the Nongo palace in Kwazulu, the only homeland which was named after an ethnic group. His addiction to costly status symbols often came under criticism.

the execution thousands of his subjects while mourning the death of his mother. Deeply disturbed, he forbade his kingdom to milk its cows, plant or harvest for an undetermined period of time, going on to order all pregnant women and their husbands to be killed. Shaka Zulu's legacy was a kingdom some 1250 miles (2000 kilometers) in diameter, but also a neighboring Boer community grown stronger from trade with the Zulu king. His successors became involved in a series of bloody wars with the Boers, and later with the British. Despite their inferior weapons, and to the surprise of their enemies, the Zulus always fought to the bitter end, putting up a good fight in the spirit of Shaka Zulu.

The Zulus were given a special role in the apartheid state, which many non-Zulus resent to this day. After the death of Albert Luthuli, the legendary leader of the ANC, Oliver Tambo, a Xhosa, took over the leadership of the party. This led to the 1970s formation of the rival Inkatha Freedom Party (IFP), which was devoted, more or less, entirely to Zulu interests. Its head, Mangosuthu Buthelezi, developed a decidedly alternative reform program. While it formally condemned apartheid, the IFP's anti-Communist platform did not rule out eventual collaboration with the government in Pretoria. In the final years of apartheid, the IFP started a genuine civil war with the ANC. Many voices suggested that the Zulus had been incited to war with the support of the government security forces. A winsome elephant family served as the IFP logo, but it was the bold symbol of the ANC, the Zulu spear and shield, that was burned into the consciousness of apartheid's opponents around the world who would later be friends of the new South Africa.

One of the best-selling songs of all time is, in fact, traditional Zulu music. Soloman Linda's »Mbube,« better known as »Wimoweh« or »The Lion Sleeps Tonight,« comes out of countless a capella song contests, a favorite evening entertainment of the impoverished Zulu. Linda lived to learn of Pete Seeger's version of his song racing up the charts. Solomon Linda died penniless in 1962, with his heirs cheated out of their share of his legacy.

MAX ANNAS

HERE & NOW

There are more than 10 million Zulu today, most living in the eastern half of South Africa. They make up more than a fifth of the country's population, making the Zulu South Africa's largest ethnic group. The 1977 apartheid-era creation of the KwaZulu homeland put a halt to the migration of Zulu families into South Africa. KwaZulu itself was not contiguous territory, but several small and smaller territories in Natal province, each stuffed full with penned-in, impoverished Zulus. After the end of apartheid, many Zulu sought their fortune in the big cities of Johannesburg and Pretoria, living among the millions of people making their way in the grim townships of Soweto, Alexandra, Benoni and Tembiso. Today, the province of KwaZulu is the most populous in all South Africa, as well as being the only province that carries the name of an ethnic group. When it came time to choose a successor to the chairmanship of the ANC in 2007, opportunistic politician Jacob Zuma mobilized his followers with speeches appealing to their Zulu heritage. The ANC had been led for more than forty years by either Nelson Mandela or Thabo Mbeki. Both were Xhosa, the country's other large ethnic group. Even accusations of rape and corruption could not harm Zuma. His victory in the campaign for the ANC chairmanship has made Zuma the favorite candidate in South Africa's coming presidential election.

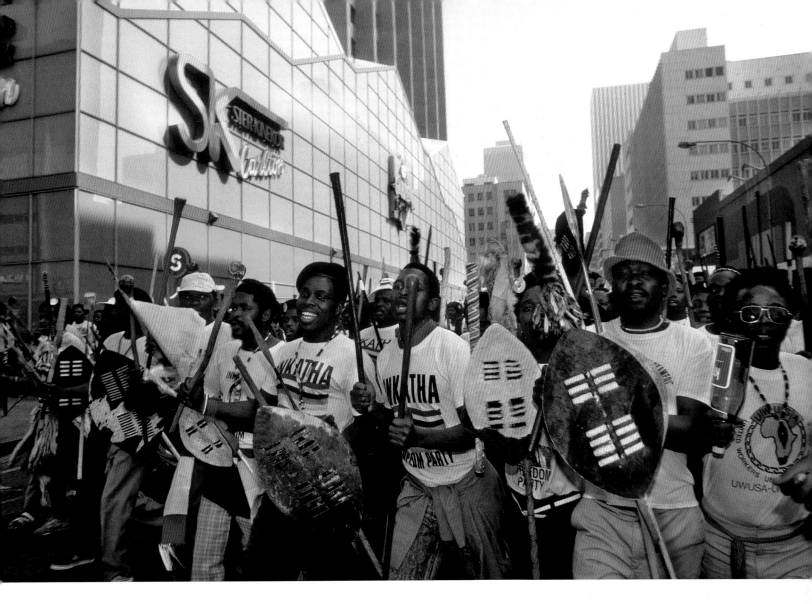

Inkatha demonstration in Johannesburg in 1996. South Africa is called »rainbow nation« since the racial segregation; it has eleven official languages. The Republic is the only industrial country in Africa and a role model for being a multi-ethnic democracy. Alas, there is still an extreme prosperity gap.

JOHNNY CLEGG: THE WHITE ZULU

They call him the white Zulu. Johnny Clegg is an anthropologist, composer and pop musician, as well as one of the most colorful characters in contemporary South Africa. Clegg grew up in England, Israel, South Africa, Rhodesia (Zimbabwe) and Zambia. He has lived in South Africa since he was a teenager. When he was 15 years old, he got to know Sipho Mchunu, a Zulu musician who was in Johannesburg looking for work. In 1969, they began to make music together, with no thought whatsoever of turning professional. A few years earlier an influential jazz combo, the Blue Notes, tried to ignore the apartheid laws by touring with a racially mixed group of musicians. Frustrated, they left South Africa for good in 1964. Clegg and Mchunu stayed together, as much out of friendship as for the love of music. In 1979, they were finally able to put out their first album, Universal Men, with their band Juluka. Naturally, the song was not played on the radio. Even the cover photo was an affront to the apartheid laws, for it showed Clegg dressed up like a white Zulu next to his colleague Mchunu.

They continued to work together for several years until Mchunu decided to return to the countryside in 1985. Clegg then founded his second band, Savuka, and had an international hit with the song »Third World Child.« His explosive mixture of Zulu sounds and rock music is stamped with the imprint of Clegg's rough vocals. Things have changed since apartheid came to an end. Clegg still brings out a new album every couple of years, has worked on the film Goodbye, Bafana and teaches anthropology at Witwatersrand University in Johannesburg.

www.johnnyclegg.com

The column of white trucks rushes over the rough desert roads. Their structures of white stanchions trembles each time they rumble over a bump. There are bumps every couple of miles. Arriving at the small village Molapo, men jump out from the front and off the back of the trucks. They knock down the little huts, empty the water tanks into the desert sand and destroy them. The humans, sitting lethargically in front of their huts, are grabbed and loaded up onto the trucks. Within a mere few minutes, over 30,000 years of history are obliterated.

Recent genetic studies have shown that the San tribe belongs to the oldest human communities and could possibly even be the oldest. Seen as a group, this would make them into a sort of genetic Adam, according to the anthropologist Spencer Wells. For an impressively long time, the San people have lived in an environment that, to most humans, would seem virtually unbearable. Yet, they have adapted extremely well to the aridity, the heat, and the sheer spaciousness of the landscape. In fact, they need this spacious territory for expansive forays through the desert, so that the women can look for plants in the austere landscape and the men can find animals to hunt. This foraging culture has saved the San tribe up to the present, but there is significant opposition to their lifestyle, which does not seem to be adapted to the so-called modern ways of life.

At the beginning of the current era, there were possibly around 400,000 San people living in southern Africa. Yet, the large-scale migrations of the Bantu, which led from western and central Africa towards the south, pushed, in turn, the San further south as well. Nowadays, the largest group of the San tribe lives in Botswana, as systematic persecution and destruction of the San people never took place in this region. From the foundation of Cape Town in 1652

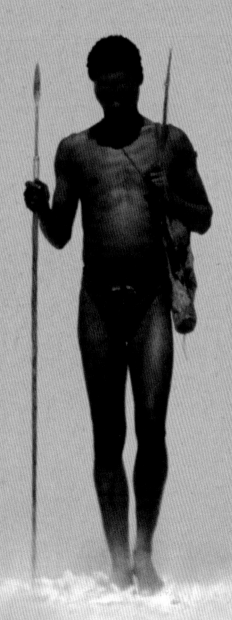

SAN

In the desert without water

until the middle of the nineteenth century, Dutchmen and Boers killed a large number of the San people around the Cape. In Namibia, Germans later persecuted the San tribe, after they had had won the Herero-German War. The San were originally the indigenous people of southern and southwestern Africa up into current-day Angola. After the wars and persecution, the San were forced to survive in Namibia's deserts and Botswana's savannahs.

Exceptionally adept at adapting to their environment, the San people were asked for help by the South African government in Namibia to help combat the independence movement SWAPO, and also by the Portuguese colonial government in Angola. As a result, the San people were largely persecuted in Angola, after the MPLA seized the power in 1975 in Luanda and the state gained independence.

Tracking is a part of daily life and means survival for the last of the traditional San population living in Botswana and Namibia. When hunting, San men chase their prey to exhaustion before the kill. Depending on the size of the animal, this can take up to forty hours, as is the case with a full-grown Kudu-antelope. When the animal collapses, the men kill it with the help of poisoned arrows, which are dipped in the poison extracted from

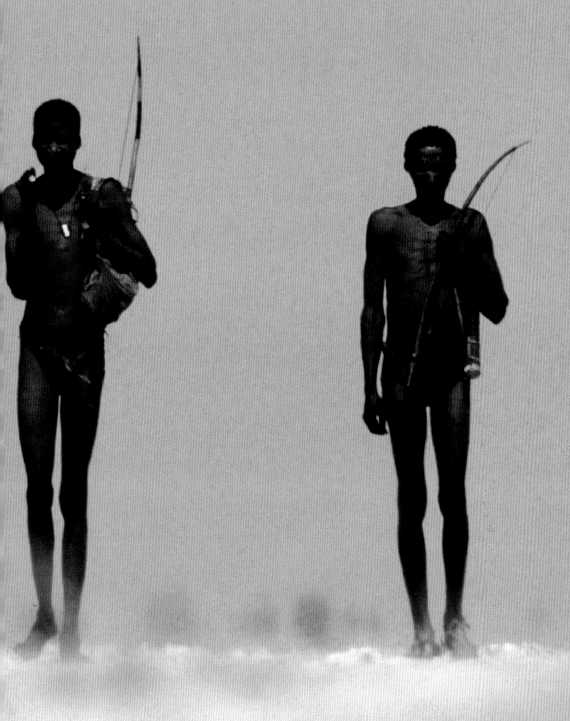

At the age of 15, a San youth is received into the adult community
ABOVE LEFT. A San boy with a self-made toy ABOVE RIGHT.
A pluriarc is a plucked instrument with four strings strung across a
resonating body, like the oil can here RIGHT.

HERE & NOW

Today there are fewer than 100,000 San people spread out over southern Africa. Around half of them live in Botswana and around 3,000 to 4,000 in Namibia. The others are scattered in small groups in South Africa, Angola, Zambia and Zimbabwe. Their traditionally egalitarian structures are dissolving because of the change in living conditions. This tendency is the result of not only the men progressively needing to leave their families to look for work, but also the loss of expansive hunting grounds. Other factors also play a role. In the 1990s, the Botswana government passed a law to forcibly remove the San people out of the Central Kalahari Game Reserve, with the rationale that the San were tired of foraging and wished to work as farmers on secured farming grounds. In addition, the living conditions of the San were not deemed compatible with the conservation of the wild animals in the park. In total, 2,200 San people were affected. Critics accused the government of ›cleansing‹ the Kalahari Park to ensure better conditions for tourists and facilitate diamond mining. It was not until 2006 that the Supreme Court acknowledged that the move was illegal and thus irreconcilable with the constitution of Botswana. Unfortunately, this judgment was of little help, for the move had already taken place and the Kalahari no longer had a functioning form of water supply. Some San people returned – their exact number is unknown – and had to learn how to survive without their former supply of water, for the Supreme Court had failed to make a provision concerning water supplies.

the larva of a diamphidia beetle. Even large animals, such as giraffes, are killed this way. The meat is dried and can thus be preserved for several months.

Survival of the San communities and their traditional lifestyle seems to be becoming more and more a subject of museum conservation. Some wildlife reservations represent a part of the world that confirms tourists' preconceived notions of ›untouched‹ Africa. The museum village of Ju'Hoansi in Namibia, a sub-group of the San tribe, reinforces, in its own way, that the San people have become a thing of the past and deserve to be exhibited in the form of a living museum. Supported by the Supreme Court of Botswana, some San people have returned to the Kalahari Desert. In view of the huts and water tanks that were destroyed by their own government, some of the San population might just concede they no longer belong.

MAX ANNAS

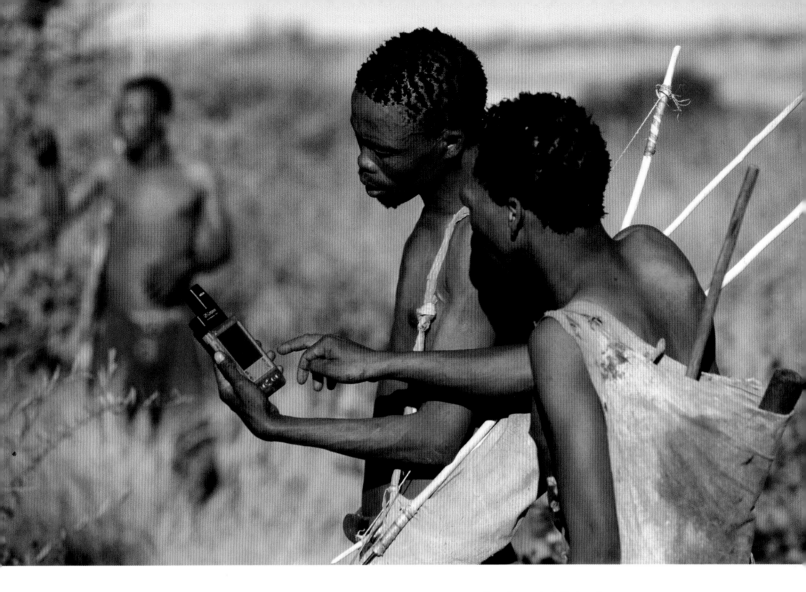

Big game hunting is for men only. A hunt can take up to forty hours, with the wild animal pursued until it can be killed at close range PAGES 306-307.
Today, simple, handheld GPS devices help show the way ABOVE.

POPS MOHAMED:
HOW FAR HAVE WE COME

›My father is a half-Indian, half-Portuguese Muslim. And my mother is half Xhosa, half-colored, with a good dose of Bushman blood. What should I say when people ask me about my ethnic roots?‹ Pops Mohamed is not well known in Europe or the USA, where a lot of money can be made with music. He is not easily labeled, nor restricted to one type of music. In Africa, he is known as the ›Minister of Music,‹ for if there is a music project, one can be sure he is involved in some way or another.

He was born in 1949, in an Indian district of Benoni, between Johannesburg and Pretoria. In addition to keyboards, he plays Kora, Mbira, Didgeridoo and, if necessary, the guitar. Pops gave up his career as a jazz musician in the 1990s. ›Given the danger of losing our own culture, I want to contribute in preventing this from happening, There are so many brilliant pianists who play jazz better than I do. It is far more gratifying for me to work with more traditional music.‹

The album How far have we come (1995) was his first step in this direction. He daringly mixed San music in his studio. Yet, at times, the sound of the San was lost when listening to the music. Pop Mohammed made a second album to do the original music more justice. Pops Mohamed presents Bushmen of the Kalahari was the result. Distractions were completely avoided; the album is good and professionally recorded music of the San. Mohamed warns, however, of the danger of those looking for pure and undiluted qualities in the traditional music. ›Of course, the Khoisan are interested in computers or want cell phones that could save lives in the desert. It is their right to want to belong to the First World. All I want to do is ensure they do not completely lose their culture in the process.‹

popsmohamed.calabashmusic.com

Missionaries

Go therefore and make disciples of all nations, baptizing them in the name of the Father and of the Son and of the Holy Spirit, teaching them to observe all that I have commanded you. (Matt. 28:19-20)This statement is known as the Mission Mandate, otherwise called the Great Commission. It is a decisive verse in the New Testament that set the course for Christianity, allowing the religion to expand beyond its narrow, eastern Mediterranean origins. In the Christian belief system, after his resurrection, Jesus Christ spoke these words, as he sent his disciples out to deliver his message for future generations.

In practice, missionary work means that one person tries to convince another that his own religion is more veritable than the other person's religion, often even the only veritable one. He promises the other an afterlife, if the other agrees to live by the new religion in the present, by taking over a value system which is strange to him. An Avowal to a religion is somewhat of a stock

Religions and their promises

option for self-salvation, the promises of salvation retroact on the structure of the proselytized society. The converted were often influenced by the armed bystanders since missionaries rarely traveled alone.

Christianity is not the only religion to take up the task of winning over others with their proclamation of »Good News.« Islam and Hinduism have also taken the offensive. It is no coincidence that these are the three faiths with the greatest number of followers around the world. While Islam has no clear directive to missionary work, its protagonists have practiced the religion as such, following the model established by the Christians. The two sister religions share a common regional origin, and came into being in an Orient with similar cultural values. Their expansion strategies are also very similar.

Missionary work cannot take place without several vital preconditions. First and foremost, there must be a genuine desire to convert others. The great world religions became what they are today because they willed it to be so. The West

Missionary work needs money and transport

African goddess Mami is of no special significance in Sweden or Pakistan, due to the fact that her worshippers did not march out to the north or east with the goal of proclaiming her divinity. In addition, considerable resources are required to bring one group into the fold of the religion of another. The sixteenth-century conquest of South America, which convinced

Mormon missionaries in action in the streets of Pnom Penh.

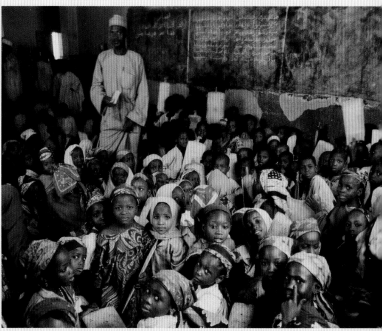

The most important Koran school in Nigeria was founded in 1950. Today, it has 8000 students.

The caption image at top:

The Pentecostal »Church of All Nations« around the Nigerian »prophet,« T. B. Joshua, at a demonstration in Lagos.

many native peoples to convert to Christianity, could not have taken place had there not been ships capable of crossing the Atlantic Ocean. The Spanish royal household paid for the expeditions, investing their gold in order to procure more of it. The conquest was not expressly planned as a missionary operation, but the money that the crown contributed was repaid many times over.

The most important factor for the conversion of a group, a region or a country, however, is something quite different. The belief systems of all societies and communities follow their own transcendental model. These have one thing in common: the conviction that greater powers govern, or at least influence, what happens to people, and between mankind and nature. Within a group, these beliefs often lead to the formation of a religion favored by the majority. Wherever missionaries went, they could rely on the fact that people are familiar with spiritual models almost anywhere in the world. There was no necessity to explain faith. Thus, proselytized people could replace their own religion with a new one. Sometimes, they created another one which combined both styles, the new and the old.

The end result of missionary presence is well known. Christianity, including Catholicism and the numerous Protestant denominations, has a tight grip on the American continent, Europe and a good-sized part of Africa. Islam dominates in western Asia, parts of South Asia, and a decent portion of southeast Europe and Africa. Hinduism has spread through the Indian subcontinent and South Asia, as well as everywhere where large Indian communities are found.

A modern wave of missionaries

The advocates of missionaries for the larger religions see more possibilities. There is hardly a West African city of any size without a new mosque, paid for by the Saudis. With their green-painted mosques built upon the best available land, the Wahhabis have come up with a sophisticated model for exerting their influence. A modern wave of Christian missionaries comes mostly from the United States of America. Evangelical sects operate in Central and South America, and in sub-Saharan Africa as well. They seemingly appear closer to the modern spirit than the Catholics, because they do not need churches, and are sometimes satisfied with a stadium. The sects run into and react to the desire for a bigger, more contemporary religion.

They are on those grounds which the Catholics prepared, in order to spread a bible-abiding and very conservative interpretation of Christianity. The conversion promises a deep personal experience of an encounter with Jesus Christ.

MAX ANNAS

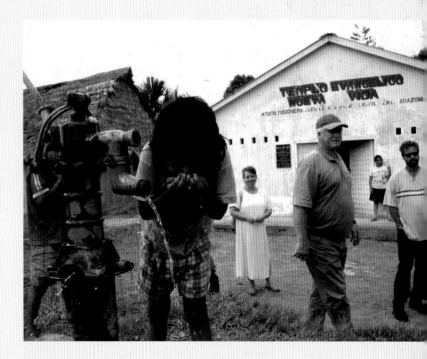

American missionaries in Peruvian Esperanza have built a desperately needed well for the community.

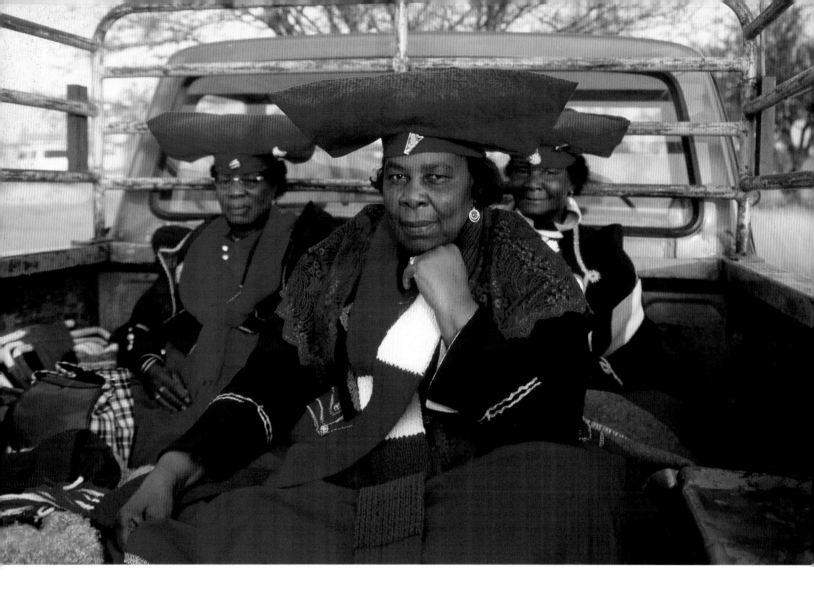

Three Herero women in their typical garbs, which go back to European prototypes from the 19th century. The hats symbolize cow horns.

HERERO

With bright colors into the future

On a dusty plain near Okahandja, the sun beats down on the people, with only a warm breeze blowing as respite from the heat. By the thousands, the Herero move past the memorial to their chieftains, who led an uprising against German colonial troops in 1904. The flamboyant, uniform-like clothing of the women is striking. Over their flowing robes of intense red or yellow, many wear black waistcoats with gold borders. Their head coverings in matching colors with the typical horizontal pad increase the impression of a uniform. The men, too, are dressed in military style. Some are wearing European uniforms; others wear their own creations derived from these, some with corresponding accessories. Red and gold epaulettes are seen, along with red-edged hat brims, medals and badges, and flag bearers.

Around a circle of white stones, all linger to remember the dead, not only the heroes of the lost war, but all ancestors. The first impression may be deceptive, for the colorful costumes are not part of a tourist event. The Herero have strong links with their ancestors, but they are far from obsessed with the past. Their performance is at the same time a mourning ritual and a political demonstration, for they are still fighting for compensation for the crime committed against them by Germany, the genocide in the early part of the last century.

At the same time, the Herero themselves had a war-like history before they were almost destroyed by the Germans. In the region now called Namibia, they fought the Nama and the Afrikaners, a hybrid people of the Orlam from the Cape of Good Hope, for the nearby fertile agricultural and pastoral land. At that time, however, there was an equilibrium between the forces, broken only by the arrival of modern weapons and German warfare. On this day of memorial, high above Okahandja, the Herero remember the trauma of the battle of Waterberg. They are sending out a message to the world: we are still here!

MAX ANNAS

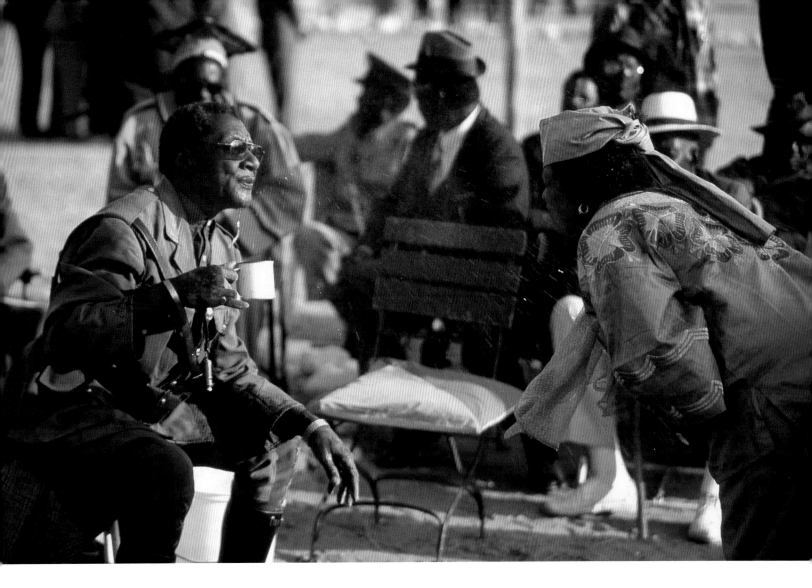

At the annual Herero feast, the newcomers need to permit a cultic cleaning: the master of ceremonies T O P fills his mouth with water and spatters every member.

HERE & NOW

The fact that today the Herero number close to a quarter of a million is almost a miracle. The German military leadership had issued the order to destroy all the Herero. About three-quarters of them, allegedly 65,000 individuals, died in the campaign of the colonial forces. Today, the Herero region lies north of the Namibian capital Windhoek, and in the course of the 20th century, the shepherds became laborers hired to work on the large farms in the area. Only rarely is land ownership still in Herero hands. Today, the Herero are an essential part of Namibian folklore, or at least their outward appearance for the economically important tourist industry. The »garden city of Okahandja« advertises in German for the German market, and the travel agents' campaigns for Namibia are based on wild animals and the costumes of the Herero women, which can actually be seen in the everyday life of Okahandja. Of course, the advertising term »traditional« is incorrect in this context, for the clothing of the Herero women is anything but that. The wide robes, repeatedly described as operetta-like, are imaginative variations on German classic clothing, corresponding to the uniforms of the men who served with the German military. On Herero Day in August when the battle was lost at Waterberg in 1904, and the locally buried Herero chieftains are remembered in Okahandja, both men and women dress themselves up. It is a historical paradox that it is precisely this moment when so many Germans stand at the edge of the street to photograph them.

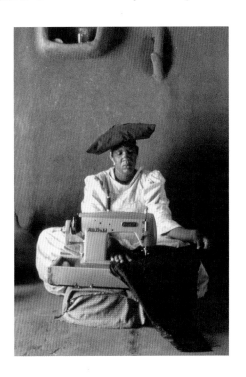

For a costume, the Herero women process up to 36 feet (12 meters) of fabric. Up to seven underskirts are part of this.

The Himba measure wealth in cattle and goats, riches that are constantly threatened by drought ABOVE. *Adolescents with their characteristic dreadlocks and jewelry. The northwestern Namibian city of Opuwo is the gateway to the Kaokoveld, the homeland of the Himba* RIGHT.

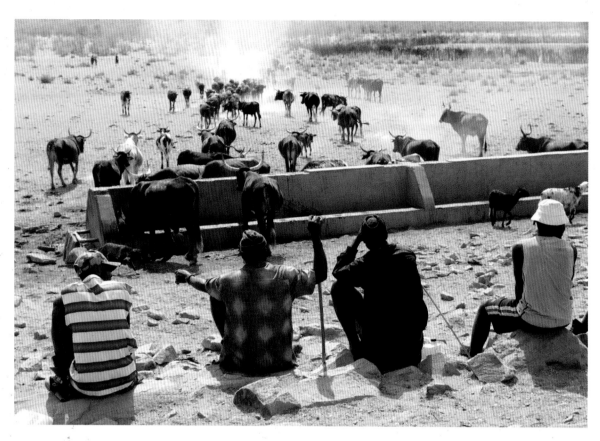

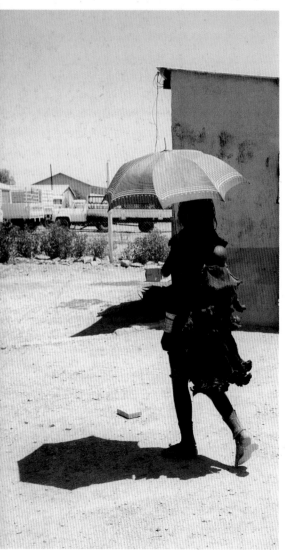

OPUWO 🌐 18°3'S 13°50'E

HIMBA

Between Drought and Flood

The SUV brakes on the dusty parking lot in front of the supermarket. The sun burns down from the sky. A few European tourists carefully climb out of the vehicle and look around them. On the edge of the parking lot, only a few yards away, stands a woman with a baby strapped on her back. The baby is asleep. The woman is wearing a short dress of animal hide and plenty of jewelry. Nothing else. The tourists are wearing light-colored safari clothes. The woman is used to seeing fully-dressed people from Europe. But the tourists are unsure how to react. The sight of so much nudity disturbs them, for the Himba woman is not alone on the parking lot.

Opuwo is the largest town in the Himba area in the northern region of Kunene in Namibia's extreme north. At closer inspection it is a small backwater that, despite its airport and supermarket, is home to only a few thousand souls. The border with Angola is not far away. By no means are all Opuwo's inhabitants Himba; they prefer to live away from the town in small settlements, and even in these for only a part of the year, since they usually roam with their cattle and goats.

The Himba have been living in this remote corner of Namibia for four to five hundred years. They came with the present-day Herero from the east, a region that now lies in Botswana. The old Herero groups split up and from then on lived at greater distance from each other, which also explains why the Herero and the Himba have developed so differently. The Herero, who settled further to the east, adopted Victorian dress as well as Christianity; while the Himba retained their traditional belief in the ancestors and their own rights of inheritance,

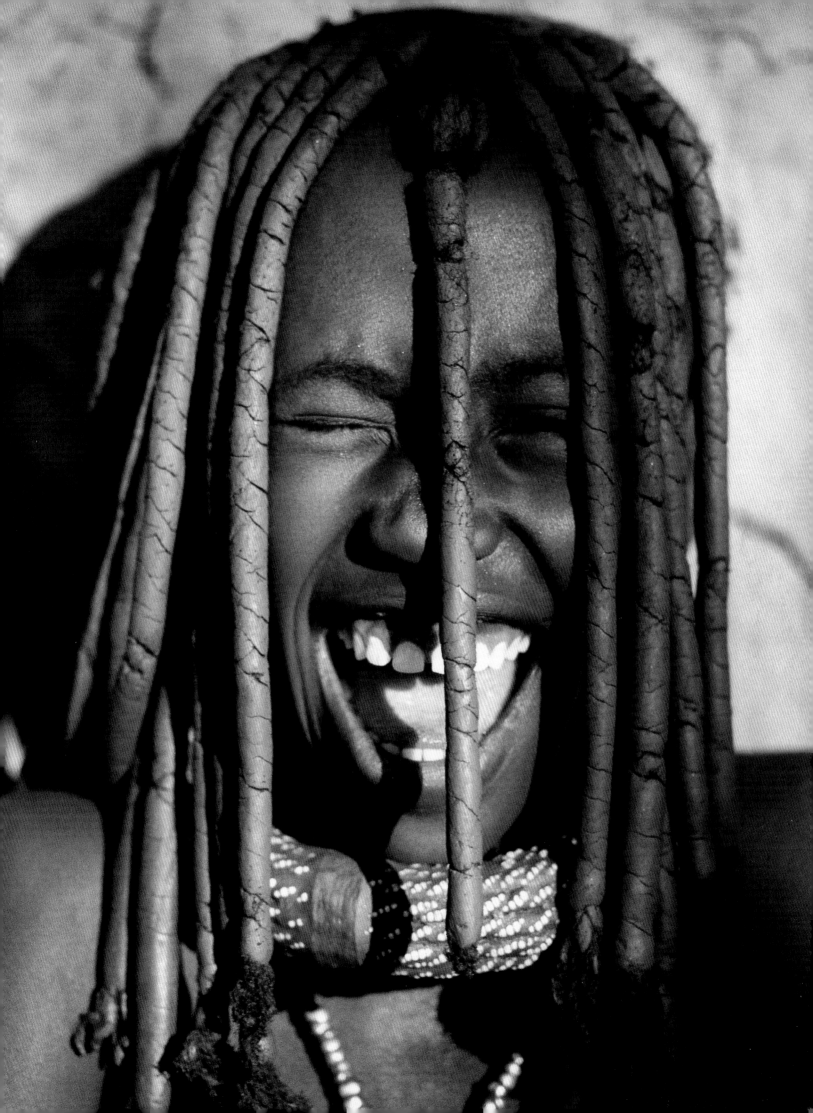

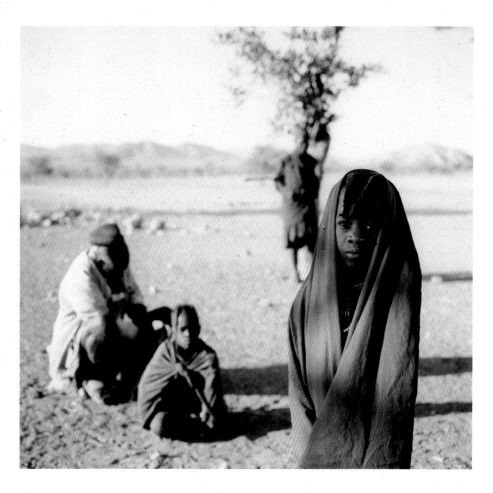

The Himba lead a precarious existence in a barren environment. Their way of life remains partially nomadic, and they set their hopes on tourism.

HERE & NOW

The Himba speak the same language as the Herero, and in the course of their history have also just as often faced the end of their existence as their relatives. They live in northern Namibia; details of their numbers very greatly between possibly 50,000 and around 15,000—sometimes even fewer. They mainly live in the scarcely developed and highly inaccessible Kunene region. Some Himba also live in Angola, on the other side of the Kunene River. The Himba are considered the least influenced by Western lifestyle of Namibia's communities. Its economy is centered on the rearing of cattle and goats; they live a nomadic life, and gather whatever milk and meat do not provide in nourishment. Every visitor to the region is struck by the Himba's lack of interest in clothes. Instead, elaborate hairstyles and jewelry are all the more important; the women protect themselves from the sun with a cream they make from butterfat, herbs, and ocher.

Some travel businesses warn against giving hospitality gifts like candy to the children and alcohol to the men; a visit to the Himba is considered an insider tip among travelers to Namibia. And it seems that thereby quite a lot of income from tourism really does flow through the channels of Himba, who are aware of their history of a slow development into a better infrastructure. They don't have just friends in the Namibian government, for in the particularly hard years of the drought in the early 1980s, a number of the men were recruited by the South African army, who maintained a large military base in Opuwo, then known as Ohopoho, the largest town of the Himba region.

according to which the cattle are inherited by the sister's children: and one's own children receive those of the maternal uncle. Only the »sacred herd,« as the Himba call the consecrated fire sticks and the responsibility for the sacred fire, are passed on to the son. The fire must never go out, for it maintains the link between the living and the dead. The Herero soon began to look down on their allegedly backward relatives.

The 20th century brought the Himba numerous hardships, mostly at the hands of their German and South African colonial rulers. Many of them fled from the Germans to Angola when, like the Herero, they were threatened with genocide. The colonial successors from the Cape assigned them to a reservation in which they were not allowed either to carry on trading or to wander with their livestock. Even before apartheid, South Africa practiced its future homeland policy in northern Namibia by confining an entire community. The result of South African rule was the total impoverishment of a once rich culture which had been based on rearing livestock. Then, in the 1980s, the Himba were threatened with the final blow. Right in the middle of the struggle to liberate Namibia, a severe drought finished off most of the remaining cattle. It is estimated that 13,000 animals died.

The situation has slowly improved since Namibia gained its independence in 1990. However, the Himba are still afraid that their government will implement a policy that the South African government had already discussed. A dam is to be built at the Epupa Waterfalls on the Kunene River to produce energy for Namibia. The Himba fear that a large part of the area they settle will be lost when this happens. Opuwo would definitely change. It would grow and have to absorb the people displaced from the land.

MAX ANNAS

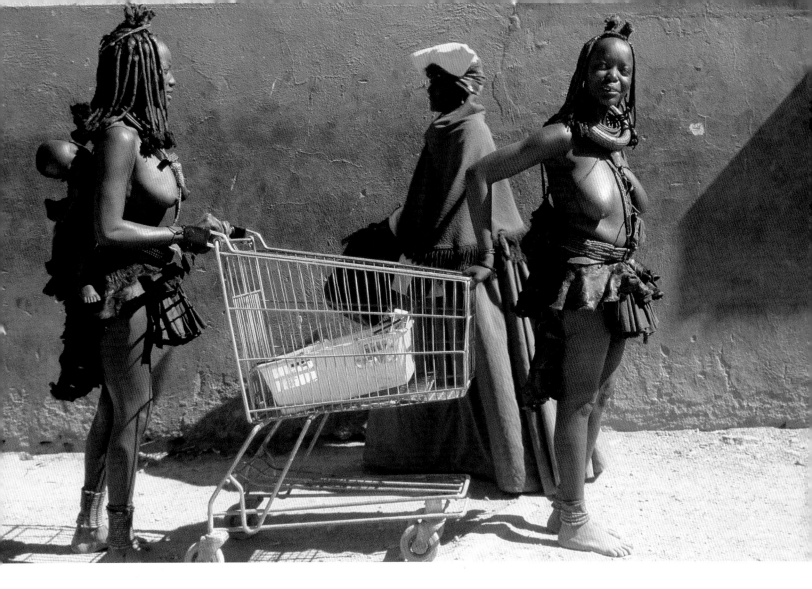

A meeting outside the supermarket in Opuwo, the center for two Namibian ethnic groups. The Himba meet a Herero after shopping. Opuwo has a population of around 5000. It provides infrastructure, including a hospital and airport, for the entire Kaokoveld region.

TRANS.SKY

Trans.Sky is a project by Warrick Sony, who is widely known for his project »Kalahari Surfers,« now running for over 25 years. Now one could think that Kalahari is somehow apt when dealing with a community from Namibia. But as those who have preoccupied themselves with the subject already know, Kalahari Surfers is the most ambitious musical avant-garde project in South Africa. In this, Warrick Sony does not shy away from anything. He cooperated with the German Electronic-Combo Can at an early stage, later with various rappers in South Africa, and in the past few years with musicians from the Himba. Together with his colleague Brendan Jury, he developed the soundtrack to a CNN documentary under the name of Trans.Sky, which is a play on words with the name of the former homeland of Transkei. The documentary about the Himba highlighted how their nomadic wander routes will be destroyed by a reservoir dam project. Brendan Jury was to work with Springbok Nude Girl, South Africa's best-known rock band, after Trans.Sky. Both then stayed with the subject: »We studied their music,« says Jury, who plays keyboard and violin. »Their vocal music is extraor-

dinarily beautiful and sounds like a clash between eastern melodies and African music. We practiced on the banks of the Kunene River and filmed the Himba as they danced to our music. Then they played with us, and we improvised over our music and their music. It was a partnership, from which we have learnt a great deal.« Sadly, Trans.Sky had only a brief lifespan; one album that appeared in 1997 called »Killing Time.«

www.kalaharisurfers.co.za

Syncretism

Religions have come into being at all times and in all parts of the world. They are on the one hand expressions of the human need for a higher power, which gives meaning to origin and destiny. On the other hand, they reflect environmental conditions as well as the cultural and social achievements which have produced them. The last is evident for example when social norms of diet or sexuality are raised to the status of religious commandments. In general, a religion formulates the canon of values of a specific community at a specific time.

Humans have migrated at all times. Most of them have done it rather unwillingly, in order to avoid conflict with other groups, to react to changing environmental conditions or to find better ones, often simply because the group had become too large to survive in the ancestral area. This caused reciprocal conflict, majority relationships changed, and minorities in particular had a hard time; many fled because they wanted to practice their religions without fearing for their lives. Even less willingly, people were forced to migrate as slaves, for example the millions of young Africans who were abducted to America.

The migration movements are one of the two main reasons why religions encounter each other. Conversely, there were and are repeated attempts to set one's

Humans have migrated at all times

The own religion as a standard for others

own religion as a standard for the lives of others. Generally, missionaries followed in the footsteps of conquerors – if they did not even go ahead of their forces. They were sent out to convince presumed unbelievers by means of more or less pressure that it was worth changing sides in order to achieve peace on earth or in heaven. The monotheistic religions, Christianity and Islam, have been prominent in this respect.

Syncretism is defined as the mixing of two ideas to create a new one. In the case of religions, this meant the creation of a new religion out of equal or unequal parts of two old religions, in situations which are outlined above. The practice is certainly complex, for it has always to do with the individual approach to the entrenched religion, with the adoption of elements of the new, and always with whether and how pressure is exerted for one's own practice to be changed, and how flexible the encounter with this pressure, by a ruling colonial power or a persuasive preacher for example, can and should be.

The African–Caribbean voodoo and Santería, as well as the Caribbean–South American Candomblé, are generally considered examples of classic syncretistic religions. In Candomblé, various elements of African religions and Christianity come together, with influences from the original inhabitants

of Brazil here and there. Here, all those participating have played with marked cards. Catholic missionaries crusading in Africa have placed objects of African veneration below images of saints of their church in order to accustom the »unbelievers« to the worship of their favorites. Conversely, in Candomblé, Brazilian slaves have built false Catholic altars behind which Candomblé objects are hidden. Both practices speak of power and powerlessness.

In Candomblé, Christian symbolism and African deities have long been inseparably mingled. The crucifix is approximately equivalent to the variations and traditions of African gods such as the Orisha of the Yoruba. There are hundreds of these, of whom however only a handful have been accepted in the Afro–Brazilian cosmos. Many varieties of Candomblé have opened up to the myths of the other disenfranchised people of Brazil. Particularly in the northern federal states influences brought in by the first inhabitants of the country can be found. Meanwhile, there is also a strong movement within Candomblé for their re-Africanization and the removal of all other elements. However, it would still remain a syncretistic religion. Even in a purely African variety, it still contains the blend of the gods of many groups which were displaced to Brazil. The traces of the past cannot be totally extinguished.

In the Haitian cemetery of Petion-Ville, a man conjures a spirit with a snake. The Christian cross in the background serves as a reminder of another tradition.

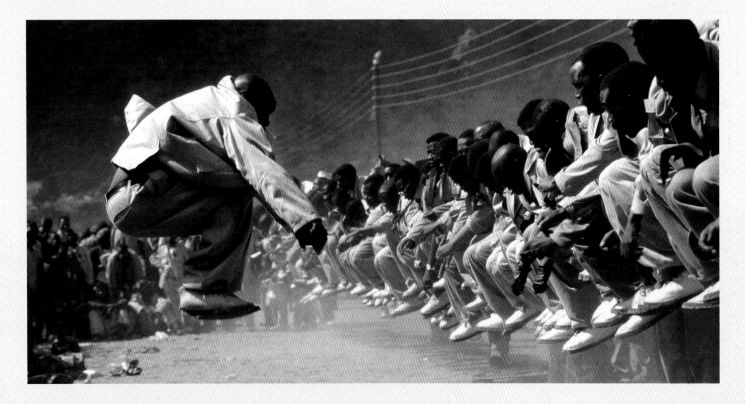

The Easter services of the South African Zion Christian Church bring together as many as one million believers. This church, founded at the beginning of the twentieth century, mixes Catholic elements with African influences. Its symbol is not the cross, but the Star of David.

Syncretism is a concept that can only be applied to a closed development. However, many people live in a religious in-between area.

A flagrant example is given by various religious affiliations within very small units, as in Ghana in West Africa, where the multiplicity of faith communities – Catholicism, Protestantism, Islam, Evangelicals, Jehovah's Witnesses, animism – cuts right through the extended families. When part of a family moves away from its ancestral home and converts to Roman Catholicism in the next town, another part reaches the coast, where the Evangelical church is particularly strong, and converts there, then nevertheless all the members meet from time to time at the place of origin to sacrifice to their ancestors or to a local deity, who must be appeased to provide the next good harvest. The monotheistic religions do not look at all favorably on this, for they quite clearly claim exclusive agency.

Finally, the great world religions are also syncretistic models. Judaism, Christianity and Islam not only have the same origin, sharing the creation and genesis myth, but can also be seen in their origins as a reaction to external influences or their own distribution in new regions. Hinduism and Buddhism have, in the course of their long existence, adopted influences from other religions, Buddhism being explicitly open to enrichment by other spiritual ideas and models. At the same time, it is the only one of the great religions to demand what happens in any case – change.

MAX ANNAS

All great religions have syncretistic elements

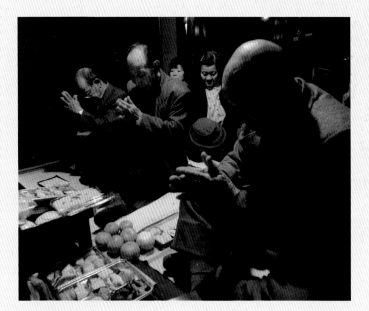

On the Japanese island Ikitsuki, local Christians have retained their beliefs, after the prohibition of Christianity in 1630, but have hidden them in a camouflage of Shinto elements. This tradition continues even today.

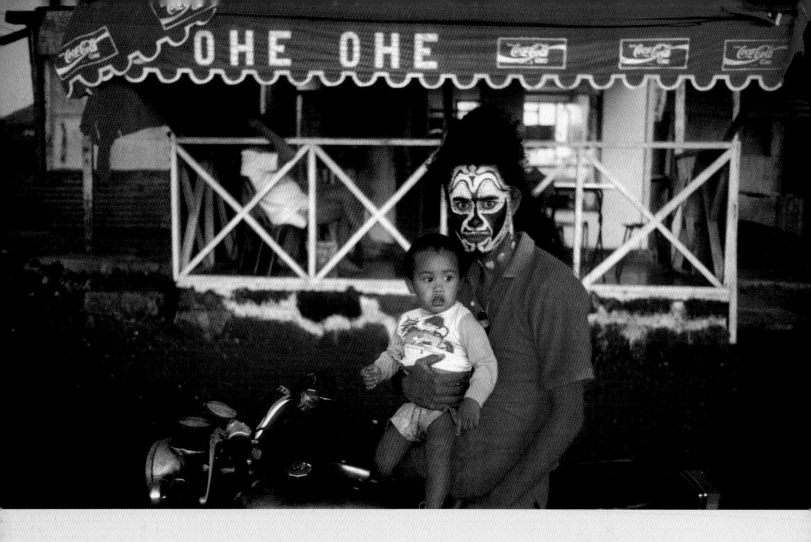

TEMPERATE CLIMATE

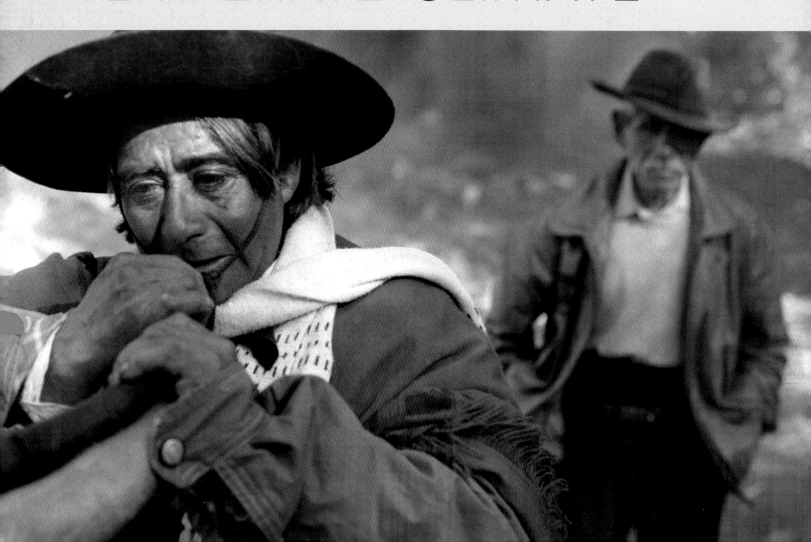

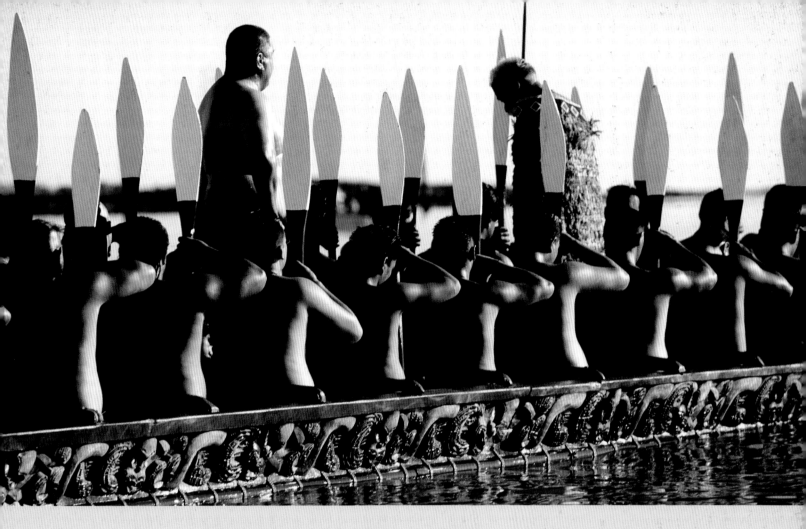

THE FAR SOUTH

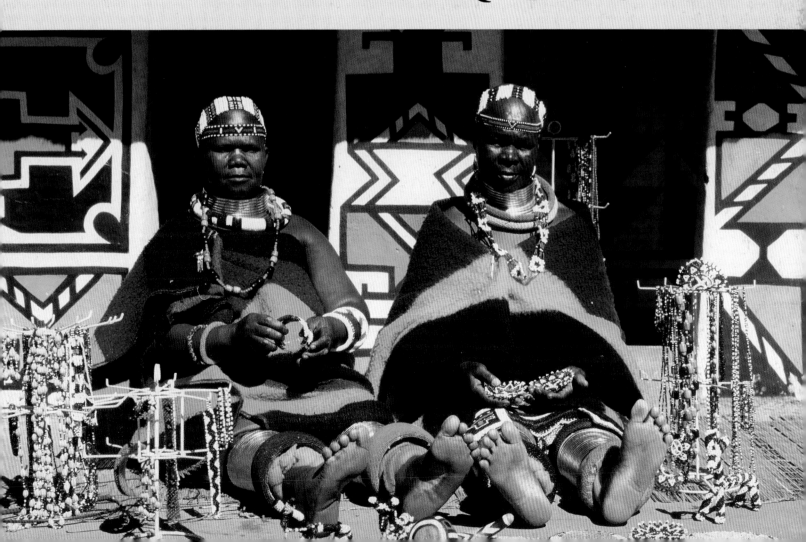

They cannot get enough of the statues, these visitors, and almost every one of them only wants to talk about how the mystery has yet to be solved today. The skilful woodcarvers of Hanga Roa, however, do not deal in enigmas. For them, carving is what it is all about. They make small models of the moai, Easter Island's world famous stone statues, a little something just the right size and price for visitors to the island's capital city. The friendly customers get to take home a miniature Easter Island head made by a real-life Easter Islander, for which they leave a fair amount of pesos or dollars behind.

From this perspective, things could hardly be better for the present day Rapa Nui, which is the name the islanders call both Easter Island and themselves. More and more tourists find their way to this small volcanic island in the Pacific, most arrive by plane from Santiago, Chile, or on a cruise ship. There were over 45,000 visitors last year alone. Most were attracted, rather than repelled, by the Easter Island's geographical isolation in an empty part of the Pacific, some 3500 km (2175 mi) from the coast of Chile and 4200 km (2,610 mi) away from Tahiti. Tourism has become the most important component of the island's economy, next to the government subsidies from Santiago. At its present scale, the tourists, most of whom stay only a few days, are not harmful to the environment. Much more threatening are the »continentals,« immigrants from Chile who come to Easter Island to stay.

Immigration from Chile reduces the proportion of Easter Islanders who are genetically related to Polynesians. In the last twenty years, their numbers have fallen from 70 to 60 percent of the population, with the last census taken in 2002. From the discos to the internet cafes, the urban infrastructure of the continentals is very much evident in and around the capital city of Hanga Roa. Young native islanders known as los yorgos are retreating to the hinterland, where they can maintain their traditional way of life. Los yorgos caused some trouble a few years ago when the government unveiled plans to build a casino

RAPA NUI

Los yorgos against the continentals

For the film Rapa Nui (1994), the sets were recreated to be as true to the original as possible. Here, one of the famous moai, the colossal stone sculptures of Easter Island.

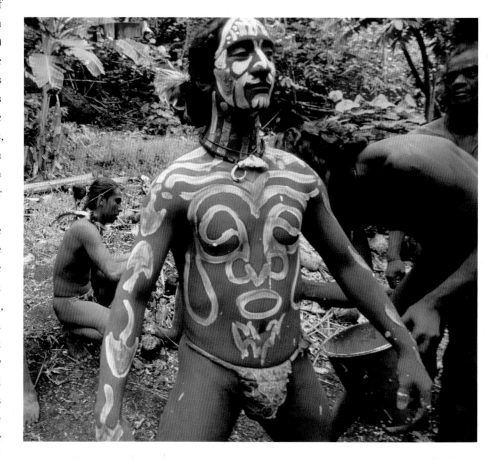

The Rapa Nui consider themselves Polynesians, not Latinos, as this performance of Rapa Nui dancers at the Marquesas Islands Arts Festival demonstrates.

Haka Pei is racing on banana tree trunks, one of several competitions taking place during the annual Tapati Rapa Nui festival ᴀʙᴏᴠᴇ. The artist Koro Pakarati, shown here with his traditional woodcarvings ʟᴇꜰᴛ, together with Benedicto Tuki Pate ʀɪɢʜᴛ, has brought international acclaim to the art of Easter Island.

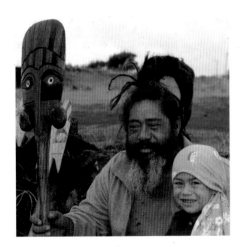

on the island. There is fishing, farming and woodcarving, los yorgos maintained, why does there have to be gambling as well?

The skeptical attitude toward foreign invaders has a long and gruesome history. In 1855, Peruvians began carrying off islanders to work as forced laborers on the guano islands off the coast of South America. Altogether, some 1500 Easter Islanders were enslaved. Soon afterward, a Chilean businessman arrived, and fenced the islanders in on a reservation. After a rebellion in 1964–1965, the fences finally came down. In 1980, the island's first indigenous governor was elected. In the last few decades, however, the meager resources of the island have been stretched to the breaking point by the continentals and their modern expectations.

As a result, many Rapa Nui feel today as though they have once again been fenced in, however more subtly than before. As one of los yorgos told a New York Time reporter a few years ago, »Things have gone wrong here because the Chileans are in charge, not the Rapa Nui.«

BERTRAM JOB

HERE & NOW

According to the 2002 census, there are now 3800 people living on Easter Island, a landmass that is three times the size of Manhattan. In 1995, it was declared a UNESCO World Heritage Site for its famous, giant stone statues and enigmatic rongorongo inscriptions. The island has an airport (Mataveri International), hospital, several schools, and two dozen police stations. An islander has served as governor under the protectorate of Chile since 1980. The island is further governed by a six-person council, which includes the mayor of the capital city of Hanga Roa. There is also a representative for indigenous peoples and a council of elders. The Rapa Nui are officially ruled from the Chilean province of Valparaiso, but demands for increased autonomy and self-government are on the rise.

Santiago de Chile. Week after week, ten thousand football fans go crazy over the goals and victories of the successful traditional club »Club Social Deportivo Colo Colo.« The club is named after a legendary Mapuche chief who died in 1560. Colo Colo and his warriors fought successfully against the Spanish conquerors. The scene changes to a children's football ground in Buenos Aires. The players kick the ball to each other with the constantly repeated shout of »Che ... Che ... Che« across the ground, which simply means »hey ... hey ... over here!«

In the Mapuche language, Mapudungun, mapu means earth and che means something like a person. The Mapuche, like many other Indian tribes, call themselves simply »people of the earth.« Today Mapudungun is still spoken by the native American population in parts of Argentina and Chile. In Argentina the concept che is part of the everyday vocabulary. »Che« Guevara was given that name because he too habitually used the word. He was not a Mapuche, but he had one thing in common with them: their huge fighting spirit. For we learn one thing from a glance at the history of this ethnic group: the »people of the earth« have always been a defensive nation. Even before the Spaniards came, they fought successfully against the Incas and repelled them. They entered into bitter battle with the Spanish forces, and were long undefeated. The treaty of Killin in 1614 forced the Spanish to conceded sovereignty and autonomy to the Mapuche nation. Their officially recognized territory in Chile now extended south of the Rio Bío Bío. Only through military »peacemaking« in Chile and Argentina from 1861 to 1883 was Mapuche territory annexed to Chilean and Argentinean land. The Mapuche were crowded into reservations, and European settlers took up residence in Mapuche ancestral land.

MAPUCHE

The eternal fighters

Today, if you fly from Buenos Aires to Temuco, the center of Mapuche country, you will find yourself in the breathtaking landscape of this ancestral country. Lush green forests and crystal-clear lakes characterize the image of the surroundings. The region is framed on one side by the Atlantic and on the other by the Andes cordillera. Temuco itself is a fairly unattractive market town, where a lively cultural scene has developed among the young Mapuche. Borne along by something like the »beat of self-determination,« artists' collectives have come together, drawing attention through poetry, painting, and music. Kolectivo We Newen calls their creative work the »Mapuchification« of hip-hop.

The rapping on the stages of Temuco is plain-speaking: the challenge »Freedom for Mapuche political prisoners« is accompanied by the call to »resistance,« and the announcement »300 years of resistance is not enough, we must recruit new fighters« by the promise »We will fight for our land.«

For this is what it is about at the southern tip of America. Before they came into contact with the Spanish, the Mapuche had occupied

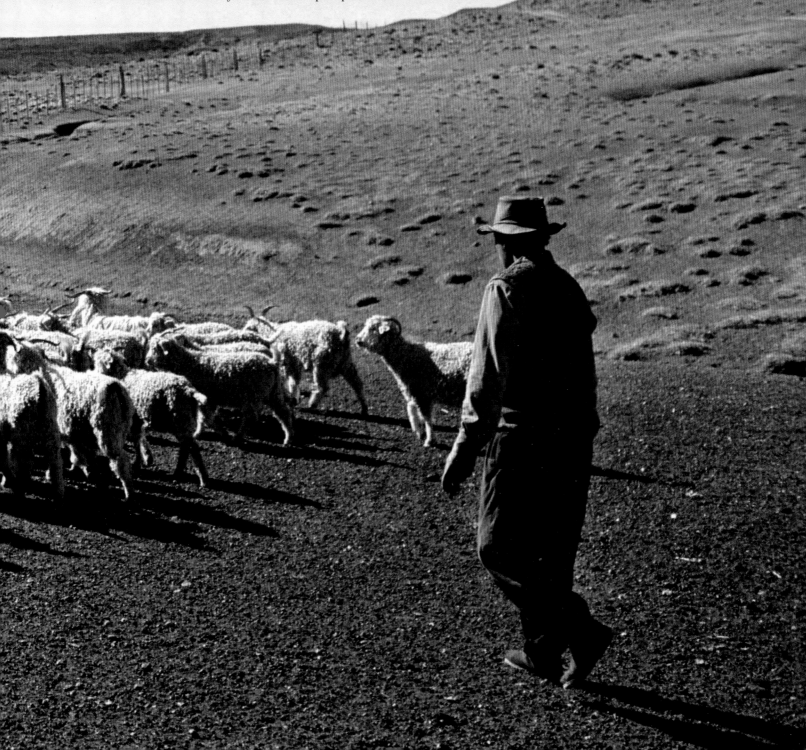

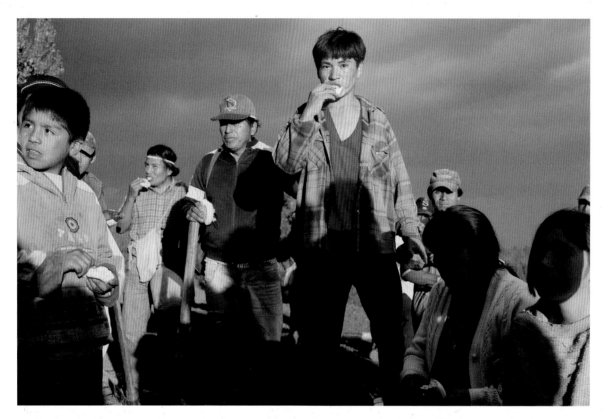

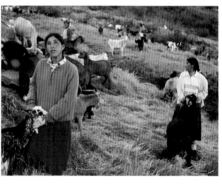

Illegal occupation of disputed land frequently leads to violence LEFT. *The oven sits in the middle of the ruka, the Mapuche house. The floors are bare, because the earth is considered holy* CENTER. *Cattle herd belonging to Mapuches living in the mountains. Here, the spring cattle drive* RIGHT.

HERE & NOW

The 600,000 Mapuche in Chile and 30,000 in Argentina are among the underprivileged groups of the population. Despite extreme pressure in both countries to integrate, there are still many Mapuche who cherish their cultural identity or want to regain it. Their language, Mapudungun, still familiar to an estimated 400,000 individuals, has meanwhile been put into writing and made available on the internet by means of online dictionaries. The World Wide Web is used by the indigenous people as an effective platform in order to care for what remains of their culture, to spread information, and to make the public at large aware of them. There are a number of blogs, and reports of the latest events spread like wildfire – for example the death of the Mapuche Matías Catrileo from Chile, who was killed on January 3, 2008 in an attempt to occupy a farm. The conflict in the south of Chile as well as in Argentina rumbles on, and is still far from being resolved.

a space of more than 30 million hectares, an area as large as Germany. After the treaty of Killin, they owned only 10 million hectares, and after the »peacemaking,« this had shrunk to about 500,000 hectares, about the size of the Saarland. During the Pinochet military dictatorship, almost a further third was taken away from them. Many Mapuche organize themselves into small groups and occupy their ancestral lands, now occupied by big landowners and forestry entrepreneurs. There are frequent clashes with the police. Political and above all legal solutions are not in sight; in the large cities, politicians react with indifference or fail to keep promises already given. This frequently results in demands becoming more forceful and breaches of the law.

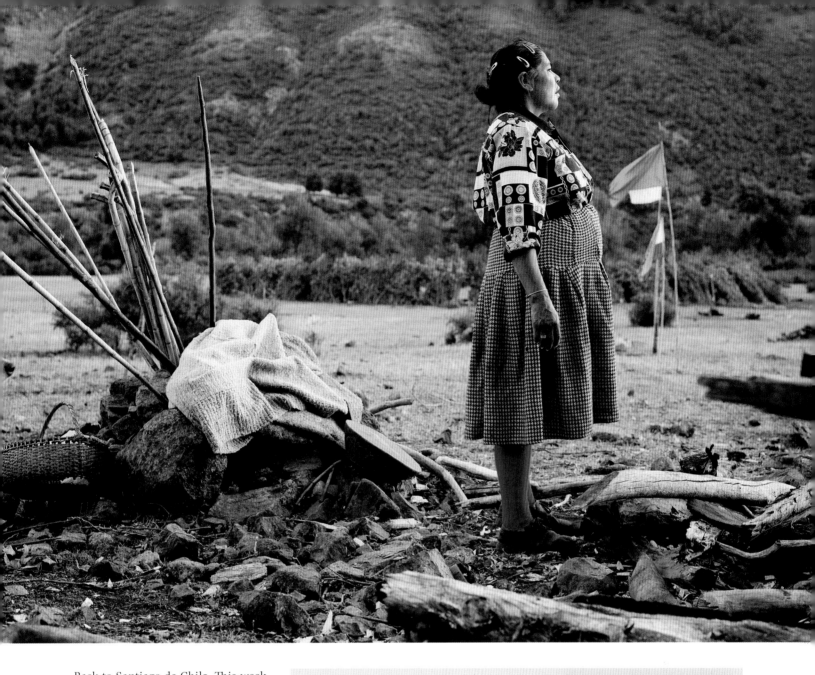

Back to Santiago de Chile. This weekend Colo Colo are playing Universidad. A local derby with a long tradition. But after a visit to Mapuche country, one has a different idea of Colo Colo and the concept of tradition. In Santiago, the Mapuche women are often employed as nannies, domestics who look after children and the household in well-off middle-class houses, and are often vulnerable to exploitation and even ill-treatment. But now it is Saturday, there is football, and the public, from managers to servants, are cheering on their team. The Colo Colo players confidently wear the emblem of the Mapuche hero on their chests.

LAURA ENGEL

BEATRIZ PICHI MALEN

Beatriz Pichi Malen does not come across as a conventional native American mama. Beautiful and proud, she stands there very confidently playing the kultrun, the shaman drum, raising and lowering her echoless voice in a spiritual manner. Now and again, she has her songs orchestrated with traditional Mapuche instruments, but the total impression is always a purist one. Since she first attracted attention with CDs such as Plata (2000), national concerts and workshops, it has been rumored that she is a direct descendant of the famous Mapuche chief Coliqueo. However, it is not the myth of her alleged ancestry that has cast international admirers such as the Austrian jazz pianist Joe Zawinul, who died in 2007, under her spell. She brings the native American soul of Tierra del Fuego onto the stage.

www.pichimalen.com

Planet Television

It happens all the time. Whether expected or unexpected, whenever a guest visits a family in Burkina Faso, the same thing will usually happen. The television will be dragged out of the corner, and set up so that everyone in the room can see it well from any angle. The electricity is turned on and the box comes to life, with conversation and idle chatter going on around it at the same time. The presence of the television lets the visitor known that this is a prosperous, worldly home. The television has taken on the role of the cosmopolitan host, keeping the conversation going and creating a lively atmosphere for the duration of the visit.

»Public Viewing«

Watching television in public is another kind of experience common in the distant corners of the world. An entire village assembles in a room of an Amazonian longhouse, or under a tree in rural Thailand, with everyone coming together to watch what might be the only television for many miles around. In more populated areas, people gather on game days to watch English Premier League football. A West African sports bar will host an arena-sized crowd, all gathered around a television screen. Here every football match is like a final, with choruses of cheers and barrages of insults flying across the room.

It is estimated that 260 million people around the world watched the 2006 World Cup soccer final in its entirety, and that an additional 600 million or more turned on the television just to see the last few minutes of the match between Italy and France. A vast number of viewers used the satellite dishes that can be seen everywhere around the world. In the midst of the wastelands of Central India, it is striking when a local indigenous tribesman enthusiastically proclaims, »We get over a hundred channels here!« What he does not mention is how much he has to scrimp and save in order to pay for his television time as the cost of electricity continues to rise. Now then, what do people generally watch the most? Soccer is always number one, followed closely by soap operas and religious programs, with music television taking up the rear.

Football, soap and religion

The fact that the majority of viewers around the world are watching soccer may not be surprising. Much more remarkable is the fact that Hollywood, Bollywood, and Brazil's TVGlobe have long since ceded their dominance of the soap opera market. This international business has become regional, with soaps acclaimed around the world now produced in Caracas, Accra, Bangkok, and Johannesburg. Mexico's leading producer, Televisa, sells its programs in fifty-nine countries, including

Korea, Russia, and Turkey. Venezuelan series have a devoted European audience in Spain, Italy, Greece, and Portugal.

Most international serial television focuses on love, sin, and passion. These days, however, there are an increasing number of Latin American and African series that reveal the darker side of life. In 1996, the main character of a Venezuelan series was faced with the devastating diagnosis of breast cancer. Over the following weeks, women wanting to schedule immediate mammograms stormed doctors' offices throughout Caracas. In 2007, the Brazilian series Vidas Opostas took the ratings charts by storm. This is a series in which, according to its director Alexandre Avancini, »we show things as they are in Rio ... slums, drug addicts, corrupt cops, dishonest politicians, and the entirely normal folks who suddenly find themselves in the middle of this life.«

The word »edu-tainment« is often used in connection with the popular South African soaps Isidingo and Soul City. The New York Times described them as »dramas with heart« that deal with one of the most urgent problems on the African continent: AIDS. The first episodes were broadcast in 1999, and more than a thousand have followed. Up to 30 million South Africans tune in to Soul City,

Children of the Karen, a Thai highland ethnos. Two pack elephants brought the satellite dish and the television set into this mountain village.

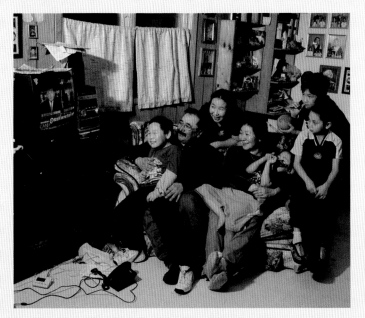
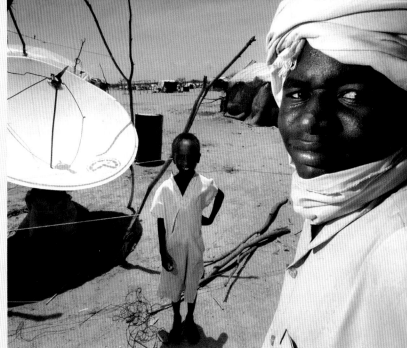

Inuit family in front of a television in Alaska ʟᴇꜰᴛ. Sudanese refugees in the Iridimi camp near Iriba in the Tschad. The average length of stay is five years. Refugees can telephone and watch television for money via satellite ʀɪɢʜᴛ.

in which the main characters often take the opportunity to remind themselves and the audience that condoms can save lives, or never to share a needle with a junkie. Watching a Soul City trailer on the Internet, viewers are transported right into the middle of a Johannesburg township and the subject of domestic violence. The scene shows a terrified woman running in the street being pursued by her husband, who shouts: »This is my wife, this is my wife...« Soul City is not only for teenagers and young adults. For the younger demographic, aged eight to twelve, there is Soul Buddyz, a program geared specifically for them. There are also Soul City radio programs and comic books. Discussing sexuality at all is something completely new for South Africa, as the apartheid government refused to mention AIDS or condoms. In 1990, when Nelson Mandela gave a speech to schoolchildren about young people and sex, he was shouted down by the parents, and as a result

avoided broaching the topic again. Into the breach marched Soul City. Today, most sociologists and medical professionals believe that, while the AIDS epidemic is far from over, its previously rampant spread has been contained to some extent by a broad increase in awareness.

»Did you see that?«

This observation has not exactly led media analysts to break out in cheers. They still maintain that television is entertainment first and foremost, a medium that at its best, serves as a »window on the world.« What they do agree on is that all over the world, not just in Burkina Faso, people sit in front of the »boob tube« and talk about what they have seen. The dialog might go something like this:

»Did you see that?«
»Man, the same thing happened to me yesterday.«

The conversing viewers know what it is really all about. What they see on television must be relevant to their everyday lives. That is why so many television nations

produce their own soap operas, why MTV is regionalized, and why the Arab nations have created their own news networks. Television adapts, functioning as a compass with which each and every focus group can navigate the great, wide world and identify once more, day in and day out,

with its own small corner of it. At the end of the day, who can deny that the subliminal message emanating from the television set daily is simply »What is going on – and how do I come to terms with my world?« At the very least, it sounds plausible.

HENDRIK NEUBAUER

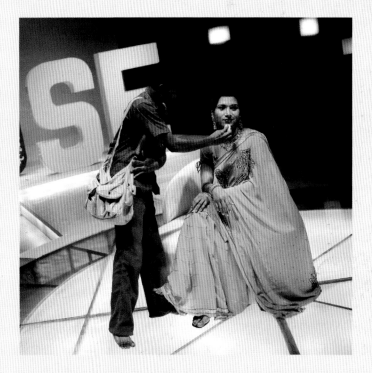

Ippadikku Rose started as a transsexual moderator of a talk show in Tamil at the end of 2007. The goal of the show is to broach the issue of sexual taboos in the Indian society.

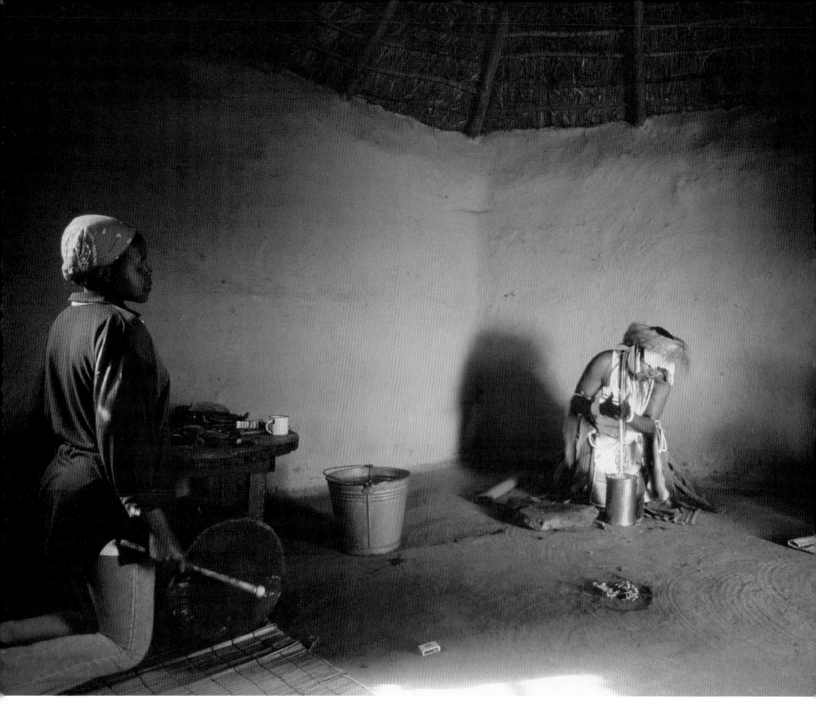

XHOSA

The price of apartheid

Glaringly bright sun blinds those waiting in line. At the taxi stand on the Hi-Road in Mdantsane, people are waiting in long lines in the hopes of catching one of the white bus taxis with the thick yellow stripe on the side. The back door is marked both as the emergency exit as well as the Noodinstand Uitgang. While most people speak Xhosa, signs like these are in English and Afrikaans. Mdantsane is big; at least 250,000 people live here. Yet, in this township outside of East London, Africa, jobs are scarce. Early in the morning, men and women drive to the large city that borders on the Indian Ocean. The men usually work in one of the factories, or wait at a busy crossing

for day-labor opportunities. The women head towards the many villa districts, where the rich live, to clean, cook or watch children. Every morning, lines of black women make their ways to the rich districts as servants, just like back during apartheid.

Like the Zulu, the Xhosa people emigrated in the first half of the 19th century from the north down to what is

now South Africa. With great probability, they originally came from the region surrounding the Great Fish River. At any rate, by the time the Boer had begun to control the country around the Cape, the Xhosa people were already there and had established themselves. They were quite adept at getting along with other communities, when they faced the Boer, who had exactly the opposite in mind. In a series of harsh

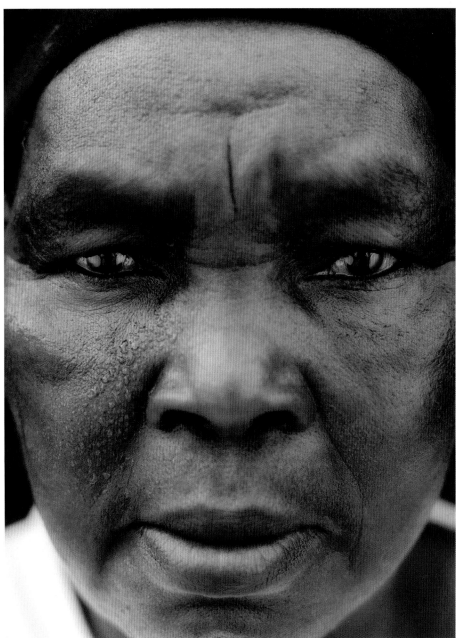

A diviner at a ritual. Most of the nature healers of the Xhosa are women LEFT. *This woman from Durban had to bury her four sons. Three lost their lives at political conflicts, the fourth one died of AIDS. She brings up the four grandchildren now* RIGHT.

and bitter battles, these new habitants pushed the Xhosa people back, who were still dealing with conflicts with the Zulu tribe to the north. Xhosa territory was increasingly lost in the process.

By the middle of the 19th century, the Xhosa community was at the brink of death. Their cattle suffered from a deadly disease and a Xhosa prophecy foretold that the dead would rise again and healthy animals would replace the sick, but only if both sick and healthy cattle were killed. As the harvest had been cursed as well, it too, would need to be destroyed. All animals

were thus killed, each and every grain was destroyed, yet not one Xhosa rose from the dead and no healthy cattle appeared. Instead, a further 10,000 Xhosa people died of starvation. In 1857, the Xhosa population shrunk from 105,000 to 35,000.

The already weakened group lost yet more members and in 1858 only 25,000 were said to be still alive. Given the number of survivors and their overall weakness, yet more land was lost as well. From the west, the Boers moved deeper into desolate regions; from the east, British and German settlers anchored

their ships and founded what is known today as East London. Members of the Xhosa community no longer put up any resistance. The Europeans knew quite well how to use the Xhosa people's state of emergency to their own benefit. Sir George Grey, Englishman, governor and high commissioner of the Cape Colony, was fully aware of their plight and refused them any form of aid.

Yet, the Xhosa survived and, in the latter half of the 20th century, some actually became leading activists in the struggle against apartheid. One reason was that

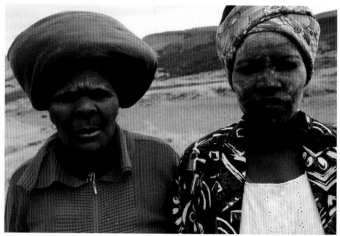

Shepherd in the Transkei. The people in the Transkei live primarily from subsistence economy LEFT. *Xhosa women with typical make-up and woolen turban* ABOVE RIGHT. *Graffiti in Johannesburg. The Xhosa Mandela became an icon among the blacks of South Africa* BOTTOM RIGHT.

THE BLUE NOTES

It took a long time for South Africa to officially give recognition to the Blue Notes. In 2007, 43 years after their flight from apartheid, President Thabo Mbeki himself honored the jazz group posthumously.

»Blue Notes goes back to a golden age in South Africa's musical history. ...They were once one of the most popular jazz bands in the country, often defying the tyrannical race laws of the country in order to perform.«

Only the drummer Louis Moholo was still alive at the time. He now lives in Cape Town and performs with his Xhosa band Sonke, which means ›We.‹ The Blue Notes jazz group played the most exciting music in all of South Africa. They broke the law, because one of the six musicians, pianist Chris McGregor, was white. He had grown up as the son of a Scottish priest in the heart of Xhosa land. The others, Moholo, Nick Moyake, Dudu Pukwana, Johnny Dyani and Mongezi Feza, were some of the best musicians of their generation. In 1964, they left the country in frustration to fulfill a completely different mission. After their arrival in Europe, they became role models for the rather unstructured generation of European jazz musicians. Towards the late 1960s and the early 1970s, these South African musicians, together with musicians in London, developed something akin to the emancipation of the European jazz avant-garde – radically different from the model from the United States. One big band lay at the core of this movement, Chris McGregor's Brotherhood of Breath, a breathtaking combo, which comprised South African enthusiasm for swing, contemporary need for free jazz, Xhosa rhythms and McGregor's adoration of Duke Ellington. With the exception of Moholo, all members of the Blue Notes died young, possibly due to the consequences of apartheid and life in exile. Yet, hundreds of albums still testify to the fact that the Blue Notes and its musicians can still be heard; they still live on.

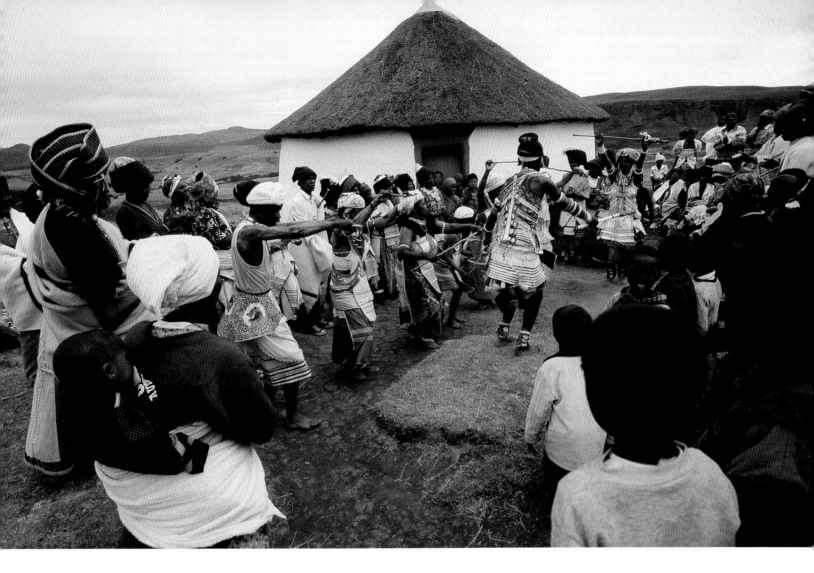

A diviner (center) carries out a ceremony in a village in the Transkei. Even when the prospect of being in employment makes more and more men migrate to the big cities, those staying behind adhere even more to their traditions.

the Zulu chiefs had led their people to different terrain. Fort Hare University, situated in the center of Xhosa land, became the educational institution for the new black elite. Nelson Mandela, as well as many other political leaders and thinkers were born or raised here, such as Mandela's successor Thabo Mbeki, or Steve Biko, the famous anti-apartheid activist.

Of course, this is of little help to the inhabitants of Mdantsane. They may have fought for the freedom of electing South Africa's government and parliament, but they are still not free to choose between poverty and wealth. The taxi drivers have increased their prices yet again in a cartel-like agreement. A trip from Mdantsane to East London now costs nine South African Rand, and gas prices are on the rise.

MAX ANNAS

HERE & NOW

Of the eight million Xhosa people, the most famous is the formerly best-known prisoner and later South African president, Nelson Mandela. The majority of the Xhosa people live in the Eastern Cape province, with such metropolises as Port Elizabeth and East London. During apartheid, most of them were forced to live in the Transkei and Ciskei Bantustan. The consequences of this policy are still visible to the present day. Some of the areas, formerly in the largest Bantustan, Transkei, are still some of the poorest in the land. Inhabitants have the least amount of social mobility and the worst chances at education in all of South Africa. Daily life for many is still subsistence. Only the two cities Port Elizabeth and East London have industrial jobs to offer,

but far too few to meet the large demand. Current politics are expecting a radical rise in development with the deepwater port, Coega, and the surrounding industrial zone. However, it remains doubtful whether the effects will reach the truly needy. More people are counting on tourism. The Eastern Cape has a lot to offer – a direct result of the neglect experienced during apartheid – particularly in the former Transkei Bantustan, the region now known as the Wild Coast. Endless sand beaches, mountains in direct proximity, untouched nature and exceptional flora and fauna abound. Surfers have already discovered the Eastern Cape; some alternative tourists have joined them. Tourism within South Africa has also become well developed.

NDEBELE

Signs on the wall

Esther Mahlangu sits in her little shop in KwaMhlanga, receiving her clients. She is one of the best-known Ndebele female artists and has already taken part in several exhibitions, some outside Africa. In her shop are ceramic panels with classic Ndebele designs, pots, and posters, and also headbands, jewelry, and dolls depicting the splendidly dressed Ndebele women. What is notable is perhaps not the exhibitions, but rather the fact that the art of the Ndebele women has become something like an export hit.

Almost every tourist to South Africa takes home some craftwork that is influenced by Ndebele ornamentation. Those interested in fashion know the colors and forms from the catwalk shows of the international fashion scene. Even the European motor and aircraft industries make use of this »folk art;« Esther Mahlangu has painted a 520i for the BMW manufacturers in Bavaria and a Boeing for British Airways. In discussing it, everyone as a matter of course uses the term »traditional,« but on closer enquiry, one discovers that this culture is not all that old, and is only inadequately described by the concept of »tradition.«

The Ndebele of South Africa have been settled since ≠the 17th century in the area of the present province of Mpumalanga, which adjoins Mozambique and Swaziland. For a long time, they lived as neighbors of the Boers, until the latter demanded more land for themselves. In 1883, a bloody war resulted in a bitter defeat for the Ndebele – until then, they

The BMW fashioned by Esther Mahlanghu has its very own industrial design LEFT. *Rondavels of the Ndebele can almost only be admired in museum villages* RIGHT. *Esther Mahlanghu in Ndebele garments with torcs which identify her as being married. Rondavels of the Ndebele can almost only be admired in museum villages* BOTTOM RIGHT.

HERE & NOW

There are two groups of Ndebele that left Zulu country at various times in order to find their own settlement areas. While in present-day Zimbabwe, 4.5 million Ndebele have departed from the Zulu lands as a result of military conflicts, the constitution of the South African Ndebele, approximately 700,000 in number, took place centuries earlier. While the Zimbabwean Ndebele are still suffering from the consequences of the massacre they had to endure in the 1980s under the government party of Robert Mugabe, the South African branch has become quite naturally part of the global village. At the same time, many traditions have been lost as a result of Apartheid, for the creation of the Bantustan KwaNdebele with its artificial capital of Siyabuswa was merely intended to degrade the Ndebele to cheap labor forces. Today Kwamhlanga, the Ndebele capital, is part of free South Africa, and since the first free elections of 1994, the city's population has increased at a blurred pace to a total of more than a quarter of a million people today. Urbanization hardly harmonizes well with the old village lifestyle; therefore today, the museum village of Botshabelo is the first visitation place for tourists who want to see the geometric wall paintings of the Ndebele women.

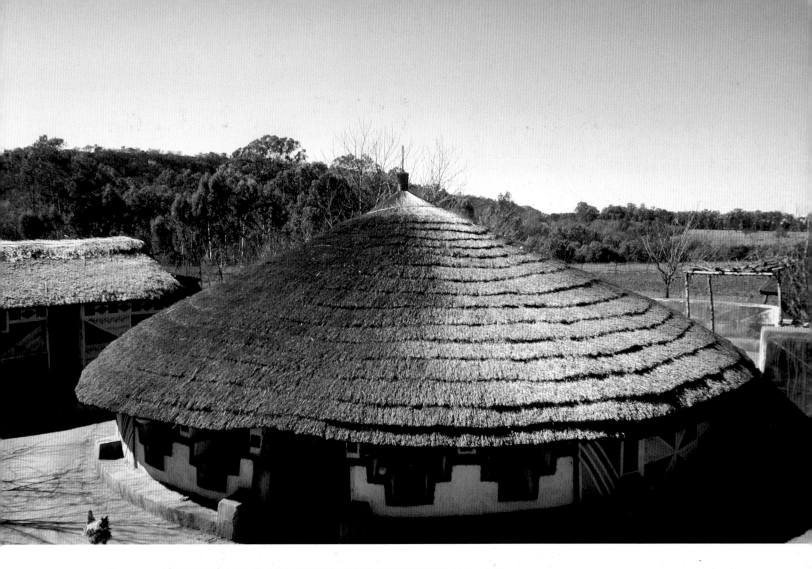

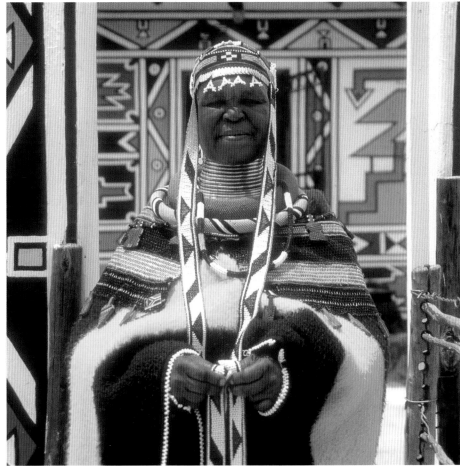

were feared as warriors. Following this defeat, they developed an exceptional method of mourning: they took up painting. They used expressive symbols to stand for despair and the loss of land and property.

They had already practiced painting on the walls of houses earlier. Since the mid-18th century, the Ndebele had lived in clay huts; before that, their huts had been of grass and reeds. They communicated by drawings about everyday as well as confidential matters. The neighboring Boers believed the paintings to be harmless child's play. It is the privilege of women to practice art, to develop it further and to pass it on. Each woman has her own free space in which to live out her own creativity in a prescribed framework, just like Esther Mahlangu, or perhaps Francina Ndimande, both of whom have achieved fame in this way.

MAX ANNAS

THE SAME, YET DIFFERENT
The Global Genome

So goes the history of genetic research. People either support or oppose it, and question marks fill the gaps in-between. The subject is complex and frequently confusing, and the results are seldom clear-cut. In the end, it has not only to do with whom you ask and whom you believe, but also with whether you think economically or ecologically. Are you an optimist or a pessimist? Are you a rationalist or a moralist? The insights, however, are the same, for idealists and pessimists alike. No matter how the results of genetic testing are put to use, and whether or not genes are manipulated, all human blood looks the same. It is all red.

Something unique about genetic research is that it is usually conducted globally.

This was the origin of the Human Genome Diversity Project. It began with a plan to draw blood from people in 722 different societies scattered across all the continents. The idea originated with Luigi Cavalli-Sforza, an Italian population geneticist and professor at Stanford University in California. The goal was to assemble a global databank of the human genome.

Cavalli-Sforza also wanted to document mankind in all its diversity. He thought it important to understand what he called the »biological history« of individual groups and thereby account for the genetic differences between human beings of different descent. The geneticist thought the most promising groups and peoples for study would be

All human blood looks the same

those that were most isolated, and that these populations would provide the most important information about the history of mankind. Cavalli-Sforza feared only that soon there would be no isolated groups left. This approach needs to be understood against the background of the widespread racist theories of the nineteenth and early twentieth centuries. These theories maintained that there were, in fact, considerable racial differences between different peoples, and that these differences could be appraised and ranked. In other words, some kinds of people were better than others. One could even speak of ruling and servant races.

Cavalli-Sforza's project was notorious for its team of blood-samplers, who traveled around the world

sticking people with needles. Most of the time, the people having blood drawn were not at all clear on what the point of all this might be. The name »Vampire Project« made the rounds, attracting loud criticism. International organizations and institutions tended to focus their criticism on two points. The first was the problematic concept of, once again, looking for differences between people, research that had long been considered to be of questionable worth. Secondly, there was some fear that the data from this scientific project, itself conducted without commercial participation, could somehow end up in the hands of industry.

It is clear that Cavalli-Sforza and his research team's hopes for pure samples from the 722 ethnic groups listed in the study are badly misplaced. The Human Genome Project takes little account of the widely accepted Out of Africa theory, which states that the cradle of all mankind lay in southern and eastern Africa, and that every population group in the world is descended from a common, original species. The differences in appearance from one group to another evolved over millennia in response to variations in environmental conditions and subsistence strategies. The Lacando living in the primeval forests of the southern Mexican province of Chiapas are a case-in-point. Anthropologists and other travelers have long considered them a separate ethnic group because the

It is common practice among African Americans to determine their African roots with a genetic test. The actore Forest Whitaker (in the picture), found out using this method that his ancestors are from West Africa.

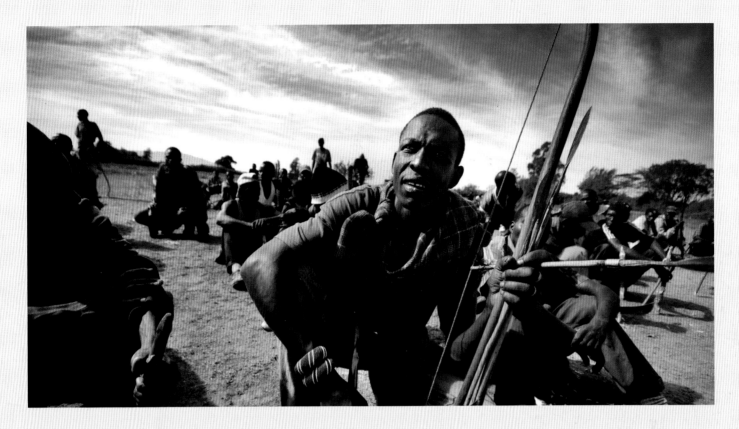

Massai after the election in Kenya at the end of 2007. Kikuyu, Luo, Kalenji, and others came into conflict with each other about the ethnic dominance in Kenya. The genes account for very little in an ethnos; they rather develop through the century-long political, cultural, and social practices.

Lacando are found in a region drenched in Mayan history. The simple truth, however, is that the Lacondo are actually descended from the dispersed remnants of several different Central American indigenous groups who fled the Spanish Conquest, banding together as a means of increasing their chances of survival. The anthropological explanation had been an artificial construct. Many scientists believe that there is no good reason why similar events could not have played a role in the constitution of other ethnic groups around the world.

What then, is the purpose of a project devoted to genetically determining similarities and differences, and what exactly could such a project hope to achieve? Genealogy has long been a human preoccupation, and genetic technology can certainly cast light on the personal history of a specific individual. African-American descendants of slaves increasingly make use of genetic data to track down their roots. Forest Whittaker, a Hollywood actor, is a well-known example. The Oscar-winning star of »The Last King of Scotland« traced his ancestors to present-day Nigeria and Ghana. Science provided his actor colleague, Morgan Freeman, with the news that the blood of North African Berbers flows in his veins.

A project and its purpose

Science provides the kind of answers that do not always fit neatly into a laboriously constructed family tree. They do not shore up nationalistic ideologies that proclaim sentiments such as »we are one people.« Groups like the Basque garner support from scientists like Stanford's Jun Li. In 2008, he published a study that shows that there are small differences between Europe's different ethnic groups. Li studied genetic material collected from 951 people around the world, with his results providing a scientific foundation for the »Europe of Regions« concept promoted by the European Union. Basques are genetically different from most of the French, and Tuscans have a different genetic history than people from the rest of Italy. Li identified a total of eight different genetic branches in Europe. It follows that there are many more groups still. At the current level of technology, many Europeans tested could not be so easily differentiated.

Genetic study provides insights that should allow entire nations to draw up a genealogical chart. The Azeri are Muslims. Armenians are Christians. Both groups live in the Caucasus region, but have different languages and cultural practices. Conflict and armed warfare between the two groups have gone on for centuries, particularly in the Mount Karabach region. Both the Azeri and Armenians are convinced that they have nothing in common with each other, but the geneticists came to a different conclusion. They compared genetic material from both groups and found only similarities. Their conclusion: Armenians and Azeri have a common origin. Genetically, they are one people that, over the course of the last few centuries, developed distinct cultural peculiarities. Unfortunately, the scientific evidence does little to make the future in the region more bearable. An ethnic map is something humans draw inside their own heads.

An ethnic map is something humans draw

MAX ANNAS

MAORI

Warriors of the tongue, warriors of rage

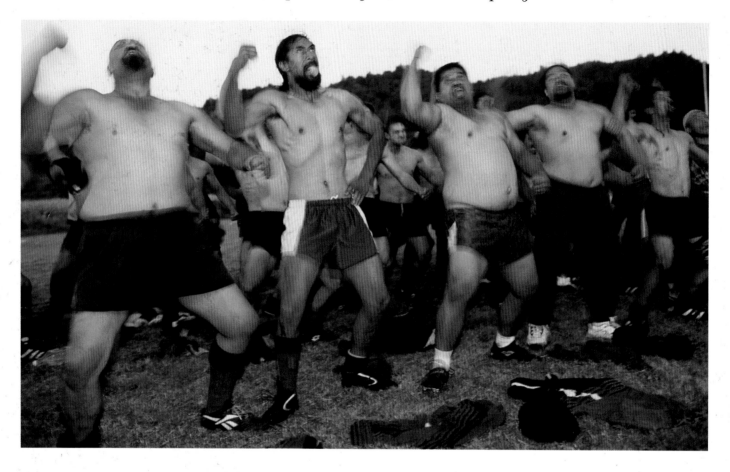

The Tuhoe Maori Nation Festival takes place every two years. It includes a rugby match that begins with a haka dance ABOVE. *Haka dancing is also a separate part of the competition. All grimaces and costumes are individually judged, along with the overall effect* RIGHT.

Ka »Ka mate, ka mate. Ka ora, ka ora. / Ka mate, ka mate. Ka ora, ka ora ...White te ra! Hi!« The New Zealand All Blacks, one of the world's most successful national rugby teams, shout their ritual phrases before every match. This national team constantly recruits players in whom the blood of the original inhabitants pulses. Kick-off! Or, welcome to Maori country. Here, as the story goes in and around New Zealand, the indigenous people are counted as citizens of the nation and do not live in reservations like outsiders.

The Maori play an undisputed major role in the TePapa National Museum, the temple of culture-seekers in the harbor of the capital, Wellington. In the Whale Rider Theater, to a live audience, Maori storytell-ers recount the myths and legends, how it all began with their ancestors. The Maori call storytellers like Hone Taumaunu »warriors of the tongue.« He tells the visitors the story of Paikea. There was once the island of Hawaiki, and in brief, the story tells of jealousy between brother and sister, dramatized by a desperate and deceitful intrigue conducted by the sister. Paikea, the brother, escapes on the back of a whale across the Pacific Ocean. He rides the whale as far as Aotearoa, the present archipelago of New Zealand.

As the museum's logo secretly pro-mises, after a visit there, the story of the Maori inevitably lingers in the memory. Not only Paikea and the ancestors come to life here, but all facets of Maori culture are experienced according to all the rules of a modern science center: everyday culture and architecture, history, stories and sounds. Just incidentally, a turn in the earthquake simulator saves you a rollercoaster ride, and the visitor will also learn quite elementary facts about life on the island. In Wellington alone, volcanic activity and plate tectonics are responsible for five earthquakes – per day – but one does not notice them all. What is striking apart from all this is the bilingualism throughout Te Papa. But this is not all that surprising, since Maori was declared a second official language in 1987.

This recognition was not granted by chance, and many activists have contributed to the renaissance of Maori culture, that has been invoked during

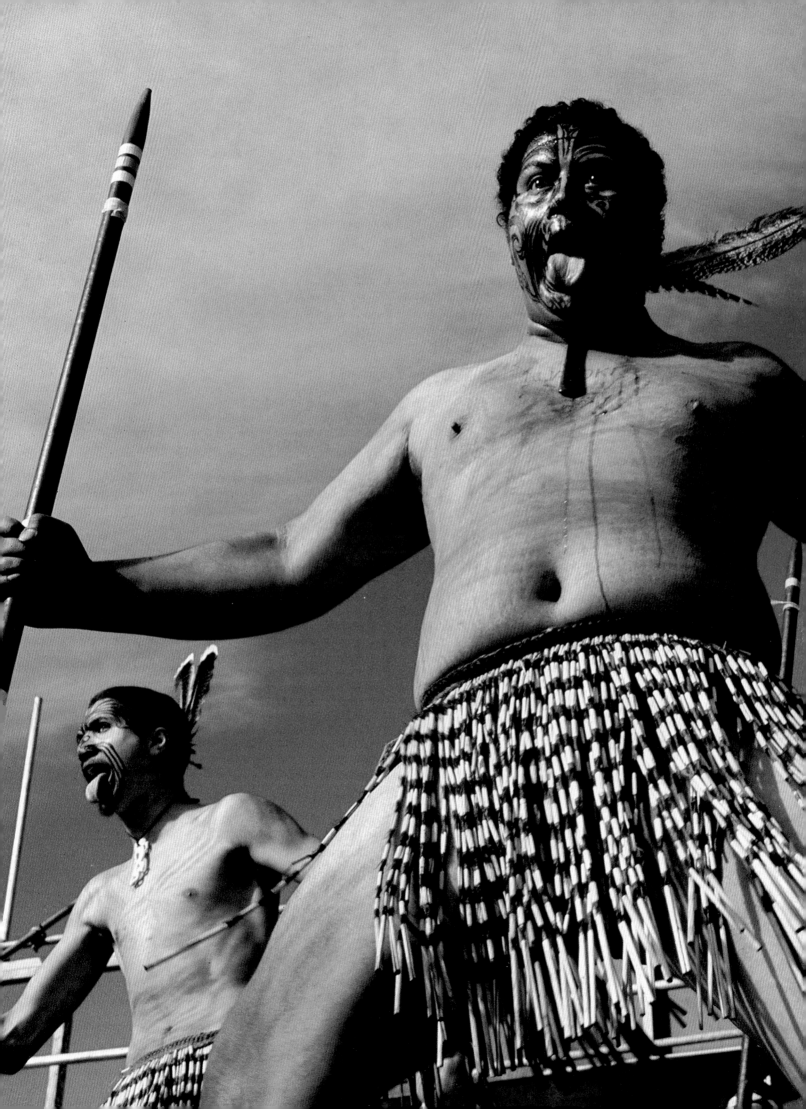

A group dances a haka during the Kahungunu Maori Festival. The trophies for the winners stand in a row in the foreground.

MOANA
I WEAR MY PRIDE
UPON MY SKIN.

Moana & the Tribe need room on the stage; two or three dancers are dancing the haka, in true Maori style. Clad in aprons, they stamp their feet alternately. Moana Maniapoto's timbre in her album Tahi, in the style of a black rhythm 'n' blues singer, is overlaid with traditional poi beat and the stamping of the haka. However, the band can do quite different things – when guitar, bass and drums drive songs like Treaty along, soul singing and rap set each other on fire. Moana always stands right in front. This lady has charisma, she has self-confidence. The song Ancestors rolls through the hall. The leading lady, all in black, combines grooves with ambitious lyrics. When she lifts the hand that holds the microphone, her Maori tattoo flashes from her wrist. The Tribe is, after The Moahunters, the second band with which she has toured since 1990 – and with more and more success.

www.moananz.com

the last decade under the catchword »Maoritonga.« Among them is the enfant terrible of New Zealand literature, Alan Duff, born in 1950 as the son of a Maori mother and European father, who grew up in a council estate in Rotorua. After his parents had separated, he lived with various relatives, ran away for the first time at the age of twelve, and was soon sent to an approved school by a juvenile court. Not an untypical, given that it was underprivileged, youth for someone of Maori descent, and one which Duff has turned into literary form in novels such as Once were Warriors of 1990. Among other topics, by means of articles and columns in the press, he continues to encourage the opposition of self-confidence and creativity to the eternal pressure from white culture to assimilate. The fact is that the Maori have reclaimed their own culture bit by bit. They are relearning their old arts and crafts and write in their own language, which existed only orally earlier. The facial tattoo called moko is also seen on the streets more often. There are radio stations such as Waatea 603AM, which promotes itself as Urban Maori Radio, and even television channels transmitting exclusively in the Maori language.

So is all well? Not quite, for the Treaty of Waitangi remains a bone of contention to this day and causes severe tensions. In 1840, the Maori chieftains signed a document that, as they understood it, secured their rights to land, their settlement areas, and their fishing grounds, and also bestowed on them all the rights and privileges of British subjects. But the reality of the land appropriation by British settlers left them no latitude to comply with the rights guaranteed in the treaty. »What kind of deal was that?« the Maori groan today, questioning to what extent their ancestors 150 years ago could understand the treaty at all, for the concepts of sovereignty, property, and rights to land were probably simply unknown to them.

This is an eternal thorn in the flesh of the Maori. The sense of having been

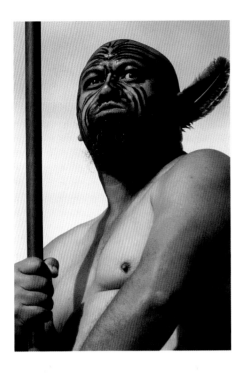 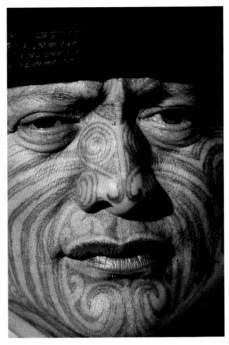

Maori tattos are called ta moko. Facial tattoos, as on these haka dancers, are a daily re-affirmation of ethnic identity LEFT. For Tame Ilti, a Maori activist, this goes without saying CENTER. Women wear mokos as a sign of Maoritonga RIGHT.

deceived by the forefathers of the white settlers arouses continually flaring protests and resistance. It is also true that the image of the inner cities today is characterized vertically by steel and glass architecture and horizontally by baseball caps, shorts, and sneakers. It is equally true that the taxi radio blasts out in Maori. The sad truth is that the Maori have nothing like the same educational opportunities as their non-indigenous contemporaries, and thus considerably worse prospects on the employment market. However, they have long enjoyed rights as citizens, and people like Duff believe these are still too hesitantly perceived by the majority of the Maori. They are citizens with a generally accepted culture of their own, not marginal figures without rights like the indigenous inhabitants of so many other states.

Respect is given to Maori sports players such as Tala Kele, a contestant from 1982 to 2001 in more than 300 league matches, an absolute record, guaranteeing him a place in rugby heaven. Shoulder to shoulder, New Zealanders of both British and Polynesian origin stand on the green: »Death, death, life!« The All Blacks roll their eyes, make throat-cut-

ting gestures, and roar. Today the Haka, the dance of death, is the impressive prelude to the premier national sport. There has not always been such harmony in these climes.

LAURA ENGEL,
HENDRIK NEUBAUER

HERE & NOW

These days, some four million individuals are distributed over the extended archipelago of New Zealand. Around 10 percent of these are Maori. But only a small minority of these can call themselves full-blooded Maori. As soon as the white settlers arrived in the mid-18th century there were marriages between Europeans and Polynesians. The Maori do not decide who belongs to their ethnic group on the basis of descent; everyone who identifies with this group becomes part of the community. Thus, over time the Maori have integrated white people in their ranks. The Maori distinguish among themselves between a series of iwi, tribes or clans, which derive from common forefathers. Each of these clans lays claim to its own territory, where necessary sues for its

rights, and is partially successful, at least managing to obtain compensation payments.

With the cultural renaissance, more and more young people are learning the language, Te Reo Maori, and its old traditions. The communities meet in the marae, the assembly house. People are once again proud to be Maori. Apart from this broad movement dedicated to its own culture, but also vociferously committed to the land question, there are radical activists whose demands extend to an independent Maori state. Thus, under the antiterrorist laws of 2007, several Maori were arrested, accused of training in illegal camps for guerrilla warfare.

Body art

When the Austrian glacier mummy Ötzi was found, his body showed signs of carbon drawings, which could probably be a precursor to what we today know as tattoos. Ötzi is assumed to be more than 5,000 years old. Making changes to ones body is probably as old as humans themselves, can manifest in many ways, and, for some, almost seems to be a cultural need. Humans etch pictures underneath their skin, pierce holes in their ears, nose and lips, or scar themselves decoratively. What for some may mark the beginning of a new life phase, or even a promotion in social status, is a religious taboo or used to humiliate or disgrace another person in other societies. Whatever the reason, those with body decorations stand out from others and give a signal with their bodies.

Giving signals

Captain James Cook is supposed to have coined the term ›tattoo‹. He encountered the ›Tatatau‹ ritual of native inhabitants of Tahiti on one of his trips to remote islands in the South Pacific. Using needles made of bone, the Tahitians rhythmically hammered ink, made out of ash and water, into the skin with a pole. Geometrical designs indicated origins and social status for each islander; without tattoos, neither men nor women could ever hope to find a partner.

In New Zealand, Cook met the Maori, whose bodies and faces were covered with black designs. Many rituals accompanied the tattoo ceremony of the ›Ta Moko‹, which represented an important milestone when the moment of transition had arrived. No longer a child, the newly tattooed was now a man with the accompanying respect and obligations this entailed.

In both cases, the initiated could easily read the tattoos; in some ways, it resembled a signature. The lines, circles and dots were, in fact, of such importance to the Maori, that they did not use their names, but rather the tattoos on their face, when the time came for the Maori chiefs to sign the Treaty of Waitangi drawn up by the English colonials. They did not even need a mirror.

The newly tattooed was now a man

Therefore, it comes as no surprise that the Christian missionaries and colonial rulers of the time greatly disliked the tattoos and did their best to put an end to them. They almost succeeded. For many years, the tattoos were a trademark of minorities and social outcasts and generally not tolerated by society. The Maori slowly rediscovered their roots and their identity. A young and active form of freedom has emerged, especially in urban areas: Maoritanga¬, life as a Maori with Ta Moko. One expression of this new political self-confidence is the increase of Maori getting tattooed traditionally, combining the old designs with new concepts, ideas and pictures. Without a doubt, this revitalization is a direct consequence of the increased rights of self-determination of the Maori.

Tarotonga, the main island of the Cook Islands, is home to the tattoo studio of Tetini Pekepo also simply known as «T.« His entire body is completely covered with enigmatic symbols, a Polynesian storybook and form of family genealogy at the same time. The sign on his door, aimed to attract customers, offers tattoos as ›visible signs of the path of life.‹ They can also render the tattooed person‹s life more difficult, as Tetini knows from first-hand experience. ›People treated me like a savage,‹ he remembers. ›They made me out to be an escaped convict, a dangerous person.‹ Today, however, he lives quite well off of his art and the trend proves to be a strong one. He is known all over the island and has given quite a few people lasting memories of Polynesia.

Some shudder in fear while others see it as a sign of beauty and eroticism. Ethnologists believe that the Mursis‹ oversized lower lip plate in Ethiopia or the lip plugs of the Zoe in Brazil might have originated to scare other tribes or serve to make the own group unattractive for slave traders. Over time, this habit has evolved into an ideal of beauty and a sign of civilization. Today, Mursi women are encouraged to stretch their lower lip from their twentieth year onwards with increasingly large clay plates and a larger lip size has been said to yield bride price

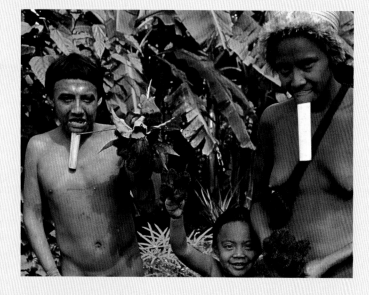

A Zoe family in the Amazon with lip plugs. Ethnologists theorize that they began adorning themselves this way in order to scare off their neighbors.

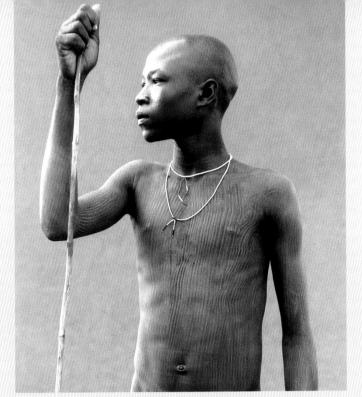

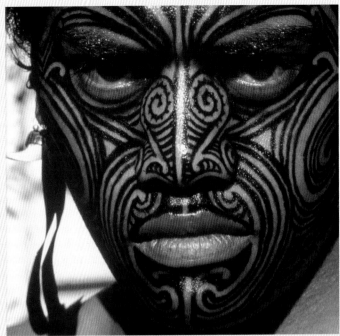

Body modification occurs all over the world. On dark skin, only decorative scarring stands out, such as the scars on this Surma man in East Africa LEFT.
On lighter skins, tattooing works just fine, as here with the moko facial tattoos of the New Zealand Maori RIGHT.

of up to 50 cattle, which is a treasure for semi-nomadic cattle farmers. The larger the lip size, the more beautiful the bride is believed to be. Tourists are equally impressed; photographs are now one of the greatest sources of income for the Mursi.

During daily life, the impractical lip plates are hardly ever worn, but once the car motors of tourists can be heard in the distance, the women quickly insert the disc in their lower lip and paint their bodies in order to present themselves to the tourists. Two Birr, the Ethiopian currency, is the standard price for a picture; the equivalent of 15 cents. In addition to their lips, the Mursi show the countless scars decorating their skin. They are proud of these bulging geometrical patterns on their body. Not only are they seen as a sign of beauty, they also tell stories of battles and victories: bodies are seen as a large-scale form of self-portrayal, the skin as the journal of life.

How long will this tradition still last? If everything goes according to the government in Addis Ababa, not long at all. Nowadays, girls enrolled in public school return to their village and refuse to have their lips cut. This can often lead to violent conflict between generations. In the past, anyone who refused the clay plates was seen as lazy and slow, and, as a woman, generally disregarded. Many of the youth take a completely different standpoint and risk breaking with tradition.

Across the world ,peoples‹ bodies represent a map to the soul, a symbol of belonging to a community and a business card indicative of the owner‹s social status. Body decoration, when the forms are those determined by a certain community,

Habits that evolved into an ideal of beauty

implies ›I belong.‹ Whatever else humans, who deliberately change their bodies, wish to communicate with their environment obviously depends on the individual societal circumstances. In New Zealand, non-Maoris also decorate their bodies with Ta Moko. What kind of signal does this send? Do they merely find the body decoration hip and

stylish? Or do they want to belong? Maybe both are true. At any rate, the Maori have no problem with accepting strangers into their community in this form.

LAURA ENGEL

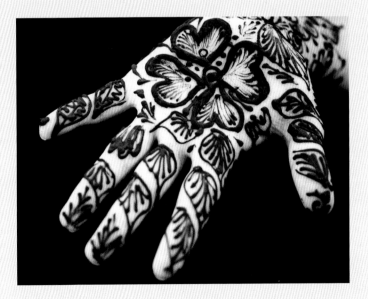

North African Berberwomen adorn themselves with henna according to a precisely laid-out ritual for specia occasions, like weddings.

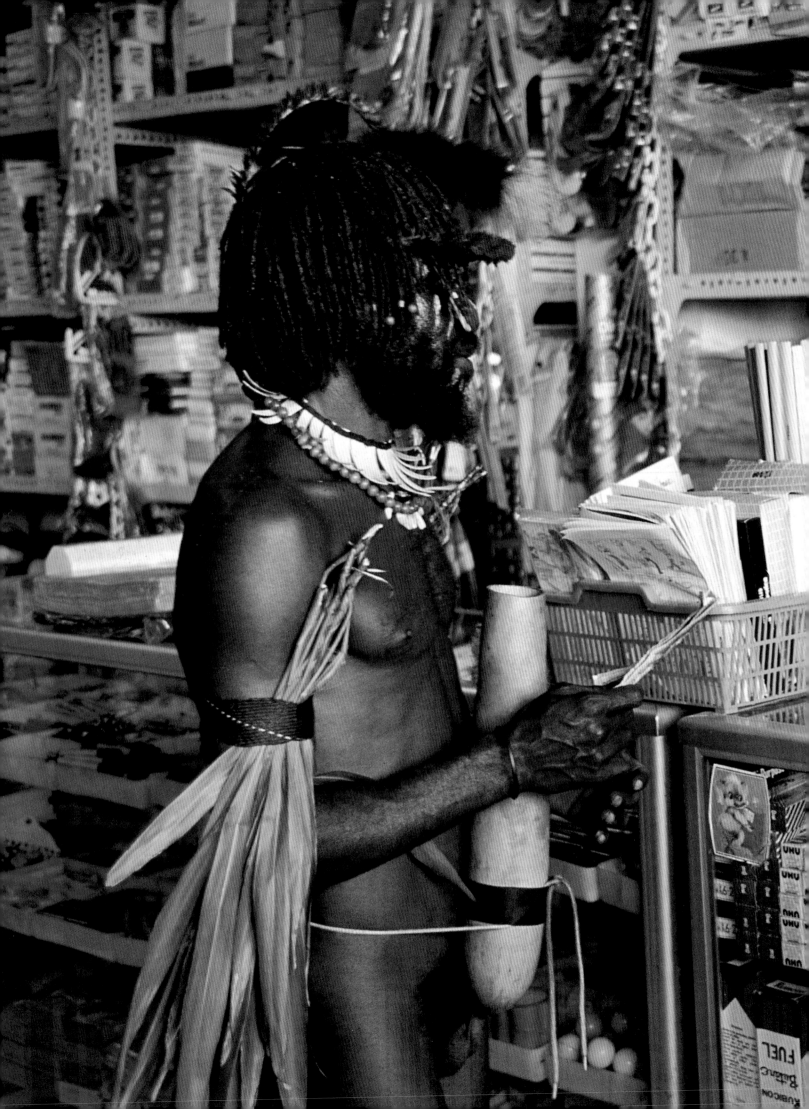

We will survive

A NEW SELF-AWARENESS BREAKS NEW GROUND

The aboriginal peoples of the world have developed strategies for survival in their ancestral territories, and continue to chalk up the occasional economic success story today. African cooperatives have defeated international conglomerates in patent court, while ethnic groups are increasingly overcoming opposition in their battle for land rights, sometimes collecting millions of dollars in compensation. People continue to fight for the right to speak their own language, leading to an increase in the number of bilingual schools and government offices. Entire villages are gaining control of their greatest treasure, their culture, and marketing it themselves, on their own terms. They draw clear boundaries, literally and figuratively, putting up signs saying »No Entry!« outside their private and sacred cult spaces. Their new self-awareness has broken new ground in the wilderness. The pages of this book do more than merely collect lives and describe cultures. They serve as testimony of a new, broader consciousness, one that loudly proclaims that culture and identity are worth fighting for.

Over time, English has become an international lingua franca. Many people throughout the world are capable of any level of language fluency, from a few broken sentences to comprehensive native speech. The world has been moving in this direction for a long time. Of all the websites in the world, 85 percent are written in English. Armenians can use the same idiom as the Mapuche when communicating through computer screens.

The globalization and regionalization movements are both marching forward, side by side. The Internet plays a decisive role, serving both as an easily accessible platform for self-marketing (»Hey World, here we are!«), and as a means of communicating beyond ethnic borders and between continents. The Maori and Hawaiians have both taken charge by developing theatrical pieces in their native tongue. Continuing this theme, they have also taken the lead in the formation of closed user groups that are only accessible to those capable of their languages. A great deal is being accomplished here all at once: protection, self-assurance, boundary setting, and the creation of an unconquerable realm of cultural identity. A worldwide, universal means of communication, the Internet, is being used to preserve particulars like language, custom, ritual and cultural identity as a whole. Pluralism has finally found its forum.

This book is all about the particulars, focusing on the differences that define cultural identity. We have been guided by the extent to which a group comes to terms with its aboriginal or indigenous heritage. This very significant component of cultural self-awareness can mean little more than consciously understanding oneself as Basque, rather than Spanish, or Kalash, instead of Pakistani. All over the world, groups of people feel the same urge to differentiate themselves from others. Be it as a people, race, or clan, self-identification means raising boundaries, digging in, and putting up fences. The typically strict demarcation between »us« and »them« can be found pretty much everywhere. One race will maintain the superiority of certain qualities about itself, nearly always denigrating another group in the process. Ethnocentrism has been described as a constant of the human existence, and one of the few genuine cultural universals.

The setting of these boundaries varies widely from culture to culture. Ethnic jokes, for example, have a lot to answer for in this regard. The French rag on the Belgians, the Zulu make fun of the Xhosa and the Korowai snipe at the Indonesians. The phenomenon can be observed worldwide. Let us take a closer look at the anthropological categorizations known as »joking relationships.« The best known examples take place among in-laws in Africa, where the practice is particularly widespread, independent of gender or tribe. Bad jokes are casually tossed off, with racist insult humor considered neither particularly offensive nor in any way

Sami in front of a stretch limousine in North Norway. The most recent history of the Sami is crowned with success. They are recognized and politically represented in Norway, Sweden, and Finland.

out of the ordinary because »it is just between us.« Joking allows reciprocal identities to be openly acknowledged and reaffirmed.

Is it all in joke, or a vile defamation? Was that an expression of spiteful glee at another's misfortunes, or a particularly clever joke? In the end, it is laughter, in all its nuances, that decides which is which. This universal form of human expression contains an

abundance of cultural information. Fear is similar, as is sadness. The ban on incest is another universal, although the degree of relationship necessary for it to be invoked can vary quite a bit. Incest taboos seem to be the cultural manifestation of human biological insight, the result of observations made in nature. Some degree of ritualization of the subjective world is another human constant. Ritual provides a measure of organization to the chaos of daily life, making it not only more bearable, but to some extent predictable as well. No human being can exist in a state of constant uncertainty. It is not only in times of need that humans animate objects around them with supernatural power, sacredness, or particular grace. This is the very definition of the animism that lies at the core of so much of human spiritual life.

Religion is indispensible to the formation of group identity because it is the stepping off point for creating myths. There are no religions that do not include some teachings on how it all began. This is another contributor to self-awareness, but also a response to the also universal, very human quality of curiosity, and to the question, »How did we get here?« Cultural specifics like speech, customs, practices and religion have been recognized by the United Nations as distinctive qualities of indigenous peoples, and therefore deserving protection. Our knowledge about religious convictions around the world today is unbelievably vast, ranging from Voodoo to syncretic religions, to belief systems that focus on the natural world.

Surviving, be it in Manhattan or Mumbai or in the rainforest of Malawi, requires earning one's daily bread. Despite all the success stories included in this book about aboriginal groups that have managed to survive all over the world, mere survival is far from certain for a great many of people on our planet. This is true in industrial countries, in borderline developed lands and within the poorest nations on earth. Over the course of the past century, a large percentage of the world's population rode on a wave of hope that continued industrialization would save them, providing work and prosperity for all. Today, whether this hope will be fulfilled remains to be seen. Apparently, there is plenty of food available, far more than enough to feed every person on earth. The problem is that it is somewhat unfairly distributed.

The often life-threatening conditions that arise from this unjust situation have a tremendous effect on any other movement toward progress, such as strengthening human rights and protecting minority populations. Yet every setback brings with it opportunities for change. Can it be that the aboriginal peoples of the world will need to change themselves as much as aboriginal Europeans once did when they cast off regional and ethnic identity in favor of organization in larger, national units? It is particularly interesting in this context that the twenty-first century began with the European Union's call for the return to a Europe of Regions. It is possible once again to speak of the Basque, Kosovars and Lombards as well as nation states. Change is, of course, a constant in human life. The conditions under which change takes place, however, are subject to a variety of influences.

The introduction mentioned the new citizen of the world as the bridge between ethnic regionalism and a cosmopolitan planet. The phrase has been given shape in the chapters of this book. A twenty-first century citizen of the world is a member of a global society comprised of the widest variety of identities. Citizens of the world scrutinize the distribution of food and develop practical alternatives. Standing up against all opposition, they push for the adoption of human rights legislation. Their identities are constantly in flux, and their development is facilitated by an international presence and self-promotion. Citizens of the world work cooperatively to assemble

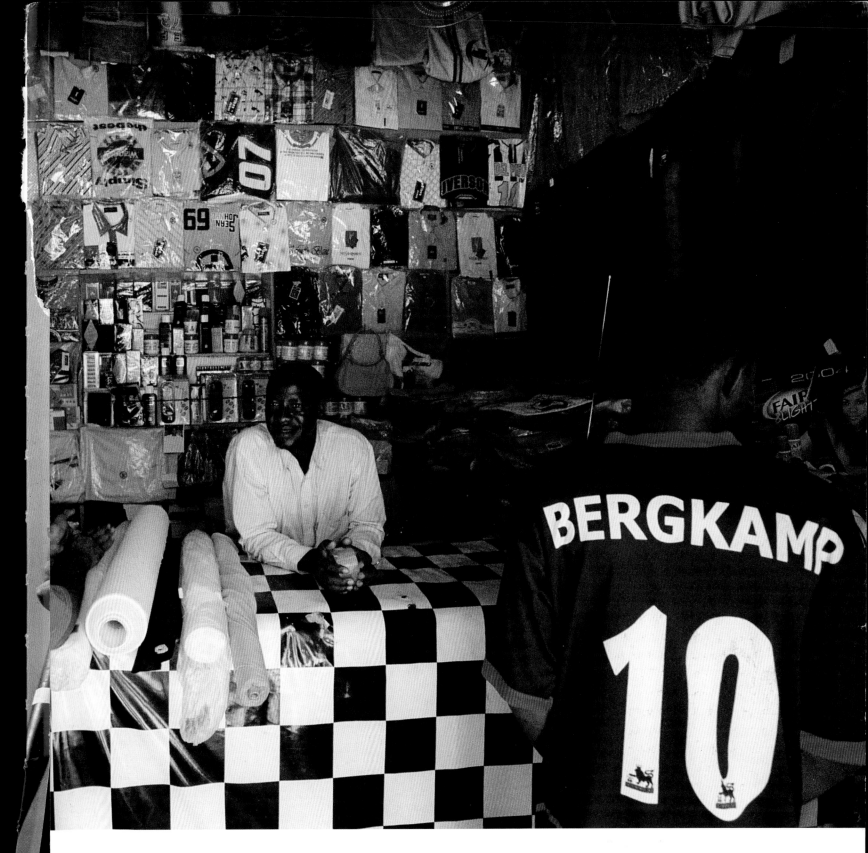

databases like Wikipedia, where they can publish data and other factual information directly from their homeland. In the process, they gain some measure of control, as well as a forum for discussing problems with people from distant lands with very different points of view. Citizens of the world emphasize their own cultural identity while respecting all their fellow humans regardless of skin color or ethnicity. Whether in the middle of a big city or on the absolute edge of habitation, citizens of the world live and work in a society made up of self-sufficient, self-aware people who treat each other with fairness and justice, as fellow citizens should.

Fabric store in Timbuktu, Mali. The trading city and civilization island in the sand is plagued by droughts, shifting sand dunes and armed conflicts. The Tuareg, Bella, Fulbe and others fight for their survival.

The ideology known as One World movement has run into a brick wall. The globalized world is taking on a much more realistic form, supported by key concepts that promote variety instead of the norm. People all over the world feel the need to distinguish themselves from one another. This is the one thing we all have in common.

HENDRIK NEUBAUER

PICTURE CREDITS

(L= left, R= right, A= above, C= center, B= below)

The following pictures come from the archive of the agency laif in Cologne and its partners around the world:
© laif – www.laif.de

Antoine Agoudjian/Rapho/eyedea: 106, Bryan & Cherry Alexander/arcticphoto: 14/15, 19 A, 22/23, 25 A, 31 L, 38/39, 56, 300, 329 L, Monica Almeida/The New York Times/Redux: 48 R, 147 R, Michael Amme: 29 RB, François Ancellet/Rapho/eyedea: 6/7, 10/11, 186–189, Andrea Artz: 170, 171 A, Vincent Audet/Hoa Qui/eyedea: 284, Patrick Aventurier/Gamma/eyedea: 84, 242/243, 244 CA, 244 RA, 244 LB, 245, 250, Eric Baccega/Hoa Qui/eyedea: 247 A, 262–265, 276/277, Eric Baccega/Jacana/eyedea: 344/345, Anita Back: 120 RA, Paul Backmore/Rapho/eyedea: 283 B, M. Reza Baharnaz/Gamma/eyedea: 105, Jan Banning: 72 B, 233 A, Franco Barbagallo: 323 LB, Gilles Bassignac/Gamma/eyedea: 136 A, 237 B, Becelj-Hodalic/Gamma/eyedea: 278 L, Serge Benhamou/Gamma/eyedea: 305 B, Peter Bialobrzeski: 251 B, Menno Boermans/Hollandse Hoogte: 272, Georges Bosio/Hoa Qui/eyedea: 18 B, Enrico Bossan/Contrasto: 174 RB, Katharina Bosse: 89 A, Eric Bouvet/Gamma/eyedea: 120 C, Henk Braam/Hollandse Hoogte: 79 A, Brian Brake/Rapho/eyedea: 343 R, Broomberg/Colors/Contrasto: 72 R, 241 B, Sabine Bungert: 144/145, Michael Bush/UPI: 291 B, Roberto Caccuri/Contrasto: 108 B, 110 LA, 113 L, John Cancalosi/Jacana/eyedea: 151 B, Haroldo Faria Castro/Gamma/eyedea: 192 LA, Juan Manuel Castro Prieto/VU: 286, Rafael Celentano: 283 A, Alan Chin/The New York Times/Redux: 142, Eric Chretien/Gamma/eyedea: 19 B, 27, 29 RA, 88 A, 94–97, Eric Chretien/Hoa Qui/eyedea: 346/347, Mario Cipollini/Hoa Qui: 154 B, Jean-Claude Coutausse/Rapho/eyedea: 204, 222, 301 A, 318, 338–341, Viviane Dalles/REA: 76 RA, 76 RB, 78, Lalo de Almeida /The New York Times/Redux: 194, Jean Pierre Degas/Le Figaro Magazine: 57 B, 152 A, 153, Stefano de Luigi/Contrasto: 20, Francis Demange/Gamma/eyedea: 214 A, Michel Denis-Huot/Hoa Qui/eyedea: 244 LA, Xavier Desmier/Le Figaro Magazine: 158, Bertrand Desprez/VU: 21, 195 B, Eric Dessons/JDD/Gamma/eyedea: 34, 35 B, Marc Deville/Gamma: 220/221, Miguel Dewever-Plana/VU: 25 B, 159 A, 161 A, 161 B, 162–165, 168, 169 B, Patrick de Wilde/Hoa Qui/eyedea: 330, 335 A, Joe Diener/eyedea: 124 L, 125 B, Clarisse Dominique/Gamma/eyedea: 269, 270 L, Thierry Dudoit/REA: 156 A, 212, Olivier Duffau/Gamma/eyedea: 172 R, J.-L. Dugast/Hoa Qui/eyedea: 192 LB, Véronique Durruty/Hoa Qui: 171 B, Véronique Durruty/Hoa Qui/eyedea: 235, 236 B, 237 L, Jean-Pierre Dutilleux/Gamma/eyedea: 30, 178–183, 196 B, 197, 198 A, 200/201, 230/231, 252/253, 260/261, 276 LA, 279, 342, Erik Eckholm/The New York Times/Redux: 80 L, Clemens Emmler: 12/13, 75 LA, 294 A, 312, 313 A, 315, 317, 321 B, 335 B, Philipp Engelhorn: 80 RA, 80 RB, 81, 104, Norbert Enker: 67 RB, eyedea: 117 L, 328, Thierry Falise/onasia: 248–249, Stefan Falke: 210 L, Gilles Favier/VU: 196 A, 198 B, 199, Adam Ferguson/The New York Times/Redux: 329 R, Stephen Ferry/Redux: 113 B, Emilio Flores/The New York Times/Redux: 48 B, 49, Olivier Föllmi: 295 A, Art Foxall/UPI: 88 B, Ruth Fremson/The New York Times/Redux: 148 B, Noah Friedman-Rudovsky/The New York Times/Redux: 205 B, 206 B, 208/209, Ronald Frommann: 244 RB, Thorsten Futh: 8/9, 31 R, 44 B, Max Galli: 28 LA, Mauro Galligani/Contrasto: 259 A, Fernando Garcia Arevalo/Cover: 143 A, Peter Gebhard: 82 L, 147 B, Boris Geilert/GAFF: 319 A, Yves Gellie/Gamma/eyedea: 62, 63 L, 124 R, 124 B, 125 A, 228 L, 229 B, 295 B, 302, 304, 305 A, 310 L, 320 A, 322 A, Georgeon-Rossi/Gamma/eyedea: 334, Eddie Gerald: 89 B, 114–116, Gregory Gerault/Gamma/eyedea: 167 B, Elizabeth Gilbert/Redux: 202 L, Pierre-Yves Ginet/Rapho/eyedea: 190, S. Gladieu/Le Figaro Magazine: back cover C, Dieter Glogowski: 210 R, Christoph Goedan: 331, Miguel Gonzalez: 37 R, 64, 67 RC, 152 B, 323 A, Ana Cecilia Gonzalez-Vigil/The New York Times/Redux: 311 B, Thomas Grabka: 32/33, 35 A, 35 C, Sylvain Grandadam/Hoa Qui/eyedea: 128 LC, 238 A, Jens Grossmann: 123 A, Paul Hahn: 31 B, 108 A, 109, Dave Hamman/TCS: 98 L, 167 A, 294 B, 306/307, Nick Hannes/Reporters: 110 B, Reiner Harscher: 314 A, Tobias Hauser: back cover A, Christian Heeb: 45 B, 48 L, 147 L, 159 B, 161 RA, Hemispheres: 37 L, 120 LA, 121, 134, 137 A, 137 B, 146 L, 192 RB, 213, 215 C, 215 B, 293 R, 301 B, 321 A, Catherine Henriette/Rapho/eyedea: 63 R, Jean-Paul Hervy/Explorer/eyedea: 215 A, Tyler Hicks/The New York Times/Redux: 150, Naftali Hilger: 120 B, 137 C, Eros Hoagland/Redux: 157 B, 289, 291 A, Jeremy Horner/Hoa Qui/eyedea: 191, 192 RA, 193, Gernot Huber: 67 C, Michel Huet/Hoa Qui/eyedea: 74, Françoise Huguier/Rapho/eyedea: 176, Rob Huibers/Hollandse Hoogte: 273 B, Jeff Jacobson/Redux: 59 B, Florian Jänicke: 82 R, Jazz-Editions/Gamma/eyedea: 211, Lv Jianping/ChinaFotoPress: 99 B, Roger Job/Gamma/eyedea: 226, 228 R, 229 L, 229 C,

229 R, Ian Jones/Gamma/eyedea: 83 A, Bernd Jonkmanns: 67 RA, 67 LB, 288, 298 B, 310 R, 332 RB, Catherine Jouan & Jeanne Rius/Jacana/eyedea: 308 RA, 308 RC, Matthias Jung: 314 B, 316, Keystone France/eyedea: 36, 79 B, Gunnar Knechtel: 60/61, Grégoire Korganow/Rapho/eyedea: 207 L, 207 B, 320 B, 326/327, Hartmut Krinitz: 59 A, Dirk Krüll: 177 A, 177 B, Andrea Künzig: 92 A, 93 L, 202 R, Damien Lafargue/Gamma/eyedea: 219 B, Eric Lafforgue/Hoa Qui/eyedea: 278 B, 280–282, Patrick Lages/Gamma/eyedea: 324/325, Catherine Lambermont/Gamma/eyedea: 332 L, 332 RA, 333, Justin Lane/The New York Times/Redux: 184/185, Yann Latronche/Gamma/eyedea: 128 A, 129 A, Dustin Leader/Gamma/eyedea: 207 R, François Le Diascorn/Rapho/eyedea: 151 A, Chang W. Lee/The New York Times/Redux: 101, C. & J. Lenars/Hoa Qui/eyedea: 258 L, Mark Leong/Redux: 293 B, Cyril le Tourneur D'Ison/Gamma/eyedea: 203 A, 227, François Lochon/Gamma/eyedea: 287, Paul Lorsignol/Reporters: 91, Emile Luider/Rapho/eyedea: 156 B, 259 B, Jean Luc Luyssen/Gamma/eyedea: 195 A, Jean-Luc Manaud/Rapho/eyedea: 128 RC, 166, 348/349, Olivier Martel/Gamma/eyedea: 83 A, 138–141, 216/217, Eric Martin/Le Figaro Magazine: 65, 66 RA, 67 LC, 67 RC, 149, 218, 223 A, 254, 255 B, 256 LA, 256 RA, Michael Martin: 57 A, 126/127, 130/131, Michele McDonald/The Boston Globe: 40/41, Jens Meier: 112, Georges Merillon/Gamma/eyedea: 234, Kevin Miyazaki/Redux: 290, Jörg Modrow: 18 A, 26, 28 LA, 54/55, 239, Fernando Moleres: 233 C, Laurent Monlau/Rapho/eyedea: 132 R, 135, Jean Claude Moschetti/REA: 223 B, Tomas Munita/Polaris: 100, Tomas Munita/The New York Times/Redux: 323 RB, Isabel Munoz/VU: 343 L, F. Nichele/Hoa Qui/eyedea: 219 A, Jeremy Nicholl: 90, Anne Nosten/eyedea: 75 RA, Nori Onishi/The New York Times/Redux: 311 A, Jiro Ose/Redux: 236 L, P. C. Othoniel/O.J.D.DS/eyedea: 58, Erik Pasquier/Le Figaro Magazine: 86/87, Michel Pellanders/Hollandse Hoogte: 113 A, 172 LA, 172 LB, 174 LB, 174 R, Eraldo Peres/Redux: 157 A, Aleksander Perkovic: 148 A, Dario Pignatelli/Polaris: 336, Hans Christian Plambeck: 44 A, 68/69, Arnaud Prudhomme/Gamma/eyedea: 266–268, 270 R, 271, 273 A, 274/275, Tony Pupkewitz/Rapho/eyedea: 292, 313 B, Noel Quidu/Gamma/eyedea: 246, Karl-Heinz Raach: 46/47, Lucille Reyboz/Rapho/eyedea: 214 B, Philippe Reynaers/Gamma/eyedea: 146 R, 293 L, Antonio Ribeiro/Gamma/eyedea: 50 A, 51 B, 173, 174 A, 175 L, Jeff Riedel/Colors/Contrasto: 73 LB, Bertrand Rieger/Gamma/eyedea: 255 A, 257, 258 R, Michael Riehle: 118/119, Martin Roemers: 240, Xavier Rossi/Gamma/eyedea: 24, 132 LA, Marc Roussel/Gamma/eyedea: 160 B, Stefan Ruiz/Colors/Contrasto: 206 R, Ruppert: 110 RA, Thomas Samson/Gamma/eyedea: 195 L, Martin Sasse: 73 RB, 251 A, David Sauveur/VU: 102/103, Ezequiel Scagnetti/Reporters: 343 B, Tolga Sezgin/Nar Photos: 107, Clive Shirley: 132 LB, 189 LB, Amit Shabi: 117 R, Jacob Silberberg/The New York Times/Redux: 224 A, João Silva/The New York Times/Redux: 247 B, David Skull/Gamma us/eyedea: 37 B, South Light/Gamma/eyedea: 303, David Steets: 225, Essdras M. Suarez/The Boston Globe/Redux: 99 A, Michel Szulc-Krzyzanowski/Hollands Hoogte: 122, 123 B, Dermot Tatlow: 205 L, TCS: 75 B, Javier Teniente/Cover: 206 L, Pierre Terdjman/Gamma/eyedea: 238 B, The New York Times/Redux/laif: 232, Emiliano Thibaut/Gamma/eyedea: 160 LA, 160 RA, Oliver Tjaden: 70/71, 72 B, 73 L, Frank Tophoven: 45 A, 169 A, Sven Torfinn: 16/17, 143 B, 329 R, 337, Jean-Michel Turpin/Le Figaro Magazine: 319 B, Penny Tweedie: cover, 203 B, 297, 298 A, 299, Guenay Ulutuncok: 241 A, Emmanuel Valentin/Hoa Qui/eyedea: 133, Marcel van den Bergh/Hollandse Hoogte: 128 B, Robert van der Hilst/Gamma/eyedea: 52 A, 53 A, Eric Vandeville/Gamma/eyedea: 308 L, 309, Greenpeace/TCS: 98 R, Francesco Venturi/eyedea: 76 LA, 77, Jean Michel Voge/Le Figaro Magazine: 2/3, Marcus Vogel: 224 B, Stefan Volk: 92 L, 93 C, Patrick Wallet/Gamma/eyedea: 236 R, Danny Wilcox Frazier/Redux: 51 A, 52 B, Damon Winter/The New York Times/Redux: 42/43, Staton R. Winter/The New York Times/Redux: 111 L, Daimon Xanthopoulos/Gamma/eyedea: 111 R, Xinhua/Gamma/eyedea: 85, Alvaro Ybarra Zavala/VU: 233 B, ZED/Gamma/eyedea: 285, Xavier Zimbardo/Gamma/eyedea: 322 B, Xavier Zimbardo/Hoa Qui/eyedea: 154 L, 155, Samuel Zuder: 67 LA.

The following musician's portraits come from other sources: © Jean Louis Bruyère 136 (Déné Issébéré), © Toast Coetzer 317 (Trans.Sky), © Rachel Connor 275 (George Telek), © Ixtlan Artists Group 52 (Kevin Locke), © Tommy Jensen 34 (Rasmus Lyberth), © Tarjei Ekenes Krogh 29 (Mari Boine), © Julian Noursi 121 (Distant Heat Festival), © Stuart Page 340 (Moana), © patrickliotta.com 327 (Beatriz Pichimalen), © Berniece Friedmann 332 (Louis Moholo), © Sheer Sound 309 (Pops Mohamed), © Xabi Solano 63 (Fermin Muguruza), © Lex van Groningen/LEXsample 66 (Nynke Laverman), © Louis Vincent Studio 116 (Le Trio Joubran), © Yat-Kha Bildarchiv 92 (Yat-Kha).

LIST OF PEOPLES

People	Place	Country	Page	People	Place	Country	Page
Aborigines	Korlobidahdah	Australia	296	Kikuyu	Nanyuki	Kenya	236
Agni	Tenguelan	Ivory Coast	216	Korowai	Dairam Kabur	Indonesia	276
Agta	Luzon	Philippines	252	Kuna	El Porvenir	Panama	170
Ainu	Shiraoi	Japan	20	Kurds	Diyarbakır	Turkey	108
Aka	Libenge	DR Kongo	232	Lacandon	Campamento Lacanja	Mexico	140
Amungme	Timiko	Indonesia	272	Lakota Sioux	Rosebud	USA	50
Apache	Mount Graham	USA	150	Maori	Wellington	New Zealand	338
Armenians	Yerevan	Armenia	106	Mapuche	Temuco	Chile	324
Ashanti	Kumasi	Ghana	220	Massai	Mererani	Tanzania	240
Asmat	Sor	Indonesia	262	Masuane	Seram	Indonesia	260
Awá Guajá	Maranhão	Brazil	182	Mongols	Chowd	Mongolia	90
Aymara	El Alto	Bolivia	204	Mosuo	Lugu-See	China	84
Bakhtiari	Schahrekord	Iran	104	Mursi	Omo	Ethiopia	230
Badjo	Sulu Sea	Philippines	254	Navajo	Page	USA	144
Basques	San Sebastián	Spain	60	Ndebele	KwaMhlanga	South Africa	334
Berber	Tafraout	Morocco	138	Nenets	Jar-Sale	Russia	22
Blackfoot	Blood 148	USA	46	Nuba	Khartum	Sudan	124
Dani	Wanema	Indonesia	268	Palestinians	Mufakara	West Bank	114
Dinka	Bor	Sudan	226	Penan	Baram	Malaysia	258
Dogon	Bandiagara	Mali	134	Quechua	Izcuchaca	Peru	190
Frisians	Leeuwarden	Netherlands	64	Rapa Nui	Easter Island	Chile	322
Fulbe	In-Gall	Niger	132	Roma	Shutka	Macedonia	70
Hawaiians	Waikiki	USA	288	Sa	Bunlap	Vanuatu	282
Hazara	Kabul	Afghanistan	100	Sami	Rovaniemi	Finland	26
Herero	Okahandja	Namibia	312	San	Molapo	Botswana	306
Himba	Opuwo	Namibia	314	Santhal	Gauhati	India	76
Hmong	Bang Rai Phan	Thailand	250	Senufo	Korhogo	Ivory Coast	212
Hopi	Old Oraibi	USA	148	Shoshone	Crescent Valley	USA	48
Howeitat	Rum	Jordan	118	Shuar	Macas	Ecuador	186
Huli	Tari	Papua New Guinea	278	Sorbs	Bautzen	Germany	68
Hutu	Kigali	Rwanda	238	Tarahumara	Creel	Mexico	152
Inuit	Kinngait	Canada	40	Tuareg	Bilma	Niger	126
Inupiat	Barrow	USA	42	Tutsi	Kigali	Rwanda	238
Jarawa	Andaman Islands	India	248	Tzotzil	Chamula	Mexiko	158
Kalaallit	Ilulissat	Greenland	32	Wa	Ongding	China	86
Kalasha	Krakal	Pakistan	94	Xhosa	Mdantsane	South Africa	330
Kamayurá	Rio Xingú	Brazil	200	Yanomami	Tootobi	Brazil	176
Kaqchikel	Sololá	Guatemala	168	Yoruba	Hévé	Benin	222
Kayapo	Rio Xingú	Brazil	196	Zoé	Pará	Brazil	178
Celts	Anglesey	Great Britain	58	Zulu	Polokwane	South Africa	302
Khampa	Litang	China	80				

The author would like to thank:

All survivors whom I was allowed to meet until now and who gave me an image of what hides behind the notion »global village.« All photographers who hunted and gathered around the globe and with whose awesome photos we were allowed to work. All authors, in particular Max Annas, with whom I crossed many valleys and without whom I would have never arrived on this mountain. All companions and guides as well as all monitors, who helped »survive« in the run-up to and during the project: Sally Bald, Peter Bitzer (laif), Dieter Cleve, Laura Engel (Survival International), Raphael Göpel (Survival International), Dr. Ulrich Isselstein, Dr. Axel Kröner, Andrea Künzig, Heiko Kügler, Dr. Dirk Levsen, Dr. Volker Meyer-Guckel, Bob Montague, Simone Pott (Deutsche Welthungerhilfe), Lienhardt Rachow, Alina Rodenkirchen (Survival International), Dr. Michael Schmitz, Prof. Dr. Detlef Siegfried, Prof. Dr. Jörn Staecker, Dr. Bianca Thierhoff. All participants in the team – special thanks to my longtime graphical companion Oliver »The Dude« Hessmann, with whom I can always affectionately laugh, and with whom I could make books for over 10 years, which were very important to me. All participants at the publisher – at this point, I would like to particularly thank the trust and always constructive criticism of Manfred Abrahamsberg, as well as the coaching on a very highly intellectual and practical level by Daniel Fischer. Last but not least, this is about »surviving« in Germany. As a North German in diasporas, I was included by the Rhinelanders like never before on my migration through Germany. I want to really thank all my friends whose friendship I could gain in Brauweiler, Cologne and Düsseldorf since 2000. My »survival,« however, is only possible because of my extended family, scattered over North Germany, and the gist of the matter. Regina Berkowitz has accompanied me since that day in 1991 when we left Kiel together. In Essen-Werden, our two daughters Nora and Lynn were born; they have since then joined the march. It says in the essay »Family. The gist of the matter,« that » in the global village, there are many ways to organize the family.« I have found for myself the one and only way.

© 2008 Tandem Verlag GmbH
h.f.ullmann is an imprint of Tandem Verlag GmbH
ISBN for original German edition: 978-3-8331-4627-5

Editor: Hendrik Neubauer

Authors: Max Annas, Claudia Biehahn, Laura Engel, Bertram Job, Sören Köppen, Bernhard Mogge, Hendrik Neubauer, Gerd Christian Rolfs, Alfried Schmitz.

Art Director: Oliver Hessmann

Layout: Oliver Hessmann; Peggy Förster, Michael Herling, Bernd Oette.

Project coordination: Daniel Fischer (for h.f.ullmann), Robert von Radetzky (for neubauerkommunikation)

Image research: neubauerkommunikation, Anne Williams (h.f.ullmann)

Editorial: Robert von Radetzky, Tim Mücke

Proofreading: Argus Korrekturservice

Lithographer: Lup AG

© 2008 for the English edition: Tandem Verlag GmbH
h.f.ullmann is an imprint of Tandem Verlag GmbH

Translation from the German:

Maureen Basedow: Introductions, Agta, Aka, Basques, Ethno-Tourism, Hazara, Holy Places, Hopi, Hutu and Tutsi, Khampa, Lakota Sioux, Migration, Missionaries, Natural Medicine, Navajo, Penan, Planet Television, Public Health, Quechua, Rapanui, Roma, Sa, Sami, Santhal, Slavery, The Global Genome, The Papua Phenomenon, Tuareg, Tzotzil, Zulu, We will survive, Captions

Margaret Buchanan: Body Art, Colonialism, Inupiat, Jarawa, Kalaallit, Kayapo, Korowai, Lacandon, Masuane, San, Shamanism, Shuar, Sorbs, Tarahumara, Xhosa, Yanomami, Yoruba

Russell Cennydd: Ancestors, Amungme, Asmat, Badjo, Belief is Rhythm, Berber, Dani, Dinka, Fair Trade, Food, Frisians, Hawaiians, Himba, Hmong, Howeitat, Huli

Sue Pickett: Apache, Blackfoot, Celts, Inuit, Kaqchikel, Mongols, Shoshone

Christine Shuttleworth: Aborigines, Agni, Ainu, Armenians, Awá Guajá, Aymara, Bakhtiari, Dogon, Economy, Family, Fulbe, Herero, Kalasha, Kamayurá, Kikuyu, Kuna, Kurds, Mapuche, Massai, Maori, Mosuo, Mursi, Music, Ndebele, Nenets, Nuba, Palestinians, Senufo, Syncretism, Trash, Voodoo, Wa, Water, Zoé

Editorial: Kim Maya Sutton, William Sutton
English typesetting: Yvonne Schmitz
Project coordination: Daniel Fischer

Printed in China

ISBN 978-3-8331-4628-2

10 9 8 7 6 5 4 3 2 1

X IX VIII VII VI V IV III II I

www.ullmann-publishing.com